U0031153

陳澄波全集
CHEN CHENG-PO CORPUS
第四卷·速寫（I）
Volume 4 · Sketch（I）

策劃／財團法人陳澄波文化基金會
發行／財團法人陳澄波文化基金會
　　　中央研究院臺灣史研究所
出版／藝術家出版社

感 謝
APPRECIATE

文化部 Ministry of Culture

嘉義市政府 Chiayi City Government

臺北市立美術館 Taipei Fine Arts Museum

高雄市立美術館 Kaohsiung Museum of Fine Arts

台灣創價學會 Taiwan Soka Association

尊彩藝術中心 Liang Gallery

吳慧姬女士 Ms. WU HUI-CHI

陳澄波全集
CHEN CHENG-PO CORPUS

第四卷・速寫（Ⅰ）
Volume 4・Sketch（Ⅰ）

藝術家

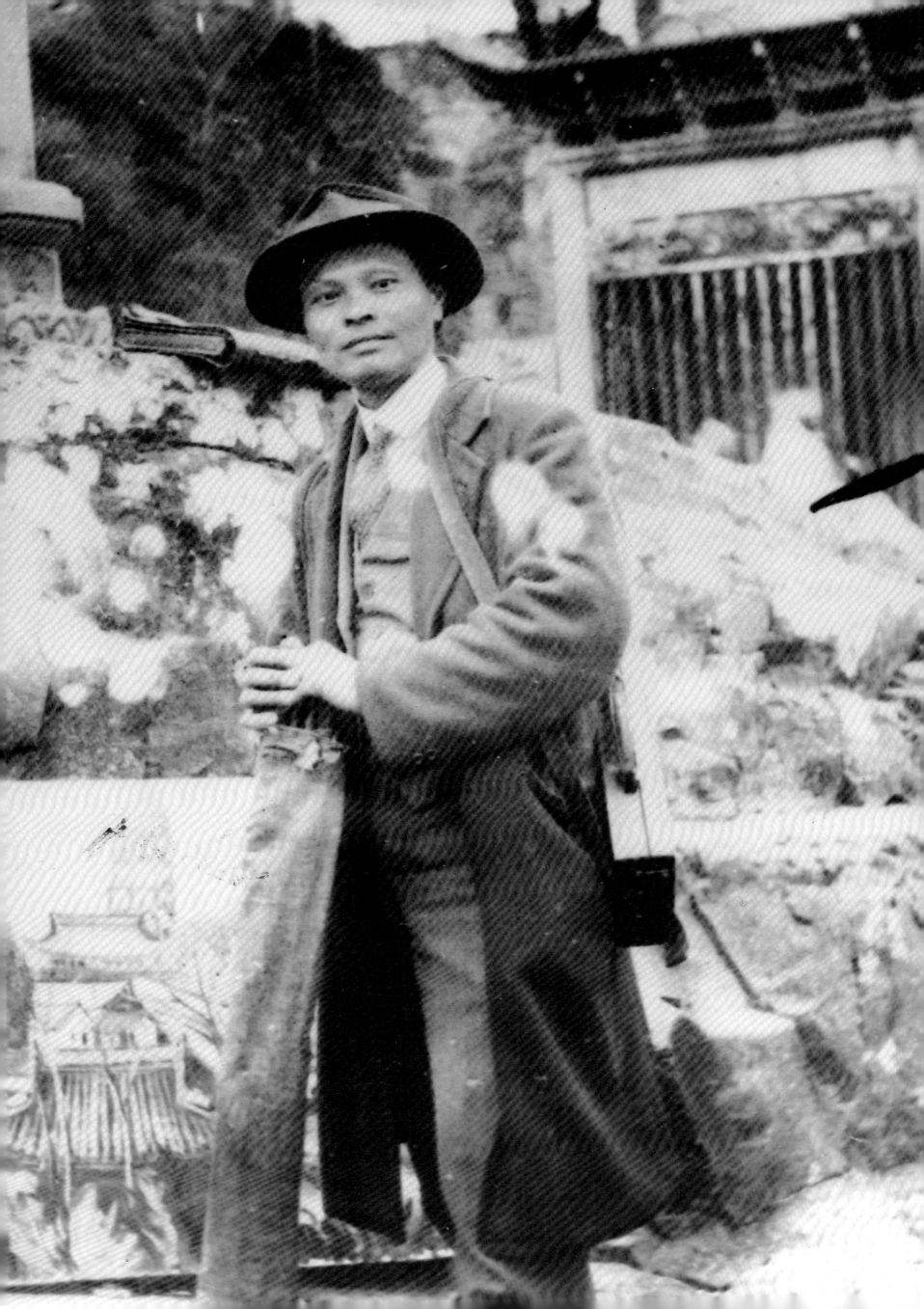

目　錄

Contents

榮譽董事長 序

　　家父陳澄波先生生於臺灣割讓給日本的乙未（1895）之年，罹難於戰後動亂的二二八事件（1947）之際。可以說：家父的生和死，都和歷史的事件有關；他本人也成了歷史的人物。

　　家父的不幸罹難，或許是一樁歷史的悲劇；但家父的一生，熱烈而精采，應該是一齣藝術的大戲。他是臺灣日治時期第一個油畫作品入選「帝展」的重要藝術家；他的一生，足跡跨越臺灣、日本、中國等地，居留上海期間，也榮膺多項要職與榮譽，可說是一位生活得極其精彩的成功藝術家。

　　個人幼年時期，曾和家母、家姊共赴上海，與父親團聚，度過一段相當愉快、難忘的時光。父親的榮光，對當時尚屬童稚的我，雖不能完全理解，但隨著年歲的增長，即使家父辭世多年，每每思及，仍覺益發同感驕傲。

　　父親的不幸罹難，伴隨而來的是政治的戒嚴與社會疑慮的眼光，但母親以她超凡的意志與勇氣，完好地保存了父親所有的文件、史料與畫作。即使隻紙片字，今日看來，都是如此地珍貴、難得。

　　感謝中央研究院翁啟惠院長和臺灣史研究所謝國興所長的應允共同出版，讓這些珍貴的史料、畫作，能夠從家族的手中，交付給社會，成為全民共有共享的資產；也感謝基金會所有董事的支持，尤其是總主編蕭瓊瑞教授和所有參與編輯撰文的學者們辛勞的付出。

　　期待家父的努力和家母的守成，都能夠透過這套《全集》的出版，讓社會大眾看到，給予他們應有的定位，也讓家父的成果成為下一代持續努力精進的基石。

　　我が父陳澄波は、台湾が日本に割譲された乙未（1895）の年に生まれ、戦後の騒乱の228事件（1947）の際に、乱に遭われて不審判で処刑されました。父の生と死は謂わば、歴史事件と関ったことだけではなく、その本人も歴史的な人物に成りました。

　　父の不幸な遭難は、一つの歴史の悲劇であるに違いません。だが、彼の生涯は、激しくて素晴らしいもので、一つの芸術の偉大なドラマであることとも言えよう。彼は、台湾の殖民時代に、初めで日本の「帝国美術展覧会」に入選した重要な芸術家です。彼の生涯のうちに、台湾は勿論、日本、中国各地を踏みました。上海に滞在していたうちに、要職と名誉が与えられました。それらの面から見れば、彼は、極めて成功した芸術家であるに違いません。

　　幼い時期、私は、家父との団欒のために、母と姉と一緒に上海に行き、すごく楽しくて忘れられない歳月を過ごしました。その時、尚幼い私にとって、父の輝き仕事が、完全に理解できなっかものです。だが、歳月の経つに連れて、父が亡くなった長い歳月を経たさえも、それらのことを思い出すと、彼の仕事が益々感心するようになりました。

　　父の政治上の不幸な非命の死のせいで、その後の戒厳令による厳しい状況と社会からの疑わしい眼差しの下で、母は非凡な意志と勇気をもって、父に関するあらゆる文献、資料と作品を完璧に保存しました。その中での僅かな資料であるさえも、今から見れば、貴重且大切なものになれるでしょう。

　　この度は、中央研究院長翁啟恵と台湾史研究所所長謝国興のお合意の上で、これらの貴重な文献、作品を共同に出版させました。終に、それらが家族の手から社会に渡され、我が文化の共同的な資源になりました。基金会の理事全員の支持を得ることを感謝するとともに、特に総編集者である蕭瓊瑞教授とあらゆる編輯作者たちのご苦労に心より謝意を申し上げます。

　　この《全集》の出版を通して、父の努力と母による父の遺物の守りということを皆さんに見せ、評価が下させられることを期待します。また、父の成果がその後の世代の精力的に努力し続ける基盤になれるものを深く望んでおります。

<div style="text-align: right">

財團法人陳澄波文化基金會
榮譽董事長　陳重光

</div>

Foreword from the Honorary Chairman

My father was born in the year Taiwan was ceded to Japan (1895) and died in the turbulent post-war period when the 228 Incident took place (1947). His life and death were closely related to historical events, and today, he himself has become a historical figure.

The death of my father may have been a part of a tragic event in history, but his life was a great repertoire in the world of art. One of his many oil paintings was the first by a Taiwanese artist featured in the Imperial Fine Arts Academy Exhibition. His life spanned Taiwan, Japan and China and during his residency in Shanghai, he held important positions in the art scene and obtained numerous honors. It can be said that he was a truly successful artist who lived an extremely colorful life.

When I was a child, I joined my father in Shanghai with my mother and elder sister where we spent some of the most pleasant and unforgettable days of our lives. Although I could not fully appreciate how venerated my father was at the time, as years passed and even after he left this world a long time ago, whenever I think of him, I am proud of him.

The unfortunate death of my father was followed by a period of martial law in Taiwan which led to suspicion and distrust by others towards our family. But with unrelenting will and courage, my mother managed to preserve my father's paintings, personal documents, and related historical references. Today, even a small piece of information has become a precious resource.

I would like to express gratitude to Wong Chi-huey, president of Academia Sinica, and Hsieh Kuo-hsing, director of the Institute of Taiwan History, for agreeing to publish the *Chen Cheng-po Corpus* together. It is through their effort that all the precious historical references and paintings are delivered from our hands to society and shared by all. I am also grateful for the generous support given by the Board of Directors of our foundation. Finally, I would like to give special thanks to Professor Hsiao Chong-ruy, our editor-in-chief, and all the scholars who participated in the editing and writing of the *Chen Cheng-po Corpus*.

Through the publication of the *Chen Cheng-po Corpus*, I hope the public will see how my father dedicated himself to painting, and how my mother protected his achievements. They deserve recognition from the society of Taiwan, and I believe my father's works can lay a solid foundation for the next generation of Taiwan artists.

Honorary Chairman, Chen Cheng-po Cultural Foundation
Chen Tsung-kuang

Chen, Tsung-kuang

院長 序

　　嘉義鄉賢陳澄波先生，是日治時期臺灣最具代表性的本土畫家之一，1926年他以西洋畫作〔嘉義街外〕入選日本畫壇最高榮譽的「日本帝國美術展覽會」，是當時臺灣籍畫家中的第一人；翌年再度以〔夏日街景〕入選「帝展」，奠定他在臺灣畫壇的先驅地位。1929年陳澄波完成在日本的專業繪畫教育，隨即應聘前往上海擔任新華藝術專校西畫教席，當時也是臺灣畫家第一人。然而陳澄波先生不僅僅是一位傑出的畫家而已，更重要的是他作為一個臺灣知識份子與文化人，在當時臺灣人面對中國、臺灣、日本之間複雜的民族、國家意識與文化認同問題上，反映在他的工作、經歷、思想等各方面的代表性，包括對傳統中華文化的繼承、臺灣地方文化與生活價值的重視（以及對臺灣土地與人民的熱愛）、日本近代性文化（以及透過日本而來的西方近代化）之吸收，加上戰後特殊時局下的不幸遭遇等，已使陳澄波先生成為近代臺灣史上的重要人物，我們今天要研究陳澄波，應該從臺灣歷史的整體宏觀角度切入，才能深入理解。

　　中央研究院臺灣史研究所此次受邀參與《陳澄波全集》的資料整輯與出版事宜，十分榮幸。臺史所近幾年在收集整理臺灣民間資料方面累積了不少成果，臺史所檔案館所收藏的臺灣各種官方與民間文書資料，包括實物與數位檔案，也相當具有特色，與各界合作將資料數位化整理保存的專業經驗十分豐富，在這個領域可說居於領導地位。我們相信臺灣歷史研究的深化需要多元的觀點與重層的探討，這一次臺史所有機會與財團法人陳澄波文化基金會合作共同出版陳澄波全集，以及後續協助建立數位資料庫，一方面有助於將陳澄波先生的相關資料以多元方式整體呈現，另一方面也代表在研究與建構臺灣歷史發展的主體性目標上，多了一項有力的材料與工具，值得大家珍惜善用。

臺北南港／中央研究院
院長　翁啟惠

Foreword from the President of the Academia Sinica

Mr. Chen Cheng-po, a notable citizen of Chiayi, was among the most representative painters of Taiwan during Japanese rule. In 1926, his oil painting *Chiayi Suburb* was featured in Imperial Fine Arts Academy Exhibition. This made him the first Taiwanese painter to ever attend the top-honor painting event. In the next year, his work *Summer Street* was selected again to the Imperial Exhibition, which secured a pioneering status for him in the local painting scene. In 1929, as soon as Chen completed his painting education in Japan, he headed for Shanghai under invitation to be an instructor of Western painting at Xinhua Art College. Such cordial treatment was unprecedented for Taiwanese painters. Chen was not just an excellent painter. As an intellectual his work, experience and thoughts in the face of the political turmoil in China, Taiwan and Japan, reflected the pivotal issues of national consciousness and cultural identification of all Taiwanese people. The issues included the passing on of Chinese cultural traditions, the respect for the local culture and values (and the love for the island and its people), and the acceptance of modern Japanese culture. Together with these elements and his unfortunate death in the post-war era, Chen became an important figure in the modern history of Taiwan. If we are to study the artist, we would definitely have to take a macroscopic view to fully understand him.

It is an honor for the Institute of Taiwan History of the Academia Sinica to participate in the editing and publishing of the *Chen Cheng-po Corpus*. The institute has achieved substantial results in collecting and archiving folk materials of Taiwan in recent years, the result an impressive archive of various official and folk documents, including objects and digital files. The institute has taken a pivotal role in digital archiving while working with professionals in different fields. We believe that varied views and multi-faceted discussion are needed to further the study of Taiwan history. By publishing the corpus with the Chen Cheng-po Cultural Foundation and providing assistance in building a digital database, the institute is given a wonderful chance to present the artist's literature in a diversified yet comprehensive way. In terms of developing and studying the subjectivity of Taiwan history, such a strong reference should always be cherished and utilized by all.

President of the Academic Sinica
Nangang, Taipei
Wong Chi-huey

總主編 序

作為臺灣第一代西畫家，陳澄波幾乎可以和「臺灣美術」劃上等號。這原因，不僅僅因為他是臺灣畫家中入選「帝國美術展覽會」（簡稱「帝展」）的第一人，更由於他對藝術創作的投入與堅持，以及對臺灣美術運動的推進與貢獻。

出生於乙未割臺之年（1895）的陳澄波，父親陳守愚先生是一位精通漢學的清末秀才；儘管童年的生活，主要是由祖母照顧，但陳澄波仍從父親身上傳承了深厚的漢學基礎與強烈的祖國意識。這些養分，日後都成為他藝術生命重要的動力。

1917年臺灣總督府國語學校畢業，1918年陳澄波便與同鄉的張捷女士結縭，並分發母校嘉義公學校服務，後調往郊區的水崛頭公學校。未久，便因對藝術創作的強烈慾望，在夫人的全力支持下，於1924年，服完六年義務教學後，毅然辭去人人稱羨的安定教職，前往日本留學，考入東京美術學校圖畫師範科。

1926年，東京美校三年級，便以〔嘉義街外〕一作，入選第七回「帝展」，為臺灣油畫家入選之第一人，震動全島。1927年，又以〔夏日街景〕再度入選。同年，本科結業，再入研究科深造。

1928年，作品〔龍山寺〕也獲第二屆「臺灣美術展覽會」（簡稱「臺展」）「特選」。隔年，東美畢業，即前往上海任教，先後擔任「新華藝專」西畫科主任教授，及「昌明藝專」、「藝苑研究所」等校西畫教授及主任等職。此外，亦代表中華民國參加芝加哥世界博覽會，同時入選全國十二代表畫家。其間，作品持續多次入選「帝展」及「臺展」，並於1929年獲「臺展」無鑑查展出資格。

居滬期間，陳澄波教學相長、奮力創作，留下許多大幅力作，均呈現特殊的現代主義思維。同時，他也積極參與新派畫家活動，如「決瀾社」的多次籌備會議。他生性活潑、熱力四射，與傳統國畫家和新派畫家均有深厚交誼。

唯1932年，爆發「一二八」上海事件，中日衝突，這位熱愛祖國的臺灣畫家，竟被以「日僑」身份，遭受排擠，險遭不測，並被迫於1933年離滬返臺。

返臺後的陳澄波，將全生命奉獻給故鄉，邀集同好，組成「臺陽美術協會」，每年舉辦年展及全島巡迴展，全力推動美術提升及普及的工作，影響深遠。個人創作亦於此時邁入高峰，色彩濃郁活潑，充份展現臺灣林木翁鬱、地貌豐美、人群和善的特色。

1945年，二次大戰終了，臺灣重回中國統治，他以興奮的心情，號召眾人學說「國語」，並加入「三民主義青年團」，同時膺任第一屆嘉義市參議會議員。1947年年初，爆發「二二八事件」，他代表市民前往水上機場協商、慰問，卻遭扣留羈押；並於3月25日上午，被押往嘉義火車站前廣場，槍決示眾，熱血流入他日夜描繪的故鄉黃泥土地，留給後人無限懷思。

陳澄波的遇難，成為戰後臺灣歷史中的一項禁忌，有關他的生平、作品，也在許多後輩的心中逐漸模糊淡忘。儘管隨著政治的逐漸解嚴，部份作品開始重新出土，並在國際拍賣場上屢創新高；但學界對他的生平、創作之理解，仍停留在有限的資料及作品上，對其獨特的思維與風格，也難以一窺全貌，更遑論一般社會大眾。

以「政治受難者」的角色來認識陳澄波，對這位一生奉獻給藝術的畫家而言，顯然是不公平的。歷經三代人的含冤、忍辱、保存，陳澄波大量的資料、畫作，首次披露在社會大眾的面前，這當中還不包括那些因白蟻蛀蝕而毀壞的許多作品。

個人有幸在1994年，陳澄波百年誕辰的「陳澄波・嘉義人學術研討會」中，首次以「視覺恆常性」的角度，試圖詮釋陳氏那種極具個人獨特風格的作品；也得識陳澄波的長公子陳重光老師，得悉陳澄波的作品、資料，如何一路從

夫人張捷女士的手中，交到重光老師的手上，那是一段滄桑而艱辛的歷史。大約兩年前〔2010〕，重光老師的長子立栢先生，從職場退休，在東南亞成功的企業經營經驗，讓他面對祖父的這批文件、史料及作品時，迅速地知覺這是一批不僅屬於家族，也是臺灣社會，乃至近代歷史的珍貴文化資產，必須要有一些積極的作為，進行永久性的保存與安置。於是大規模作品修復的工作迅速展開：2011年至2012年之際，兩個大型的紀念展：「刋切故鄉情」與「行過江南」，也在高雄市立美術館、臺北市立美術館先後且重疊地推出。眾人才驚訝這位生命不幸中斷的藝術家，竟然留下如此大批精采的畫作，顯然真正的「陳澄波研究」才剛要展開。

基於為藝術家留下儘可能完整的生命記錄，也基於為臺灣歷史文化保留一份長久被壓縮、忽略的珍貴資產，《陳澄波全集》在眾人的努力下，正式啟動。這套全集，合計十八卷，前十卷為大八開的巨型精裝圖版畫冊，分別為：第一卷的油畫，搜羅包括僅存黑白圖版的作品，約近300餘幅；第二卷為炭筆素描、水彩畫、膠彩畫、水墨畫及書法等，合計約241件；第三卷為淡彩速寫，約400餘件，其中淡彩裸女占最大部份，也是最具特色的精采力作；第四卷為速寫（Ｉ），包括單張速寫約1103件；第5卷為速寫（II），分別出自38本素描簿中的約1200餘幅作品；第六、七卷為個人史料（Ｉ）、（II），分別包括陳氏家族照片、個人照片、書信、文書、史料等；第八、九卷為陳氏收藏，包括相當完整的「帝展」明信片，以及各式畫冊、圖書；第十卷為相關文獻資料，即他人對陳氏的研究、介紹、展覽及相關周邊產品。

至於第十一至十八卷，為十六開本的軟精裝，以文字為主，分別包括：第十一卷的陳氏文稿及筆記；第十二、十三卷的評論集，即歷來對陳氏作品研究的文章彙集；第十四卷的二二八相關史料，以和陳氏相關者為主；第十五至十七卷，為陳氏作品歷年來的修復報告及材料分析；第十八卷則為陳氏年譜，試圖立體化地呈現藝術家生命史。

對臺灣歷史而言，陳澄波不只是個傑出且重要的畫家，同時他也是一個影響臺灣深遠（不論他的生或他的死）的歷史人物。《陳澄波全集》由財團法人陳澄波文化基金會和中央研究院臺灣史研究所共同發行出版，正是名實合一地呈現了這樣的意義。

感謝為《全集》各冊盡心分勞的學界朋友們，也感謝執行編輯賴鈴如、何冠儀兩位小姐的辛勞；同時要謝謝藝術家出版社何政廣社長，尤其他的得力助手美編柯美麗小姐不厭其煩的付出。當然《全集》的出版，背後最重要的推手，還是陳重光老師和他的長公子立栢夫婦，以及整個家族的支持。這件歷史性的工程，將為臺灣歷史增添無限光采與榮耀。

<div align="right">

《陳澄波全集》總主編
國立成功大學歷史系所教授 蕭瓊瑞

</div>

Foreword from the Editor-in-Chief

As an important first-generation painter, the name Chen Cheng-po is virtually synonymous with Taiwan fine arts. Not only was Chen the first Taiwanese artist featured in the Imperial Fine Arts Academy Exhibition (called "Imperial Exhibition" hereafter), but he also dedicated his life toward artistic creation and the advocacy of art in Taiwan.

Chen Cheng-po was born in 1895, the year Qing Dynasty China ceded Taiwan to Imperial Japan. His father, Chen Shou-yu, was a Chinese imperial scholar proficient in Sinology. Although Chen's childhood years were spent mostly with his grandmother, a solid foundation of Sinology and a strong sense of patriotism were fostered by his father. Both became Chen's Office impetus for pursuing an artistic career later on.

In 1917, Chen Cheng-po graduated from the Taiwan Governor-General's Office National Language School. In 1918, he married his hometown sweetheart Chang Jie. He was assigned a teaching post at his alma mater, the Chiayi Public School and later transferred to the suburban Shuikutou Public School. Chen resigned from the much envied post in 1924 after six years of compulsory teaching service. With the full support of his wife, he began to explore his strong desire for artistic creation. He then travelled to Japan and was admitted into the Teacher Training Department of the Tokyo School of Fine Arts.

In 1926, during his junior year, Chen's oil painting *Outside Chiayi Street* was featured in the 7th Imperial Exhibition. His selection caused a sensation in Taiwan as it was the first time a local oil painter was included in the exhibition. Chen was featured at the exhibition again in 1927 with *Summer Street Scene*. That same year, he completed his undergraduate studies and entered the graduate program at Tokyo School of Fine Arts.

In 1928, Chen's painting *Longshan Temple* was awarded the Special Selection prize at the second Taiwan Fine Arts Exhibition (called "Taiwan Exhibition" hereafter). After he graduated the next year, Chen went straight to Shanghai to take up a teaching post. There, Chen taught as a Professor and Dean of the Western Painting Departments of the Xinhua Art College, Changming Art School, and Yiyuan Painting Research Institute. During this period, his painting represented the Republic of China at the Chicago World Fair, and he was selected to the list of Top Twelve National Painters. Chen's works also featured in the Imperial Exhibition and the Taiwan Exhibition many more times, and in 1929 he gained audit exemption from the Taiwan Exhibition.

During his residency in Shanghai, Chen Cheng-po spared no effort toward the creation of art, completing several large-sized paintings that manifested distinct modernist thinking of the time. He also actively participated in modernist painting events, such as the many preparatory meetings of the Dike-breaking Club. Chen's outgoing and enthusiastic personality helped him form deep bonds with both traditional and modernist Chinese painters.

Yet in 1932, with the outbreak of the 128 Incident in Shanghai, the local Chinese and Japanese communities clashed. Chen was outcast by locals because of his Japanese expatriate status and nearly lost his life amidst the chaos. Ultimately, he was forced to return to Taiwan in 1933.

On his return, Chen devoted himself to his homeland. He invited like-minded enthusiasts to found the Tai Yang Art Society, which held annual exhibitions and tours to promote art to the general public. The association was immensely successful and had a profound influence on the development and advocacy for fine arts in Taiwan. It was during this period that Chen's creative expression climaxed — his use of strong and lively colors fully expressed the verdant forests, breathtaking landscape and friendly people of Taiwan.

When the Second World War ended in 1945, Taiwan returned to Chinese control. Chen eagerly called on everyone around him to adopt the new national language, Mandarin. He also joined the Three Principles of the People Youth Corps, and served as a councilor of the Chiayi City Council in its first term. Not long after, the 228 Incident broke out in early 1947. On behalf of the Chiayi citizens, he went to the Shueishang Airport to negotiate with and appease Kuomintang troops, but instead was detained and imprisoned without trial. On the morning of March 25, he was publicly executed at the Chiayi Train Station Plaza. His warm blood flowed down onto the land which he had painted day and night, leaving only his works and memories for future generations.

The unjust execution of Chen Cheng-po became a taboo topic in postwar Taiwan's history. His life and works were gradually lost to the minds of the younger generation. It was not until martial law was lifted that some of Chen's works re-emerged and were sold at record-breaking prices at international auctions. Even so, the academia had little to go on about his life and works due to scarce resources. It was a difficult task for most scholars to research and develop a comprehensive view of Chen's unique philosophy and style given the limited resources available, let alone for the general public.

Clearly, it is unjust to perceive Chen, a painter who dedicated his whole life to art, as a mere political victim. After three generations of

suffering from injustice and humiliation, along with difficulties in the preservation of his works, the time has come for his descendants to finally reveal a large quantity of Chen's paintings and related materials to the public. Many other works have been damaged by termites.

I was honored to have participated in the "A Soul of Chiayi: A Centennial Exhibition of Chen Cheng-po" symposium in celebration of the artist's hundredth birthday in 1994. At that time, I analyzed Chen's unique style using the concept of visual constancy. It was also at the seminar that I met Chen Chung-kuang, Chen Cheng-po's eldest son. I learned how the artist's works and documents had been painstakingly preserved by his wife Chang Chie before they were passed down to their son. About two years ago, in 2010, Chen Chung-kuang's eldest son, Chen Li-bo, retired. As a successful entrepreneur in Southeast Asia, he quickly realized that the paintings and documents were precious cultural assets not only to his own family, but also to Taiwan society and its modern history. Actions were soon taken for the permanent preservation of Chen Cheng-po's works, beginning with a massive restoration project. At the turn of 2011 and 2012, two large-scale commemorative exhibitions that featured Chen Cheng-po's works launched with overlapping exhibition periods — "Nostalgia in the Vast Universe" at the Kaohsiung Museum of Fine Arts and "Journey through Jiangnan" at the Taipei Fine Arts Museum. Both exhibits surprised the general public with the sheer number of his works that had never seen the light of day. From the warm reception of viewers, it is fair to say that the Chen Cheng-po research effort has truly begun.

In order to keep a complete record of the artist's life, and to preserve these long-repressed cultural assets of Taiwan, we publish the *Chen Cheng-po Corpus* in joint effort with coworkers and friends. The works are presented in 18 volumes, the first 10 of which come in hardcover octavo deluxe form. The first volume features nearly 300 oil paintings, including those for which only black-and-white images exist. The second volume consists of 241 calligraphy, ink wash painting, glue color painting, charcoal sketch, watercolor, and other works. The third volume contains more than 400 watercolor sketches most powerfully delivered works that feature female nudes. The fourth volume includes 1,103 sketches. The fifth volume comprises 1,200 sketches selected from Chen's 38 sketchbooks. The artist's personal historic materials are included in the sixth and seventh volumes. The materials include his family photos, individual photo shots, letters, and paper documents. The eighth and ninth volumes contain a complete collection of Empire Art Exhibition postcards, relevant collections, literature, and resources. The tenth volume consists of research done on Chen Cheng-po, exhibition material, and other related information.

Volumes eleven to eighteen are paperback decimo-sexto copies mainly consisting of Chen's writings and notes. The eleventh volume comprises articles and notes written by Chen. The twelfth and thirteenth volumes contain studies on Chen. The historical materials on the 228 Incident included in the fourteenth volumes are mostly focused on Chen. The fifteen to seventeen volumes focus on restoration reports and materials analysis of Chen's artworks. The eighteenth volume features Chen's chronology, so as to more vividly present the artist's life.

Chen Cheng-po was more than a painting master to Taiwan — his life and death cast lasting influence on the Island's history. The *Chen Cheng-po Corpus*, jointly published by the Chen Cheng-po Cultural Foundation and the Institute of Taiwan History of Academia Sinica, manifests Chen's importance both in form and in content.

I am grateful to the scholar friends who went out of their way to share the burden of compiling the corpus; to executive editors Lai Ling-ju and Ho Kuan-yi for their great support; and Ho Cheng-kuang, president of Artist Publishing co. and his capable art editor Ke Mei-li for their patience and support. For sure, I owe the most gratitude to Chen Tsung-kuang; his eldest son Li-po and his wife Hui-ling; and the entire Chen family for their support and encouragement in the course of publication. This historic project will bring unlimited glamour and glory to the history of Taiwan.

Editor-in-Chief, *Chen Cheng-po Corpus*
Professor, Department of History, National Cheng Kung University
Hsiao Chong-ray

Chong-ray Hsiao

速寫，作為藝術創作的一種表現
──陳澄波人體速寫作品導讀

前言

在陳澄波的藝術創作裡，我們相當訝異地發現大量的人物速寫，尤其是人體速寫。本文將以陳澄波的人體速寫為主題，交探討在其藝術養成及藝術創作中的一些可能線索。綜觀陳澄波一生的繪畫創作，無論在質或量方面均相當的豐碩，近年來國內藝壇都密集舉辦他的大型展覽，特別是從2011年高美館的「切切故鄉情──陳澄波紀念展」、2012年北美館的「行過江南──陳澄波藝術探索歷程」兩個展覽，我們終於能比較大規模的欣賞到陳澄波的繪畫作品。正當我們訝異於他的油畫作品包括風景及人物的創作風格，是如此的具有個人特質與特殊面貌，我們是否也同時想一探其藝術風格形成的可能因由。在上述兩展中，我們有另一個驚訝！那就是大量的速寫作品的面世，特別是人體速寫。

當然，速寫作品更貼近藝術家的當下創作思維，甚至是意識的反射；因此，速寫也可說是藝術家創作思維的密碼。本卷所收集之內容，全為陳澄波的速寫作品，其創作年代多數介於1925-1932年之間，包含日本留學時期（1925-1929）、及上海時期（1929-1932）；其中絕大多數之創作主題為單一女體，另有少數作品是兩女體以上的畫面構成，以及有人物為點景的風景速寫。陳澄波在日本求學的階段，人體的觀察與表現本來就是日本當時學院中美術課程訓練的重點，且前往上海任教新華藝專等校期間的美術氛圍，因為1920年代劉海粟掀起的裸體畫浪潮，與1928年潘玉良從法國帶回來「巴黎畫派」色彩的人體繪畫，使得人體繪畫在當時的上海各個美術學院的課堂上備受重視。陳澄波一個是扮演日本留學時期求學者的角色；另一個是上海時期教學者的角色，而他在人體速寫上所下的工夫究竟影響如何？若以本卷的速寫作品當線索，或可顯示出陳澄波在各個創作階段所潛伏的藝術思維。

一、速寫，驚嘆號！

速寫在技術表現的比擬，如同弦樂器的演奏，右手持弓擦弦─拉、推、跳、顫；左手移指按弦─壓、揉、滑、挑，一曲精湛的演奏，常能扣人心弦。速寫，從字義的理解上可解釋為─快速描寫、快速寫生、快速描繪等，無論創作者以速寫作為何種創作上的訴求，速寫在特質上所顯現的是短時間內的繪畫創作，諸如：即興創作、隨意線條記錄、快速掌握對象姿態特點與神韻、快速呈現創作者當時的心境……；或因為考量創作的便利性、即時性，以及對於繪畫材料的實驗性，甚至藝術觀念的表達……，速寫已不只是一種滿足可短時間內創作出大量作品的創作技術，它更可精準的傳達出創作者的藝術思維。

誠如《中國現代美術全集20：速寫》主編李路明所說：「速寫與寫生由於兩者模糊性而難以給予明晰的界定，就像素描與速寫也從來不是兩個並行的藝術學科，它們的交叉性是一個基本事實。」[1]因此，本文所述及「速寫」一詞，其詞意或已擴充並與素描、寫生之認知相交叉。陳澄波的速寫在臺灣美術史的論述中是一個驚嘆號！相同的，從速寫的發展歷程來看，它也是人類文化的一個驚嘆號！人類的繪畫並非一開始就進入典雅形式，無論東方或西方美術，總得經歷過一段冗長的過程及意識的覺醒，才發展出具普遍性的美感內容。在理想性美感的出現之前，繪畫應該是「野性的」，它是相對於文字、語言的一種圖像表達方式並且充滿想像性與創造性；它跟人類生活應該是緊密結合的，在不同的地區，會慢慢形成該區域的一種文明表達方式。如同現在我們已經發現包括舊石器時期的洞穴壁畫及史前出土的陶瓶紋飾，這些原始時期藝術的表現方式大部分都是速寫，那種充滿野趣、生動的線性圖飾，在在已經揭示了人類繪畫創作的才華。也許我們可以這麼說，速寫是人類共通的繪畫語言，所以速寫和音樂、舞蹈一般，流露著人類強烈的情感，活靈活現的表露出我們潛在的思維與情感。

二、速寫—作為一種創作技術訓練與藝術的表達

從上述中我們理解了速寫作為一種藝術的表達，它表露出我們潛在的思維與情感。但我們可以進一步追問藝術家在從事速寫時可能的動機？或在速寫的創作中藝術家想要追尋及表現的意圖？其一，從「再現」的角度來看，也許是客體形象給予藝術家強烈的感受，而客體形象的呈現又是短暫的，當下的視覺記憶與感受無法一直持續維持，藝術家想快速抓取看到的或感受到的客體形象，此時速寫便可克服此條件並滿足藝術家的創作需求。西洋在十九世紀後半葉出現的印象畫派主要的藝術理念之一，便是以快速的短筆觸，來捕捉稍縱即逝的光線變化與瞬間動態的客體形象，其中羅特列克（Toulouse Lautrec, 1864-1901）與羅丹（Augeuste Rodin, 1840-1917）更是以迅捷的流性線條，表現出舞蹈者在擺動身體的瞬間形象；另也許是客體形象符合藝術家的美感品味與創作主題，他必須使用大量的速寫去強化自己的視覺記憶，累積自己的視覺經驗與感受，以方便之後能依據自己的視覺記憶、視覺經驗與感受來輔助藝術創作表現。羅丹美術館主任研究員克勞蒂‧瞿德翰（Claudie Judrin）說：「羅丹從中（指素描）學習到兩點，一是要捕捉鮮活的摹寫實物，另外一點則是要運用眼睛的記憶。……臨摹是學習的手段，而記憶的重現是羅丹年輕時常作的練習。」[2]；中國傳統水墨畫系統特別重視這樣的工夫，藝術家們可以在自己的畫室，表現視覺經驗中的大山、大水與花石、禽鳥、走獸等。

其二，從「創作技術」的角度來看，速寫是一種創作技術的自我訓練，透過速寫，創作者可以單純對所描繪的對象，做整體結構的觀察力訓練及創作技術訓練，養成及開創出藝術創作技術的可能。就以羅丹為例，他在論及自己的立體雕塑與素描之間的關係時表示：「這其實很簡單，我的素描是我作品的鎖鑰，我的雕塑只是立體展現的素描。」[3]1883年羅丹和詩人雨果（Victor-Marie Hugo, 1802-1885）會面，想為他製作半身胸像，雨果對羅丹說：「我沒辦法為你擺姿勢，但我很樂意接待你，儘管來寒舍用早餐、晚餐，你就像記小抄般地畫速寫，你將發現這樣就足夠了。」[4]這次的會面羅丹一共為雨果畫了60幾張的速寫。速寫在某些層面來說就是素描的現代性，羅丹的素描其實絕大部分是速寫，他說「線條的速度要跟上敏捷的目光，只有非常成熟的技巧才能如此靈巧敏捷。」[5]只有速寫才能傳達他表現人物瞬間動態的創作理念，因此每一張速寫創作的進行，都具有時間與空間的雙重意涵；每一件立體雕塑創作的進行，就如當下的一次速寫創作，速寫成為羅丹從事藝術創作的重要「創作技術」。

李路明在論及近代中國水墨大師齊白石時認為：「在齊白石的觀念中，肯定沒有我們今天所持有的有關『速寫』的定義。但是以較短的時間面對實物進行寫生卻是他一貫的作法，而且正是這種藝術態度的堅持使他後來能有氣魄來改良傳統花鳥畫……齊白石不少作品我們的確無法排除它們的『速寫』意味，尤其是他大量的運用大寫意手法來寫生實景實物一類作品。」[6]齊白石以觀察寫生突破了傳統花鳥畫的格局，從他筆下的田蛙、河蝦與螃蟹，可以看到他從繁複的結構中做出最純化的圖像表現，而他的筆墨工夫及獨特的創作手法之養成，便是得力於大量的速寫經驗。在反覆的速寫創作自我訓練中，熟練所欠缺的下筆精準度，或者是線條使用的可能性；速寫也可單純作為一種藝術的表達，藝術家可以使用速寫成為創作的表現。不同於齊白石的經驗，中國近代水墨大師黃賓虹所追求的藝術境界，不是一種只重視下筆精準的形象描繪，李路明說：「黃賓虹對運用傳統筆墨來描寫『真山水』有一種極為執著而堅定的信念，在這個當時看來是非凡的信念的支持下，畫下了大量的速寫式的山水寫生稿。這些精彩的山水寫生稿與創作的界限相當模糊，有些速寫性的作品實際上便是一幅完整的作品，這也是黃賓虹藝術創作的一大特徵。」[7]相對於齊白石大刀闊斧的簡鍊筆墨，黃賓虹以樸拙的繁筆面對眼前的山水景色做速寫性的寫生，而其所堅持的速寫創作表現的風格，也就成了他承繼傳統水墨並開創新局的重要關鍵。

三、「本我」中的非理性意識與「快速描繪」

　　從傳統的角度來看古典素描與速寫的分別，若以繪畫時間的長短來作區別，通常長時間經營的為素描，短時間完成的為速寫。因此素描作品相對於速寫作品較具理性，著重觀察，對於細節的表現也比較充分，對於畫面上的情境表現的掌握與創作的意向性也比較明確。相對的來看，「速寫」就會因為創作時間較短、線條的表現的速度較快速，因此較具「非理性」特質。「非理性」特質是一種由創作者本能內在的需求所引發的衝動與能量，在強大的驅動力中完成作品。

　　非理性線條在表現風格上相對於理性的線條，它跨越理性的制約，是一種藝術家創作的內在潛能，具有瞬間的爆發性。20世紀初是現代藝術與新學科百花齊放的時代，非理性線條的表現，來自如同佛洛依德（Sigmund Freud, 1856-1919）在其精神分析心理學所謂的個人無意識（非理性）之原始衝動和各種本能（Libido）。[8]非理性不等於不理性，它是個人無意識裡「本我」[9]的一種潛在特質，因此速寫的創作其實更接近創作者的本能。通常速寫線條的表現越接近「快速描繪」，則線條的表現越能超越理性的控制，在快速描繪的表現之中把理性的制約拋離在後，讓藝術表現脫離舊美感經驗的束縛，以追求最高的自由。相對於古典素描的理性，速寫因擁有線條簡潔與快速度繪畫的表現特質，因此可以快速掌握畫面的核心骨架結構及純化的外形，表現出不同於古典素描的趣味性筆觸及誇張線條；因為快速度繪畫，所以呈現出瞬間性、即時性、爆發性、偶發性等感性及隨性即發的非理性線條。

四、人體速寫的繪畫表現

　　以人體作為藝術創作的主題源自西元前450年的古希臘古典主義時期，古希臘人認為人體是諸神所創造最優美的形式，古希臘人以大理石所創作的諸神形象，便是以最優美的人體形式做為表徵，並成為西洋藝術的濫觴。而西洋美術的大放異彩為西元第15、16世紀的文藝復興，文藝復興所復興的便是古希臘、羅馬的藝術與文化。以人物畫來說，15世紀人文主義興起，相對於中世紀基督教（神性）文明，人類文化的探討與揭發，成為當時期的重要命題。從回歸最基礎的個人、社會及民族文化的差異，云云　生成了演繹每一個時代歷程的最佳註解。而人體繪畫自是文藝復興以降五百年來畫者所不斷挑戰的對象，人體骨架、肌肉所蘊含的複雜結構，甚至人類深沈易感的心靈，在每一個時代，成就了多少世界級的藝術大師，經由他們所創作的人物畫，引領觀者回到每一個時代的現場，與之相會神遊。

　　西洋美術自文藝復興開始，藝術家以科學的方式，透過人體解剖的知識，從人體內部的骨骼架構、肌肉走向與運動工學，並經由明暗對比技法，在二度平面的畫布上，虛擬表現出立體的寫實呈現，以追求視覺的真實性。雖然各個時代的美術思潮在明暗光影、色彩觀念、線條筆觸等形式要素中，創造了藝術家的個人風格，但人體解剖的科學知識，一直都是扮演著重要的角色。一直到19世紀下半葉，五百年來的人物繪畫，才有了突破性的發展。

　　再現視覺的真實性是傳統西洋繪畫在創作技術上的一項指標，被尊稱為現代繪畫之父的保羅・塞尚（Paul Cezanne, 1839-1906）所提出的「將大自然界的所有物體歸納為圓球體、圓柱體、圓錐體與方體」的造形理念，開展出視覺藝術的新的一頁。就以人物繪畫來說，畫面中的人物不再以解剖學的知識為依據，反之是以畫面的整體結構與視覺平衡為主，他的理念啟發了往後發展的野獸派、立體派……等各個現代繪畫流派，人物繪畫的表現當然也就更多樣性了。從具解剖學的傳統人物畫到純視覺結構的現代人物繪畫，想必19世紀末至今的藝術家們，無不想建立自己的繪畫語彙。在近代歐洲以快速描繪來呈現人物繪畫創作，表現極出色的藝術家除了前述的羅丹與羅特列克外，諸如杜米埃（Honoré Daumier, 1808-1879）、席勒（Egon Schiele, 1890-1918）……等，我們均可以從他們的作品中，看到藝術家所賦予的

每一根線條、筆觸的能量張力，在突破所有的前人影響之後，所有的線條、筆觸都因為其唯一的獨特性，進而形塑了藝術家的創作風格，所有的線條、筆觸也成了我們辨識藝術家的藝術符號。速寫對於藝術家而言，是一種自我突破及追求藝術創作自由的重要表現方式。

速寫對於藝術創作者，有其一定的重要性，尤其是無意識（非理性）的快速描繪，創作的時間越短越壓縮，越能呈現本能的反射，突破理性與繪畫的慣性，讓繪畫的表現不斷獲得新的自由，而不受侷限。面對西洋美術現代性的議題，研究中國現代美術的李路明表示：「與此同時，更多的藝術家由於本世紀初西方文化的大規模介入而擁有了明確而獨立的『速寫』觀念。速寫作為一個藝術家當擁有的經常性的創作輔助手段，成為一種較為普遍的現象。」[10]因此，快速描繪更是畫者挑戰自我創作極限的價值也就毋庸置疑，這當然也直接影響到二十世紀之後的日本、中國大陸和臺灣的學院美術及藝術生態。

五、日本明治時期美術的風起雲湧及其影響

19世紀的亞洲面對西歐強勢文化壓迫，不得不救亡圖存，急速歐化。日本在明治維新以後，奮力追求人文科學技術以創造富國強兵的現代國家，隨之，在美術界積極引進西方寫實主義，在美學、美術史學及藝術學方面亦逐漸紮根苗壯，其得到的成果也在往後影響處於殖民地的臺灣。陳澄波1924年到了日本，進入了東京美術學校接受日本美術學院的藝術教育，他藝術觀念的養成與對藝術理念的追尋與當時日本的藝術風潮必有相對之關係。本小節以探索日本明治時期的美學思潮，進而試圖探尋陳澄波在繪畫創作理念的思維成因。

日本明治時期因為全盤西化，因此美術界一味追求逼真的西方美術形式，然而1882年（明治15年）5月在龍池會所舉行的費諾羅沙（Earnest Fenollosa, 1853-1908）[11]「美術真說」講演中，費諾羅沙表示：「美術的性質無疑地存在其事物本體當中。然而，其性質，在於靜坐澄澈心靈而對此加以凝視之際，宛如神馳魂飛，爽然忘我。」[12]費諾羅沙於美術真說所表達的意涵應是心靈的審美，他認為事物的本體應該存在著一種美的性質，也就是因為這種美的性質，讓所有觀看它的人，都能夠在心靈上達到一種極高的享受。前述所提到的美的性質，或也可以理解為美的本質，為詮釋甚麼是美的本質，費諾羅沙說：「保有各分子相互之間的內部關係，始終相依、產生完全唯一的感覺，稱此為美術妙想。」也就是說費諾羅沙以為美術之所以為美術，端賴「妙想」。

費諾羅沙的「美術真說」演講，讓日本明治時期美術界一味追求逼真的西方美術傾向起了轉變，並且擁有多數的支持者，進而轉向傳統日本美術的復興。為了幫助大家理解「妙想」之意，費諾羅沙進一步說「文人畫主要並非模擬天然實物，就此點而言，應可稍勝，不離文學之妙想……視文人畫當為雙眼所見的真誠之畫，則雙眼視畫應如同理解音樂一般。」[13]從文中我們可以會意費諾羅沙認為富有妙想的文人畫，應該可以與文學或音樂相比擬，它不是現實的再現，而是在心靈中揚昇的一種靈光，跨越東方與西方的差異，而達到繪畫的理想性。以「妙想」作為藝術品質的判斷，費諾羅沙引領我們進一步地探索的「妙想」概念，費諾羅沙以為：「當時的西歐畫家大多傾向實物模寫，妙想的表現變成愚昧，日本畫並非追求寫實，妙想的表現上較為出色。」[14]在此，費諾羅沙的「妙想」之論，指出了繪畫的純粹性，而這也是世界近代美術的主流形式，費諾羅沙從歐化寫實主義的反省中，指引出以「妙想」作為日本繪畫的新主流。

認同費諾羅沙理念的東京美術學校第一任校長岡倉天心（1863-1913）[15]，本來就對移植的歐化政策保持戒心，面對日本文化的全盤西化，他從東方文化的角度指出東西文明本質的差異，並試圖在傳統的基礎之上，開闢日本邁向未來的新道路。在此尋找時代定位與新精神的關鍵時刻，天心對東京美術學校學生指出了新方針：「余勉諸君以下數言：「若

徒模仿古人者必亡，此乃歷史所證。應勉凝視系統而進，研究國故，更為前進。宜參考西畫。雖此，應要以己為主，以彼為輔，以求進步。」[16]岡倉天心主張可以接受吸收西歐文化、藝術的精神態度，但並非全盤地接收。他主張面對西歐文化應該「以己為主，以彼為客」、「凝視系統而進」，並將其移植到日本精神傳統土壤之上，為日本文化注入新養份。

除了以東方文化的角度來審視西歐文化的植入，岡倉天心在東方性藝術上積極提出「書畫一致」的審美意識：「西方繪畫與雕刻並進，東方繪畫則與書法同行。因此，西方繪畫注重陰影，相反地東方繪畫則是藉重線條粗細，從而表現陰影。『諺語有言，善書者能畫。』因此，筆力者，東方繪畫之基本，據此得以貫穿古今。」[17]東方繪畫重視線條粗細，因此岡倉天心強調用筆的妙味，他說：「基於東方繪畫與書法的聯繫，用筆成為繪畫的精神，因為不僅止於形象之妙，而且當有用筆的妙味。西方繪畫用陰影，至於線條，並非幾何學上的存在，只表示形狀的輪廓。東方繪畫用筆，線有肥瘦，筆中得以表現妙意。總之，不管如何，東方美術的精神，不應離開用筆的表現。」[18]費諾羅沙的「妙想」之論，讓「日本」美的意識有了自我肯定的覺醒，岡倉天心的「東方性藝術」的審美意識，讓「日本」美的意識更具擴張性的意義，其不僅是「日本」美且是「東方」美的審美意識。岡倉天心的思想，經常被引用的就是「東洋的理想─亞洲一體」，這也是日本浪漫派人士推崇天心為「大東亞共榮圈」的理想先知的原因。

明治乃日本史上最富自覺的時代，從明治15年（1882）5月在龍池會所舉行的費諾羅沙「美術真說」講演所引發的「日本」美意識，到五年後東京美術學校（1987）的創立，首任校長岡倉天心提出「東方性藝術」乃至「東洋的理想─亞洲一體」的思想理念。東京美術學校從日本這樣的自覺性精神，將對日本後代的藝術發展持續著潛移默化的作用。1924年就學於東京美術學校的陳澄波，在繪畫創作理念的思維上，應該也從日本美術史的發展脈絡與精神思維中獲得啟發。

六、中國現代美術風潮

陳澄波於1929年3月畢業於日本東京美術學校研究科，之後任教於中國上海的新華藝專等美術學堂，並因日本的侵華戰爭之故於1933年離開中國大陸回到臺灣，因此中國大陸在1920及30年代初的現代美術風潮，必然影響著陳澄波的藝術創作與思維。本小節以中國近代藝術家在20世紀初的藝術自覺，以及美術學堂的繪畫改革作為論述的重點，以了解身在同樣時空的陳澄波對於速寫創作的理念與藝術風格。

日本從明治維新的全盤西化，在美術方面派遣留學生到歐洲習畫，追尋歐洲學院藝術的表現風格，以至「美術真說」所引發的日本美術自覺，以及東京美術學校兼容並蓄於1898年增設西洋畫科教授西洋近代美術。中國大陸也於20世紀初在勤工儉學的風潮下，一大批的中國留學生遠赴國外學習。當時留學法國並從藝術之都巴黎帶回最新式的歐洲美術的劉海粟、徐悲鴻、林風眠……等，與留學美國的李鐵夫、留學日本的高劍父、李叔同，他們都同時積極的從事藝術革命，更把這樣的美術風格根植於中國大陸的美術學院，並且蔚為風潮。相對於日本明治時期「日本」美的審美意識自覺，中國大陸的美術學堂正興起一股藝術改革的風潮。

從傳統的水墨畫到水墨畫現代化，甚或西洋近代繪畫風潮的平行植入美術學堂之中，都對當時的中國美術產生極大的撞擊。而在這劃時代的藝術革命之際，速寫的革命性變化便產生在新式美術學堂的興起與留學群體中，此時速寫已不只是單純的寫生，而是已進化為一種新的創作表現形式。李路明在研究20世紀初期中國美術的改革時提出：「中國的速寫在齊白石、黃賓虹等藝術家身上如果看作是一種古典形態的話，那麼，在高劍父、李鐵夫、劉海粟、徐悲鴻、林風眠等藝術家那裡，則非常明確地轉換成了現代形態。速寫與創作的分野也日益清晰。」[19]從文中李路明認為雖然齊白石、黃賓虹的水墨作品得力於其所畫的速寫，但還無法完全歸化為獨立的藝術作品；而高劍父、李鐵夫、劉海粟、徐悲鴻、

林風眠等藝術家所做的速寫作品，本身就是獨立的藝術作品。

讓我們先來觀察嶺南畫派的藝術改革，高劍父以改革中國畫為己任並創立「嶺南畫派」，「『嶺南畫派』確立了以寫生為基礎來對抗以臨古為基礎的傳統國畫，所以，速寫便是高劍父極為重視的一種手段。」[20]高劍父以寫生觀察的水墨畫作為改革傳統國畫的創新表現，「在高劍父留下的速寫中，我們可以看到他極為重視光影與透視諸西畫因素的運用，同時速寫的獨立性也從他那裡脫穎而出。」[21]除了高劍父的嶺南畫派使用了速寫作為中國水墨畫的改革，林風眠也運用了速寫的線性特質，讓東方的水墨意味與西洋現代美術風格相互融合，開創了東方水墨畫的新格局。

速寫在中國現代美術的進展可以說扮演著重要的角色，對於中國近代藝術大師，李路明分析說：「……徐悲鴻的速寫是建立在其素描基石之上的，『盡精微，致廣大』的藝術宗旨，在他的水墨速寫體現了他整合東西藝術的成就，使每一個筆痕同時具有了動勢與結構描述的功能。……劉海粟努力與東方藝術體系達成溝通，他的速寫成就主要在於油畫速寫中，畫面中恣肆狂放與富於節奏感的用筆，使藝術家對自然的激情作了成功的表述。……在林風眠的一系列水墨速寫中，線的自由處理與東方意味的再造使得水墨畫的現代形式有了開創性的進展。……吳作人在速寫中特別重視『線』的表達性探索，著力於物象結構上的表現性的『寫意』。」[22]中國在1920年代光榮歸國的藝術家，致力於將西洋現代美術面貌帶進美術學院中，而1930年代的藝術家致力於中、西藝術的融合表現與傳統國畫的改革，並且都大放異采、影響深遠，而速寫在這一波的藝術運動中，可謂舉足輕重。李路明肯定的認為：「有了本世紀初至二三十年代這一代藝術家在整合中西的道路上對速寫這一藝術樣式鋪墊的相當結實的基石，速寫本身的功能受到高度重視。」[23]陳澄波在上海時期對人體速寫的重視與龐大數量的創作，應是大時局的必然，也是他對自我的創作要求與期待新局的重要線索。在論述完整個大時代的前因與時局，接著論述的重點便要聚焦在陳澄波的身上及其所創作的速寫作品了。

七、擁有高度自覺性的人體速寫創作

誠如上文所揭示，陳澄波在1925-32年之間創作了大量的人體速寫作品，速寫作品更貼近藝術家的當下創作思維，甚至是意識的反射，因此，速寫也可說是藝術家創作思維的密碼。陳澄波在就讀臺灣總督府國語學校的時期，受其恩師石川欽一郎（1871-1945）的影響，即熱愛寫生。留日時期無論是風景或人物題材，寫生亦是其藝術創作的主要方式。陳澄波大量的人體速寫作品直到近期才面世，面對這一大批的人體速寫，我們當然讚嘆陳澄波對於繪畫創作的投入與狂熱，我們是否也可以進一步，從陳澄波每一個時期的人物速寫去揭發每一個時期的創作思維。一張人體速寫可以是對一個人體的觀察與練習，也可以是創作與表現。但讓我們更加好奇的是，是否這一批速寫裡頭，隱藏著陳澄波藝術思維的創作密碼。

陳澄波的藝術經歷三個不同的文化區的洗禮—臺灣、日本及中國大陸。在臺灣總督府國語學校接受基礎的美術教育的啟蒙，並將藝術的創作與研究當成終身的目標；在日本東京美術學校接受專業的藝術養成，並獲得帝展入選的肯定；在中國大陸任教於上海新華藝專等美術學院，並從藝術創作的實踐中形塑自我藝術風格。從學術背景的養成來看，他是日本的陳澄波；從藝術風格的奠立及藝術教育的奉獻來看，他是上海的陳澄波；但臺灣才是他真正的母土，他精神上真正的寄託，從這面向看，他是臺灣的陳澄波。可是這三個文化區域卻同時在屬性上，是一個迥異於西洋文化系統的大東亞的文化圈。陳澄波的人體速寫只是西洋美術視覺風格的追尋與再現，亦或者在其大量的人體速寫中，同時融合著中國近代水墨畫創新改革，以及岡倉天心所提出「東方性藝術」乃至「東洋的理想—亞洲一體」的思想理念，而開始出現東方意味的創作思維，是應該值得我們進一步去推敲與探討。

八、東京美校時期的人體速寫

　　1925年是陳澄波就讀東京美校的第二年，從所保存的速寫作品當中，除了大部分人體速寫，我們還可以看到一些包含人物頭像、手部、足部以及人體軀幹的習作，例如：〔頭像與人體速寫-25.10.10（1）〕（頁41）、〔頭像速寫-25.10.16（2）〕（頁42）。陳澄波於1925年所創作的人體速寫作品從用筆的謹慎，及對人體結構的琢磨，可以推測他想要做較精確的形象掌握與表現，這應該也是每一位初體驗人體繪畫的創作者所抱持的態度。基本上人體的掌握，在關於比例、陰影、輪廓線與骨架、肌肉變化……等要素，整體速寫作品帶有理性觀察意識，知性味道濃厚（例如：、〔立姿裸女速寫-25.10.5（2）〕（頁40）、〔坐姿裸女速寫-25.10.17（1）〕（頁43））。1926年的人體速寫作品，形式比較純化，承接上一年對人體的觀察經驗與理解身體結構。特別是此時期的人體速寫作品，特別強調較精準的單一輪廓線，表現人體的骨骼架構及肌肉起伏，並輔以簡略的明暗光線，形式簡捷明確，完整度高。

　　1927年是陳澄波在東京美校的第四年，畢業並繼續就讀東美的研究科，這一年的人體速寫作品的創作量大增，其實不僅作品的數量，尤其是作品的品質相當整齊。1926年的人體速寫作品，形式雖較為完整，但可以發現線條筆法較單一，所表現出來的人體空間也比較扁平。接下來在1927年的人體速寫，著重援用西方解剖學的知識，進行對人體的觀察，關於人體骨骼結構的認知，及肌肉因運動而產生的緊張與鬆弛，做出了深入的表現（例如：〔坐姿裸女速寫-27.4.9（72）〕（頁89）、〔立姿裸女速寫-27.4.9（89）〕（頁89）、〔坐姿裸女速寫-27.5.21（97）〕（頁102）、〔立姿裸女速寫-27.5.21（108）〕（頁103）、〔坐姿裸女速寫-27.11（106）〕（頁108））。此時期的速寫線條變化較豐富，無論是線條速度的快或慢所引發的視覺張力、線條的輕重及粗細所營造的空間表現，甚至是對線條形式的品味所形塑的筆法風格。從上述作品中我們可以看到人體的結構都相當的準確，並有著落筆肯定且形式相似的線條筆法，這樣的創作技術有著西洋古典藝術大師的品質，這應該有破除過往認為陳澄波的作品略欠學院訓練的精準寫實能力，只是陳澄波的創作並沒有在這裡停歇。

　　另外值得一提的是〔坐姿裸女速寫-27.4.2（69）〕（頁87）在單線輪廓的勾勒中，呈顯出坐姿女體的身體放鬆感，尤其是鬆弛的背部肌肉所帶出的身體情境，所表現的已經不只是人體的物理結構，進而傳達了模特兒的內心情感。1927年陳澄波在人體速寫的創作可以說是豐收的一年，不僅為人體描繪紮下深厚的根基，且為接下來的東美研究科做了最好的準備。

　　從作品的線條速度及樣式來看，1928年的人體速寫作品，在創作時間的限定上應該比1927年為短，1927年的作品比較有充裕的時間來觀察細節，1928年的線條速度顯示創作時間的壓縮。一件人體速寫以二十分鐘來完成，及以十分鐘、五分鐘、三分鐘或一分鐘以內來完成，其創作過程所產生的線條自然大不相同。基本上速寫創作所花的時間越長，則觀察到的細部與創作思考的時間就相對增長，線條也就相對越理性；若時間越壓縮，則必需做出對整體結構的反射動作，因此線條越不受控制。一個藝術家可以有意的縮短創作時間，以突破自己線條表現的慣性，但對於人體創作來說，若沒有紮實的人體結構訓練，光是有線條表現的秘器還是不足的。1928年陳澄波在人體描繪的雄厚基礎上，舒展人體描繪的可塑性，無論在姿態上、形式上及模特兒的身體情境上，注入了更多的情感，畫面的模特兒已不再只是被觀察的對象，陳澄波賦予畫面上的人物更多的身體表情，並生動的成為故事中的主角，例如：〔立姿裸女速寫-28.2.10（217）〕（頁184）、〔女體速寫-28.2.10（18）〕（頁184）、〔立姿裸女速寫-28.3.3（240）〕（頁199）、〔立姿裸女速寫-28.3.31（268）〕（頁216）。

　　此時期，西方人體解剖的知識不再成為唯一的課題，在科學的解剖知識與略帶誇張的人物身形中，創造出非學院訓

練式的衝突美感。這種衝突美感的追尋是一種意志，一種追求自我藝術精神完成的意志，並且在人物速寫的創作中完成。當速寫或人體速寫在繪畫的分類中，不斷地被邊緣化或只被當成是一種基礎練習及底稿的弱勢中，陳澄波用嚴謹的態度、用數以千計的作品、用精進、創作的態度，讓他的人體速寫成為其藝術創作中的另一個核心。在我們將所有的目光都投注在他的油畫創作的同時，這一大批人體速寫的面世，無疑讓我們強烈的感受到，陳澄波除了在艷陽中用油彩刻畫人文的大自然，在畫室裡面對單一性的人物主題，也能在人體的觀察與描繪中精鍊起藝術創作的理念，在沉靜中不斷提昇與突破。

九、上海時期的人體速寫—速寫的狂奔

　　1929年陳澄波畢業於東京美校的研究科，後赴上海任教於新華藝專兼昌明藝專教師。此時期的人體速寫作品若從人體結構本身來看，在經過五、六年不間斷的專注創作，幾乎張張都能在瞬間掌握精準的架構，如同前述：「此時期（1928），西方人體解剖的知識不再成為唯一的課題，在科學的解剖知識與略帶誇張的人物身形中，創造出非學院訓練式的衝突美感。」1929年的陳澄波非僅是東京美校的研究科畢業生，此時，他更是上海新華藝專的教授，他關注的已經不只是自己的創作，還有等待他引導邁向藝術之路的學生們。觀察此期的人體速寫作品，線條的張力開始擴張，理性的制約開始鬆綁，大量的速寫挾帶著快速度的非理性（無意識）的線條，在雄厚的人體架構基礎下，於畫面上自由遊走。值得我們注意的是，這批人體速寫作品開始從古典形式中出走，且開始帶有現代性。無論是用來表現光影的即興斜線（非強調準確性的）、略帶誇張及具韻律的身體曲線（有野獸派的線條味道，例如：〔坐姿裸女速寫-29.3.9（259）〕（頁225）、〔坐姿裸女速寫-29.3.23（265）〕（頁230）、〔立姿裸女速寫-29.3.23（291）〕（頁231））、加強視覺重覆塗抹的輪廓邊線（有表現主義的特質，例如：〔立姿裸女速寫-29.7.13（297）〕（頁238）、〔立姿裸女速寫-29.12.17（298）〕（頁241）），充分顯露出其所表現出的筆勢、筆趣、筆法、筆味的線條筆觸。可以說，陳澄波駕馭著線條的表現性，在人體速寫的創作中，表達了自己的現代藝術理念。

　　人體其實是藝術家作為藝術創作的載體，藝術家從人體的創作中再回到自然，借用達文西大宇宙與小宇宙（身體）的創作理念[24]，筆者想說，當陳澄波所描繪的對象超越人的屬性，而與自然等觀，那我們所看到的人物形體就是山，就是水，就是風、石，就是飛鳥、魚……。它是自然的縮形，並且充滿能動，它不只是一個靜止的固體，而是充滿擴張的空間。人體的描繪若只在技術上打轉，會逃不開形式上的束縛，往往缺乏藝術的靈氣。1929年的陳澄波以人體速寫的創作，邁向繪畫的現代性（例如：〔立姿裸女速寫-29.3.9（285）〕（頁226）、〔立姿裸女速寫-29.3.9（287）〕（頁227）、〔立姿裸女速寫-29.3.23（289）〕（頁231））。

　　陳澄波的人體繪畫以其蓄積的藝術能量，如同植物行經光合作用般的苗長，開展出鮮綠的枝葉，並蒂結美麗且豐碩的花果。這樣的藝術創作成果，來自於自我創作技術的不斷提煉，在創作的審美中，忠實地呈現自己的藝術品味，並形成自我藝術創作的理念，歷經各不同時期的自我探索，陳澄波沒有給自己限制，讓自己藝術的根深入到土壤的每一個角落，吸足飽滿的藝術養份，在自我的肯定中創造屬於陳澄波的風格。在1930年的陳澄波的繪畫中，可以看到前面各個時期的統合，此時期的人體繪畫的形式是非單一的，它保留了各時期的精華，而且漸入佳境。這樣的創作經驗，是值得我們注重的，藝術風格的形塑應該不是速成的，甚至只是平行地植入別人的創作經驗，陳澄波的創作態度為後學者樹立了一個典範（例如：〔立姿裸男速寫-30.4.2（1）〕（頁246）、〔立姿裸男速寫-30.4.2（4）〕（頁247）、〔臥姿裸女速寫-30.11.5（41）〕（頁248）、〔坐姿裸女速寫-30.11.13（281）〕（頁248）、〔坐姿與臥姿裸女速寫-30.11.15（2）〕（頁249））。

若說1927年陳澄波在東京美術學校，在人體速寫的表現奠立了深厚的基礎，1931年的上海時期就是陳澄波人體速寫的璀璨年代，每一件人體繪畫作品中的人物都千姿百綽，每一個人物一舉手一投足，咨意的線條隨著創作的意識自由流動─激可奔、靜可幽、趣可扭、肅可抑，人生百態一一都在陳澄波的畫筆的顫動中現出原形，真可謂人體風華的展現，現代意味十足。〔立姿裸女速寫-31.10.26（319）〕（頁270）模特兒的姿態或伸展手臂或伸展身軀以展現人體骨架與肌肉的關係，提供給畫家最佳視覺觀察材料，尤其是身體肌肉緊張與鬆放的對比。此件作品的臉部表現，以象徵性表現的方式，做為個人化的繪畫語言。〔跳舞女-31.10.8（1）〕（頁270）為舞姿，上輕下重的線條表現了舞者下盤穩重及上身的輕盈。更值得一提的是，1930年的速寫作品絕大多數都是單一人體的練習，1931年的速寫作品中三人（例如：〔立姿與坐姿裸女速寫-31.9.23（5）〕（頁266）、〔立姿裸女速寫-31.10.4（317）〕（頁267）），甚至多達十人（例如：〔洗身群女一見-31.7.2〕（頁258））的群像圖都經常可見。絕大多數的人體線條所創作的時間，都呈現一再壓縮的現象，讓線條的流動超越理性（意識）的控制，而到達無意識的非理性表現，換句話說，陳澄波創造了線條，而線條創造了畫面。這樣的創作理念與二十世紀初佛洛依德心理派美學的觀點同時，讓我們不得不再次肯定陳澄波在藝術上的現代性。

從作品顯示，1932年11月間陳澄波有一日本之旅，期間回到本鄉研究所再做研習，十件作品有九件畫面上標示著「1932.11.26日本研或本鄉研」的字跡，這批作品的創作形式均有共同的特質，具有如西方野獸派馬諦斯流暢的單線條、塞尚多視點觀察所得簡化且誇張的形體，其中〔坐姿裸女速寫-32.11.26（315）〕至〔坐姿裸女速寫-32.11.26（319）〕（頁281-282）畫中模特兒幾乎為同一個姿勢，但肩膀以上、頭部有不同變化，可看到頭部的轉動。除了脛骨的骨架暗示外，人體的骨架並非以嚴謹的解剖學概念來表現。肌肉的起伏，團塊的堆疊，骨架與肌肉的關連，在瞬息之間作出決定，這決定來自對人的身體長時間的觀察與視覺經驗的累積，及自我風格的形塑。〔坐姿裸女速寫-32.11.26（308）〕（頁279）、〔坐姿裸女速寫-32.11.26（310）〕（頁280）、〔坐姿裸女速寫-32.11.26（311）〕（頁280），陳澄波雖以快速的鉛筆線條，掌握整體人物姿態，但依舊能夠從畫面看見，其對人物骨架及肌肉細微變化的敏銳觀察力，尤其是〔坐姿裸女速寫-32.11.26（310）〕S形的女體自肩膀以下到腳盤的骨架與肌肉，雖簡潔但精準顯示出陳澄波學院訓練的火候。

結語

速寫創作對所有藝術創作者是重要的，每一位藝術創作者或多或少都會留下一定數量的速寫作品，作為藝術創作階段的見證。西洋的藝術大師中杜勒、達文西、米開朗基羅、林布蘭、泰納、羅特列克和羅丹……等人的速寫傳世最為人所知，尤其是羅丹的人體速寫創作幾乎與其雕塑齊名，而今，陳澄波的人體速寫創作以一千餘張的氣勢，寫下令人震撼的一頁。但速寫又因其創作的形式不一，尤其是以快速度所表現的速寫作品，最容易引起爭議。以羅丹的速寫為例，克勞蒂·瞿德翰說：「畫家不再有充裕的時間來創作作品，線條的速度要跟上敏捷的目光。只有非常純熟的技巧才能如此靈巧敏捷，當代的觀眾發現，羅丹和當時的畫家不一樣，他的目光緊盯著模特兒而不是畫紙。結果是讓觀賞大眾有點看不懂，失去評判的依據而大肆批評，認為是未完成的畫作。」[25]同樣的，陳澄波的人體速寫特別注重創作形式的研究與發展，其中「不再有充裕的時間來創作作品」的快速度速寫幾乎是最為精采的部份。

陳澄波的快速速寫追求當下意識的反射，是「野性的」，是一種藝術家創作的內在潛能，具有瞬間的爆發，它跨越理性的制約，快速掌握對象姿態特點與神韻性。「美術真說」講演中，費諾羅沙表示美術之所以為美術，端賴「妙

想」，「妙想」之論，指出了繪畫的純粹性。岡倉天心在東方性藝術上提出「書畫一致」，東方繪畫重視線條粗細，因此岡倉天心強調用筆的妙味。求學於日本的陳澄波，應該能深刻體會費諾羅沙的「妙想」以及岡倉天心的「用筆的妙味」，並在充分掌握人體解剖知識與架構後，進一步使其人體速寫以「用筆的妙味」達至純粹性繪畫的「妙想」境界。以教授身份任教於上海各美術學院的陳澄波，在時代洪流的衝激中，當然明白速寫在中國現代美術的進展所扮演著重要的角色，無論油畫創作或純粹鉛筆、炭精筆的人體寫生，都要向快速度逼近，以展現繪畫的現代性。

　　事實證明，陳澄波以堅定的毅力，完成這令人訝異的人體速寫創作質量，這不僅是歷史的一頁，也是「速寫」得以展現藝術能量，並齊身於古典素描的充分證明。

　　靜看陳澄波的速寫線條：「一個高亢、一個沉默，對筆觸一種自然的和諧，恢宏大氣超越霸氣，將霸氣轉為純淨的

撰文／*

【註釋】

* 蔡獻友現任正修科技大學時尚生活創意設計系專任副教授兼藝文處展演組組長。

1. 李路明〈二十世紀中國速寫〉《中國現代美術全集20－速寫》，頁3，1998，錦繡出版事業有限公司。

2. 克勞蒂‧瞿德翰〈羅丹的素描〉《羅丹水彩與素描特展》，頁14，2000年，高雄市立美術館。

3. 克勞蒂‧瞿德翰〈圖版說明-I青年時期〉《羅丹水彩與素描特展》，頁40，2000年，高雄市立美術館。

4. 克勞蒂‧瞿德翰〈圖版說明-VI肖像〉《羅丹水彩與素描特展》，頁91，2000年1月，高雄市立美術館。

5. 同註2，頁17。

6. 同註1。

7. 同註1。

8. 佛洛依德以自己的醫療和精神分析的實踐為依據，確認存在著一個無意識的心理領域，第一次建立了系統的無意識學說。他認為，人的心理內容主要是無意識，無意識是指人的原始衝動和各種本能（Libido）。

9. 人格由本我、自我、超我三部分所組成，本我是各種本能的動力之源，能量和活力最大，完全是無意識的，非理性的。

10. 同註1，頁4。

11. 費諾羅沙出生於美國麻州。一八七四年哈佛大學畢業，一八七八年起八年間於東京大學教授政治學、哲學與經濟學。其間，致力於研究日本美術。一八八二年在龍池會演講「美術真說」，提倡新日本畫，排斥受中國影響之文人畫與西洋畫。與岡倉天心組織鑑畫會意圖復興日本畫，並培育狩野芳崖、橋本雅邦，致力於創造新日本畫。此外參與籌畫設立東京美術學校。

12. 神林恆道著，龔詩文譯《東亞美術前史》，頁40，2007。

13. 同註1，頁42。

14. 同註1，頁62。

15. 明治19年費諾羅沙與岡倉天心以文部省（教育部）美術調查委員身分，赴歐洲調查美術學校之創設，次年（明治20年，1887）十月東京美術學校成立，1889年正式開校，岡倉於1888年任校長。最初，專修科三年，分設繪畫（日本畫）、雕刻（木雕）與美術工藝（金工、漆工）。1898年始增設西洋畫科，由黑田清輝主導。

16. 同註1，頁50。

17. 同註1，頁65。

18. 同註1，頁66。

19. 同註1。

20. 同註1。

21. 同註1，頁5。

22. 同註9。

23. 同註1，頁6。

24. 達文西認為人類的身體是一個微型宇宙，人的身軀如土、體溫如火、呼吸如風、體液如水，就如宇宙的生成元素一般。

25. 同註2，頁17。

Sketches as an Expression of Artistic Creation :
A Guide to Reading the Human Body Sketches of Chen Cheng-po

Foreword

Among Chen Cheng-po's works, we are quite surprised to find a large number of figure sketches and in particular human body ones. This article will use the human body sketches of Chen Cheng-po as a theme to examine some possible clues to his artistic nurturing and artistic works. An overview of the drawings he had made throughout his lifetime reveals that his achievements are remarkable in terms of both quality and quantity. In recent years, large-scale exhibitions of his works have been frequently organized by domestic art circles. We now finally have a chance to enjoy his works on a sizeable scale especially from the "Nostalgia in the Vast Universe: Commemorative Exhibition of Chen Cheng-po" held in Kaohsiung Museum of Fine Arts in 2011 and "Journey through Jiangnan: A Pivotal Moment in Chen Cheng-po's Artistic Quest" held in Taipei Fine Art's Museum in 2012. While we are astonished that the creative styles of his landscape and figure paintings are so rich in his personal characteristics and hallmarks, do we not also want to investigate the possible causes for the formation of his artistic style? In the two exhibitions mentioned above we have another surprise: the unveiling of a large number of sketches, not least human body sketches.

There is no doubt that sketches are closer to the instantaneous creative thinking of an artist, or even the reflection of his consciousness. For this, sketches can also be called the code to unlocking an artist's creative thinking. The contents collected in this volume are sketches made by Chen Cheng-po during 1925-1932, covering the period of his studying abroad in Japan (1925-1932) and his Shanghai period (1929-1932). The themes for the majority of these sketches are single female bodies, but a few of the works are compositions of two or more female bodies. There are also some landscape sketches with figures as staffage. At the time when Chen Cheng-po was studying in Japan, the studying and depicting of the human body was as a matter of fact a key training area in Japanese college art programs in those days. Then when he went to Shanghai and taught art courses in Xinhua Art College, because of the raging trend of nude paintings set off by Liu Hai-su in the 1920s and the figure paintings with "School of Paris" characteristics brought back by Pan Yu-liang from France in 1928, the art ethos in Shanghai at that time was such that human body drawings were getting a lot of attention in the classrooms of art colleges. Chen Cheng-po was a student when he was in Japan and a teacher when he was in Shanghai, so what were the influences of the efforts he had put into human body sketches? If the sketches in this volume are taken as clues, it may be possible to reveal the artistic thinking underlain in the various stages of his creative work.

1.Awe inspiring sketches

The demonstration of techniques in sketches can be likened to the playing of a bowed string instrument: with the right hand making up bow, down bow, or skipping movements on the strings, and with the left hand pressing, vibrating, or plucking the strings, a heart-touching superb performance may result. By definition, a sketch is a rapidly executed freehand drawing and, irrespective of the creative intent of the artist, it is made in a short period of time. Thus, a sketch may be an extemporary creation, an impromptu graphic record, a quick way of capturing the gist of the posture and the nuances of a subject, or a quick way of expressing the mood of the moment of the artist….As well, a sketch is a form of expression of choice considering its convenience, instantaneity, its experimental nature as applied to the drawing material used, or even its use in expressing artistic concepts. Sketching is not merely a technique that fulfills the purpose of producing a large number of works in a short period of time; it can also be used to precisely convey the artistic mindset of the artist.

As stated by Li Lu-ming, editor-in-chief of *The Complete Works of Chinese Modern Art, Volume 20* : Sketches, "Sketches and life drawings are hard to distinguish from each other because of the fuzziness of their distinction, just as drawings and sketches have never been two parallel art disciplines; their overlapping nature is a basic fact."[1] Therefore, in this article, the meaning of the term "sketches" may have been extended to overlap with perceptions on drawings and life drawings. In the discourse of Taiwan art history, Chen Cheng-po's sketches are awe-inspiring. Likewise, from the point of view of their development, sketches are also an awe-inspiring phenomenon in human culture. Paintings made by man did not appear elegant in form right from the very beginning. In both eastern and western art, it took a lengthy process and an awakening of consciousness before esthetic contents with universal appeal could develop. Before the appearance of idealistic esthetics, paintings should be "untamed" in nature. In contrast to written words and spoken languages, paintings are a graphic form of expression that is replete with imagination and creativity. Paintings should be closely intertwined with human life and will, in different regions, gradually become a form of

cultural expression of the region. Such are the cases for the Paleolithic cave murals and decorative designs on unearthed prehistoric pottery vases. Primitive art works are often expressed as sketches. These line drawings are so full of unsophisticated charm and liveliness that they are demonstrative of man's drawing talents. Perhaps we can say that sketches are the common drawing language of mankind. So, like music and dancing, sketches also reveal the strong emotions of mankind and vividly disclose our hidden thinking and feelings.

2.Sketches as creative technique training and an expression of art

From the above we understand that, as a kind of art expression, sketches disclose our hidden thinking and feelings. But we can further ask the artist what his possible motive could be, what is being sought after, and what his intent of expression is when he is making sketches. First, from the "reproduction" point of view, perhaps an object image is imparting a strong feeling to an artist. Since the appearance of the object image is so short in duration that there is no way to maintain the visual memory and feeling of the moment for any length of time, if the artist wants to quickly capture the object image seen or felt, sketches would help overcome the temporariness while fulfilling his desire to create. For impressionism that appeared in the West in the second half of the 19th century, one of its main artistic concepts is to use quick, short strokes to capture the fleeting changes in light and instantaneous movements of object images. Toulouse Lautrec (1864-1901) and Auguste Rodin (1840-1917), in particular, are known for their use of quick flowing lines to depict the instantaneous images of the swinging bodies of dancers. Or perhaps an object image appeals to an artist's esthetic taste and creative theme, so he has to employ a massive use of sketches to reinforce his visual memory and to accumulate his visual experience and feelings so that he can facilitate his artistic creation afterwards by means of such visual memory, visual experience and feelings. Claudie Judrin, chief curator of Rodin Museum, said, "From which [drawings] Rodin had learnt two things. First, it was necessary to catch lively fresh actual objects for copying. The second was to make use of the memories of the eyes….Copying is a means of learning, and memory reproduction was an exercise frequently practiced by Rodin when he was young."[2] This is a skill much emphasized in making Chinese traditional ink-wash paintings; artists can stay in their own studios and depict the mountains, rivers, flowers, rocks, birds and animals within their visual experience.

Second, from the point of view of "creative techniques", sketching is a type of self-training in creative techniques. Through sketches, an artist can simply use the objects to be depicted to carrying out practices in the observation of overall structures and in creative techniques. From such practices, he may cultivate or even innovate art-making techniques. Take Rodin for example. When talking about the relation between his three-dimensional sculptures and his sketches, he said, "This is actually very straightforward: my drawings are the key to my works and my sculptures are but drawings in three-dimensional appearances."[3] In 1883, when Rodin met Victor-Marie Hugo (1802-1885) the poet and offered to make a bust for him, Hugo told him, "I cannot pose for you, but I'd be happy to receive you. By all means come to my house to join me for breakfast or dinner. You can make sketches like note-taking and find this sufficient for your purposes."[4] In that encounter Rodin made more than 60 sketches of Hugo. In certain dimensions sketches are the contemporary form of drawings and the great majority of Rodin's drawings are in fact sketches. To him, "The speed of the lines should keep up with the agility of sight, but such dexterity and agility are only evident in very mature techniques."[5] It was only sketches that could convey his creative concept of showing the instantaneous movements of his characters, so the making of every sketch to him had the dual connotation of time and space. The creation of each piece of sculpture was therefore the instantaneous making of a sketch, which had become an important "creative technique" in Rodin's art work engagements.

When talking about Qi Bai-shi, a modern maestro in Chinese ink-wash paintings, Li Lu-ming said, "In Qi Bai-shi's mind, the notion of "sketches" as we know it today is definitely absent. Yet drawing from life against real objects within a relatively short period of time was what he had been doing all along, and it was exactly this persistence in art approach that had given him the strength of purpose later to reform traditional Chinese "flowers and birds" paintings….In a lot of Qi's paintings we cannot rule out the suggestion of "sketches", and this is especially true of a large number of his works in which he used a minimum number of freehand strokes to draw from life against real landscapes/objects."[6] Qi Bai-shi achieved breakthroughs in the status quo of traditional "flowers and birds" paintings through his observations and life drawings. From the frogs, shrimps and crabs he drew, we can see how he succeeded in extracting the simplest graphic representations from complicated structures. In fact, the nurturing of his brush-and-ink techniques and his unique creative approach were attributable to

a substantial amount of sketching experiences. Through repetitive self-training in making sketches, he was able to perfect the precision of applying his brushstrokes and explore the possibilities of using lines. Sketches can also be regarded simply as an expression of art through which the artist's creative impulse is manifested. Different from Qi Bai-shi's experience, the artistic level pursued by another modern Chinese ink-wash painting master Huang Bin-hong was not image depiction that only emphasizes the precision of brushstroke applications. Li Lu-ming said, "Huang Bin-hong nourished an extremely obstinate and unswerving conviction in the use of traditional brush and ink in depicting 'real landscapes'. Prodded up by such a conviction which appeared very unusual in his time, Huang Bin-hong had made a large number of life drawing drafts of landscapes in sketching style. The difference between these superb life drawing drafts and finished works is very murky: many of his drafts in sketching style are in fact finished works and this is also a significant characteristic of Huang Bin-hong's art work."[7] While Qi Bai-shi used broad, concise strokes, Huang Bin-hong used simple and plain strokes to draw from life in sketching style the landscape in front of him. What is more, the sketching style that he had persisted had played a key role when he continued with the legacy of traditional ink-wash while leading it to a new phase.

3. The non-rational conscious in "id" and "quick depiction"

From a traditional viewpoint, if the time taken for making a drawing is used as a criterion, the difference between classical drawings and sketches is that drawings take longer time to execute while sketches require a short time to complete. So, compared to sketches, drawings are more rational, more inclined to observation, and give more attention to depicting details. Also, they are clearer in setting the context of the picture and determining the intent of creating the work. In contrast, because they take less time to make and the speed of the lines is quicker, "sketches" are more "non-rational". "Non-rational" properties are a type of impulse and energy instigated by the innate needs of artists and it is under such strong driving forces that artists complete their works.

Compared to rational lines, non-rational lines as a style of expression have transcended the constraints of rationality and are a kind of innate capability of an artist to create that may break out instantaneously. The early 20th century was a period in which modern schools of art and new disciplines flourished. The expression of non-rational lines came from the basic impulses and various types of instincts of the so called "personal unconsciousness" (non-rationality) such as explained in the psychoanalysis put forward by Sigmund Freud (1856-1919)[8]. Non-rational is not the same as irrational; it is a latent property of "id"[9] in a person's unconsciousness, so the making of sketches is in fact closer to the artist's instinct. Usually, if the lines in a sketch are more akin to "quick depiction", the lines are more likely to overcome the control of rationality. Through quick depiction, the drawing has forsaken the constraints of rationality, so much so that the expression of art has broken away from the restrictions of previous esthetic experiences and is pursuing freedom of the highest order. In contrast to the rationality of classical drawings, sketches have such properties as conciseness of lines and quickness of depiction, so they are capable of quickly expressing the core framework structure of a picture, bringing out interesting brushstrokes and exaggerated lines which are not normally found in classical drawings. Since the drawings are made quickly, such perceptions as instantaneousness, immediacy, explosiveness, and accidentalness are evident in the sensitive and randomly occurring non-rational lines that may appear.

4. The artistic expression of human body sketches

Adopting human bodies as a theme in artistic creation originated from the classical period of ancient Greece around 450 BC. The ancient Greeks believed that the human body was the most elegant form created by the gods. The various statues of deities they carved out of marble were modelled after the most elegant human forms and these had become the origin of Western art. Western art reached a zenith during the Renaissance in the 15th and 16th century. Renaissance means the revival of arts and literature, and what it sought to revive were the arts and culture of the ancient Greeks and Romans. As far as figure paintings are concerned, with the rise of humanism in the 15th century against a background of Christian (divinity) culture in the Middle Ages, the exploration and discovery of human culture had become an important proposition of the time. By returning to the most basic differences in individuals, societies and national cultures, ordinary mortals become the

best footnote in the interpretation of the course of every era. It turns out that the drawing of the human figure has been the target challenged by artists time and again since the 500 odd years after the Renaissance. In every era, the human skeletal frame, the complicated structures contained in the muscles, and the profound yet delicate human souls have helped elevate untold number of artists to world-class master stature. The figure paintings these masters made are leading spectators back to the arena of each era where their spirits meet.

In Western art, since the Renaissance, artists have been adopting a scientific approach and applying human anatomy knowledge such as skeletal structure, muscle orientation, and sports engineering. Using chiaroscuro techniques, they recreate three-dimensional realism on two-dimensional canvasses or drawing paper to achieve visual authenticity. Though the artistic trends of every era have given rise to the personal styles of artists through variations in chiaroscuro techniques, color concepts, and line strokes, scientific knowledge in human anatomy has always played a vital role. It was not until the second half of the 19th century that a breakthrough was made in the 500-year history of figure drawing.

The reproduction of visual reality is an important criterion in traditional Western painting techniques. The concept that "everything in nature can be reduced to a sphere, a cone, a cylinder or a cube" put forward by Paul Cezanne (1839-1907), also known as the "father of modern art", has opened up a new page in visual art. Taking figure paintings as an example, figures depicted in paintings are no longer based on anatomy knowledge. Instead, they are based mainly on the overall composition and visual balance of the pictures as a whole. This concept has inspired the subsequent development of various modern schools of painting such as Fauvism, cubism, etc. and the expression of figure paintings has become more diversified. From traditional figure paintings based on anatomy knowledge to modern figure paintings of purely visual structures, it can be conjectured that artists since the end of the 19th century have all been trying to establish their own painting language. Among modern European artists who used quick depiction to make figure paintings, outstanding ones besides Rodin and Lautrec include Honoré Daumier (1808-1879), Egon Schiele (1890-1919) and many others. From their works, we can see the energy and tension bestowed by the artists to every line and every brushstroke after they have freed themselves from the influences of the predecessors, eventually shaping their painting styles as the result of the uniqueness of the lines and brushstrokes. As well, all the lines and brushstrokes have also become art symbols through which we can identify the artist. To artists, sketches are an important way of expressing one's personal breakthrough and pursuance of artistic freedom.

Sketches bear a certain degree of significance to artists and this is particularly so for quick drawings carried out unconsciously (non-rationally). The shorter or more compressed the time for making a painting, the more it can reflect instincts and deviate from rationality and painting habits. The expressions of the painting will then be repeatedly afforded new freedom without being restricted. Looking into the issue of the modernization of Western art, Li Lu-ming said, "Meanwhile, because of the large-scale influx of Western culture early this [the 20th] century, more artists have developed distinct and independent concepts in 'sketches'. As a frequently applied supplementary measure an artist ought to possess, sketches have become a more common phenomenon."[10] For this reason, the value of rapid depiction as a means for the artist to challenge his own limits is beyond doubt, and this will of course directly affect the academic ecology in arts and fine art in Japan, mainland China and Taiwan after the 20th Century.

5. The turbulence of art in the Meiji Era in Japan and its effects

In the 19th century, confronted with the dominating culture of Western Europe, Asia was left with no choice but to seek survival through rapid westernization. After Meiji Restoration, Japan relentlessly pursued knowledge in humanities, science and technologies to make itself a strong and rich modern country. Subsequently, the Japanese art circle was active in adopting realism from the West and gained gradual progress in esthetics, art history and art studies. The achievements it reaped had also influenced colonial Taiwan afterwards. Chen Cheng-po went to Japan in 1924 and was admitted to the Tokyo School of Fine Arts to receive Japanese art education. The development of his art concepts and his pursuit of art ideals must therefore bear a corresponding relationship to Japanese art trends of that period. In this section, the esthetic trends of Japan in Meiji Era will be examined and then an attempt to identify the causes of Chen Cheng-po's painting philosophy will be made.

Because of Japan's wholesale westernization in Meiji Era, the lifelike art form of the West was single-mindedly pursued by its art circle.

Yet in 1882 (Meiji 15), at Ryūchikai (The Dragon Pond Society), Earnest Fenollosa (1853-1908)[11] delivered a lecture entitled *Bijutsu Shinsetsu* (An Explanation of the Truth of Art). He said, "Undoubtedly the nature of art lies within an object. This nature can be discerned when we gaze at the object with a clarity of mind attained through meditation so that our spirits are liberated and we become selfless."[12] What Fenollosa implied in *Bijutsu Shinsetsu* should be a kind of spiritual esthetics. He believed that there exists within an object a nature of beauty. It is this very nature of beauty that evokes spiritual ecstasy in all people looking at the object. The nature of beauty mentioned above can also be interpreted as an intrinsic quality of beauty. In explaining what is meant by intrinsic quality of beauty, Fenollosa said, "Keeping the internal relationship among all components so that they remain interdependent on each other and generate a sense of completeness and uniqueness, this can be called the exquisite thinking of art." In other words, Fenollosa thought that art qualifies as art because of such "exquisite thinking".

Fenollosa's talk on *Bijutsu Shinsetsu* brought about a change in the Meiji Era Japanese art circle that had a Western art inclination of pursuing lifelikeness. It gained majority support and led subsequently to a revival of traditional Japanese art. To help people understand the meaning of "exquisite thinking", Fenollosa further explained that "Most literati paintings do not simulate natural, real objects. From this point of view, they should have an edge in keeping to the exquisite thinking of literature… If we take literati paintings as good faith paintings of what the eyes have been seeing, then eyes watching the paintings should be the same as if they were comprehending music."[13] From this we can understand that, in Fenollosa's mind, literati paintings replete with exquisite thinking should be comparable to literature and music. Such paintings are not reproductions of realism; rather, they are a kind of aura arising from the spirit that transcends differences between the East and the West and attains idealism in painting. In using "exquisite thinking" as a criterion in judging art quality, Fenollosa further led us into exploring its concept. He was of the opinion that "Most western painters at that time inclined towards depiction of real objects and their expression of exquisite thinking was unenlightened. Japanese paintings did not aim at realism and so their expression of exquisite thinking was superior."[14] Here, Fenollosa's notion of "exquisite thinking" pointed to the pureness of paintings and it is also the mainstream form of global modern art. From an introspection of westernized realism, Fenollosa had pointed to regarding "exquisite thinking" as a new mainstream in Japanese paintings.

As the founding headmaster of Tokyo School of Fine Arts who identified with Fenollosa's idea, Okakura Tenshin (1863-1913)[15] was wary of transplanted westernization in the first place. Confronted with the wholesale westernization of Japanese culture, he pointed out the fundamental differences between Eastern and Western cultures from an Eastern culture point of view and attempted to open up a new traditional-based route through which Japan would advance towards the future. At that critical juncture of searching for a positioning and a new spirit of the time, Tenshin pointed out a new goal to the students of Tokyo School of Fine Arts: I'd like to remind you of the following words—If you just imitate the ancients you will have no future because this has been proven by history. You should focus on the western system in order to make advancement. You should study our national cultural heritage in order to progress further. Even though you should make references to Western paintings, you should take Japan as the principal and the West as an ancillary."[16] He advocated a stance that West European culture and art could be absorbed and accepted but not on an indiscriminate basis. In dealing with West European culture he advocated "taking Japan as the principal and the West as an ancillary" and "focus on the western system in order to make advancement". He advocated transplanting West European culture to the soil of traditional Japanese spirit as a way to inject new nutrients to Japanese culture.

In addition to reviewing the implantation of West European culture from an Eastern culture point of view, Okakura Tenshin vigorously proposed the esthetic awareness of "oneness in calligraphy and paintings" in the area of Eastern art. He said, "In the West, painting and sculpturing go side by side; in the East, painting and calligraphy go together. For this reason, Western paintings are concerned with shading, whereas in Eastern paintings shading is expressed through the thickness of brushstrokes. As the saying goes, 'anyone proficient in calligraphy can also draw'. Therefore, brushwork is the basis of Eastern paintings and it is through brushwork that the past and the present are linked up."[17] As Eastern paintings are concerned with the thickness of lines, so Okakura Tenshin emphasized the exquisiteness of brushwork. He said, "Due to the connection between painting and calligraphy in the East, brushwork becomes the essence of painting. The essence is not only about the exquisiteness of the images, there is also exquisiteness of brushwork. In Western paintings, shading is used. Lines exist not out of geometric considerations but just as outlines of shapes. In Eastern paintings, brushes are used. Brushstrokes can be thick or thin and brushes are used to express exquisiteness. In short, no matter what, the essence of Eastern art cannot dissociate itself from the expressions

of brushwork."[18] Fenollosa's "exquisite thinking" theory woke up the esthetic awareness of "Japan" and allowed it to affirm itself. Okakura Tenshin's esthetic awareness of "Eastern art" conferred a more expansionary significance to the awareness of beauty in "Japan"—it is an esthetic awareness not just of the "Japanese" sense of beauty but also of the "Eastern" sense of beauty. Of Okakura Tenshin's ideas, the one most often sited is "The ideal of Japan—Asia is one", and this is also why Japan's romantics esteem Tenshin as the perfect prophet of the Greater East Asia Co-prosperity Sphere.

The Meiji period was the one in which Japan had the strongest sense of self-awareness. This sense of self-awareness was started in May in the year Meiji 15 (1882) when Fenollosa delivered the *Bijutsu Shinsetsu* lecture at Ryūchikai and initiated the "Japanese" awareness of beauty. It came to a peak five years afterwards (1987) when Tokyo School of Fine Arts was founded and its founding headmaster Okakura Tenshin proposed the philosophy of "Eastern Art" and even "The ideal of Japan—Asia is one" concept. With such a spirit of Japanese self-awareness, Tokyo School of Fine Arts has always had a silent transforming influence on the development of art in Japan's later generations. Since he started studying in Tokyo School of Fine Arts in 1924, Chen Cheng-po's painting philosophy should somehow find inspiration from the developmental lines of thought and essence of thinking of Japanese art history.

6.Modern art trends in China

After graduating from the graduate course of the Tokyo School of Fine Arts in March 1929, Chen Cheng-po took off directly from Japan to take up teaching posts in Shanghai art academies such as the Xinhua School of Fine Arts. In 1933, he had to leave the Chinese mainland and return to Taiwan because of the outbreak of the Japanese invasion. Inevitably, Chen Cheng-po's art work and philosophy were affected by the modern art trends in the mainland during the early 20's and 30's. This section will mainly focus on discussing the artistic awareness of contemporary Chinese artists in the early 20th century and the reform on painting in art schools. It is hoped that by putting Chen Cheng-po against the same historical background, we can have a better understanding of his philosophy on sketches and his artistic style.

Subsequent to Japan's wholesale westernization in the Meiji period, students were sent to Europe to learn painting and efforts were made to pursue the expression styles of European academic art. Other than that, a new awareness in Japanese art was triggered off by the *Bijutsu Shinsetsu* talk. For inclusive reasons, a Western painting department was set up in the Tokyo School of Fine Arts in 1898 to teach contemporary Western art. In China, with the prevalence of work-study programs in the early 20th century, bulks of students were also sent overseas. Bringing back the latest European art trends from Paris, the capital of fine arts, were Liu Hai-su, Xu Bei-hong, Lin Feng-mian etc, who pursued their studies in France. Together with their counterparts Li Tie-fu who returned from America; Gao Jian-fu and Li Shu-tong who returned from Japan, they engaged themselves actively in reforming the arts, allowing different artistic styles to take root in China's art academies and eventually forming a prevalent trend.

Compared with the esthetic awareness of "Japanese" beauty during Meiji Era, a storm of art reform was taking shape in the art schools of China. From traditional ink-wash paintings to the modernization of ink-wash, or even the parallel implantation of Western contemporary painting styles into art schools, such reforms all had profound impacts on Chinese art at that time. And in this epochal art revolution, drastic changes in sketching were made with the emergence of modern art schools and among groups of overseas returnees. Consequently, sketching was no longer confined to drawing from life but elevated to a new form of creative expression. In his study on Chinese art reform during the early 20th century, Li Lu-ming raised the point: "If Chinese sketches are seen as a classical form from artists such as Qi Bai-shi and Huang Bin-hong, then there is an obvious transformation into the contemporary from Gao Jian-fu, Li Tie-fu, Liu Hai-su, Xu Bei-hong, Lin Feng-mian and the like, and the difference between sketches and creative work becomes more distinct."[19] From his article, Li Lu-ming thought that although the ink-wash works of Qi Bai-shi and Huang Bin-hong drew benefits from their sketches, such works still could not be fully recognized as independent works of art. Whereas for Gao Jian-fu, Li Tie-fu, Liu Hai-su, Xu Bei-hong and Lin Fung-mian, their sketches were indisputably so.

Let us take a look at the art reform initiated by the "Lingnan School of Painting". Taking himself responsible for reforming Chinese painting, Gao Jian-fu founded the Lingnan School of Painting, which "established drawing from life as the foundation skill as opposite to

copying ancient paintings in the case of traditional Chinese paintings. So sketching is a means highly regarded by Gao Jian-fu."[20] Gao Jian-fu's bold attempt to employ life ink-wash drawings was a novelty in the reform of traditional Chinese paintings. "From the sketches left by Gao Jian-fu, we can see that he put great importance on the use of light and perspective which are common in Western paintings. Moreover, the independence of sketches was also stemmed from him."[21] Gao Jian-fu's Lingnan School of Art reformed Chinese ink-wash paintings by employing sketching skills. Likewise Lin Feng-mian also made use of the characteristics of sketch lines to merge the flavor of oriental ink-wash with the style of contemporary Western art, thus creating a new chapter in the former.

Sketches had indeed played a vital role in the development of modern Chinese art. Regarding China's maestros, Li Lu-ming had these comments: "Xu Bei-hong's sketches were grounded on his art philosophy of 'attending to the details, embracing the magnitude'. His ink-wash sketches demonstrated his achievement in integrating Eastern and Western art, such that every stroke was empowered with the simultaneous functions of expressing movement and describing structure…Liu Hai-su made tremendous efforts to establish communication with the Eastern art system. His achievements in sketches lay mainly with his oil sketches. His paintings showed unrestrained and rhythmic use of the brush, by which the artist successfully described his passion towards nature…In the series of ink-wash sketches by Lin Feng-mian, the free use of lines and the makeover of oriental flavors were a breakthrough in advancing a modern form of ink-wash paintings…In his sketches, Wu Zuo-ren put emphasis on the expository exploration of "lines" and the "spontaneous expression" in image structures."[22] Those overseas artists who returned to China with fame in the 1920's were keen to bring features of contemporary Western painting into art schools. Those in the 1930's committed themselves to the amalgamation of Chinese and Western art and the reform of traditional Chinese painting. The splendor and impact they brought were significant, and sketches definitely played a vital role in this art campaign. Li Lu-ming was certain that, "From the beginning of this century to the 20's and 30's, artists had laid a firm foundation for sketching as an art form when they set off to integrate Chinese and Western art. As the result, the function of sketching was highly valued."[23] Chen Cheng-po's attention given to human body sketches and the large collection of such works produced during his Shanghai years should be an inevitable outcome of the overall situation of his time. It also provided important clues to Chen's urge for creative excellence and his hopes for a new phase. After going through the causes and overall situation of the big time, the discussion that follows will focus on Chen Cheng-po and his sketches.

7.Human body sketches demonstrating a high degree of self-awareness

As pointed out above, Chen Cheng-po produced a large collection of human body sketches during 1925-32. Sketches are closer to an artist's instantaneous creative thinking, or even becomes the reflection of their consciousness. Hence sketches can be seen as the code for an artist's creative thinking. When Chen Cheng-po was studying in Taiwan Governor-General's Office National Language School, he had developed an enthusiasm for drawing from life under the influence of his teacher Kinichiro Ishikawa (1871-1945). During his stay in Japan, drawing from life was also the main art form he had chosen irrespective of the theme being landscapes or figures. It was only recently that his collection of human body sketches was uncovered. Faced with the large bulk of human body sketches, of course we would marvel at Chen Cheng-po's devotion and zeal for creative drawing. Perhaps we may even go further to unveil each stage of his creative philosophy based on the different phases of his figure sketches. While a human body sketch can be an observation of and a practice on a human body, it can also be a creative product and a form of expression. But what kept us even more curious was whether the code for Cheng Cheng-po's creative thinking was hidden within this collection.

Chen Cheng-po's artistic experience covered three different cultural regions: Taiwan, Japan and mainland China. In Taiwan, he was first enlightened in art when he received elementary art education in Taiwan Governor-General's Office National Language School and made up his mind to take art making and research as his life goals. In Japan, he acquired professional art training in the Tokyo School of Fine Arts and gained recognition when his work was chosen for the Imperial Art Exhibition. In mainland China, he taught in various art schools, such as the Xinhua Art School, and shaped his own artistic style through practical experience in art making. As far as academic nurturing is concerned, Chen was Japanese. But from the establishment of his artistic style and his contribution to art education, he was Shanghainese. Nonetheless, Taiwan was his true motherland and his spiritual sustenance. So in this regard, he was Taiwanese. However, all these three places are by their

properties a greater East Asia cultural circle vastly different from the cultural system in the West. Chen's human body sketches are but a quest and a reproduction of the Western style in visual arts. Or it could be said that in his large quantity of human body sketches, there was the revolutionary integration of Chinese contemporary ink-wash and the philosophical concepts of "Eastern Art" or even "The ideal of Japan—Asia is one" advocated by Okakura Tenshin. As such, a creative thinking with Eastern flavor began to emerge, a phenomenon which warranted our further deliberation and exploration.

8.Human body sketches in the Tokyo Art School stage

1925 was Chen Cheng-po's second year of study at the Tokyo School of Fine Arts. Among the sketches preserved, other than a majority of human body sketches, we can see exercises depicting the heads, hands and feet of characters and the human torso, for examples, *Portrait and Body Sketch-25.10.10 (1)* (p.41) and *Portrait Sketch-25.10.16 (2)* (p.42). The human body sketches drawn by Chen Cheng-po in 1925 demonstrated a cautious application of the brush and a thorough study of the human anatomy. From this we can deduce that he wanted to be more precise in grasping and expressing images, which was the responsible attitude for any artist who set off to experiment on the depiction of the human body. As a whole, the sketches demonstrated rational observation awareness and rich intellectuality in terms of the artist's grasp of the human anatomy and elements such as proportion, shadow, contour, skeletal frame and muscle changes etc. (e.g. *Standing Female Nude Sketch-25.10.5 (2)* (p.40) and *Seated Female Nude Sketch-25.10.17 (1)* (p.43)). The human body sketches in 1926 were more puristic in form, following the observation experience and understanding of human anatomy gathered in the previous year. Specifically the human body sketches in this period emphasized more precise single contour lines to depict the skeletal structure of the human body and the bulges and depressions of muscles and supplemented by simple light and shade. The forms were simple and clear, with a high degree of completeness.

1927 was the fourth year of Chen Cheng-po's study at Tokyo School of Fine Arts. After graduation in the same year, he enrolled himself in a graduate course there. A substantial increase in the number of human body sketches was witnessed in this year. In fact, these human body sketches were remarkable not only in quantity; they were also consistent in quality. In comparison, although the human body sketches in 1926 were more intact in form, their lines and stokes were rather unchanging and the body space expressed was also rather flat. In the human body sketches that followed in 1927, an application of Western knowledge of anatomy and the observation of the human body were in evidence. Knowledge of the human skeletal structure and the tension and relaxation of the muscles during exercise were expressed in considerable depth (e.g. *Seated Female Nude Sketch-27.4.9 (72)* (p.89), *Standing Female Nude Sketch-27.4.9 (89)* (p.89), *Seated Female Nude Sketch-27.5.21 (97)* (p.102), *Standing Female Nude Sketch-27.5.21 (108)* (p.103) and *Seated Female Nude Sketch-27.11 (106)* (p.108)). In this period, a richer variety of sketch lines was observable in respect to the visual tension created from the speed of the lines; the spatial effect created from the weight and thickness of the lines; or even the brushwork style shaped by the artist's preference on the form of the lines. From the above works, we can see that there was a precise grasp of the human body structure and a firmness and regularity shown in the brushwork. Such creative skills were compatible to those of the great masters in Western classical art. This also helped to rectify the misconception that Chen Cheng-po's works showed a lack in capability for precise realistic expression that came with proper academic training. The fact was that his art creation had moved further on.

Also worth-mentioning were his sketches *Seated Female Nude Sketch-27.4.2 (69)* (p.87). By outlining the profile with single lines, it highlighted the relaxed feeling of the female body in a sitting posture, especially the physical condition resulted from the relaxation of the back muscles. What this work had displayed was not only the physiological construct of the human body. It also succeeded in communicating the inner feelings of the model. 1927 was a prolific year for Chan Cheng-po in terms of human body sketching. Not only did he build a firm foundation in the depiction of the human body, he also made the best preparation for his graduate studies in the Tokyo School of Fine Arts.

Judging from the speed and pattern of the lines, the human body sketches in 1928 were presumably given a shorter time limit for completion. Those done in 1927 displayed sufficient time to observe details whereas the line speed of the works in 1928 showed a compression in creation time. It makes a lot of difference whether a human body sketch is done within 20 minutes, 10 minutes, 3 minutes or 1 minute. This is revealed in the difference of lines generated during the process of creation. Generally speaking, the longer the time is spent on a sketch, then relatively longer is the time available for meticulous observation and creation thinking, which means that the lines would be relatively more

rational. On the other hand, if time is more pressing, then the artist has to respond to the overall composition by reflective actions, and in this way, the lines will appear more out of control. An artist may intentionally shorten the time of his creative work in order to break away from his habitual use of lines. But for human body works, without a solid foundation in human anatomy training, the sole mastery of line expression would still be inadequate. In 1928, having established a firm foundation in human body depiction, Chen Cheng-po attempted to stretch the malleability of human body depiction by infusing more emotions into the models, whether it be their postures, their forms or their physical conditions such that the models themselves were no longer the objects of observation. Instead, by projecting more physical expressions into the characters in his drawings, Chen Cheng-po had vividly turned them into protagonists of stories. Examples were *Standing Female Nude Sketch-28.2.10 (217)* (p.184), *Female Body Sketch-28.2.10 (18)* (p.184), *Standing Female Nude Sketch-28.3.3 (240)* (p.199) and *Standing Female Nude Sketch-28.3.31 (268)* (p.216).

In this period, knowledge of Western human anatomy was no longer the only theme. Between scientific knowledge of anatomy and the slightly exaggerated portrayal of the body forms of characters, a conflicting sense of beauty outside of academic training was created. The seeking of this conflicting sense of beauty came from determination—a determination to pursue the realization of a personal artistic philosophy through figure sketching. Within the classification of drawings, when sketches or human body sketches continued to be marginalized or misunderstood as basic drills or drafts, Chen Cheng-po made human body sketching another focus of his artistic creation through his serious attitude, thousands of his artworks and a precise and creative stance. While all our attention are focused on his oil paintings, the emergence of this huge collection of human body sketches undoubtedly give us the strong impression that Chen Cheng-po was not only able to depict the humanistic Nature with oil under broad sunlight, but he was also able to refine his artistic philosophy through the observation and depiction of the human body in the quietness of his studio.

9.Human body sketches made in Shanghai period—a sprint of the sketch

In 1929, Chen Cheng-po graduated from the graduate course of the Tokyo School of Fine Arts and took up teaching posts at Xinhua Art School and Chang Ming Art School. From the perspective of human anatomy, almost every human body sketch produced in this period could grasp the precision of the body structure in a split-second because of the continuous attention paid to this genre in the past five or six years. As quoted before: "In this period (1928), knowledge of Western human anatomy was no longer the only theme. Between scientific knowledge and the slightly exaggerated portrayal of the bodies of characters, a conflicting sense of beauty outside of academic training was formed." In 1929, Chen Cheng-po was not only an alumnus of the Tokyo School of Fine Arts graduate course, he was also a professor of Xinhua Art School in Shanghai. He was not only concerned about his own art creation but also his students who were anxiously waiting for him to guide them along the journey of fine arts. As observed from his human body sketches in this period, the tension of the lines was expanding while the restraint of the rationality was loosening. With quick non-rational (unconscious) lines produced under the firm foundation of human anatomy, large quantities of sketches roamed freely in the drawings. We should note that this collection of human body sketches were beginning to free themselves from classical forms and gradually developing dimensions of modernism. Whether it be extemporaneous slashes for depicting light (precision not emphasized); body lines which were slightly exaggerating and rhythmic (similar to Fauvism in flavor, such as works *Seated Female Nude Sketch-29.3.9 (259)* (p.225), *Seated Female Nude Sketch-29.3.23 (265)* (p.230) and *Standing Female Nude Sketch-29.3.23 (291)* (p.231)) or contour edges of repeated smearing for reinforcing visual effects (similar to Expressionism in character, such as works *Standing Female Nude Sketch-29.7.13 (297)* (p.238) and *Standing Female Nude Sketch-29.12.17 (298)* (p.241)), they vividly projected the dynamism, intrigues, methodology and flavor of the brushstrokes. In other words, Chen Cheng-po could harness the expressions of lines and was able to realize his own conception of contemporary art through the making of human body sketches.

The human body is actually a carrier for the artist to bring across his creative ideas; an artist starts off with the human body and then returns back to Nature. To borrow from da Vinci's creative concept of macrocosm and microcosm (the human body)[24], I wish to explain that when an object that Chen Cheng-po depicted transcended the properties of the human species, it became equivalent to Nature itself, then the human form we could perceive might as well be water, wind, a rock, a bird, a fish... It was a miniature of Nature and was filled with energy and

dynamism; it was more than a stationary solid, but was also an expandable space. If the depicting of the human body is only revolving around skills, it will never free itself from the bondage of the form and be lacking in the sublimity of art. In 1929, Chen Cheng-po made bold strides towards contemporary art through his human body sketches (e.g. *Standing Female Nude Sketch-29.3.9 (285)* (p.226), *Standing Female Nude Sketch-29.3.9 (287)* (p.227), *Standing Female Nude Sketch-29.3.23 (289)* (p.231)).

With the artistic energy they had accumulated, Chen Cheng-po's human body paintings proliferated like plants after photo-synthesis. They displayed green leaves and branches, and eventually bore pretty flowers and bountiful fruits. Such an artistic achievement was the result of a self-initiated and continuous refinement of creative skills. The esthetic judgment of the creative art honestly reflected the artist's creative style and formulated his artistic concepts. After different phases of self-exploration, Chen Cheng-po had never allowed himself to be confined. Instead, he let the roots of his art penetrate to every corner of the soil and devour artistic nutrients to the full. And in the course of self-recognition, Chen Cheng-po had developed a style of his own. Among Chen Cheng-po's drawings in the 1930's, we can see an integration of all the previous periods. The form of human body paintings in this period was no longer unchanging; it preserved the essence of all the other periods and was getting better. This kind of creative experience was significant. It proved that the formulation of an artistic style should not be expeditious, nor should it be the parallel adoption of other people's creative experience. With respect to his creative attitude, Chen Cheng-po had set an exemplary model for artists of later generations. (e.g. *Standing Male Nude Sketch-30.4.2 (1)* (p.246) and *Standing Male Nude Sketch-30.4.2 (4)* (p.247), *Reclining Female Nude Sketch-30.11.5 (41)* (p.248), *Seated Female Nude Sketch-30.11.13 (281)* (p.248), *Seated and Reclining Female Nude Sketch-30.11.15 (2)* (p.249)).

If we say that Chen Cheng-po had established a solid foundation in human body sketching in 1927 when he was studying at the Tokyo School of Fine Arts, then the Shanghai era in 1931 was the most glamorous years for his human body sketches. Every character in his human body sketches was charismatic and charming—every move and gesture the characters made was captured by the free flow of the lines according to the consciousness of the artist—they could run in ecstasy, repose in serenity, twist in amusement, or suppressed in solemnity. All myriads of facets in life were captured and unveiled by Chen Cheng-po's paintbrushes. It was a charade of the elegance of the human body and a truthful representation of contemporary art. In his artworks *Standing Female Nude Sketch-31.10.26 (319)* (p.270), the models were posed with either the hands or the body stretched in order to display the relationship between the human bone structure and the muscles. They provided the best visual observation material for artists, especially the contrast in the tension and relaxation of the muscles. The facial expressions of the models in this artwork were presented in symbolic form as the artist's personal language of drawing. *A Dancer Girl-31.10.8 (1)* (p.270) was a dancing posture. The light lines at the top and the heavy lines at the bottom demonstrated the firmness of the dancer's lower parts and the agility of her upper parts. Another worth-mentioning fact was that the human body sketches in 1930 were mostly single-body exercises. But among those produced in 1931, models of three (*Standing and Seated Female Nude Sketch-31.9.23 (5)* (p.266), *Standing Female Nude Sketch-31.10.4 (317)* (p.267), or even group portraits with as many as ten (*Bathing Girls-31.7.2* (p.258)) were commonly found. For most of the lines in depicting the bodies, the phenomenon of repeated time compression was observed. This allowed the flow of the lines to transcend the control of the rationality (consciousness) and be elevated to the non-rational and unconscious level. In other words, Chen Cheng-po created the lines, and the lines subsequently created the drawings. This creative philosophy occurred at the same time as Sigmund Freud's psychological school of esthetics, leaving us with no alternative but to affirm once again the modernism of Chen Cheng-po's art.

As evident from his works, Chen Cheng-po made a trip to Japan in November 1932. During that period, he went back to Hongo Painting Institute to undertake some research and studies. Nine out of ten pieces of work bore the words: "1932.11.26 Japan Inst or 1932.11.16 Hongo Inst". This collection all shared similar characteristics: they had flowing single lines like those of Matisse of the Fauvist school and the simplified yet exaggerating forms of Cezanne, which came from multi-perspective observation. In *Seated Female Nude Sketch-32.11.26 (315)* to *Seated Female Nude Sketch-32.11.26 (319)* (p.281-282), almost all the models were in the same posture, except for some variations from above the shoulder and the head, the movement of which was discernible. Except for the implication of bone structure of the tibia, human bone structure was not presented in precise anatomy concepts. The movement of the muscles, the stacking of clumps, the connection between the skeleton and the muscles etc. were all to be decided in a fleeting moment. This decision depended on the prolonged observation of the human body and the formulation of the artist's personal style. In *Seated Female Nude Sketch-32.11.26 (308)* (p.279), *Seated Female Nude Sketch-32.11.26*

(310) (p.280) and *Seated Female Nude Sketch-32.11.26 (311)* (p.280), although Chen Cheng-po was able to grasp the overall posture of the model by quick pencil lines, his sharp observation of the subtle changes of the human bone structure and muscles was still visible from the drawings. This was especially evident in *Seated Female Nude Sketch-32.11.26 (310)*, in which the bone structure and muscles of the "S" shaped female body from the shoulders down to the feet were portrayed concisely but with precision, fully demonstrating Chen Cheng-po's remarkable mastery of academic training.

Conclusions

The making of sketches is important to all creators of art. Every creator of art will inevitably leave a certain number of sketches as testimony to stages of art creation. Among Western art masters, the sketch masterpieces of Dürer, da Vinci, Michelangelo, Rembrandt, Turner, Lautrec, and Rodin are the best known. In particular, the human body sketches of Rodin are almost as famous as his sculptures. Now, with the distinction of more than 1,000 human body sketches, Chen Cheng-po has written an awe-inspiring page in art history. Yet because there are diversified forms of creation in sketches, particularly those made quickly, debates can arise easily. Take Rodin's sketches as an example, Claudie Judrin said, "If an artist no longer has ample time to make a drawing, the speed of his lines has to catch up with the agility of his sight. Such dexterity and agility is feasible only with very proficient skills. Modern-day viewers notice that what distinguishes Rodin from the artists of his time is that Rodin's sight was fixed on the model and not the drawing paper. The results are that the majority of viewers do not fully understand his drawings, so they lose track of a basis of critique and criticize the drawings vehemently, believing that they are incomplete drawings."[25] Likewise, Chen Cheng-po's human body sketches are particularly concerned with the study and development of the forms of creation, and those drawings with "no ample time to make" are almost always the most magnificent ones.

Chen Cheng-po's hasty sketches seek reflections of consciousness of the moment; they are "untamed"; they are a kind of innate potential in creation of an artist; they possess instantaneous explosiveness; they have transcended the constraints of rationality to quickly come to grasp with the posture characteristics and spiritual charm of the drawing objects. According to Fenollosa's talk on *Bijutsu Shinsetsu*, a piece of art work is so all because of "exquisite thinking" and this "exquisite thinking" theory points to the pureness of drawings. Okakura Tenshin proposed "oneness in calligraphy and paintings" in the area of Eastern art. As Eastern paintings are concerned with the thickness of lines, so he emphasized the exquisiteness of brushwork. As Chen Cheng-po had pursued studies in Japan, he should well appreciate Fenollosa's "exquisite thinking" and Okakura Tenshin's "exquisiteness of brushwork". After his full mastery of human anatomy and human framework, he was able to further elevate his human body sketches through "exquisiteness of brushwork" to attend the realm of "exquisite thinking" in pure painting. As a professor teaching in various art academies in Shanghai and as someone who was under the impacts of the torrents of the time, Chen Cheng-po certainly knew the important role played by sketches in the advancement of Chinese modern art: be it an oil painting or a nude figure from life with ordinary pencils or carbon pencils, the trend was towards speedier works as a way to demonstrate the modernity of the drawing.

The fact is that, with his unwavering determination, Chen Cheng-po had succeeded in producing such an astounding large number of human body sketches. This is not just a page in history, but also sufficient proof that "sketches" can explicit enough energy of art to claim their standing along with classic drawings.

In taking a contemplative view of Chen Cheng-po's sketch lines, we discover "a sense of sonority and a sense of reticence that give a natural harmony of brushstrokes that magnificently transcend arrogance and turn any arrogance into unadulterated esthetics."

Hsiao Yin Tsoi *

∗ **Tsai Hsien-yiu is currently associate professor for the Department of Modern Living and Creative Design and leader of the Office of Arts and Culture Performance Group at Cheng Siu University, Taiwan.**

1. Li Lu-ming, "Twentieth Century Chinese Sketches" in *Complete Works of Chinese Modern Art*, Vol. 20: Sketches, p. 3, 1988, Jin Xiu Publishing Co Ltd .

2. Claudie Judrin, "Rodin's Sketches" in *Rodin's Watercolors and Sketches: A Special Exhibition*, p. 14, 2000, Kaohsiung Museum of Fine Arts.

3. Claudie Judrin, "Plate Descriptions I: Youth Period" in *Rodin's Watercolors and Sketches: A Special Exhibition*, p. 40, 2000, Kaohsiung Museum of Fine Arts.

4. Claudie Judrin, "Plate Descriptions VI: Portraits" in *Rodin's Watercolors and Sketches: A Special Exhibition*, p. 91, 2000, Kaohsiung Museum of Fine Arts.

5. Ibid, Footnote 2 above, p. 17.

6. Ibid, Footnote 1 above.

7. Ibid, Footnote 1 above.

8. Based on his practices in medical treatment and psychoanalysis, Freud confirmed the existence of an unconscious psychological domain and established for the first time a systematic doctrine on unconsciousness. He believed that the psychological contents of man are mainly unconsciousness, which refers to man's various basic impulses and various types of instincts.

9. There are three elements personality—the id, the ego, and the superego. The id is the source of power for various instincts; it has the greatest energy and vitality and is entirely unconscious and non-rational.

10. Ibid, Footnote 1 above, p. 4.

11. Earnest Fenollosa was born in Massachusetts, USA. He graduated from Harvard in 1874 and, for eight years beginning 1878, he taught philosophy and political economy at Tokyo Imperial University. During his years in Japan, he committed himself to the study of Japanese art. In his lecture at Ryūchikai on "An Explanation of the Truth of Art", he advocated a new style of Japanese paintings and condemned literati paintings influenced by China and Western paintings. He had established Kangakai (Painting Appreciation Society) with Okakura Tenshin in an attempt to revived traditional Japanese painting styles and had nurtured Kanou Kougai and Hashimoto Gahou in creating a new Japanese style of painting. In addition, he had helped found the Tokyo School of Fine Arts.

12. Kanbayashi Tsunemichi, translated by Gong Shi-wen, p. 40, 2007, A Prehistory of East Asian Art.

13. Ibid, Footnote 1 above, p. 42.

14. Ibid, Footnote 1, p. 62.

15. In Meiji 19, as art commissioners of the Ministry of Education, Fenollosa and Okakura Tenshin went to Europe to study the establishment of art schools. In October the next year (Meiji 20, 1887), Tokyo School of Fine Arts was established. The school was formally opened in 1889 while Okakura was appointed founding headmaster of the school in 1888. Initially, in the three-year specialist program, courses in painting (Japanese painting), sculpturing (wood sculpturing) as well as art & craft (metalworking, lacquering) were given. Beginning 1898 a Western painting course was started under the leadership of Kuroda Seiki.

16. Ibid, Footnote 1, p. 50.

17. Ibid, Footnote 1, p. 65.

18. Ibid, Footnote 1, p. 66.

19. Ibid, Footnote 1 above.

20. Ibid, Footnote 1 above.

21. Ibid, Footnote 1 above, p. 5.

22. Ibid, Footnote 9 above.

23. Ibid, Footnote 1 above, p. 6.

24. Da Vinci believed that the human body is a microcosm: its carcass is likened to earth, its body temperature is likened to fire, its breathing is likened to wind, and its body fluid is likened to water, just like the elements which make up the cosmos.

25. Ibid, Footnote 2 above, p. 17.

速寫
Sketch

1920-1927

· 1920-1925

手部速寫（1）Hand Sketch（1）

約1920-1924　紙本鉛筆色筆　16×24.4cm

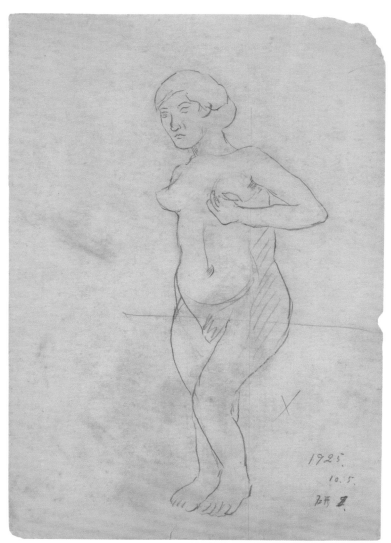

立姿裸女速寫-25.10.5（1）
Standing Female Nude Sketch-25.10.5（1）

1925　紙本鉛筆　26.7×18.5cm

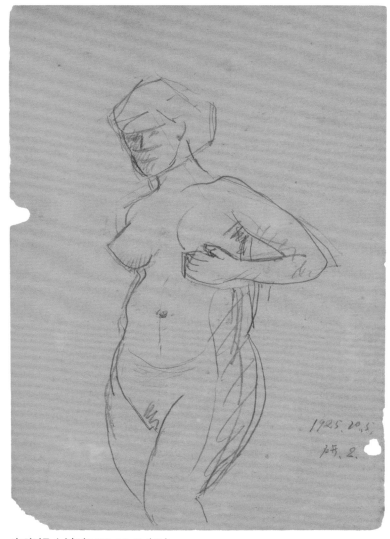

立姿裸女速寫-25.10.5（2）
Standing Female Nude Sketch-25.10.5（2）

1925　紙本鉛筆　26.7×18.5cm

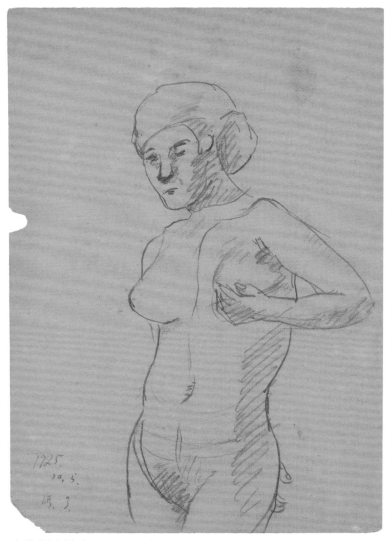

立姿裸女速寫-25.10.5（3）
Standing Female Nude Sketch-25.10.5（3）

1925　紙本鉛筆　26.7×18.5cm

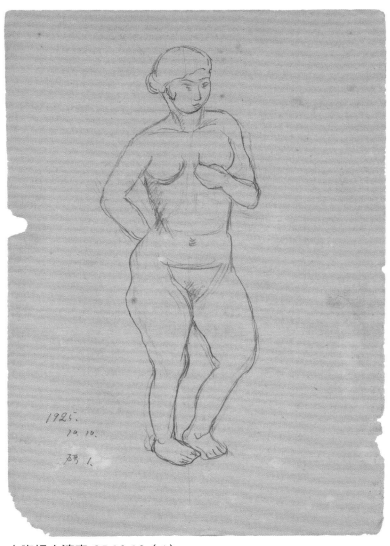

立姿裸女速寫-25.10.10（4）
Standing Female Nude Sketch-25.10.10（4）

1925　紙本鉛筆　26.7×18.5cm

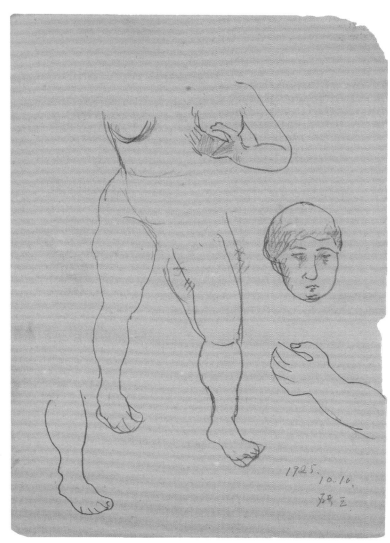

頭像與人體速寫-25.10.10（1）
Portrait and Body Sketch-25.10.10（1）

1925　紙本鉛筆　26.7×18.8cm

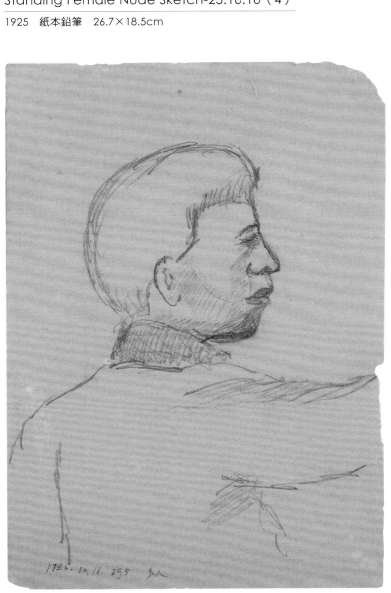

人物速寫-25.10.16（1） Figure Sketch-25.10.16（1）

1925　紙本鉛筆　26.7×18.8cm

頭像速寫-25.10.16（1） Portrait Sketch-25.10.16（1）

1925　紙本鉛筆　26.6×18.7cm

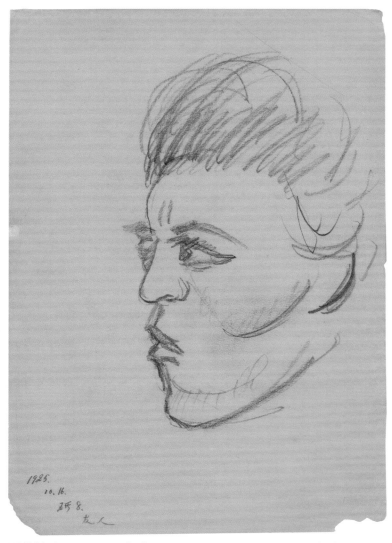

頭像速寫-25.10.16（2） Portrait Sketch-25.10.16（2）
1925　紙本鉛筆　26.7×18.7cm

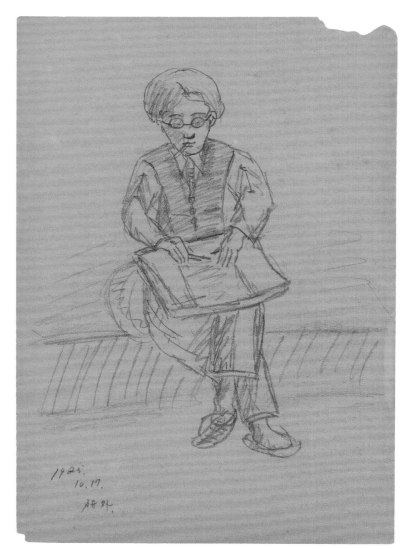

人物速寫-25.10.17（2） Figure Sketch-25.10.17（2）
1925　紙本鉛筆　26.7×18.8cm

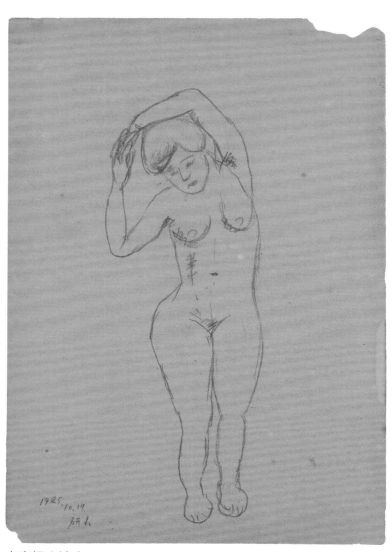

立姿裸女速寫-25.10.17（5）
Standing Female Nude Sketch-25.10.17（5）
1925　紙本鉛筆　26.9×18.8cm

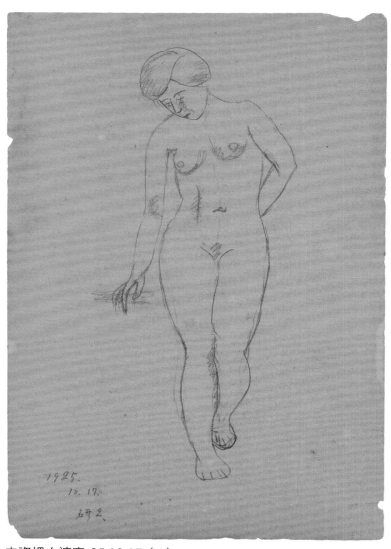

立姿裸女速寫-25.10.17（6）
Standing Female Nude Sketch-25.10.17（6）
1925　紙本鉛筆　26.7×18.8cm

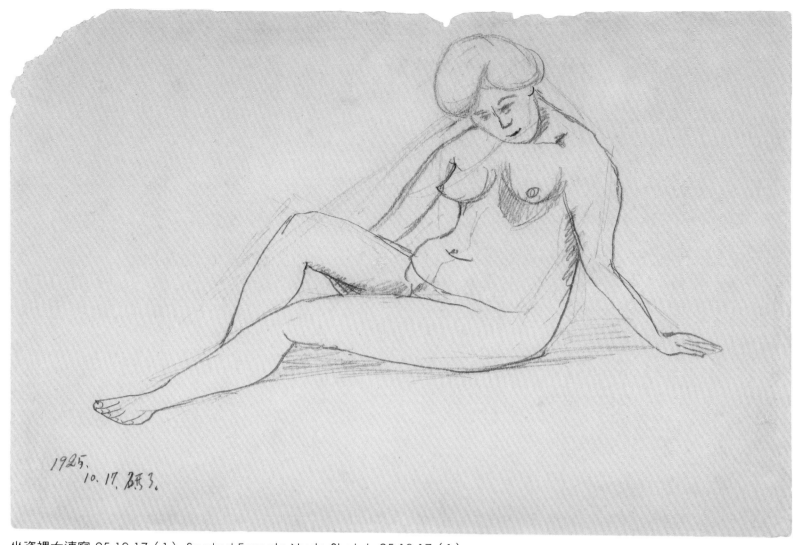

坐姿裸女速寫-25.10.17（1） Seated Female Nude Sketch-25.10.17（1）

1925　紙本鉛筆　18.8×26.8cm

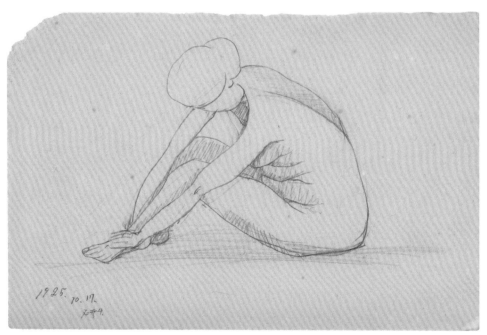

坐姿裸女速寫-25.10.17（2）
Seated Female Nude Sketch-25.10.17（2）

1925　紙本鉛筆　18.5×26.8cm

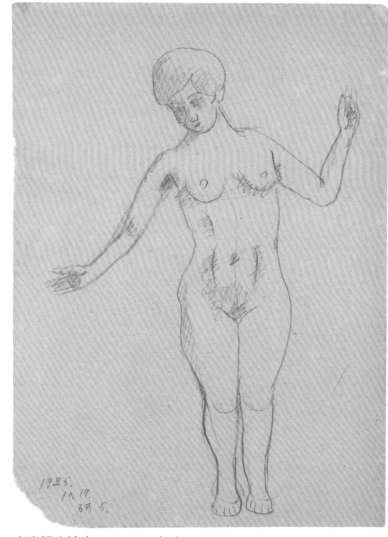

立姿裸女速寫-25.10.17（7）
Standing Female Nude Sketch-25.10.17（7）

1925　紙本鉛筆　26.8×18.6cm

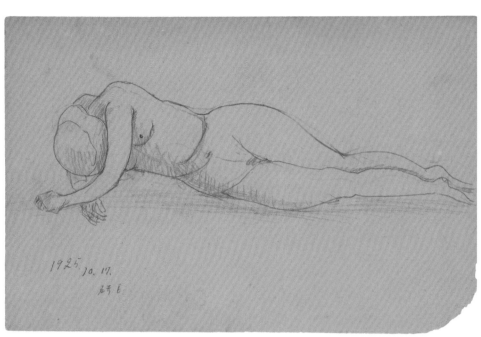

臥姿裸女速寫-25.10.17（1）
Reclining Female Nude Sketch-25.10.17（1）

1925　紙本鉛筆　18.5×26.8cm

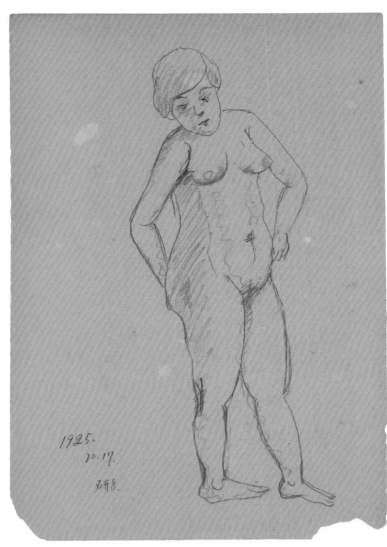

立姿裸女速寫-25.10.17（8）
Standing Female Nude Sketch-25.10.17（8）

1925　紙本鉛筆　26.7×18.5cm

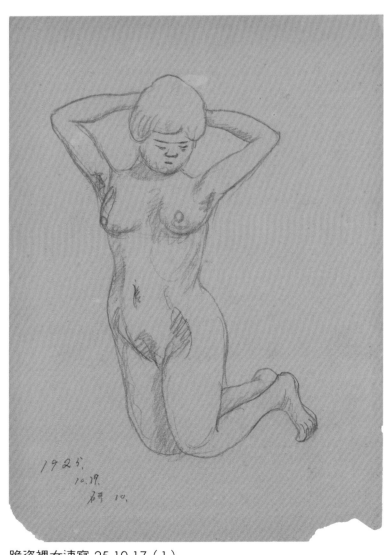

跪姿裸女速寫-25.10.17（1）
Kneeling Female Nude Sketch-25.10.17（1）

1925　紙本鉛筆　26.7×18.5cm

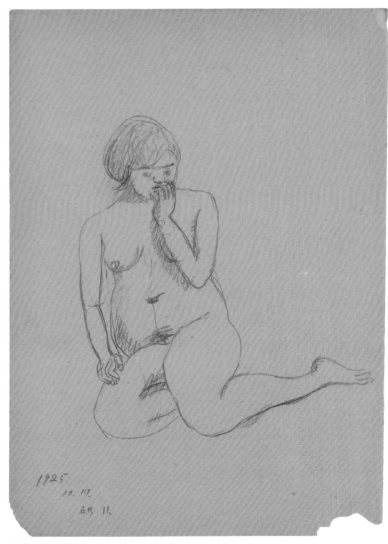

坐姿裸女速寫-25.10.17（3）
Seated Female Nude Sketch-25.10.17（3）

1925　紙本鉛筆　26.7×18.8cm

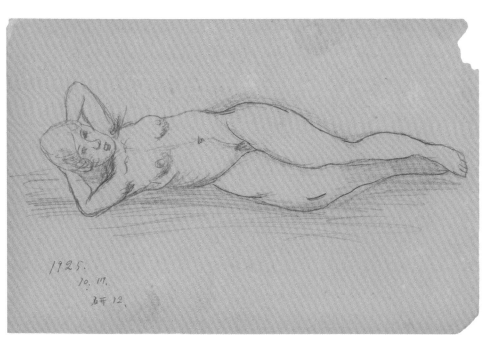

臥姿裸女速寫-25.10.17（2）
Reclining Female Nude Sketch-25.10.17（2）

1925　紙本鉛筆　18.5×26.7cm

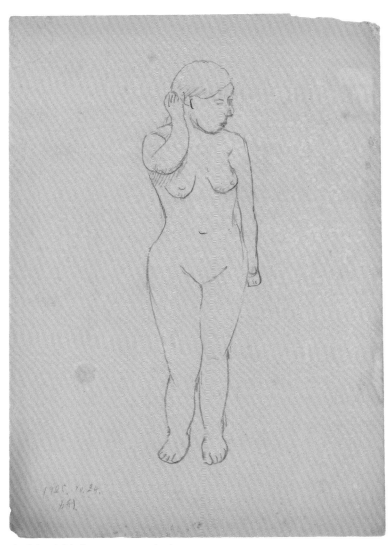

立姿裸女速寫-25.10.24（9）
Standing Female Nude Sketch-25.10.24（9）

1925　紙本鉛筆　26.3×18.6cm

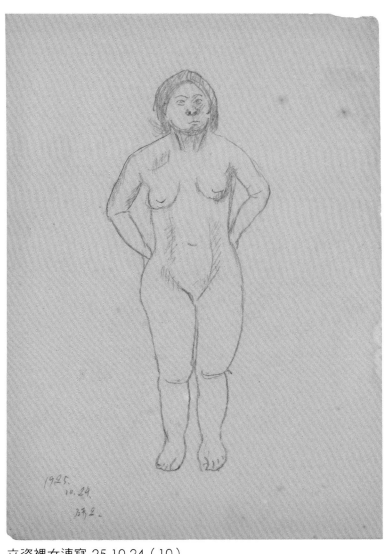

立姿裸女速寫-25.10.24（10）
Standing Female Nude Sketch-25.10.24（10）

1925　紙本鉛筆　26.7×18.6cm

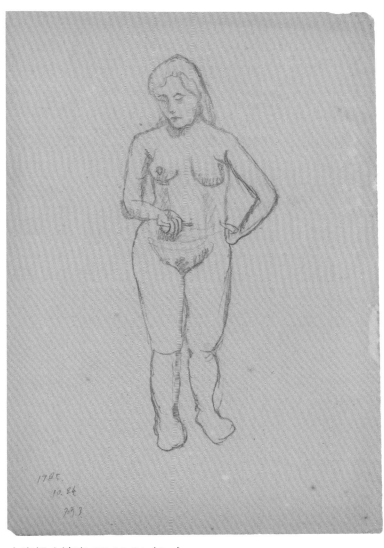

立姿裸女速寫-25.10.24（11）
Standing Female Nude Sketch-25.10.24（11）

1925　紙本鉛筆　26.8×18.6cm

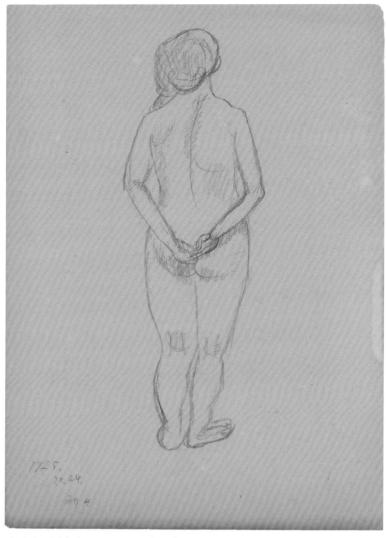

立姿裸女速寫-25.10.24（12）
Standing Female Nude Sketch-25.10.24（12）

1925　紙本鉛筆　26.8×18.6cm

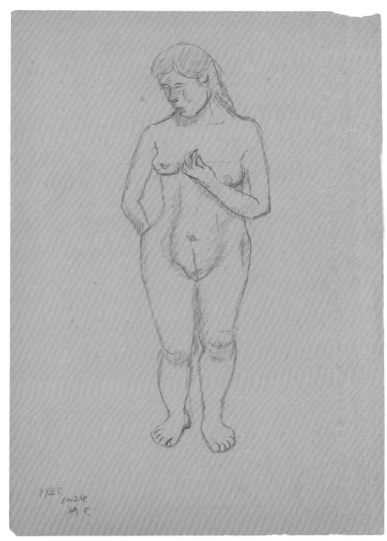

立姿裸女速寫-25.10.24（13）
Standing Female Nude Sketch-25.10.24（13）

1925　紙本鉛筆　26.8×18.5cm

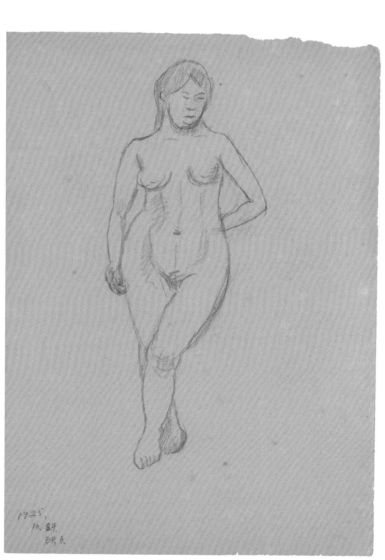

立姿裸女速寫-25.10.24（14）
Standing Female Nude Sketch-25.10.24（14）

1925　紙本鉛筆　26.7×18.6cm

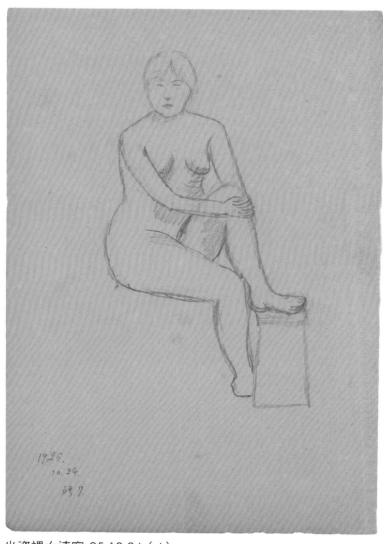

坐姿裸女速寫-25.10.24（4）
Seated Female Nude Sketch-25.10.24（4）

1925　紙本鉛筆　26.7×18.4cm

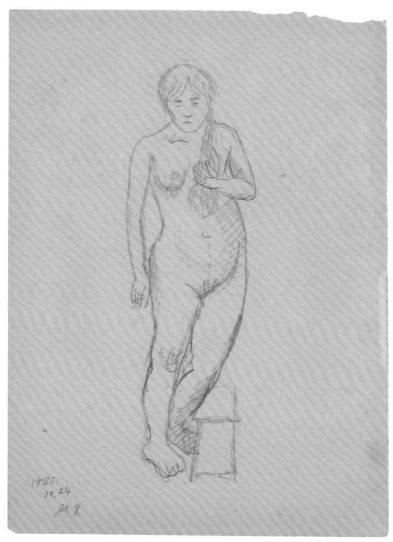

立姿裸女速寫-25.10.24（15）
Standing Female Nude Sketch-25.10.24（15）

1925　紙本鉛筆　26.7×18.5cm

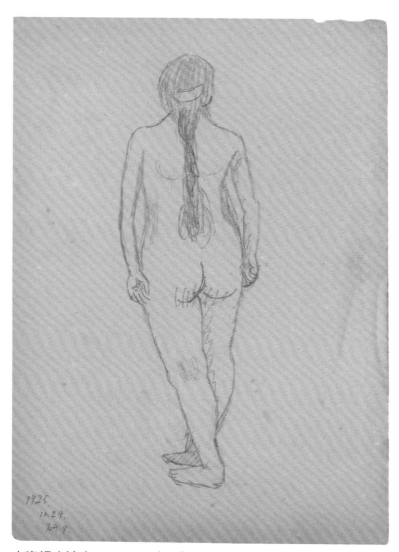

立姿裸女速寫-25.10.24（16）
Standing Female Nude Sketch-25.10.24（16）

1925　紙本鉛筆　26.6×18.5cm

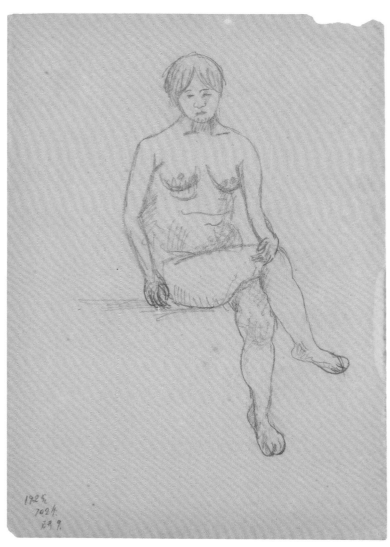

坐姿裸女速寫-25.10.24（5）
Seated Female Nude Sketch-25.10.24（5）

1925　紙本鉛筆　26.7×18.5cm

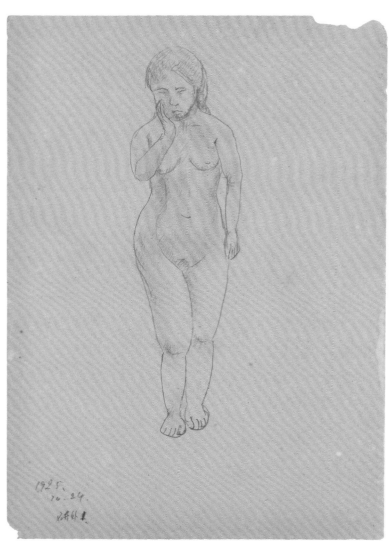

立姿裸女速寫-25.10.24（17）
Standing Female Nude Sketch-25.10.24（17）

1925　紙本鉛筆　26.7×18.7cm

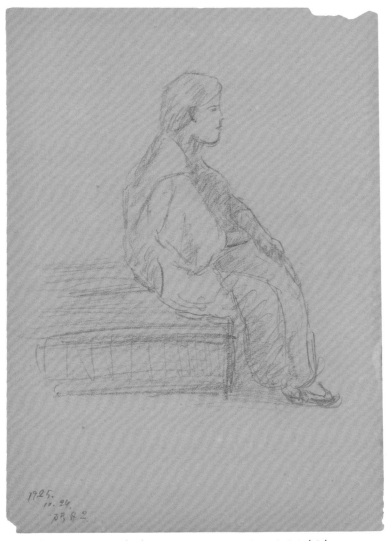

人物速寫-25.10.24（3） Figure Sketch-25.10.24（3）

1925　紙本鉛筆　26.8×18.6cm

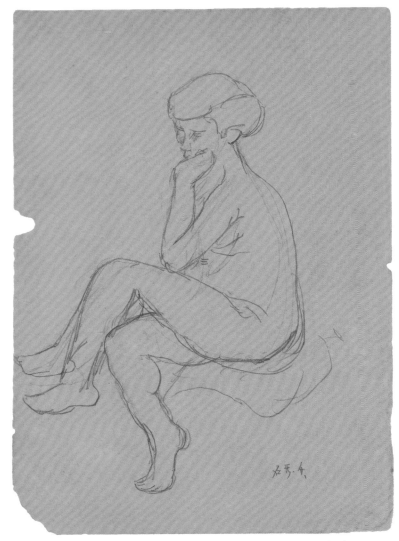

坐姿裸女速寫（6） Seated Female Nude Sketch（6）

約1925　紙本鉛筆　26.9×18.8cm

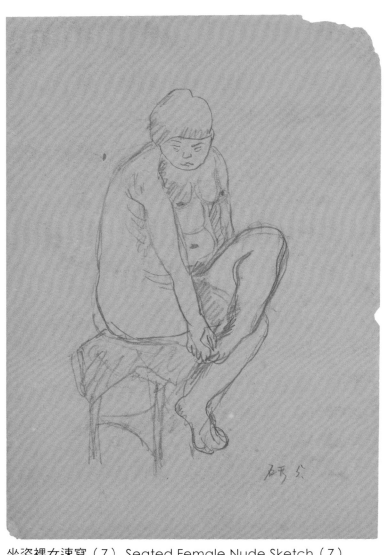

坐姿裸女速寫（7） Seated Female Nude Sketch（7）

約1925　紙本鉛筆　26.7×18.6cm

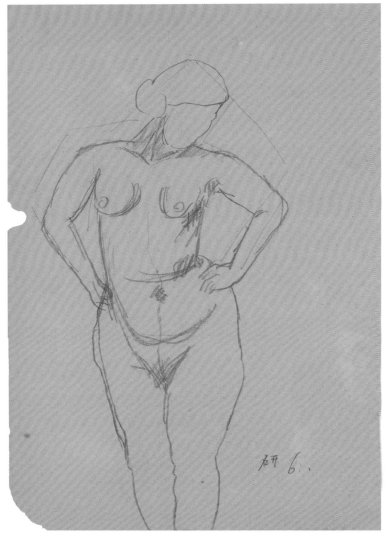

立姿裸女速寫（18） Standing Female Nude Sketch（18）

約1925　紙本鉛筆　26.6×18.7cm

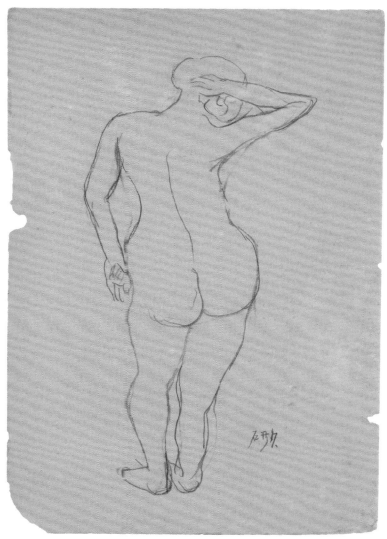

立姿裸女速寫（19） Standing Female Nude Sketch（19）

約1925　紙本鉛筆　26.7×18.6cm

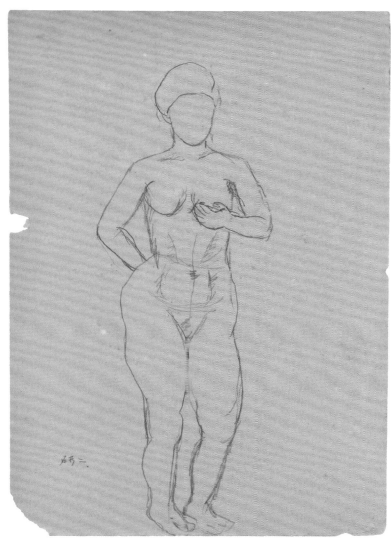

立姿裸女速寫（20） Standing Female Nude Sketch（20）

約1925　紙本鉛筆　26.7×18.8cm

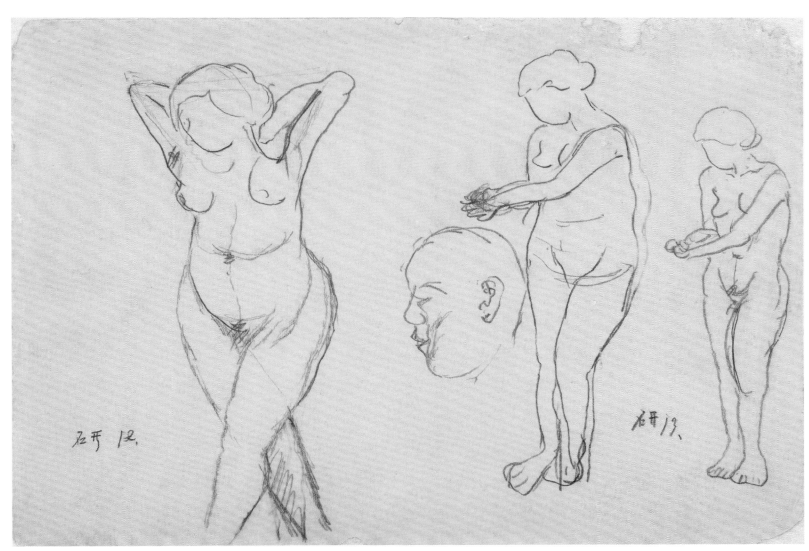

立姿裸女速寫（21） Standing Female Nude Sketch（21）

約1925　紙本鉛筆　18.6×26.6cm

· 1926

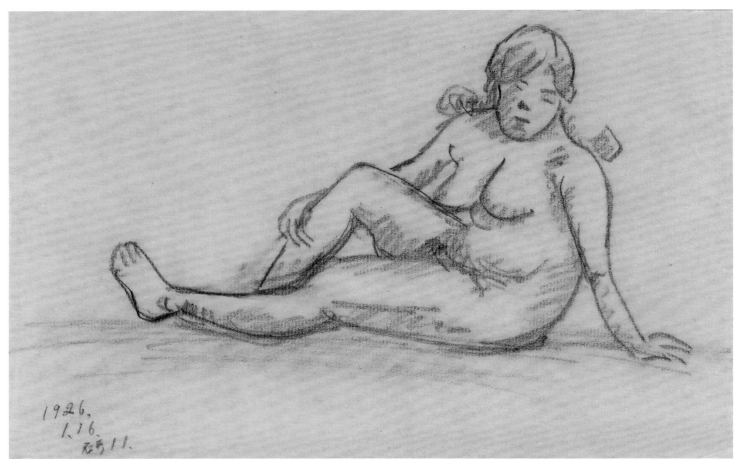

坐姿裸女速寫-26.1.16（8） Seated Female Nude Sketch-26.1.16（8）

1926　紙本鉛筆　15.7×24.1cm

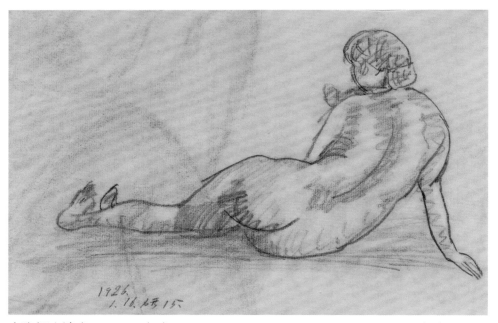

坐姿裸女速寫-26.1.16（9） Seated Female Nude Sketch-26.1.16（9）

1926　紙本鉛筆　16.1×24.2cm

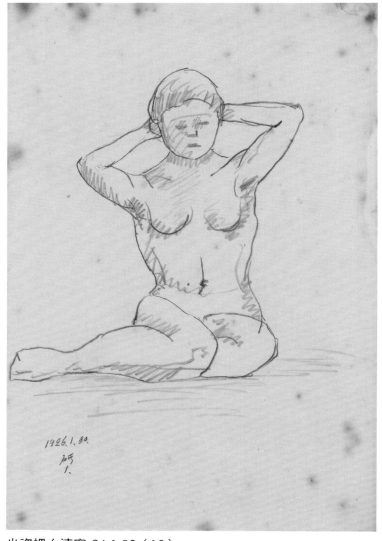

坐姿裸女速寫-26.1.30（10）
Seated Female Nude Sketch-26.1.30（10）

1926　紙本鉛筆　24.1×16.6cm

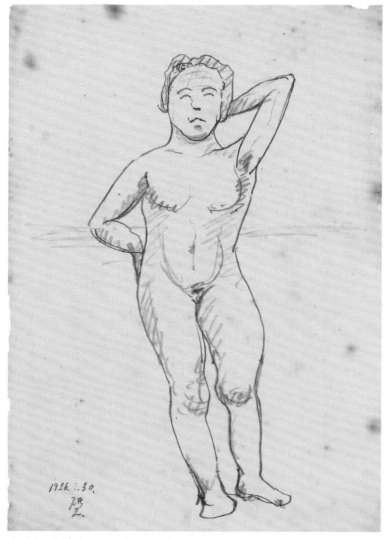

立姿裸女速寫-26.1.30（22）
Standing Female Nude Sketch-26.1.30（22）

1926　紙本鉛筆　24.3×16.7cm

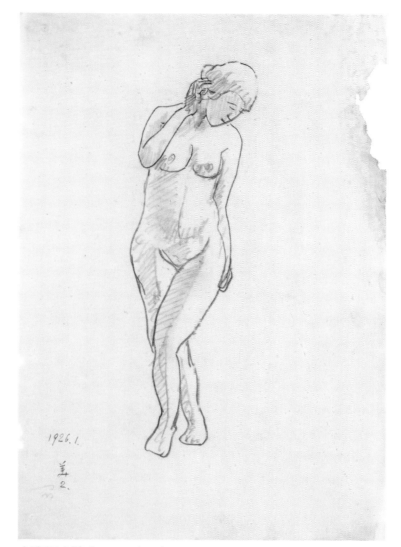

立姿裸女速寫-26.1（23）
Standing Female Nude Sketch-26.1（23）

1926　紙本鉛筆　24.2×16.4cm

立姿裸女速寫-26.1（24）
Standing Female Nude Sketch-26.1（24）

1926　紙本鉛筆　24.3×16.4cm

立姿裸女速寫-26.1（25）
Standing Female Nude Sketch-26.1（25）

1926　紙本鉛筆　24.3×16.6cm

蹲姿裸女速寫-26.1（1）
Squatting Female Nude Sketch-26.1（1）

1926　紙本鉛筆　24.3×16.5cm

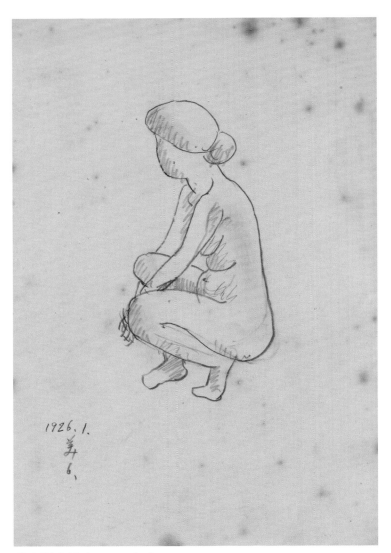

蹲姿裸女速寫-26.1（2）
Squatting Female Nude Sketch-26.1（2）

1926　紙本鉛筆　24.3×16.6cm

立姿裸女速寫-26.2.1（26）
Standing Female Nude Sketch-26.2.1（26）

1926　紙本鉛筆　24.3×16.8cm

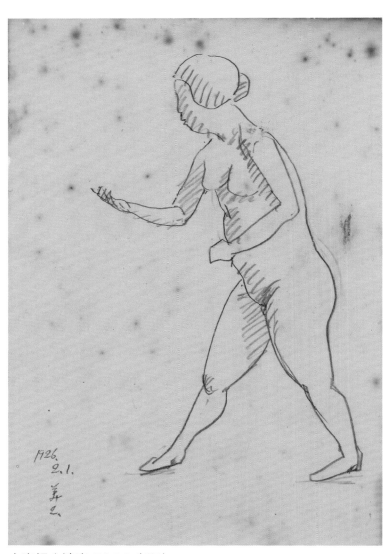

立姿裸女速寫-26.2.1（27）
Standing Female Nude Sketch-26.2.1（27）

1926　紙本鉛筆　24.3×16.8cm

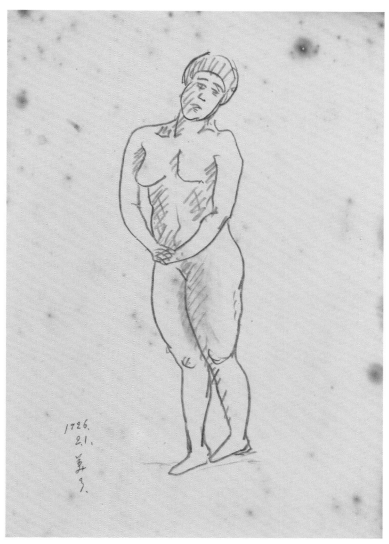

立姿裸女速寫-26.2.1（28）
Standing Female Nude Sketch-26.2.1（28）

1926　紙本鉛筆　24.3×16.8cm

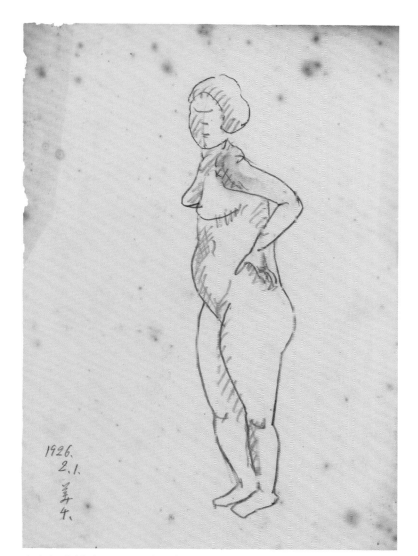

立姿裸女速寫-26.2.1（29）
Standing Female Nude Sketch-26.2.1（29）

1926　紙本鉛筆　24.3×16.8cm

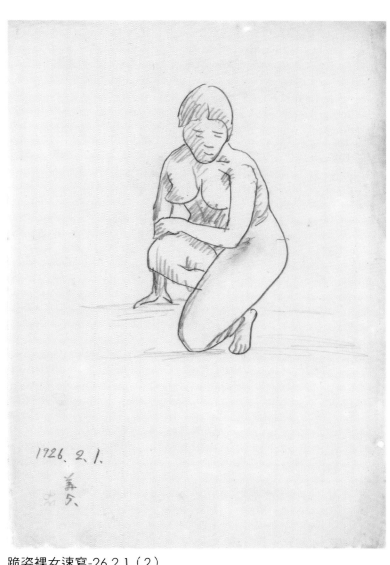

跪姿裸女速寫-26.2.1（2）
Kneeling Female Nude Sketch-26.2.1（2）

1926　紙本鉛筆　24×16.8cm

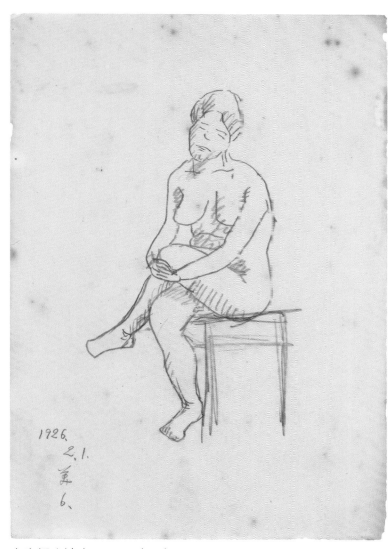

坐姿裸女速寫-26.2.1（11）
Seated Female Nude Sketch-26.2.1（11）

1926　紙本鉛筆　24.3×16.8cm

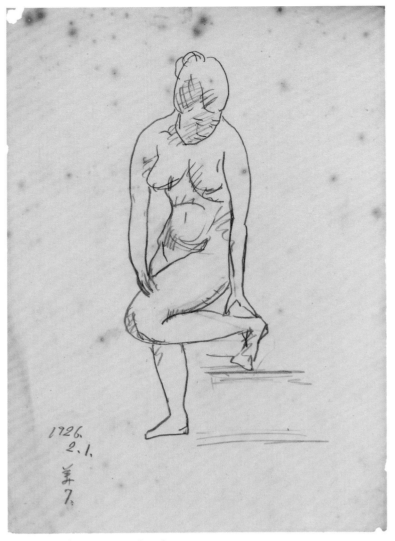

立姿裸女速寫-26.2.1（30）
Standing Female Nude Sketch-26.2.1（30）

1926　紙本鉛筆　24.3×16.8cm

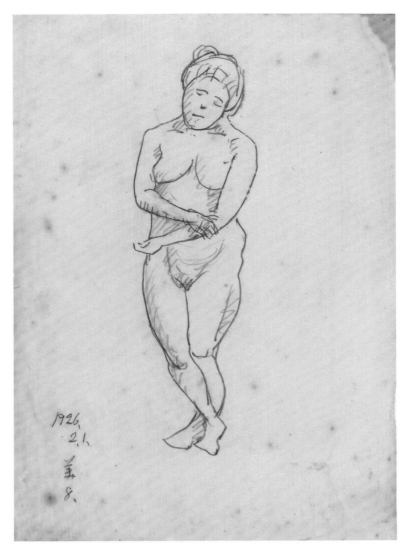

立姿裸女速寫-26.2.1（31）
Standing Female Nude Sketch-26.2.1（31）

1926　紙本鉛筆　24.3×16.8cm

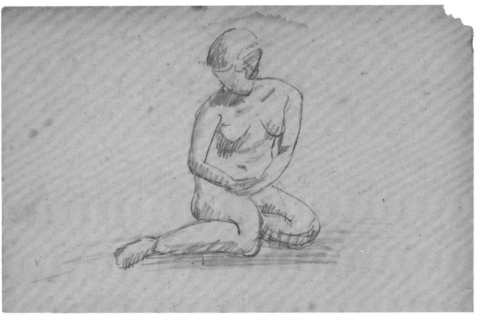

坐姿裸女速寫（12）　Seated Female Nude Sketch（12）

約1926　紙本鉛筆　16.6×24.6cm

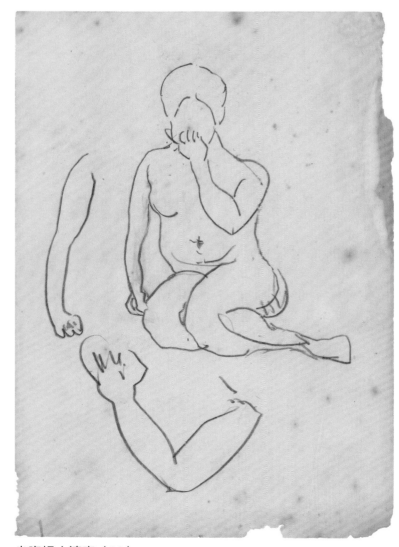

坐姿裸女速寫（13）
Seated Female Nude Sketch（13）

約1926　紙本鉛筆　24.1×16.3cm

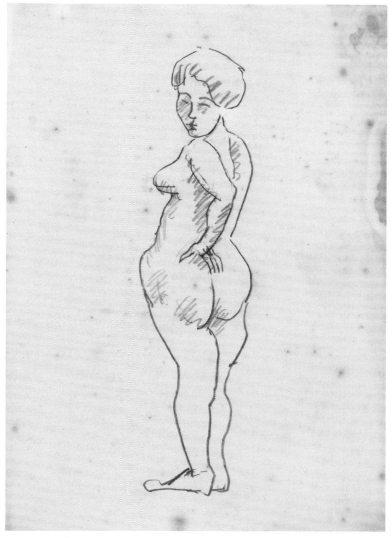

立姿裸女速寫（32）
Standing Female Nude Sketch（32）

約1926　紙本鉛筆　24.3×16.5cm

立姿裸女速寫（33）
Standing Female Nude Sketch（33）

約1926　紙本鉛筆　24.3×16.6cm

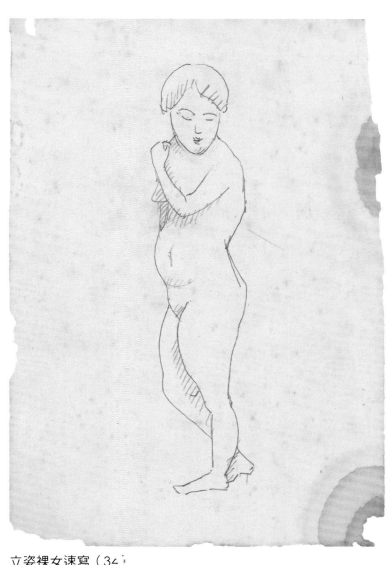

立姿裸女速寫（34）
Standing Female Nude Sketch（34）

約1926　紙本鉛筆　24.3×16.6cm

立姿裸女速寫（35）
Standing Female Nude Sketch（35）

約1926　紙本鉛筆　24×16.5cm

立姿裸女速寫（36）
Standing Femcle Nude Sketch（36）

約1926　紙本鉛筆　24.3×16.5cm

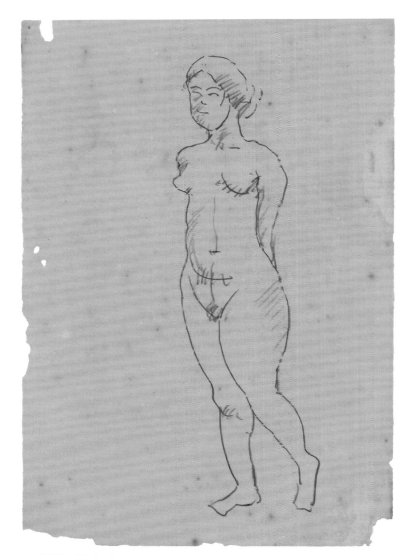

立姿裸女速寫（37）
Standing Female Nude Sketch（37）

約1926　紙本鉛筆　24.3×16.7cm

立姿裸女速寫（38）
Standing Female Nude Sketch（38）

約1926　紙本鉛筆　24.2×16.7cm

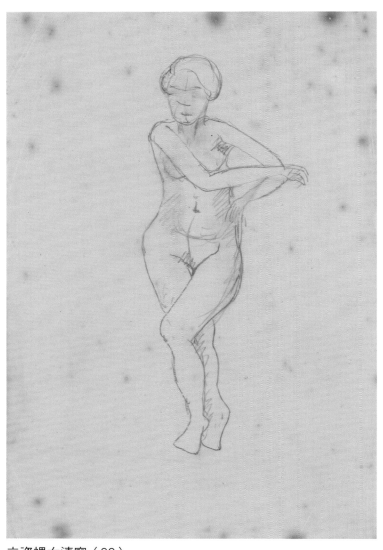

立姿裸女速寫（39）
Standing Female Nude Sketch（39）

約1926　紙本鉛筆　24.3×16.5cm

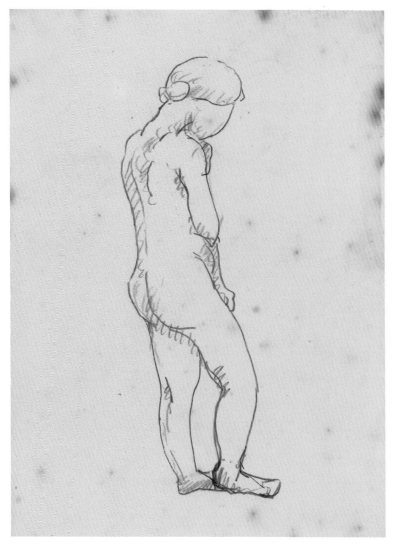

立姿裸女速寫（40）
Standing Female Nude Sketch（40）

約1926　紙本鉛筆　24.2×16.7cm

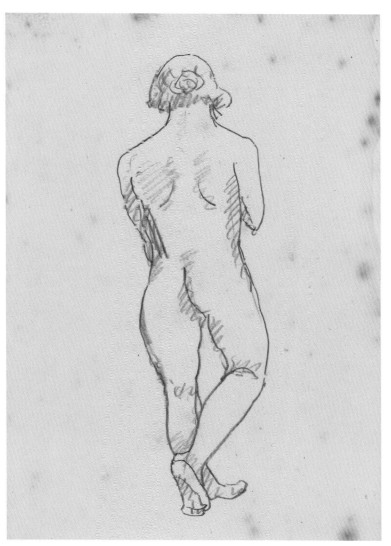

立姿裸女速寫（41）
Standing Female Nude Sketch（41）

約1926　紙本鉛筆　24.2×16.7cm

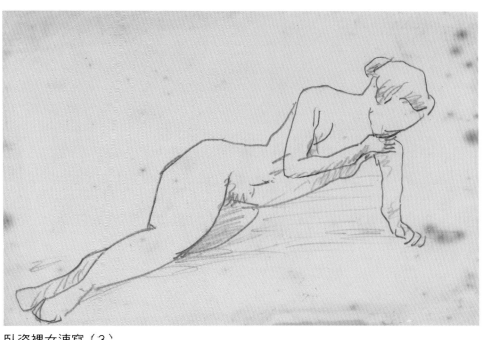

臥姿裸女速寫（3）
Reclining Female Nude Sketch（3）

約1926　紙本鉛筆　16.7×24.3cm

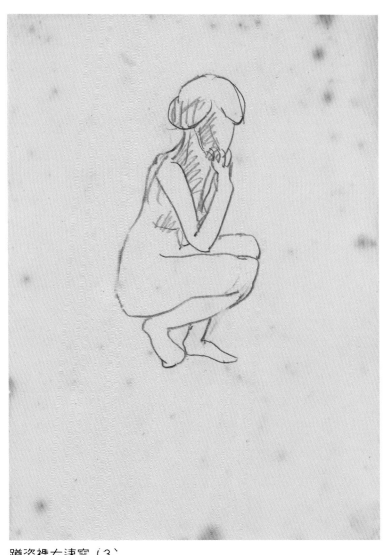

蹲姿裸女速寫（3）
Squating Female Nude Sketch（3）

約1926　紙本鉛筆　24.2×16.5cm

女體速寫（1）Female Body Sketch（1）

約1926　紙本鉛筆　24.3×16.8cm

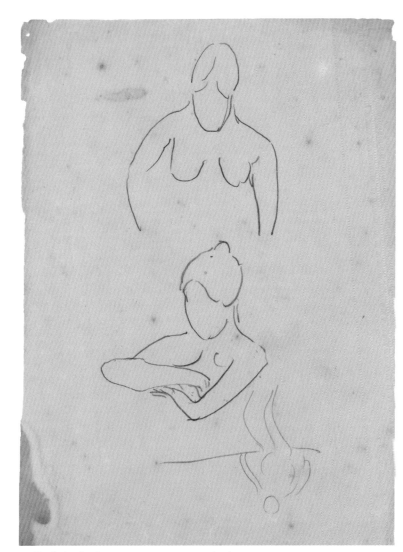

頭像速寫（3）Portrait Sketch（3）

約1926　紙本鉛筆　24.2×16.7cm

人物速寫（4）Figure Sketch（4）

約1926　紙本鉛筆　24.3×16.4cm

人物速寫（5）Figure Sketch（5）

約1926　紙本鉛筆　24.3×16.5cm

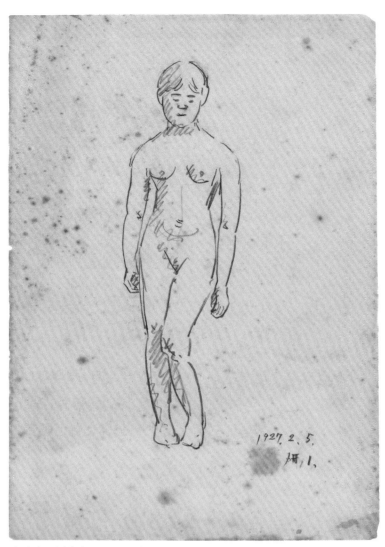

立姿裸女速寫-27.2.5（42）
Standing Female Nude Sketch-27.2.5（42）

1927　紙本鉛筆　24.4×16.6cm

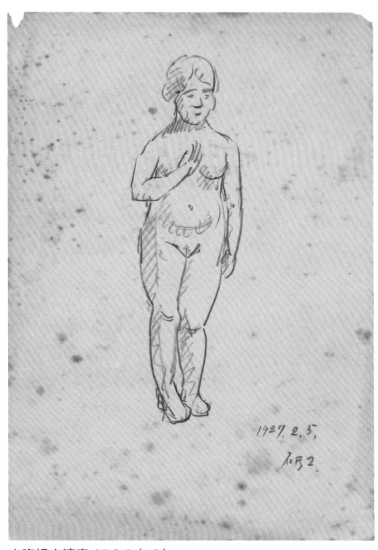

立姿裸女速寫-27.2.5（43）
Standing Female Nude Sketch-27.2.5（43）

1927　紙本鉛筆　24.4×16.5cm

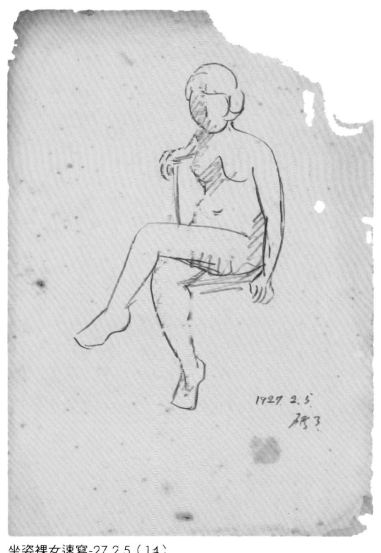

坐姿裸女速寫-27.2.5（14）
Seated Female Nude Sketch-27.2.5（14）

1927　紙本鉛筆　24.4×16.5cm

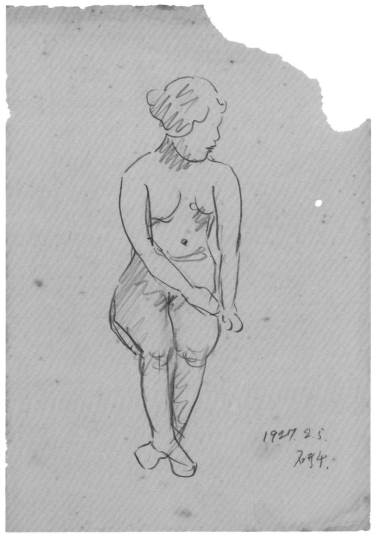

坐姿裸女速寫-27.2.5（15）
Seated Female Nude Sketch-27.2.5（15）

1927　紙本鉛筆　24.4×16.5cm

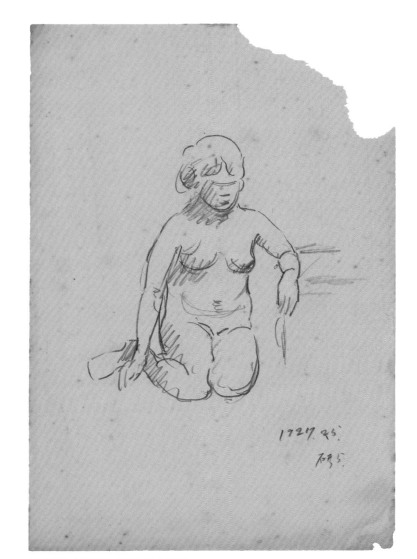

坐姿裸女速寫-27.2.5（16）
Seated Female Nude Sketch-27.2.5（16）

1927　紙本鉛筆　24.3×16.5cm

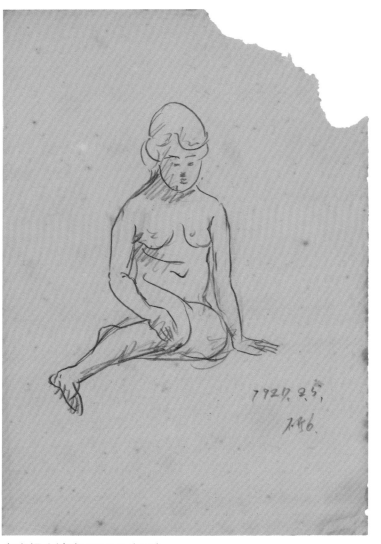

坐姿裸女速寫-27.2.5（17）
Seated Female Nude Sketch-27.2.5（17）

1927　紙本鉛筆　24.3×16.4cm

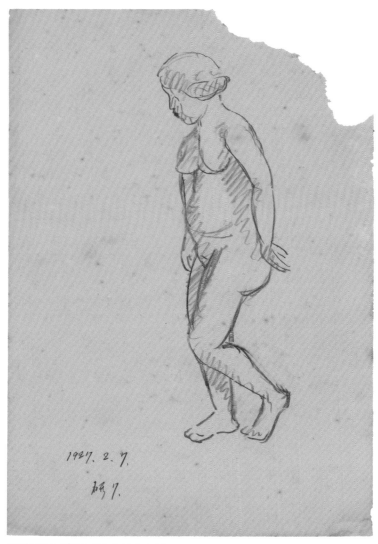

立姿裸女速寫-27.2.5（44）
Standing Female Nude Sketch-27.2.5（44）

1927　紙本鉛筆　24.4×16.4cm
※落款日期疑為1927.2.5之筆誤。

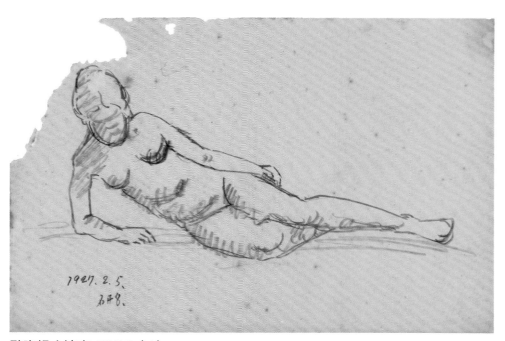

臥姿裸女速寫-27.2.5（4）
Reclining Female Nude Sketch-27.2.5（4）

1927　紙本鉛筆　16.5×24.5cm

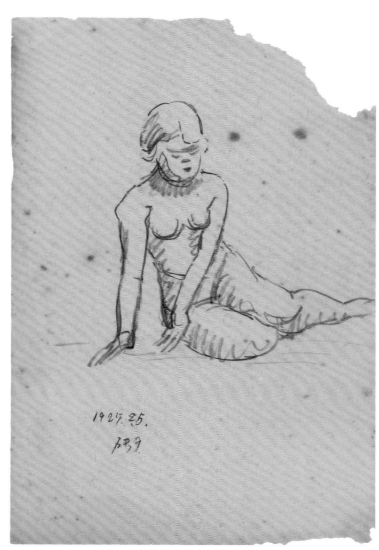

坐姿裸女速寫-27.2.5（18）
Seated Female Nude Sketch-27.2.5（18）

1927　紙本鉛筆　24.3×16.4cm

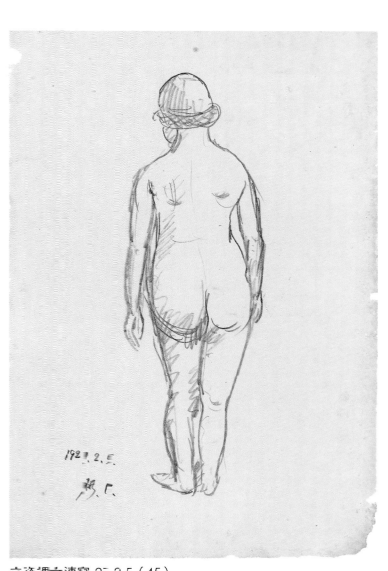

立姿裸女速寫-27.2.5（45）
Standing Female Nude Sketch-27.2.5（45）

1927　紙本鉛筆　24.2×16.5cm

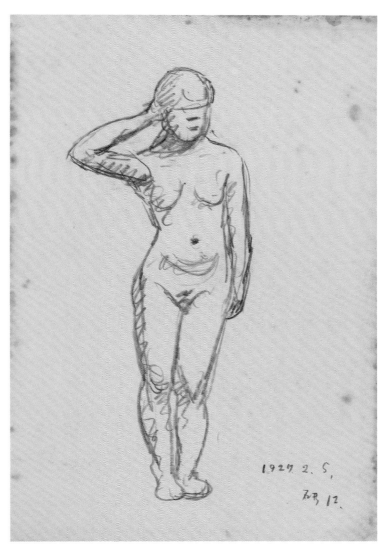

立姿裸女速寫-27.2.5（46）
Standing Female Nude Sketch-27.2.5（46）

1927　紙本鉛筆　24.1×16.6cm

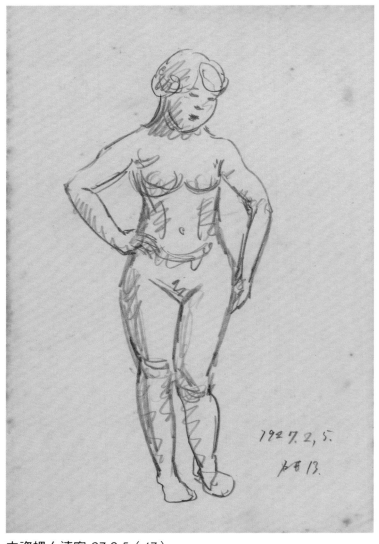

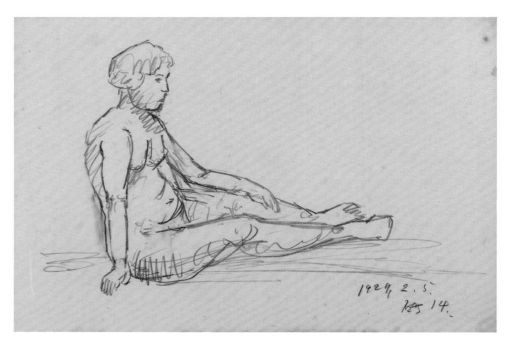

立姿裸女速寫-27.2.5（47）
Standing Female Nude Sketch-27.2.5（47）

1927　紙本鉛筆　24.2×16.6cm

坐姿裸女速寫-27.2.5（19）
Seated Female Nude Sketch-27.2.5（19）

1927　紙本鉛筆　16.5×24.2cm

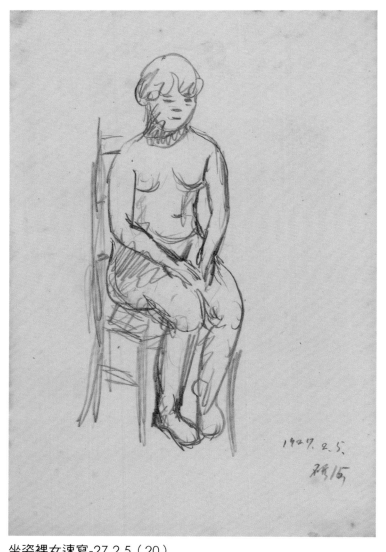

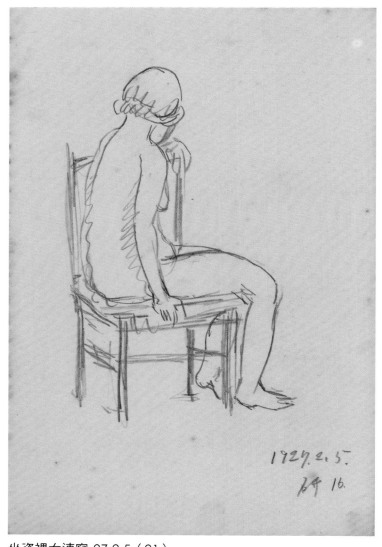

坐姿裸女速寫-27.2.5（20）
Seated Female Nude Sketch-27.2.5（20）

1927　紙本鉛筆　24.3×16.5cm

坐姿裸女速寫-27.2.5（21）
Seated Female Nude Sketch-27.2.5（21）

1927　紙本鉛筆　24.3×16.5cm

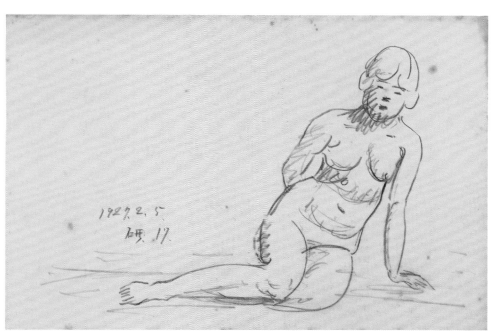

坐姿裸女速寫-27.2.5（22）
Seated Female Nude Sketch-27.2.5（22）

1927　紙本鉛筆　16.4×24.3cm

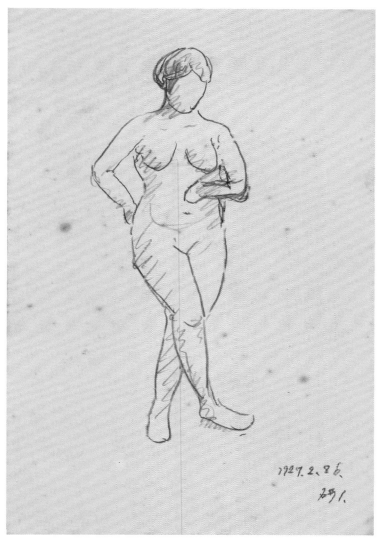

立姿裸女速寫-27.2.26（48）
Standing Female Nude Sketch-27.2.26（48）

1927　紙本鉛筆　24.2×16.5cm

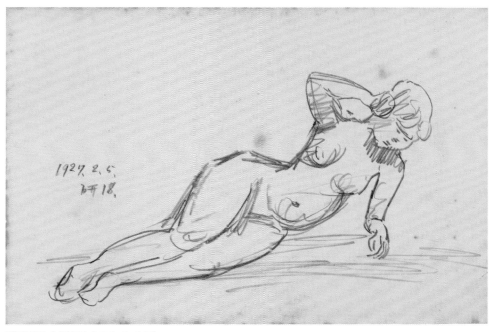

臥姿裸女速寫-27.2.5（5）
Reclining Female Nude Sketch-27.2.5（5）

1927　紙本鉛筆　16.6×24.3cm

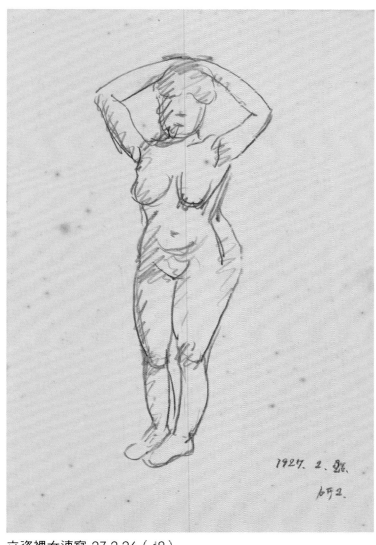

立姿裸女速寫-27.2.26（49）
Standing Female Nude Sketch-27.2.26（49）

1927　紙本鉛筆　24.3×16.6cm

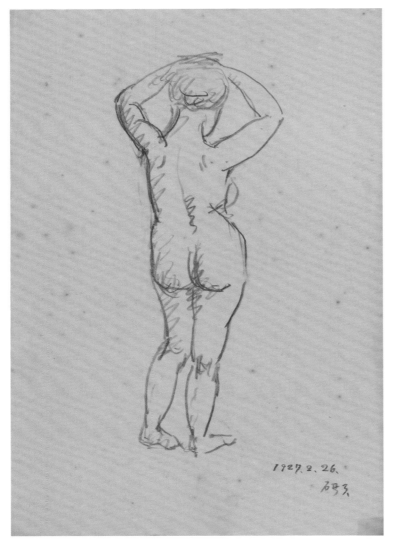

立姿裸女速寫-27.2.26（50）
Standing Female Nude Sketch-27.2.26（50）

1927　紙本鉛筆　24.3×16.6cm

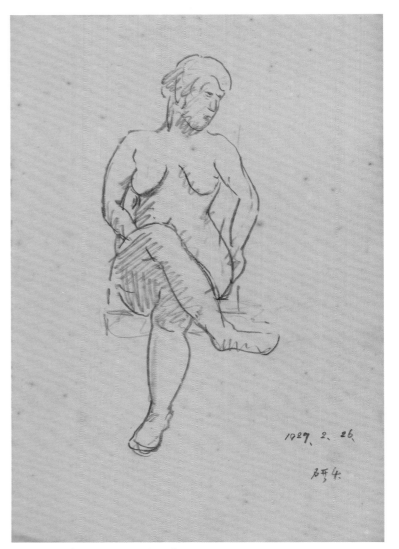

坐姿裸女速寫-27.2.26（23）
Seated Female Nude Sketch-27.2.26（23）

1927　紙本鉛筆　24.3×16.7cm

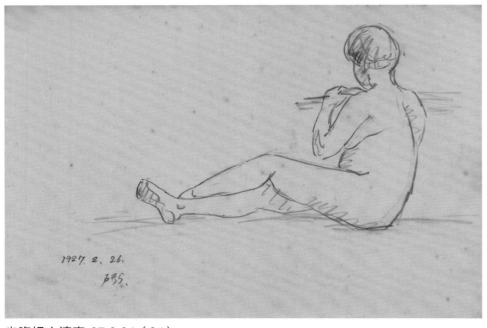

坐姿裸女速寫-27.2.26（24）
Seated Female Nude Sketch-27.2.26（24）

1927　紙本鉛筆　16.7×24.4cm

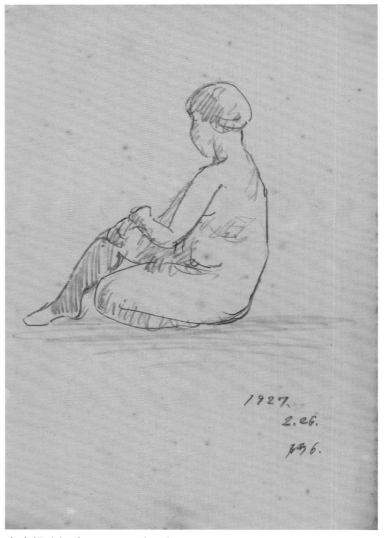

坐姿裸女速寫-27.2.26（25）
Seated Female Nude Sketch-27.2.26（25）

1927　紙本鉛筆　24.3×16.6cm

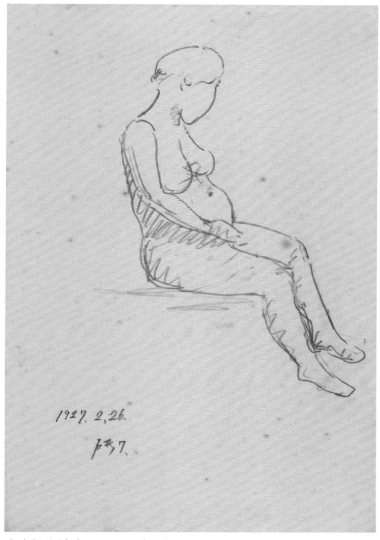

坐姿裸女速寫-27.2.26（26）
Seated Female Nude Sketch-27.2.26（26）

1927　紙本鉛筆　24.4×16.6cm

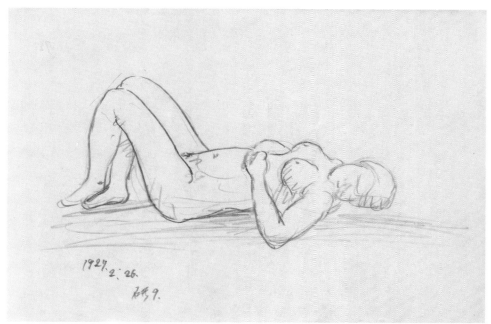

臥姿裸女速寫-27.2.26（6）
Reclining Female Nude Sketch-27.2.26（6）

1927　紙本鉛筆　16.6×24.3cm

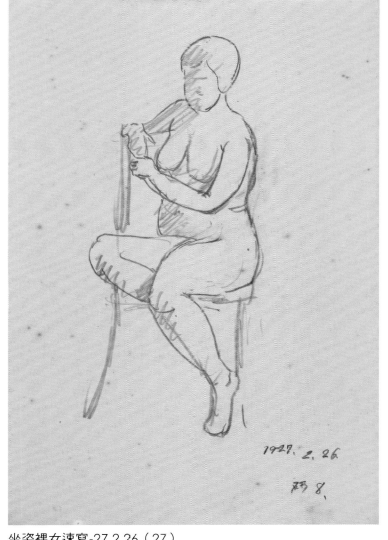

坐姿裸女速寫-27.2.26（28）
Seated Female Nude Sketch-27.2.26（28）

1927　紙本鉛筆　16.6×24.3cm

坐姿裸女速寫-27.2.26（27）
Seated Female Nude Sketch-27.2.26（27）

1927　紙本鉛筆　24.3×16.6cm

立姿裸女速寫-27.2.26（51）
Standing Female Nude Sketch-27.2.26（51）

1927　紙本鉛筆　24.4×16.8cm

立姿裸女速寫-27.2.26（52）
Standing Female Nude Sketch-27.2.26（52）

1927　紙本鉛筆　24.4×16.6cm

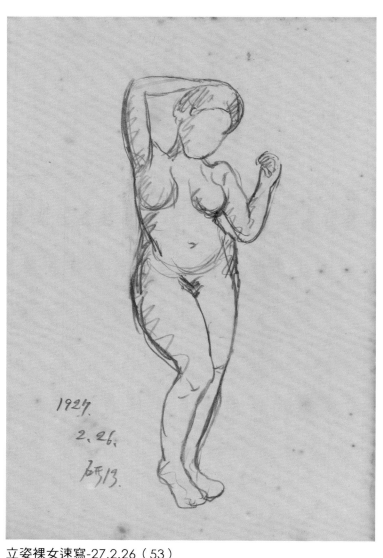

立姿裸女速寫-27.2.26（53）
Standing Female Nude Sketch-27.2.26（53）

1927　紙本鉛筆　24.3×16.6cm

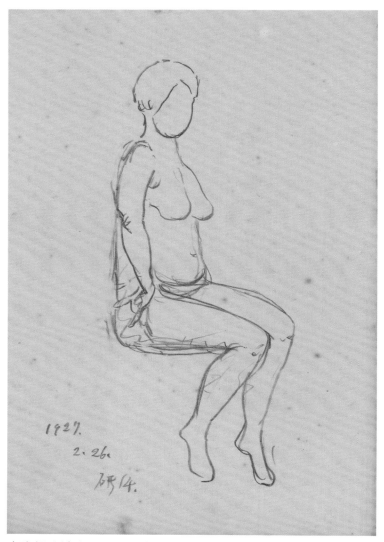

坐姿裸女速寫-27.2.26（29）
Seated Female Nude Sketch-27.2.26（29）

1927　紙本鉛筆　24.3×16.6cm

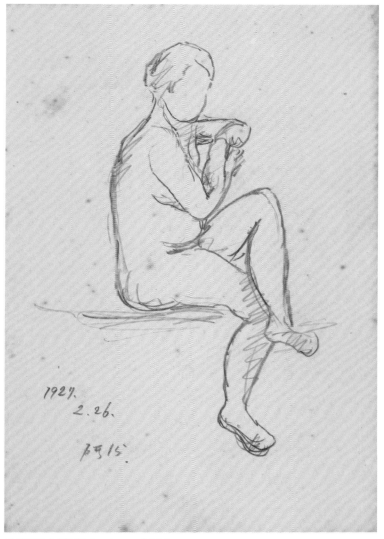

坐姿裸女速寫-27.2.26（30）
Seated Female Nude Sketch-27.2.26（30）

1927　紙本鉛筆　24.2×16.8cm

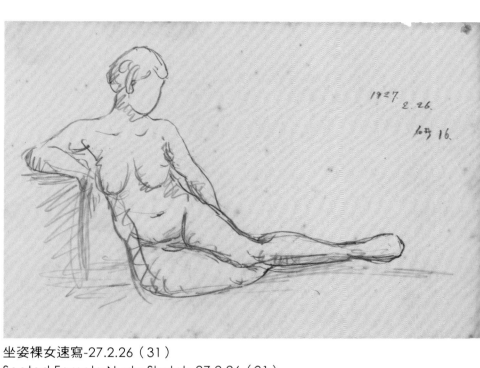

坐姿裸女速寫-27.2.26（31）
Seated Female Nude Sketch-27.2.26（31）

1927　紙本鉛筆　16.8×24.3cm

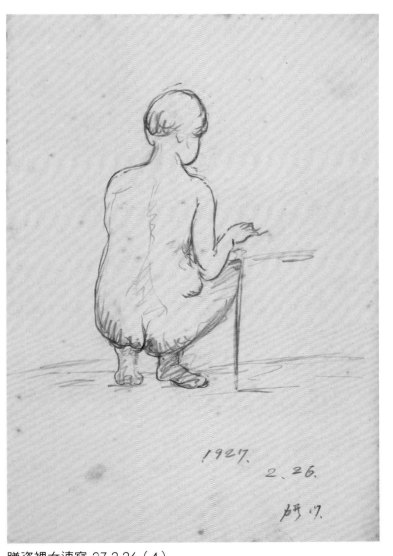

蹲姿裸女速寫-27.2.26（4）
Squatting Female Nude Sketch-27.2.26（4）

1927　紙本鉛筆　24.3×16.7cm

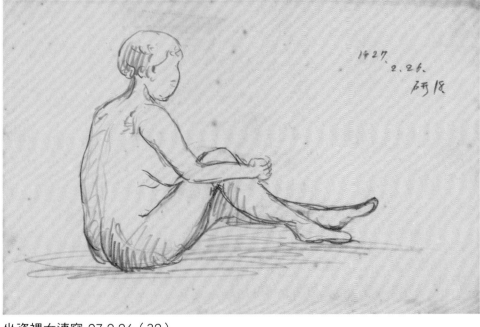

坐姿裸女速寫-27.2.26（32）
Seated Female Nude Sketch-27.2.26（32）

1927　紙本鉛筆　16.6×24.3cm

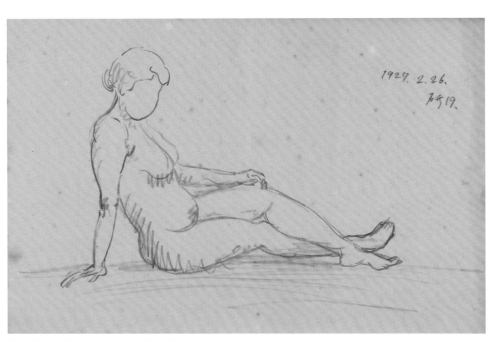

坐姿裸女速寫-27.2.26（33）
Seated Female Nude Sketch-27.2.26（33）

1927　紙本鉛筆　16.7×24.3cm

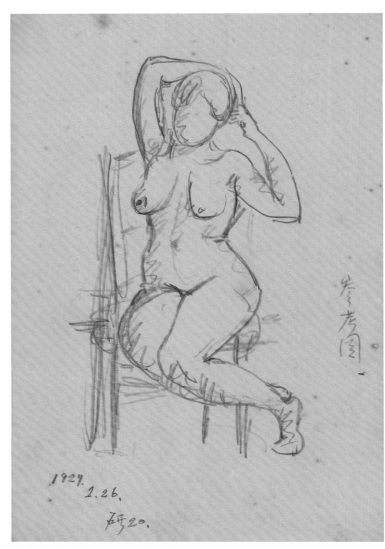

坐姿裸女速寫-27.2.26（34）
Seated Female Nude Sketch-27.2.26（34）

1927　紙本鉛筆　24.3×16.7cm

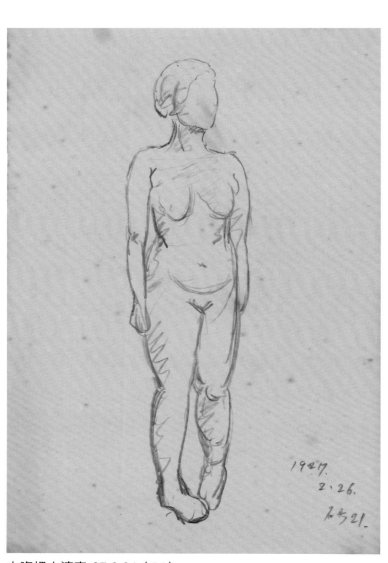

立姿裸女速寫-27.2.26（54）
Standing Female Nude Sketch-27.2.26（54）

1927　紙本鉛筆　24.3×16.7cm

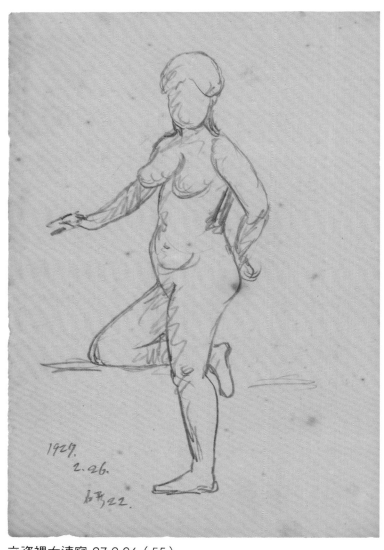

立姿裸女速寫-27.2.26（55）
Standing Female Nude Sketch-27.2.26（55）

1927　紙本鉛筆　24.3×16.7cm

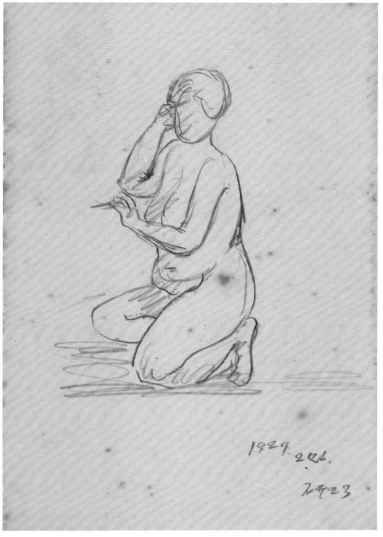

跪姿裸女速寫-27.2.26（3）
Kneeling Female Nude Sketch-27.2.26（3）

1927　紙本鉛筆　24.2×16.7cm

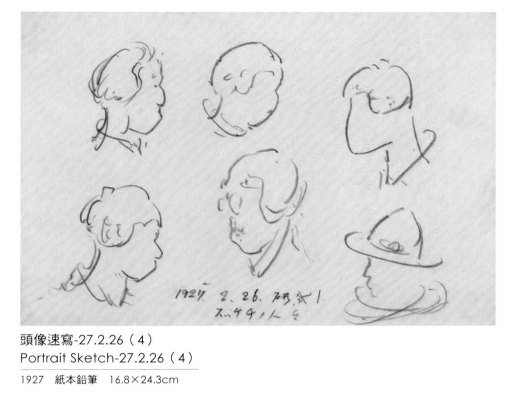

頭像速寫-27.2.26（4）
Portrait Sketch-27.2.26（4）

1927　紙本鉛筆　16.8×24.3cm

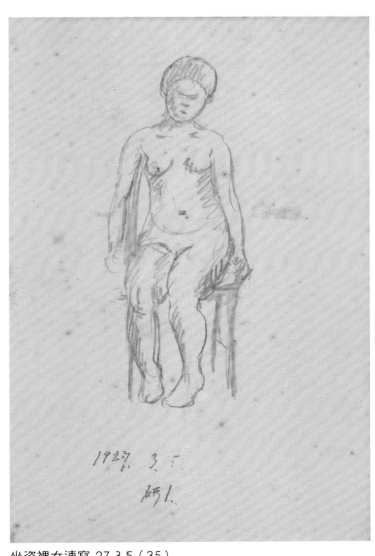

坐姿裸女速寫-27.3.5（35）
Seated Female Nude Sketch-27.3.5（35）

1927　紙本鉛筆　24.4×16.5cm

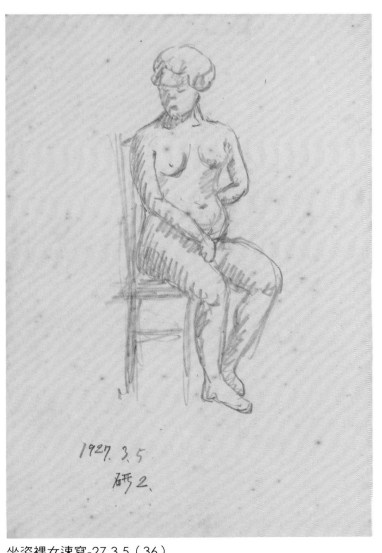

坐姿裸女速寫-27.3.5（36）
Seated Female Nude Sketch-27.3.5（36）

1927　紙本鉛筆　24.5×16.4cm

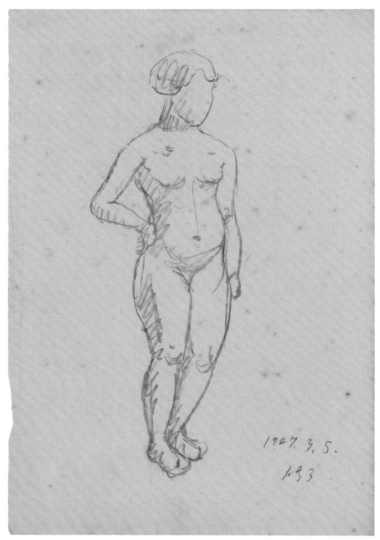

立姿裸女速寫-27.3.5（56）
Standing Female Nude Sketch-27.3.5（56）

1927　紙本鉛筆　24.3×16.4cm

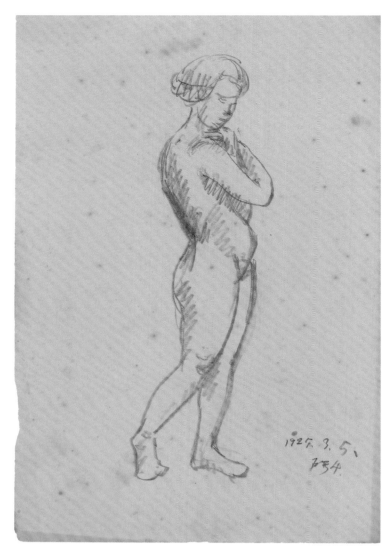

立姿裸女速寫-27.3.5（57）
Standing Female Nude Sketch-27.3.5（57）

1927　紙本鉛筆　24.5×16.5cm

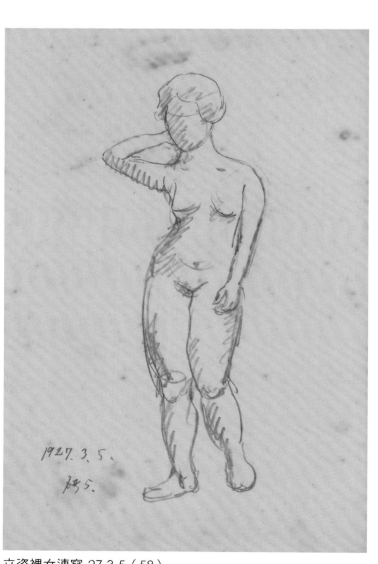

立姿裸女速寫-27.3.5（58）
Standing Female Nude Sketch-27.3.5（58）

1927　紙本鉛筆　24.4×16.4cm

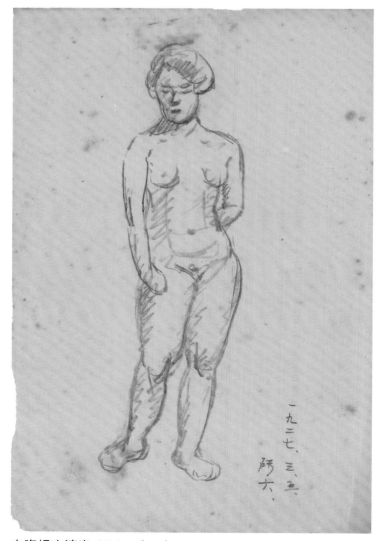

立姿裸女速寫-27.3.5（59）
Standing Female Nude Sketch-27.3.5（59）

1927　紙本鉛筆　24.4×16.3cm

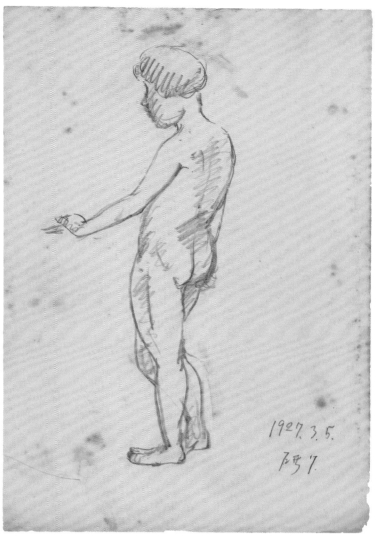

立姿裸女速寫-27.3.5（60）
Standing Female Nude Sketch-27.3.5（60）

1927　紙本鉛筆　24.3×16.5cm

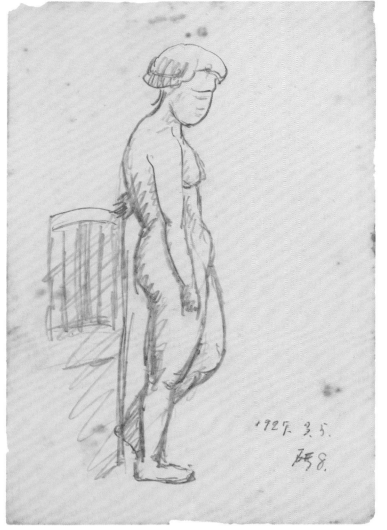

立姿裸女速寫-27.3.5（61）
Standing Female Nude Sketch-27.3.5（61）

1927　紙本鉛筆　24.3×16.5cm

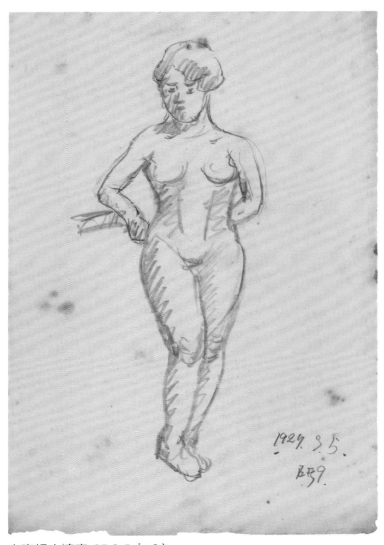

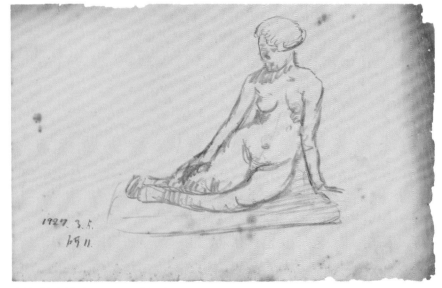

坐姿裸女速寫-27.3.5（37）
Seated Female Nude Sketch-27.3.5（37）

1927　紙本鉛筆　16.5×24.3cm

立姿裸女速寫-27.3.5（62）
Standing Female Nude Sketch-27.3.5（62）

1927　紙本鉛筆　24.2×16.4cm

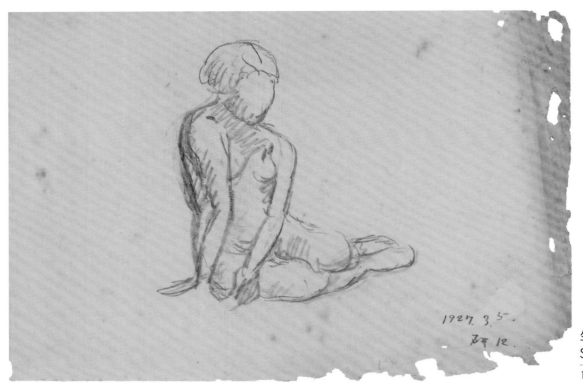

坐姿裸女速寫-27.3.5（38）
Seated Female Nude Sketch-27.3.5（38）

1927　紙本鉛筆　16.5×24.3cm

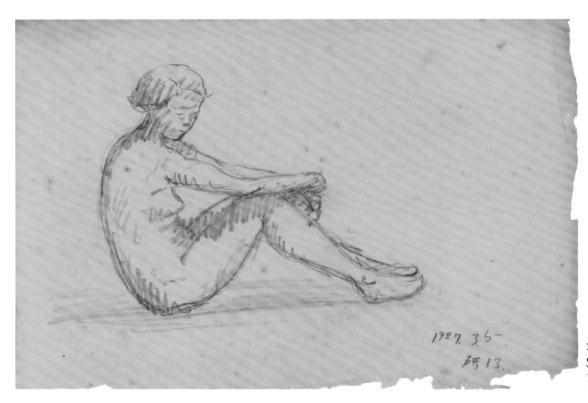

坐姿裸女速寫-27.3 5（39）
Seated Female Nude Sketch-27.3.5（39）

1927　紙本鉛筆　16.7×24.3cm

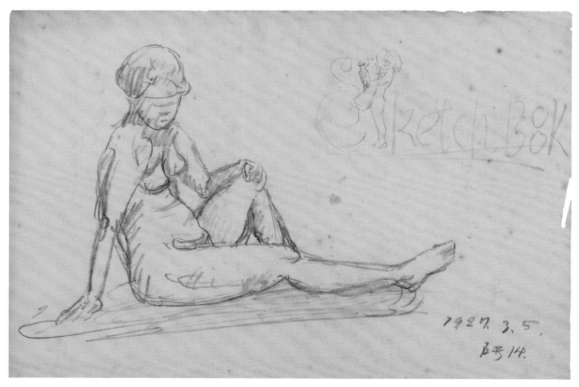

坐姿裸女速寫-27.3.5（40）
Seated Female Nude Sketch-27.3.5（40）

1927　紙本鉛筆　16.6×24.3cm

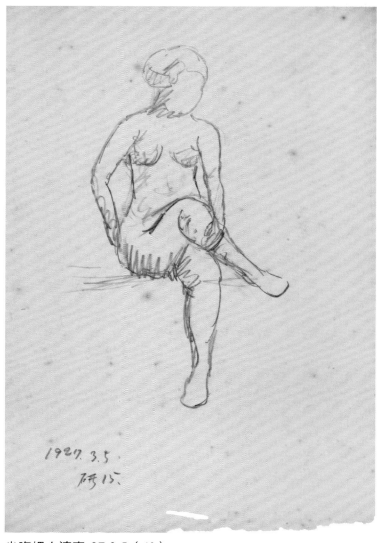

坐姿裸女速寫-27.3.5（41）
Seated Female Nude Sketch-27.3.5（41）

1927　紙本鉛筆　24.3×16.6cm

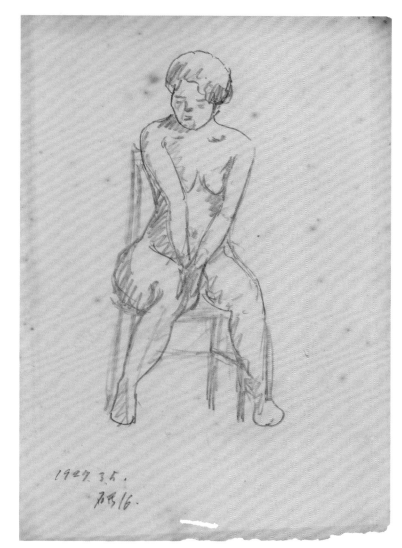

坐姿裸女速寫-27.3.5（42）
Seated Female Nude Sketch-27.3.5（42）

1927　紙本鉛筆　24.3×16.6cm

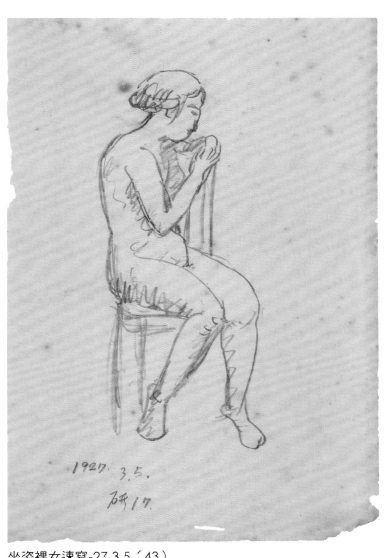

坐姿裸女速寫-27.3.5（43）
Seated Female Nude Sketch-27.3.5（43）

1927　紙本鉛筆　24.3×16.6cm

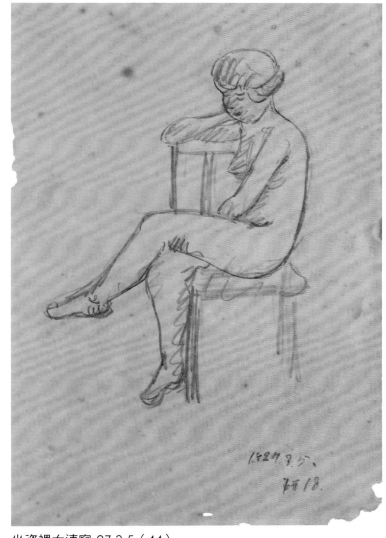

坐姿裸女速寫-27.3.5（44）
Seated Female Nude Sketch-27.3.5（44）

1927　紙本鉛筆　24.3×16.6cm

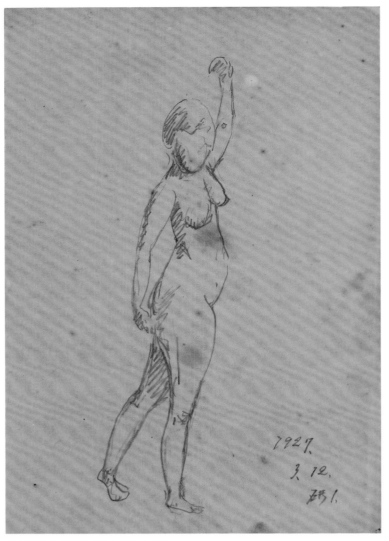

立姿裸女速寫-27.3.12（63）
Standing Female Nude Sketch-27.3.12（63）

1927　紙本鉛筆　24.2×16.7cm

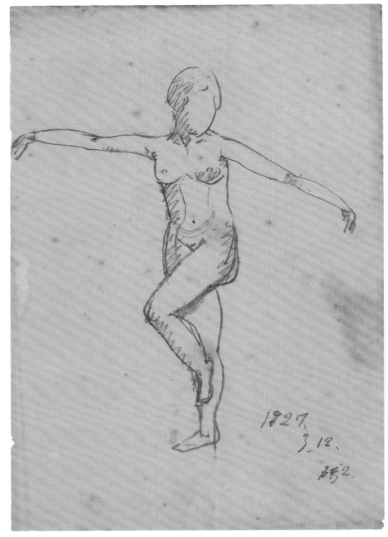

立姿裸女速寫-27.3.12（64）
Standing Female Nude Sketch-27.3.12（64）

1927　紙本鉛筆　24.2×16.7cm

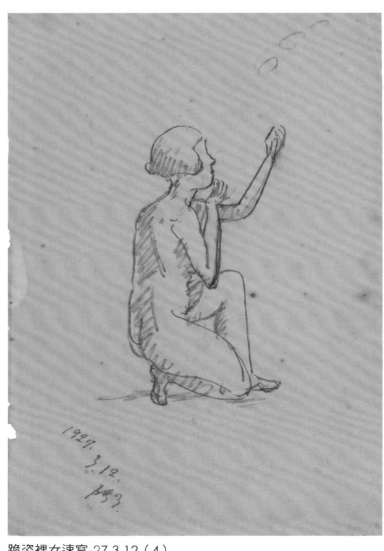

跪姿裸女速寫-27.3.12（4）
Kneeling Female Nude Sketch-27.3.12（4）

1927　紙本鉛筆　24.3×16.7cm

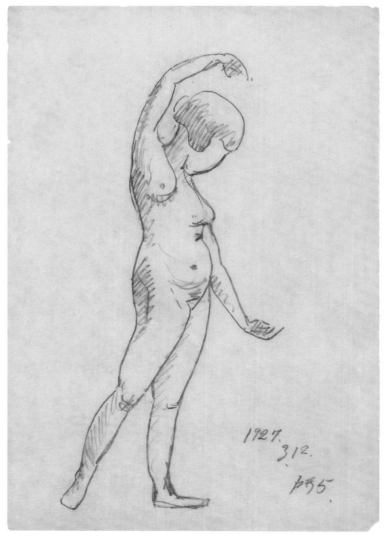

立姿裸女速寫-27.3.12（65）
Standing Female Nude Sketch-27.3.12（65）

1927　紙本鉛筆　24.3×16.6cm

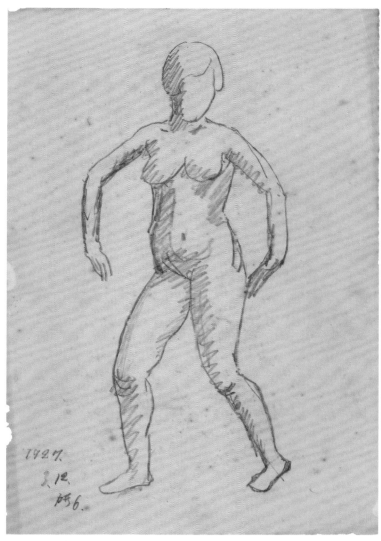

立姿裸女速寫-27.3.12（66）
Standing Female Nude Sketch-27.3.12（66）

1927　紙本鉛筆　24.2×16.8cm

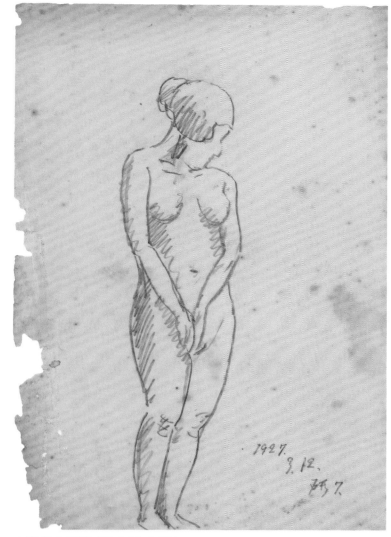

立姿裸女速寫-27.3.12（67）
Standing Female Nude Sketch-27.3.12（67）

1927　紙本鉛筆　24.4×16.6cm

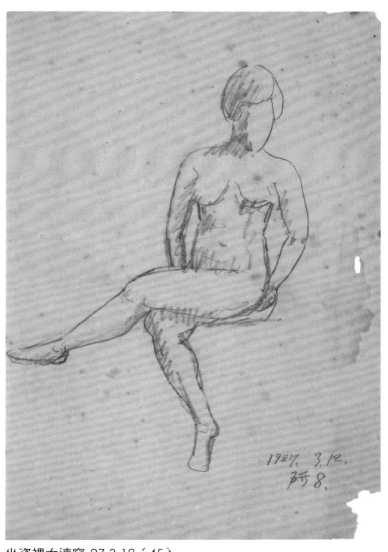

坐姿裸女速寫-27.3.12（45）
Seated Female Nude Sketch-27.3.12（45）

1927　紙本鉛筆　24.3×16.7cm

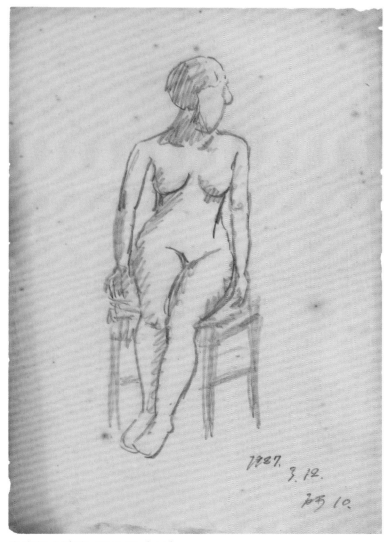

坐姿裸女速寫-27.3.12（46）
Seated Female Nude Sketch-27.3.12（46）

1927　紙本鉛筆　24.3×16.8cm

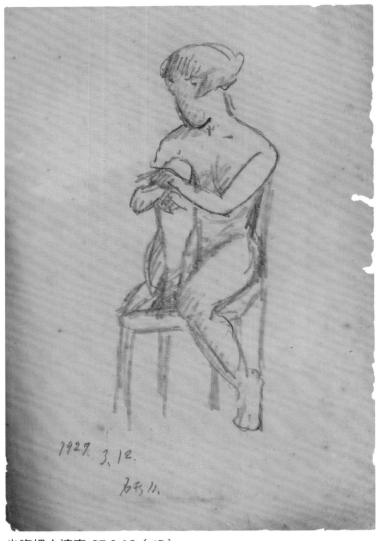

坐姿裸女速寫-27.3.12（47）
Seated Female Nude Sketch-27.3.12（47）

1927　紙本鉛筆　24.4×16.5cm

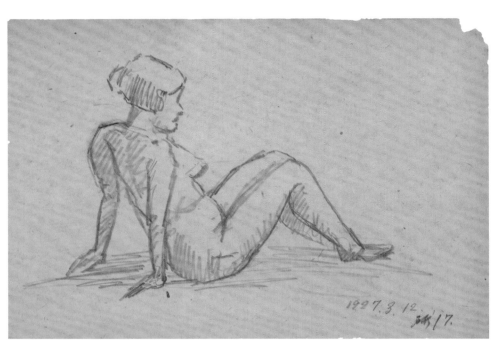

坐姿裸女速寫-27.3.12（48）
Seated Female Nude Sketch-27.3.12（48）

1927　紙本鉛筆　16.7×24.5cm

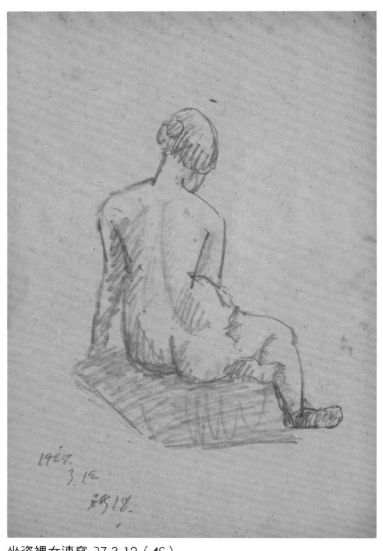

坐姿裸女速寫-27.3.12（49）
Seated Female Nude Sketch-27.3.12（49）

1927　紙本鉛筆　24.4×15.6cm

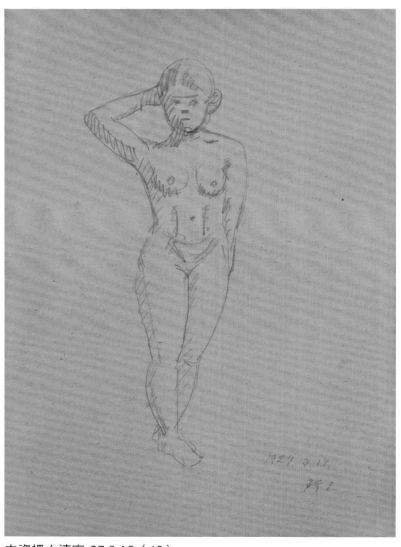

立姿裸女速寫-27.3.19（68）
Standing Female Nude Sketch-27.3.19（68）

1927　紙本鉛筆　34×24cm

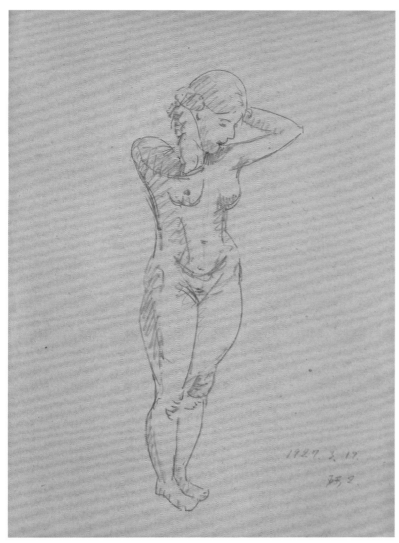

立姿裸女速寫-27.3.19（69）
Standing Female Nude Sketch-27.3.19（69）

1927　紙本鉛筆　34×24cm

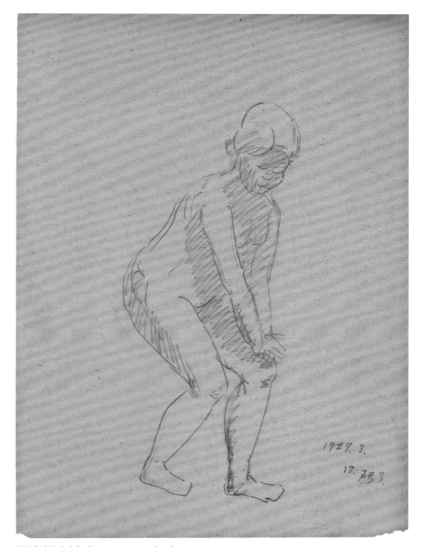

蹲姿裸女速寫-27.3.19（5）
Squatting Female Nude Sketch-27.3.19（5）

1927　紙本鉛筆　33×23.9cm

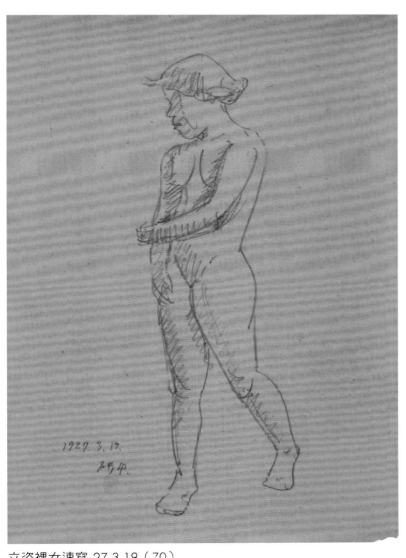

立姿裸女速寫-27.3.19（70）
Standing Female Nude Sketch-27.3.19（70）

1927　紙本鉛筆　33.2×23.9cm

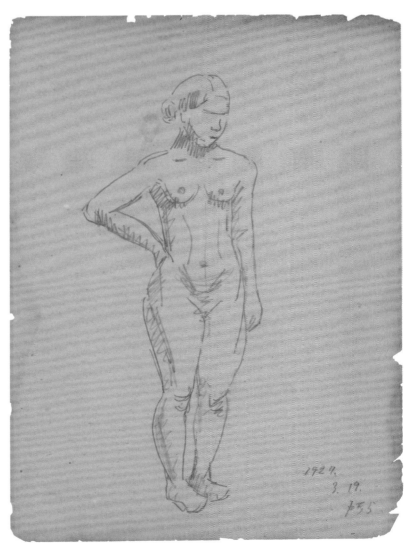

立姿裸女速寫-27.3.19（71）
Standing Female Nude Sketch-27.3.19（71）

1927　紙本鉛筆　33×23.9cm

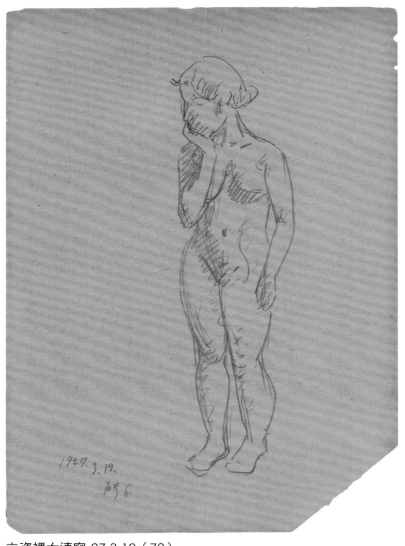

立姿裸女速寫-27.3.19（72）
Standing Female Nude Sketch-27.3.19（72）

1927　紙本鉛筆　34×24cm

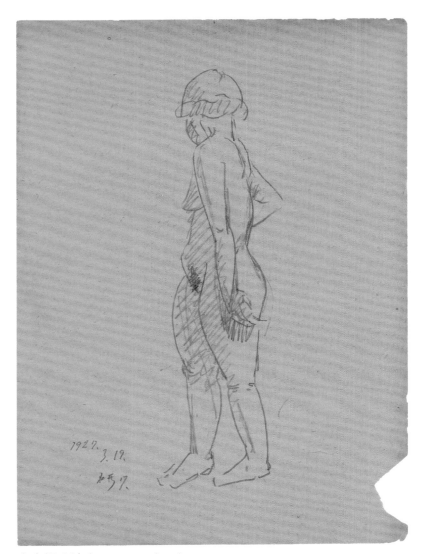

立姿裸女速寫-27.3.19（73）
Standing Female Nude Sketch-27.3.19（73）

1927　紙本鉛筆　34×24cm

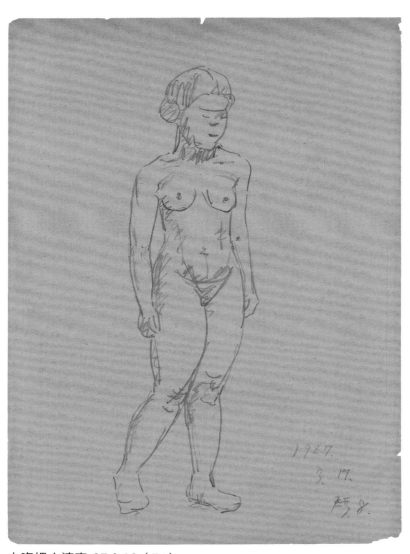

立姿裸女速寫-27.3.19（74）
Standing Female Nude Sketch-27.3.19（74）

1927　紙本鉛筆　34×24cm

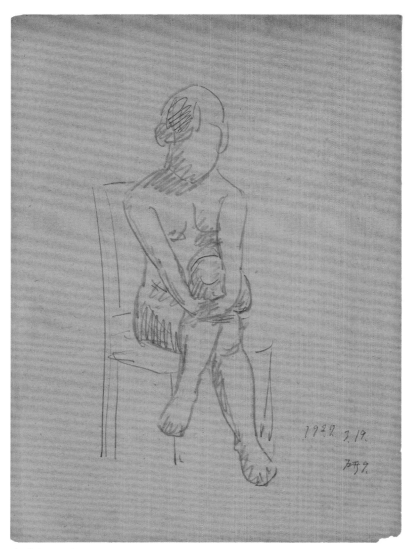

坐姿裸女速寫-27.3.19（50）
Seated Female Nude Sketch-27.3.19（50）

1927　紙本鉛筆　33×24cm

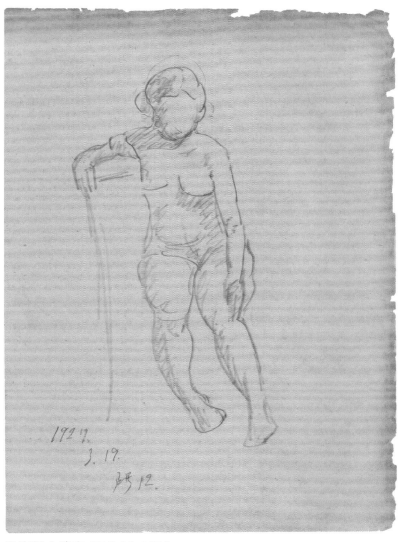

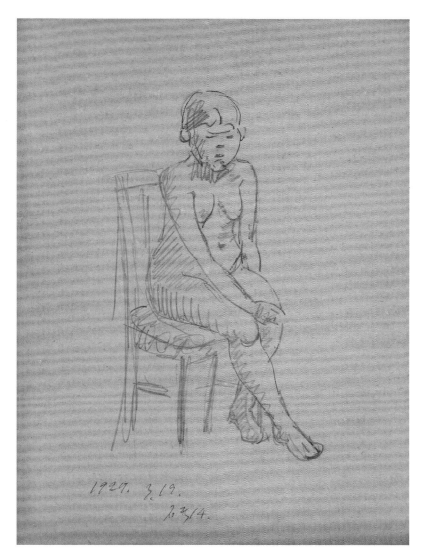

坐姿裸女速寫-27.3.19（51）
Seated Female Nude Sketch-27.3.19（51）

1927　紙本鉛筆　34×24cm

坐姿裸女速寫-27.3.19（52）
Seated Female Nude Sketch-27.3.19（52）

1927　紙本鉛筆　33.1×24cm

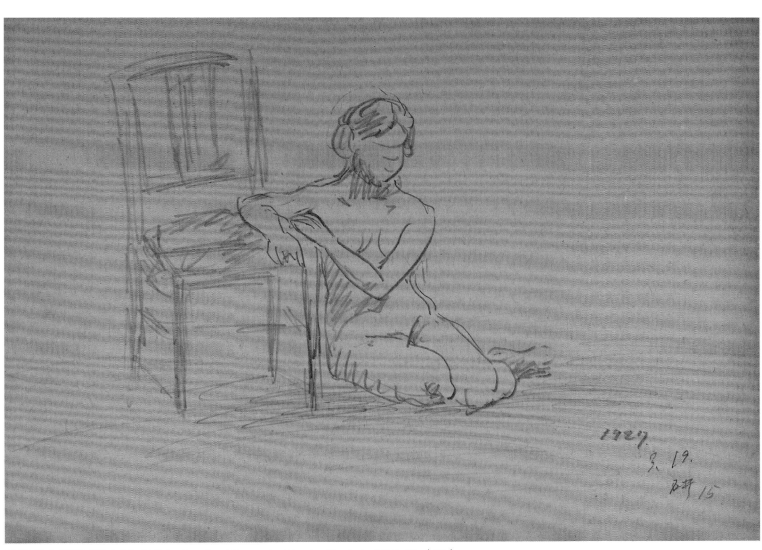

坐姿裸女速寫-27.3.19（53）Seated Female Nude Sketch-27.3.19（53）

1927　紙本鉛筆　24×33cm

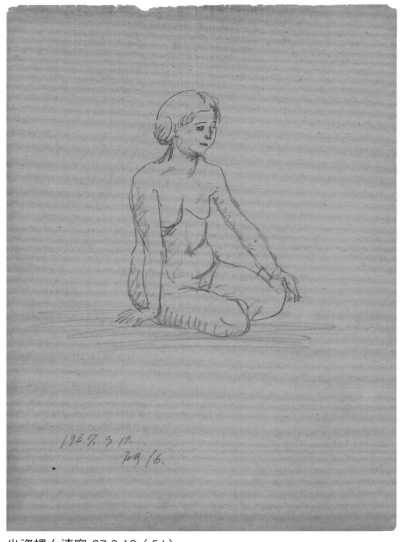

坐姿裸女速寫-27.3.19（54）
Seated Female Nude Sketch-27.3.19（54）

1927　紙本鉛筆　33×24cm

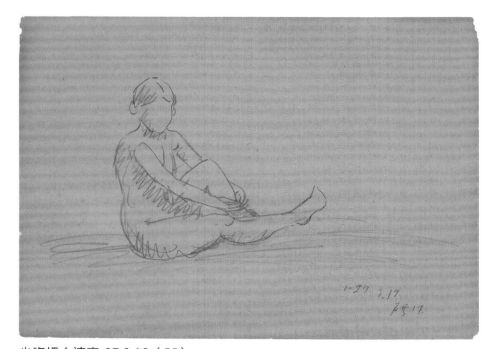

坐姿裸女速寫-27.3.19（55）
Seated Female Nude Sketch-27.3.19（55）

1927　紙本鉛筆　23.9×32.9cm

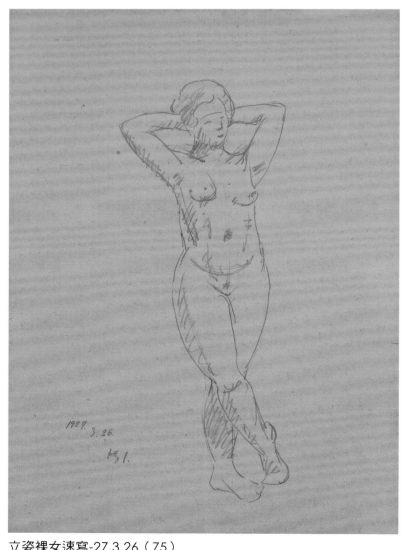

立姿裸女速寫-27.3.26（75）
Standing Female Nude Sketch-27.3.26（75）

1927　紙本鉛筆　34×24cm

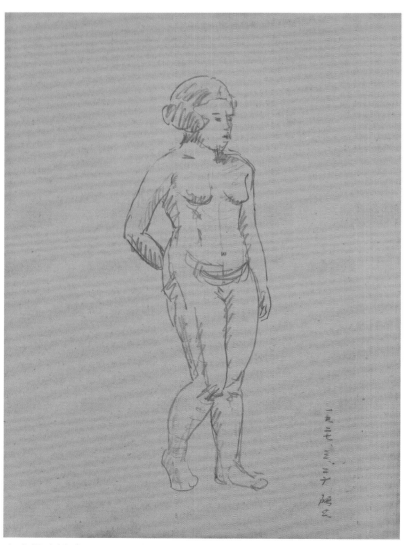

立姿裸女速寫-27.3.26（76）
Standing Female Nude Sketch-27.3 26（76）

1927　紙本鉛筆　34×24cm

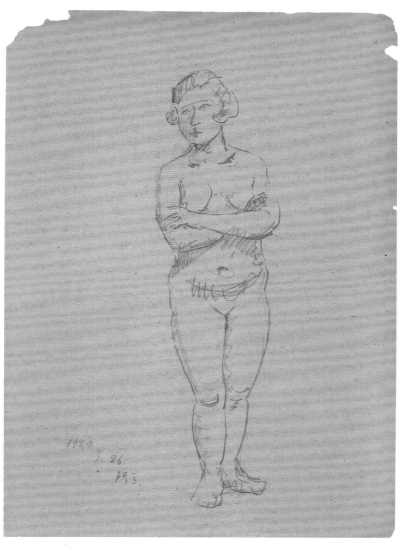

立姿裸女速寫-27.3.26（77）
Standing Female Nude Sketch-27.3.26（77）

1927　紙本鉛筆　34×24cm

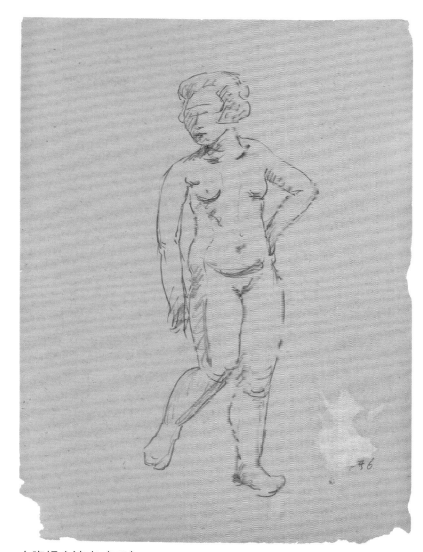

立姿裸女速寫（78）
Standing Female Nude Sketch（78）

約1927（疑1927.3.26）　紙本鉛筆　34×24cm

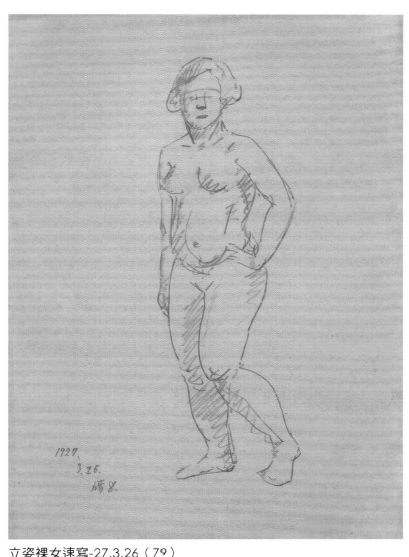

立姿裸女速寫-27.3.26（79）
Standing Female Nude Sketch-27.3.26（79）

1927　紙本鉛筆　34×24cm

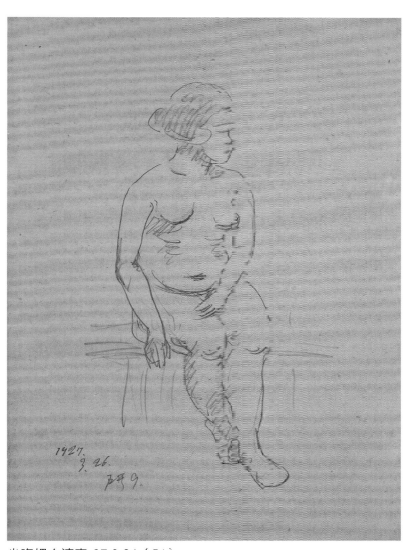

坐姿裸女速寫-27.3.26（56）
Seated Female Nude Sketch-27.3.26（56）

1927　紙本鉛筆　33×23.9cm

坐姿裸女速寫-27.3.26（57）
Seated Female Nude Sketch-27.3.26（57）

1927　紙本鉛筆　33×23.9cm

坐姿裸女速寫-27.3.26（58）
Seated Female Nude Sketch-27.3.26（58）

1927　紙本鉛筆　33×23.9cm

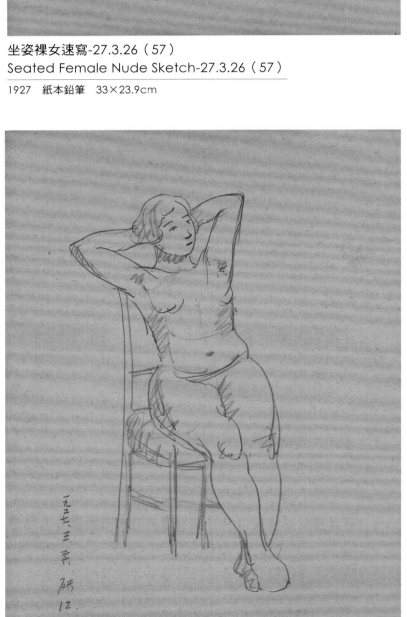

坐姿裸女速寫-27.3.26（59）
Seated Female Nude Sketch-27.3.26（59）

1927.　紙本鉛筆　33×23.9cm

立姿裸女速寫-27.3.26（80）
Standing Female Nuce Sketch-27.3.26（80）

1927　紙本鉛筆　32.9×23.9cm

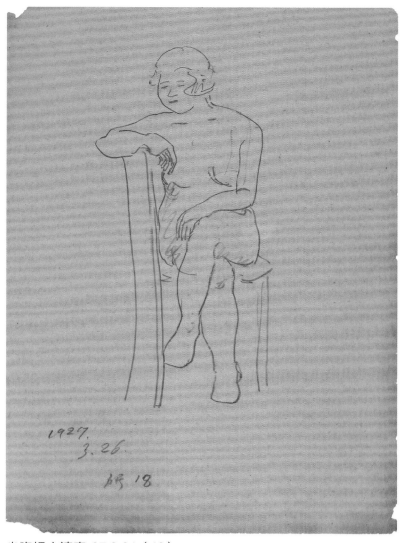

坐姿裸女速寫-27.3.26（60）
Seated Female Nude Sketch-27.3.26（60）

1927　紙本鉛筆　32.9×23.9cm

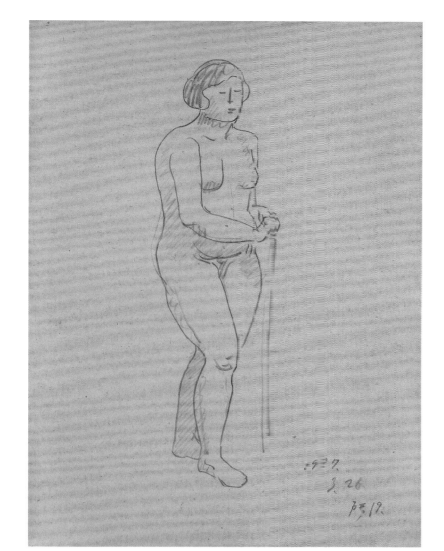

立姿裸女速寫-27.3.26（81）
Standing Female Nude Sketch-27.3.26（81）

1927　紙本鉛筆　34×24cm

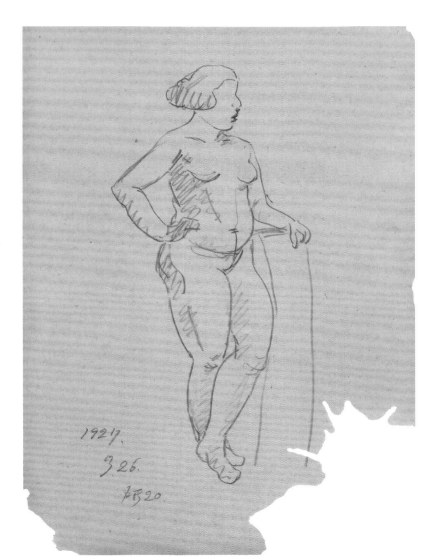

立姿裸女速寫-27.3.26（32）
Standing Female Nude Sketch-27.3.26（82）

1927　紙本鉛筆　34×24cm

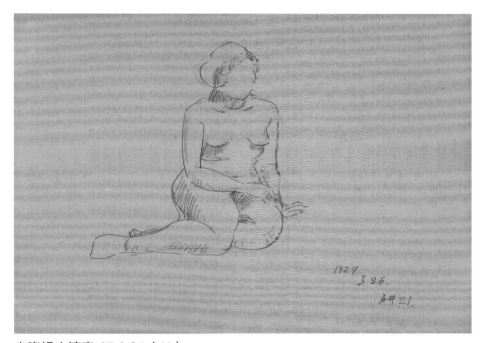

坐姿裸女速寫-27.3.26（61）
Seated Female Nude Sketch-27.3.26（61）

1927　紙本鉛筆　23.8×32.8cm

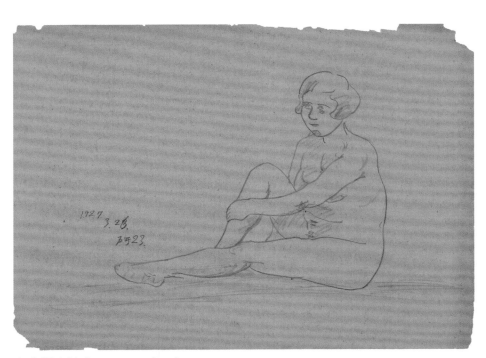

坐姿裸女速寫-27.3.26（63）
Seated Female Nude Sketch-27.3.26（63）

1927　紙本鉛筆　23.9×32.3cm

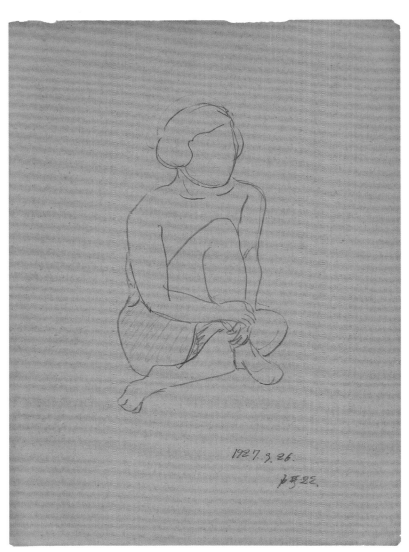

坐姿裸女速寫-27.3.26（62）
Seated Female Nude Sketch-27.3.26（62）

1927　紙本鉛筆　32.3×23.8cm

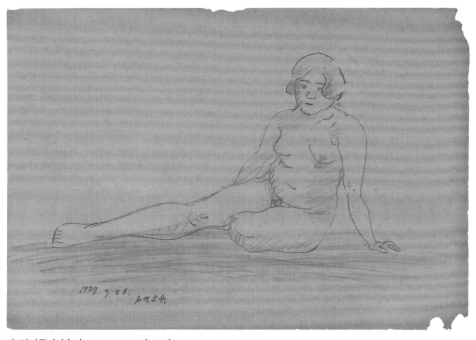

坐姿裸女速寫-27.3.26（64）
Seated Female Nude Sketch-27.3.26（64）

1927　紙本鉛筆　23.5×33cm

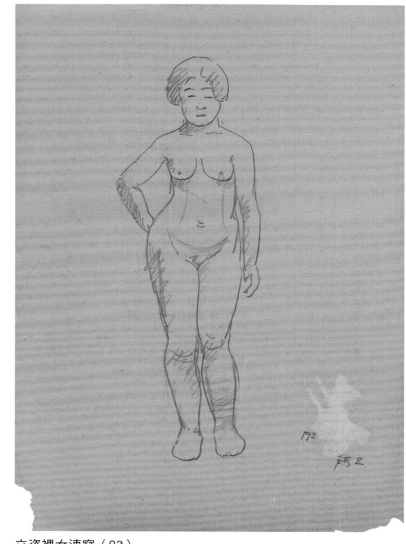

立姿裸女速寫（83）
Standing Female Nude Sketch（83）

約1927（疑為1927.4.2）　紙本鉛筆　34×24cm

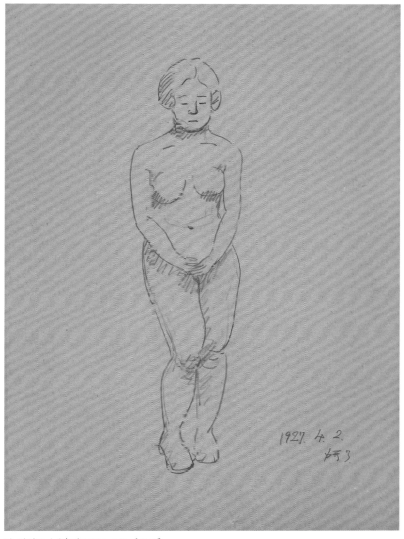

立姿裸女速寫-27.4.2（84）
Standing Female Nude Sketch-27.4.2（84）

1927　紙本鉛筆　32.9×24cm

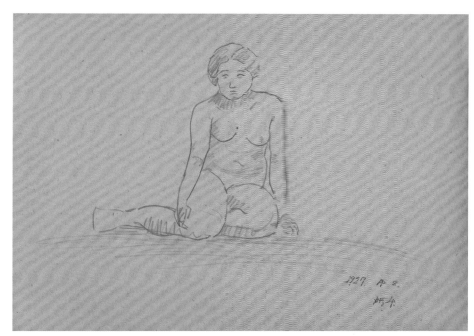

坐姿裸女速寫-27.4.2（65）
Seated Female Nude Sketch-27.4.2（65）

1927　紙本鉛筆　23.8×32.8cm

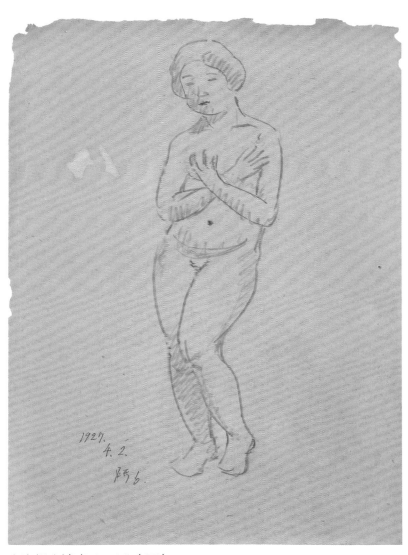

立姿裸女速寫-27.4.2（85）
Standing Female Nude Sketch-27.4.2（85）

1927　紙本鉛筆　34×24cm

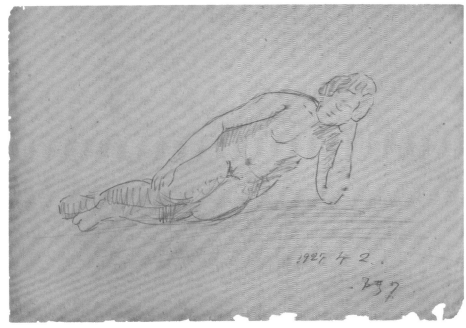

臥姿裸女速寫-27.4.2（7）
Reclining Female Nude Sketch-27.4.2（7）

1927　紙本鉛筆　24×33cm

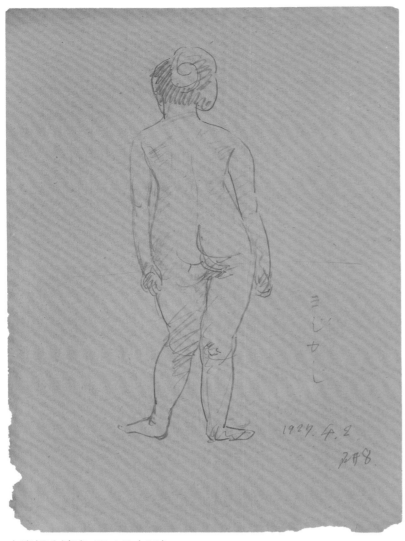

立姿裸女速寫-27.4.2（86）
Standing Female Nude Sketch-27.4.2（86）

1927　紙本鉛筆　34×24cm

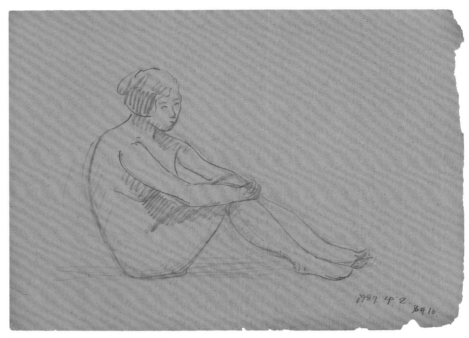

坐姿裸女速寫-27.4.2（66）
Seated Female Nude Sketch-27.4.2（66）

1927　紙本鉛筆　23.8×32.8cm

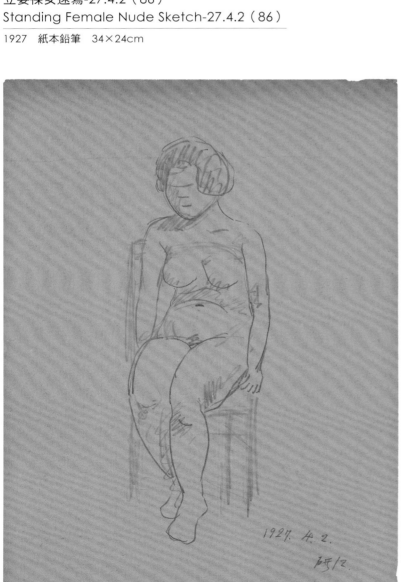

坐姿裸女速寫-27.4.2（68）
Seated Female Nude Sketch-27.4.2（68）

1927　紙本鉛筆　33×23.8cm

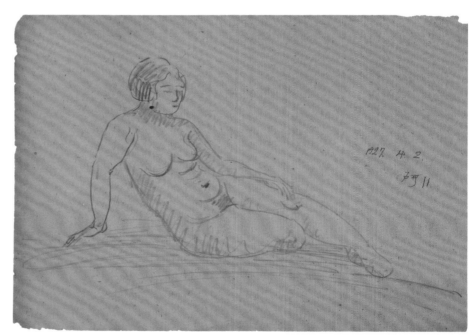

坐姿裸女速寫-27.4.2（67）
Seated Female Nude Sketch-27.4.2（67）

1927　紙本鉛筆　24×32.8cm

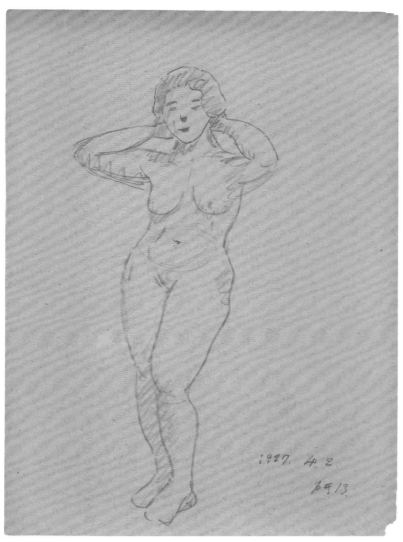

立姿裸女速寫-27.4.2（87）
Standing Female Nude Sketch-27.4.2（87）

1927　紙本鉛筆　34×24cm

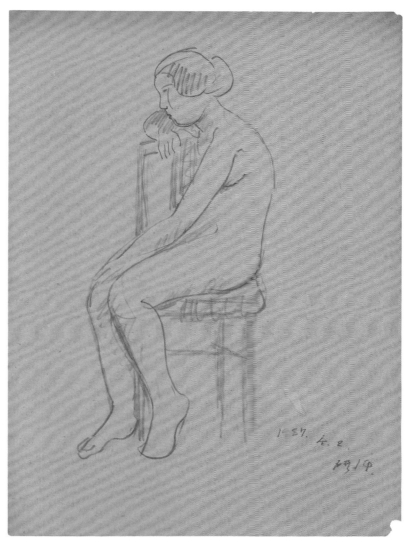

坐姿裸女速寫-27.4.2（69）
Seated Female Nude Sketch-27.4.2（69）

1927　紙本鉛筆　33×23.8cm

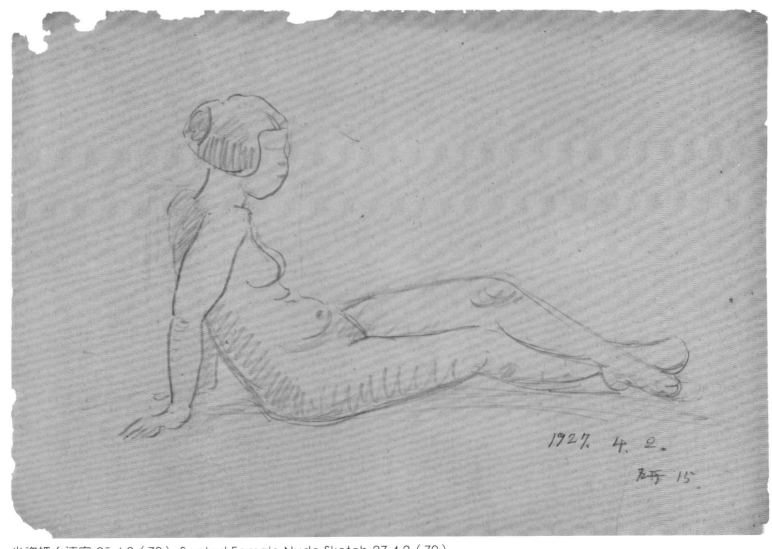

坐姿裸女速寫-27.4.2（70）Seated Female Nude Sketch-27.4.2（70）

1927　紙本鉛筆　23.9×32.7cm

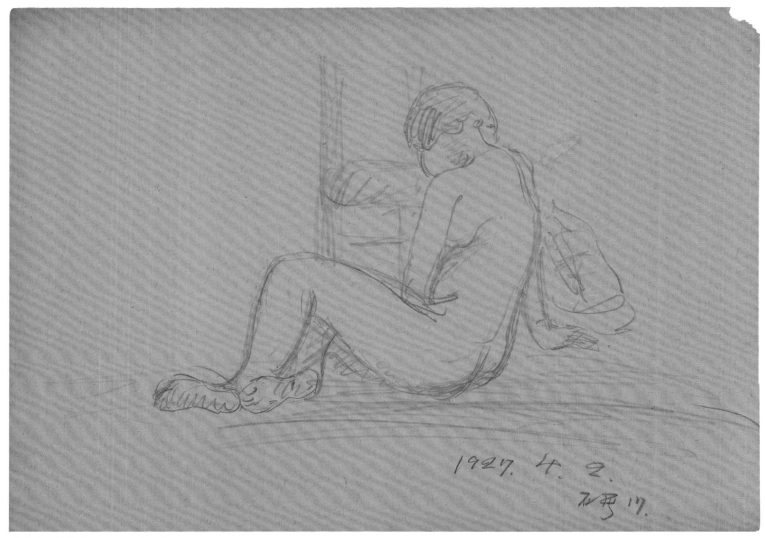

坐姿裸女速寫-27.4.2（71） Seated Female Nude Sketch-27.4.2（71）

1927　紙本鉛筆　23.8×33cm

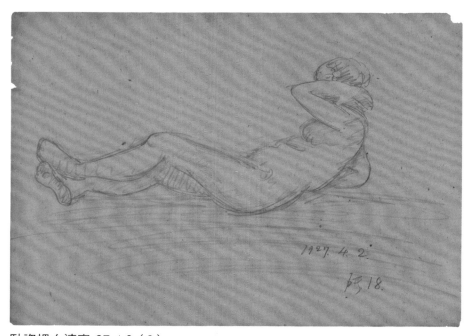

臥姿裸女速寫-27.4.2（8）
Reclining Female Nude Sketch-27.4.2（8）

1927　紙本鉛筆　24×32.9cm

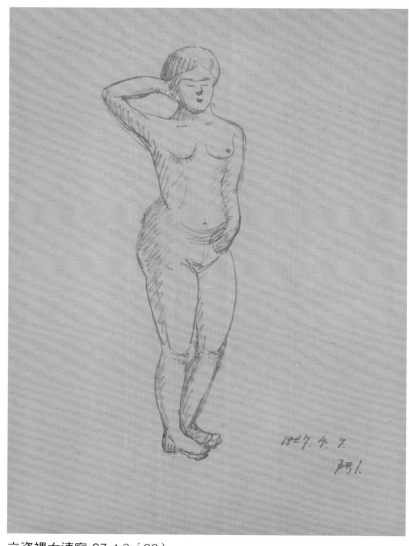

立姿裸女速寫-27.4.9（88）
Standing Female Nude Sketch-27.4.9（88）

1927　紙本鉛筆　34×24cm

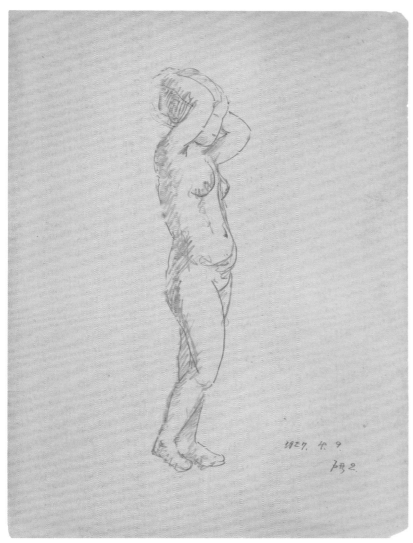

立姿裸女速寫-27.4.9（89）
Standing Female Nude Sketch-27.4.9（39）

1927　紙本鉛筆　34×24cm

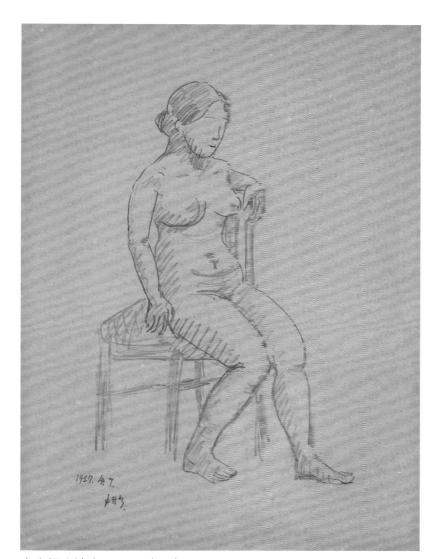

坐姿裸女速寫-27.4.9（72）
Seated Female Nude Sketch-27.4.9（72）

1927　紙本鉛筆　33.5×24.8cm

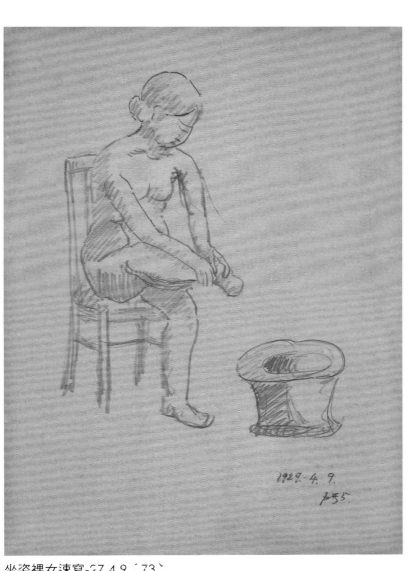

坐姿裸女速寫-27.4.9（73）
Seated Female Nude Sketch-27.4.9（73）

1927　紙本鉛筆　33.5×24.7cm

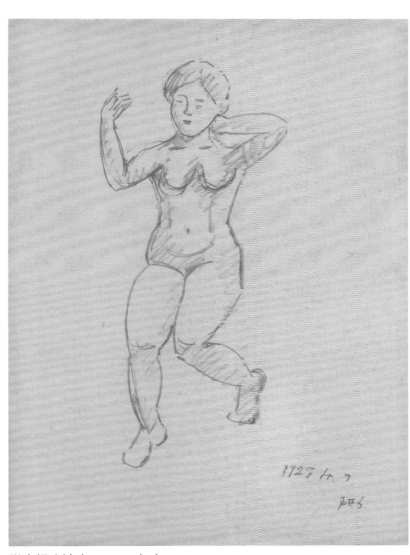

蹲姿裸女速寫-27.4.9（6）
Squatting Female Nude Sketch-27.4.9（6）

1927　紙本鉛筆　34×24cm

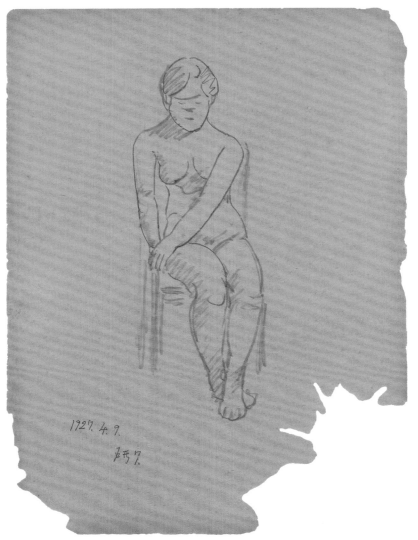

坐姿裸女速寫-27.4.9（74）
Seated Female Nude Sketch-27.4.9（74）

1927　紙本鉛筆　33.5×24.7cm

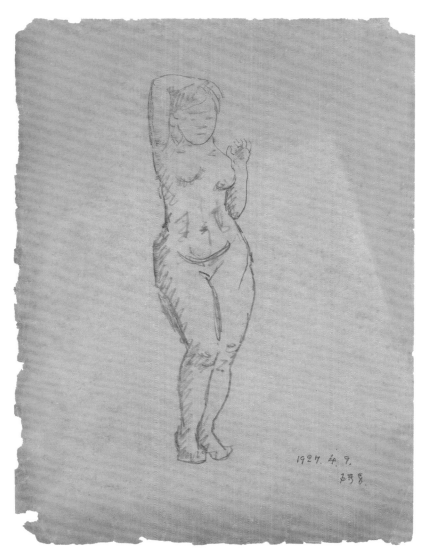

立姿裸女速寫-27.4.9（90）
Standing Female Nude Sketch-27.4.9（90）

1927　紙本鉛筆　34×24cm

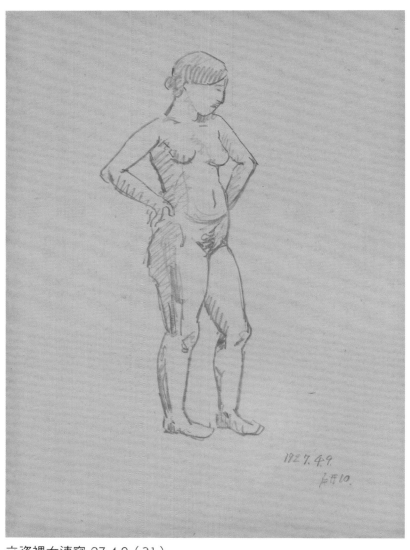

立姿裸女速寫-27.4.9（91）
Standing Female Nude Sketch-27.4.9（91）

1927　紙本鉛筆　34×24cm

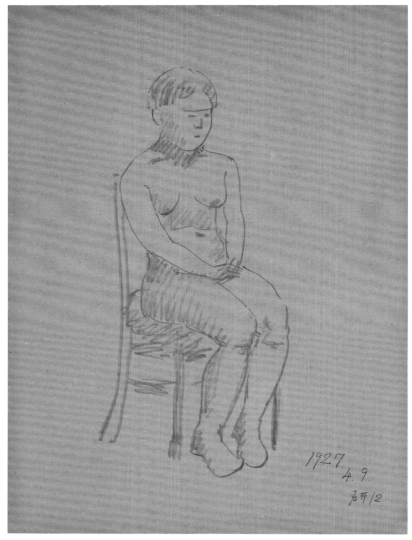

坐姿裸女速寫-27.4.9（75）
Seated Female Nude Sketch-27.4.9（75）

1927　紙本鉛筆　33.5×24.7cm

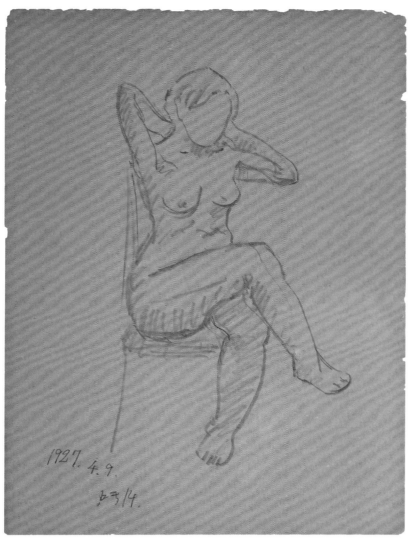

坐姿裸女速寫-27.4.9（76）
Seated Female Nude Sketch-27.4.9（76）

1927　紙本鉛筆　33.5×24.7cm

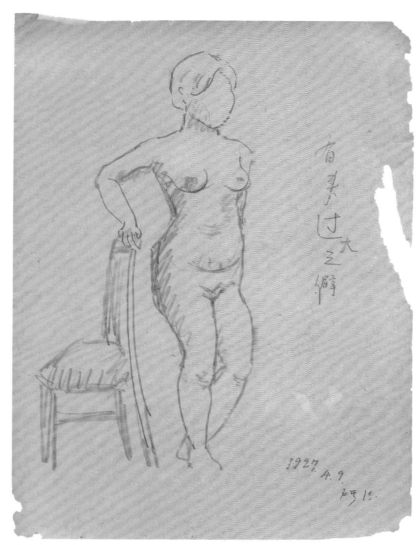

立姿裸女速寫-27.4.9（92）
Standing Female Nude Sketch-27.4.9（92）

1927　紙本鉛筆　34×24cm

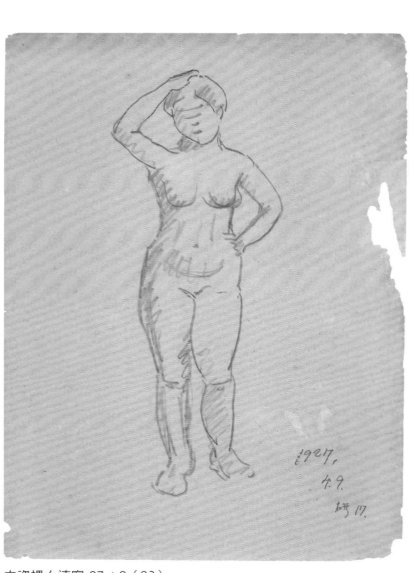

立姿裸女速寫-27.4.9（93）
Standing Female Nude Sketch-27.4.9（93）

1927　紙本鉛筆　34×24cm

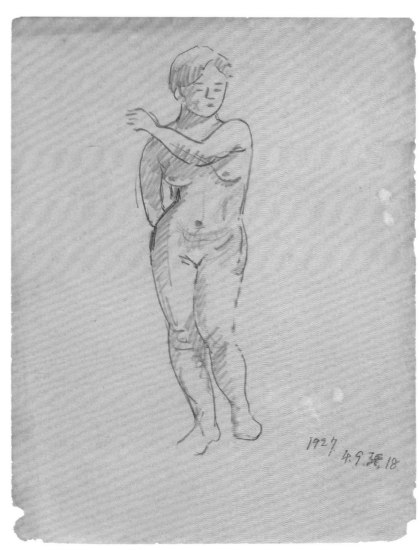

立姿裸女速寫-27.4.9（94）
Standing Female Nude Sketch-27.4.9（94）

1927　紙本鉛筆　34×24cm

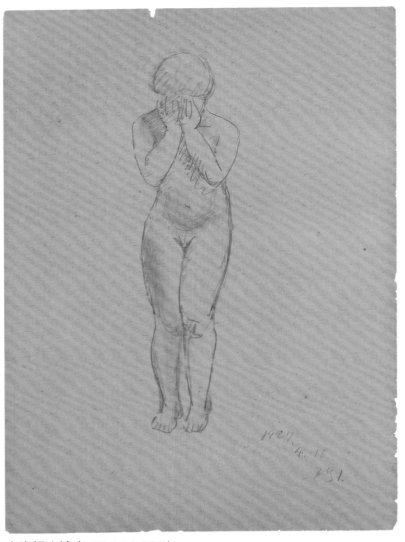

立姿裸女速寫-27.4.16（95）
Standing Female Nude Sketch-27.4.16（95）

1927　紙本鉛筆　34×24cm

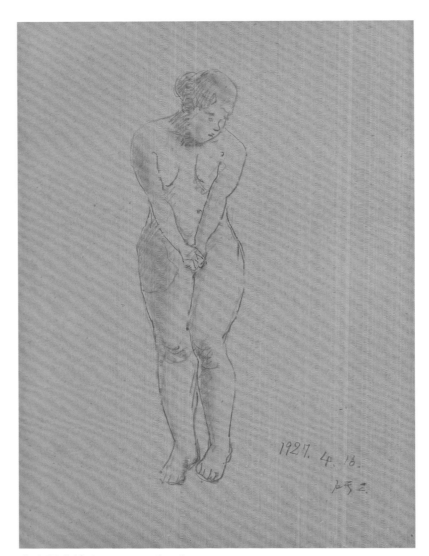

立姿裸女速寫-27.4.16（96）
Standing Female Nude Sketch-27.4.16（96）

1927　紙本鉛筆　32.9×23.7cm

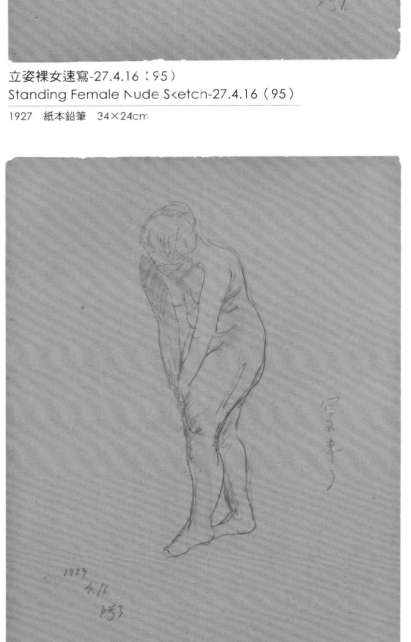

立姿裸女速寫-27.4.16（97）
Standing Female Nude Sketch-27.4.16（97）

1927　紙本鉛筆　34×24cm

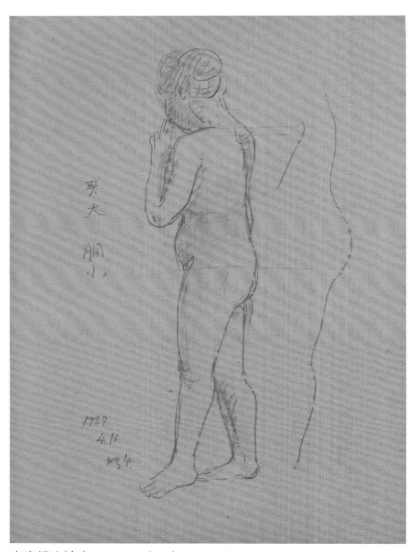

立姿裸女速寫-27.4.16（98）
Standing Female Nude Sketch-27.4.16（98）

1927　紙本鉛筆　34×24cm

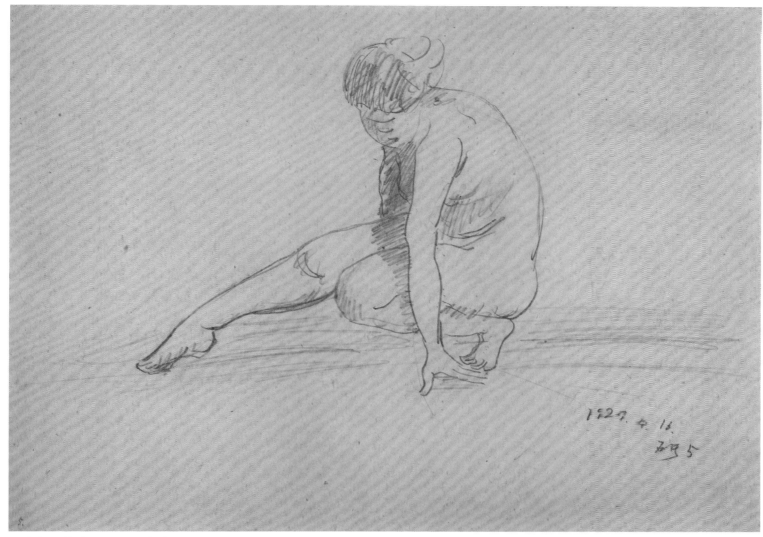

蹲姿裸女速寫-27.4.16（7） Squatting Female Nude Sketch-27.4.16（7）

1927　紙本鉛筆　23.7×33.2cm

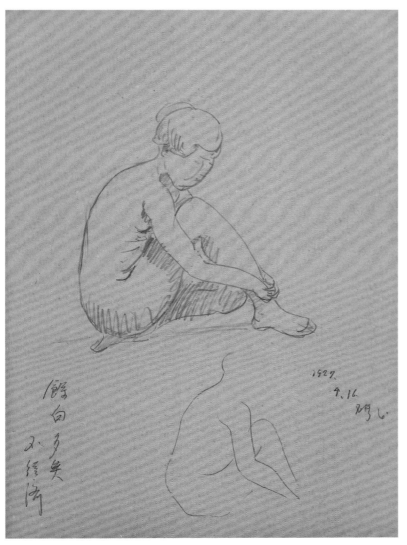

坐姿裸女速寫-27.4.16（77）
Seated Female Nude Sketch-27.4.16（77）

1927　紙本鉛筆　32.9×23.9cm

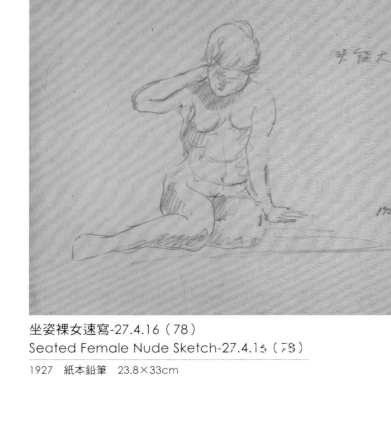

坐姿裸女速寫-27.4.16（78）
Seated Female Nude Sketch-27.4.16（78）

1927　紙本鉛筆　23.8×33cm

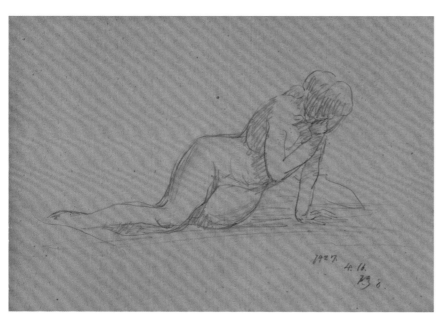

臥姿裸女速寫-27.4.16（9）
Reclining Female Nude Sketch-27.4.16（9）

1927　紙本鉛筆　23.9×32.8cm

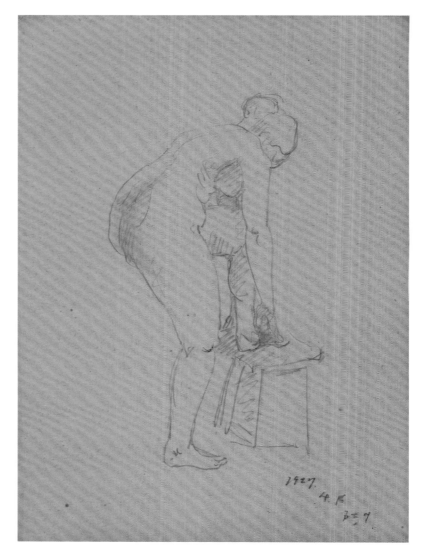

立姿裸女速寫-27.4.16（99）
Standing Female Nude Sketch-27.4.16（99）

1927　紙本鉛筆　33×23.9cm

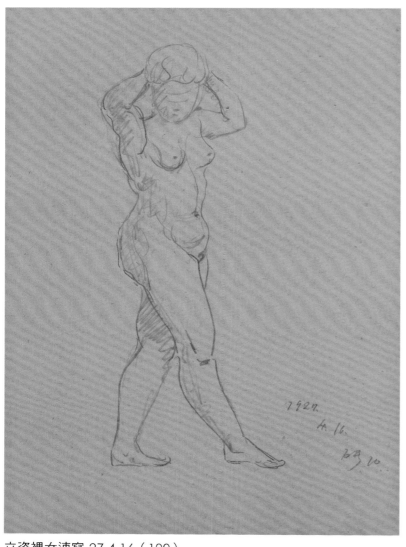

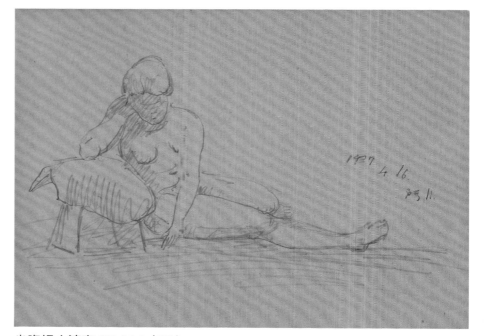

坐姿裸女速寫-27.4.16（79）
Seated Female Nude Sketch-27.4.16（79）

1927　紙本鉛筆　23.8×32.9cm

立姿裸女速寫-27.4.16（100）
Standing Female Nude Sketch-27.4.16（100）

1927　紙本鉛筆　34×24cm

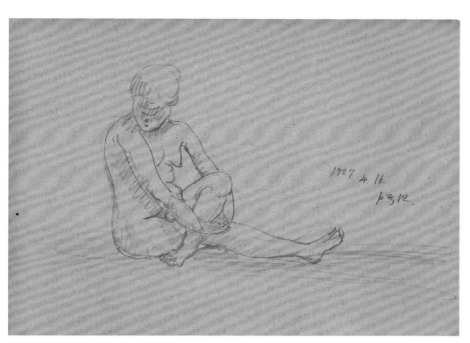

坐姿裸女速寫-27.4.16（80）
Seated Female Nude Sketch-27.4.16（80）

1927　紙本鉛筆　22.9×32.9cm

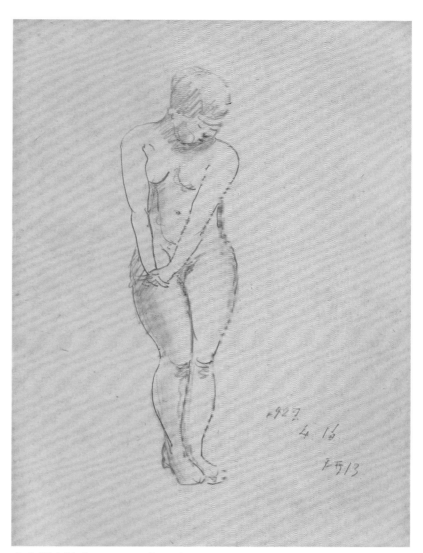

立姿裸女速寫-27.4.16（101）
Standing Female Nude Sketch-27.4.16（101）

1927　紙本鉛筆　34×24cm

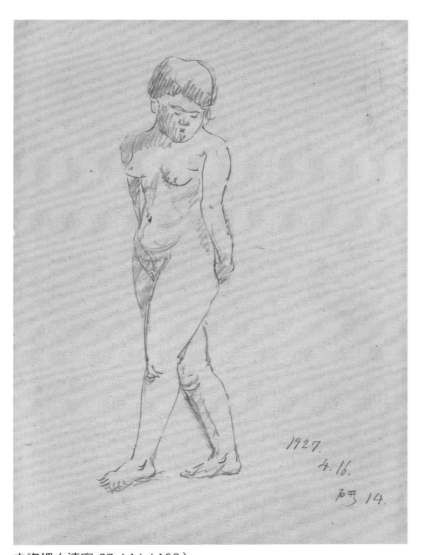

立姿裸女速寫-27.4.16（102）
Standing Female Nude Sketch-27.4.16（102）

1927　紙本鉛筆　34×24cm

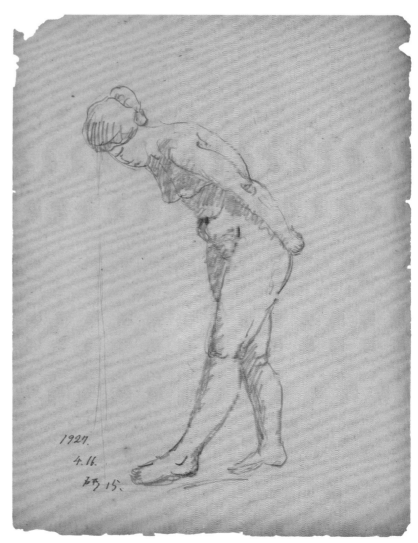

立姿裸女速寫-27.4.16（103）
Standing Female Nude Sketch-27.4.16（103）

1927　紙本鉛筆　33.5×24.7cm

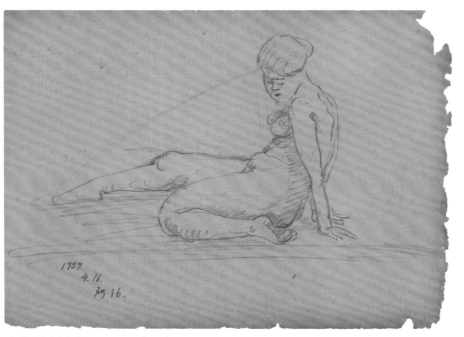

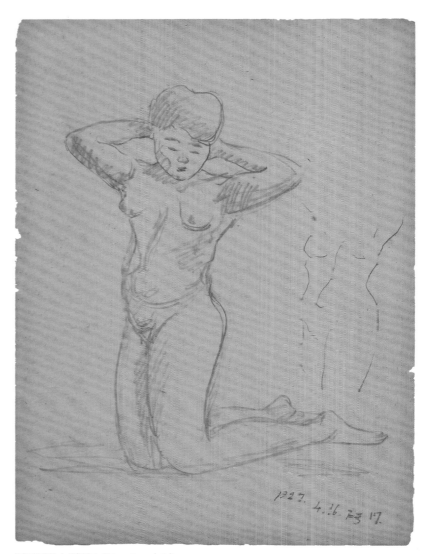

坐姿裸女速寫-27.4.16（81）
Seated Female Nude Sketch-27.4.16（81）

1927　紙本鉛筆　24.7×33.5cm

跪姿裸女速寫-27.4.16（5）
Kneeling Female Nude Sketch-27.4.16（5）

1927　紙本鉛筆　33.5×24.7cm

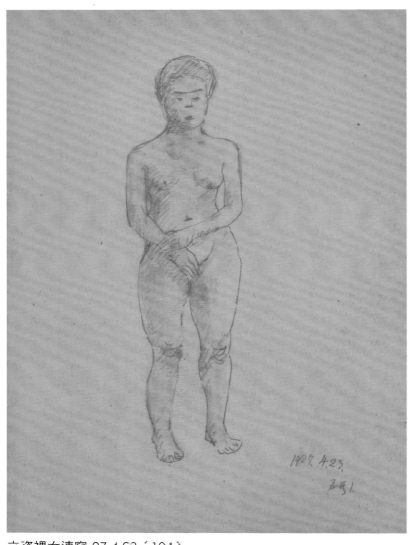

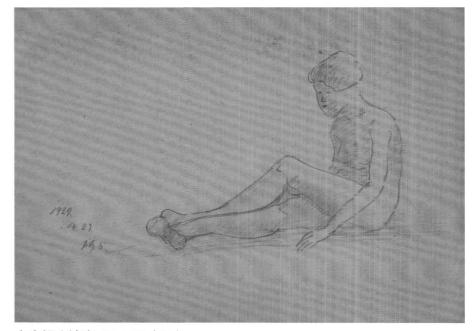

坐姿裸女速寫-27.4.23（82）
Seated Female Nude Sketch-27.4.23（82）

1927　紙本鉛筆　24.4×33cm

立姿裸女速寫-27.4.23（104）
Standing Female Nude Sketch-27.4.23（104）

1927　紙本鉛筆　34×24cm

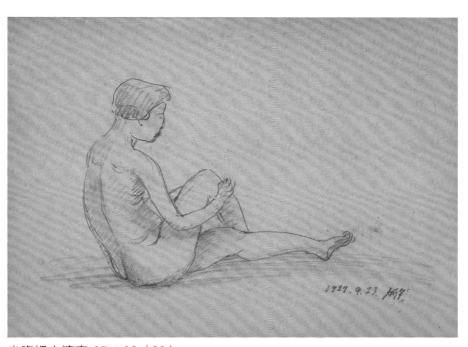

坐姿裸女速寫-27.4.23（83）
Seated Female Nude Sketch-27.4.23（83）

1927　紙本鉛筆　24.5×33cm

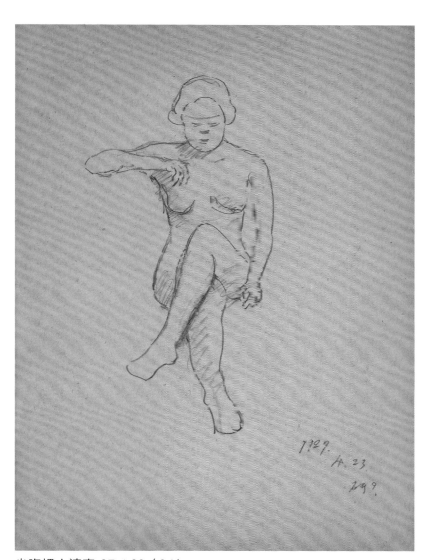

坐姿裸女速寫-27.4.23（84）
Seated Female Nude Sketch-27.4.23（84）

1927　紙本鉛筆　33×24.3cm

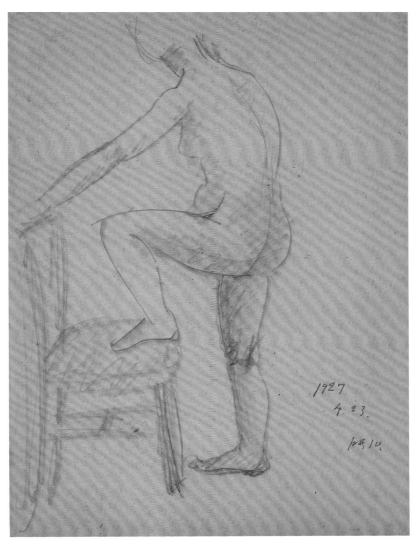

女體速寫-27.4.23（2）
Female Body Sketch-27.4.23（2）

1927　紙本鉛筆　33×24.4cm

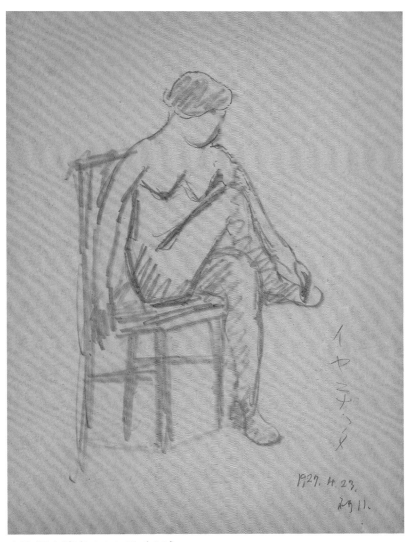

坐姿裸女速寫-27.4.23（85）
Seated Female Nude Sketch-27.4.23（85）

1927　紙本鉛筆　33×24cm

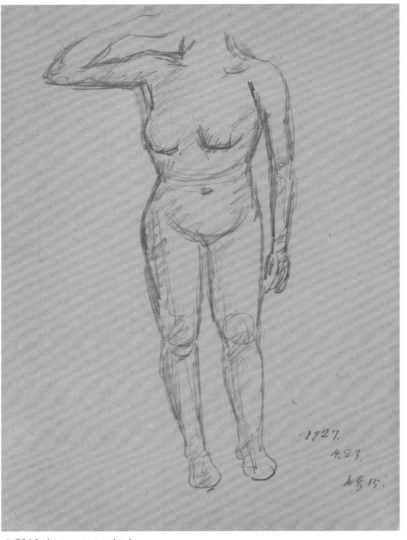

女體速寫-27.4.23（3）
Female Body Sketch-27.4.23（3）

1927 紙本鉛筆 34×24cm

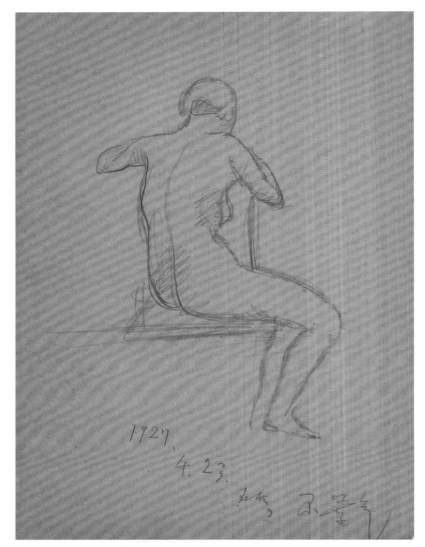

坐姿裸女速寫-27.4.23（86）
Seated Female Nude Sketch-27.4.23（86）

1927 紙本鉛筆 33.1×24cm

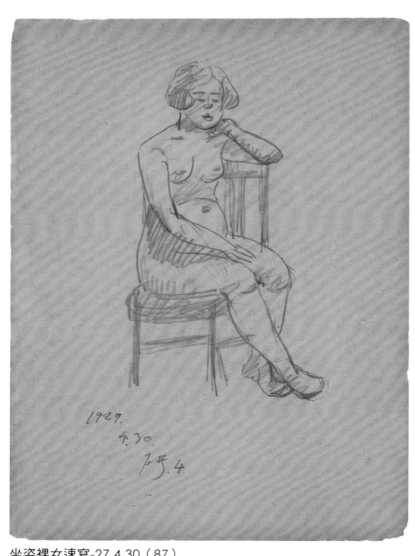

坐姿裸女速寫-27.4.30（87）
Seated Female Nude Sketch-27.4.30（87）

1927 紙本鉛筆 33.5×24.7cm

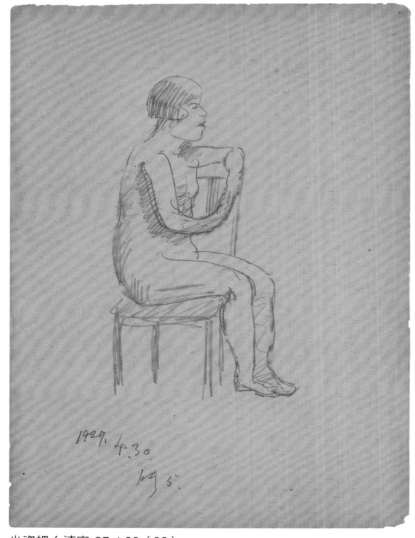

坐姿裸女速寫-27.4.30（88）
Seated Female Nude Sketch-27.4.30（88）

1927 紙本鉛筆 33.5×24.7cm

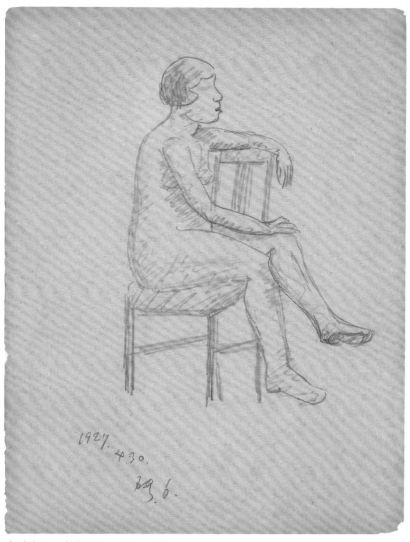

坐姿裸女速寫-27.4.30（89）
Seated Female Nude Sketch-27.4.30（89）

1927　紙本鉛筆　33.5×24.6cm

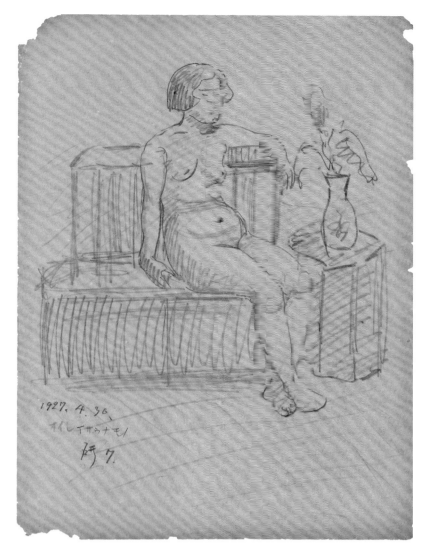

坐姿裸女速寫-27.4.30（90）
Seated Female Nude Sketch-27.4.30（90）

1927　紙本鉛筆　33.5×24.5cm

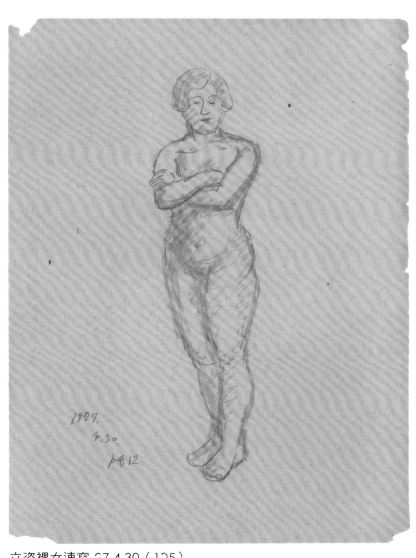

立姿裸女速寫-27.4.30（105）
Standing Female Nude Sketch-27.4.30（105）

1927　紙本鉛筆　34×24cm

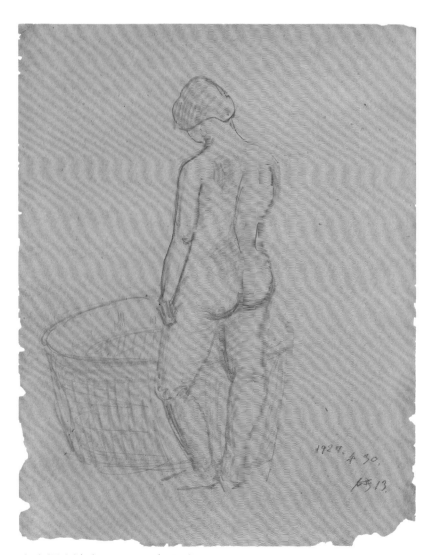

立姿裸女速寫-27.4.30（106）
Standing Female Nude Sketch-27.4.30（106）

1927　紙本鉛筆　34×24cm

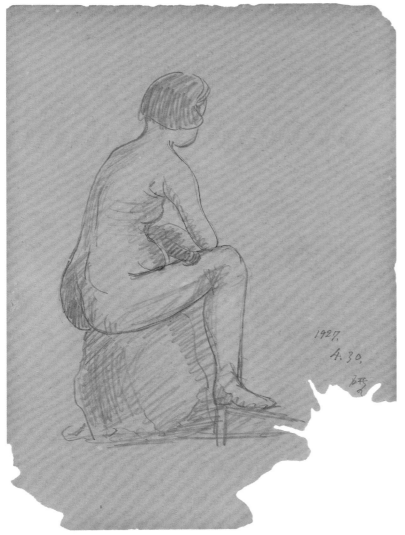

坐姿裸女速寫-27.4.30（91）
Seated Female Nude Sketch-27.4.30（91）

1927　紙本鉛筆　33.5×24.7cm

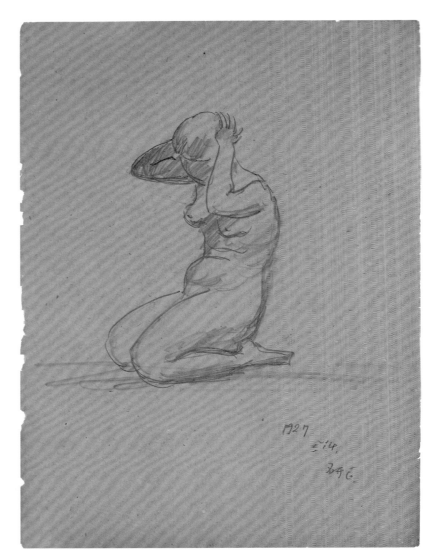

坐姿裸女速寫-27.5.14（92）
Seated Female Nude Sketch-27.5.14（92）

1927　紙本鉛筆　33×24.3cm

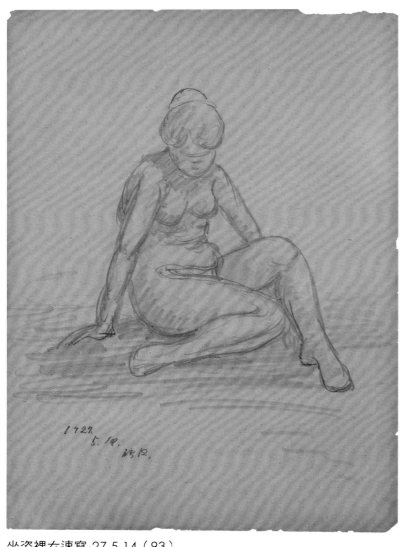

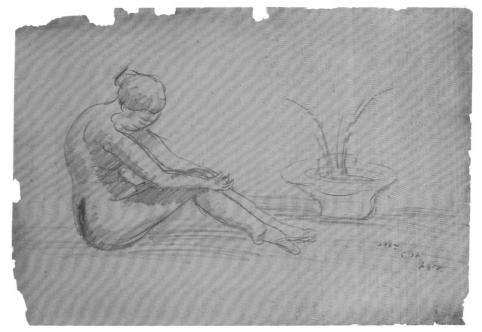

坐姿裸女速寫-27.5.14（94）
Seated Female Nude Sketch-27.5.14（94）

1927　紙本鉛筆　24×33.2cm

坐姿裸女速寫-27.5.14（93）
Seated Female Nude Sketch-27.5.14（93）

1927　紙本鉛筆　33.3×24cm

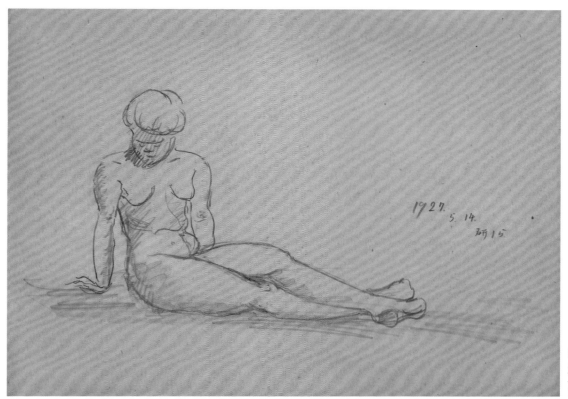

坐姿裸女速寫-27.5.14（95）
Seated Female Nude Sketch-27.5.14（95）

1927　紙本鉛筆　24×33.2cm

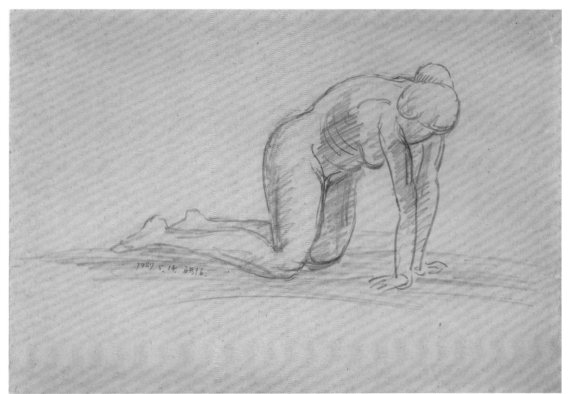

跪姿裸女速寫-27.5.14（6）
Kneeling Female Nude Sketch-27.5.14（6）

1927　紙本鉛筆　24.1×33.3cm

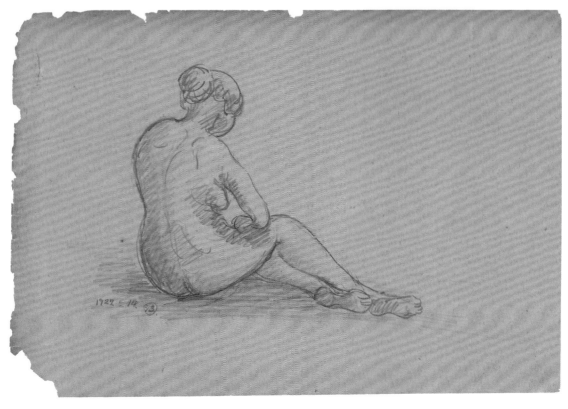

坐姿裸女速寫-27.5.14（96）
Seated Female Nude Sketch-27.5.14（96）

1927　紙本鉛筆　24×33.4cm

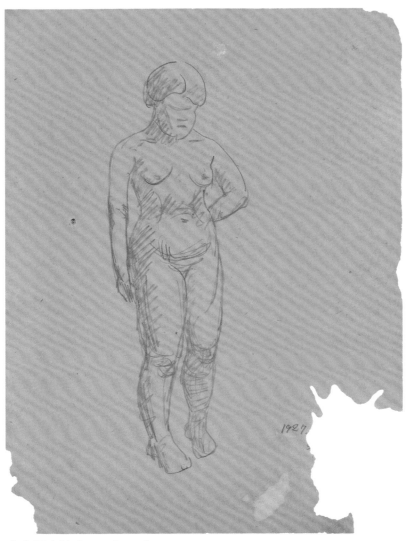

立姿裸女速寫-27（107）
Standing Female Nude Sketch-27（107）

1927（疑為1927.5.14）　紙本鉛筆　34×24cm

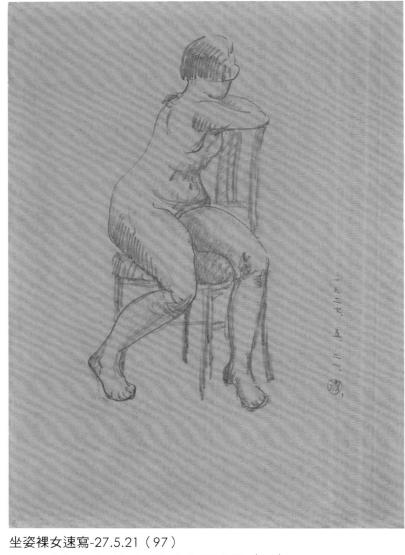

坐姿裸女速寫-27.5.21（97）
Seated Female Nude Sketch-27.5.21（97）

1927　紙本鉛筆　33.5×24.6cm

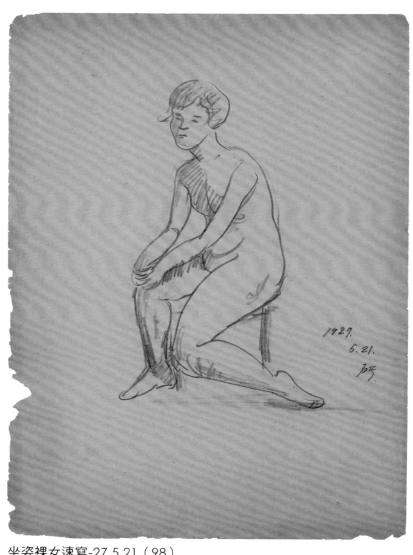

坐姿裸女速寫-27.5.21（98）
Seated Female Nude Sketch-27.5.21（98）

1927　紙本鉛筆　33.4×24.5cm

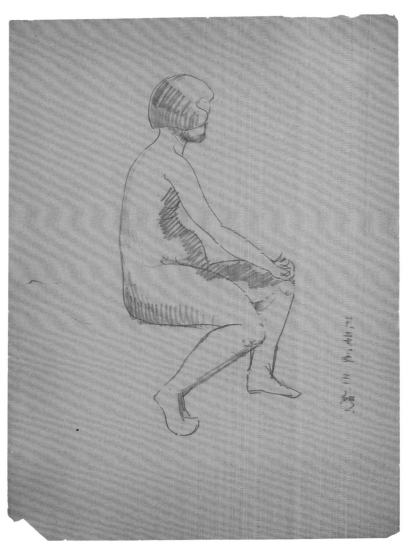

坐姿裸女速寫-27.5.21（99）
Seated Female Nude Sketch-27.5 2（99）

1927　紙本鉛筆　33.3×24.2cm

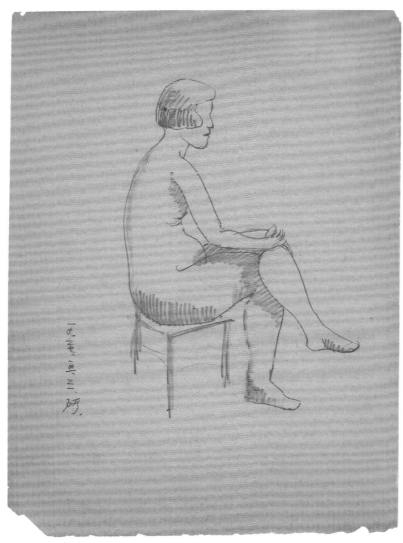

坐姿裸女速寫-27.5.21（100）
Seated Female Nude Sketch-27.5.21（100）

1927　紙本鉛筆　33.2×24.2cm

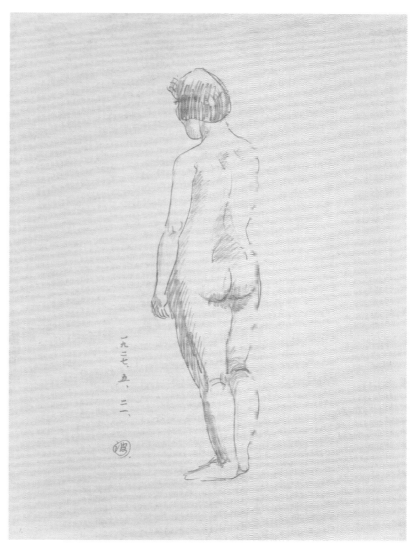

立姿裸女速寫-27.5.21（108）
Standing Female Nude Sketch-27.5.21（108）

1927　紙本鉛筆　34×24cm

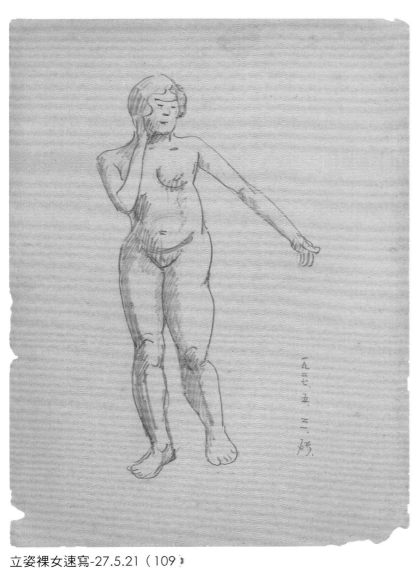

立姿裸女速寫-27.5.21（109）
Standing Female Nude Sketch-27.5.21（109）

1927　紙本鉛筆　34×24cm

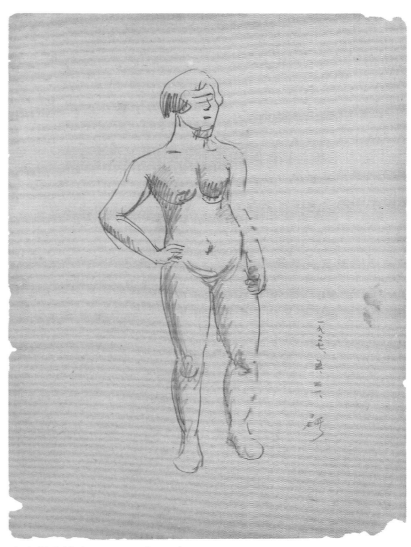

立姿裸女速寫-27.5.21（110）
Standing Female Nude Sketch-27.5.21（110）

1927　紙本鉛筆　34×24cm

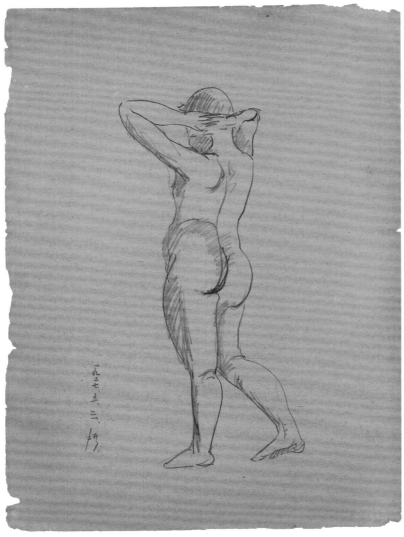

立姿裸女速寫-27.5.21（111）
Standing Female Nude Sketch-27.5.21（111）

1927　紙本鉛筆　34×24cm

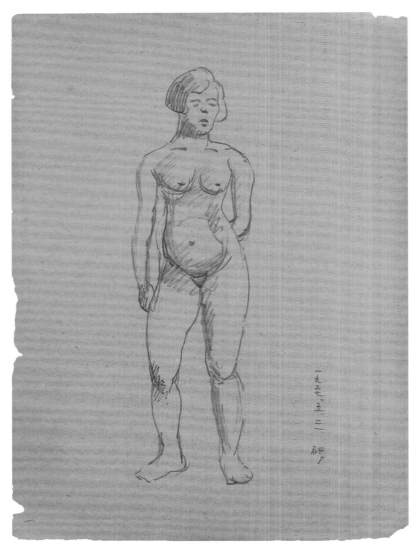

立姿裸女速寫-27.5.21（112）
Standing Female Nude Sketch-27.5.21（112）

1927　紙本鉛筆　34×24cm

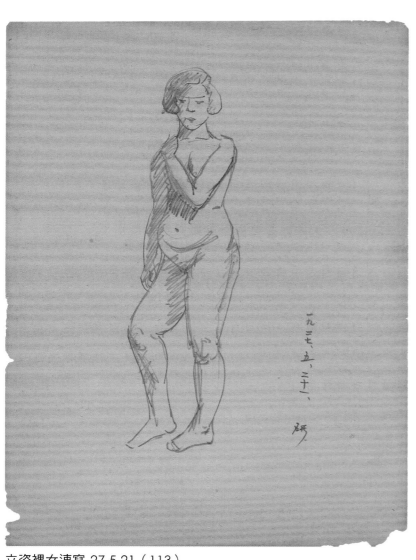

立姿裸女速寫-27.5.21（113）
Standing Female Nude Sketch-27.5.21（113）

1927　紙本鉛筆　34×24cm

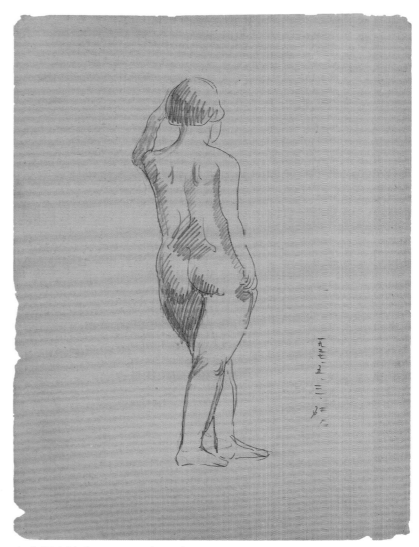

立姿裸女速寫-27.5.21（114）
Standing Female Nude Sketch-27.5.21（114）

1927　紙本鉛筆　34×24cm

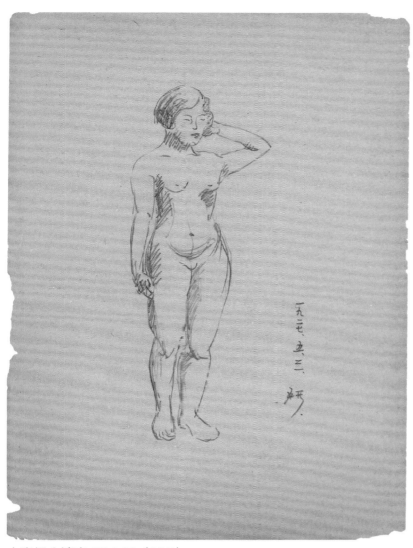

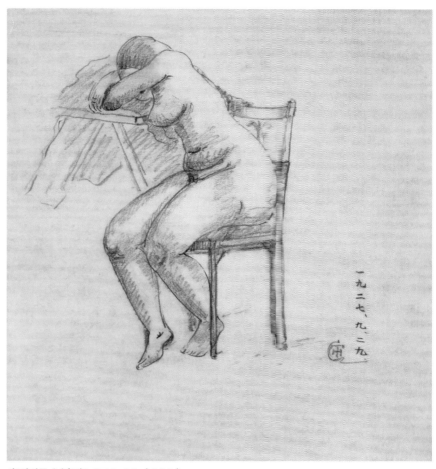

立姿裸女速寫-27.5.21（115）
Standing Female Nude Sketch-27.5.21（115）

1927　紙本鉛筆　34×24cm

坐姿裸女速寫-27.9.29（101）
Seated Female Nude Sketch-27.9.29（101）

1927　紙本鉛筆　26.6×23.9cm

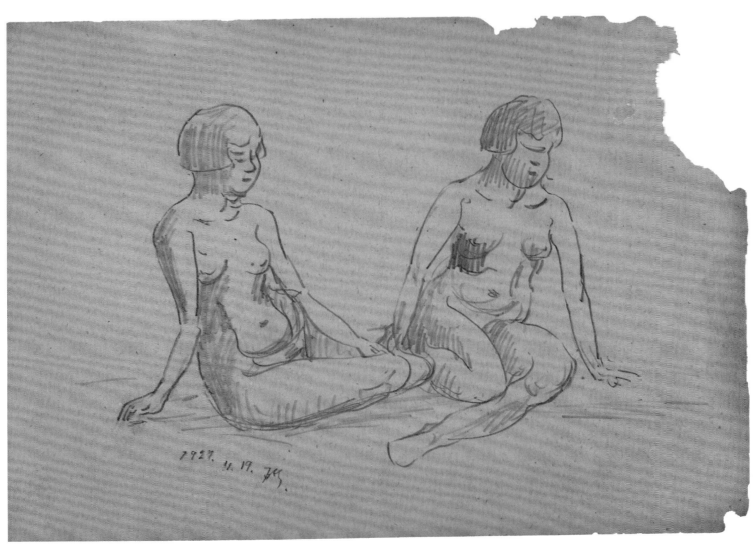

坐姿裸女速寫-27.11.19（102）　Seated Female Nude Sketch-27.11.19（102）

1927　紙本鉛筆　24×33cm

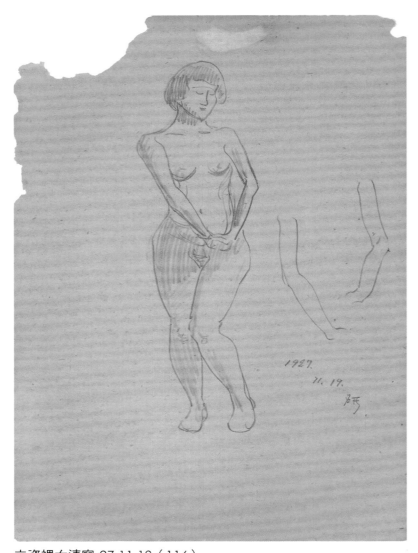

立姿裸女速寫-27.11.19（116）
Standing Female Nude Sketch-27.11.19（116）

1927　紙本鉛筆　34×24cm

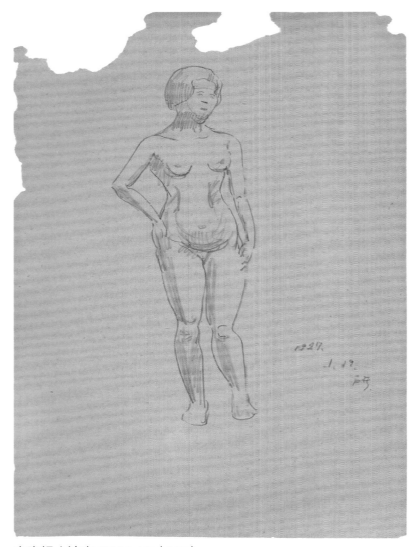

立姿裸女速寫-27.11.19（117）
Standing Female Nude Sketch-27.1 .19（117）

1927　紙本鉛筆　34×24cm

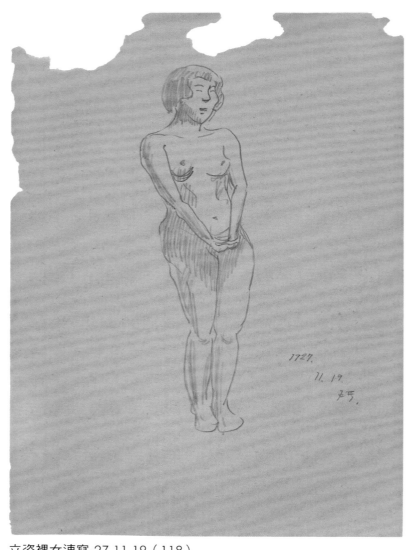

立姿裸女速寫-27.11.19（118）
Standing Female Nude Sketch-27.11.19（118）

1927　紙本鉛筆　34×24cm

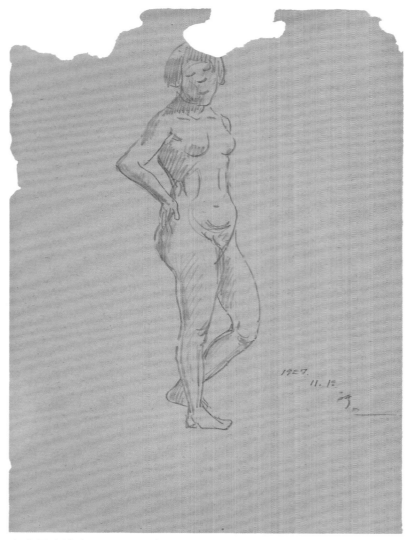

立姿裸女速寫-27.11.19（119）
Standing Female Nude Sketch-27.11.19（119）

1927　紙本鉛筆　34×24cm

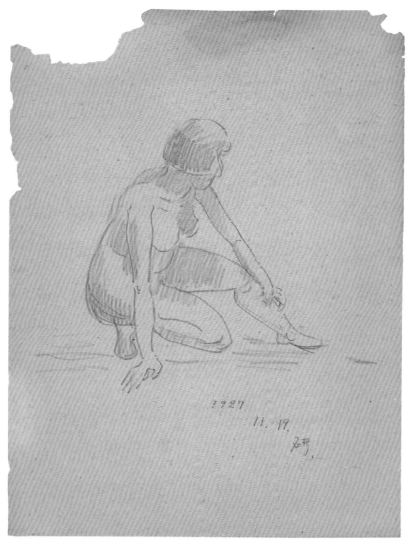

蹲姿裸女速寫-27.11.19（8）
Squatting Female Nude Sketch-27.11.19（8）

1927　紙本鉛筆　32.9×23.9cm

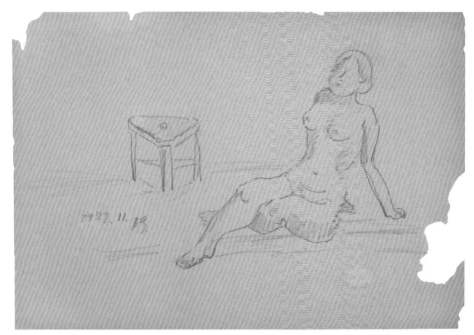

坐姿裸女速寫-27.11（103）　Seated Female Nude Sketch-27.11（103）

1927　紙本鉛筆　24×33cm

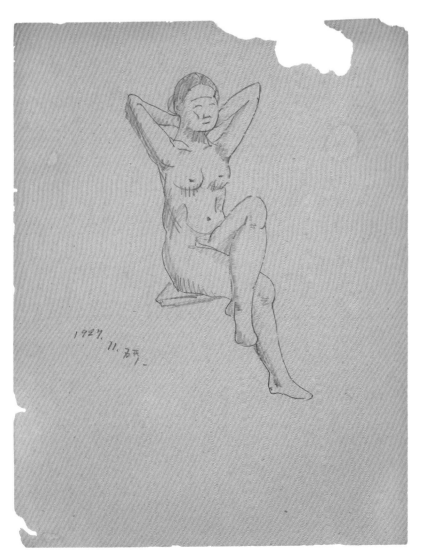

坐姿裸女速寫-27.11（104）
Seated Female Nude Sketch-27.11（104）

1927　紙本鉛筆　33×24cm

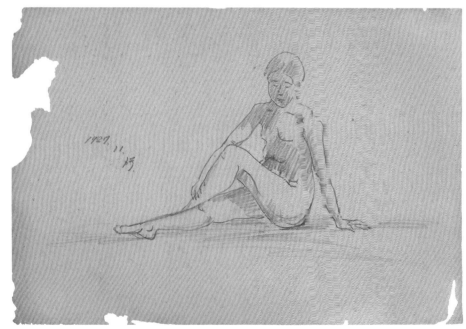

坐姿裸女速寫-27.11（105）
Seated Female Nude Sketch-27.11（105）

1927　紙本鉛筆　23.9×32.7cm

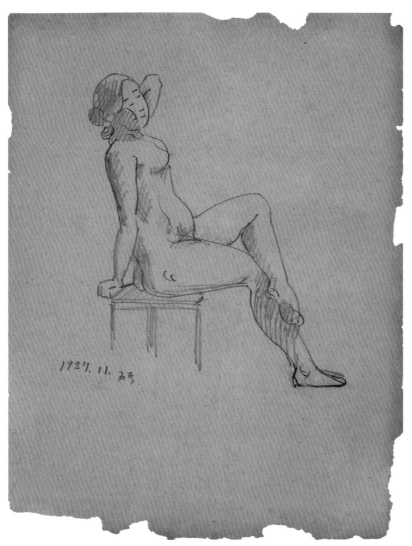

坐姿裸女速寫-27.11（106）
Seated Female Nude Sketch-27.11（106）

1927　紙本鉛筆　33×23.8cm

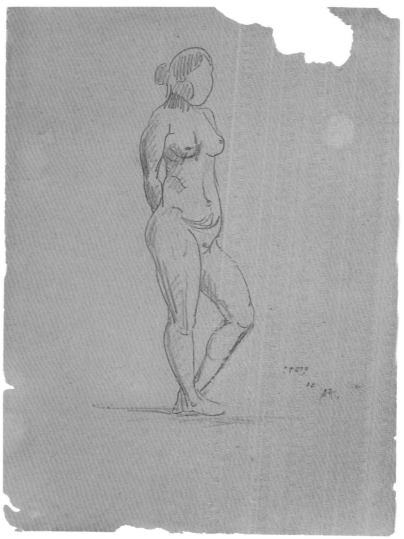

立姿裸女速寫-27.11（120）
Standing Female Nude Sketch-27.11（120）

1927　紙本鉛筆　34×24cm

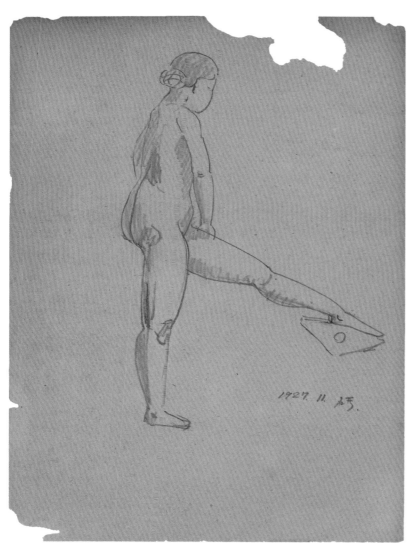

立姿裸女速寫-27.11（121）
Standing Female Nude Sketch-27.11（121）

1927　紙本鉛筆　32.8×23.9cm

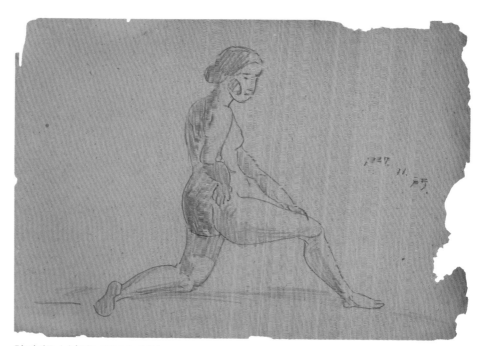

跪姿裸女速寫-27.11（7）
Kneeling Female Nude Sketch-27.11（7）

1927　紙本鉛筆　24×33cm

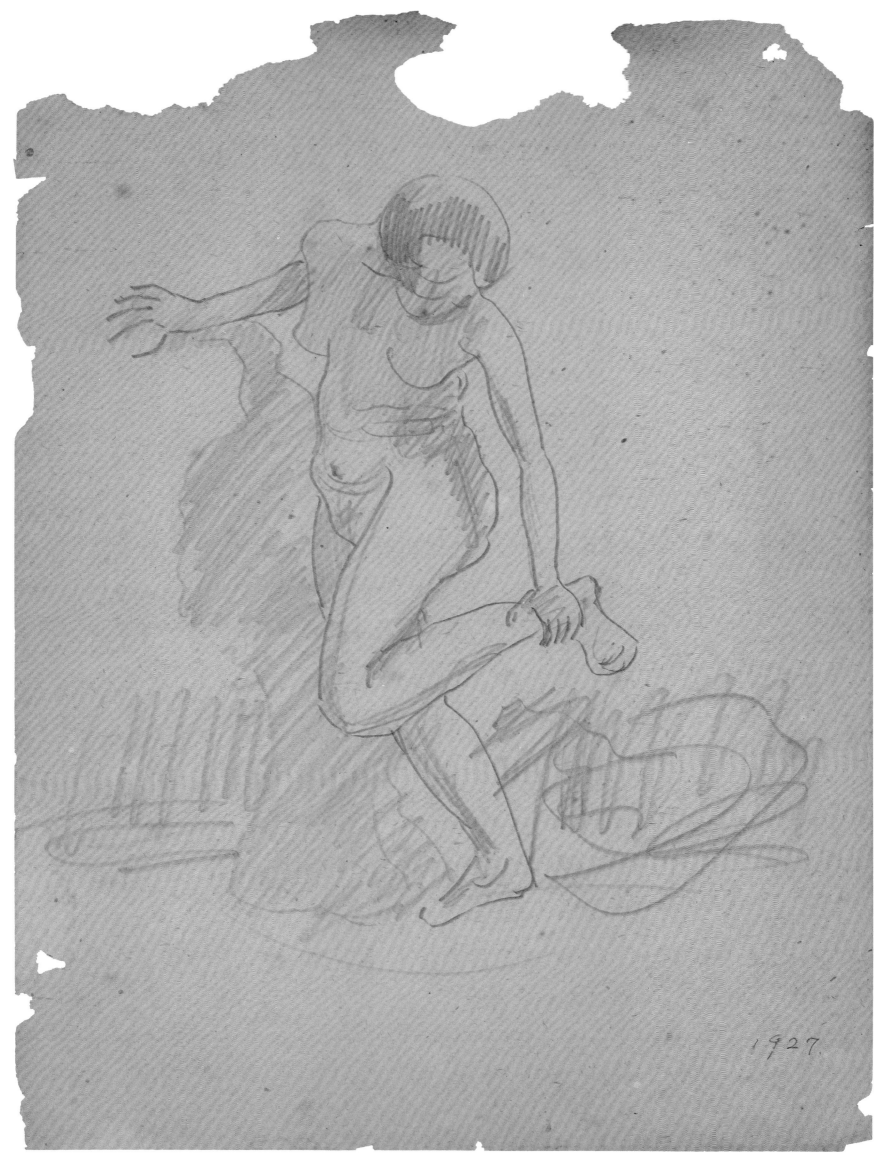

1927.

立姿裸女速寫-27（122）
Standing Female Nude Sketch-27（122）

1927 紙本鉛筆 32.8×23.8cm

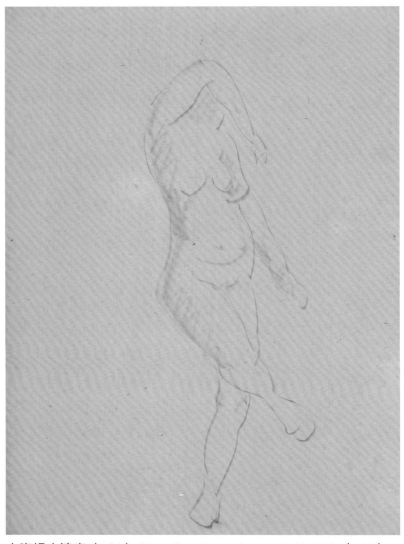

立姿裸女速寫（123）Standing Female Nude Sketch（123）

約1927-1929　紙本鉛筆　33.2×24cm

頭像速寫（5）Portrait Sketch（5）

約1927-1929　紙本鉛筆　33.2×24cm
※為前一張之背面圖

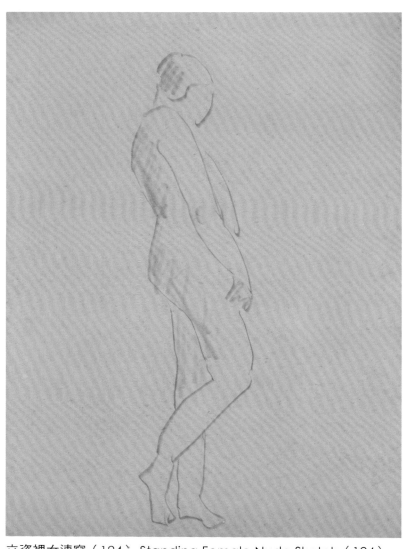

立姿裸女速寫（124）Standing Female Nude Sketch（124）

約1927-1929　紙本鉛筆　33.2×24.2cm

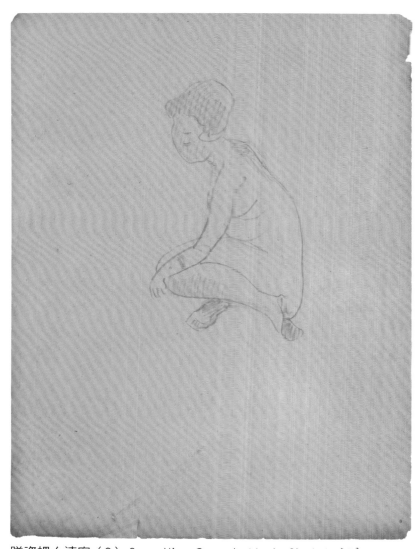

蹲姿裸女速寫（9）Squatting Female Nude Sketch（9）

約1927-1929　紙本鉛筆　33.2×24.6cm

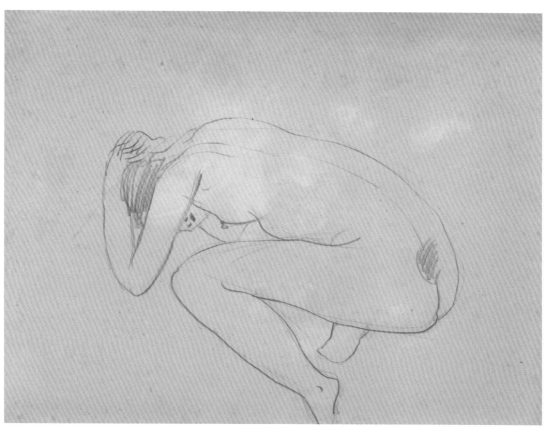

蹲姿裸女速寫（10）
Squatting Female Nude Sketch（10）

約1927-1929　紙本鉛筆　25.1×32cm

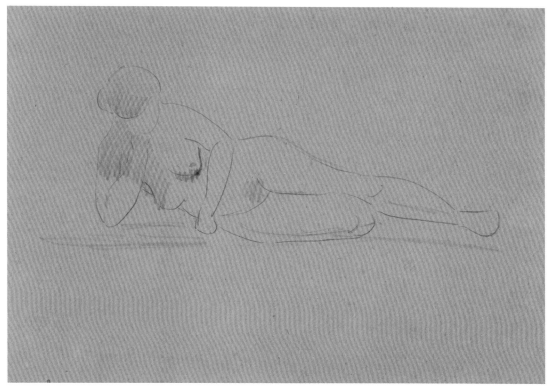

臥姿裸女速寫（10）
Reclining Female Nude Sketch（10）

約1927-1929　紙本鉛筆　24×33.4cm

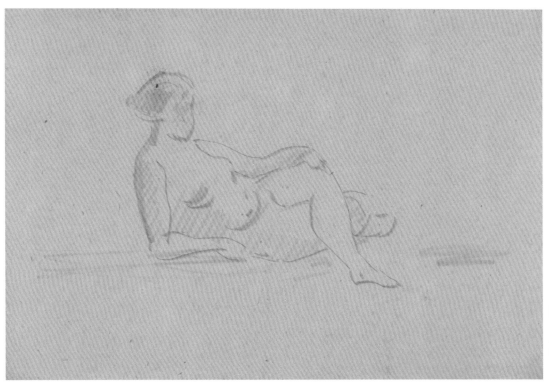

臥姿裸女速寫（11）
Reclining Female Nude Sketch（11）

約1927-1929　紙本鉛筆　24×33.3cm

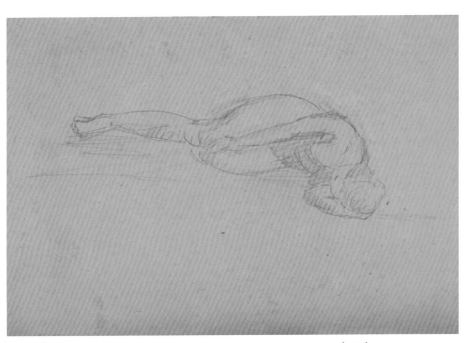

臥姿裸女速寫（12） Reclining Female Nude Sketch（12）

約1927-1929　紙本鉛筆　24.2×33.2cm

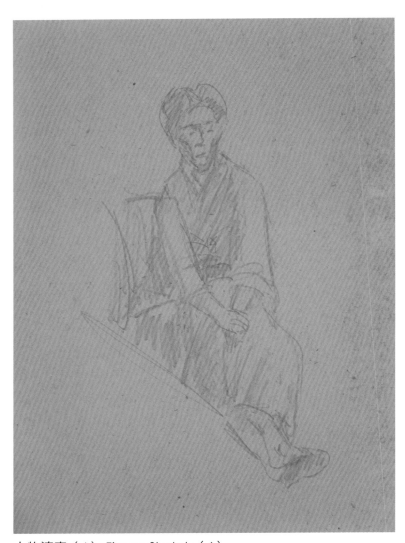

人物速寫（6） Figure Sketch（6）

約1927-1929　紙本鉛筆　33.1×24.1cm

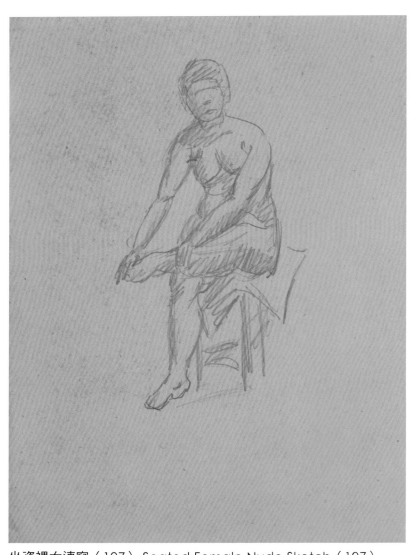

坐姿裸女速寫（107） Seated Female Nude Sketch（107）

約1927-1929　紙本鉛筆　33.2×24.3cm

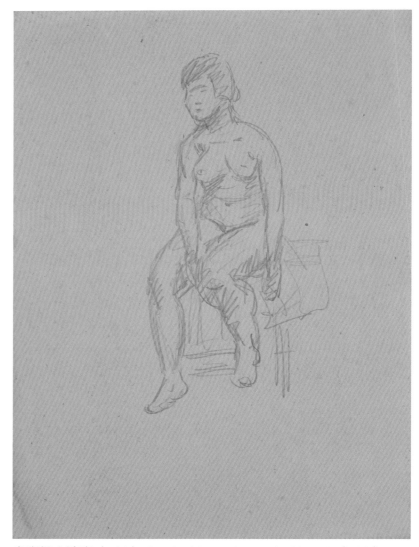

坐姿裸女速寫（108） Seated Female Nude Sketch（108）

約1927-1929　紙本鉛筆　33.2×24.4cm

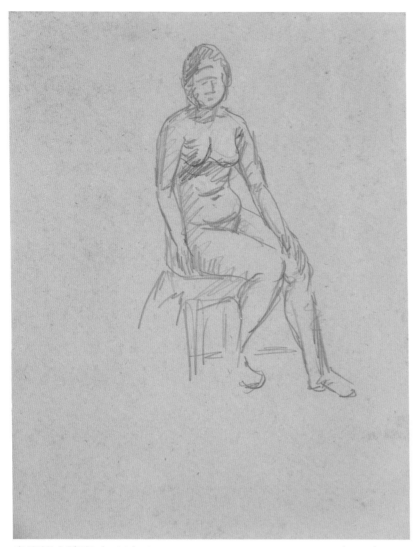

坐姿裸女速寫（109） Seated Female Nude Sketch（109）

約1927-1929　紙本鉛筆　33.2×24.4cm

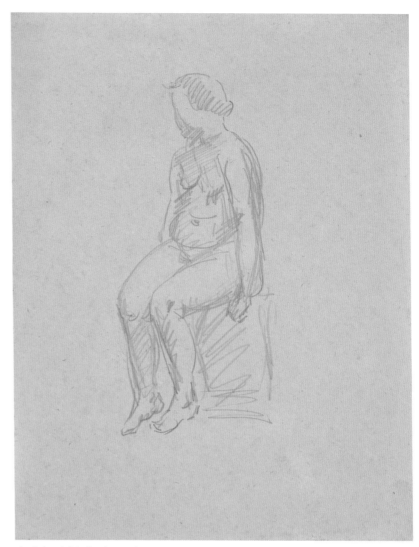

坐姿裸女速寫（110） Seated Female Nude Sketch（110）

約1927-1929　紙本鉛筆　33.2×24.4cm

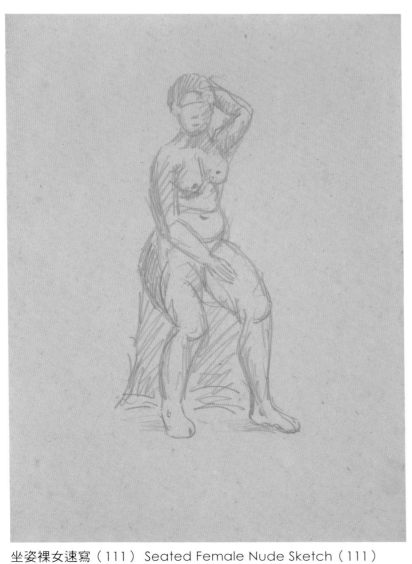

坐姿裸女速寫（111） Seated Female Nude Sketch（111）

約1927-1929　紙本鉛筆　33.3×24.4cm

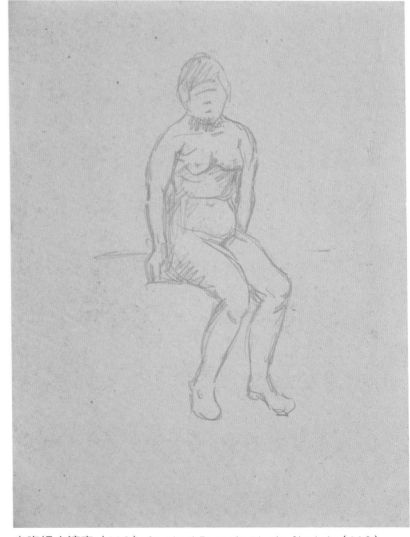

坐姿裸女速寫（112） Seated Female Nude Sketch（112）

約1927-1929　紙本鉛筆　33.2×24.4cm

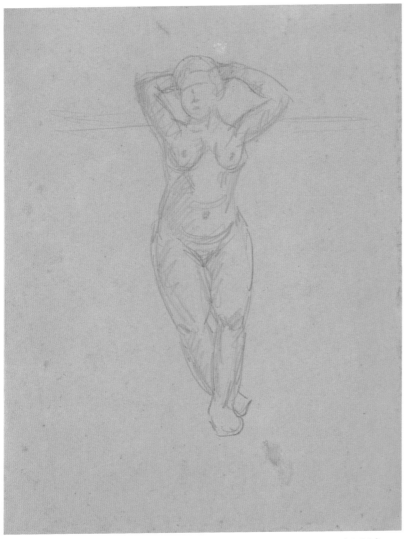

立姿裸女速寫（125）Standing Female Nude Sketch（125）

約1927-1929　紙本鉛筆　33.1×24.4cm

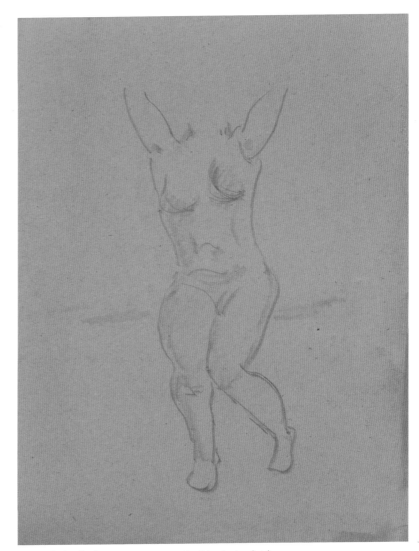

女體速寫（4）Female Body Sketch（4）

約1927-1929　紙本鉛筆　33.4×24cm

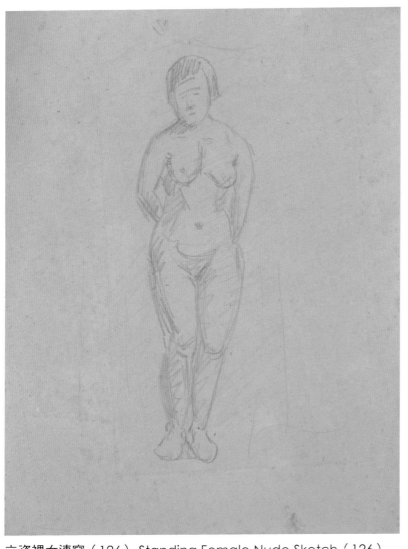

立姿裸女速寫（126）Standing Female Nude Sketch（126）

約1927-1929　紙本鉛筆　33.3×24.5cm

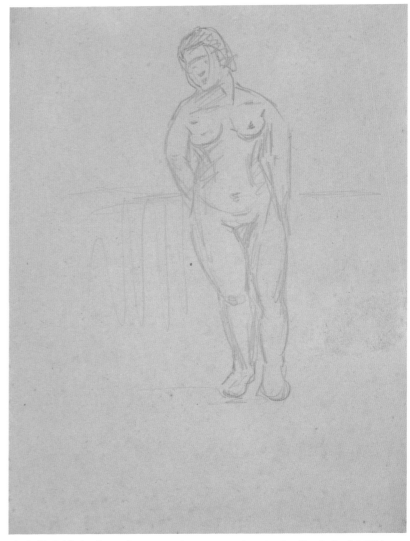

立姿裸女速寫（127）Standing Female Nude Sketch（127）

約1927-1929　紙本鉛筆　33.3×24.4cm

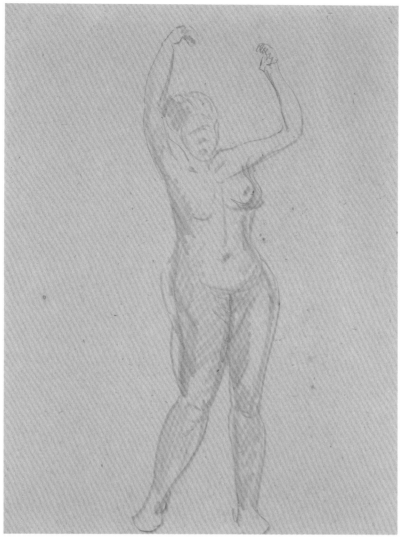

立姿裸女速寫（128） Standing Female Nude Sketch（128）

約1927-1929　紙本鉛筆　33.2×24.2cm

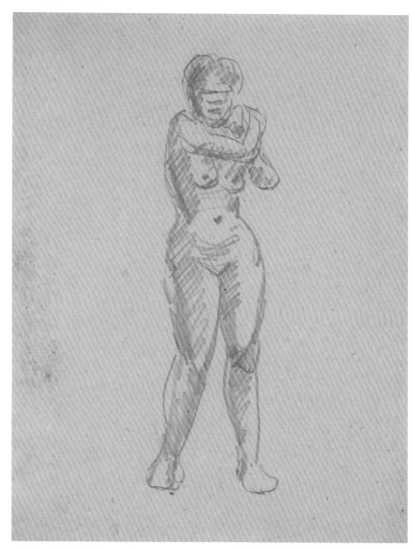

立姿裸女速寫（129） Standing Female Nude Sketch（129）

約1927-1929　紙本鉛筆　33.1×24.2cm

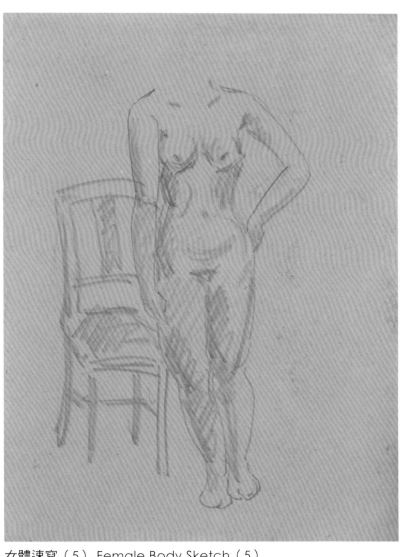

女體速寫（5） Female Body Sketch（5）

約1927-1929　紙本鉛筆　33.1×24.1cm

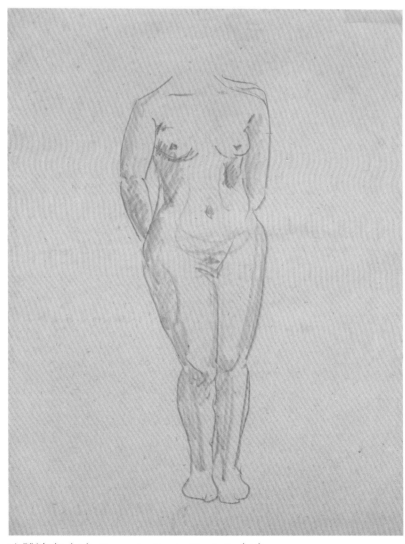

女體速寫（6） Female Body Sketch（6）

約1927-1929　紙本鉛筆　33×24.1cm

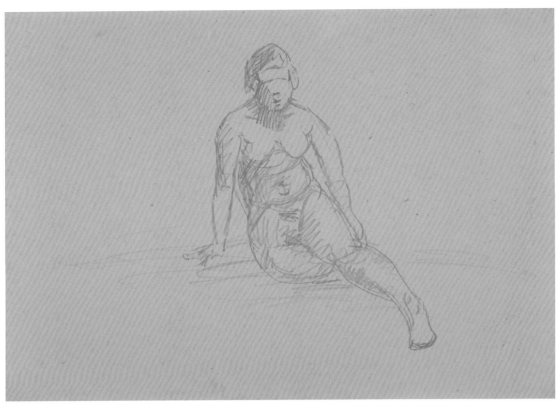

坐姿裸女速寫（113）
Seated Female Nude Sketch（113）

約1927-1929　紙本鉛筆　24.4×33.2cm

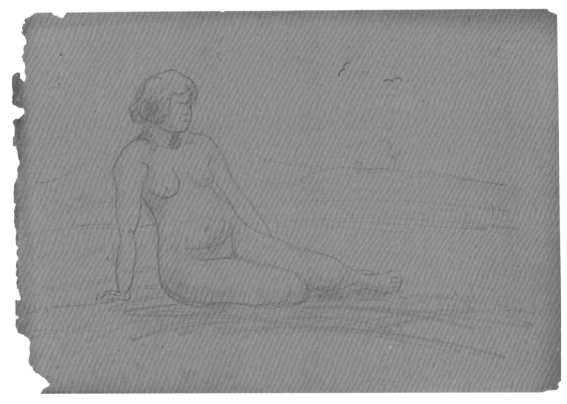

坐姿裸女速寫（114）
Seated Female Nude Sketch（114）

約1927-1929　紙本鉛筆　24.2×33.3cm

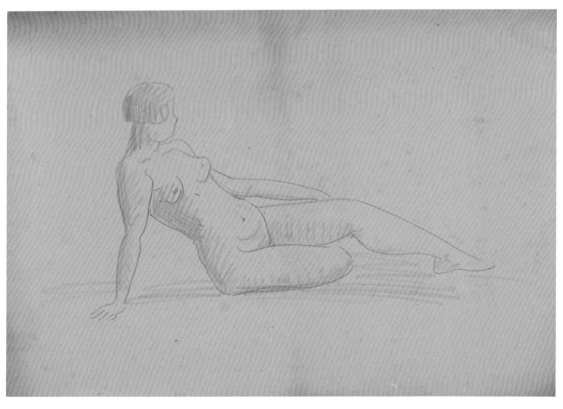

坐姿裸女速寫（115）
Seated Female Nude Sketch（115）

約1927-1929　紙本鉛筆　24.3×33.1cm

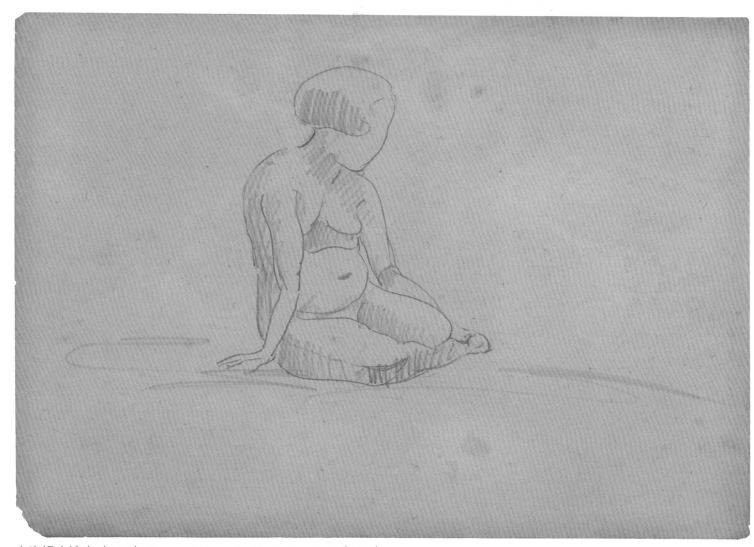

坐姿裸女速寫（116）Seated Female Nude Sketch（116）

約1927-1929　紙本鉛筆　24.7×33.2cm

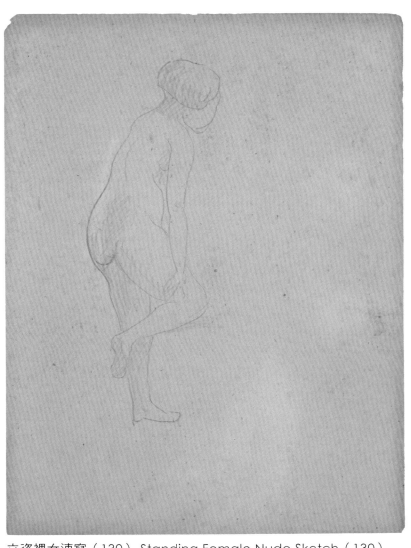

立姿裸女速寫（130）Standing Female Nude Sketch（130）

約1927-1929　紙本鉛筆　33.3×24.6cm

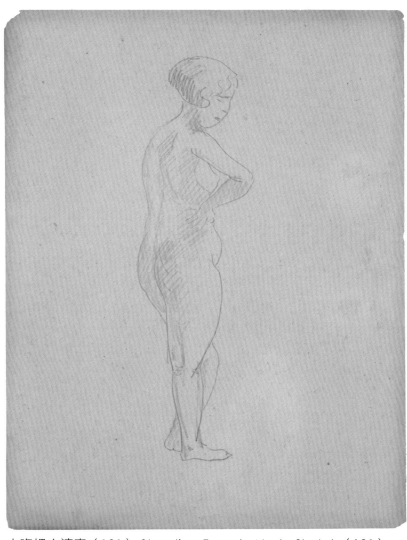

立姿裸女速寫（131）Standing Female Nude Sketch（131）

約1927-1929　紙本鉛筆　33.2×24.7cm

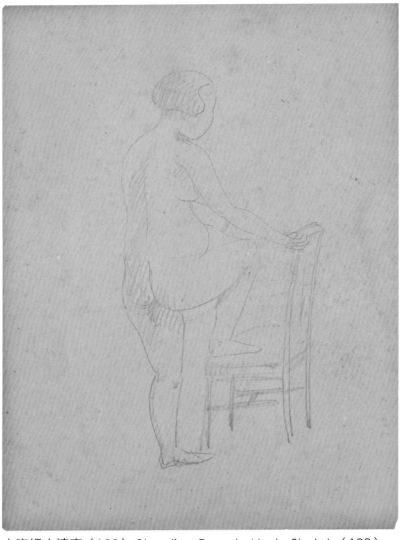

立姿裸女速寫（132） Standing Female Nude Sketch（132）
約1927-1929　紙本鉛筆　33.2×24.5cm

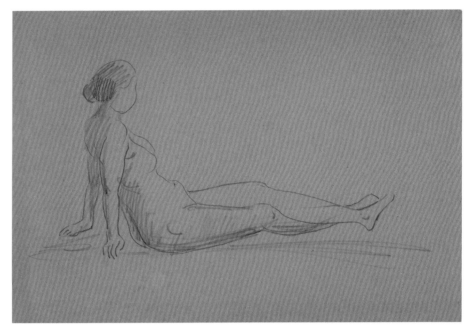

坐姿裸女速寫（117） Seated Female Nude Sketch（117）
約1927-1929　紙本鉛筆　24×33.2cm

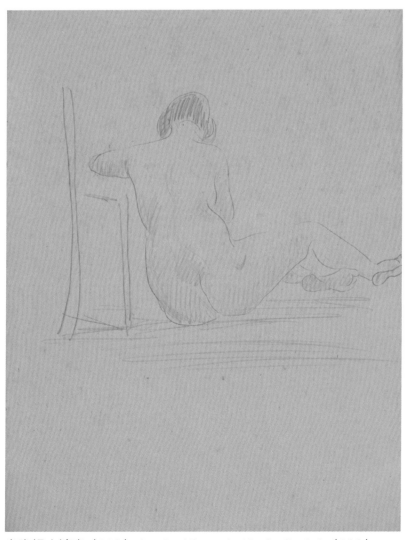

坐姿裸女速寫（118） Seated Female Nude Sketch（118）
約1927-1929　紙本鉛筆　33.2×24.3cm

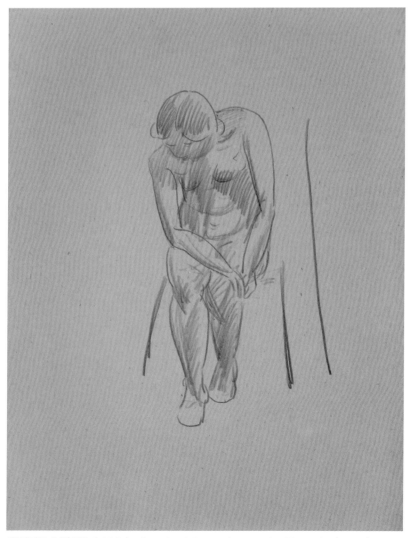

坐姿裸女速寫（119） Seated Female Nude Sketch（119）
約1927-1929　紙本鉛筆　33.1×24.2cm

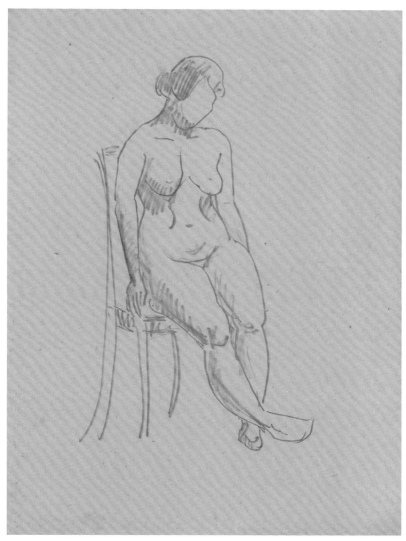

坐姿裸女速寫（120） Seated Female Nude Sketch（120）

約1927-1929　紙本鉛筆　33.1×24.2cm

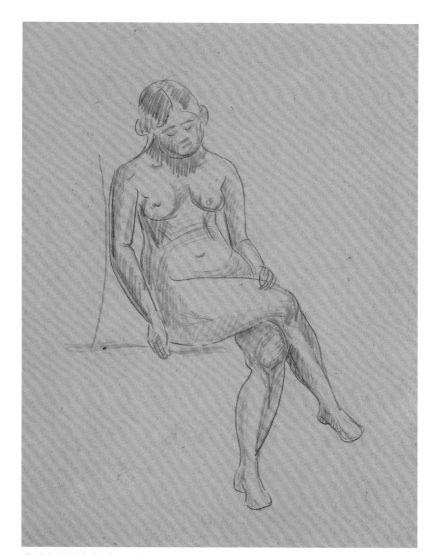

坐姿裸女速寫（121） Seated Female Nude Sketch（121）

約1927-1929　紙本鉛筆　33×24.2cm

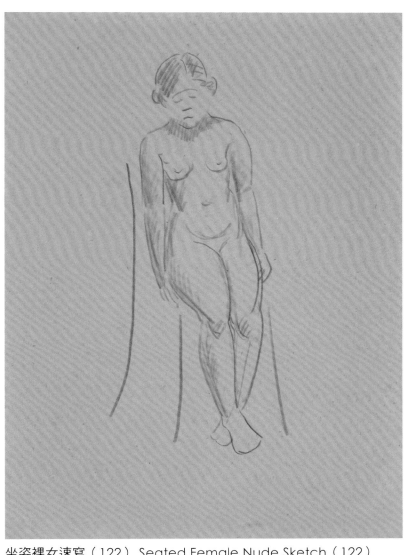

坐姿裸女速寫（122） Seated Female Nude Sketch（122）

約1927-1929　紙本鉛筆　33.1×24.2cm

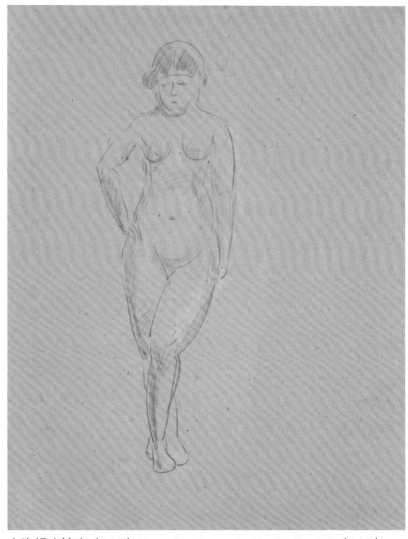

立姿裸女速寫（133） Standing Female Nude Sketch（133）

約1927-1929　紙本鉛筆　33×24.2cm

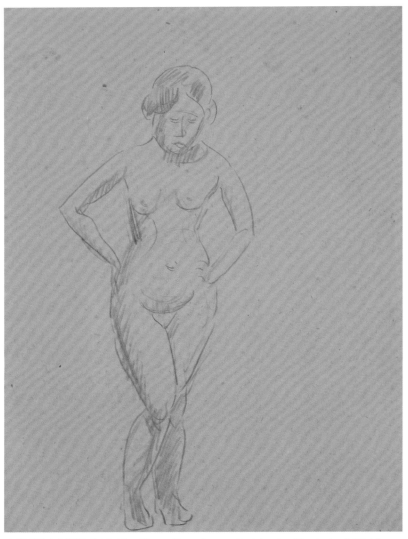

立姿裸女速寫（134）Standing Female Nude Sketch（134）
約1927-1929　紙本鉛筆　33.1×24.3cm

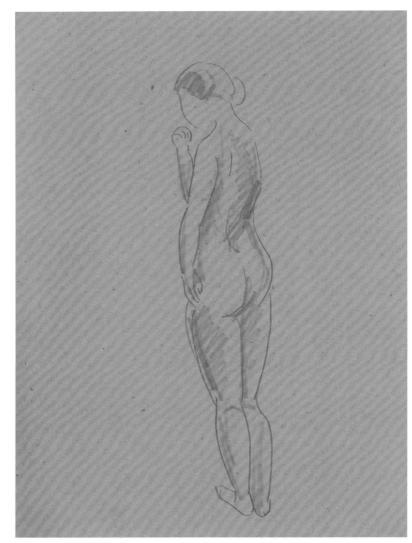

立姿裸女速寫（135）Standing Female Nude Sketch（135）
約1927-1929　紙本鉛筆　33.1×24.2cm

立姿裸女速寫（136）Standing Female Nude Sketch（136）
約1927-1929　紙本鉛筆　33×24.3cm

人物速寫（7）Figure Sketch（7）
約1927-1929　紙本鉛筆　32.8×23.9cm

坐姿裸女速寫（123）
Seated Female Nude Sketch（123）

約1927-1929　紙本鉛筆　24.6×33.2cm

臥姿裸女速寫（13）
Reclining Female Nude Sketch（13）

約1927-1929　紙本鉛筆　24.5×33.2cm

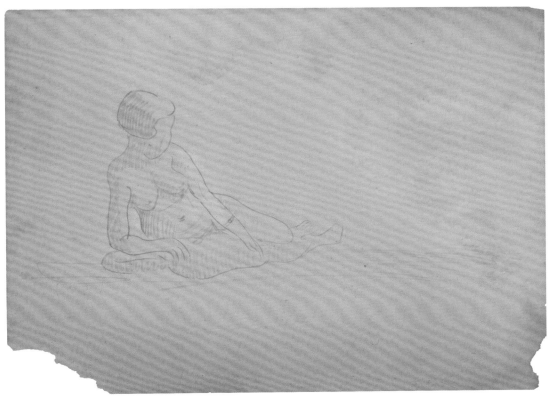

臥姿裸女速寫（14）
Reclining Female Nude Sketch（14）

約1927-1929　紙本鉛筆　24.5×33.2cm

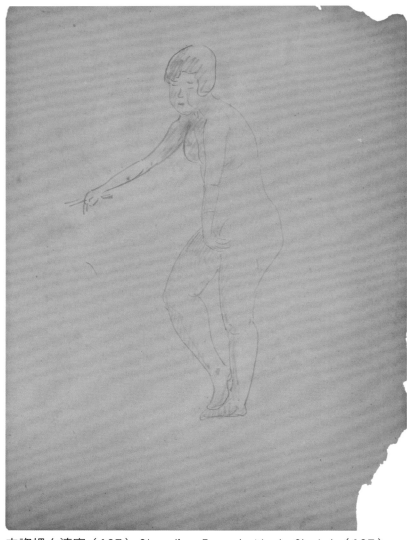

立姿裸女速寫（137） Standing Female Nude Sketch（137）
約1927-1929　紙本鉛筆　33.1×24.5cm

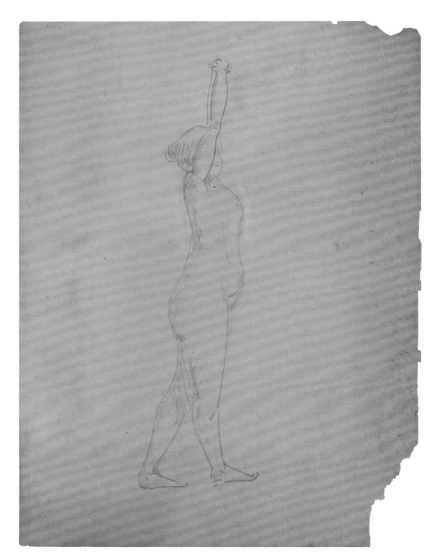

立姿裸女速寫（138） Standing Female Nude Sketch（138）
約1927-1929　紙本鉛筆　33.2×24.5cm

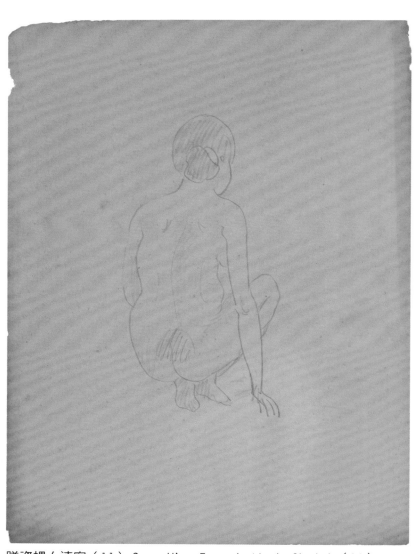

蹲姿裸女速寫（11） Squatting Female Nude Sketch（11）
約1927-1929　紙本鉛筆　33.2×24.7cm

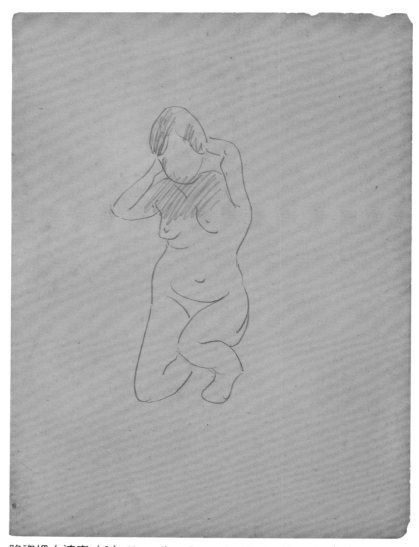

跪姿裸女速寫（8） Kneeling Female Nude Sketch（8）
約1927-1929　紙本鉛筆　33.2×24.5cm

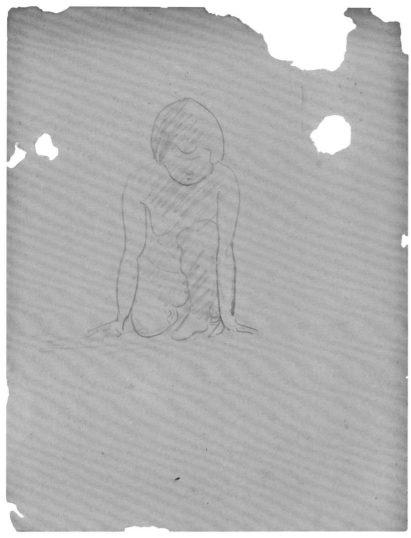

跪姿裸女速寫（9） Kneeling Female Nude Sketch（9）

約1927-1929　紙本鉛筆　33.2×24.7cm

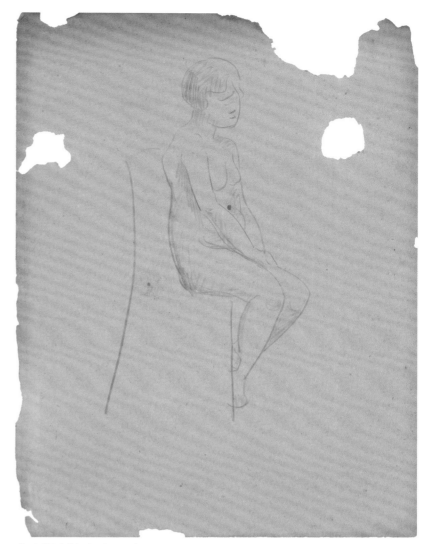

坐姿裸女速寫（124） Seated Female Nude Sketch（124）

約1927-1929　紙本鉛筆　33.2×24.5cm

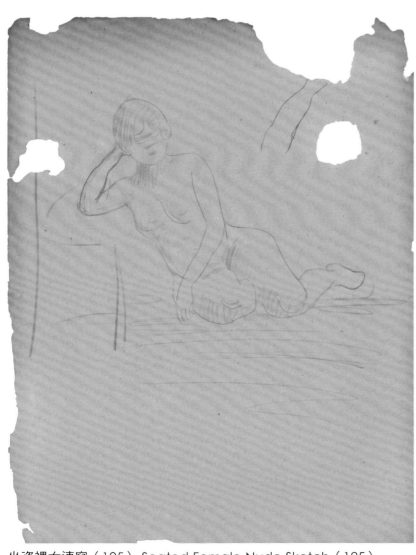

坐姿裸女速寫（125） Seated Female Nude Sketch（125）

約1927-1929　紙本鉛筆　33.3×24.7cm

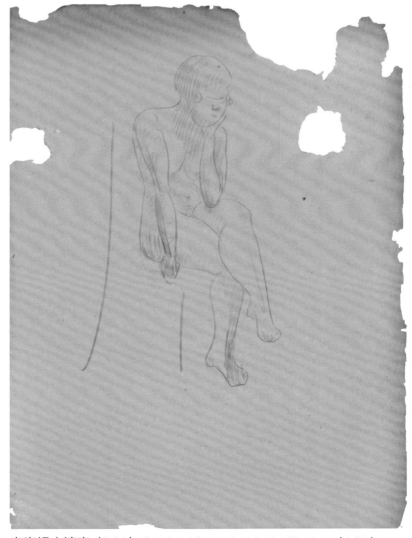

坐姿裸女速寫（126） Seated Female Nude Sketch（126）

約1927-1929　紙本鉛筆　33.1×24.5cm

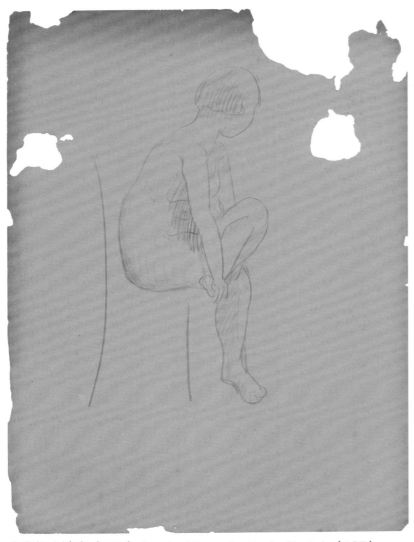

坐姿裸女速寫（127） Seated Female Nude Sketch（127）

約1927-1929　紙本鉛筆　33.1×24.5cm

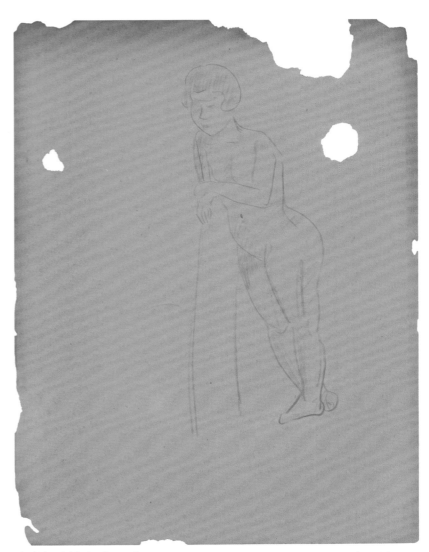

立姿裸女速寫（139） Standing Female Nude Sketch（139）

約1927-1929　紙本鉛筆　33.2×24.8cm

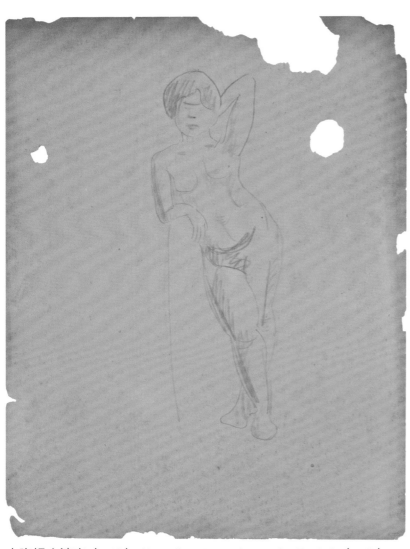

立姿裸女速寫（140） Standing Female Nude Sketch（140）

約1927-1929　紙本鉛筆　33×24.7cm

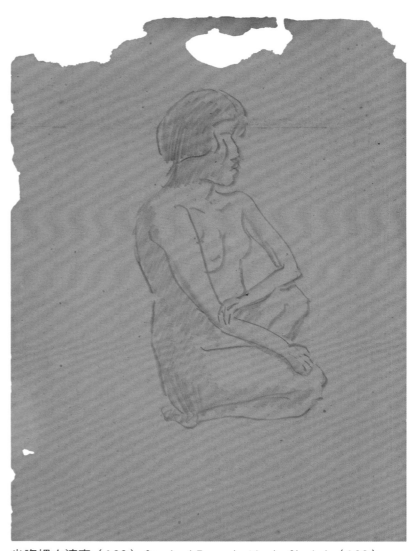

坐姿裸女速寫（128） Seated Female Nude Sketch（128）

約1927-1929　紙本鉛筆　32.7×23.8cm

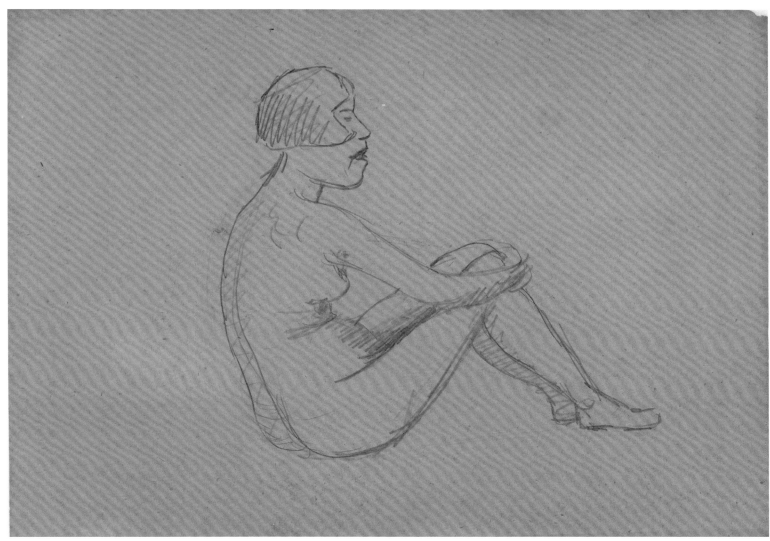

坐姿裸女速寫（129） Seated Female Nude Sketch（129）

約1927-1929　紙本鉛筆　24.4×32.9cm

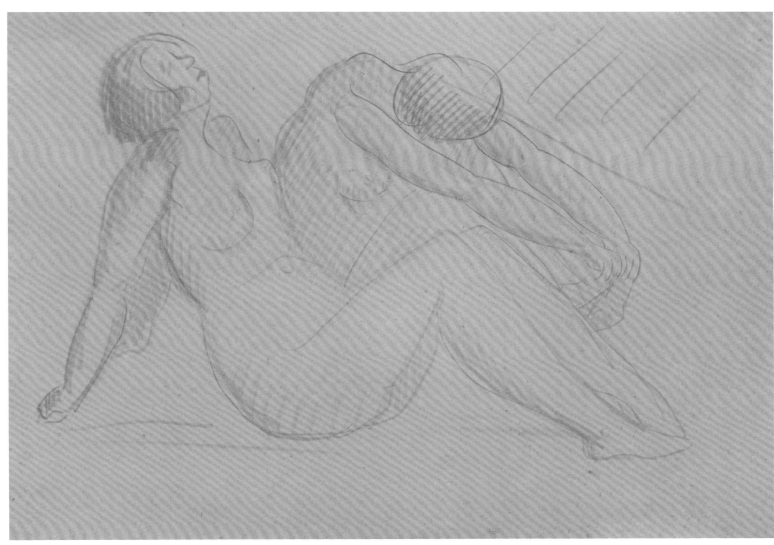

坐姿裸女速寫（130） Seated Female Nude Sketch（130）

約1927-1929　紙本鉛筆　22.5×31.5cm

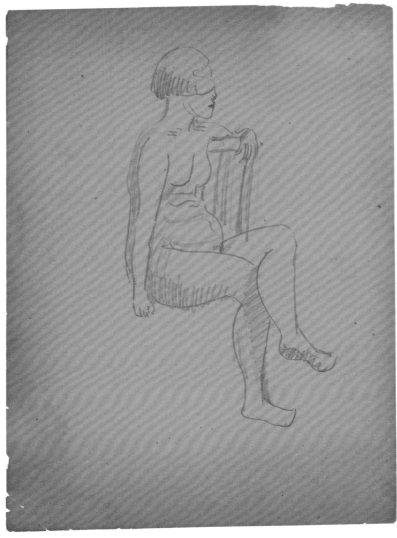

坐姿裸女速寫（131） Seated Female Nude Sketch（131）
約1927-1929　紙本鉛筆　33.2×24.2cm

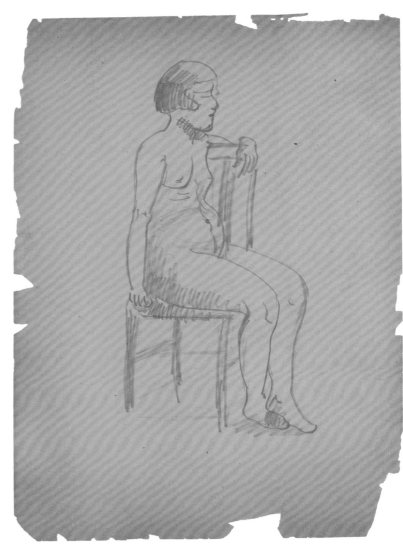

坐姿裸女速寫（132） Seated Female Nude Sketch（132）
約1927-1929　紙本鉛筆　33.3×24.2cm

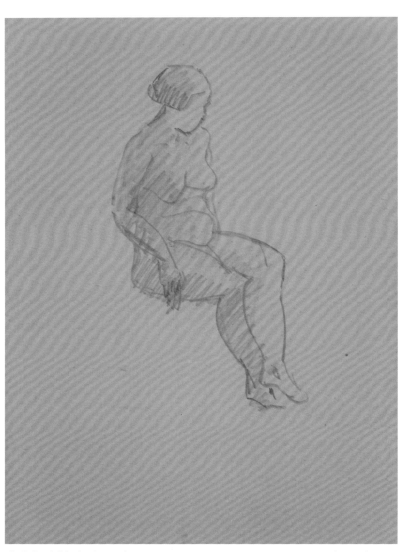

坐姿裸女速寫（133） Seated Female Nude Sketch（133）
約1927-1929　紙本鉛筆　33.4×24cm

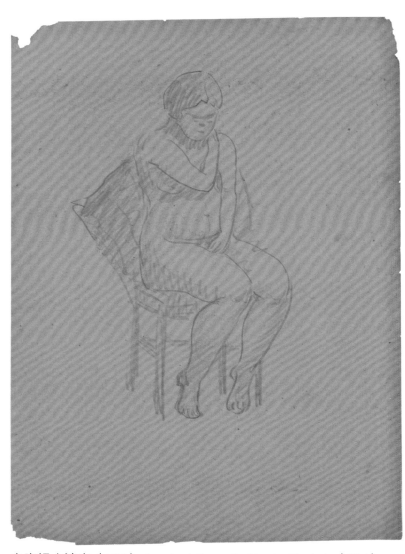

坐姿裸女速寫（134） Seated Female Nude Sketch（134）
約1927-1929　紙本鉛筆　33.2×24.2cm

坐姿裸女速寫（135）Seated Female Nude Sketch（135）

約1927-1929　紙本鉛筆　33.1×24.2cm

坐姿裸女速寫（136）Seated Female Nude Sketch（136）

約1927-1929　紙本鉛筆　33.2×24.5cm

跪姿裸女速寫（10）Kneeling Female Nude Sketch（10）

約1927-1929　紙本鉛筆　33.7×23.8cm

立姿裸女速寫（141）Standing Female Nude Sketch（141）

約1927-1929　紙本鉛筆　33.6×23.9cm

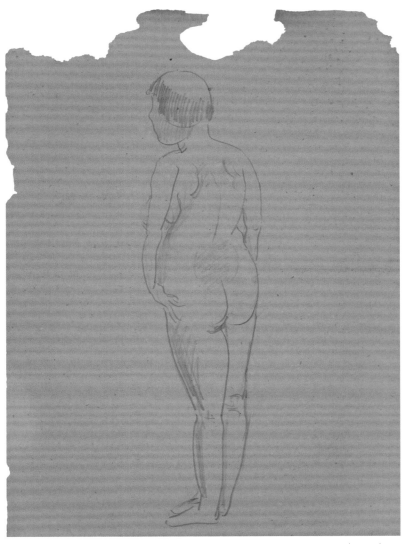

立姿裸女速寫（142）Standing Female Nude Sketch（142）

約1927-1929　紙本鉛筆　31.9×23.9cm

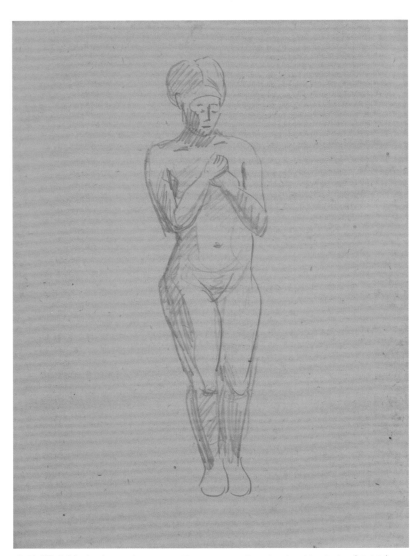

立姿裸女速寫（143）Standing Female Nude Sketch（143）

約1927-1929　紙本鉛筆　33×24.1cm

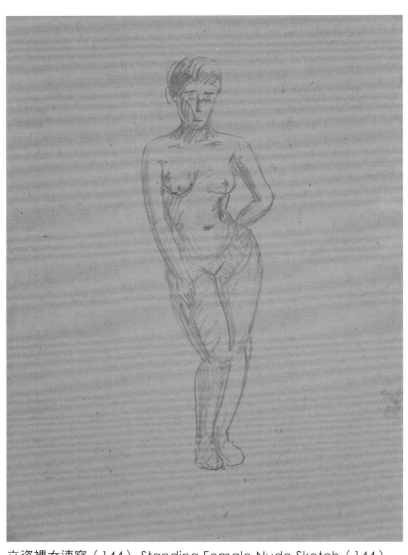

立姿裸女速寫（144）Standing Female Nude Sketch（144）

約1927-1929　紙本鉛筆　33.1×24.2cm

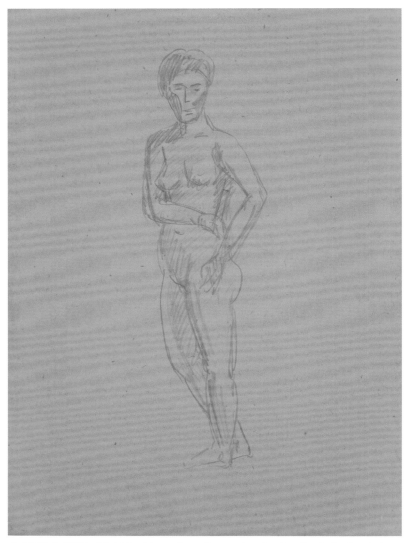

立姿裸女速寫（145）Standing Female Nude Sketch（145）

約1927-1929　紙本鉛筆　33.1×24.2cm

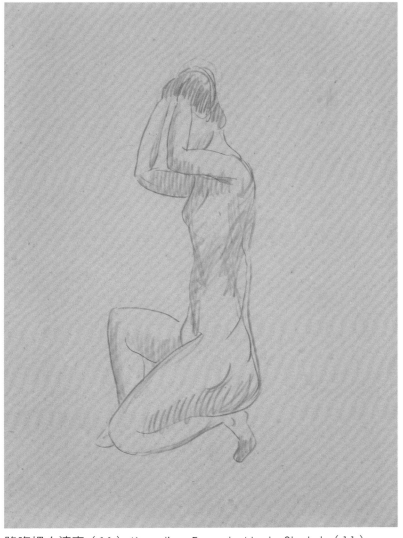

跪姿裸女速寫（11） Kneeling Female Nude Sketch（11）

約1927-1929　紙本鉛筆　33.4×24.2cm

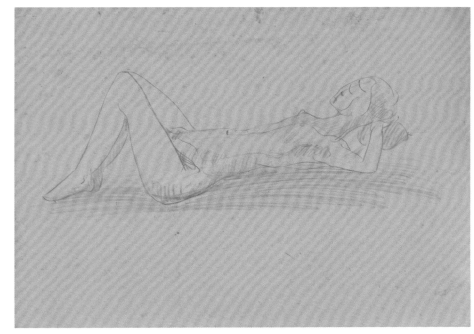

臥姿裸女速寫（15） Reclining Female Nude Sketch（15）

約1927-1929　紙本鉛筆　24.7×33.3cm

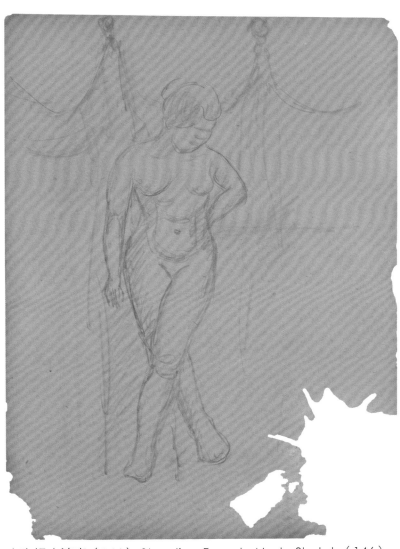

立姿裸女速寫（146） Standing Female Nude Sketch（146）

約1927-1929　紙本鉛筆　33.3×24cm

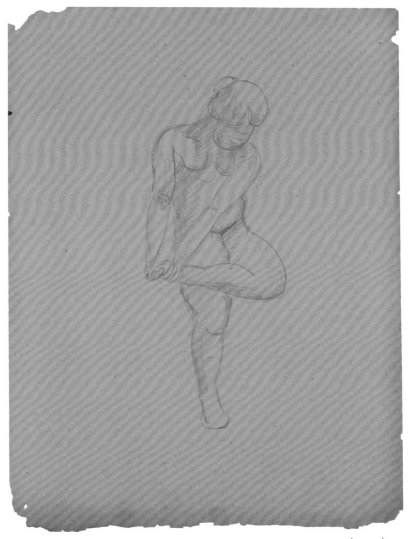

立姿裸女速寫（147） Standing Female Nude Sketch（147）

約1927-1929　紙本鉛筆　33×24cm

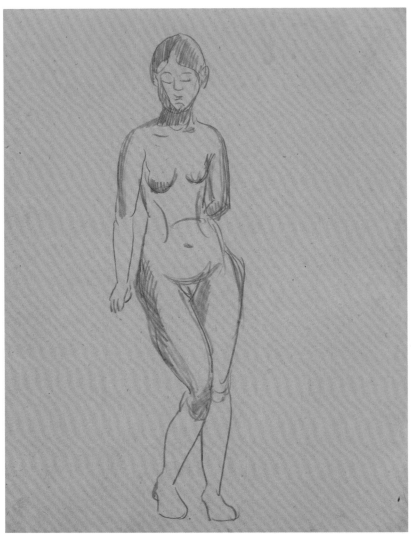

立姿裸女速寫（148）Standing Female Nude Sketch（148）
約1927-1929　紙本鉛筆　33.2×24.7cm

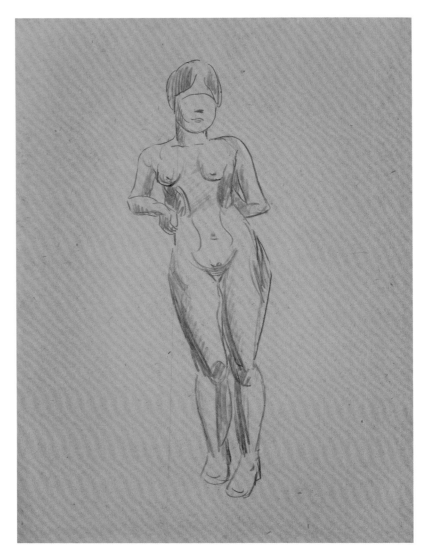

立姿裸女速寫（149）Standing Female Nude Sketch（149）
約1927-1929　紙本鉛筆　33.1×24.3cm

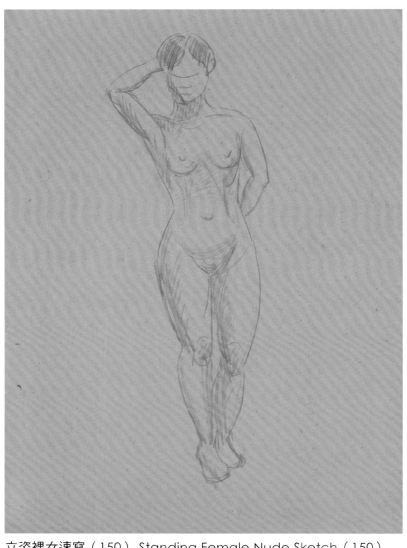

立姿裸女速寫（150）Standing Female Nude Sketch（150）
約1927-1929　紙本鉛筆　33.3×24.6cm

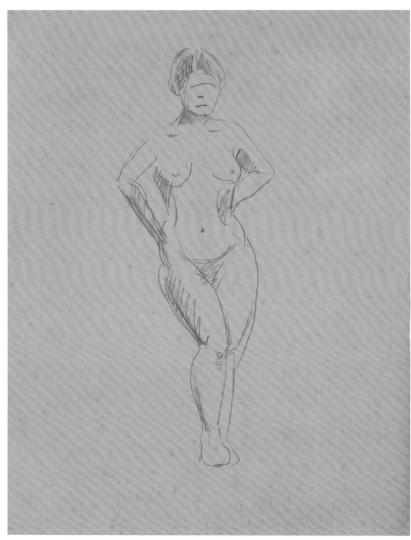

立姿裸女速寫（151）Standing Female Nude Sketch（151）
約1927-1929　紙本鉛筆　33.2×24.5cm

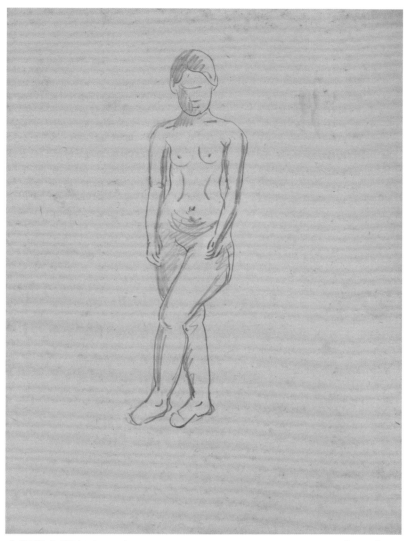

立姿裸女速寫（152） Standing Female Nude Sketch（152）
約1927-1929　紙本鉛筆　33.3×24.2cm

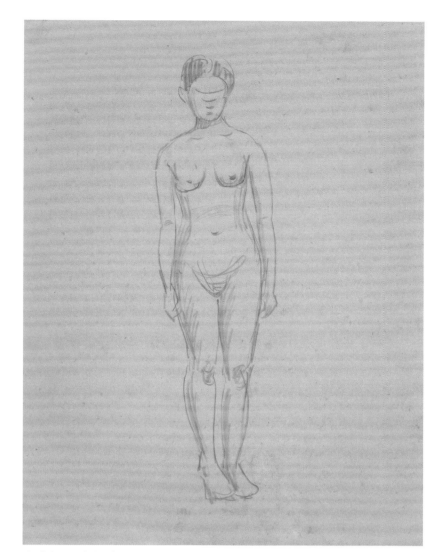

立姿裸女速寫（153） Standing Female Nude Sketch（153）
約1927-1929　紙本鉛筆　33.3×24.6cm

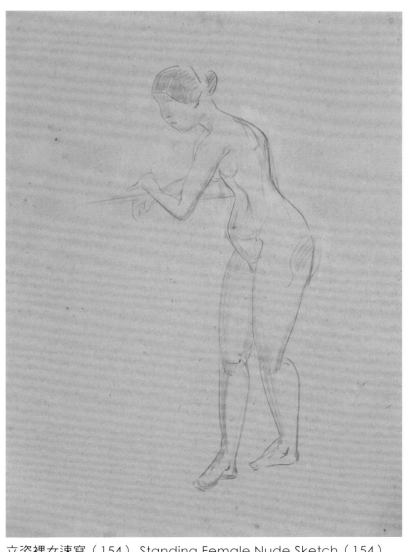

立姿裸女速寫（154） Standing Female Nude Sketch（154）
約1927-1929　紙本鉛筆　33×24.3cm

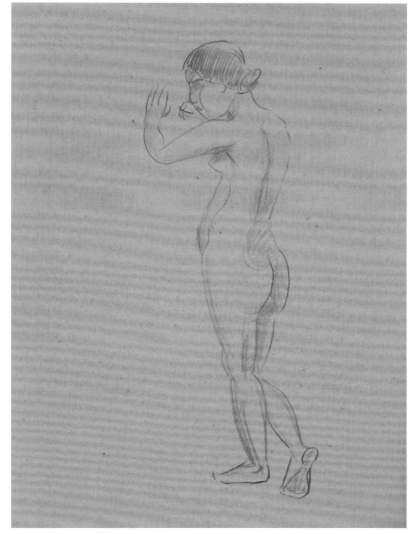

立姿裸女速寫（155） Standing Female Nude Sketch（155）
約1927-1929　紙本鉛筆　32.7×23.8cm

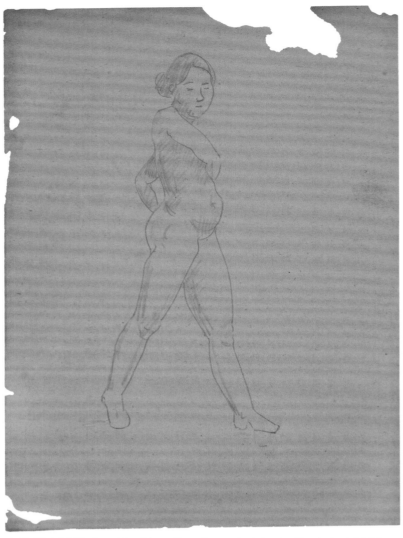

立姿裸女速寫（156） Standing Female Nude Sketch（156）
約1927-1929　紙本鉛筆　32.7×23.9cm

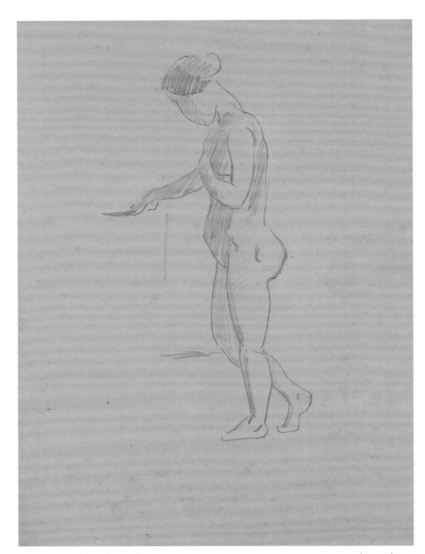

立姿裸女速寫（157） Standing Female Nude Sketch（157）
約1927-1929　紙本鉛筆　33.3×24.2cm

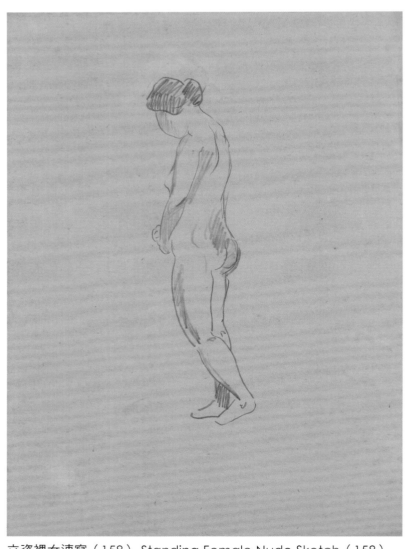

立姿裸女速寫（158） Standing Female Nude Sketch（158）
約1927-1929　紙本鉛筆　33.3×24.2cm

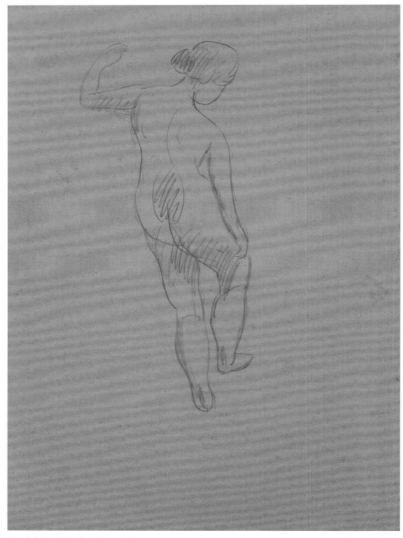

立姿裸女速寫（159） Standing Female Nude Sketch（159）
約1927-1929　紙本鉛筆　33.5×24cm

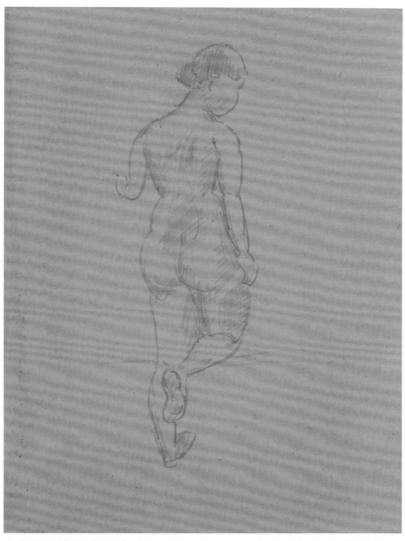

立姿裸女速寫（160）Standing Female Nude Sketch（160）
約1927-1929　紙本鉛筆　32.9×24.4cm

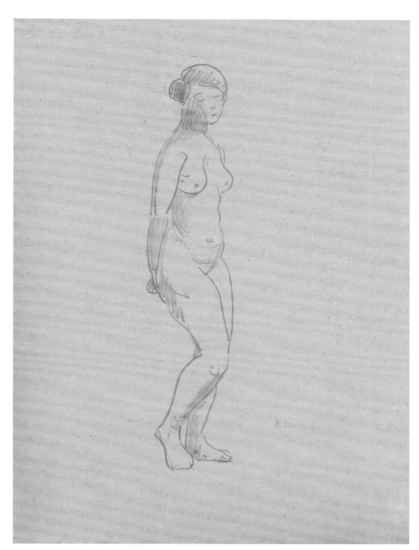

立姿裸女速寫（161）Standing Female Nude Sketch（161）
約1927-1929　紙本鉛筆　33.3×24.1cm

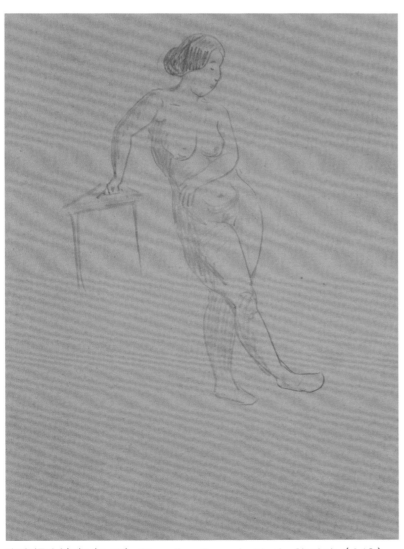

立姿裸女速寫（162）Standing Female Nude Sketch（162）
約1927-1929　紙本鉛筆　33.4×24cm

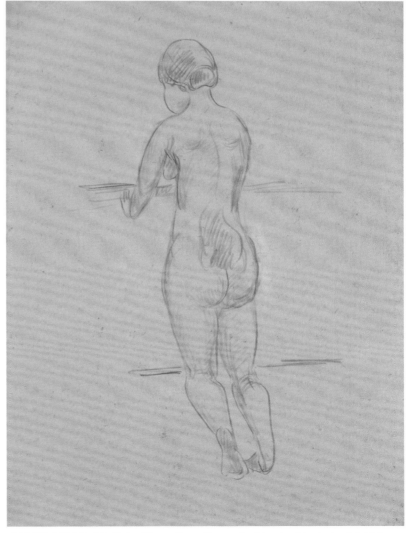

立姿裸女速寫（163）Standing Female Nude Sketch（163）
約1927-1929　紙本鉛筆　33.1×24.3cm

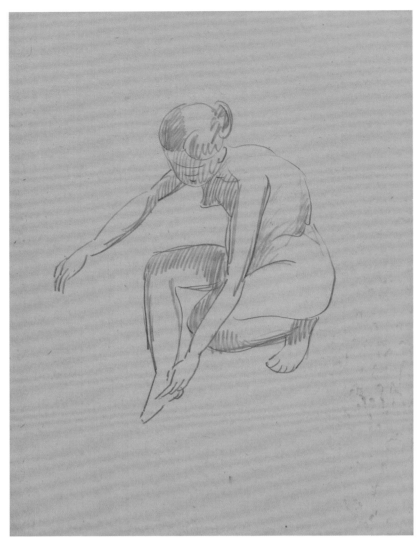

蹲姿裸女速寫（12） Squatting Female Nude Sketch（12）

約1927-1929　紙本鉛筆　33.3×24.7cm

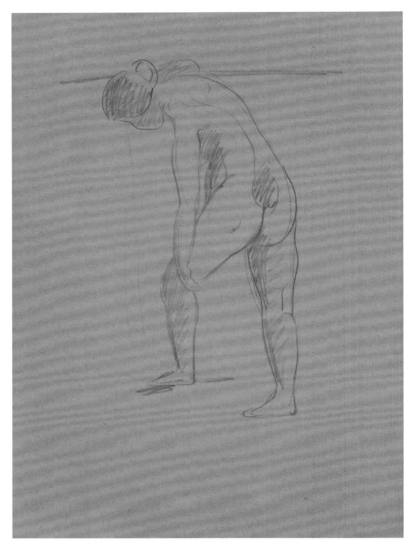

立姿裸女速寫（164） Standing Female Nude Sketch（164）

約1927-1929　紙本鉛筆　33.3×24cm

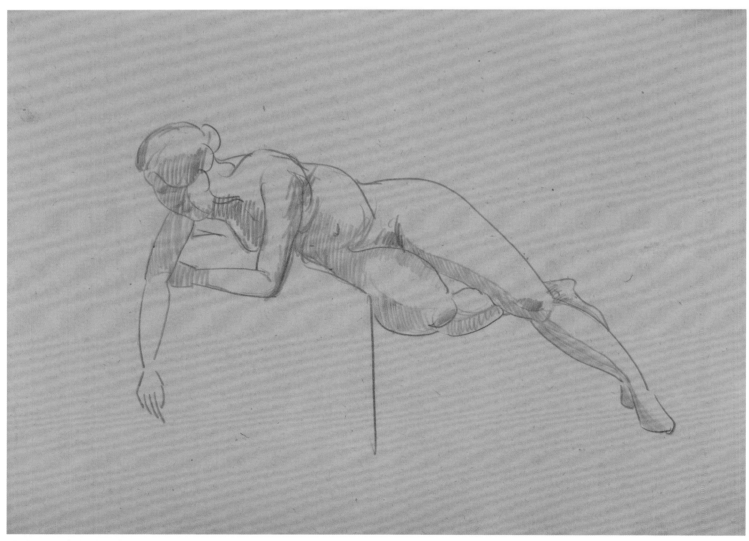

臥姿裸女速寫（16） Reclining Female Nude Sketch（16）

約1927-1929　紙本鉛筆　24.6×33.2cm

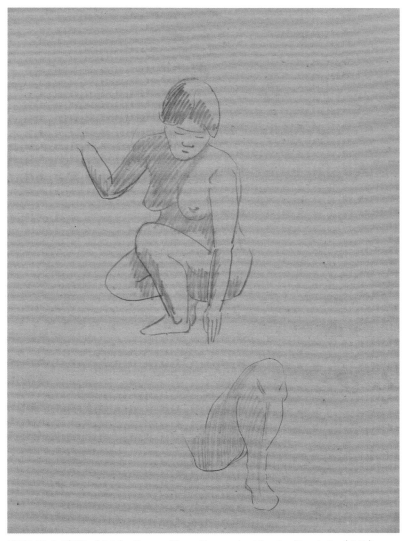

立姿裸女速寫（13）Squatting Female Nude Sketch（13）

約1927-1929　紙本鉛筆　33.2×24cm

立姿裸女速寫（165）Standing Female Nude Sketch（165）

約1927-1929　紙本鉛筆　32.6×23.9cm

立姿裸女速寫（166）Standing Female Nude Sketch（166）

約1927-1929　紙本鉛筆　33.3×24.5cm

立姿裸女速寫（167）Standing Female Nude Sketch（167）

約1927-1929　紙本鉛筆　33.2×24.6cm

立姿裸女速寫（168）Standing Female Nude Sketch（168）
約1927-1929　紙本鉛筆　33.2×24.1cm

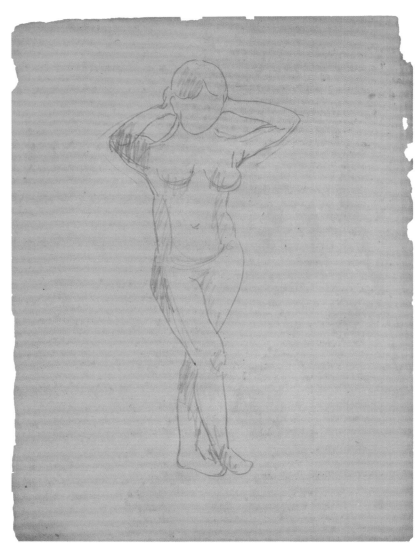

立姿裸女速寫（169）Standing Female Nude Sketch（169）
約1927-1929　紙本鉛筆　33.3×24.6cm

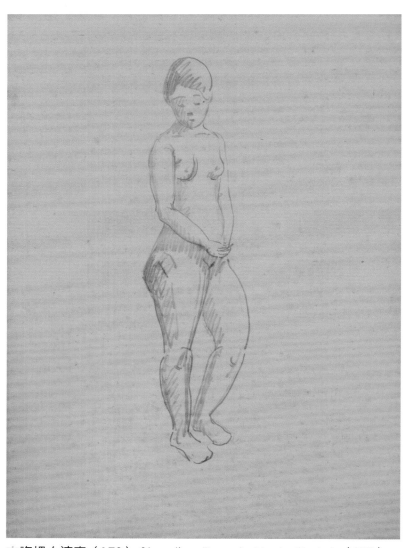

立姿裸女速寫（170）Standing Female Nude Sketch（170）
約1927-1929　紙本鉛筆　33.2×24.2cm

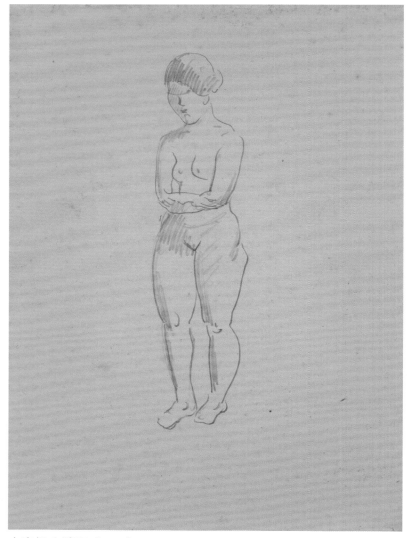

立姿裸女速寫（171）Standing Female Nude Sketch（171）
約1927-1929　紙本鉛筆　33.3×24.2cm

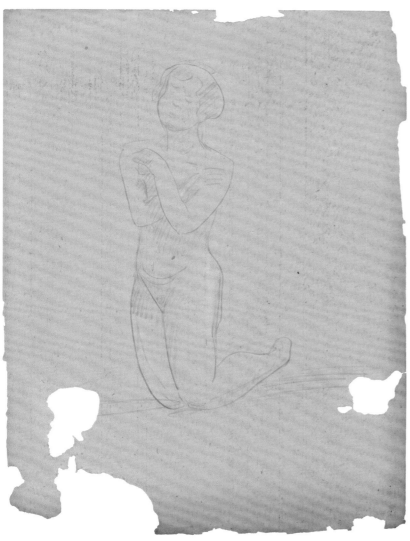

跪姿裸女速寫（12） Kneeling Female Nude Sketch（12）
約1927-1929　紙本鉛筆　33.3×24.6cm

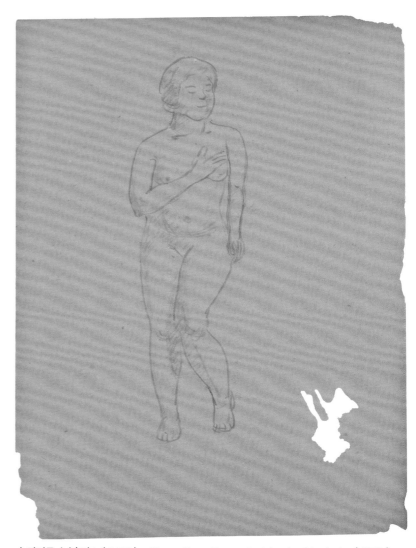

立姿裸女速寫（172） Standing Female Nude Sketch（172）
約1927-1929　紙本鉛筆　33.2×24.2cm

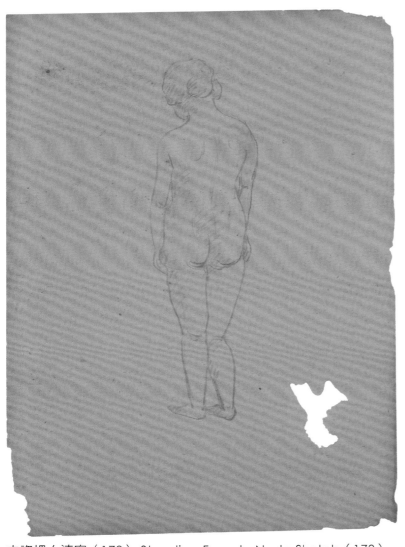

立姿裸女速寫（173） Standing Female Nude Sketch（173）
約1927-1929　紙本鉛筆　33.2×24.1cm

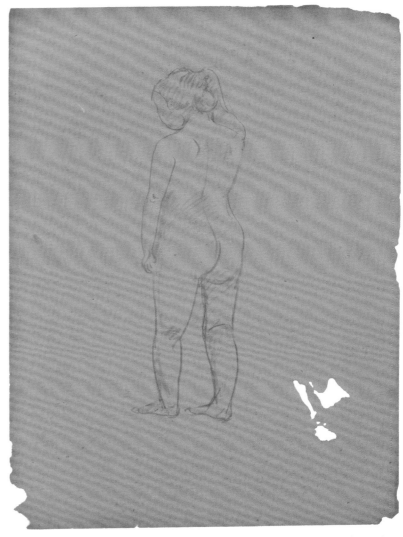

立姿裸女速寫（174） Standing Female Nude Sketch（174）
約1927-1929　紙本鉛筆　33.2×24cm

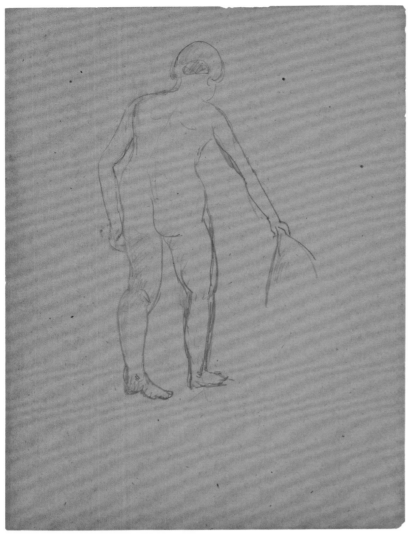

立姿裸女速寫（175） Standing Female Nude Sketch（175）

約1927-1929　紙本鉛筆　32.9×24.4cm

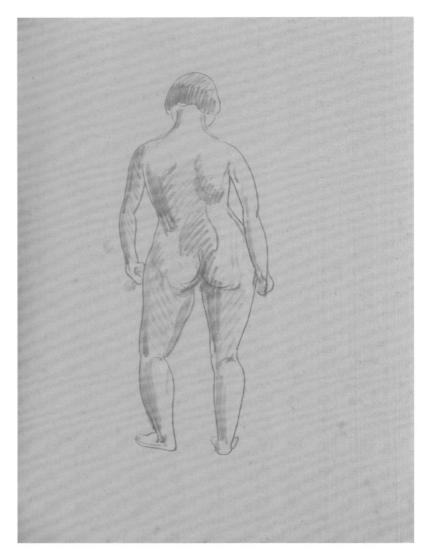

立姿裸女速寫（176） Standing Female Nude Sketch〈176〉

約1927-1929　紙本鉛筆　33.1×24.2cm

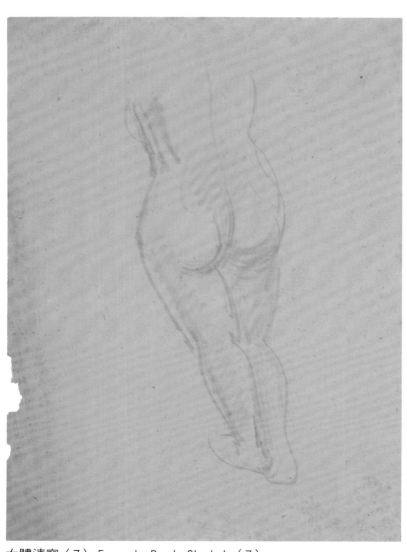

女體速寫（7） Female Body Sketch（7）

約1927-1929　紙本鉛筆　33.2×24.2cm

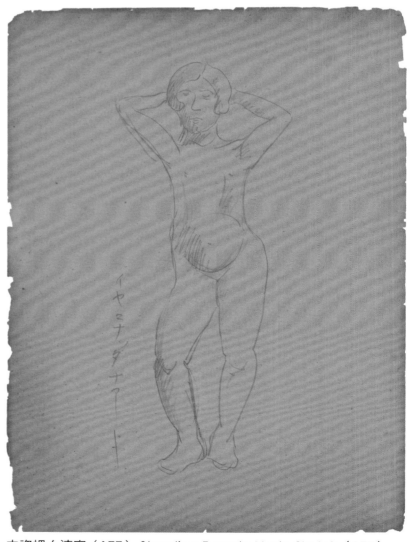

立姿裸女速寫（177） Standing Female Nude Sketch（177）

約1927-1929　紙本鉛筆　33.5×24.5cm

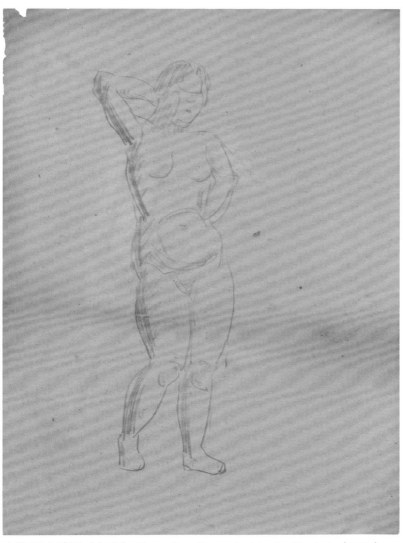

立姿裸女速寫（178） Standing Female Nude Sketch（178）
約1927-1929　紙本鉛筆　33.2×24.2cm

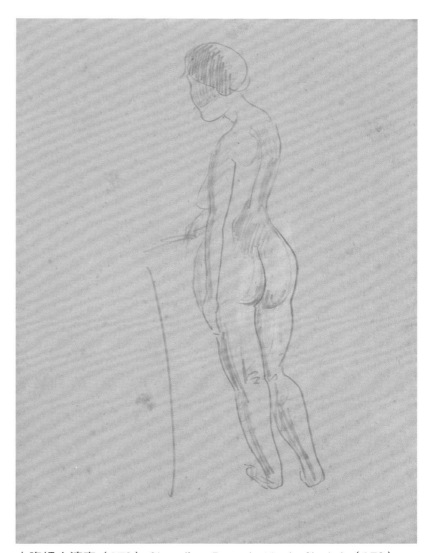

立姿裸女速寫（179） Standing Female Nude Sketch（179）
約1927-1929　紙本鉛筆　33.1×24.7cm

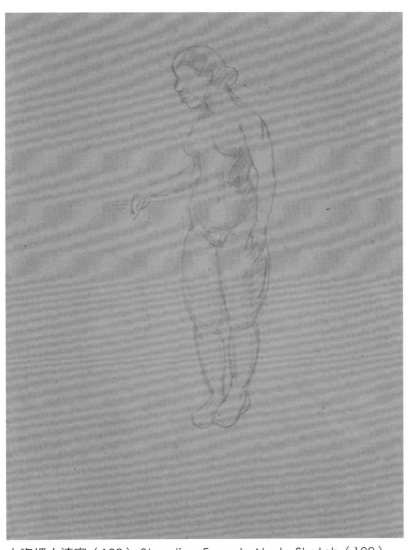

立姿裸女速寫（180） Standing Female Nude Sketch（180）
約1927-1929　紙本鉛筆　32.9×24.3cm

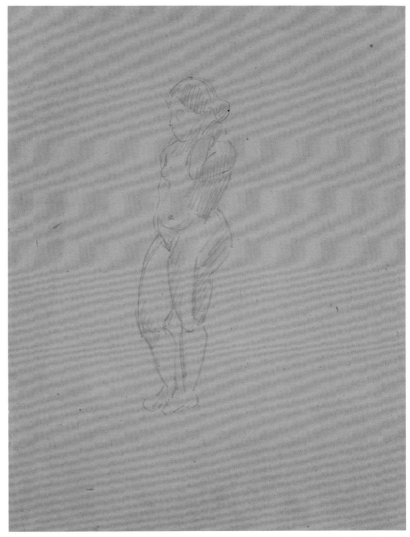

立姿裸女速寫（181） Standing Female Nude Sketch（181）
約1927-1929　紙本鉛筆　33×24.3cm

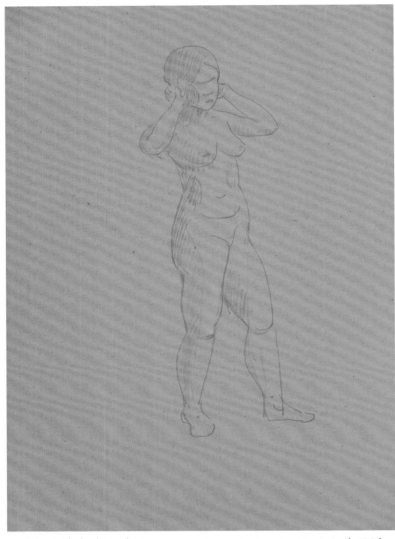

立姿裸女速寫（182）Standing Female Nude Sketch（182）

約1927-1929　紙本鉛筆　33.2×23.7cm

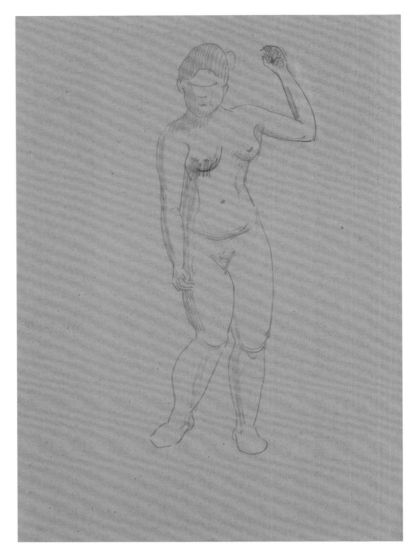

立姿裸女速寫（183）Standing Female Nude Sketch（183）

約1927-1929　紙本鉛筆　33.2×23.6cm

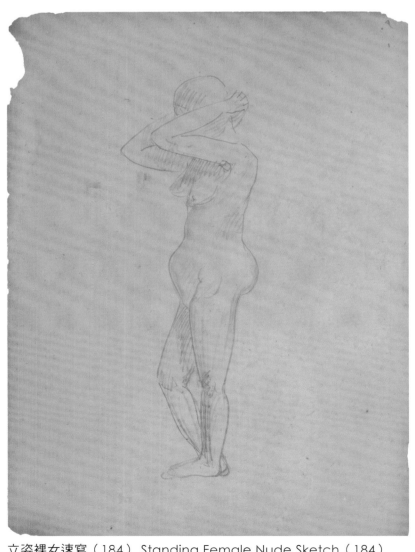

立姿裸女速寫（184）Standing Female Nude Sketch（184）

約1927-1929　紙本鉛筆　33.2×24.6cm

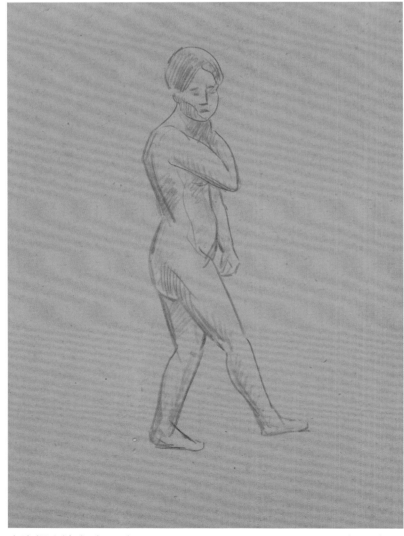

立姿裸女速寫（185）Standing Female Nude Sketch（185）

約1927-1929　紙本鉛筆　32.7×23.9cm

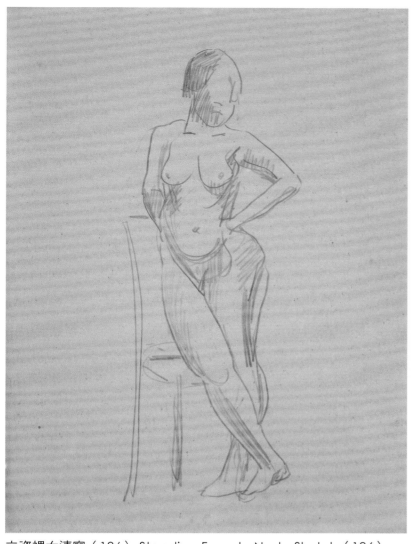

立姿裸女速寫（186） Standing Female Nude Sketch（186）

約1927-1929　紙本鉛筆　33.2×24.6cm

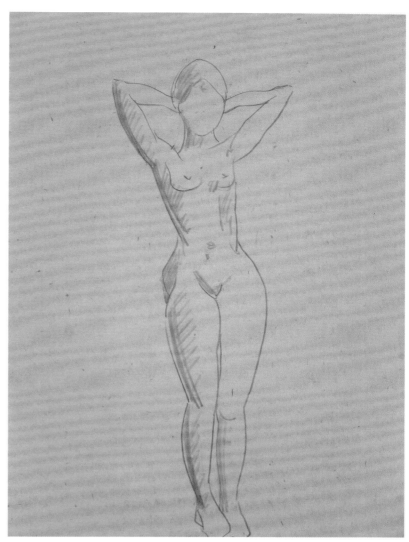

立姿裸女速寫（187） Standing Female Nude Sketch（187）

約1927-1929　紙本鉛筆　33×24.3cm

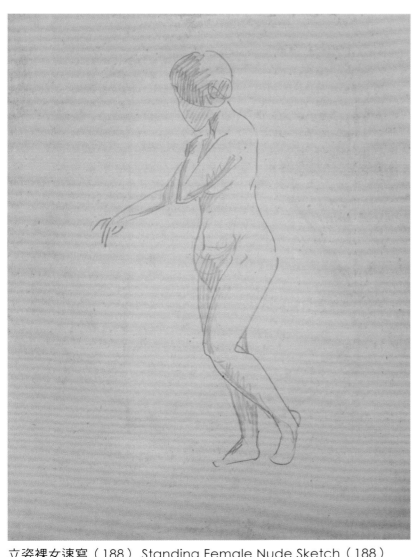

立姿裸女速寫（188） Standing Female Nude Sketch（188）

約1927-1929　紙本鉛筆　33.1×24.6cm

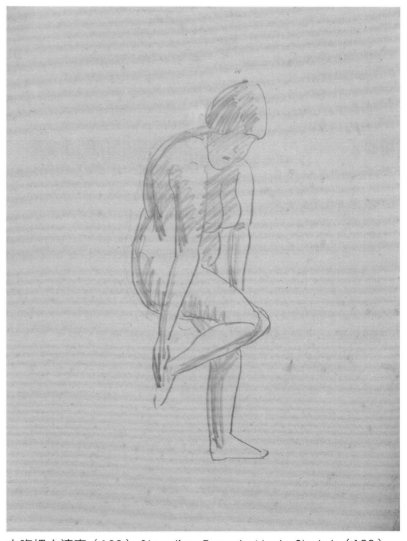

立姿裸女速寫（189） Standing Female Nude Sketch（189）

約1927-1929　紙本鉛筆　33.3×24.2cm

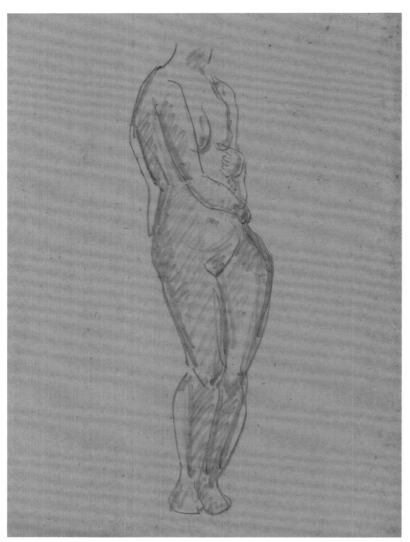

女體速寫（8）Female Body Sketch（8）
約1927-1929　紙本鉛筆　33×24.2cm

女體速寫（9）Female Body Sketch（9）
約1927-1929　紙本鉛筆　33×24.2cm

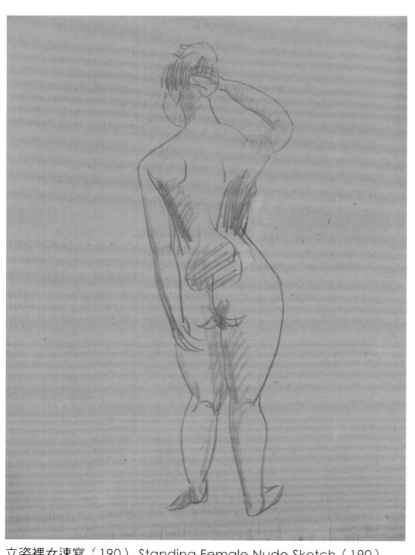

立姿裸女速寫（190）Standing Female Nude Sketch（190）
約1927-1929　紙本鉛筆　33.3×24.6cm

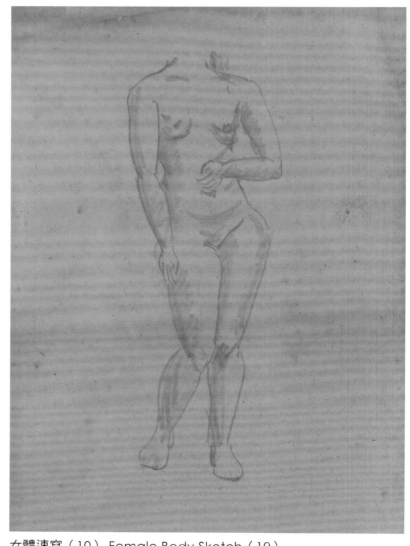

女體速寫（10）Female Body Sketch（10）
約1927-1929　紙本鉛筆　33.1×24.2cm

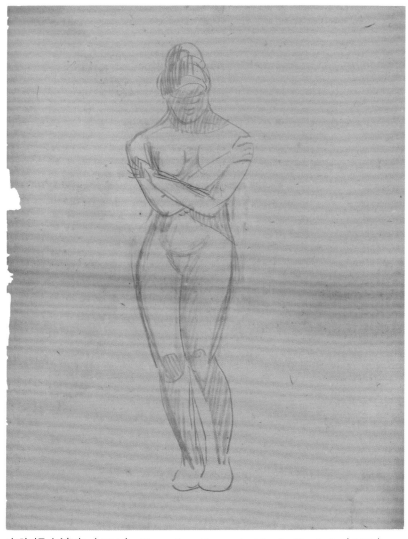

立姿裸女速寫（191） Standing Female Nude Sketch（191）

約1927-1929　紙本鉛筆　33.4×24.6cm

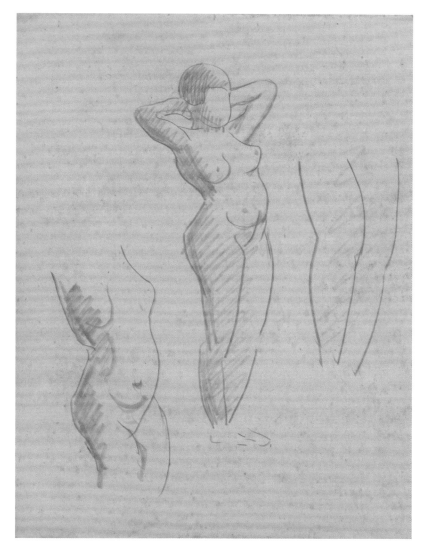

立姿裸女速寫（192） Standing Female Nude Sketch（192）

約1927-1929　紙本鉛筆　33.1×24.2cm

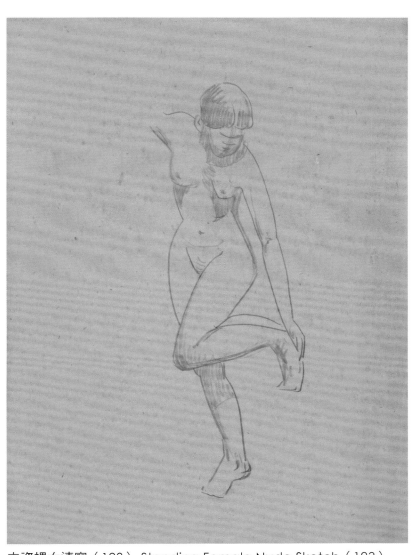

立姿裸女速寫（193） Standing Female Nude Sketch（193）

約1927-1929　紙本鉛筆　33.2×24.5cm

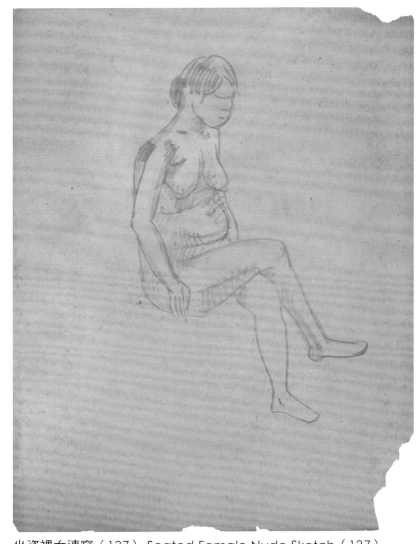

坐姿裸女速寫（137） Seated Female Nude Sketch（137）

約1927-1929　紙本鉛筆　33.1×24.7cm

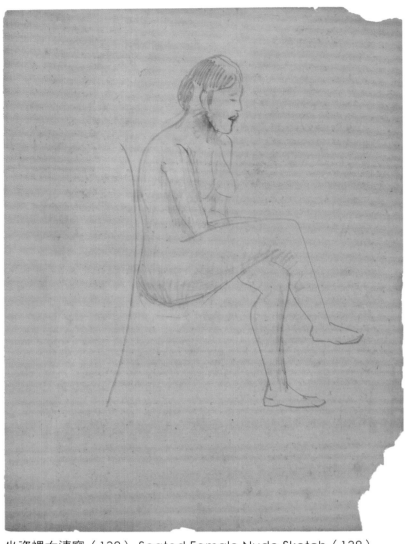

坐姿裸女速寫（138） Seated Female Nude Sketch（138）

約1927-1929　紙本鉛筆　33×24.5cm

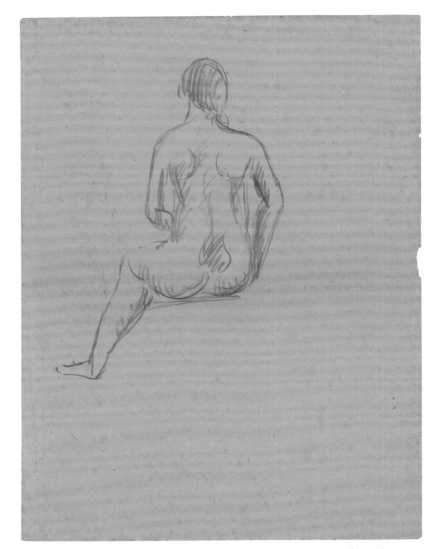

坐姿裸女速寫（139） Seated Female Nude Sketch（139）

約1927-1929　紙本鉛筆　33.2×24.7cm

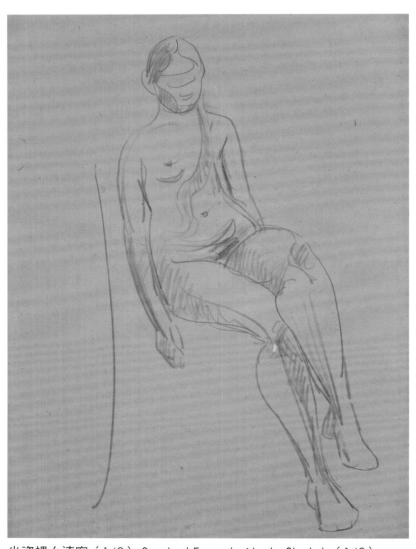

坐姿裸女速寫（140） Seated Female Nude Sketch（140）

約1927-1929　紙本鉛筆　33.2×24.7cm

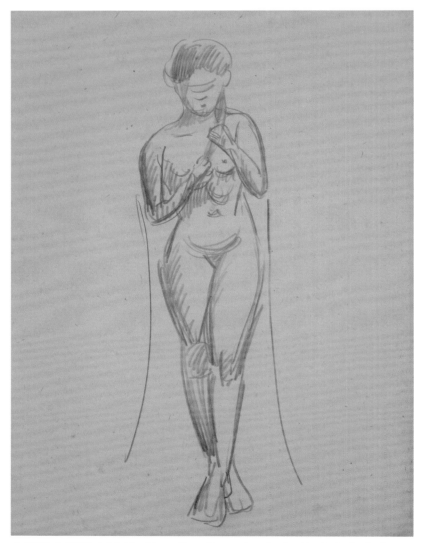

立姿裸女速寫（194） Standing Female Nude Sketch（194）

約1927-1929　紙本鉛筆　33.3×24.8cm

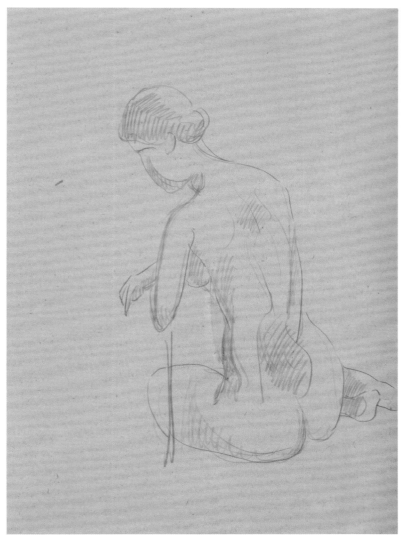

坐姿裸女速寫（141）Seated Female Nude Sketch（141）
約1927-1929　紙本鉛筆　33.2×24.7cm

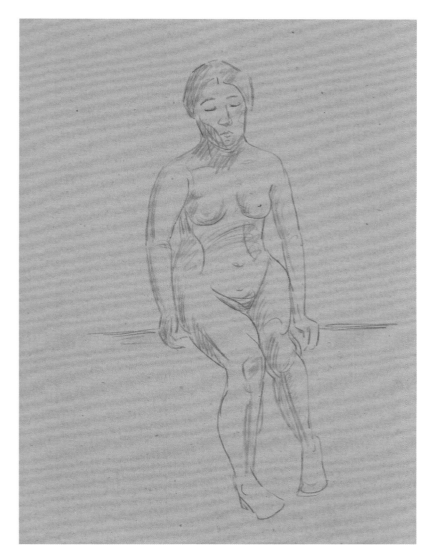

坐姿裸女速寫（142）Seated Female Nude Sketch（142）
約1927-1929　紙本鉛筆　32.7×23.8cm

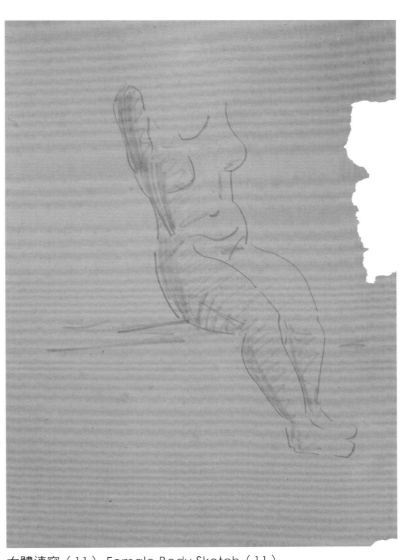

女體速寫（11）Female Body Sketch（11）
約1927-1929　紙本鉛筆　33.3×24cm

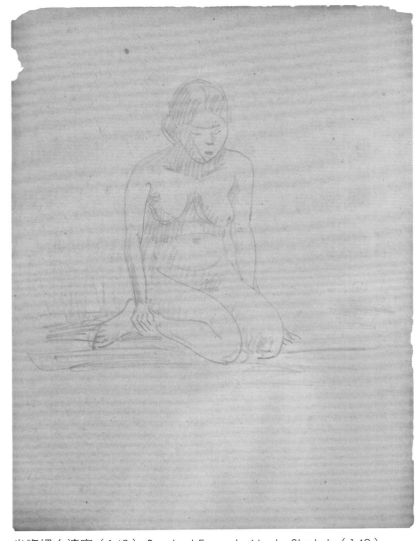

坐姿裸女速寫（143）Seated Female Nude Sketch（143）
約1927-1929　紙本鉛筆　33.2×24.5cm

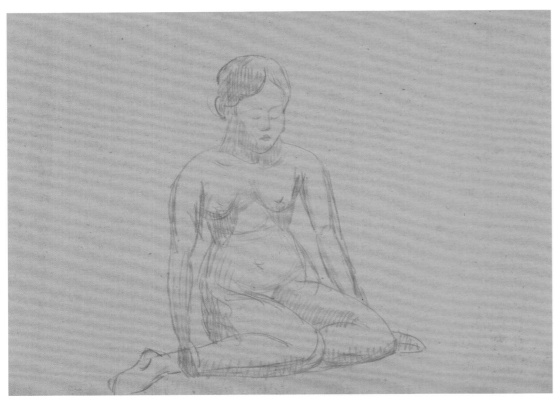

坐姿裸女速寫（144）
Seated Female Nude Sketch（144）

約1927-1929　紙本鉛筆　24.6×33.3cm

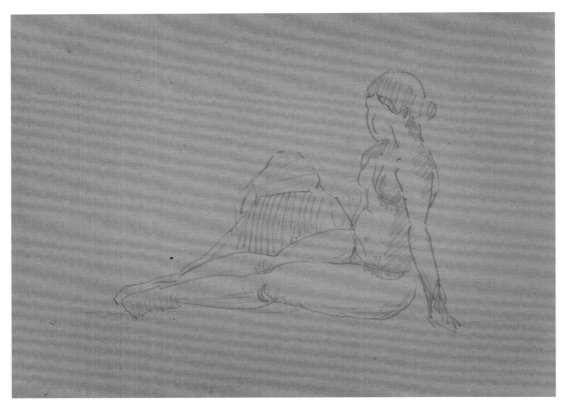

坐姿裸女速寫（145）
Seated Female Nude Sketch（145）

約1927-1929　紙本鉛筆　24.2×33.1cm

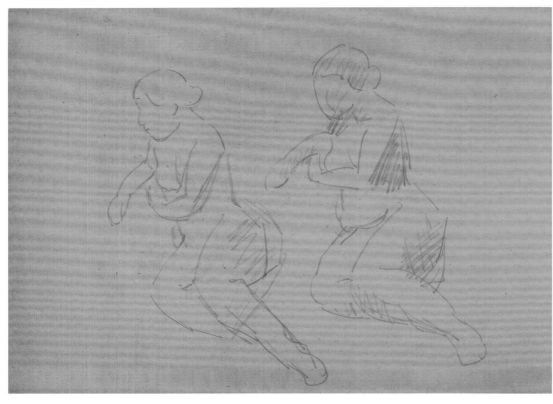

坐姿裸女速寫（146）
Seated Female Nude Sketch（146）

約1927-1929　紙本鉛筆　24.4×33.3cm

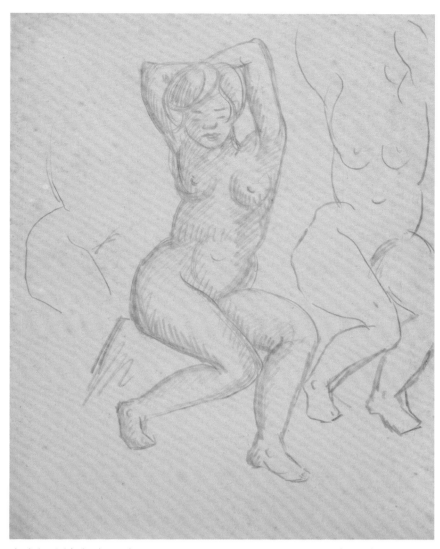

坐姿裸女速寫（147） Seated Female Nude Sketch（147）
約1927-1929　紙本鉛筆　31.5×24.7cm

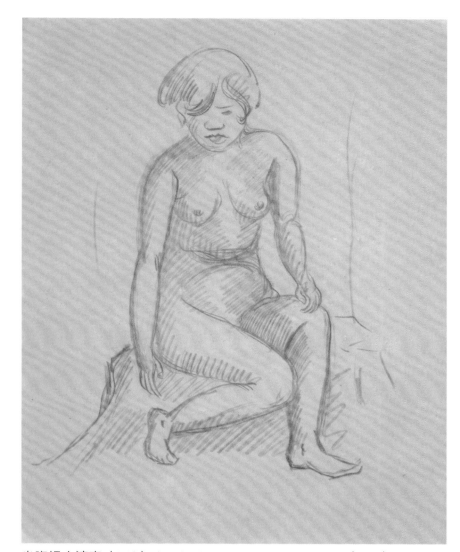

坐姿裸女速寫（148） Seated Female Nude Sketch（148）
約1927-1929　紙本鉛筆　31.6×25cm

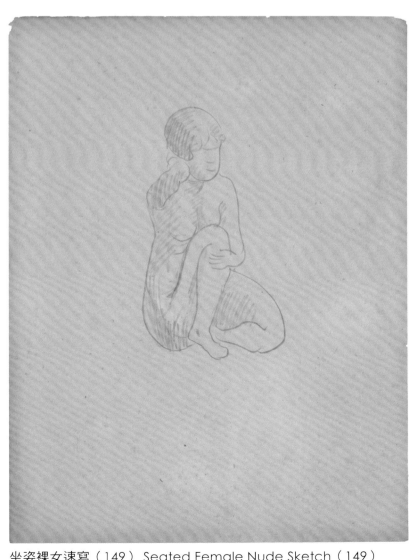

坐姿裸女速寫（149） Seated Female Nude Sketch（149）
約1927-1929　紙本鉛筆　33.2×24.5cm

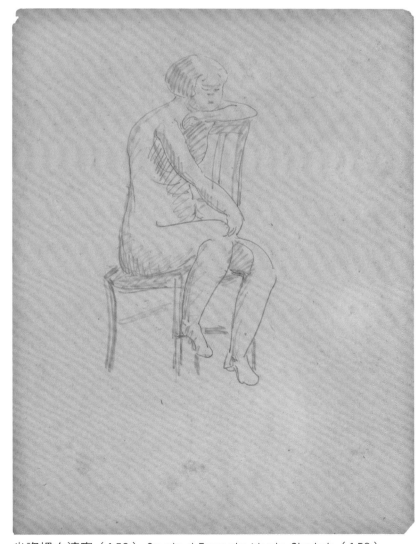

坐姿裸女速寫（150） Seated Female Nude Sketch（150）
約1927-1929　紙本鉛筆　33.1×24.6cm

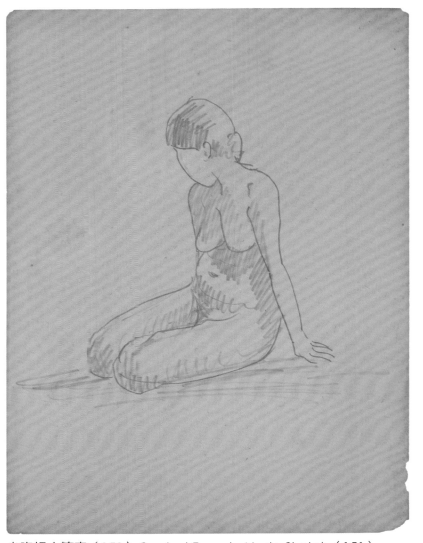

坐姿裸女速寫（151） Seated Female Nude Sketch（151）

約1927-1929　紙本鉛筆　33.1×24.6cm

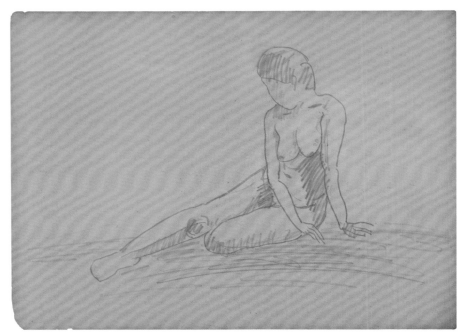

坐姿裸女速寫（152） Seated Female Nude Sketch（152）

約1927-1929　紙本鉛筆　24.7×33.2cm

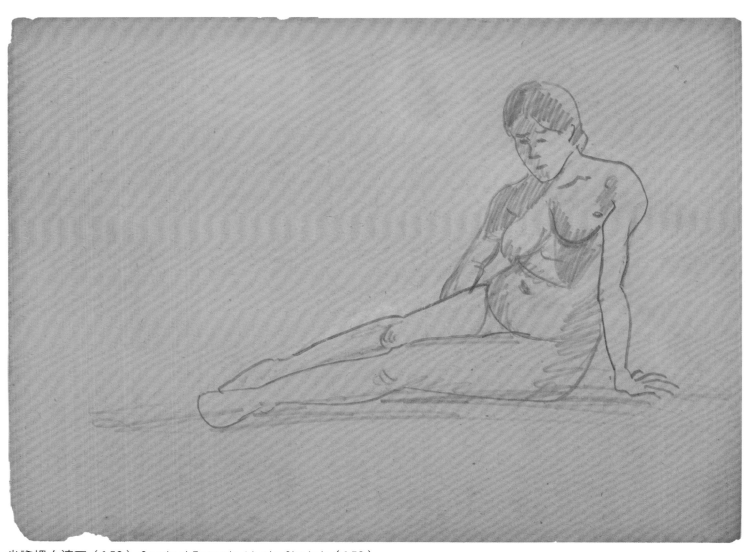

坐姿裸女速寫（153） Seated Female Nude Sketch（153）

約1927-1929　紙本鉛筆　24.7×33.2cm

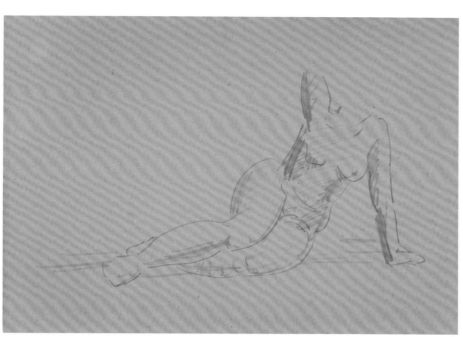

女體速寫（12）Female Body Sketch（12）

約1927-1929　紙本鉛筆　24×33.3cm

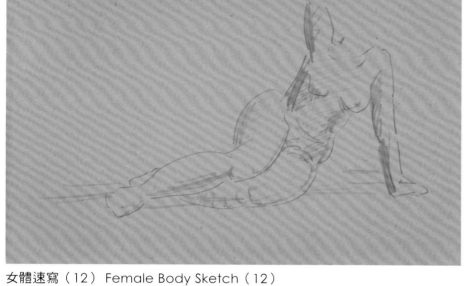

坐姿裸女速寫（154）Seated Female Nude Sketch（154）

約1927-1929　紙本鉛筆　33×24.3cm

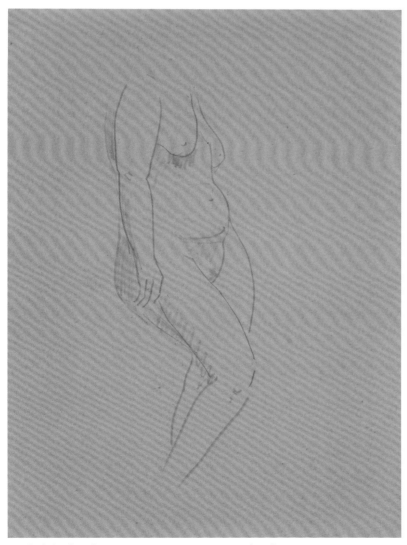

女體速寫（13）Female Body Sketch（13）

約1927-1929　紙本鉛筆　33.2×24cm

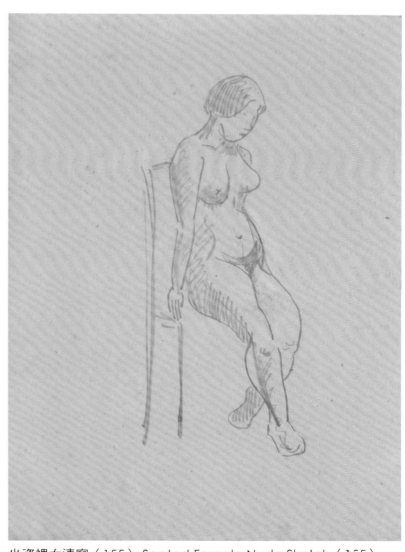

坐姿裸女速寫（155）Seated Female Nude Sketch（155）

約1927-1929　紙本鉛筆　33.2×24.3cm

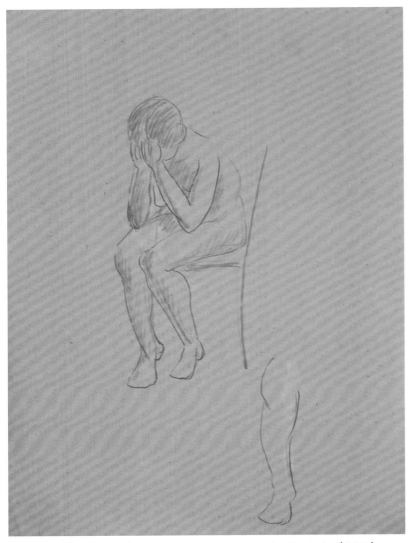

坐姿裸女速寫（156）Seated Female Nude Sketch（156）

約1927-1929　紙本鉛筆　33×24.3cm

女體速寫（14）Female Body Sketch（14）

約1927-1929　紙本鉛筆　33.2×24.1cm

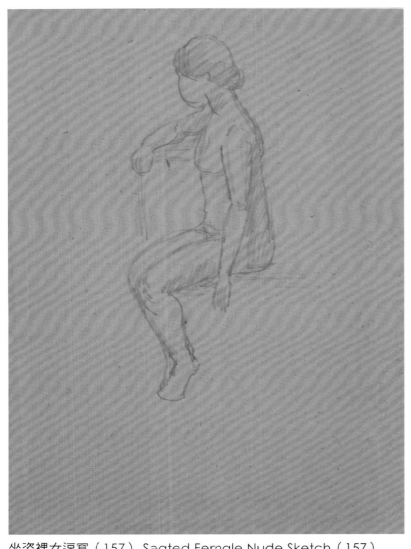

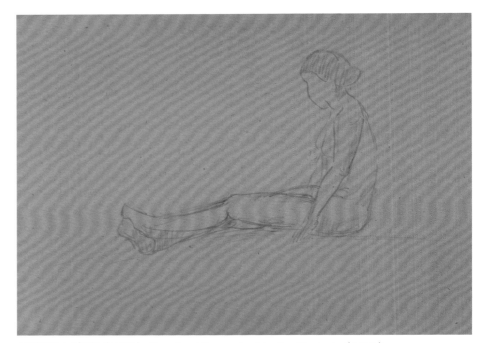

坐姿裸女速寫（158）Seated Female Nude Sketch（158）

約1927-1929　紙本鉛筆　24.4×33.2cm

坐姿裸女速寫（157）Seated Female Nude Sketch（157）

約1927-1929　紙本鉛筆　33×24.4cm

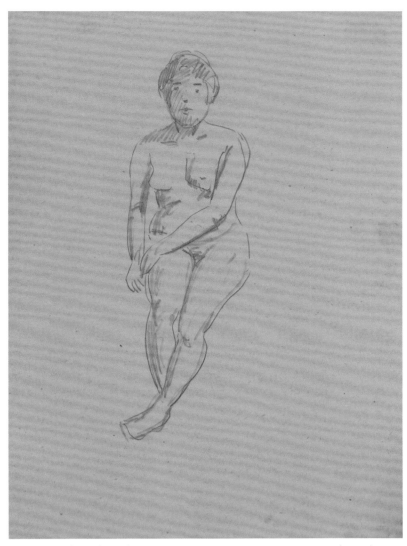

坐姿裸女速寫（159） Seated Female Nude Sketch（159）

約1927-1929　紙本鉛筆　33.2×24.1cm

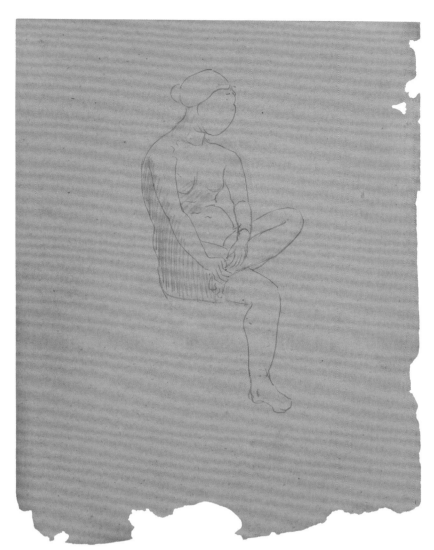

坐姿裸女速寫（160） Seated Female Nude Sketch（160）

約1927-1929　紙本鉛筆　33.2×23.8cm

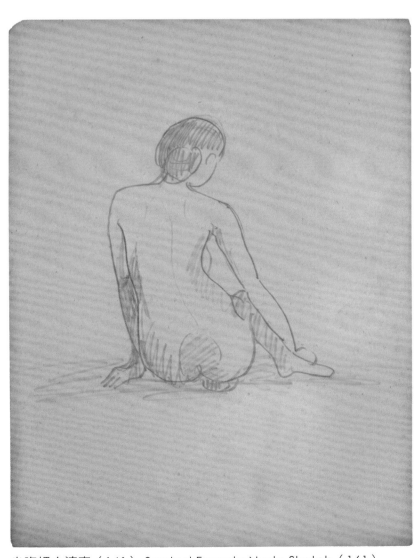

坐姿裸女速寫（161） Seated Female Nude Sketch（161）

約1927-1929　紙本鉛筆　33.2×24.5cm

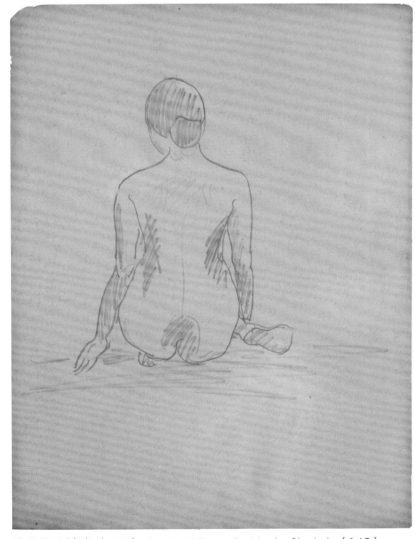

坐姿裸女速寫（162） Seated Female Nude Sketch（162）

約1927-1929　紙本鉛筆　33.1×24.5cm

坐姿裸女速寫（163）Seated Female Nude Sketch（163）

約1927-1929　紙本鉛筆　33×24.3cm

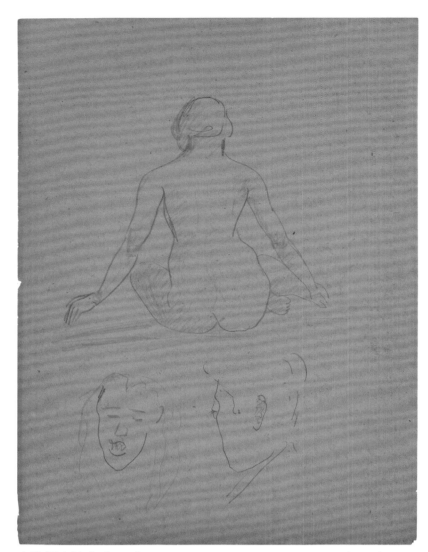

坐姿裸女速寫（164）Seated Female Nude Sketch（164）

約1927-1929　紙本鉛筆　32.9×24.3cm

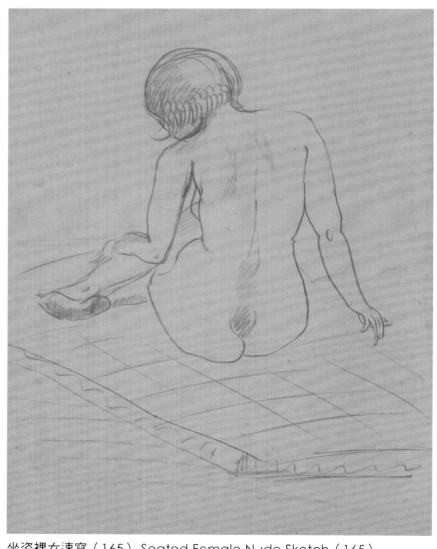

坐姿裸女速寫（165）Seated Female Nude Sketch（165）

約1927-1929　紙本鉛筆　31.9×25.2cm

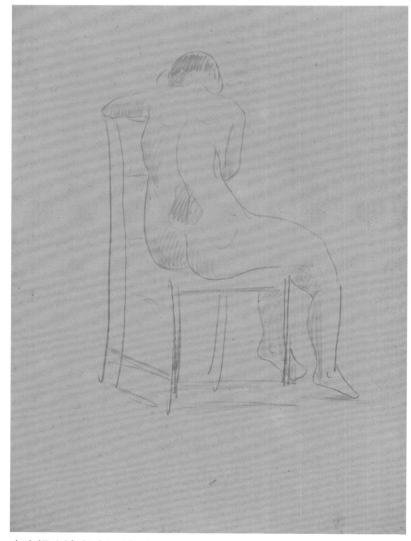

坐姿裸女速寫（166）Seated Female Nude Sketch（166）

約1927-1929　紙本鉛筆　33.2×24.2cm

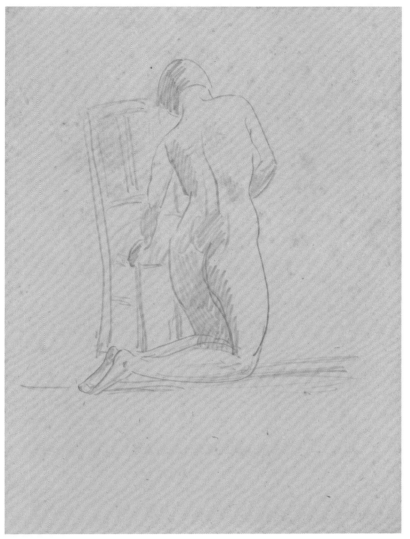

跪姿裸女速寫（13） Kneeling Female Nude Sketch（13）

約1927-1929　紙本鉛筆　33.2×24.3cm

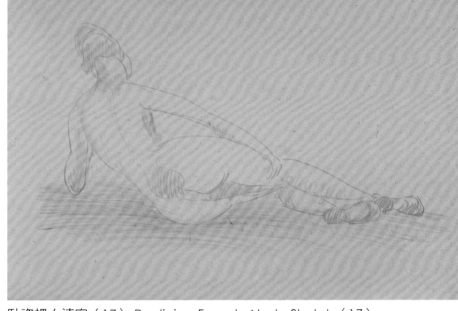

臥姿裸女速寫（17） Reclining Female Nude Sketch（17）

約1927-1929　紙本鉛筆　24.6×33.3cm

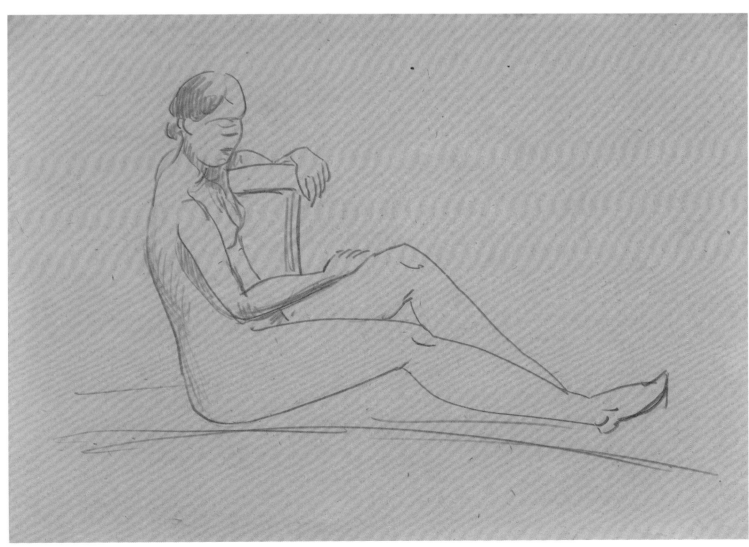

坐姿裸女速寫（167） Seated Female Nude Sketch（167）

約1927-1929　紙本鉛筆　24.5×33.2cm

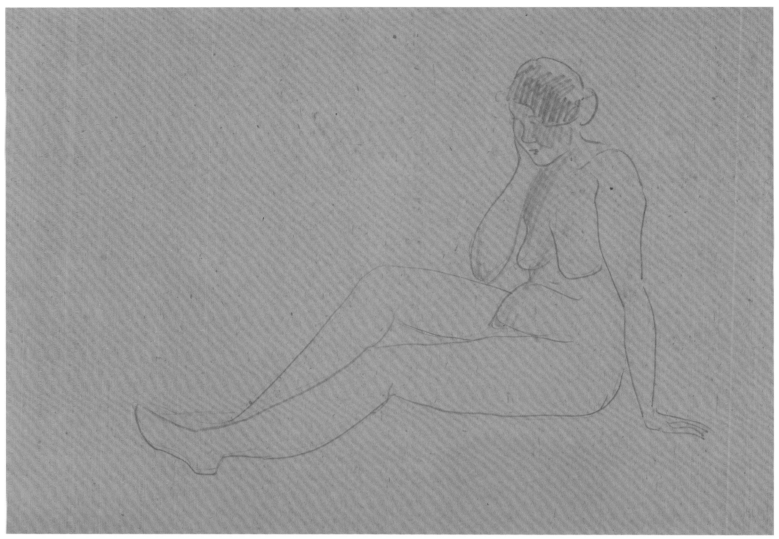

坐姿裸女速寫（168）Seated Female Nude Sketch（168）

約1927-1929　紙本鉛筆　23.7×33.2cm

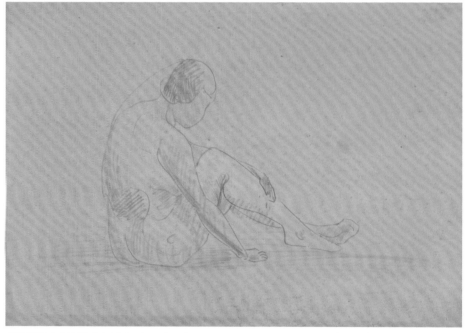

坐姿裸女速寫（169）Seated Female Nude Sketch（169）

約1927-1929　紙本鉛筆　24.6×33.1cm

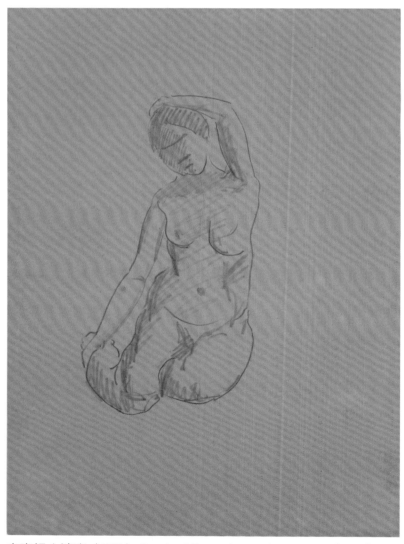

坐姿裸女速寫（170）Seated Female Nude Sketch（170）

約1927-1929　紙本鉛筆　33.2×24cm

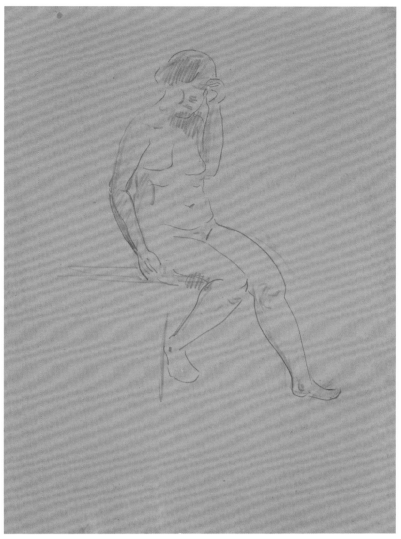

坐姿裸女速寫（171） Seated Female Nude Sketch（171）

約1927-1929　紙本鉛筆　33.3×24cm

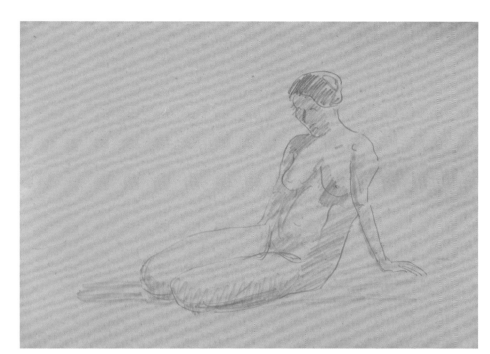

坐姿裸女速寫（172） Seated Female Nude Sketch（172）

約1927-1929　紙本鉛筆　24.6×33.1cm

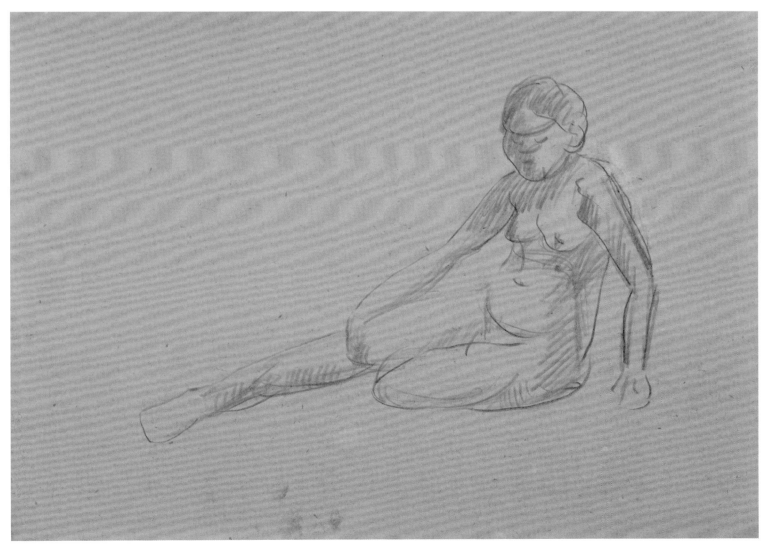

坐姿裸女速寫（173） Seated Female Nude Sketch（173）

約1927-1929　紙本鉛筆　24.2×33.1cm

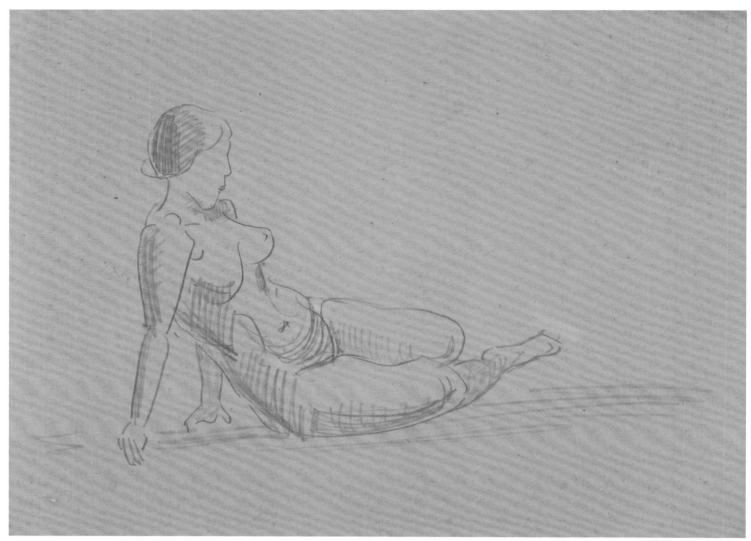

坐姿裸女速寫（174） Seated Female Nude Sketch（174）
約1927-1929　紙本鉛筆　24.7×33cm

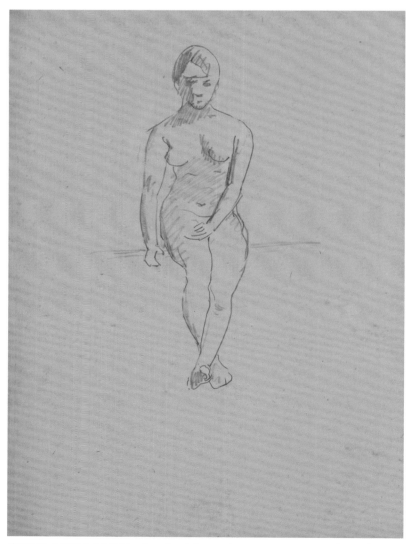

坐姿裸女速寫（175） Seated Female Nude Sketch（175）
約1927-1929　紙本鉛筆　33.2×24 2cm

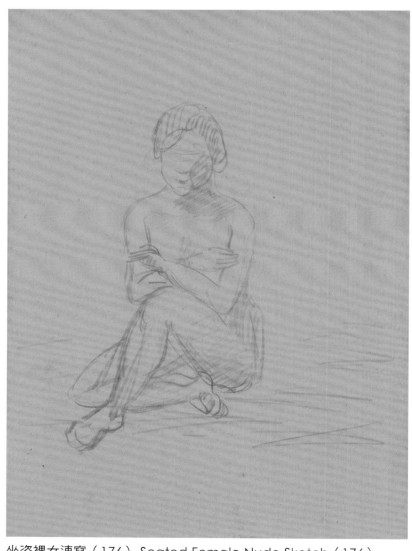

坐姿裸女速寫（176） Seated Female Nude Sketch（176）
約1927-1929　紙本鉛筆　33.3×24.6cm

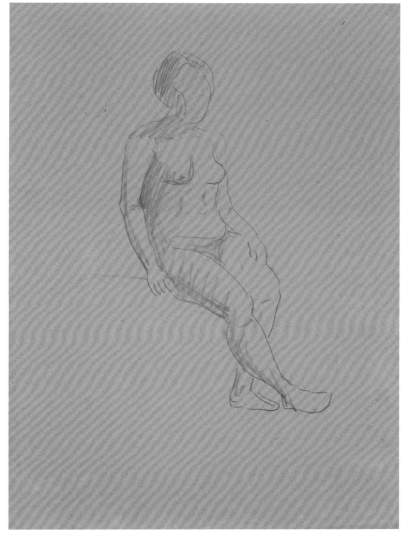

坐姿裸女速寫（177） Seated Female Nude Sketch（177）

約1927-1929　紙本鉛筆　33.3×24cm

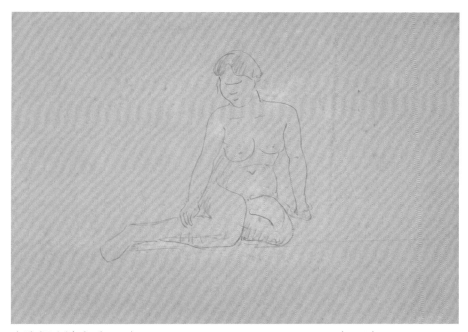

坐姿裸女速寫（178） Seated Female Nude Sketch（178）

約1927-1929　紙本鉛筆　24.1×33.3cm

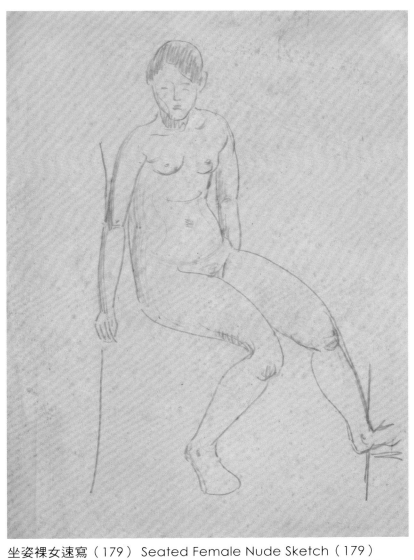

坐姿裸女速寫（179） Seated Female Nude Sketch（179）

約1927-1929　紙本鉛筆　33.2×24.7cm

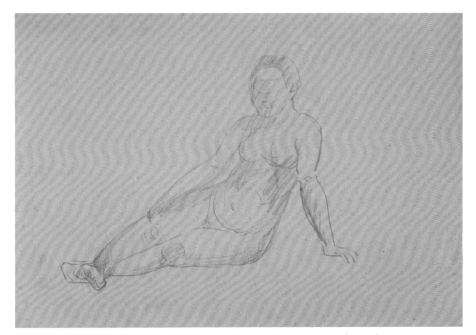

坐姿裸女速寫（180） Seated Female Nude Sketch（180）

約1927-1929　紙本鉛筆　24.2×33.2cm

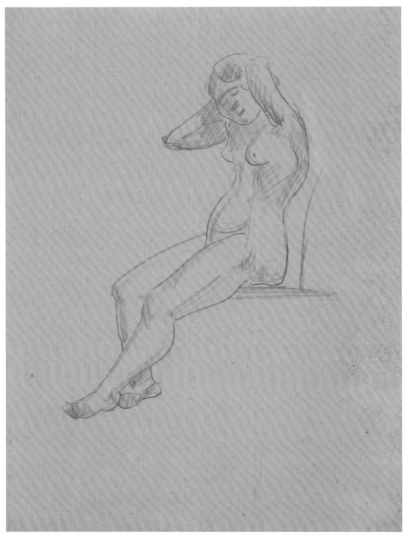

坐姿裸女速寫（181） Seated Female Nude Sketch（181）
約1927-1929　紙本鉛筆　33×24.2cm

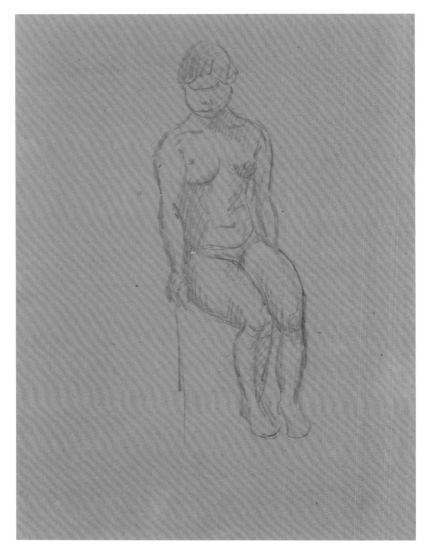

坐姿裸女速寫（182） Seated Female Nude Sketch（182）
約1927-1929　紙本鉛筆　33×24.5cm

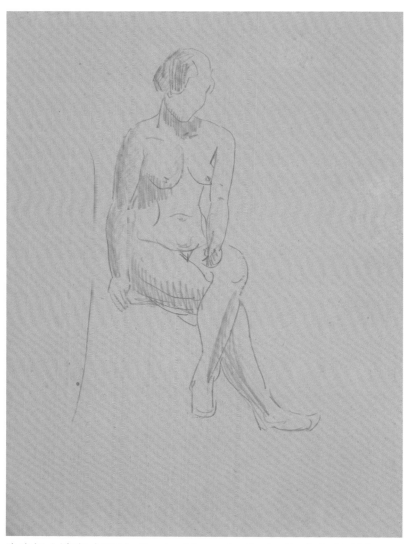

坐姿裸女速寫（183） Seated Female Nude Sketch（183）
約1927-1929　紙本鉛筆　33.2×24.7cm

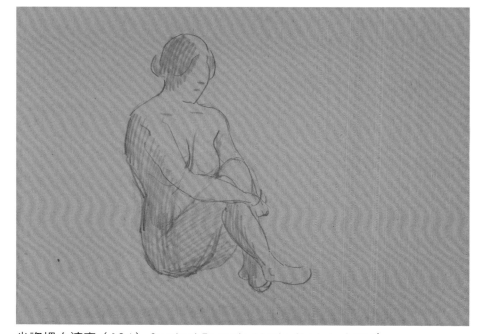

坐姿裸女速寫（184） Seated Female Nude Sketch（184）
約1927-1929　紙本鉛筆　23.9×33.2cm

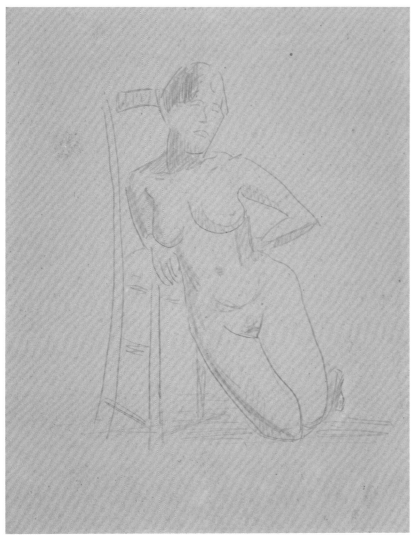

跪姿裸女速寫（14） Kneeling Female Nude Sketch（14）
約1927-1929　紙本鉛筆　33.1×24.7cm

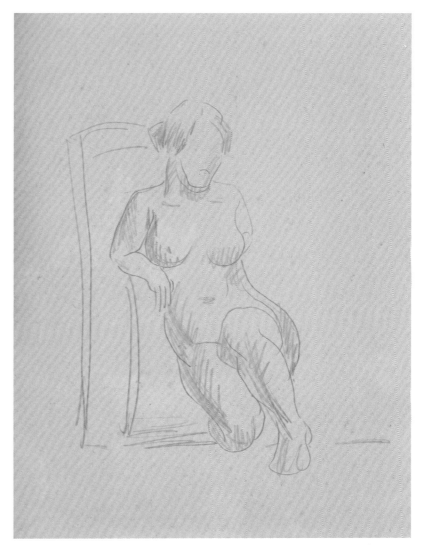

跪姿裸女速寫（15） Kneeling Female Nude Sketch（15）
約1927-1929　紙本鉛筆　33.2×24.2cm

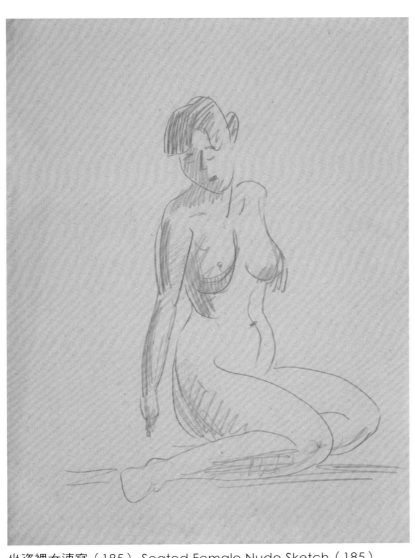

坐姿裸女速寫（185） Seated Female Nude Sketch（185）
約1927-1929　紙本鉛筆　33.2×24.6cm

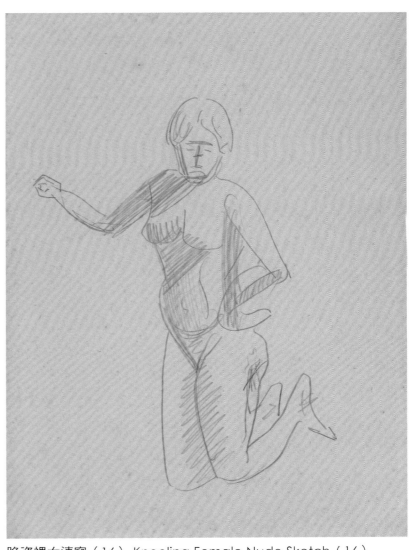

跪姿裸女速寫（16） Kneeling Female Nude Sketch（16）
約1927-1929　紙本鉛筆　33.2×24.7cm

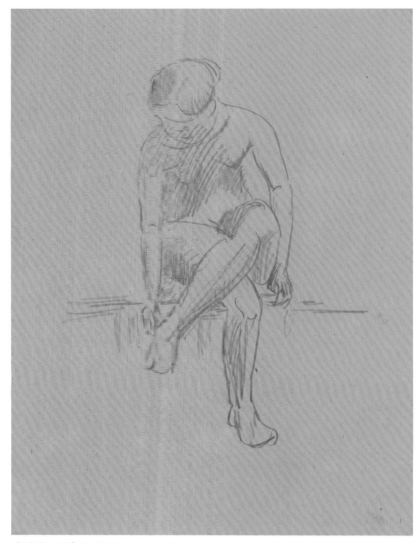

坐姿裸女速寫（186） Seated Female Nude Sketch（186）

約1927-1929　紙本鉛筆　33.1×24.7cm

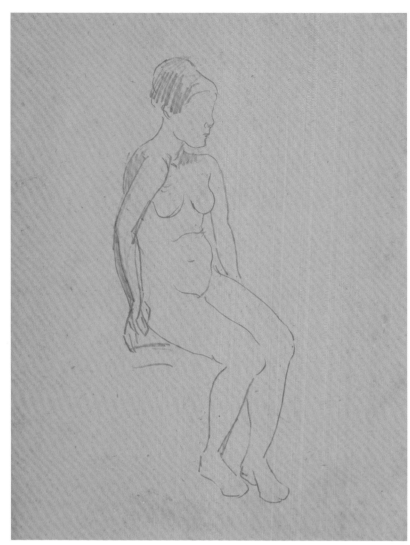

坐姿裸女速寫（187） Seated Female Nude Sketch（187）

約1927-1929　紙本鉛筆　33×24.2cm

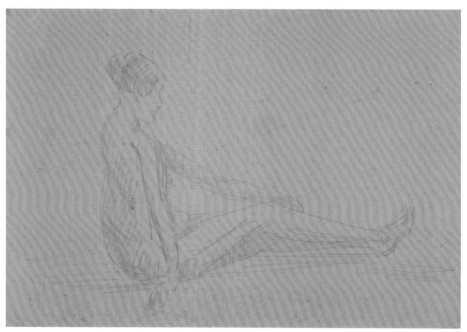

坐姿裸女速寫（188） Seated Female Nude Sketch（188）

約1927-1929　紙本鉛筆　24.1×33.3cm

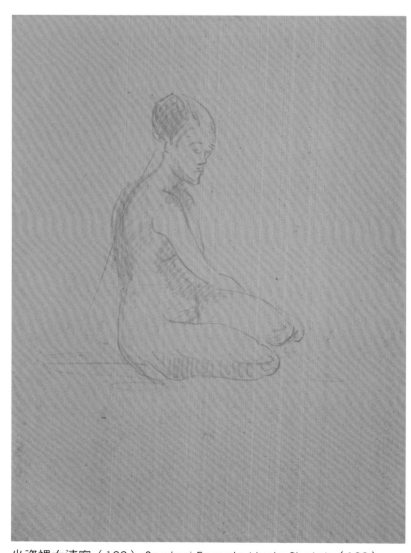

坐姿裸女速寫（189） Seated Female Nude Sketch（189）

約1927-1929　紙本鉛筆　33×24.2cm

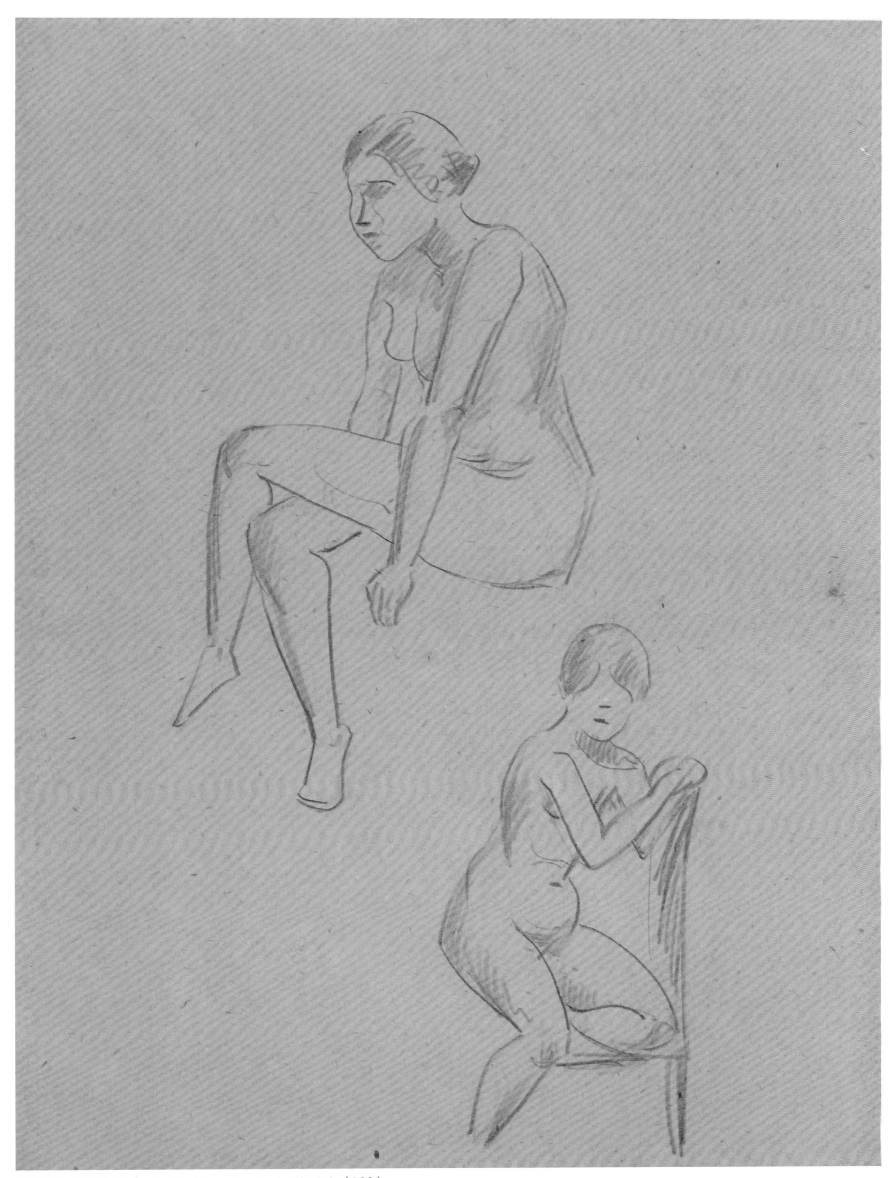

坐姿裸女速寫（190） Seated Female Nude Sketch（190）

約1927-1929　紙本鉛筆　33.1×24.3cm

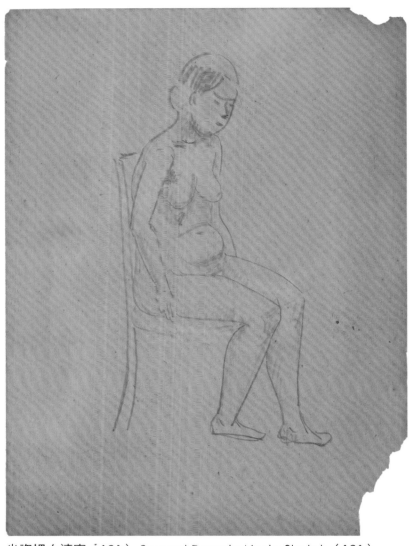

坐姿裸女速寫（191）Seated Female Nude Sketch（191）

約1927-1929　紙本鉛筆　33.2×24.6cm

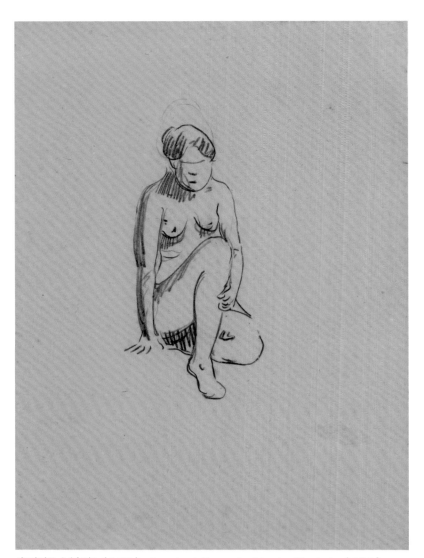

坐姿裸女速寫（192）Seated Female Nude Sketch（192）

約1927-1929　紙本鉛筆　33.2×24.1cm

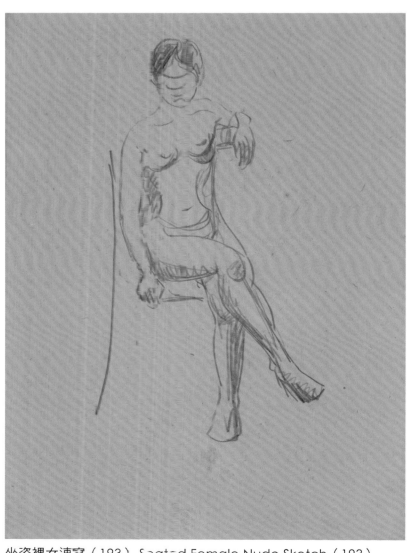

坐姿裸女速寫（193）Seated Female Nude Sketch（193）

約1927-1929　紙本鉛筆　33.2×24.6cm

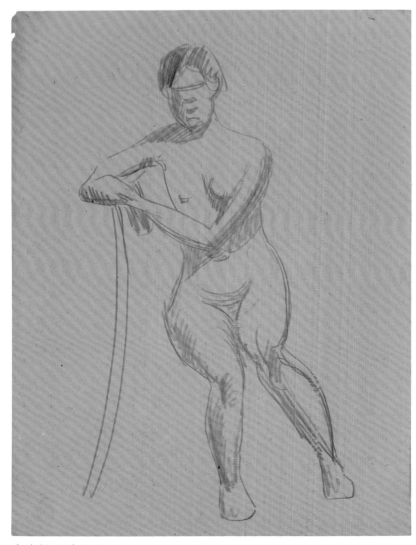

坐姿裸女速寫（194）Seated Female Nude Sketch（194）

約1927-1929　紙本鉛筆　33.2×24.7cm

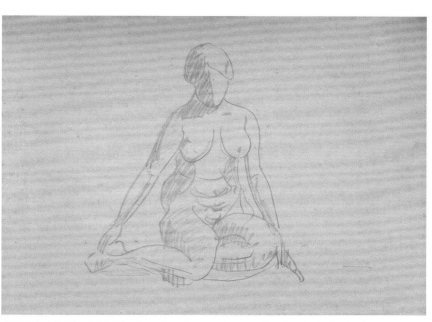

坐姿裸女速寫（195）Seated Female Nude Sketch（195）

約1927-1929　紙本鉛筆　24.3×33.3cm

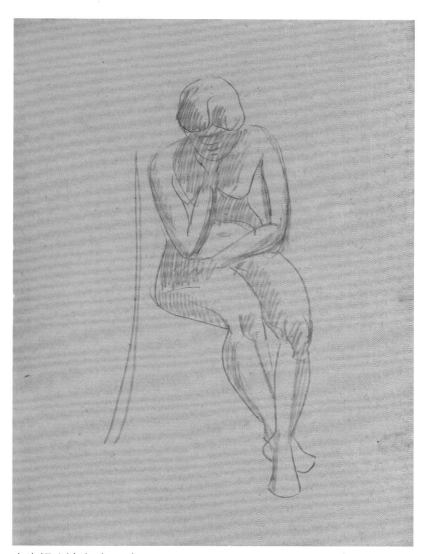

坐姿裸女速寫（196）Seated Female Nude Sketch（196）

約1927-1929　紙本鉛筆　33.2×24.7cm

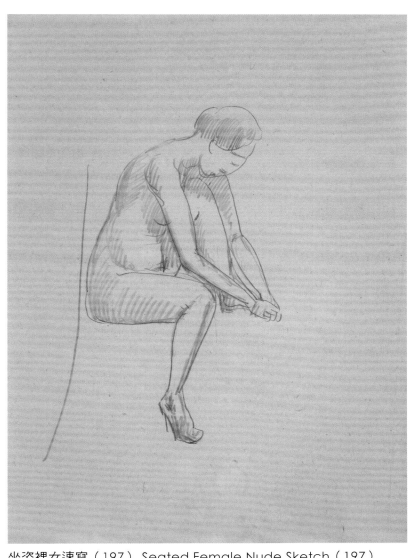

坐姿裸女速寫（197）Seated Female Nude Sketch（197）

約1927-1929　紙本鉛筆　33.3×24.6cm

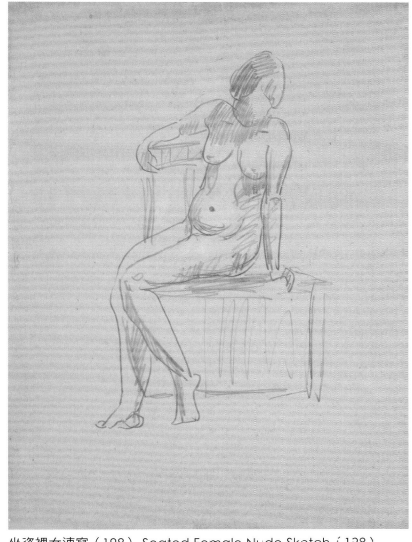

坐姿裸女速寫（198）Seated Female Nude Sketch（198）

約1927-1929　紙本鉛筆　33.2×24.6cm

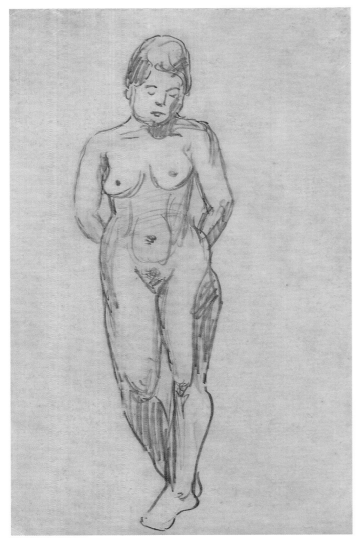

立姿裸女速寫（195）
Standing Female Nude Sketch（195）

約1927-1929　紙本鉛筆　24×16.8cm

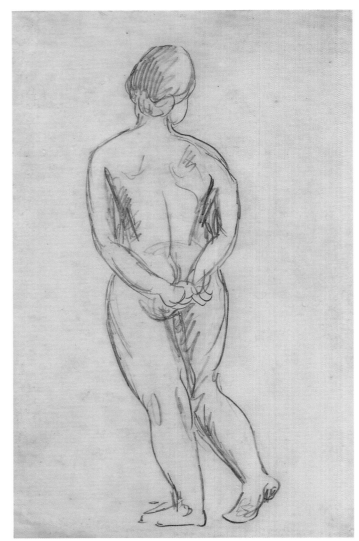

立姿裸女速寫（196）
Standing Female Nude Sketch（196）

約1927-1929　紙本鉛筆　21.5×13.7cm

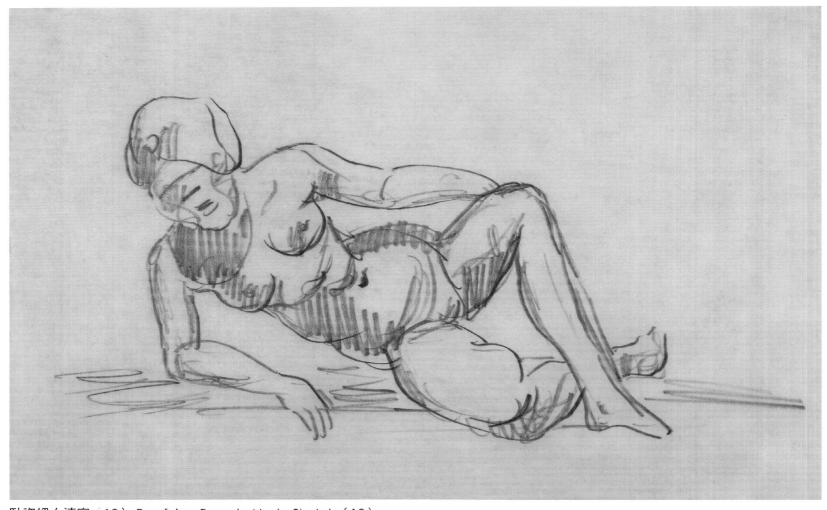

臥姿裸女速寫（18）　Reclining Female Nude Sketch（18）

約1927-1929　紙本鉛筆　13.7×21.7cm

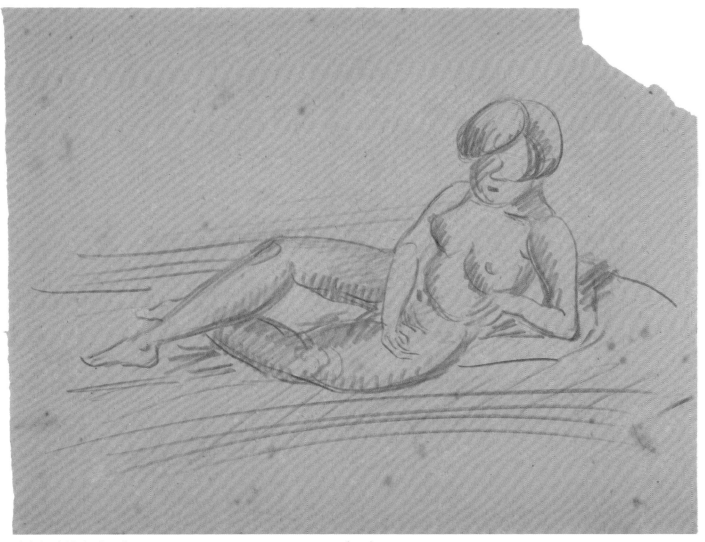

臥姿裸女速寫（19） Reclining Female Nude Sketch（19）

約1927-1929　紙本鉛筆　21.4×27.2cm

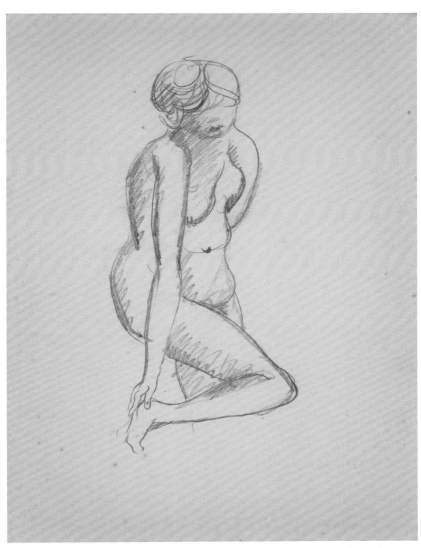

立姿裸女速寫（197） Standing Female Nude Sketch（197）

約1927-1929　紙本鉛筆　38.3×29.1cm

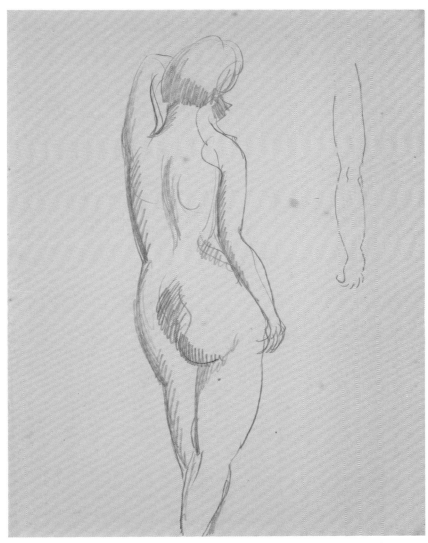

立姿裸女速寫（198） Standing Female Nude Sketch（198）

約1927-1929　紙本鉛筆　38.1×29.2cm

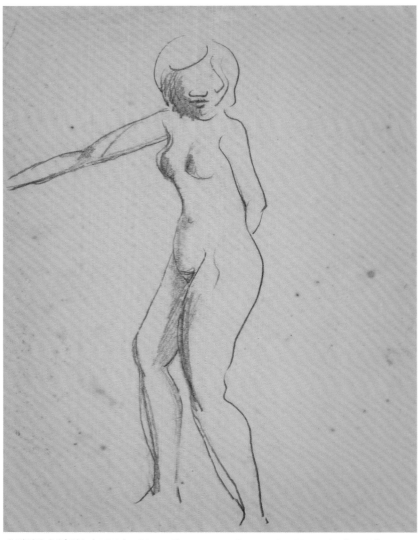

立姿裸女速寫（199） Standing Female Nude Sketch（199）

約1927-1929　紙本鉛筆　38.4×29.1cm

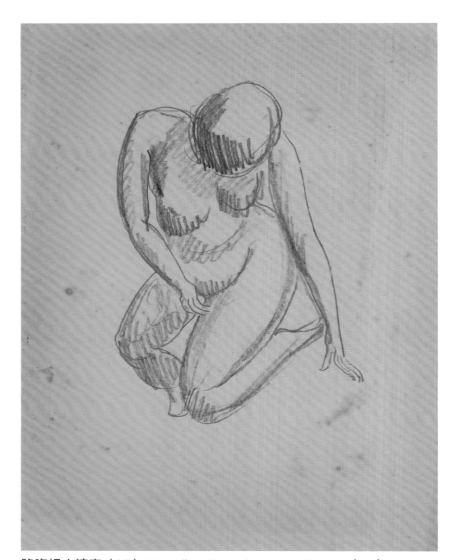

跪姿裸女速寫（17） Kneeling Female Nude Sketch（17）

約1927-1929　紙本鉛筆　38.4×29.1cm
※為前一張之背面圖。

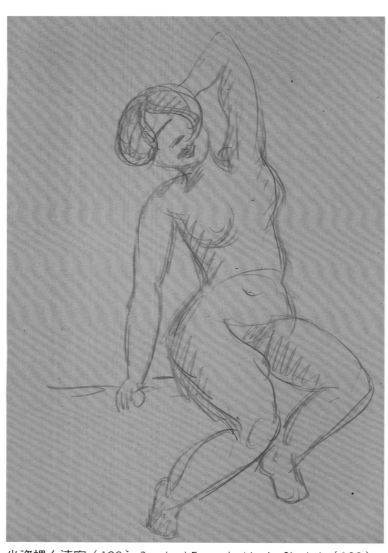

坐姿裸女速寫（199） Seated Female Nude Sketch（199）

約1927-1929　紙本鉛筆　39.1×27.2cm

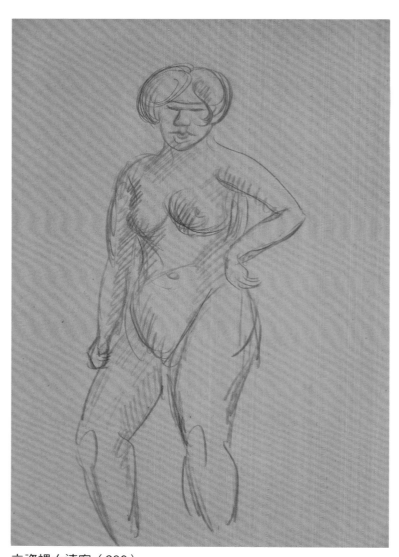

立姿裸女速寫（200）
Standing Female Nude Sketch（200）

約1927-1929　紙本鉛筆　39.3×27.5cm

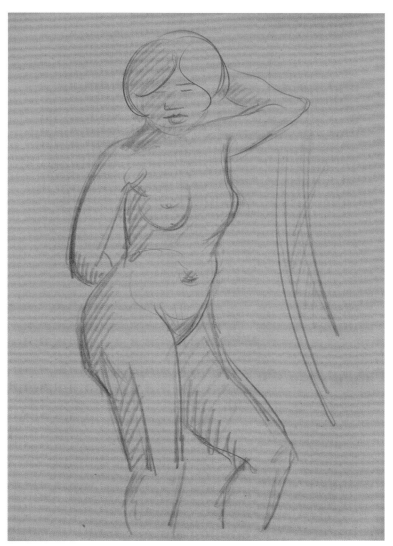

立姿裸女速寫（201）
Standing Female Nude Sketch（201）

約1927-1929　紙本鉛筆　39.4×27cm

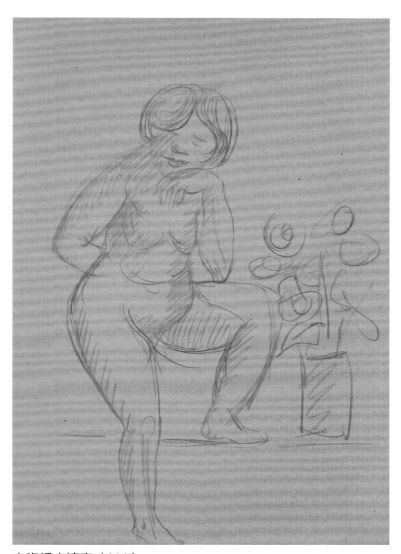

立姿裸女速寫（202）
Standing Female Nude Sketch（202）

約1927-1929　紙本鉛筆　39.1×27.2cm

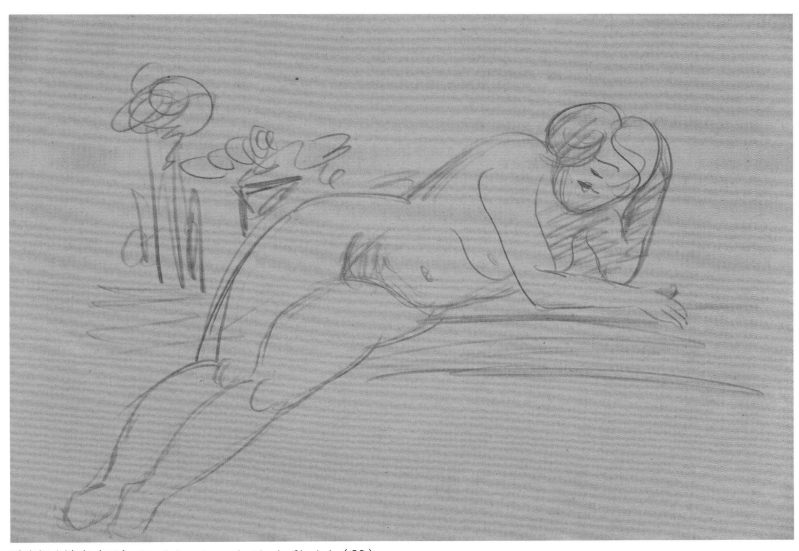

臥姿裸女速寫（20）　Reclining Female Nude Sketch（20）

約1927-1929　紙本鉛筆　27×39cm

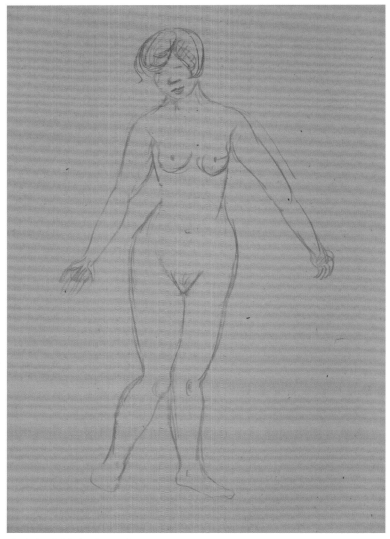

立姿裸女速寫（203）
Standing Female Nude Sketch（203）

約1927-1929　紙本鉛筆　39.2×27.2cm

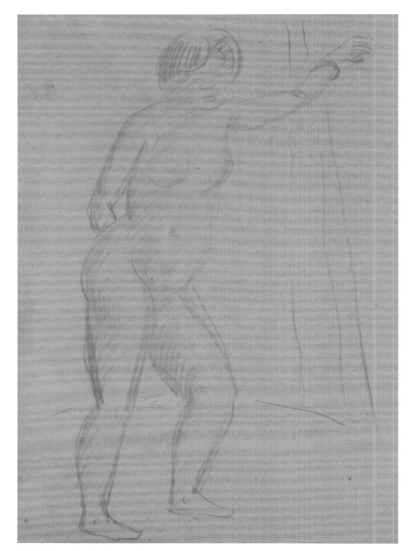

立姿裸女速寫（204）
Standing Female Nude Sketch（204）

約1927-1929　紙本鉛筆　31.7×22.5cm

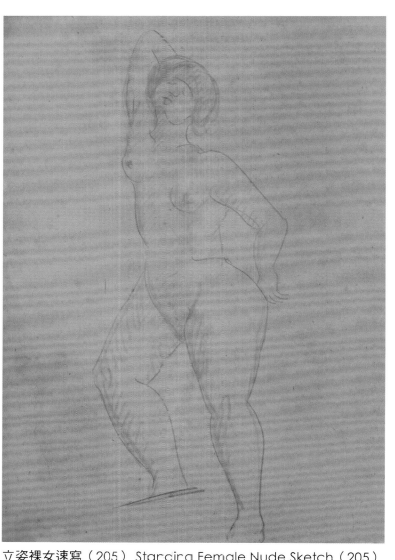

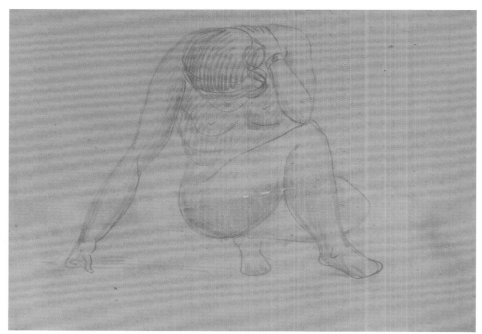

蹲姿裸女速寫（14）　Squatting Female Nude Sketch（14）

約1927-1929　紙本鉛筆　22.5×31.5cm

立姿裸女速寫（205）　Standing Female Nude Sketch（205）

約1927-1929　紙本鉛筆　31.4×22.6cm

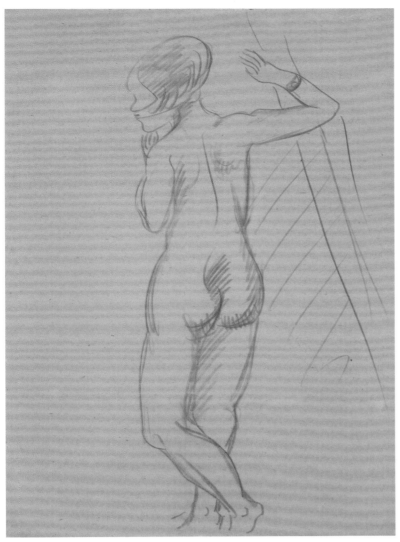

立姿裸女速寫（206）Standing Female Nude Sketch（206）

約1927-1929　紙本鉛筆　36.5×26.4cm

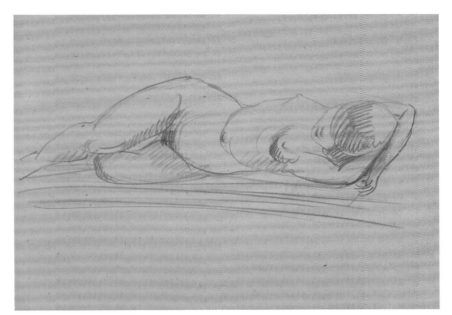

臥姿裸女速寫（21）Reclining Female Nude Sketch（21）

約1927-1929　紙本鉛筆　26.5×36.1cm

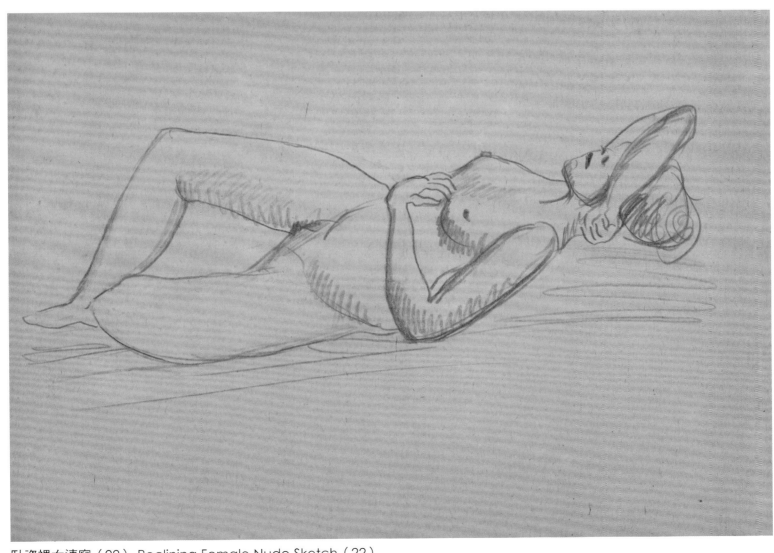

臥姿裸女速寫（22）Reclining Female Nude Sketch（22）

約1927-1929　紙本鉛筆　26.3×36.5cm

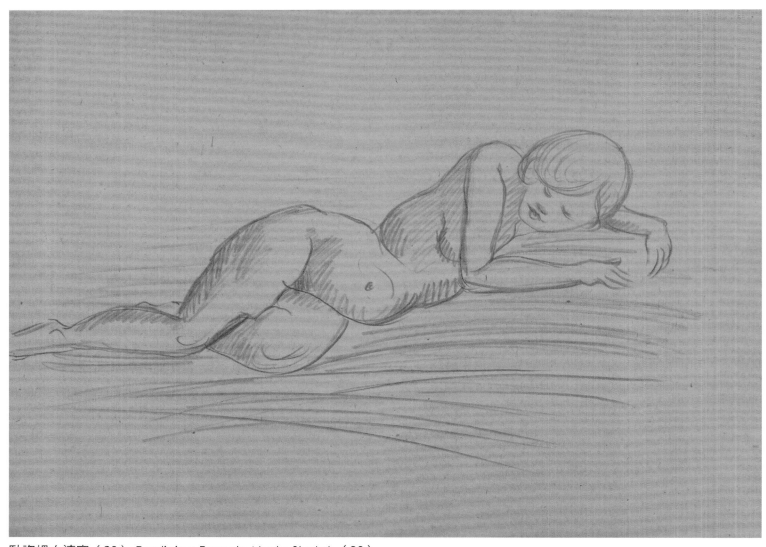

臥姿裸女速寫（23） Reclining Female Nude Sketch（23）
約1927-1929　紙本鉛筆　26.5×36.5cm

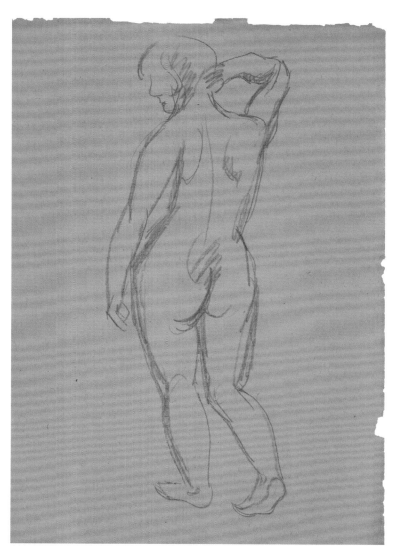

立姿裸女速寫（207）
Standing Female Nude Sketch（207）
約1927-1929　紙本鉛筆　39.4×27cm

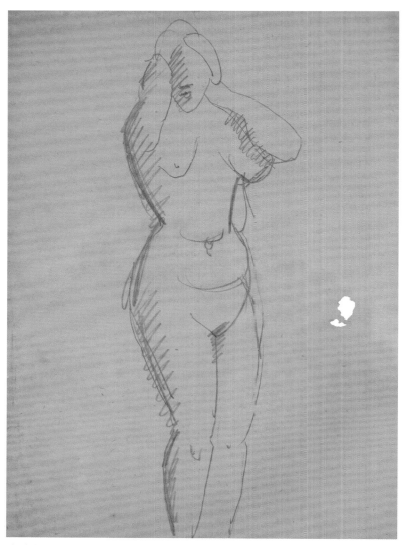

立姿裸女速寫（208） Standing Female Nude Sketch（208）
約1927-1929　紙本鉛筆　37.3×27.3cm

女體速寫（15） Female Body Sketch（15）

約1927-1929　紙本鉛筆　37.2×27.5cm

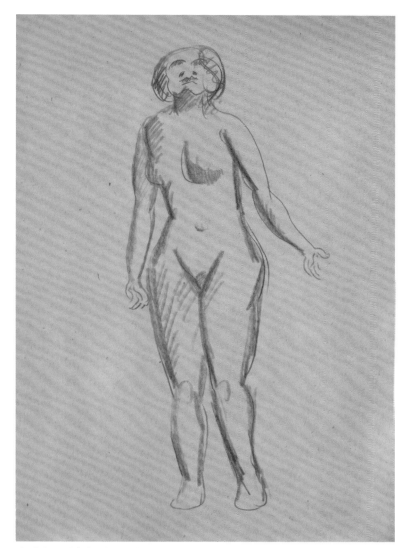

立姿裸女速寫（209） Standing Female Nude Sketch（209）

約1927-1929　紙本鉛筆　38.8×27.1cm

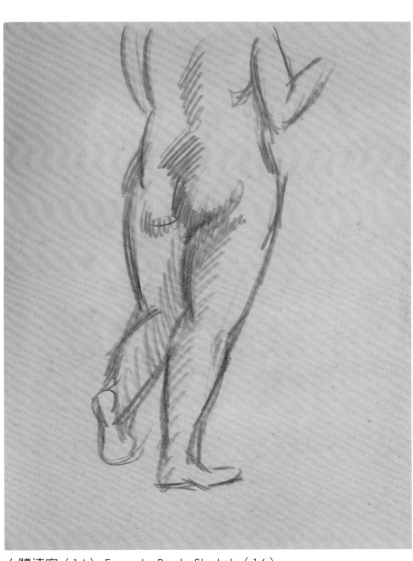

女體速寫（16） Female Body Sketch（16）

約1927-1929　紙本鉛筆　32×24cm

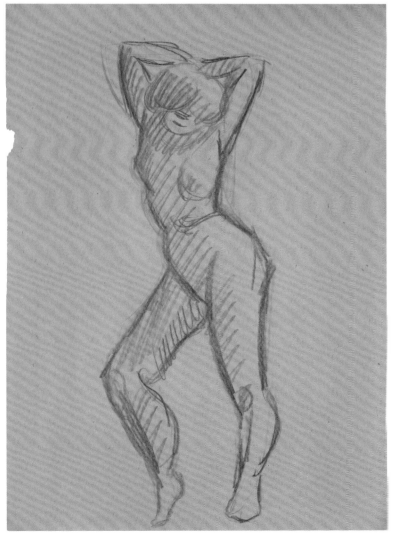

立姿裸女速寫（210） Standing Female Nude Sketch（210）

約1927-1929　紙本鉛筆　38.8×27.1cm

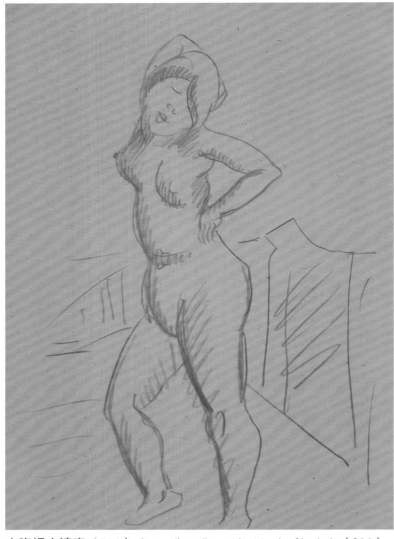

立姿裸女速寫（211） Standing Female Nude Sketch（211）

約1927-1929　紙本鉛筆　36.4×26.3cm

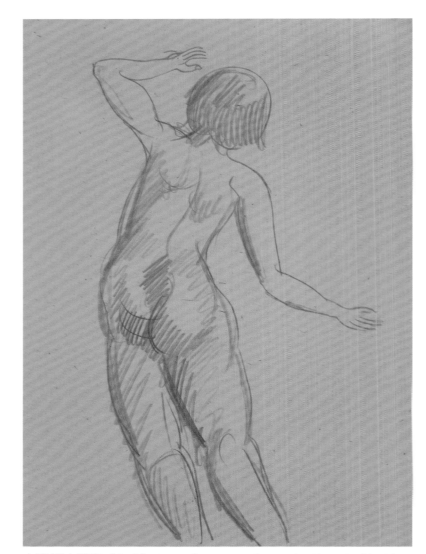

立姿裸女速寫（212） Standing Female Nude Sketch（212）

約1927-1929　紙本鉛筆　36.5×26.2cm

人物速寫（9） Figure Sketch（9）

約1927-1929　紙本鉛筆　24.2×33cm

人物速寫（8） Figure Sketch（8）

約1927-1929　紙本鉛筆　33×24.3cm

人物速寫（10）Figure Sketch（10）

約1927-1929　紙本鉛筆　33.1×24.3cm

人物速寫（11）Figure Sketch（11）

約1927-1929　紙本鉛筆　33×24.2cm

人物速寫（12）Figure Sketch（12）

約1927-1929　紙本鉛筆　32.8×24.3cm

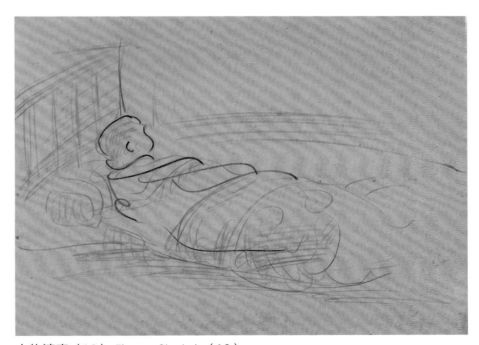

人物速寫（13）Figure Sketch（13）

約1927-1929　紙本鉛筆　24.2×33.1cm

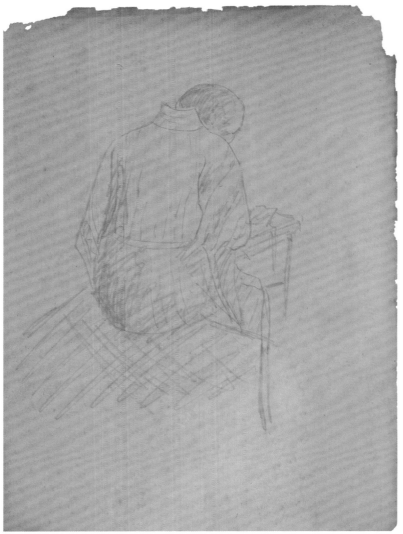

人物速寫（14）Figure Sketch（14）
約1927-1929　紙本鉛筆　33.2×24.6cm

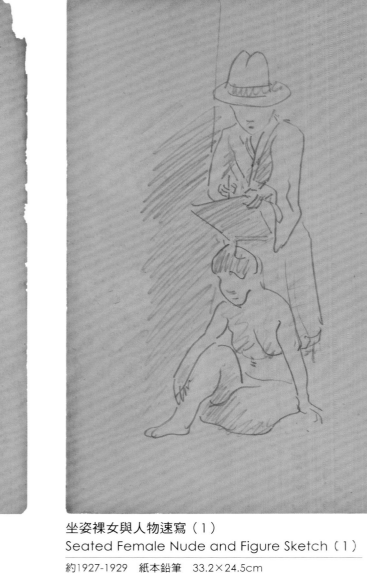

坐姿裸女與人物速寫（1）
Seated Female Nude and Figure Sketch（1）
約1927-1929　紙本鉛筆　33.2×24.5cm

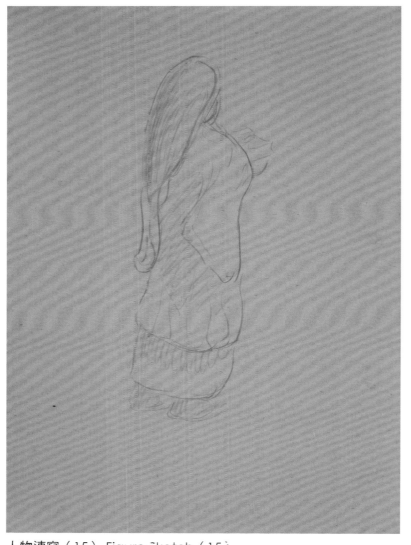

人物速寫（15）Figure Sketch（15）
約1927-1929　紙本鉛筆　33.5×24cm

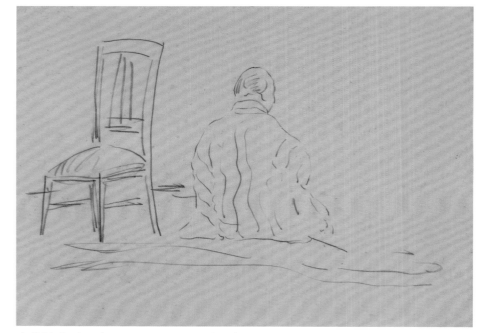

人物速寫（16）Figure Sketch（16）
約1927-1929　紙本鉛筆　24.1×33cm

174

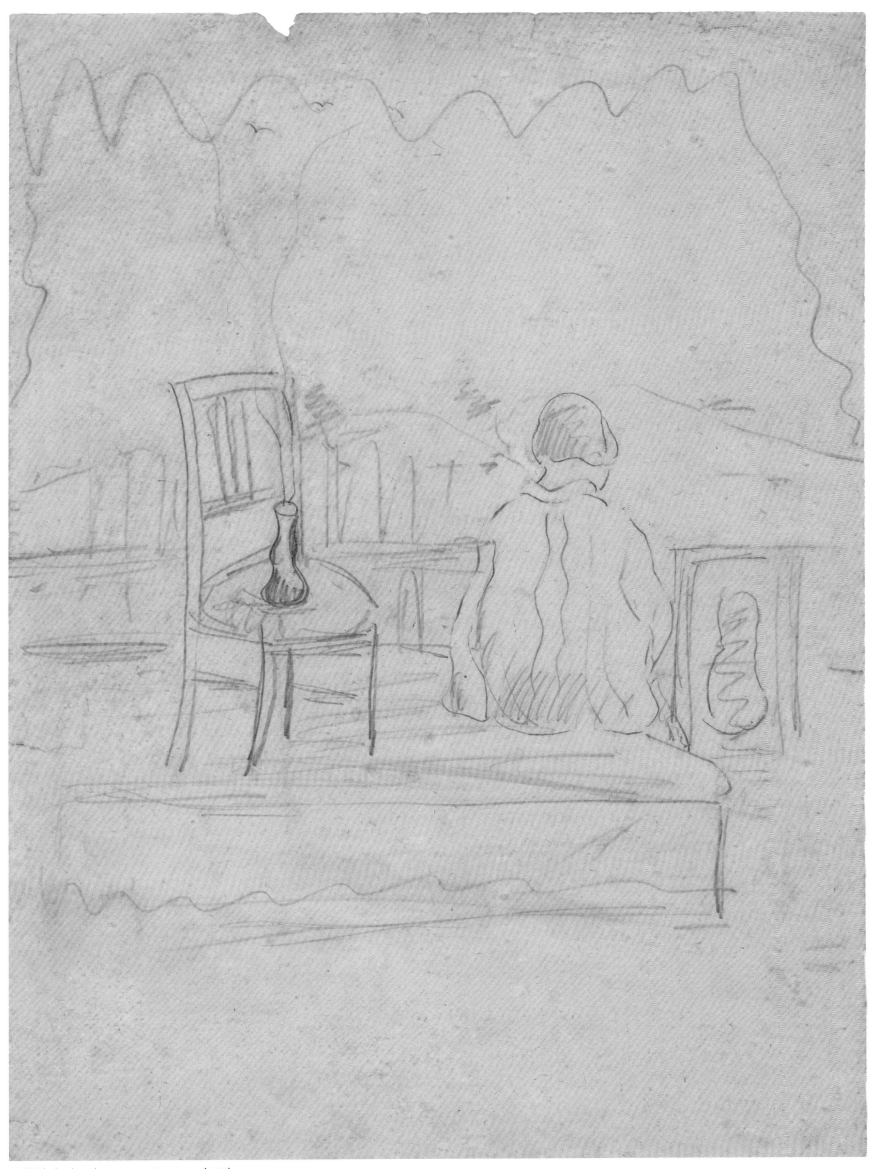

人物速寫（17）Figure Sketch（17）

約1927-1929　紙本鉛筆　33.3×24.1cm

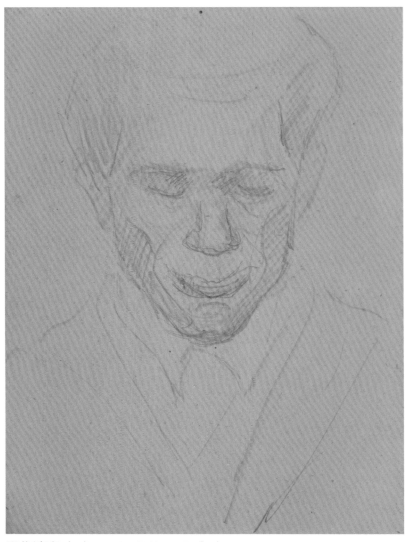

頭像速寫（6） Portrait Sketch（6）
約1927-1929　紙本鉛筆　33×24.2cm

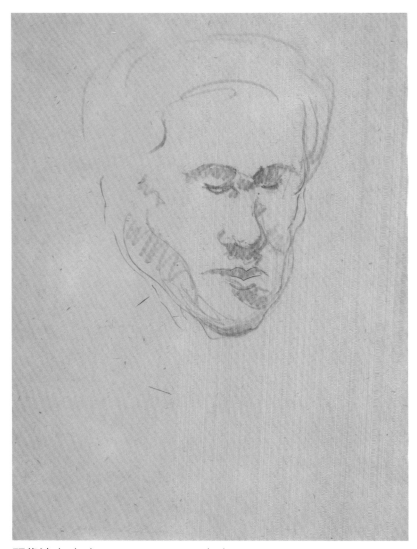

頭像速寫（7） Portrait Sketch（7）
約1927-1929　紙本鉛筆　33.2×24.2cm

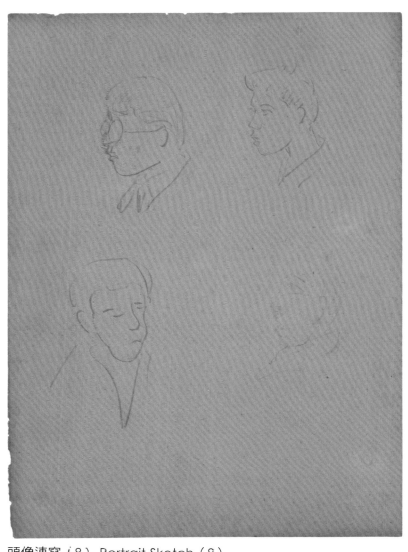

頭像速寫（8） Portrait Sketch（8）
約1927-1929　紙本鉛筆　32.9×23.8cm

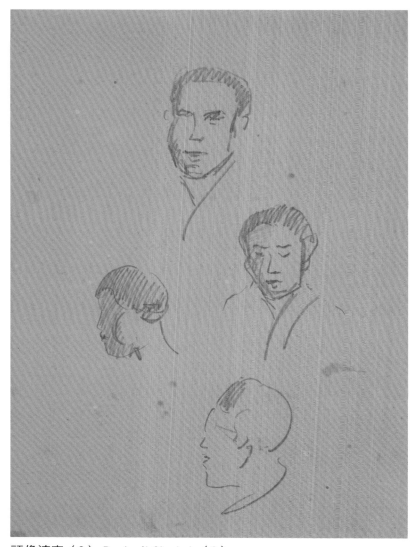

頭像速寫（9） Portrait Sketch（9）
約1927-1929　紙本鉛筆　33.2×24.2cm

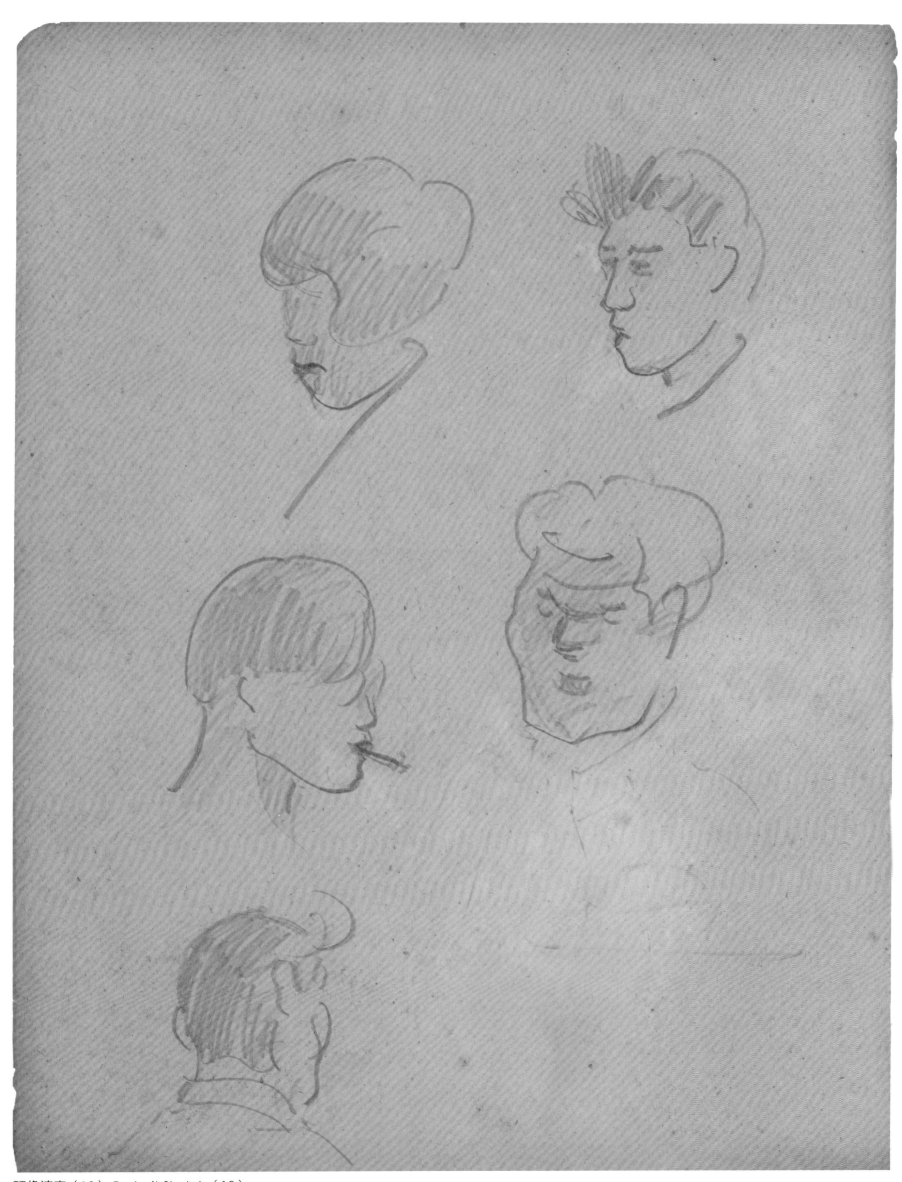

頭像速寫（10）Portrait Sketch（10）

約1927-1929　紙本鉛筆　33.1×24.7cm

頭像速寫（11） Portrait Sketch（11）

約1927-1929　紙本鉛筆　33.2×24.1cm

頭像速寫（12） Portrait Sketch（12）

約1927-1929　紙本鉛筆　33.4×24.3cm

頭像速寫（13） Portrait Sketch（13）

約1927-1929　紙本鉛筆　33.2×24.1cm

頭像速寫（14） Portrait Sketch（14）

約1927-1929　紙本鉛筆　33.1×24.5cm

頭像速寫（15）Portrait Sketch（15）

約1927-1929　紙本鉛筆　23.8×32.6cm

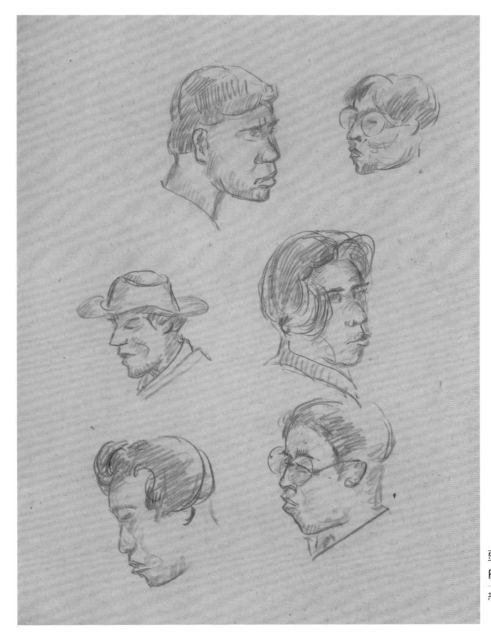

頭像速寫（16）
Portrait Sketch（16）

約1927-1929　紙本鉛筆　33.2×24.3cm

179

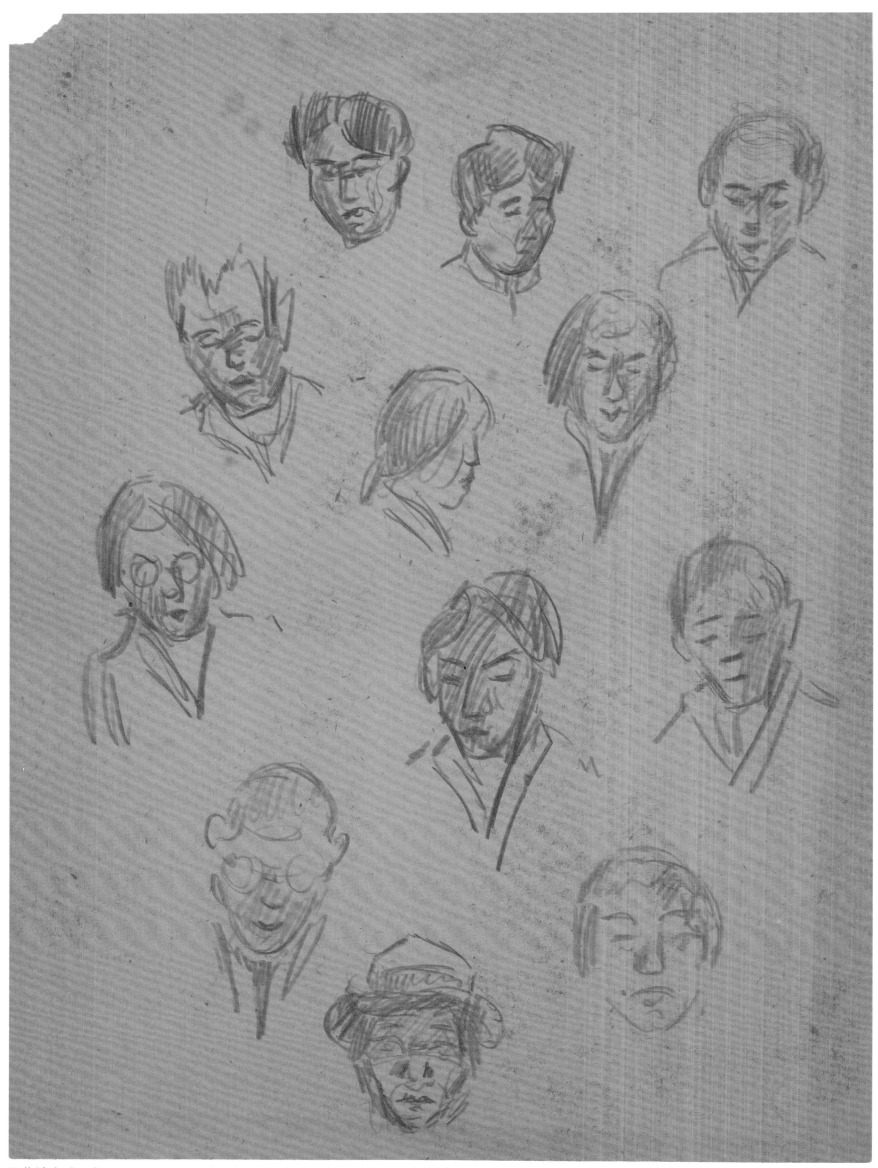

頭像速寫（17） Portrait Sketch（17）

約1927-1929　紙本鉛筆　33×24cm

速寫
Sketch

1928-1929

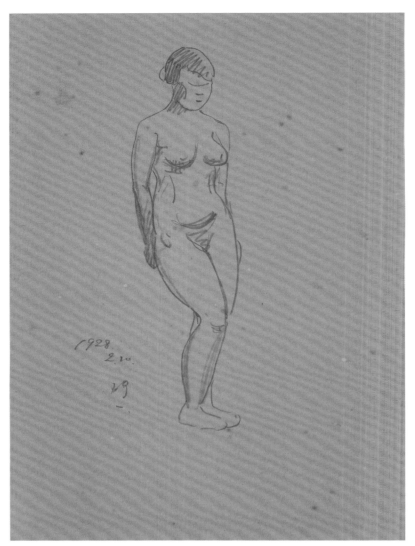

立姿裸女速寫-28.2.10（213）
Standing Female Nude Sketch-28.2.10（213）

1928　紙本鉛筆　33.3×24.1cm

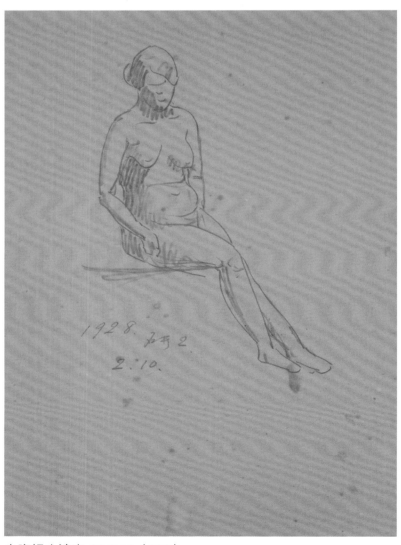

坐姿裸女速寫-28.2.10（200）
Seated Female Nude Sketch-28.2.10（200）

1928　紙本鉛筆　33.3×24.1cm

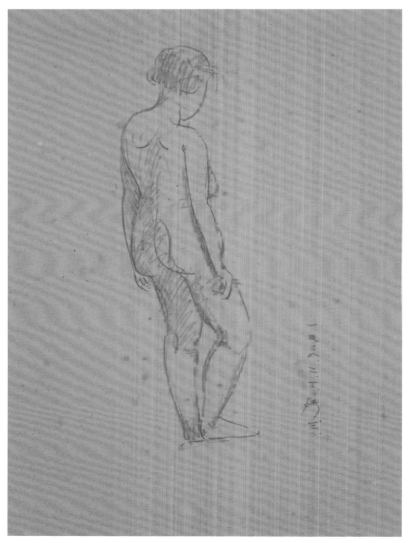

立姿裸女速寫-28.2.10（214）
Standing Female Nude Sketch-28.2.10（214）

1928　紙本鉛筆　33.4×24.1cm

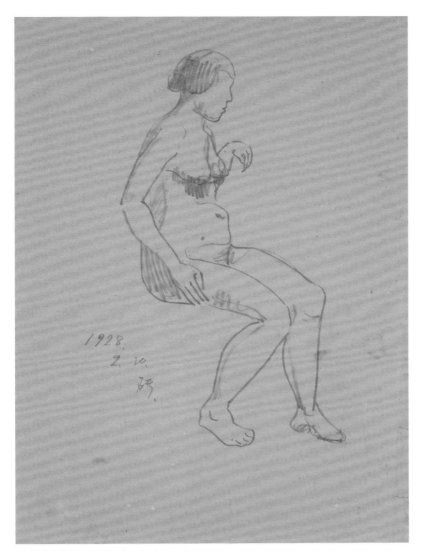

坐姿裸女速寫-28.2.10（201）
Seated Female Nude Sketch-28.2.10（201）

1928　紙本鉛筆　33.4×24.1cm

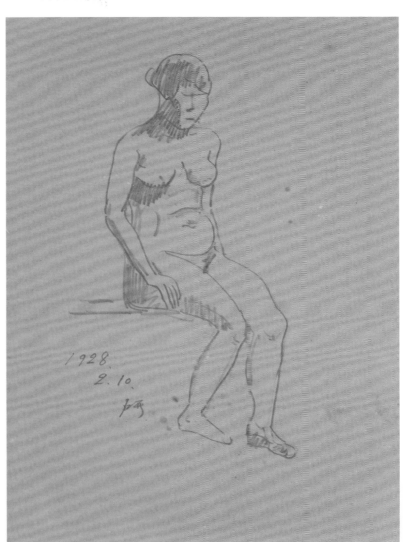

坐姿裸女速寫-28.2.10（202）
Seated Female Nude Sketch-28.2.10（202）

1928　紙本鉛筆　33.4×24cm

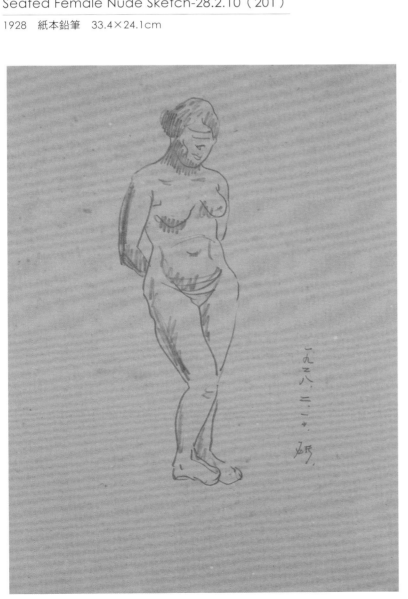

立姿裸女速寫-28.2.10（215）
Standing Female Nude Sketch-28.2.10（215）

1928　紙本鉛筆　33.4×24.1cm

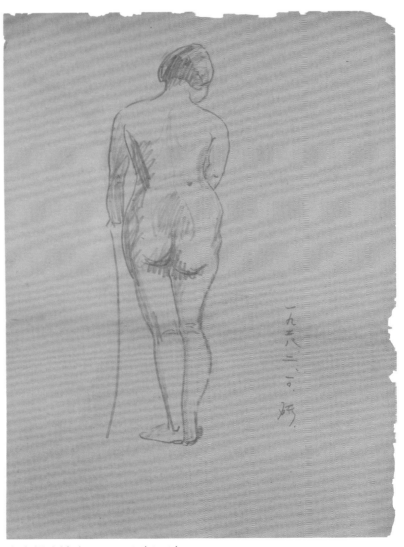

立姿裸女速寫-28.2.10（216）
Standing Female Nude Sketch-28.2.10（216）

1928　紙本鉛筆　33.5×24cm

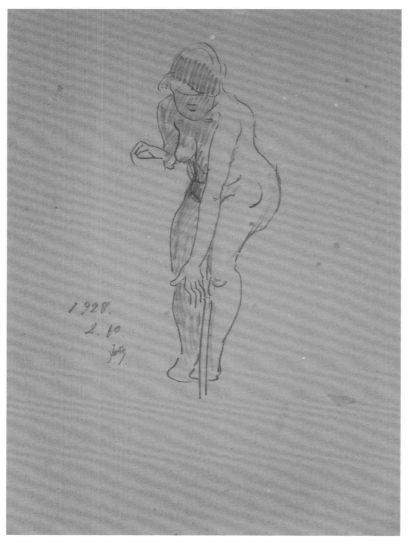

立姿裸女速寫-28.2.10（217）
Standing Female Nude Sketch-28.2.10（217）

1928　紙本鉛筆　33.3×24cm

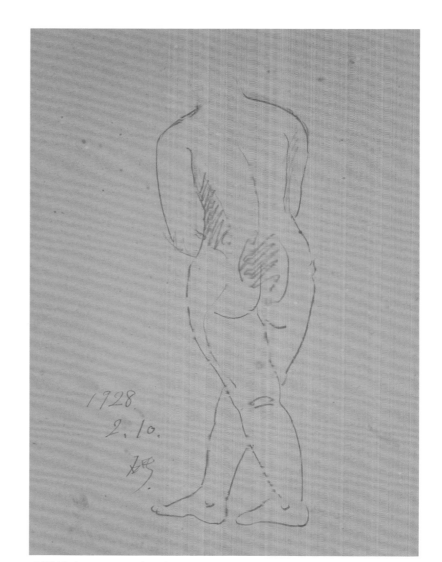

女體速寫-28.2.10（17）
Female Body Sketch-28.2.10（17

1928　紙本鉛筆　33.3×23.7cm

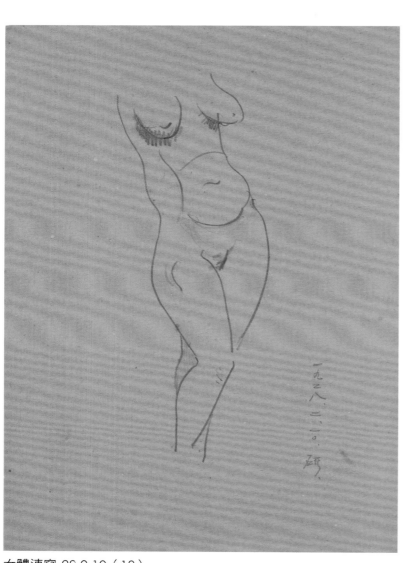

女體速寫-28.2.10（18）
Female Body Sketch-28.2.10（18）

1928　紙本鉛筆　33.3×24.1cm

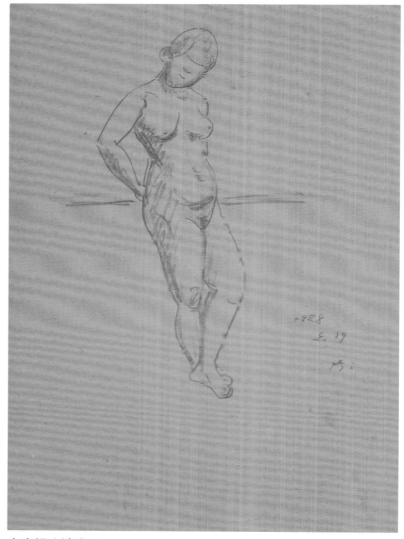

立姿裸女速寫-28.2.17（218）
Standing Female Nude Sketch-28.2.17（218）

1928　紙本鉛筆　33.2×24cm

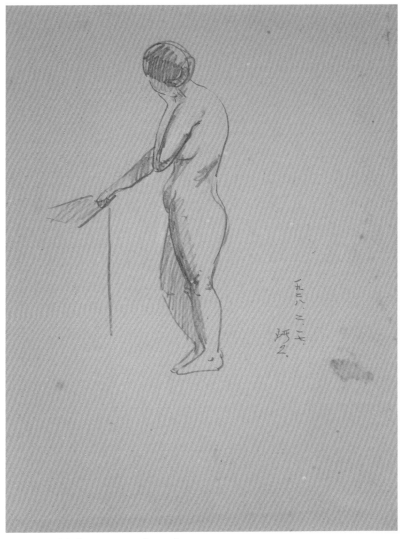

立姿裸女速寫-28.2.17（219）
Standing Female Nude Sketch-28.2.17（219）

1928　紙本鉛筆　33.2×24cm

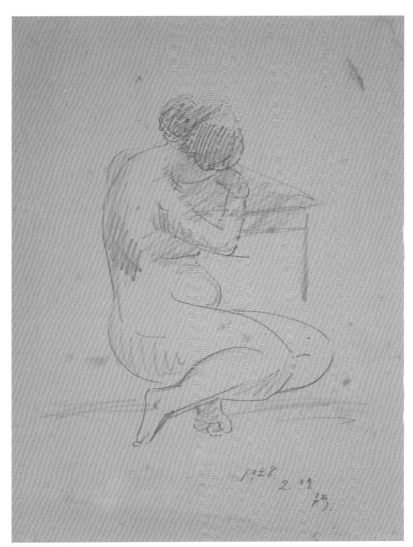

坐姿裸女速寫-28.2.17（203）
Seated Female Nude Sketch-28.2.17（203）

1928　紙本鉛筆　33.3×24cm

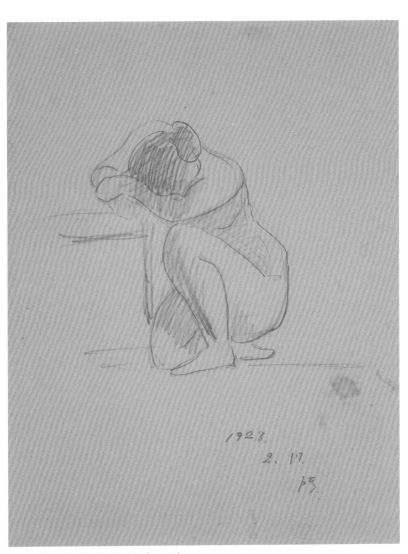

坐姿裸女速寫-28.2.17（204）
Seated Female Nude Sketch-28.2.17（204）

1928　紙本鉛筆　33.3×24cm

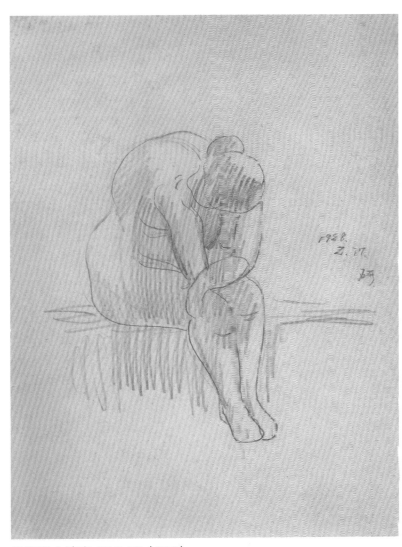

坐姿裸女速寫-28.2.17（205）
Seated Female Nude Sketch-28.2.17（205）

1928　紙本鉛筆　33.2×24cm

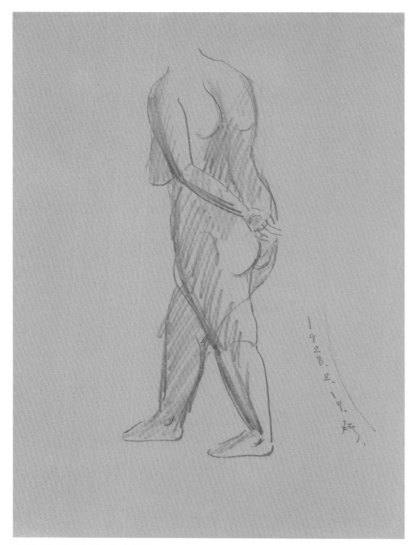

女體速寫-28.2.17（19）
Female Body Sketch-28.2.17（19）

1928　紙本鉛筆　34×24cm

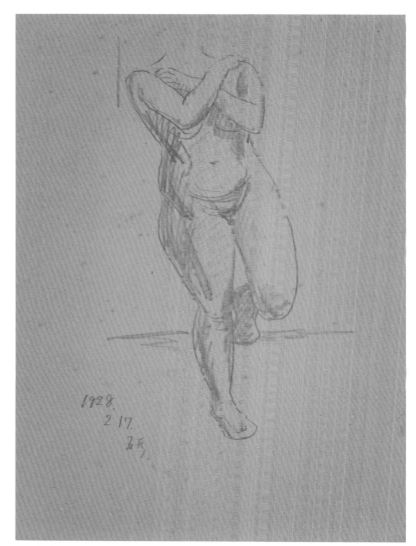

女體速寫-28.2.17（20）
Female Body Sketch-28.2.17（20）

1928　紙本鉛筆　33.3×24cm

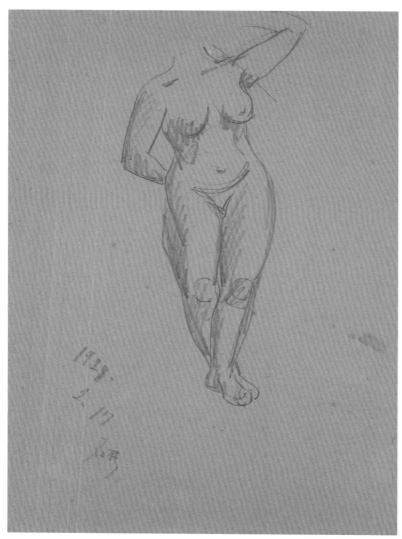

女體速寫-28.2.17（21）
Female Body Sketch-28.2.17（21）

1928　紙本鉛筆　33.3×24cm

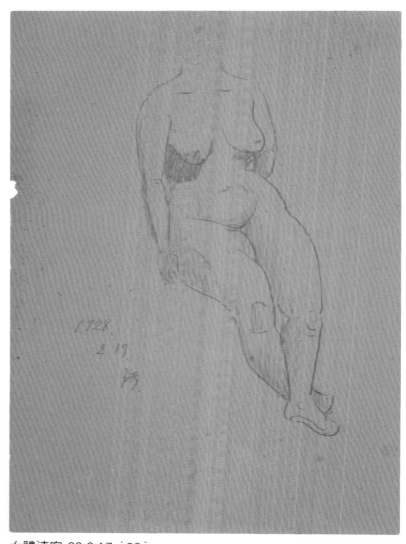

女體速寫-28.2.17（22）
Female Body Sketch-28.2.17（22）

1928　紙本鉛筆　33.4×24.1cm

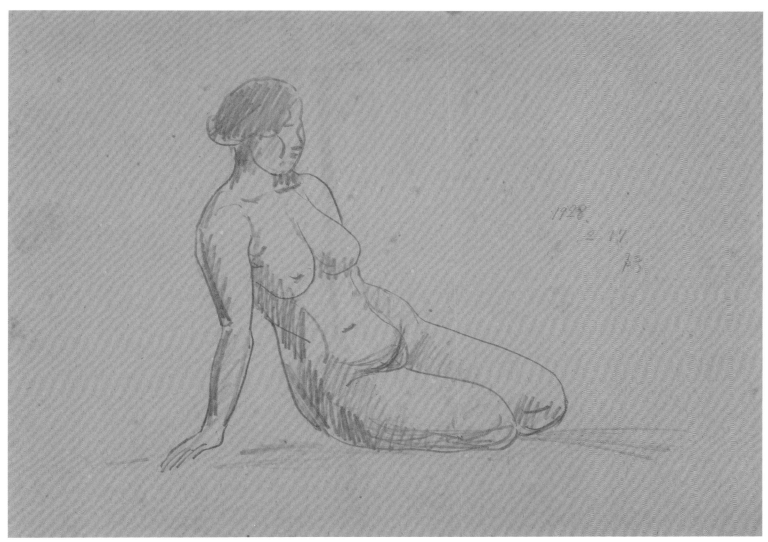

坐姿裸女速寫-28.2.17（206） Seated Female Nude Sketch-28.2.17（206）

1928 紙本鉛筆 24×33.3cm

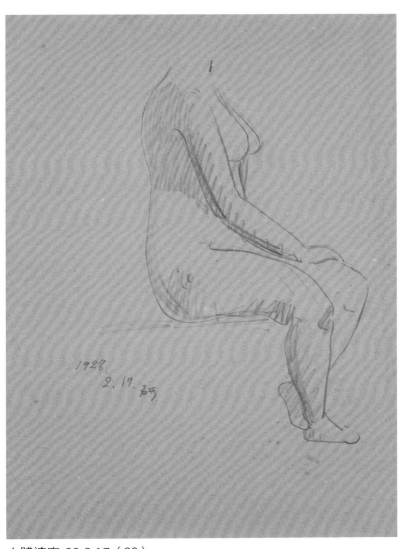

女體速寫-28.2.17（23）
Female Body Sketch-28.2.17（23）

1928 紙本鉛筆 33.4×24.1cm

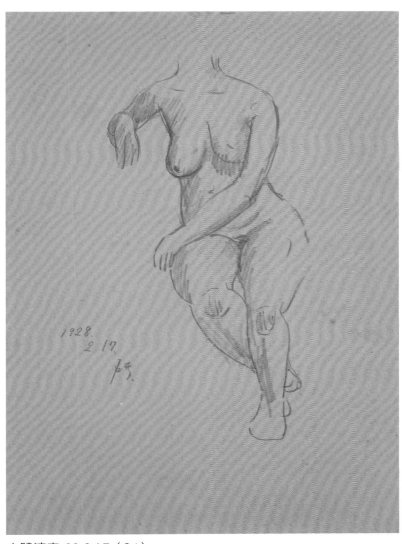

女體速寫-28.2.17（24）
Female Body Sketch-28.2.17（24）

1928 紙本鉛筆 33.4×24.1cm

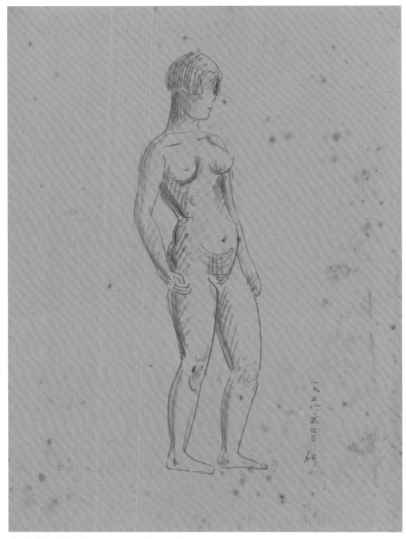

立姿裸女速寫-28.2.23（220）
Standing Female Nude Sketch-28.2.23（220）

1928　紙本鉛筆　33.2×24.3cm

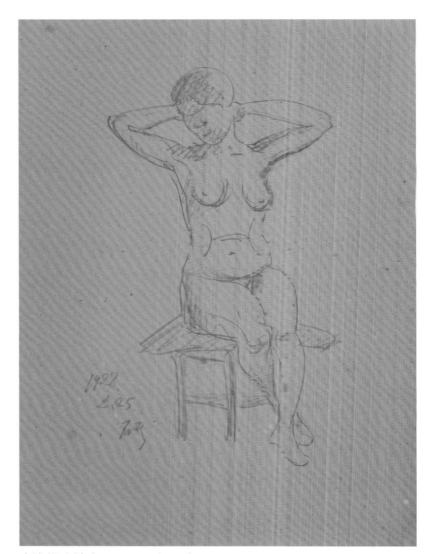

坐姿裸女速寫-28.2.25（207）
Seated Female Nude Sketch-28.2.25（207）

1928　紙本鉛筆　33.2×24.2cm

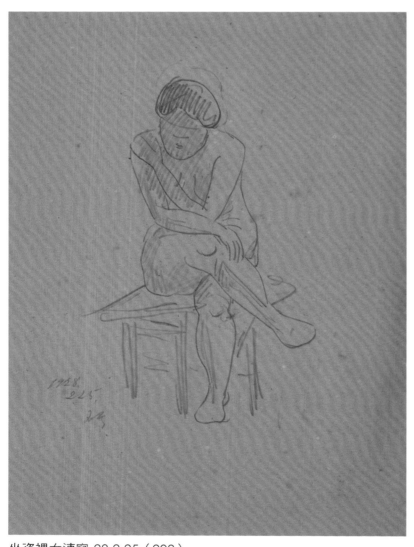

坐姿裸女速寫-28.2.25（208）
Seated Female Nude Sketch-28.2.25（208）

1928　紙本鉛筆　33.2×24.2cm

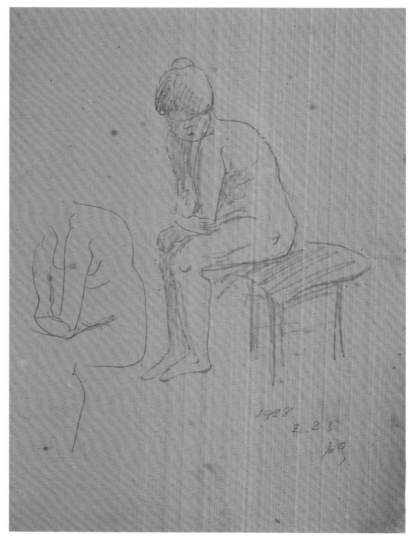

坐姿裸女速寫-28.2.25（209）
Seated Female Nude Sketch-28.2.25（209）

1928　紙本鉛筆　33.2×24.2cm

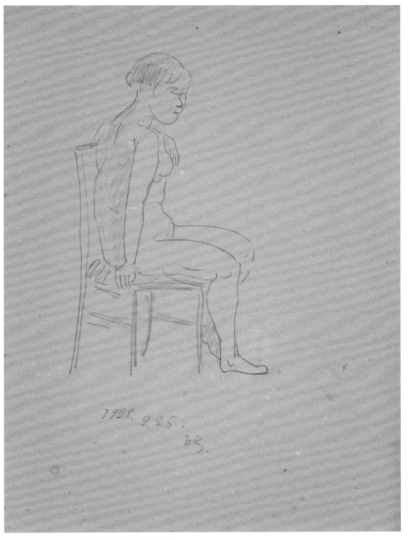

坐姿裸女速寫-28.2.25（210）
Seated Female Nude Sketch-28.2.25（210）

1928　紙本鉛筆　33.2×24.2cm

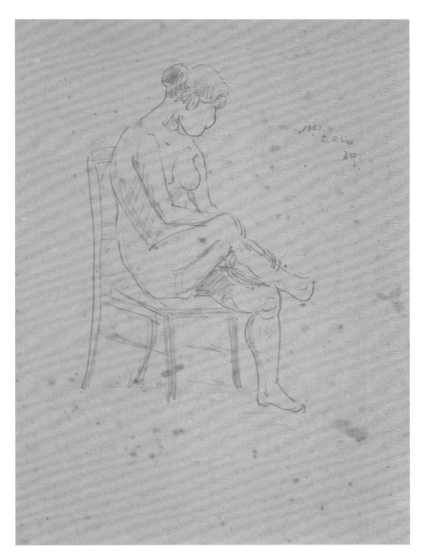

坐姿裸女速寫-28.2.25（211）
Seated Female Nude Sketch-28.2.25（211）

1928　紙本鉛筆　33.2×24.2cm

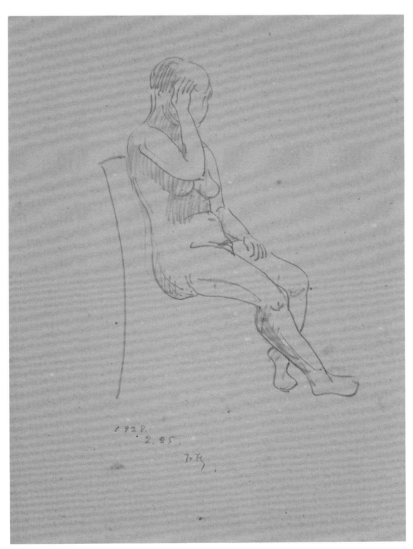

坐姿裸女速寫-28.2.25（212）
Seated Female Nude Sketch-28.2.25（212）

1928　紙本鉛筆　33.2×24.2cm

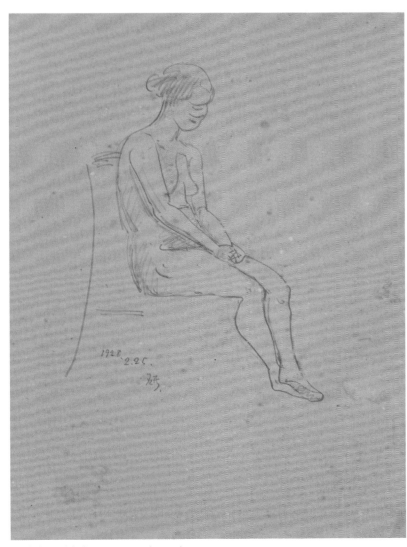

坐姿裸女速寫-28.2.25（213）
Seated Female Nude Sketch-28.2.25（213）

1928　紙本鉛筆　33.2×24.2cm

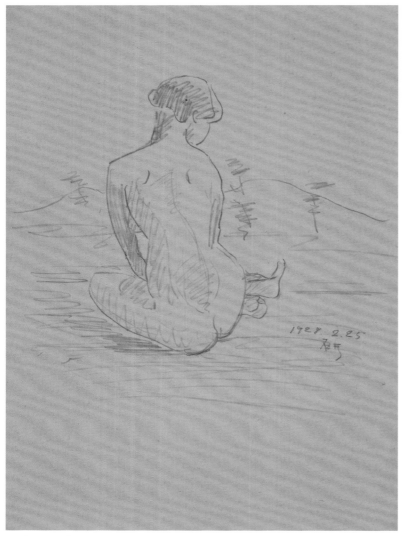

坐姿裸女速寫-28.2.25（214）
Seated Female Nude Sketch-28.2.25（214）

1928　紙本鉛筆　33.5×24.1cm

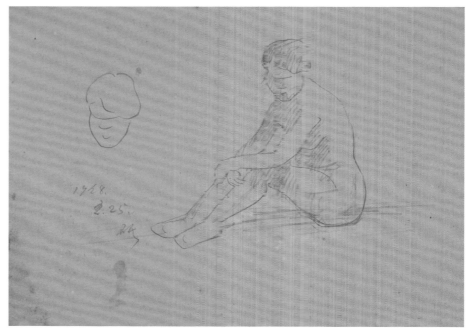

坐姿裸女速寫-28.2.25（215）
Seated Female Nude Sketch-28.2.25（215）

1928　紙本鉛筆　24.2×33.2cm

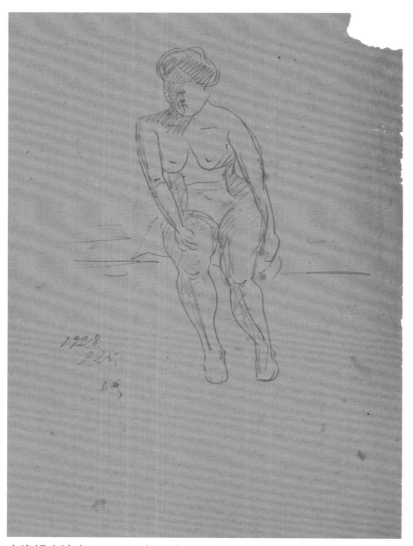

坐姿裸女速寫-28.2.25（216）
Seated Female Nude Sketch-28.2.25（216）

1928　紙本鉛筆　33.2×24.2cm

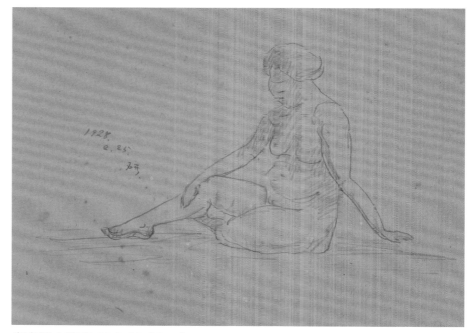

坐姿裸女速寫-28.2.25（217）
Seated Female Nude Sketch-28.2.25（217）

1928　紙本鉛筆　24.2×33.2cm

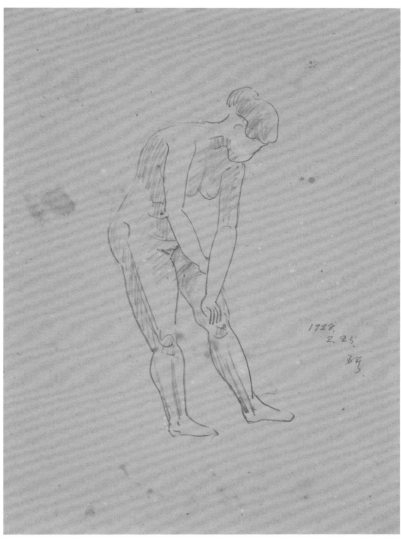

立姿裸女速寫-28.2.25（221）
Standing Female Nude Sketch-28.2.25（221）

1928　紙本鉛筆　33.2×24.2cm

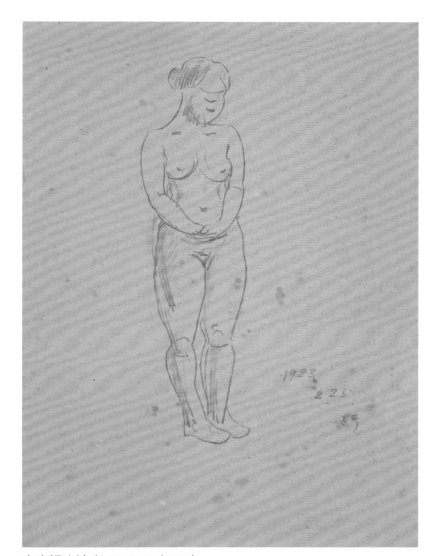

立姿裸女速寫-28.2.25（222）
Standing Female Nude Sketch-28.2.25（222）

1928　紙本鉛筆　33.2×24.2cm

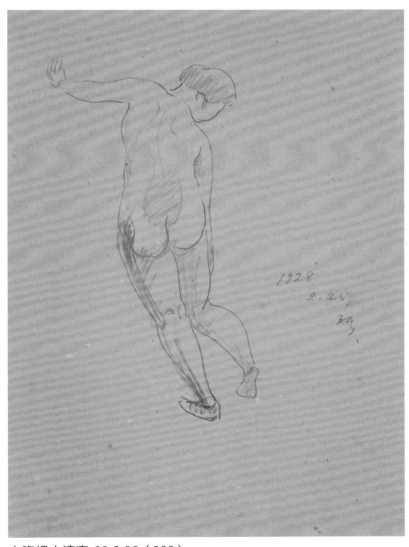

立姿裸女速寫-28.2.25（223）
Standing Female Nude Sketch-28.2.25（223）

1928　紙本鉛筆　33.1×24.2cm

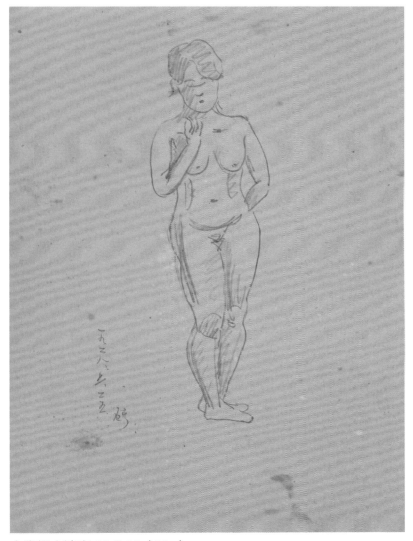

立姿裸女速寫-28.2.25（224）
Standing Female Nude Sketch-28.2.25（224）

1928　紙本鉛筆　33.2×24.2cm

立姿裸女速寫-28.2.25（225）
Standing Female Nude Sketch-28.2.25（225）

1928　紙本鉛筆　33.2×24.2cm

立姿裸女速寫-28.2.25（226）
Standing Female Nude Sketch-28.2.25（226）

1928　紙本鉛筆　33.2×24.2cm

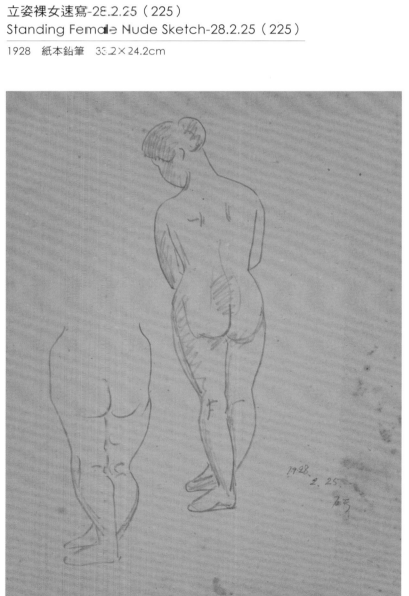

立姿裸女速寫-28.2.25（227）
Standing Female Nude Sketch-28.2.25（227）

1928　紙本鉛筆　33.2×24.2cm

立姿裸女速寫-28.2.25（228）
Standing Female Nude Sketch-28.2.25（228）

1928　紙本鉛筆　33.2×24.2cm

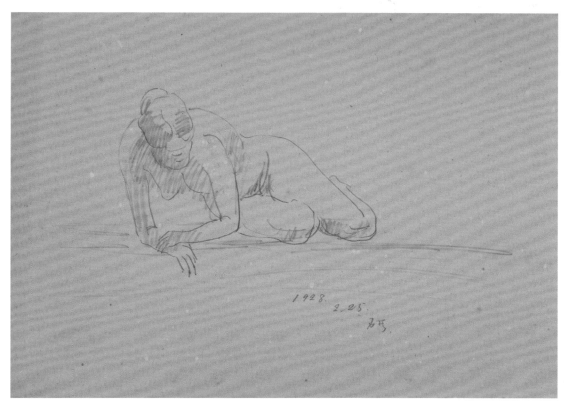

臥姿裸女速寫-28.2.25（24）
Reclining Female Nude Sketch-28.2.25（24）

1928　紙本鉛筆　24.2×33.2cm

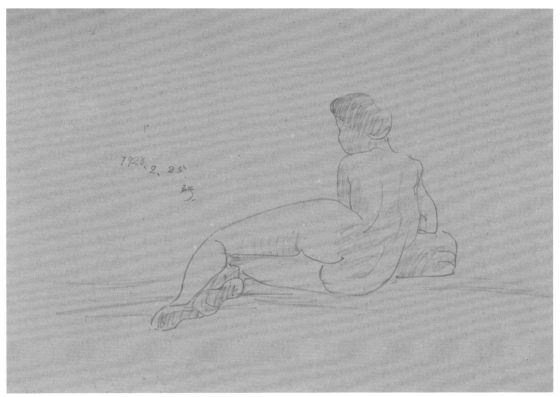

臥姿裸女速寫-28.2.25（25）
Reclining Female Nude Sketch-28.2.25（25）

1928　紙本鉛筆　24.2×33.2cm

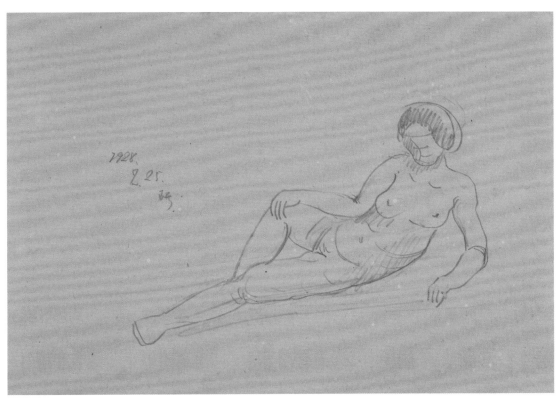

臥姿裸女速寫-28.2.25（26）
Reclining Female Nude Sketch-28.2.25（26）

1928　紙本鉛筆　24.2×33.1cm

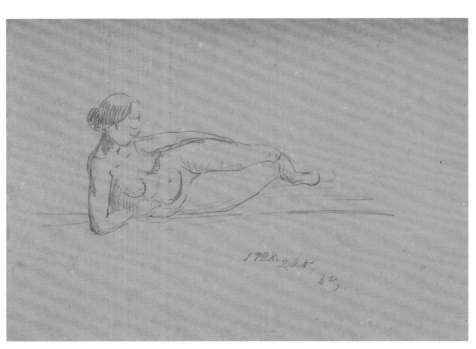

臥姿裸女速寫-28.2.25（27）
Reclining Female Nude Sketch-28.2.25（27）

1928　紙本鉛筆　24.2×33.1cm

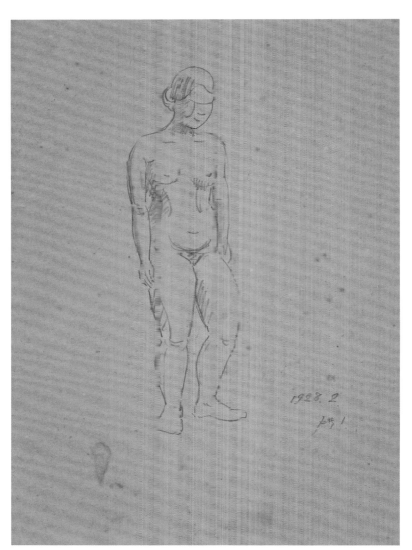

立姿裸女速寫-28.2（229）
Standing Female Nude Sketch-28.2（229）

1928　紙本鉛筆　32.8×24cm

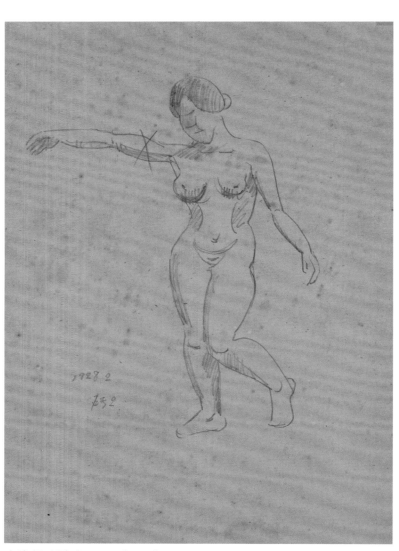

立姿裸女速寫-28.2（230）
Standing Female Nude Sketch-28.2（230）

1928　紙本鉛筆　33.1×23.8cm

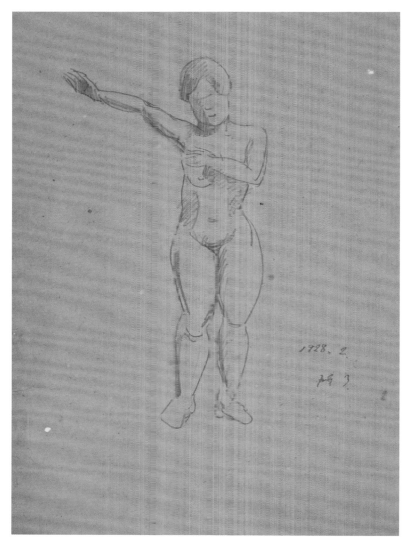

立姿裸女速寫-28.2（231）
Standing Female Nude Sketch-28.2（231）

1928　紙本鉛筆　33×23.5cm

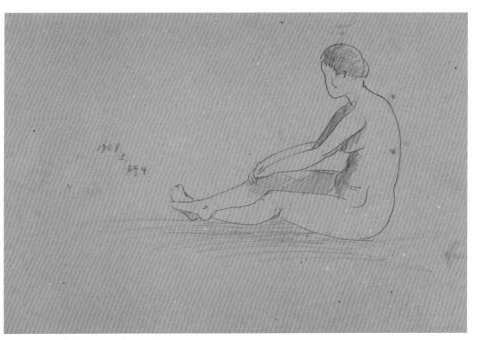

坐姿裸女速寫-28.2（218）
Seated Female Nude Sketch-28.2（218）

1928　紙本鉛筆　24×33.6cm

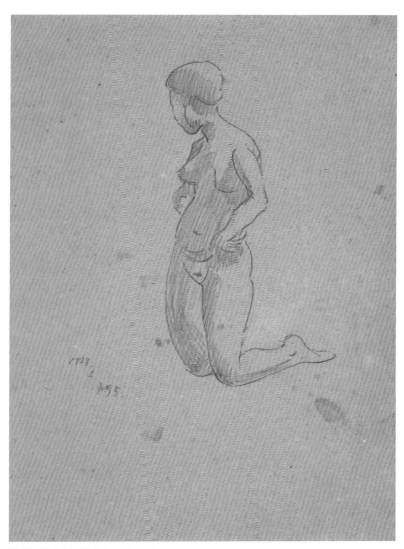

跪姿裸女速寫-28.2（18）
Kneeling Female Nude Sketch-28.2（18）

1928　紙本鉛筆　33×23.5cm

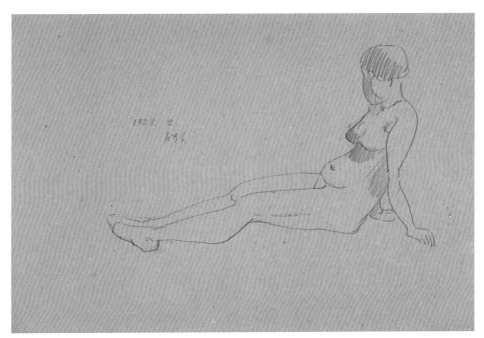

坐姿裸女速寫-28.2（219）
Seated Female Nude Sketch-28.2（219）

1928　紙本鉛筆　23.5×32cm

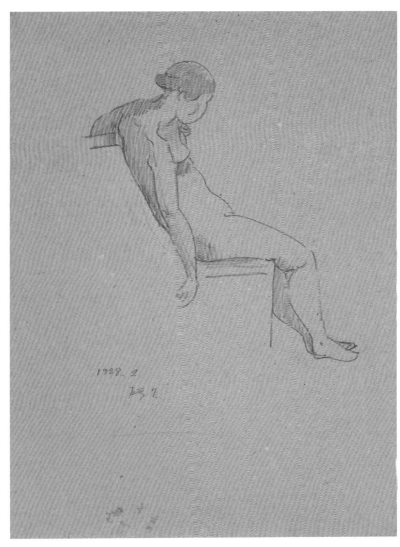

坐姿裸女速寫-28.2（220）
Seated Female Nude Sketch-28.2（220）

1928　紙本鉛筆　33.1×23.7cm

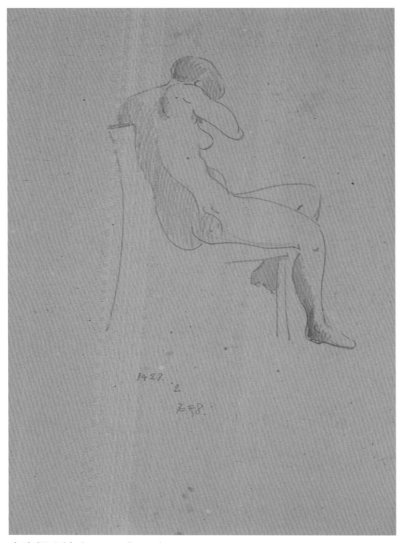

坐姿裸女速寫-28.2（221）
Seated Female Nude Sketch-28.2（221）

1928　紙本鉛筆　33.3×23.7cm

坐姿裸女速寫-28.2（222）
Seated Female Nude Sketch-28.2（222）

1928　紙本鉛筆　33.2×23.7cm

坐姿與臥姿裸女速寫-28.2（1）　Seated and Reclining Female Nude Sketch-28.2（1）

1928　紙本鉛筆　23.7×33.5cm

坐姿裸女速寫-28.2（223）
Seated Female Nude Sketch-28.2（223）

1928　紙本鉛筆　23.7×33.2cm

立姿裸女速寫-28.3.3（232）
Standing Female Nude Sketch-28.3.3（232）

1928　紙本鉛筆　33.4×24.2cm

立姿裸女速寫-28.3.3（233）
Standing Female Nude Sketch-28.3.3（233）

1928　紙本鉛筆　33.2×24.2cm

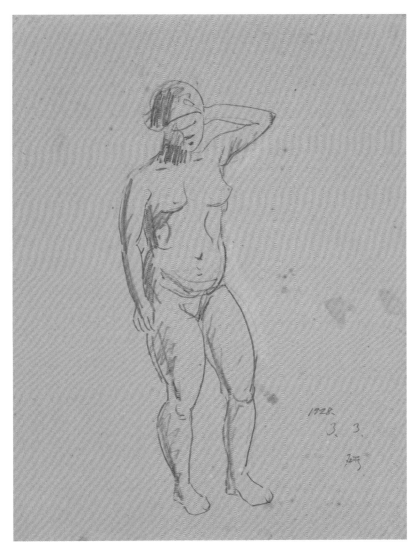

立姿裸女速寫-28.3.3（234）
Standing Female Nude Sketch-28.3.3（234）

1928　紙本鉛筆　33.3×24.2cm

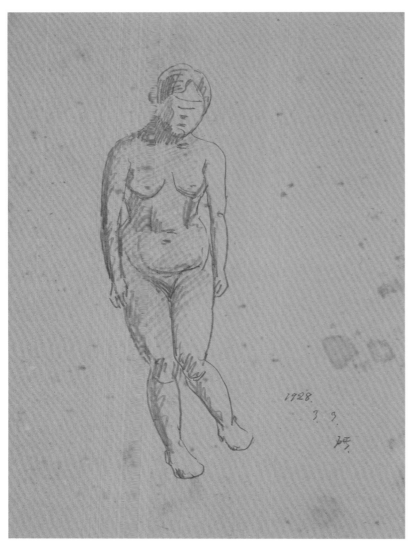

立姿裸女速寫-28.3.3（235）
Standing Female Nude Sketch-28.3.3（235）

1928　紙本鉛筆　33.2×24.2cm

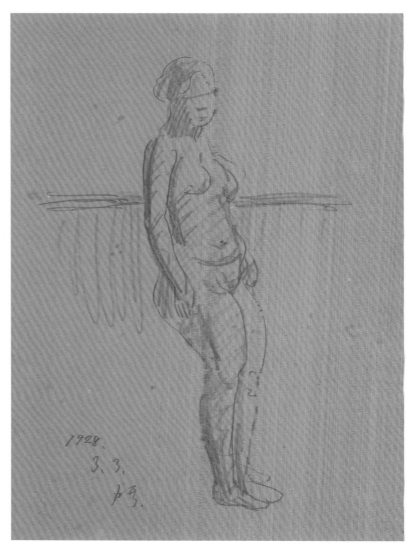

立姿裸女速寫-28.3.3（236）
Standing Female Nude Sketch-28.3.3（236）

1928　紙本鉛筆　33.3×24.2cm

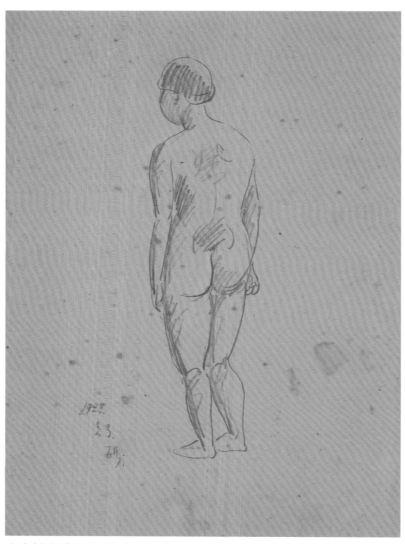

立姿裸女速寫-28.3.3（237）
Standing Female Nude Sketch-28.3.3（237）

1928　紙本鉛筆　33.3×24.2cm

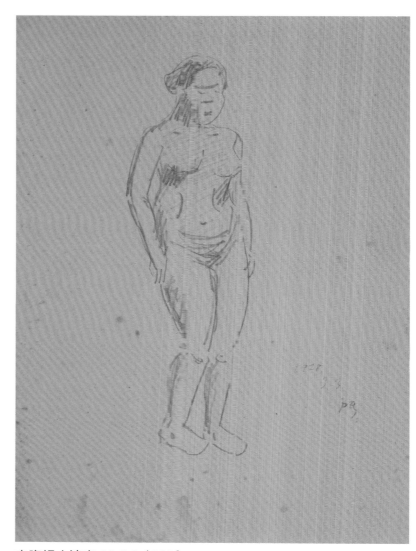

立姿裸女速寫-28.3.3（238）
Standing Female Nude Sketch-28.3.3（238）

1928　紙本鉛筆　33.2×24.2cm

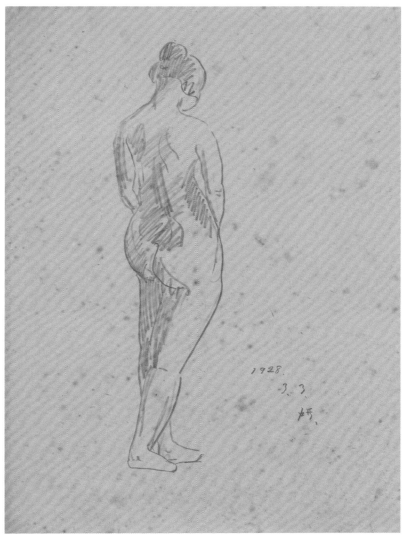

立姿裸女速寫-28.3.3（239）
Standing Female Nude Sketch-28.3.3（239）

1928　紙本鉛筆　33.2×24.2cm

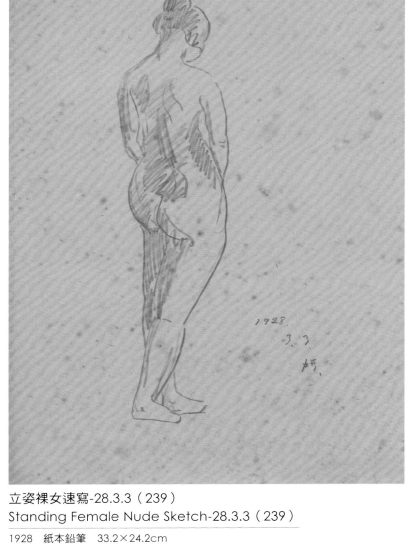

立姿裸女速寫-28.3.3（240）
Standing Female Nude Sketch-28.3.3（240）

1928　紙本鉛筆　33.1×24.2cm

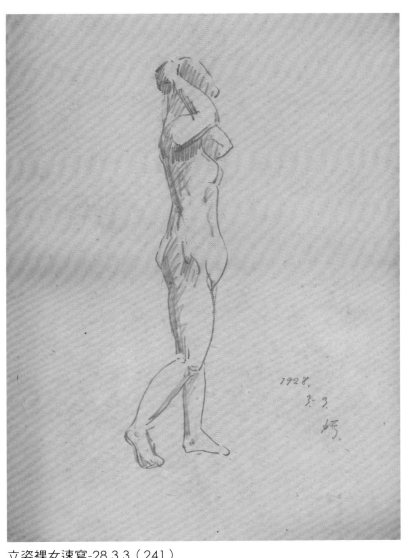

立姿裸女速寫-28.3.3（241）
Standing Female Nude Sketch-28.3.3（241）

1928　紙本鉛筆　33.2×24.2cm

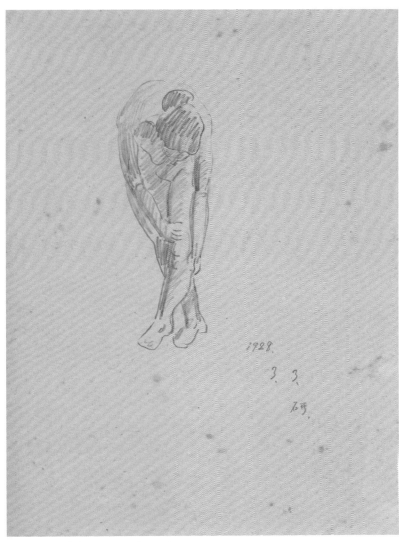

立姿裸女速寫-28.3.3（242）
Standing Female Nude Sketch-28.3.3（242）

1928　紙本鉛筆　33.2×24.1cm

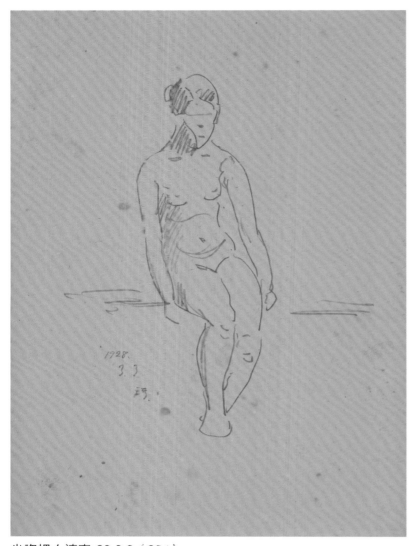

坐姿裸女速寫-28.3.3（224）
Seated Female Nude Sketch-28.3.3（224）

1928　紙本鉛筆　33.2×24.3cm

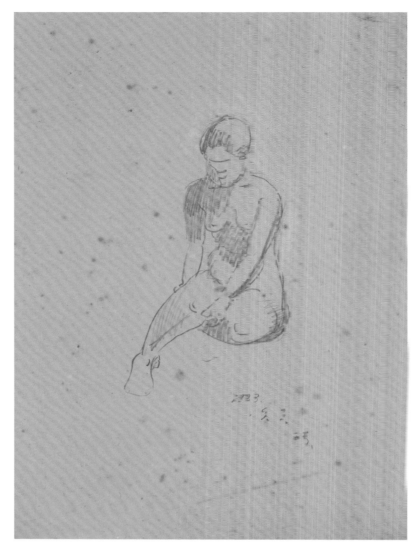

坐姿裸女速寫-28.3.3（225）
Seated Female Nude Sketch-28.3.3（225）

1928　紙本鉛筆　33.3×24.1cm

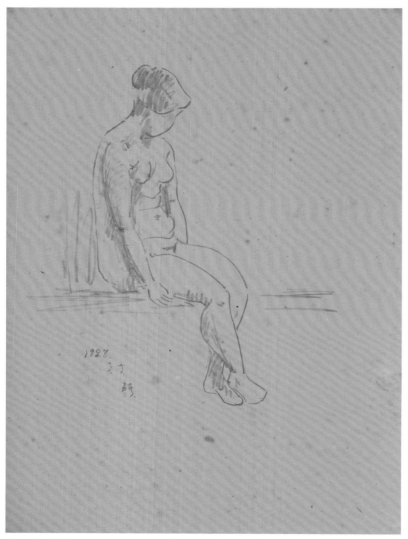

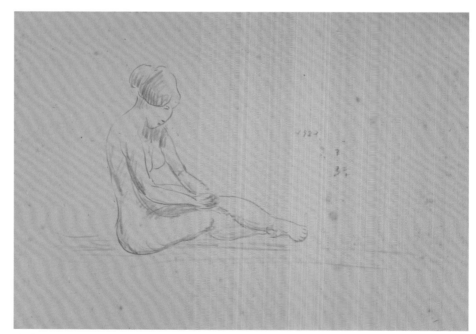

坐姿裸女速寫-28.3.3（227）
Seated Female Nude Sketch-28.3.3（227）

1928　紙本色筆　24.2×33.3cm

坐姿裸女速寫-28.3.3（226）
Seated Female Nude Sketch-28.3.3（226）

1928　紙本鉛筆　33.4×24.2cm

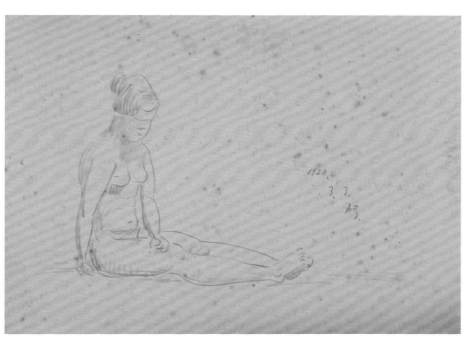

坐姿裸女速寫-28.3.3（228）
Seated Female Nude Sketch-28.3.3（228）

1928　紙本色筆　24.1×33.3cm

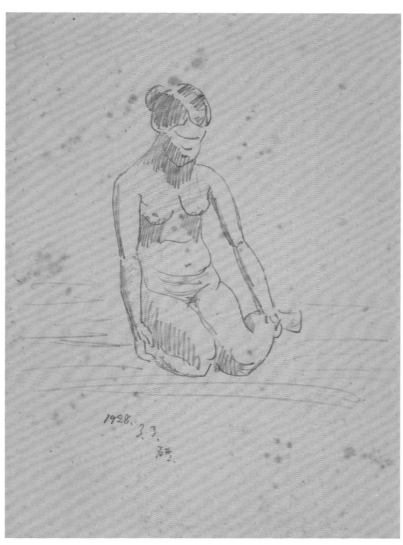

坐姿裸女速寫-28.3.3（229）
Seated Female Nude Sketch-28.3.3（229）

1928　紙本鉛筆　33.2×24.2cm

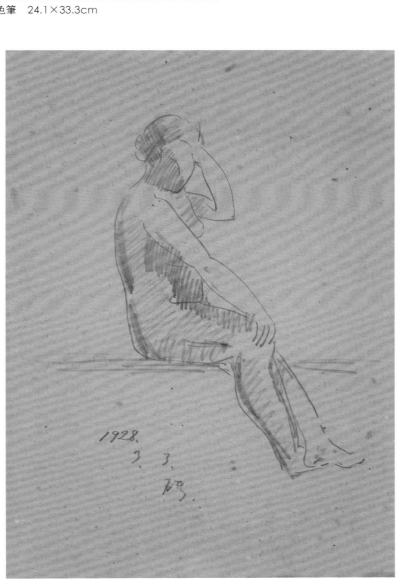

坐姿裸女速寫-28.3.3（230）
Seated Female Nude Sketch-28.3.3（230）

1928　紙本鉛筆　33.1×23.7cm

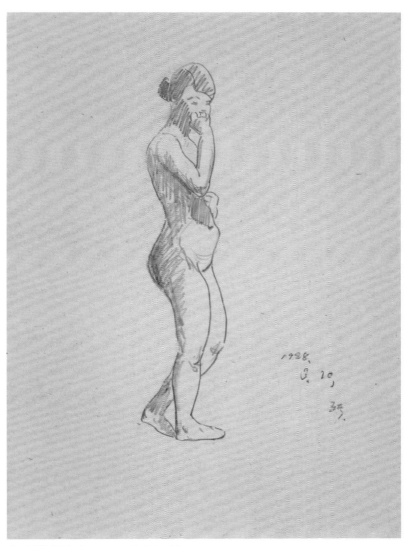

立姿裸女速寫-28.3.10（243）
Standing Female Nude Sketch-28.3.10（243）

1928　紙本鉛筆　33.2×24.2cm

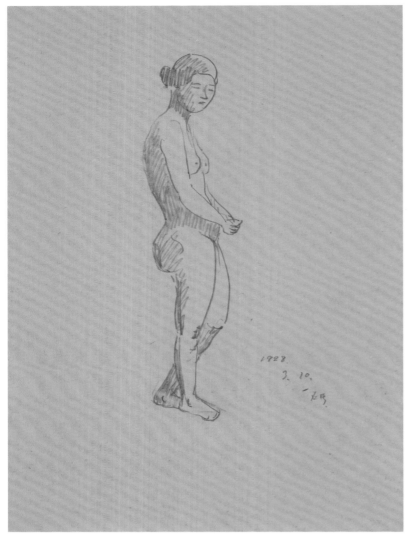

立姿裸女速寫-28.3.10（244）
Standing Female Nude Sketch-28.3.10（244）

1928　紙本鉛筆　33.2×24.2cm

坐姿裸女速寫-28.3.15（231）
Seated Female Nude Sketch-28.3.15（231）

1928　紙本鉛筆　33.1×24.1cm

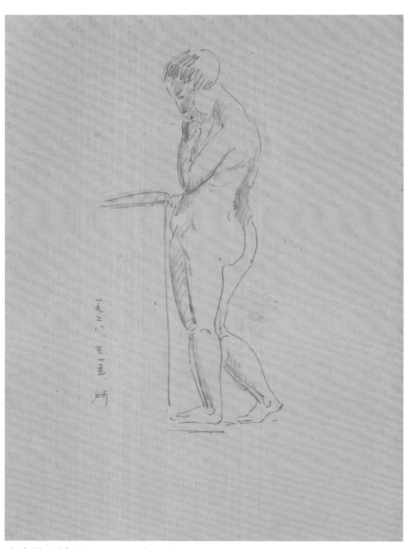

立姿裸女速寫-28.3.15（245）
Standing Female Nude Sketch-28.3.15（245）

1928　紙本鉛筆　33.2×24.2cm

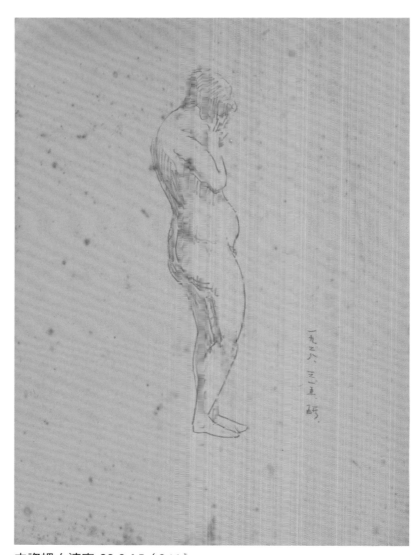

立姿裸女速寫-28.3.15（243）
Standing Female Nude Sketch-28.3.15（246）

1928　紙本鉛筆　33.1×24.2cm

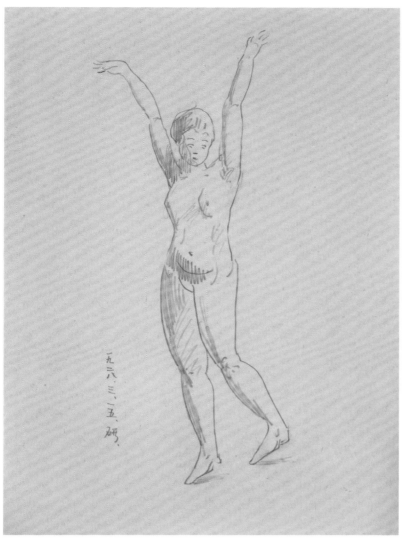

立姿裸女速寫-28.3.15（247）
Standing Female Nude Sketch-28.3.15（247）

1928　紙本鉛筆　33.2×24.2cm

人物速寫-28.3.15（18）
Figure Sketch-28.3.15（18）

1928　紙本鉛筆　33×23.8cm

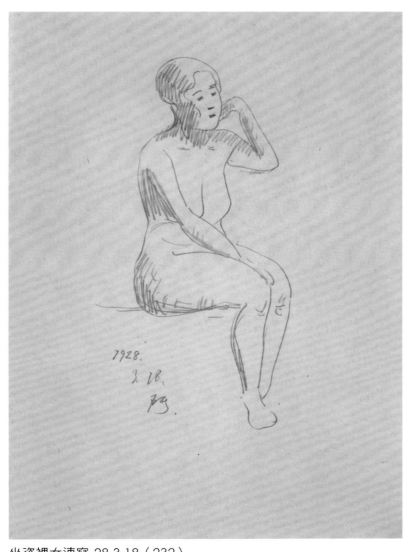

坐姿裸女速寫-28.3.18（232）
Seated Female Nude Sketch-28.3.18（232）

1928　紙本鉛筆　33.2×24.2cm

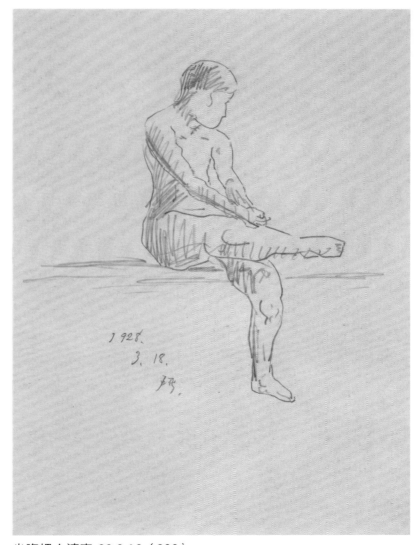

坐姿裸女速寫-28.3.18（233）
Seated Female Nude Sketch-28.3.18（233）

1928　紙本鉛筆　33.2×24.2cm

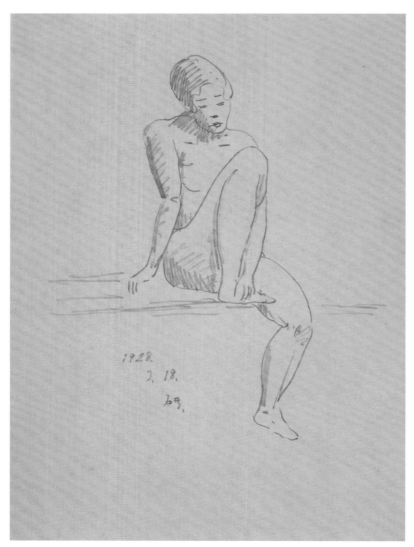

坐姿裸女速寫-28.3.18（234）
Seated Female Nude Sketch-28.3.18（234）

1928　紙本鉛筆　33.2×24.2cm

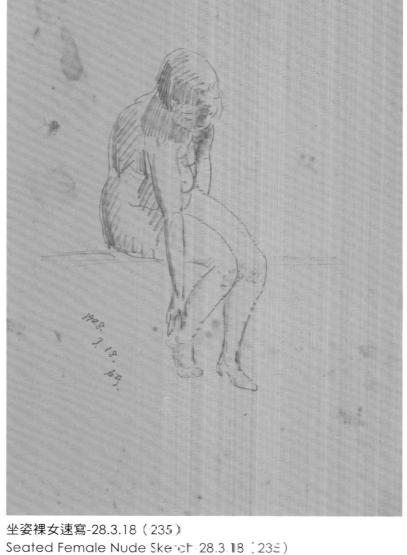

坐姿裸女速寫-28.3.18（235）
Seated Female Nude Sketch-28.3.18（235）

1928　紙本鉛筆　33.2×24.1cm

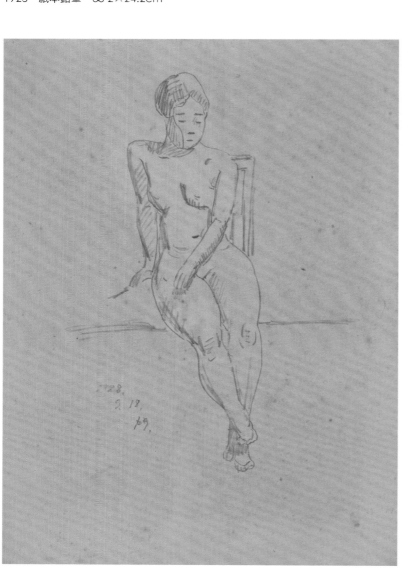

坐姿裸女速寫-28.3.18（236）
Seated Female Nude Sketch-28.3.18（236）

1928　紙本鉛筆　33.2×24.1cm

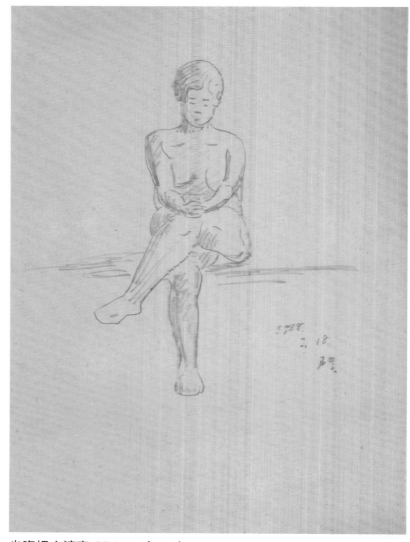

坐姿裸女速寫-28.3.18（237）
Seated Female Nude Sketch-28.3.18（237）

1928　紙本鉛筆　33.2×24.1cm

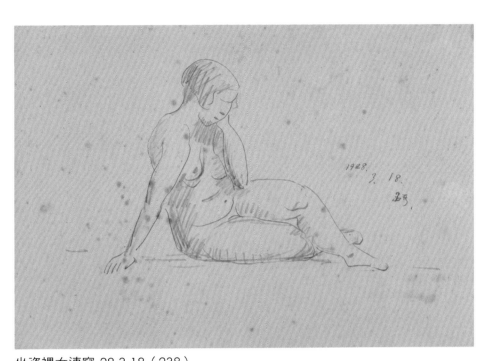

坐姿裸女速寫-28.3.18（238）
Seated Female Nude Sketch-28.3.18（238）

1928　紙本鉛筆　24.2×33.2cm

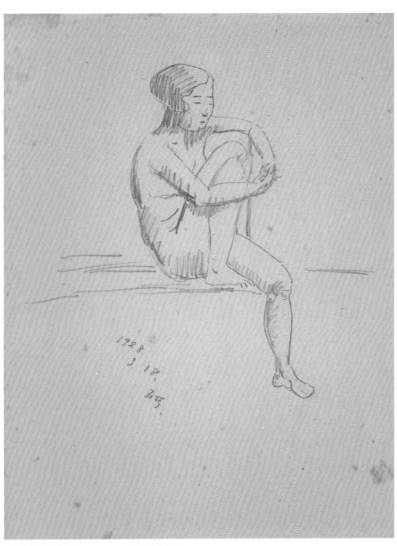

坐姿裸女速寫-28.3.18（239）
Seated Female Nude Sketch-28.3.18（239）

1928　紙本鉛筆　33.2×24.1cm

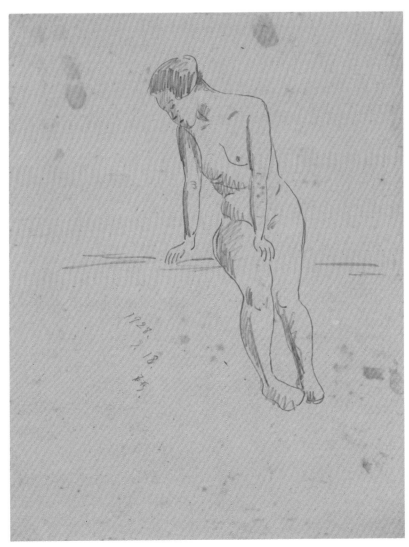

坐姿裸女速寫-28.3.18（240）
Seated Female Nude Sketch-28.3.18（240）

1928　紙本鉛筆　33.3×24.2cm

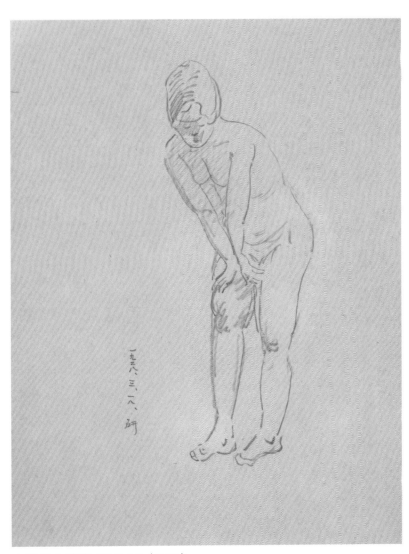

立姿裸女速寫-28.3.18（248）
Standing Female Nude Sketch-23.3.18（248）

1928　紙本鉛筆　33.2×24.2cm

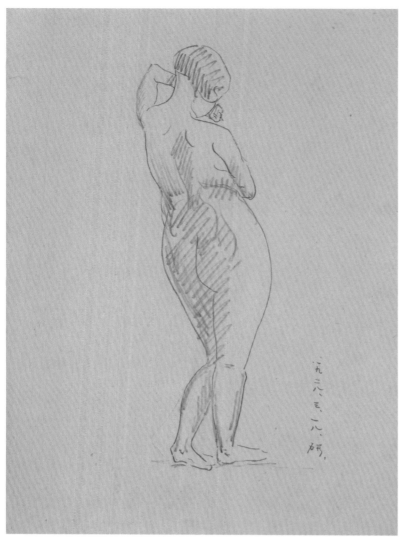

立姿裸女速寫-28.3.18（249）
Standing Female Nude Sketch-28.3.18（249）

1928　紙本鉛筆　33.2×24.2cm

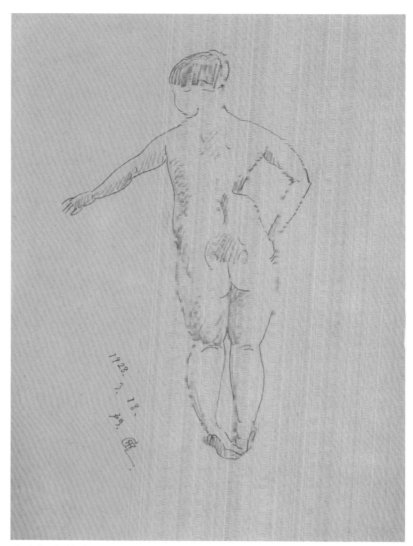

立姿裸女速寫-28.3.18（250）
Standing Female Nude Sketch-28.3.18（250）

1928　紙本鉛筆　33.2×24.2cm

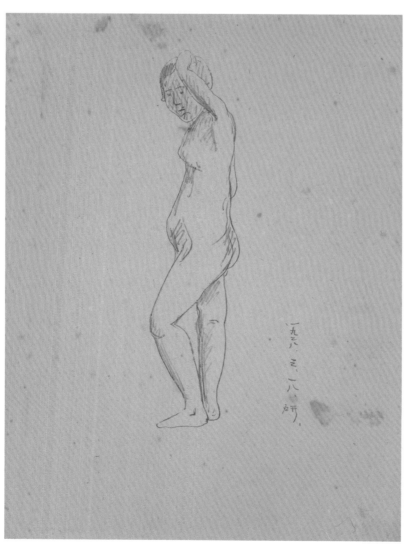

立姿裸女速寫-28.3.18（251）
Standing Female Nude Sketch-28.3.18（251）

1928　紙本鉛筆　33.2×24.2cm

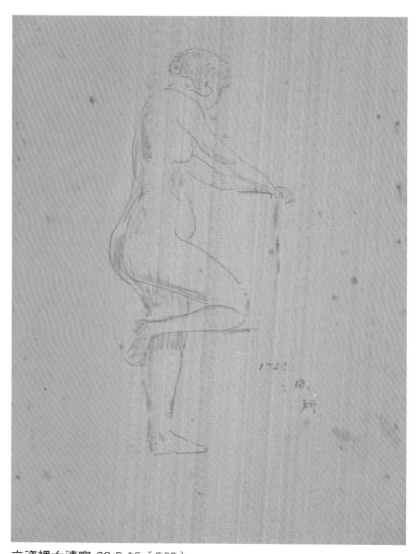

立姿裸女速寫-28.3.18（252）
Standing Female Nude Sketch-28.3.18（252）

1928　紙本色筆　33.2×24.1cm

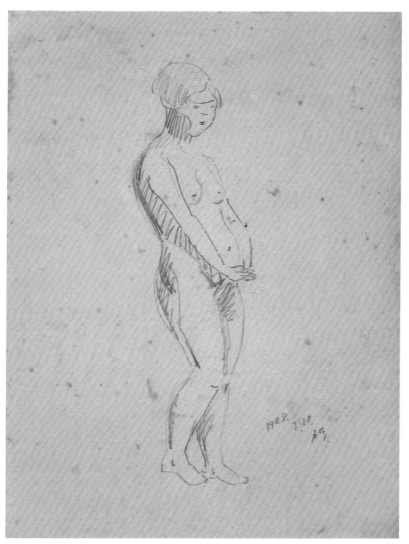

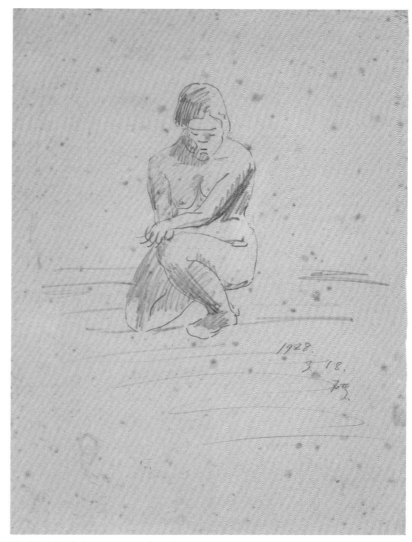

立姿裸女速寫-28.3.18（253）
Standing Female Nude Sketch-28.3.18（253）

1928　紙本鉛筆　33.2×24.1cm

跪姿裸女速寫-28.3.18（19）
Kneeling Female Nude Sketch-28.3.18〔19〕

1928　紙本鉛筆　33.3×24.2cm

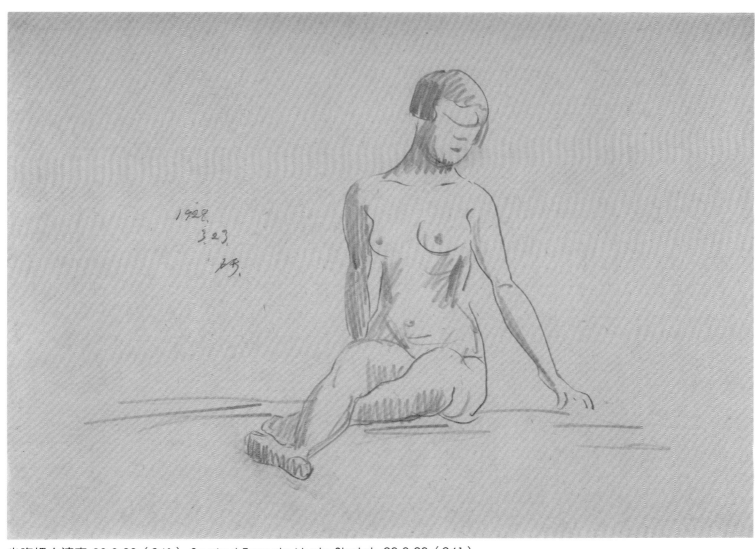

坐姿裸女速寫-28.3.23〔241〕 Seated Female Nude Sketch-28.3.23（241）

1928　紙本鉛筆　24.3×33.2cm

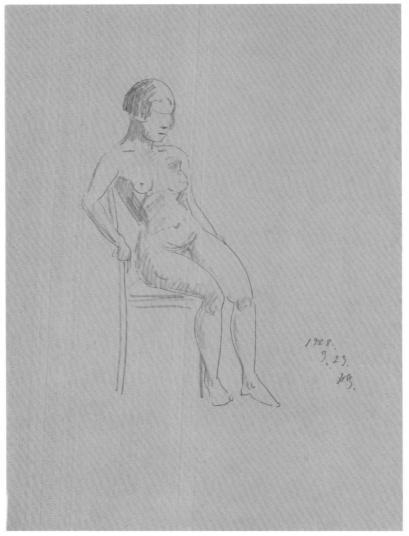

坐姿裸女速寫-28.3.23（242）
Seated Female Nude Sketch-28.3.23（242）

1928　紙本鉛筆　33.2×24.2cm

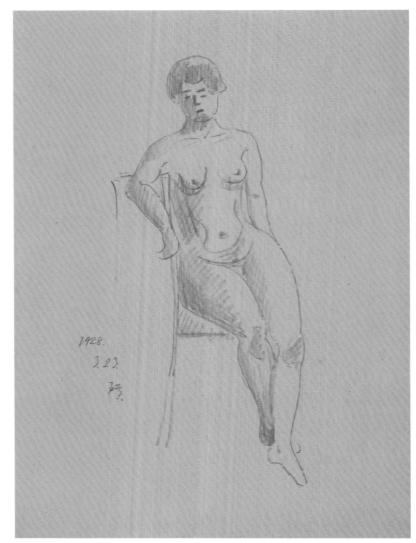

坐姿裸女速寫-28.3.23（243）
Seated Female Nude Sketch-28.3.23（243）

1928　紙本鉛筆　33.2×24.2cm

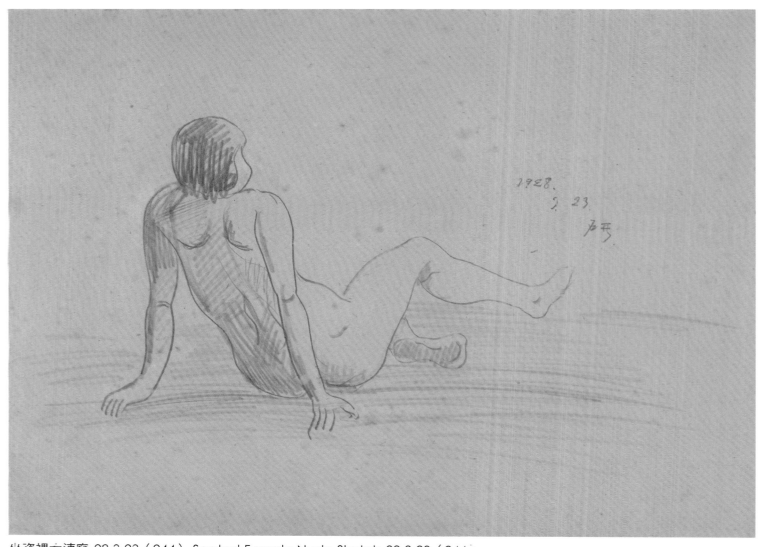

坐姿裸女速寫-28.3.23（244）Seated Female Nude Sketch-28.3.23（244）
1928　紙本鉛筆　24×33.1cm

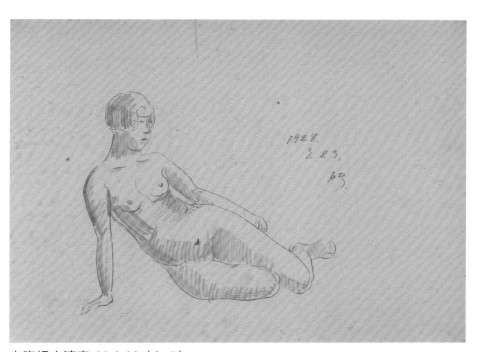

坐姿裸女速寫-28.3.23（245）
Seated Female Nude Sketch-28.3.23（245）

1928　紙本鉛筆　24×33.1cm

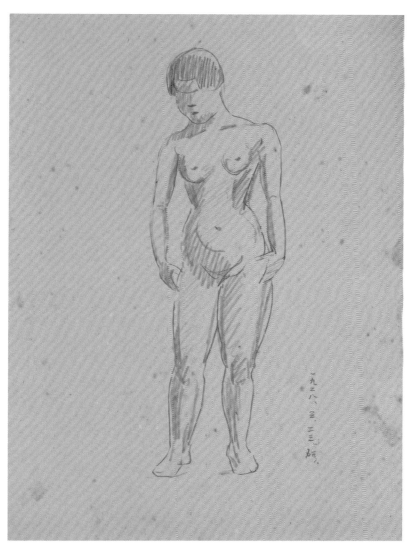

立姿裸女速寫-28.3.23（254）
Standing Female Nude Sketch-28.3.23（254）

1928　紙本鉛筆　33.2×24.1cm

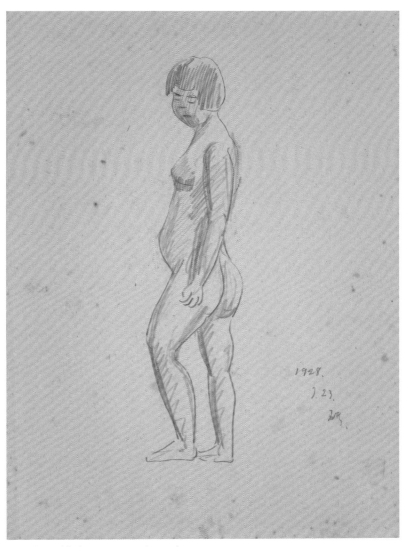

立姿裸女速寫-28.3.23（255）
Standing Female Nuce Sketch-28.3.23（255）

1928　紙本鉛筆　33.2×24.1cm

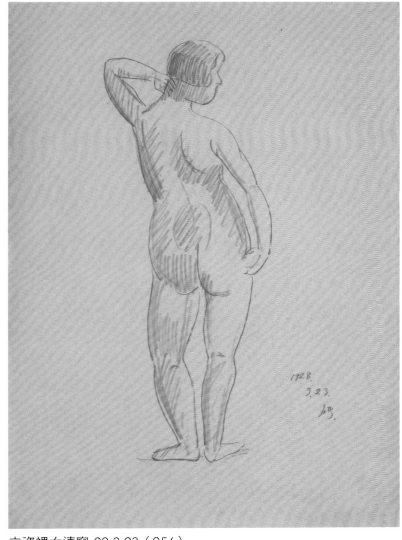

立姿裸女速寫-28.3.23（256）
Standing Female Nude Sketch-28.3.23（256）

1928　紙本鉛筆　33.2×24.2cm

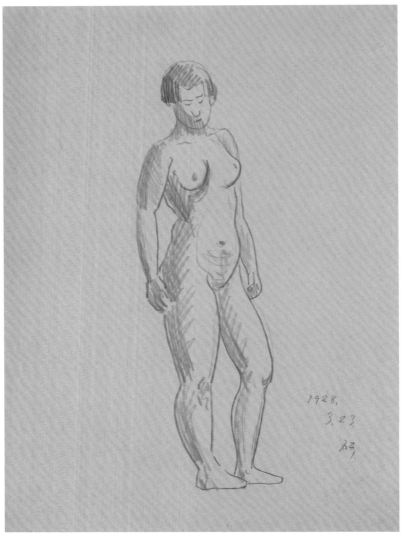

立姿裸女速寫-28.3.23（257）
Standing Female Nude Sketch-28.3.23（257）

1928　紙本鉛筆　33.2×24.2cm

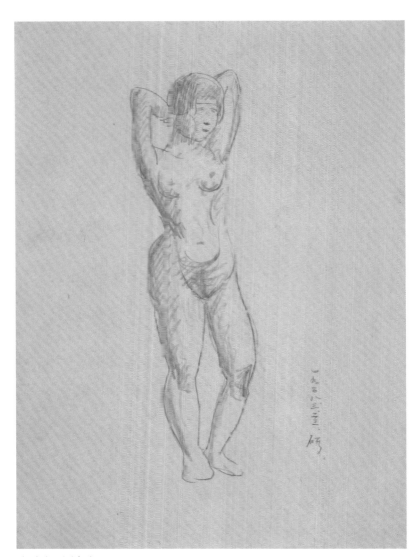

立姿裸女速寫-28.3.23（258）
Standing Female Nude Sketch-28.3.23（258）

1928　紙本鉛筆　33.2×24.2cm

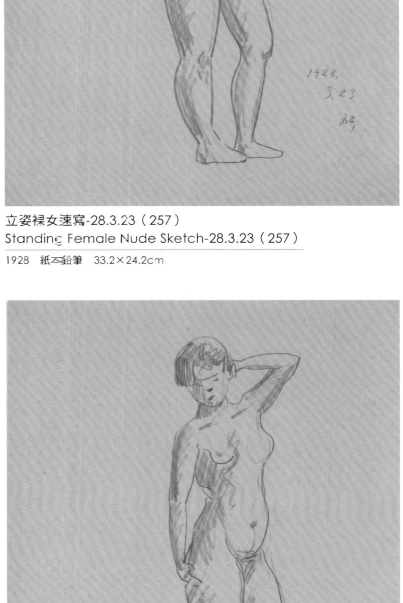

立姿裸女速寫-28.3.23（259）
Standing Female Nude Sketch-28.3.23（259）

1928　紙本鉛筆　33.2×24.2cm

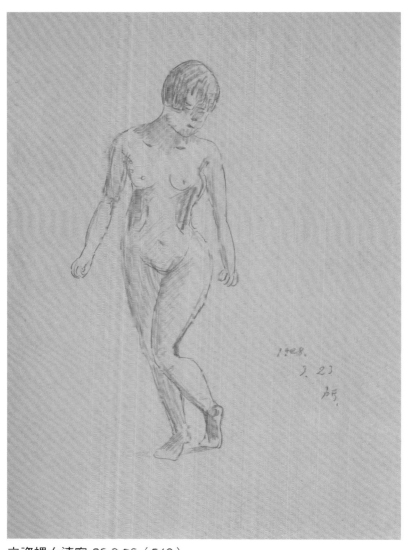

立姿裸女速寫-28.3.23（260）
Standing Female Nude Sketch-28.3.23（260）

1928　紙本鉛筆　33.2×24.2cm

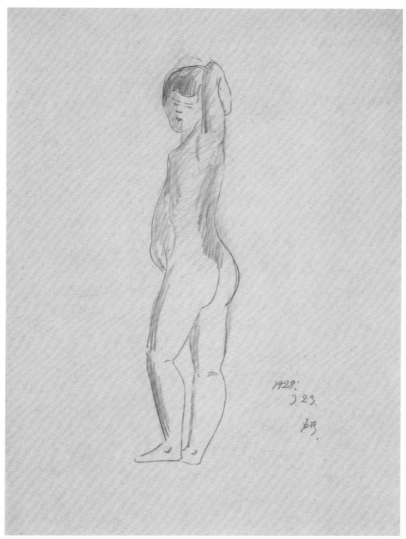

立姿裸女速寫-28.3.23（261）
Standing Female Nude Sketch-28.3.23（261）

1928　紙本鉛筆　33.2×24.2cm

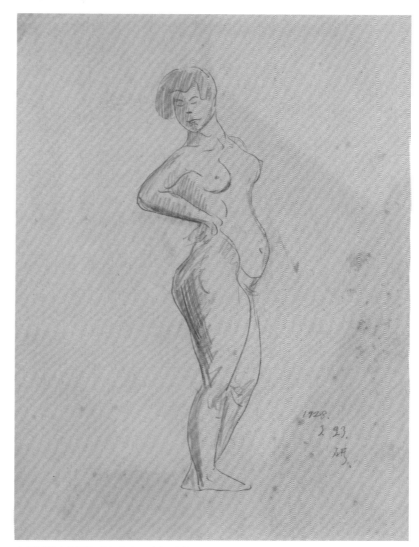

立姿裸女速寫-28.3.23（262）
Standing Female Nude Sketch-28.3.23（262）

1928　紙本鉛筆　33×23.9cm

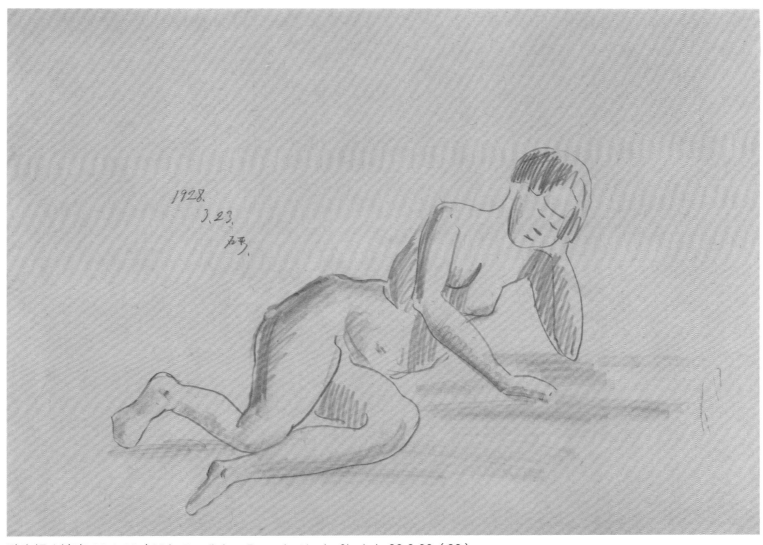

臥姿裸女速寫-28.3.23（28）　Reclining Female Nude Sketch-28.3.23（28）

1928　紙本鉛筆　24.3×33.2cm

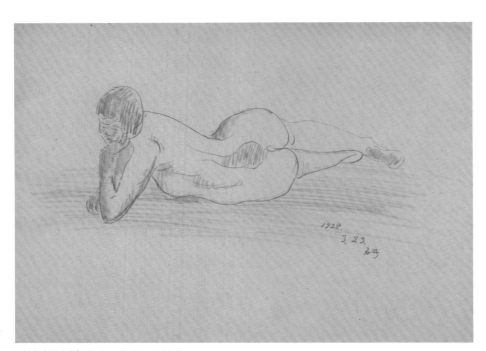

臥姿裸女速寫-28.3.23（29）
Reclining Female Nude Sketch-28.3.23（29）

1928　紙本鉛筆　24.3×33.2cm

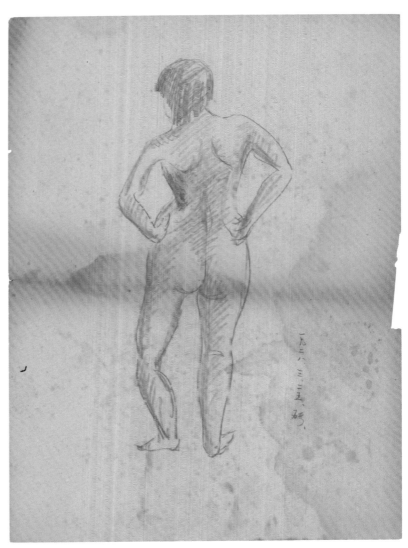

立姿裸女速寫-28.3.25（263）
Standing Female Nude Sketch-28.3.25（263）

1928　紙本鉛筆　33.3×24cm

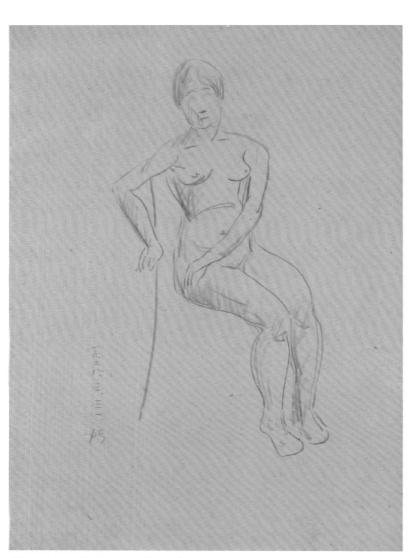

坐姿裸女速寫-28.3.31（246）
Seated Female Nude Sketch-28.3.31（246）

1928　紙本色筆　33.3×24.2cm

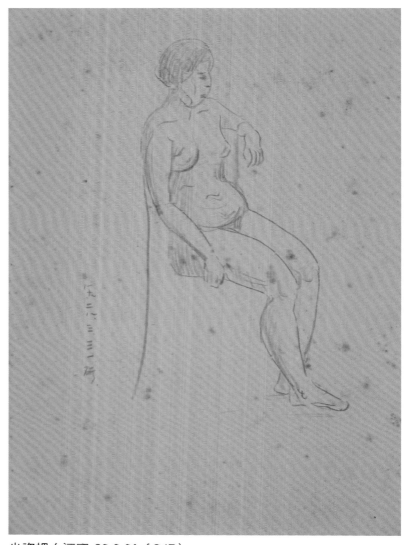

坐姿裸女速寫-28.3.31（247）
Seated Female Nude Sketch-28.3.31（247）

1928　紙本色筆　33.1×24.2cm

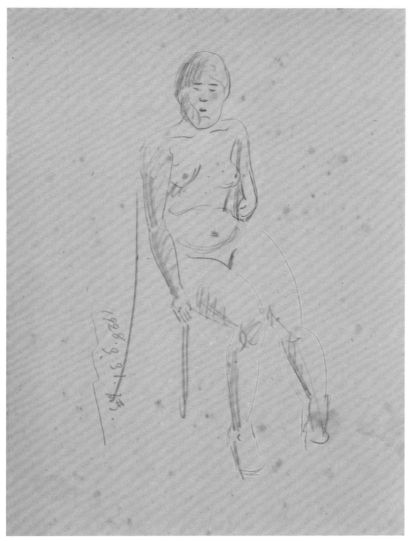

坐姿裸女速寫-28.3.31（248）
Seated Female Nude Sketch-28.3.31（248）

1928　紙本鉛筆色筆　33.2×24.2cm

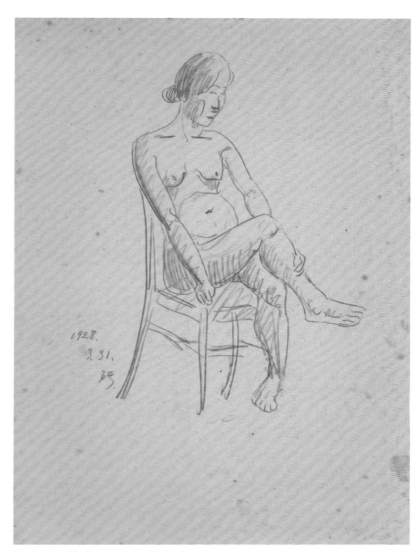

坐姿裸女速寫-28.3.31（249）
Seated Female Nude Sketch-28.3.31（249）

1928　紙本鉛筆　33.2×24.2cm

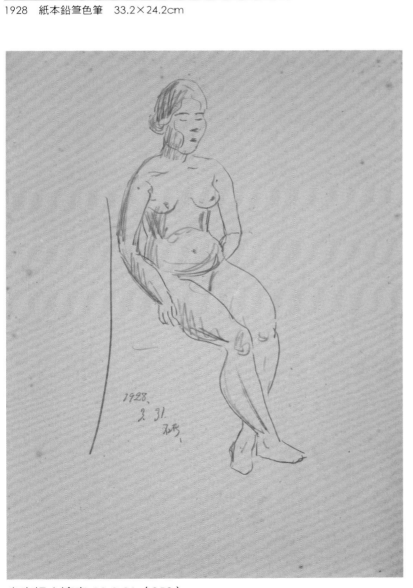

坐姿裸女速寫-28.3.31（250）
Seated Female Nude Sketch-28.3.31（250）

1928　紙本鉛筆　33.1×24.2cm

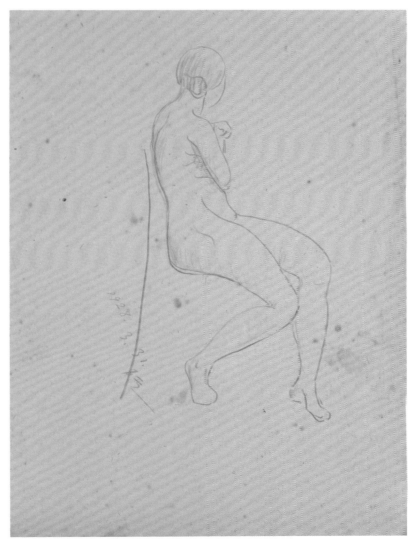

坐姿裸女速寫-28.3.31（251）
Seated Female Nude Sketch-28.3.31（251）

1928　紙本色筆　33.1×24.2cm

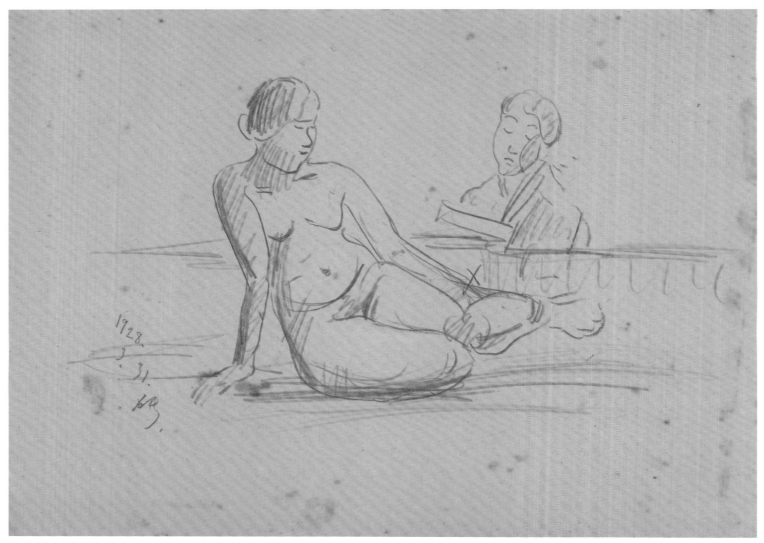

坐姿裸女與人物速寫-28.3.31（2） Seated Female Nude and Figure Sketch-28.3.31（2）
1928　紙本鉛筆　24.2×33.2cm

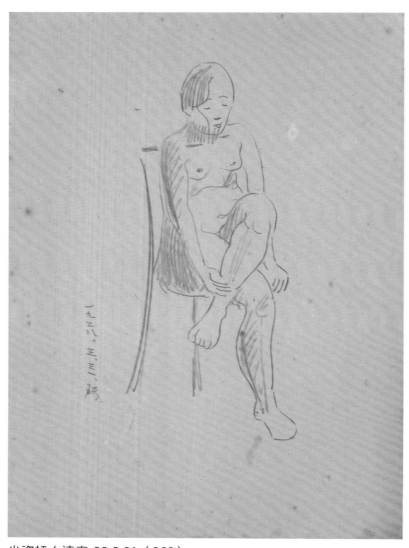

坐姿裸女速寫-28.3.31（252）
Seated Female Nude Sketch-28.3.31（252）
1928　紙本鉛筆　33.2×24.2cm

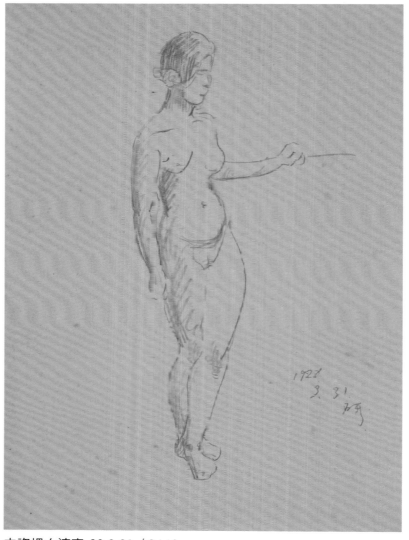

立姿裸女速寫-28.3.31（264）
Standing Female Nude Sketch-28.3.31（264）
1928　紙本鉛筆　33.2×24.2cm

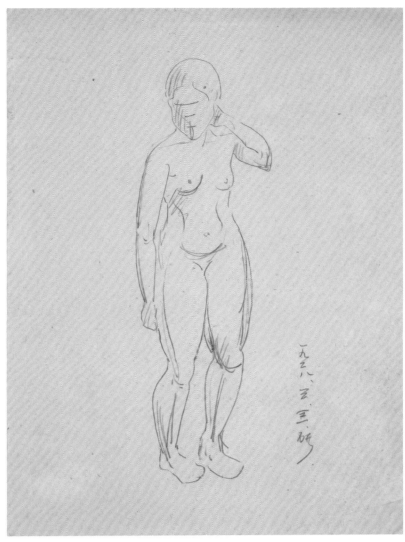

立姿裸女速寫-28.3.31（265）
Standing Female Nude Sketch-28.3.31（265）

1928　紙本鉛筆　33.2×24.2cm

頭像速寫（18）Portrait Sketch（18）

約1928　紙本鉛筆　33.2×24.2cm
※為前一張之背面圖。

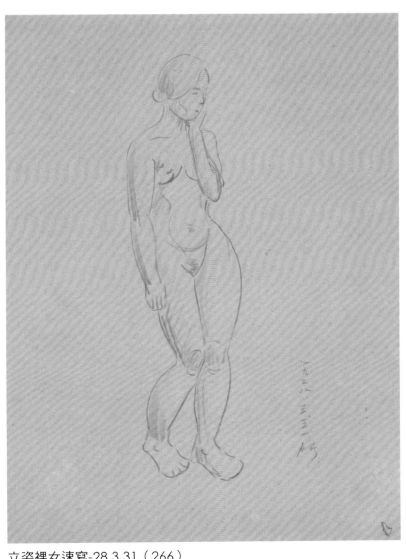

立姿裸女速寫-28.3.31（266）
Standing Female Nude Sketch-28.3.31（266）

1928　紙本色筆　33.1×24.3cm

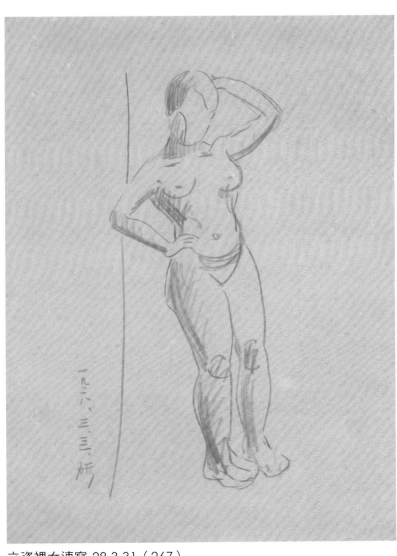

立姿裸女速寫-28.3.31（267）
Standing Female Nude Sketch-28.3.31（267）

1928　紙本色筆　33.4×24.3cm

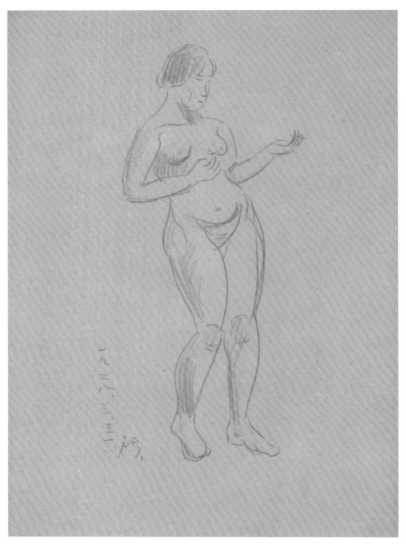

立姿裸女速寫-28.3.31（268）
Standing Female Nude Sketch-28.3.31（268）

1928　紙本色筆　33.4×24.2cm

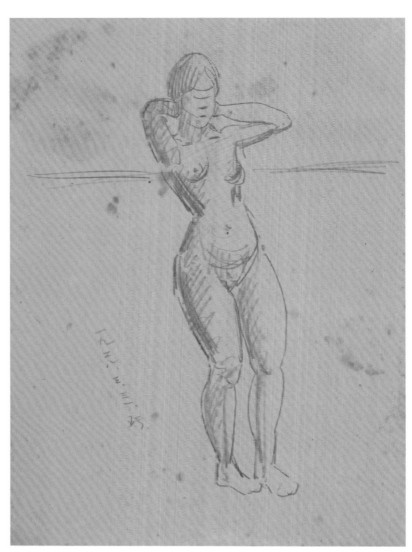

立姿裸女速寫-28.3.31（269）
Standing Female Nude Sketch-28.3.31（269）

1928　紙本鉛筆　33.×24.2cm

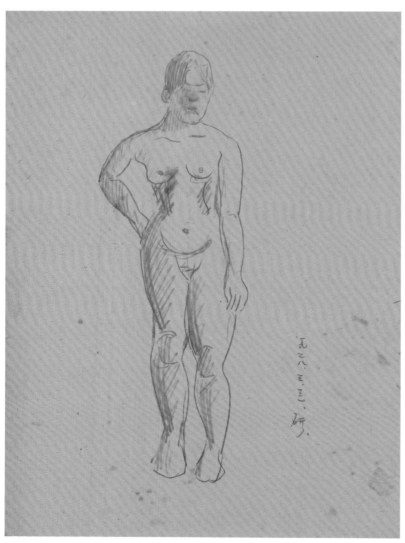

立姿裸女速寫-28.3.31（270）
Standing Female Nude Sketch-28.3.31（270）

1928　紙本鉛筆　33.4×24.1cm

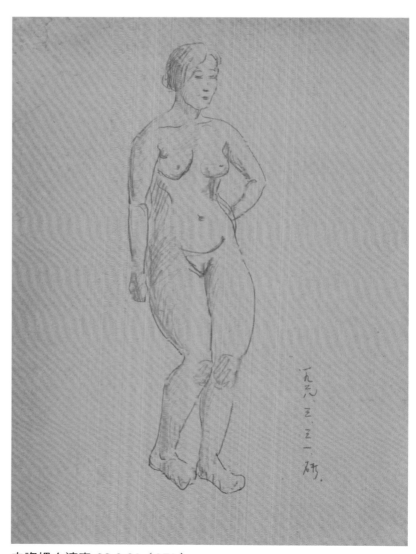

立姿裸女速寫-28.3.31（271）
Standing Female Nude Sketch-28.3.31（271）

1928　紙本鉛筆　33.2×24.2cm

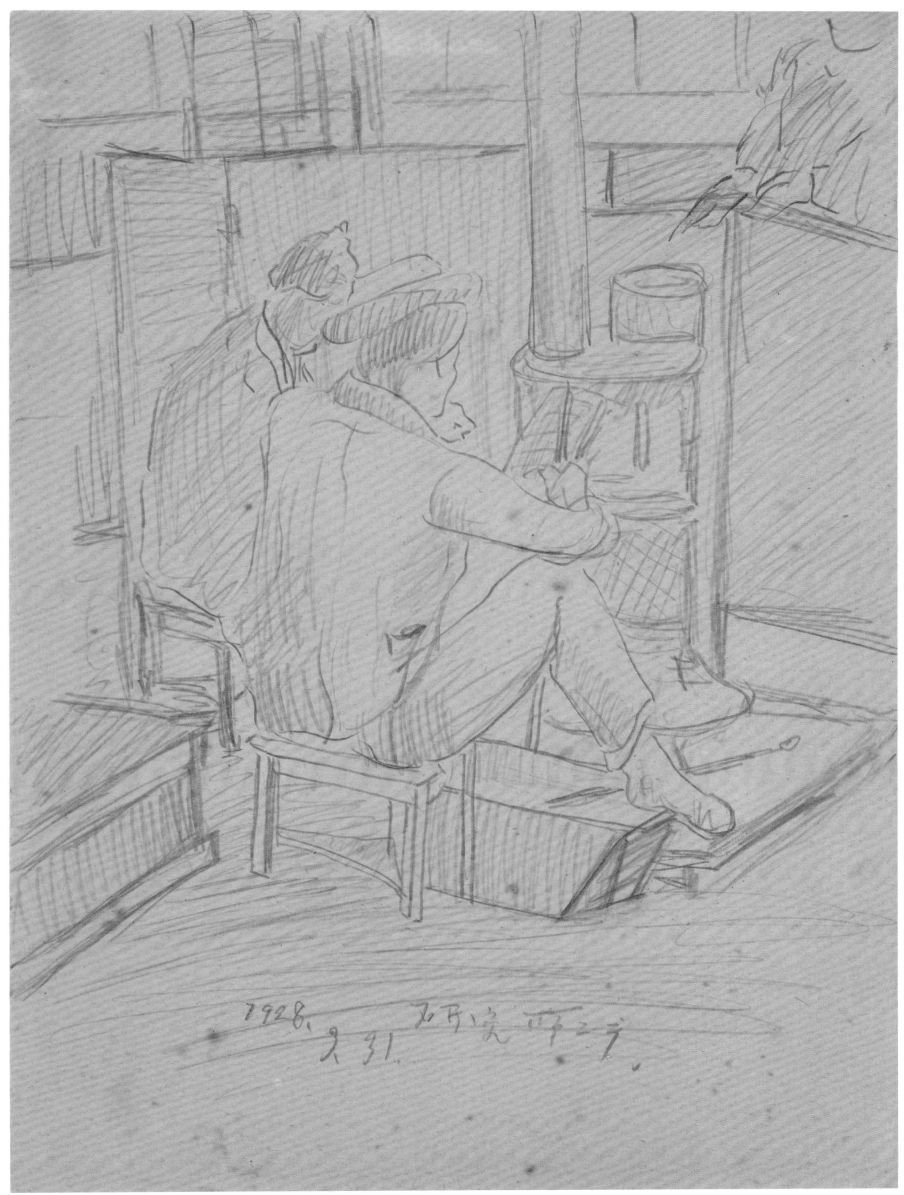

人物速寫-28.3.31（19）Figures Sketch-28.3.31（19）
1928 紙本鉛筆 33.3×24.2cm

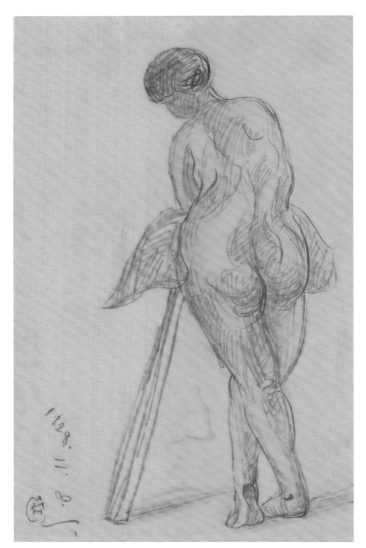

立姿裸女速寫-28.11.8（272）
Standing Female Nude Sketch-28.11.8（272）

1928　紙本鉛筆　21.5×13.9cm

頭像速寫-28.11.8（19）
Portrait Sketch-28.11.8（19）

1928　紙本鉛筆　21.5×13.8cm

頭像速寫-28.11.8（20）
Portrait Sketch-28.11.8（20）

1928　紙本鉛筆　21.6×13.8cm

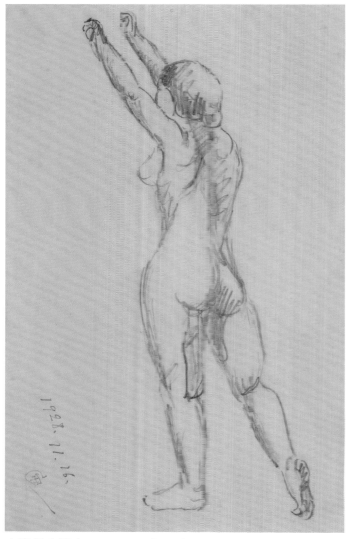

立姿裸女速寫-28.11.16（273）
Standing Female Nude Sketch-28.11.16（273）

1928　紙本鉛筆　21.5×13.8cm

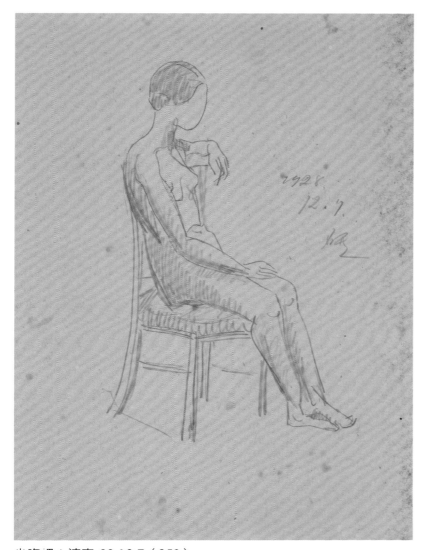

坐姿裸女速寫-28.12.7（253）
Sected Female Nude Sketch-28.12.7（253）

1928　紙本鉛筆　33.2×24.3cm

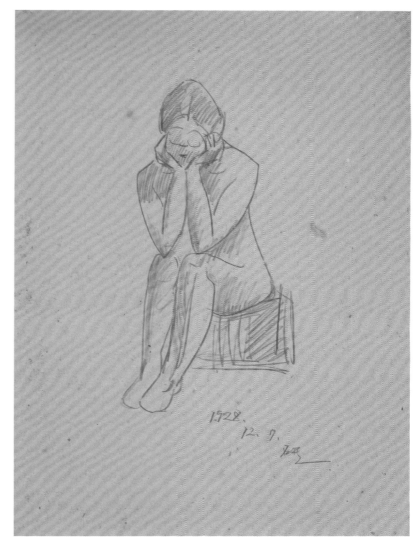

坐姿裸女速寫-28.12.7（254）
Seated Female Nude Sketch-28.12.7（254）

1928　紙本鉛筆　33.3×24.3cm

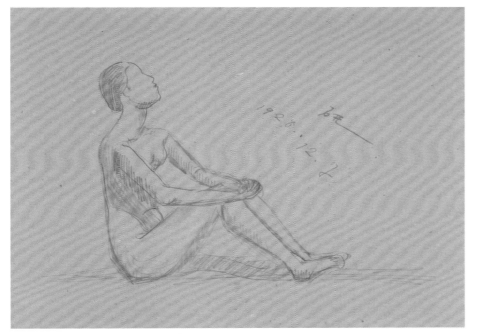

坐姿裸女速寫-28.12.7（255）
Seated Female Nude Sketch-28.12.7（255）

1928　紙本鉛筆　24.2×33.2cm

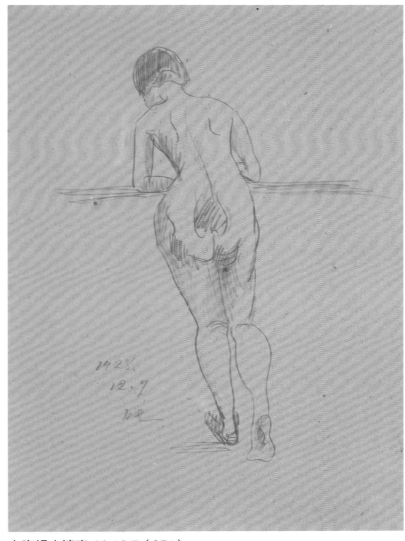

立姿裸女速寫-28.12.7（274）
Standing Female Nude Sketch-28.12.7（274）

1928　紙本鉛筆　33.2×24.3cm

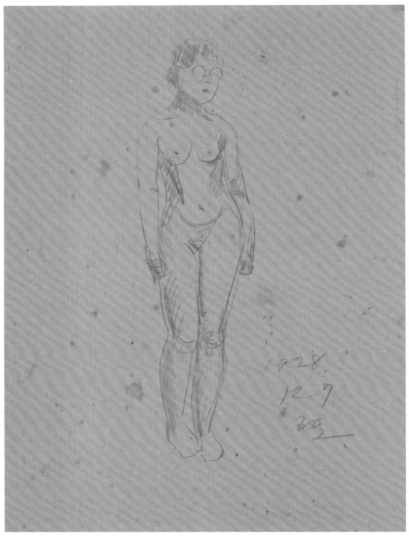

立姿裸女速寫-28.12.7（275）
Standing Female Nude Sketch-28.12.7（275）

1928　紙本鉛筆　33.2×24.3cm

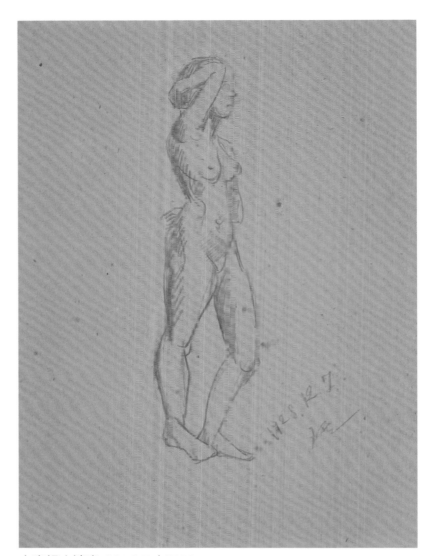

立姿裸女速寫-28.12.7（276）
Standing Female Nude Sketch-28.12.7（276）

1928　紙本鉛筆　33.2×24.3cm

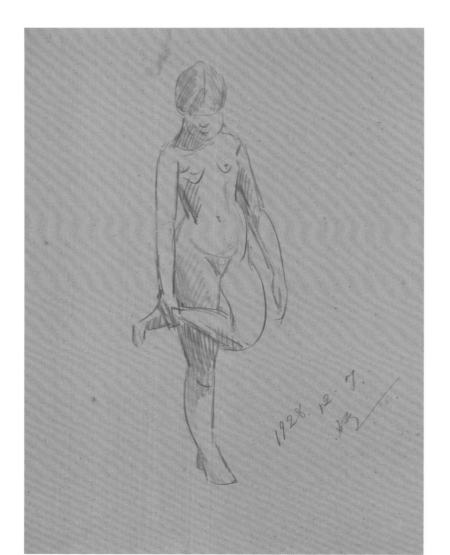

立姿裸女速寫-28.12.7（277）
Standing Female Nude Sketch-28.12.7（277）

1928　紙本鉛筆　33.2×24.3cm

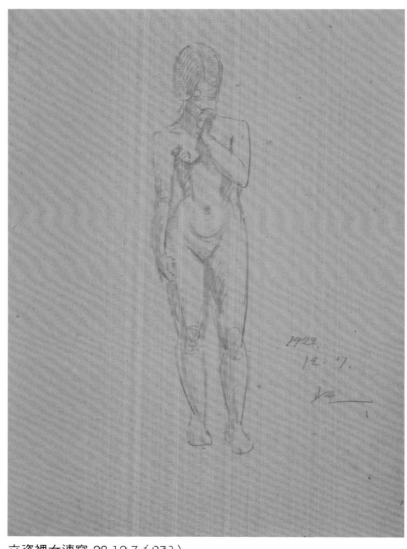

立姿裸女速寫-28.12.7（278）
Standing Female Nude Sketch-28.12.7（278）

1928　紙本鉛筆　33.2×24.3cm

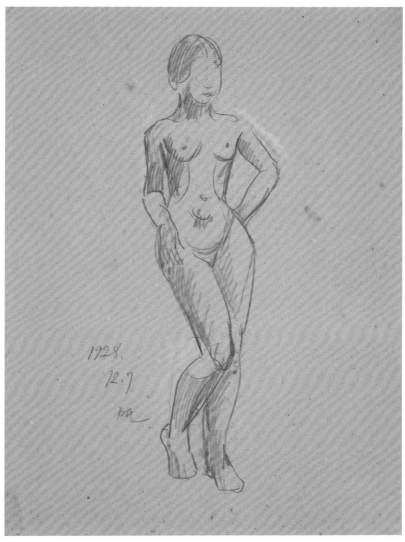

立姿裸女速寫-28.12.7（279）
Standing Female Nude Sketch-28.12.7（279）

1928　紙本鉛筆　33.2×24.3cm

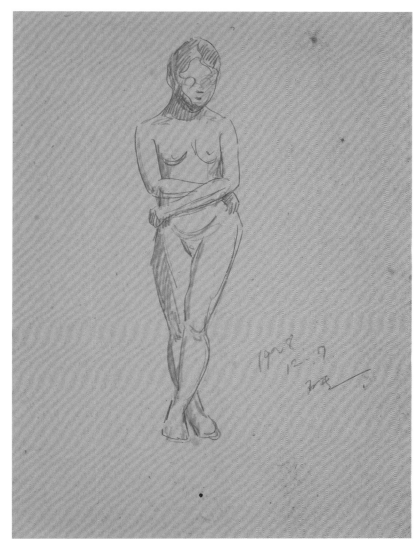

立姿裸女速寫-28.12.7（280）
Standing Female Nude Sketch-28.12.7（280）

1928　紙本鉛筆　33.2×24.3cm

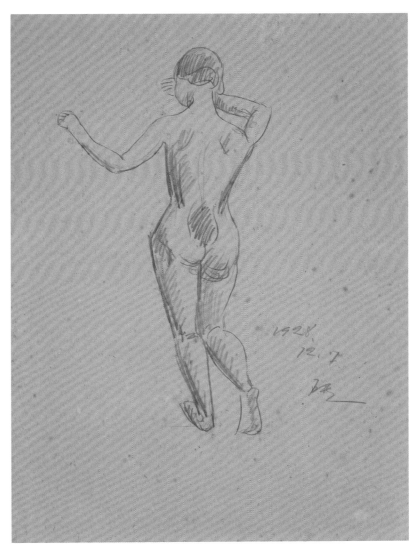

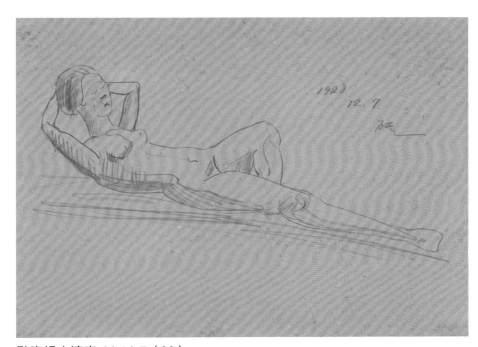

臥姿裸女速寫-28.12.7（30）
Reclining Female Nude Sketch-28.12.7（30）

1928　紙本鉛筆　24.3×33.2cm

立姿裸女速寫-28.12.7（281）
Standing Female Nude Sketch-28.12.7（281）

1928　紙本鉛筆　33.2×24.2cm

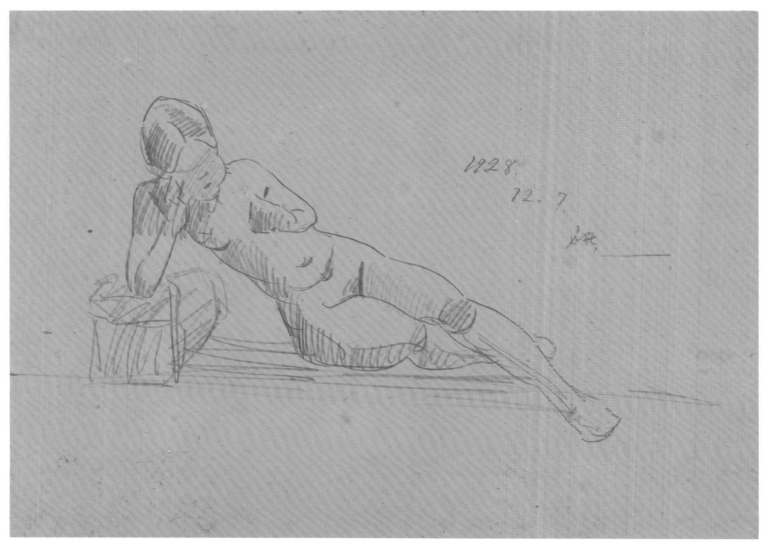

臥姿裸女速寫-28.12.7（31）
Reclining Female Nude Sketch-28.12.7（31）

1928　紙本鉛筆　24.3×33.2cm

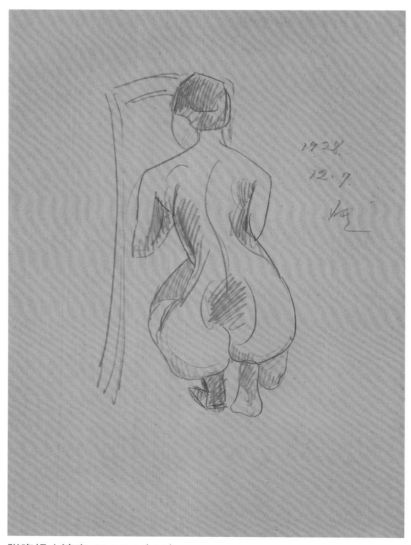

蹲姿裸女速寫-28.12.7（15）
Squatting Female Nude Sketch-28.12.7（15）

1928　紙本鉛筆　33.2×24.2cm

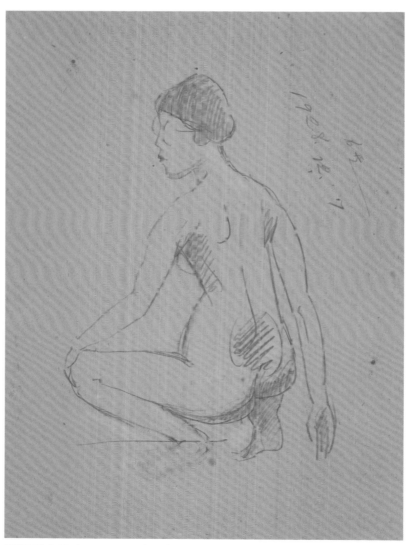

蹲姿裸女速寫-28.12.7（16）
Squatting Female Nude Sketch-28.12.7（16）

1928　紙本鉛筆　33.2×24.3cm

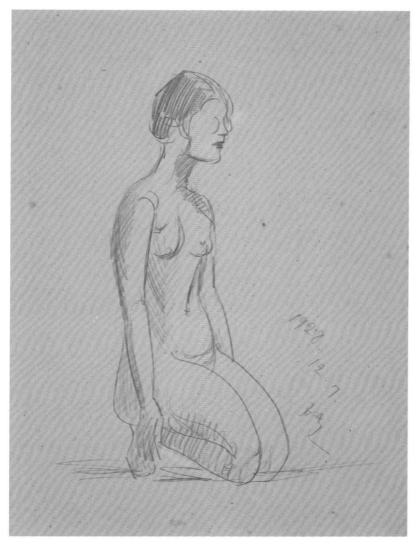

跪姿裸女速寫-28.12.7（20）
Kneeling Female Nude Sketch-28.12.7（20）

1928　紙本鉛筆　33.2×24.3cm

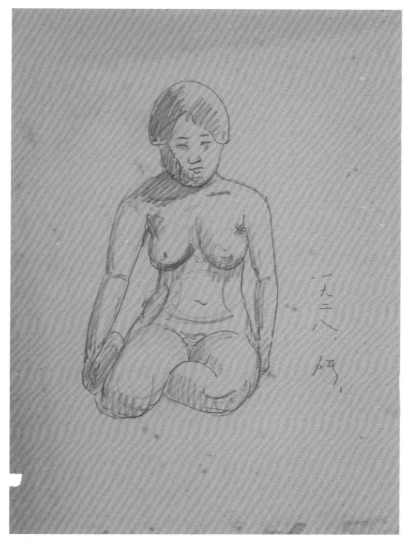

坐姿裸女速寫-28（256）
Seated Female Nude Sketch（256）

1928　紙本鉛筆　33.4×24.1cm

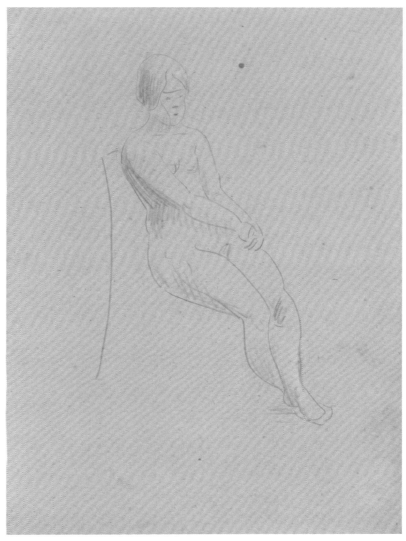

坐姿裸女速寫（257）
Seated Female Nude Sketch（257）

約1928　紙本色筆　33.2×24.3cm

· 1929

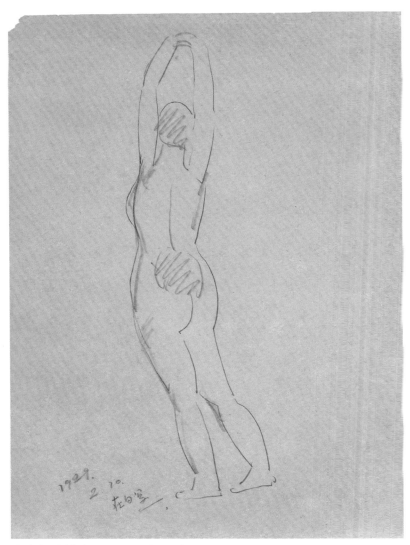

立姿裸女速寫-29.2.10（282）
Standing Female Nude Sketch-29.2.10（282）

1929　紙本鉛筆　33.5×24.5cm

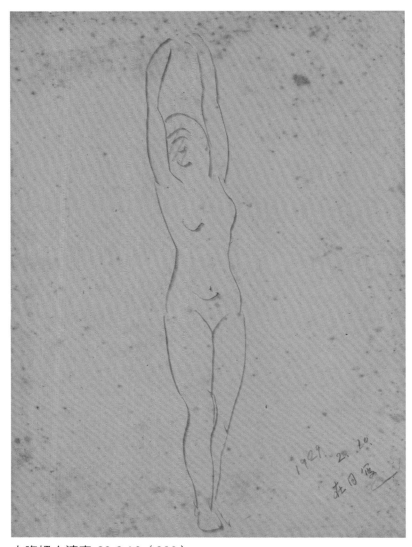

立姿裸女速寫-29.2.10（283）
Standing Female Nude Sketch-29.2.10（283）

1929　紙本鉛筆　33.2×24.2cm

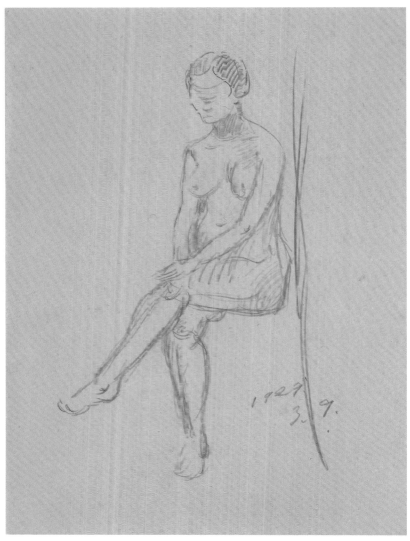

坐姿裸女速寫-29.3.9（258）
Seated Female Nude Sketch-29.3.9（258）

1929　紙本鉛筆　33.5×24.5cm

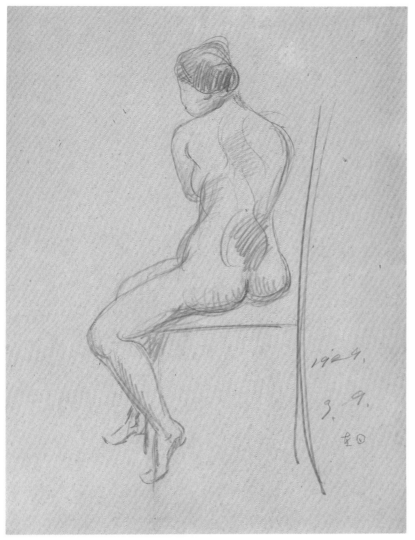

坐姿裸女速寫-29.3.9（259）
Seated Female Nude Sketch-29.3.9（259）

1929　紙本鉛筆　33.5×24.5cm

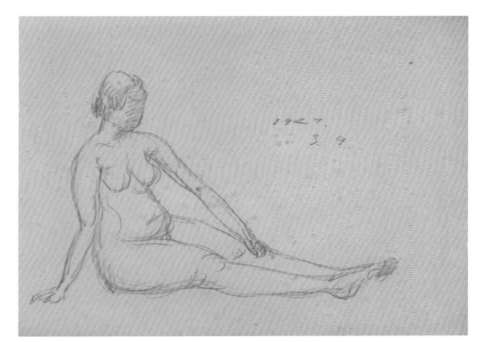

坐姿裸女速寫-29.3.9（260）
Seated Female Nude Sketch-29.3.9（260）

1929　紙本鉛筆　24.6×33.4cm

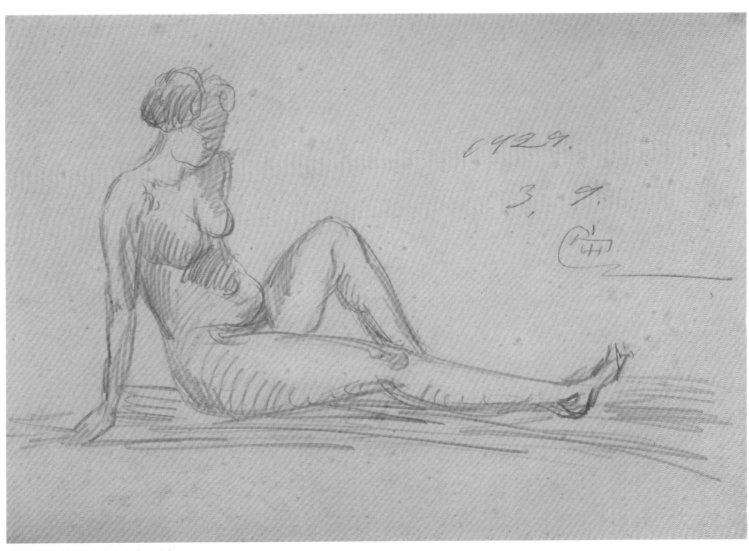

坐姿裸女速寫-29.3.9（261）
Seated Female Nude Sketch-29.3.9（261）

1929　紙本鉛筆　24.6×33.4cm

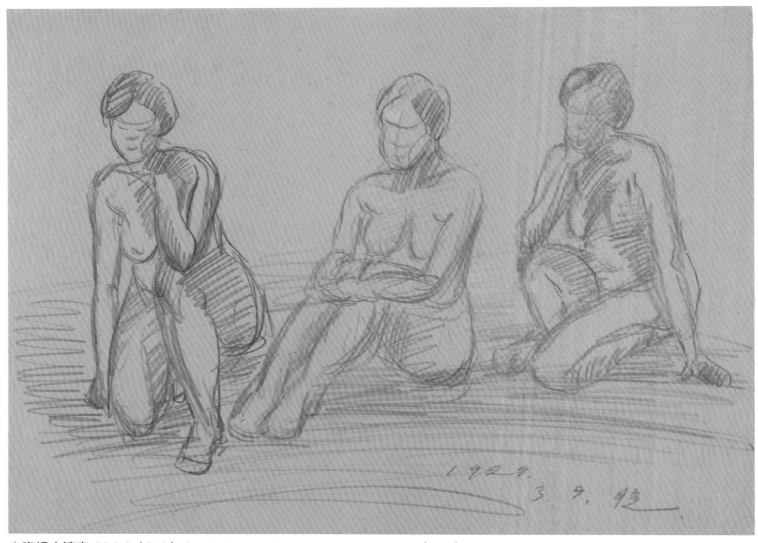

坐姿裸女速寫-29.3.9（262） Seated Female Nude Sketch-29.3.9（262）

1929　紙本鉛筆　24.7×33.5cm

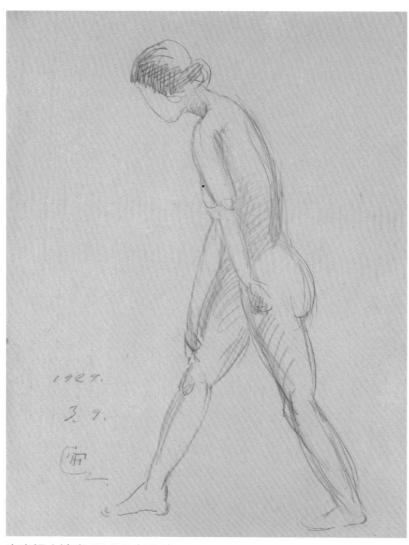

立姿裸女速寫-29.3.9（284）
Standing Female Nude Sketch-29.3.9（284）

1929　紙本鉛筆　33.5×24.5cm

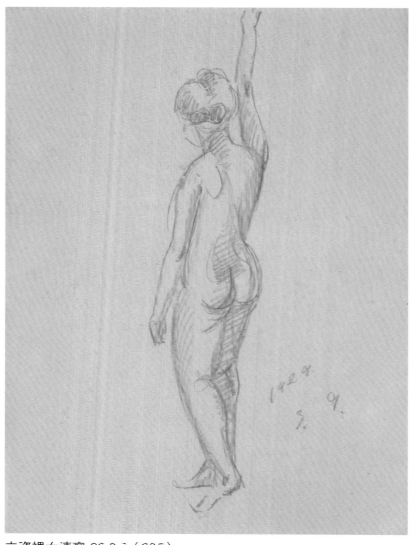

立姿裸女速寫-29.3.9（285）
Standing Female Nude Sketch-29.3.9（285）

1929　紙本鉛筆　33.5×24.5cm

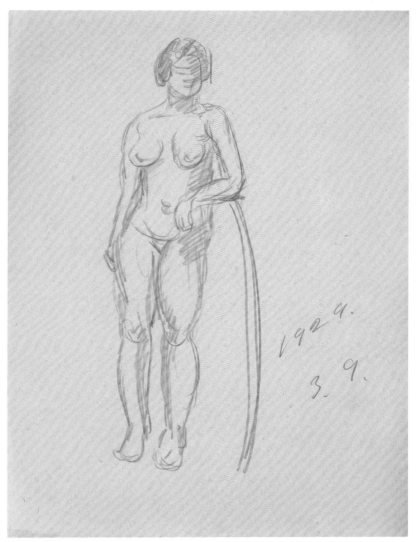

立姿裸女速寫-29.3.9（286）
Standing Female Nude Sketch-29.3.9（286）

1929　紙本鉛筆　33.5×24.5cm

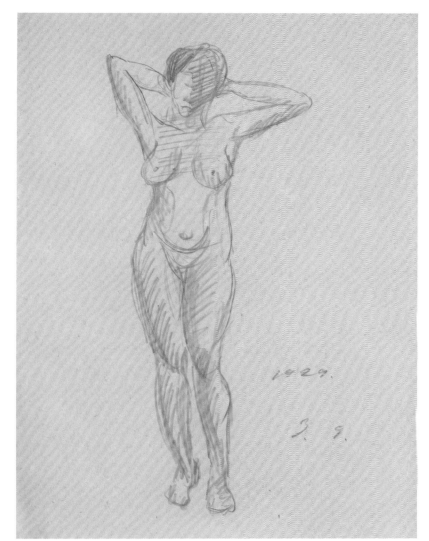

立姿裸女速寫-29.3.9（287）
Standing Female Nude Sketch-29.3.9（287）

1929　紙本鉛筆　33.5×24.5cm

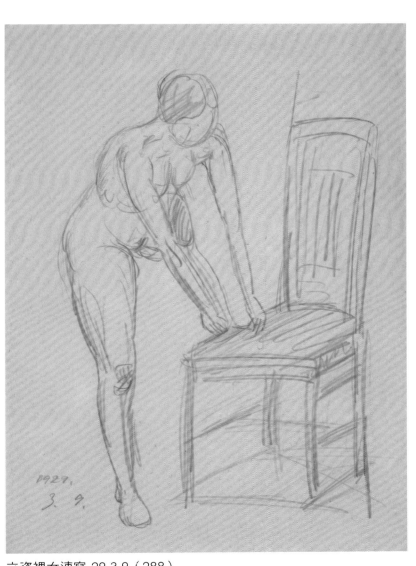

立姿裸女速寫-29.3.9（288）
Standing Female Nude Sketch-29.3.9（288）

1929　紙本鉛筆　33.4×24.7cm

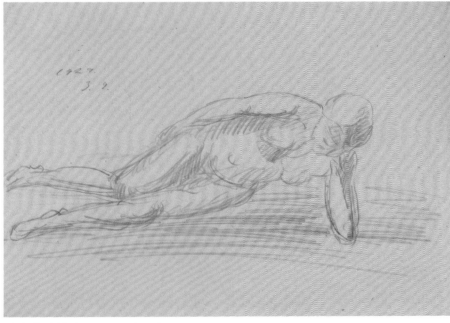

臥姿裸女速寫-29.3.9（32）
Reclining Female Nude Sketch-29.3.9（32）

1929　紙本鉛筆　24.2×33.5cm

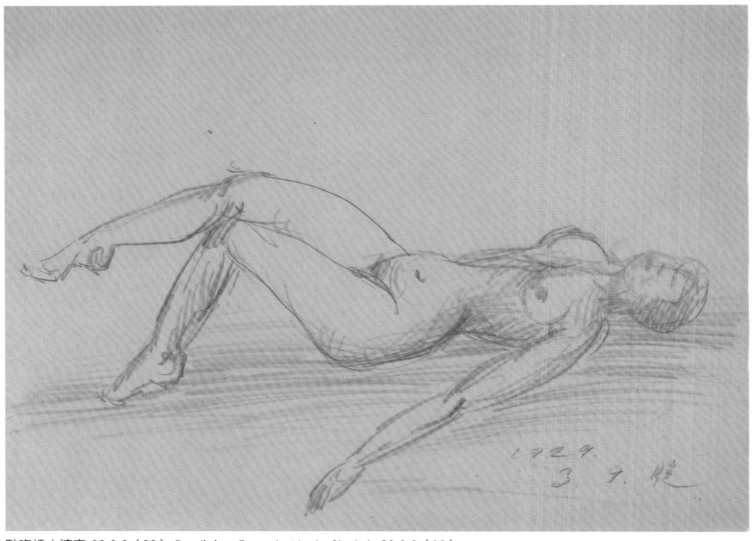

臥姿裸女速寫-29.3.9（33） Reclining Female Nude Sketch-29.3.9（33）

1929　紙本鉛筆　24.7×33.4cm

臥姿裸女速寫-29.3.9（34）
Reclining Female Nude Sketch-29.3.9（34）

1929　紙本鉛筆　24.7×33.4cm

跪姿裸女速寫-29.3.9（21）
Kneeling Female Nude Sketch-29.3.9（21）

1929　紙本鉛筆　33.4×24.7cm

跪姿裸女速寫-29.3.9（22）
Kneeling Female Nude Sketch-29.3.9（22）

1929　紙本鉛筆　24.7×33.4cm

跪姿裸女速寫-29.3.9（23）
Kneeling Female Nude Sketch-29.3.9（23）

1929　紙本鉛筆　33.4×24.7cm

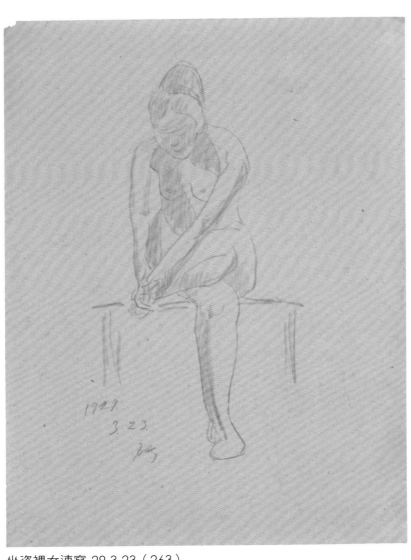

坐姿裸女速寫-29.3.23（263）
Seated Female Nude Sketch-29.3.23（263）

1929　紙本鉛筆　33.2×24.6cm

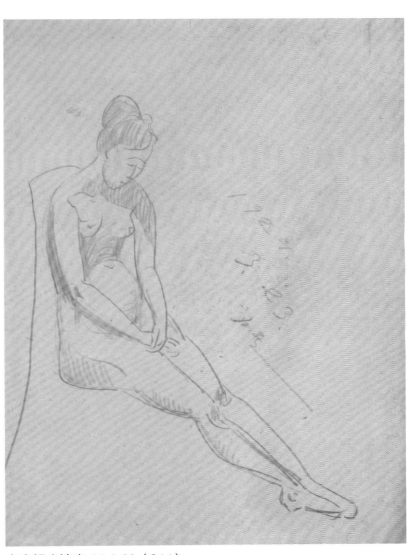

坐姿裸女速寫-29.3.23（264）
Seated Female Nude Sketch-29.3.23（264）

1929　紙本鉛筆　33.3×24.7cm

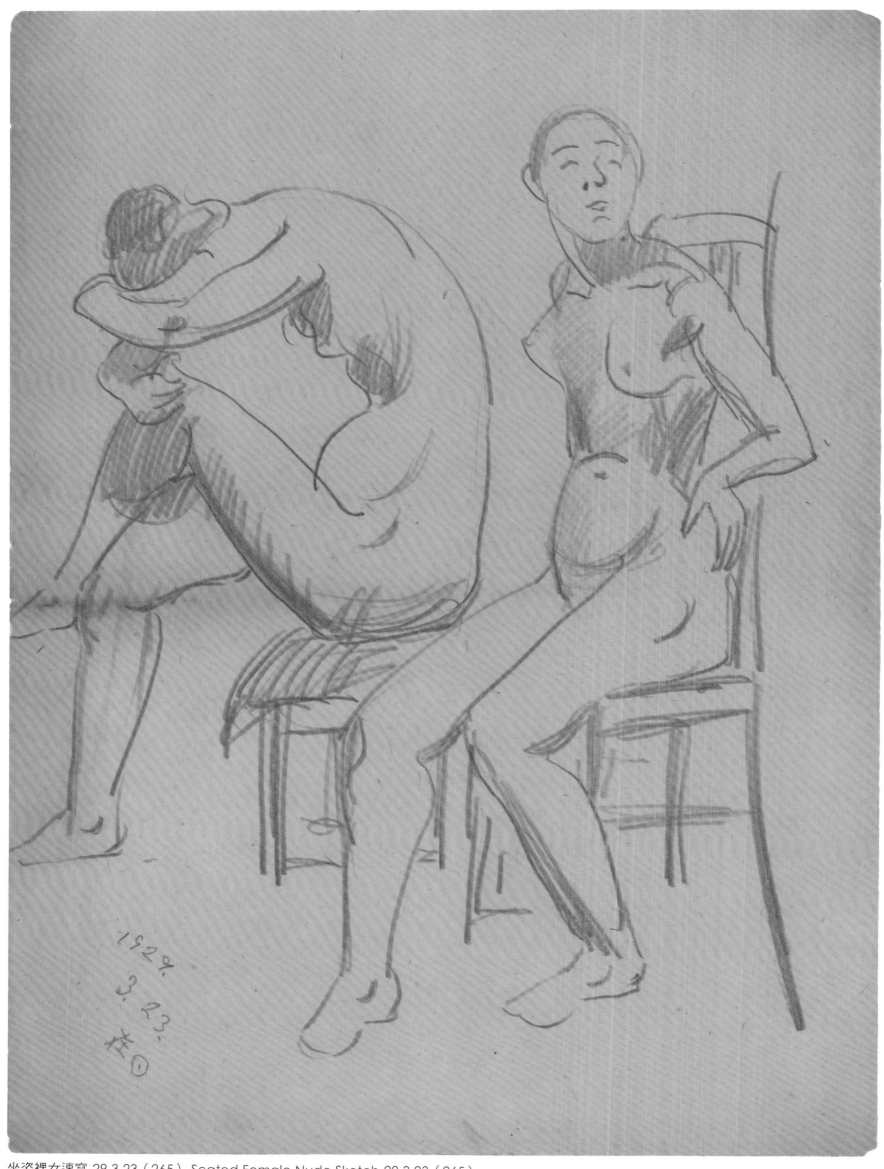

坐姿裸女速寫-29.3.23（265）Seated Female Nude Sketch-29.3.23（265）

1929　紙本鉛筆　33.4×22.7cm

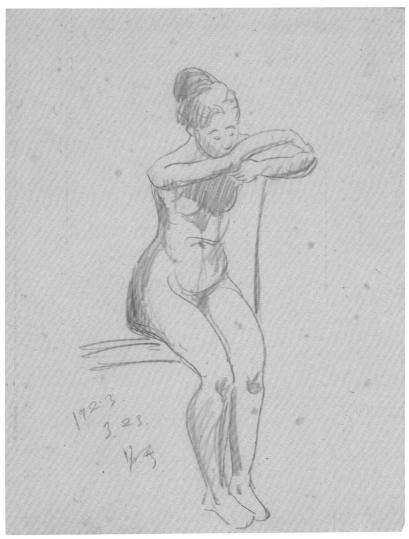

坐姿裸女速寫-29.3.23（266）
Seated Female Nude Sketch-29.3.23（266）

1929　紙本鉛筆　33.3×24.6cm
※落款年代疑為筆誤，應為1929.3.23所畫。

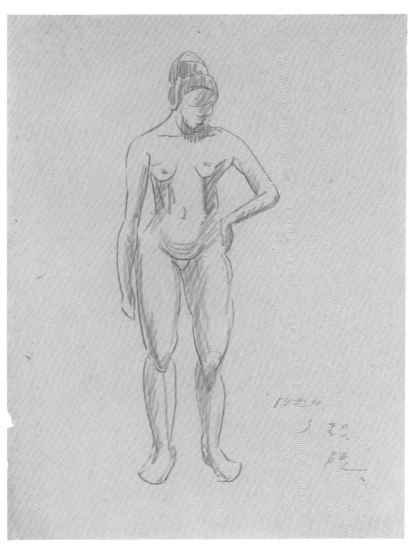

立姿裸女速寫-29.3.23（289）
Standing Female Nude Sketch-29.3.23（289）

1929　紙本鉛筆　33.5×24.5cm

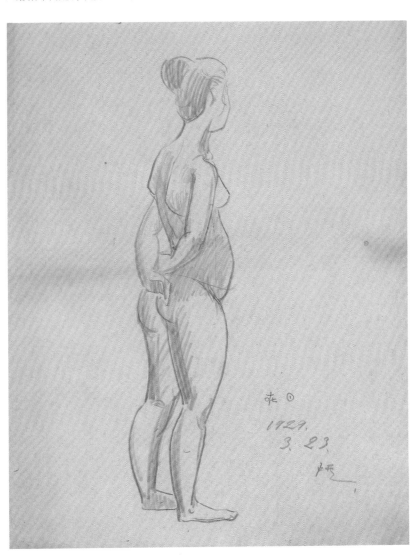

立姿裸女速寫-29.3.23（290）
Standing Female Nude Sketch-29.3.23（290）

1929　紙本鉛筆　33.5×24.5cm

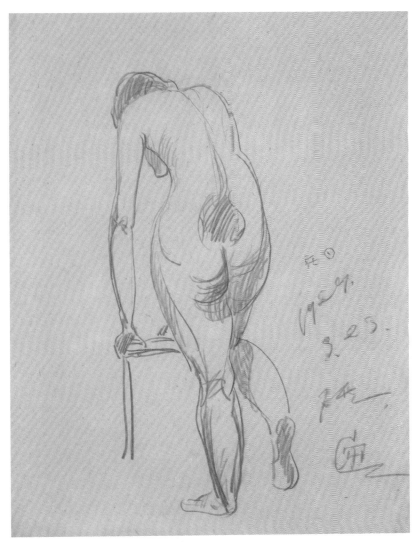

立姿裸女速寫-29.3.23（291）
Standing Female Nude Sketch-29.3.23（291）

1929　紙本鉛筆　33.3×24.5cm

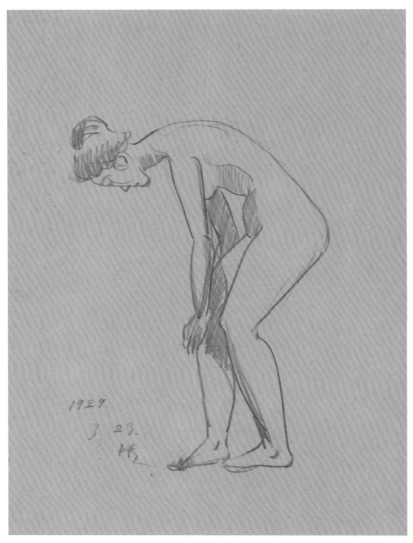

立姿裸女速寫-29.3.23（292）
Standing Female Nude Sketch-29.3.23（292）

1929　紙本鉛筆　33.5×24.7cm

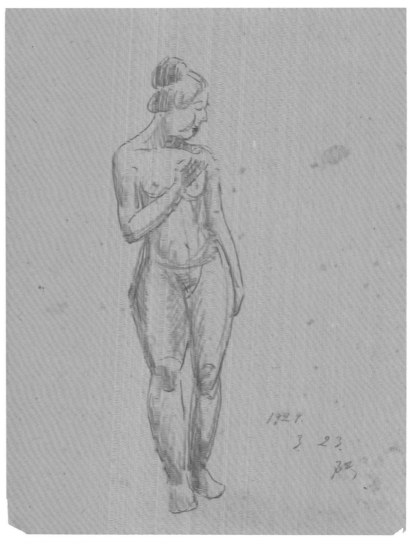

立姿裸女速寫-29.3.23（293）
Standing Female Nude Sketch-29.3.23（293）

1929　紙本鉛筆　33.3×24.6cm

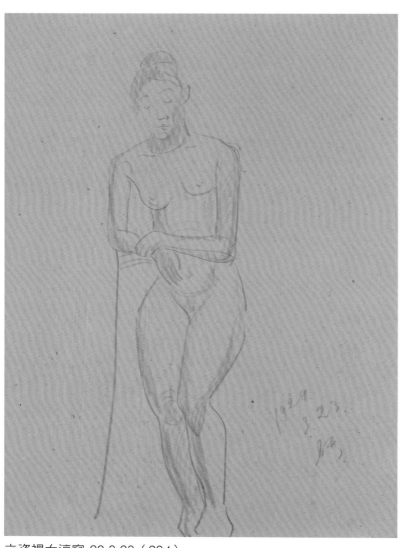

立姿裸女速寫-29.3.23（294）
Standing Female Nude Sketch-29.3.23（294）

1929　紙本鉛筆　33.2×24.5cm

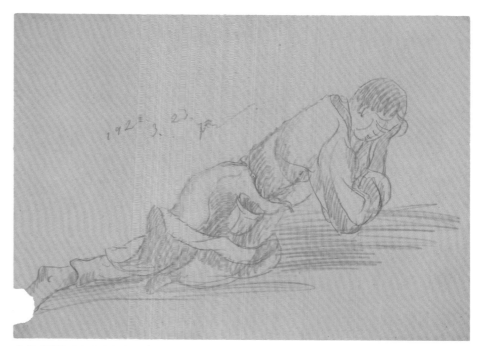

人物速寫-29.3.23（20）
Figure Sketch-29.3.23（20）

1929　紙本鉛筆　24.7×33.4cm

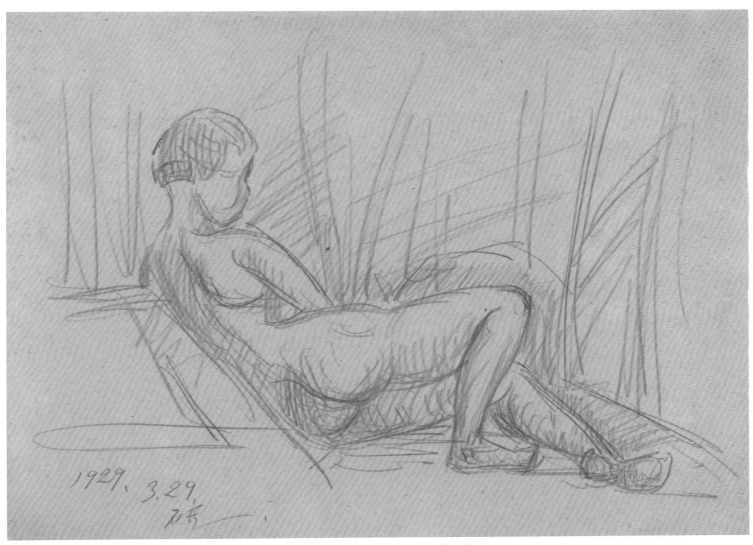

臥姿裸女速寫-29.3.29（35） Reclining Female Nude Sketch-29.3.29（35）
1929　紙本鉛筆　24.5×33.3cm

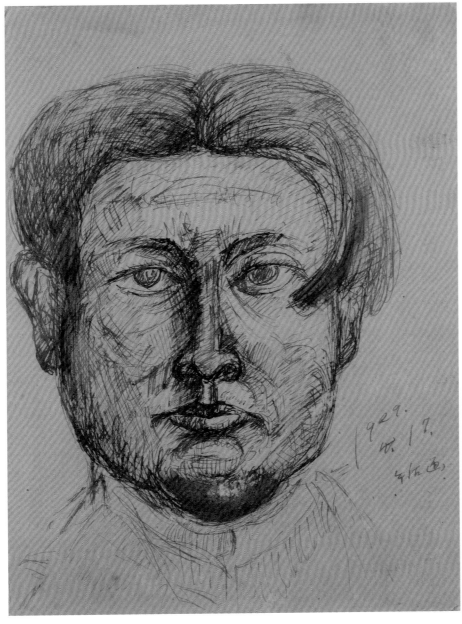

頭像速寫-29.4.17（21） Portrait Sketch-29.4. 7（21）
1929　紙本鋼筆　30.3×22.1cm

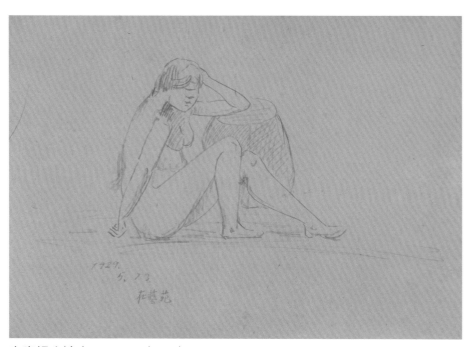

坐姿裸女速寫-29.5.13（267）
Seated Female Nude Sketch-29.5.13（267）

1929　紙本鉛筆　24.7×33.2cm

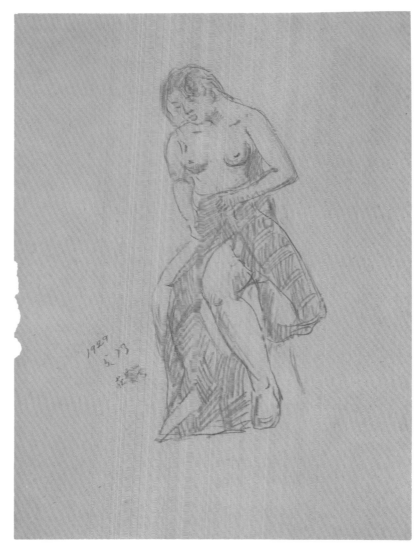

坐姿裸女速寫-29.5.13（268）
Seated Female Nude Sketch-29.5.13（268）

1929　紙本鉛筆　33.5×24.2cm

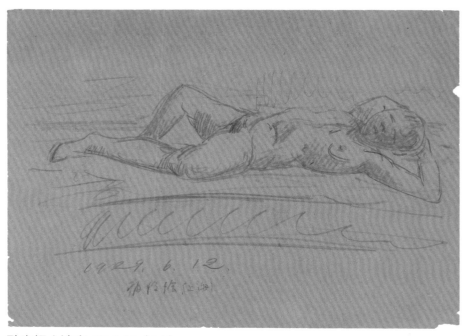

臥姿裸女速寫-29.6.12（36）
Reclining Female Nude Sketch-29.6.12（36）

1929　紙本鉛筆　24.2×32.9cm

臥姿裸女速寫-29.6.12（37）
Reclining Female Nude Sketch-29.6.12（37）

1929　紙本鉛筆　33×24.2cm

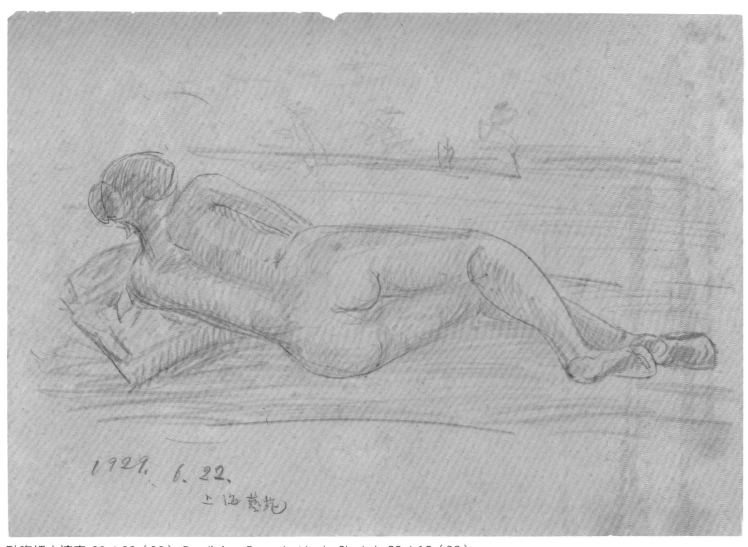

臥姿裸女速寫-29.6.22（38） Reclining Female Nude Sketch-29.6.12（38）

1929　紙本鉛筆　24.6×33.5cm

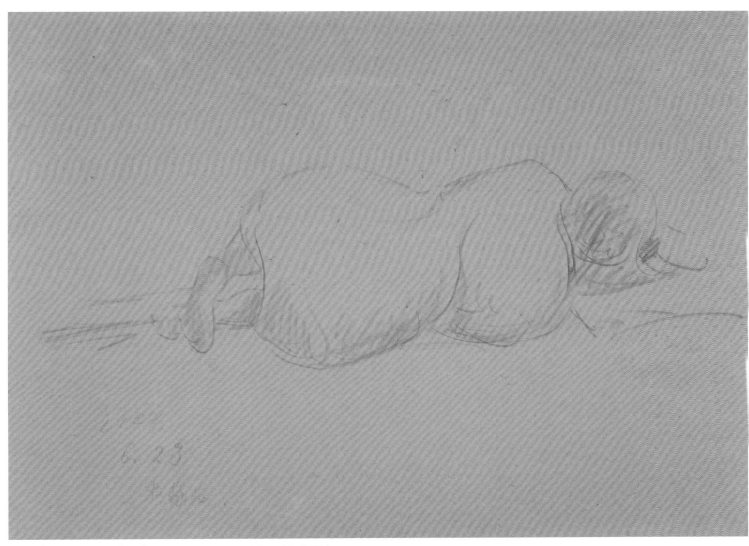

人物速寫-29.6.23（21） Figure Sketch-29.6.23（21）

1929　紙本鉛筆　24.2×33cm

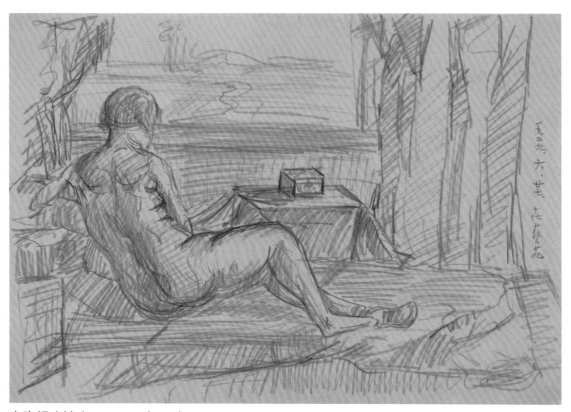

坐姿裸女速寫-29.6.27（269） Seated Female Nude Sketch-29.6.27（269）

1929　紙本鉛筆　24.4×33.4cm

頭像速寫（22） Portrait Sketch（22）

約1929　紙本鉛筆　33.4×24.7cm
※為前一張之背面圖

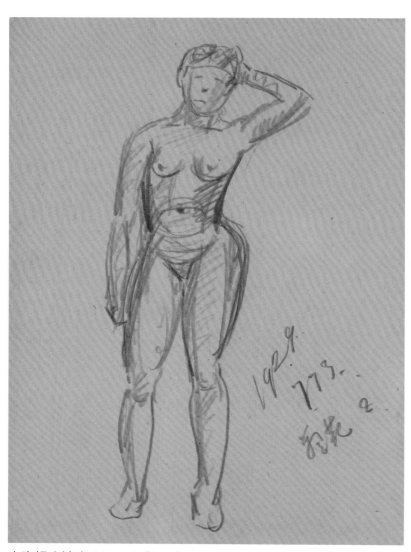

立姿裸女速寫-29.7.13（295）
Standing Female Nude Sketch-29.7.13（295）

1929　紙本鉛筆　33.4×24.7cm

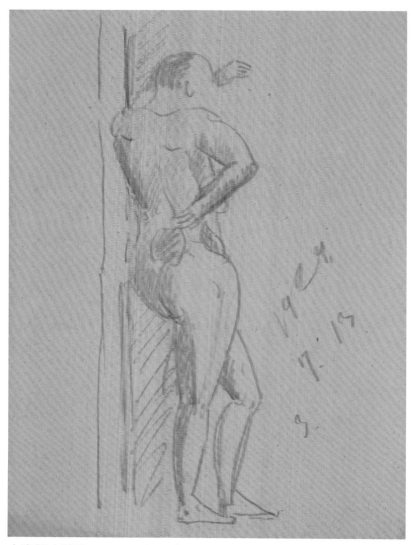

立姿裸女速寫-29.7.13（296）
Standing Female Nude Sketch-29.7.13（296）

1929　紙本鉛筆　33.2×24.5cm

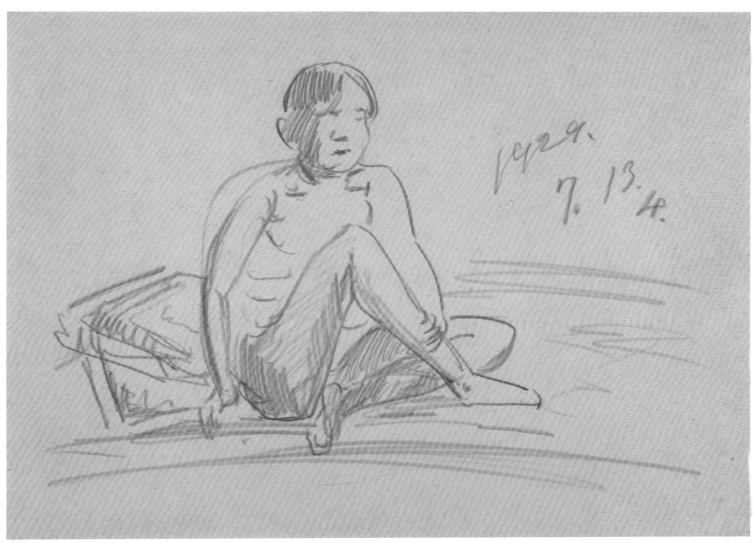

坐姿裸女速寫-29.7.13（270）
Seated Female Nude Sketch-29.7.13（27C）

1929　紙本鉛筆　24.4×33.3cm

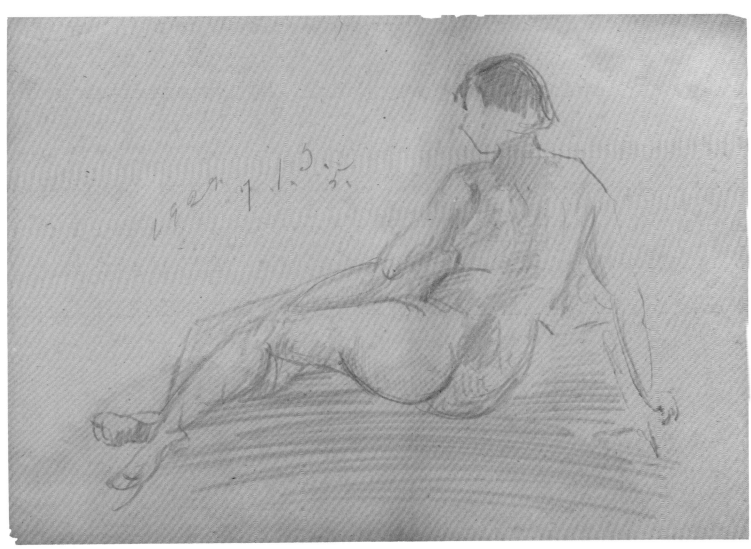

坐姿裸女速寫-29.7.13（271）
Seated Female Nude Sketch-29.7.13（271）

1929　紙本鉛筆　24.5×33.2cm

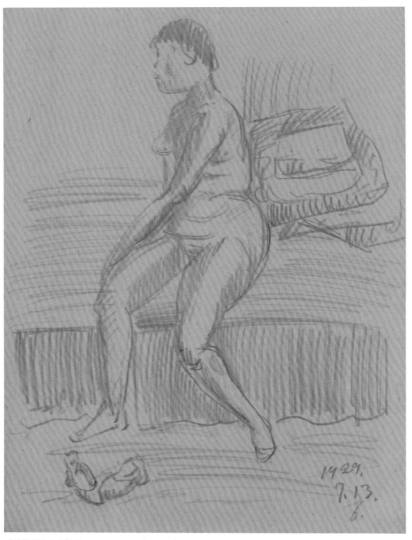

坐姿裸女速寫-29.7.13（272）
Seated Female Nude Sketch-29.7.13（272）

1929　紙本鉛筆　33.1×24.5cm

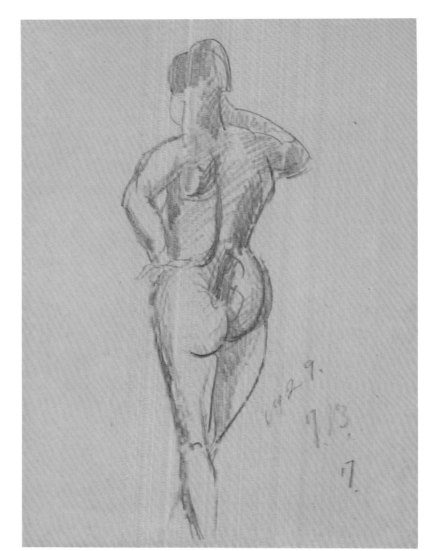

立姿裸女速寫-29.7.13（297）
Standing Female Nude Sketch-29.7.13（297）

1929　紙本鉛筆　33×24.2cm

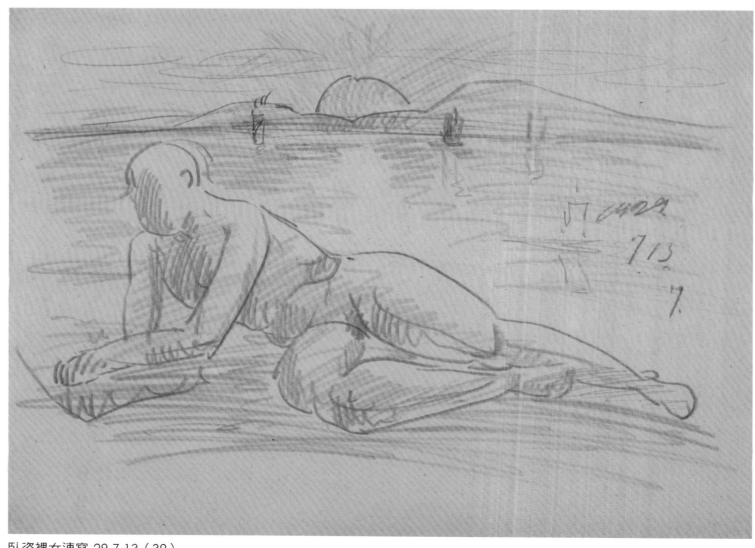

臥姿裸女速寫-29.7.13（39）
Reclining Female Nude Sketch-29.7.13（39）

1929　紙本鉛筆　24.5×33.3cm

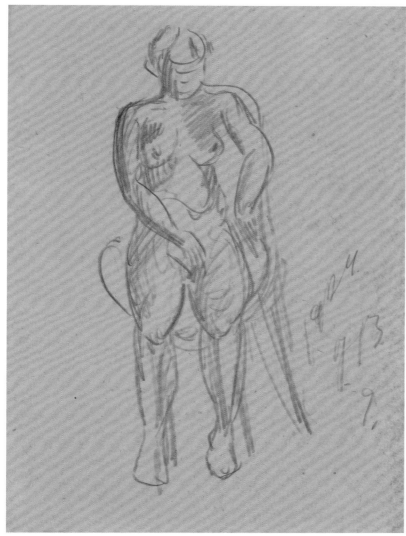

坐姿裸女速寫-29.7.13（273）
Seated Female Nude Sketch-29.7.13（273）

1929　紙本鉛筆　33×24.2cm

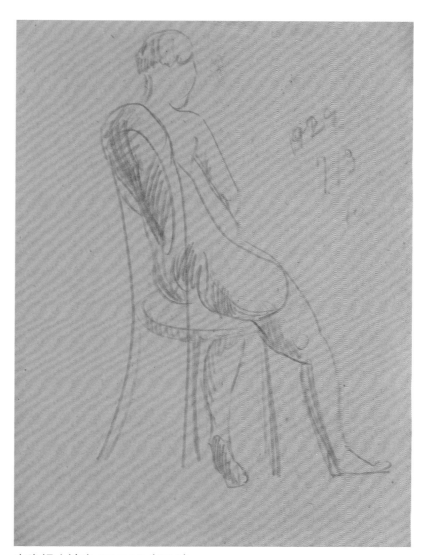

坐姿裸女速寫-29.7.13（274）
Seated Female Nude Sketch-29.7.13（274）

1929　紙本鉛筆　33×24.2cm

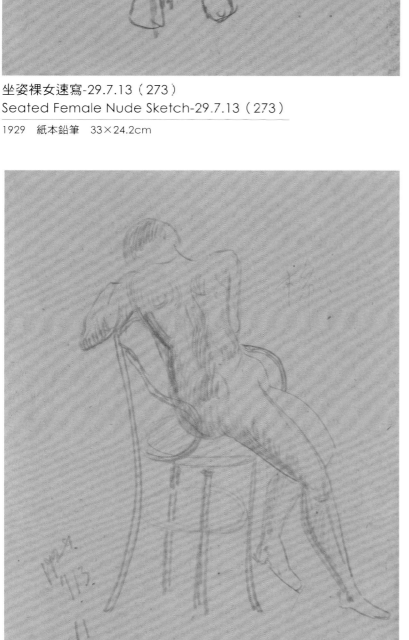

坐姿裸女速寫-29.7.13（275）
Seated Female Nude Sketch-29.7.13（275）

1929　紙本鉛筆　33×24.2cm

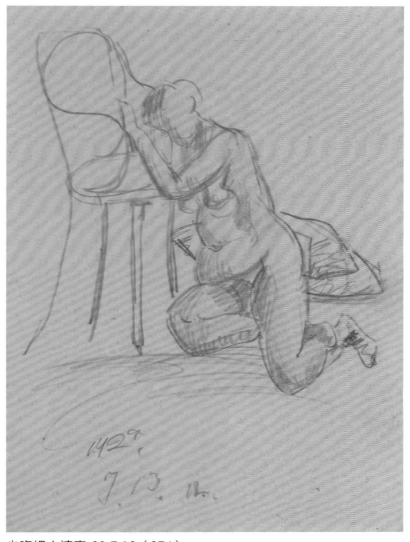

坐姿裸女速寫-29.7.13（276）
Seated Female Nude Sketch-29.7.13（276）

1929　紙本鉛筆　33×24.2cm

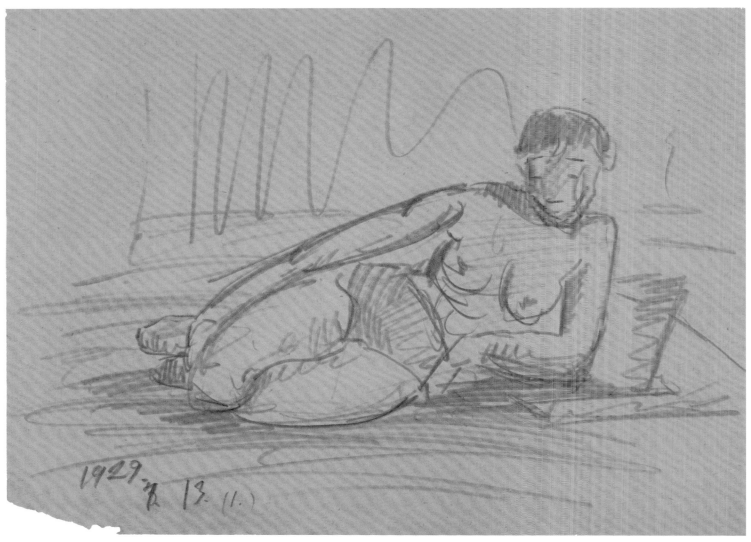

臥姿裸女速寫-29.7.13（40） Reclining Female Nude Sketch-29.7.13（40）

1929　紙本鉛筆　24.5×33.3cm

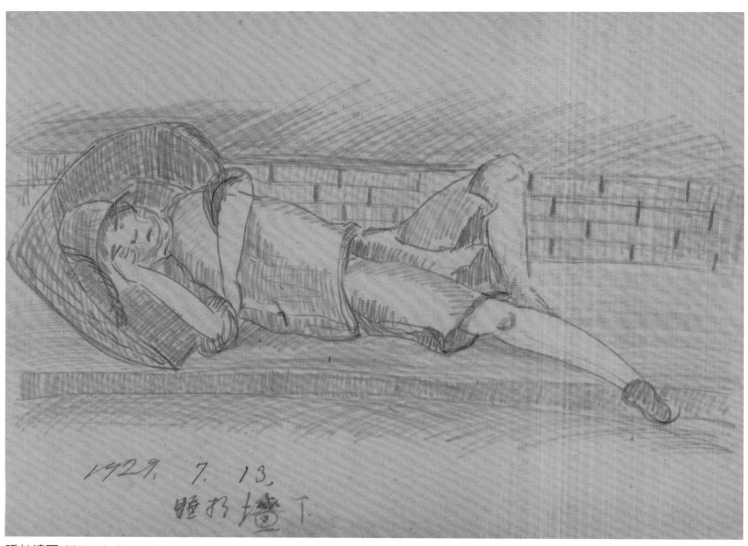

睡於墙下-29.7.13 Sleeping Against a Wall-29.7.13

1929　紙本鉛筆　24.5×33.1cm

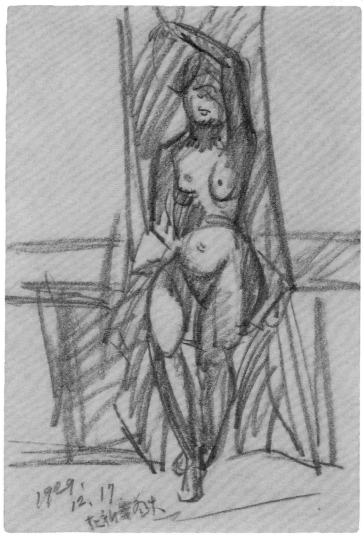

立姿裸女速寫-29.12.17（298）
Standing Female Nude Sketch-29.12.17（298）

1929　紙本鉛筆　24.2×15.8cm

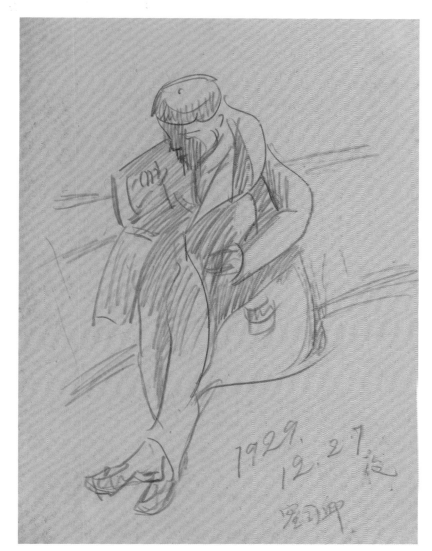

人物速寫-29.12.27（22）
Figure Sketch-29.12.27（22）

1929　紙本鉛筆　33×24.4cm

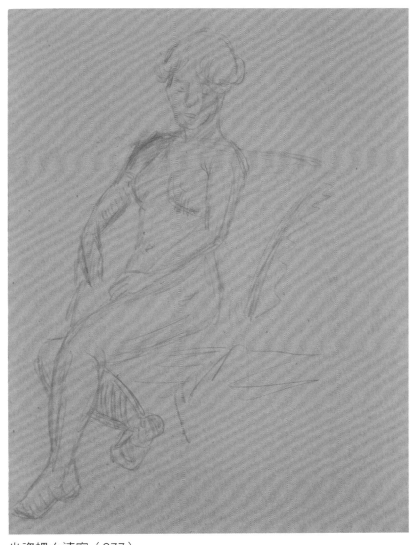

坐姿裸女速寫（277）
Seated Female Nude Sketch（277）

約1929　紙本鉛筆　32.9×24.5cm

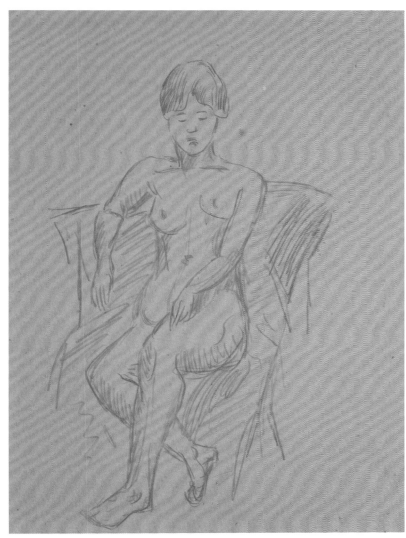

坐姿裸女速寫（278）
Seated Female Nude Sketch（278）

約1929　紙本鉛筆　33.1×24.2cm

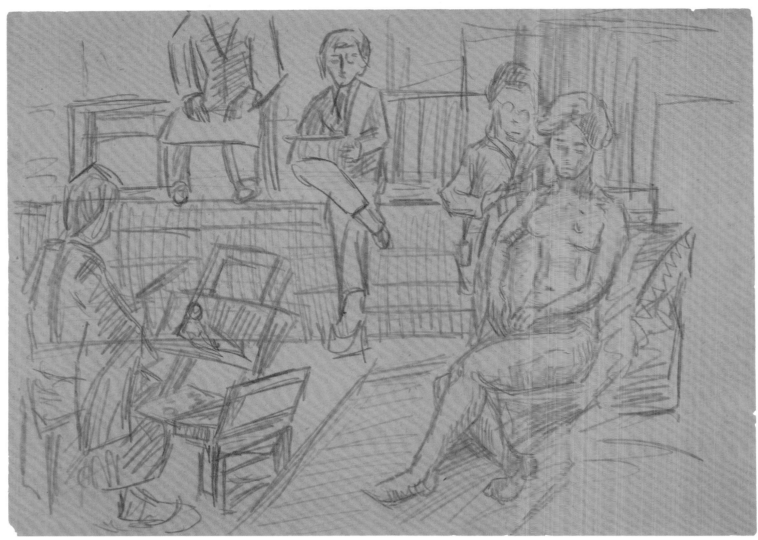

畫室速寫（1）Studio Sketch（1）
約1929　紙本鉛筆　24.1×33cm

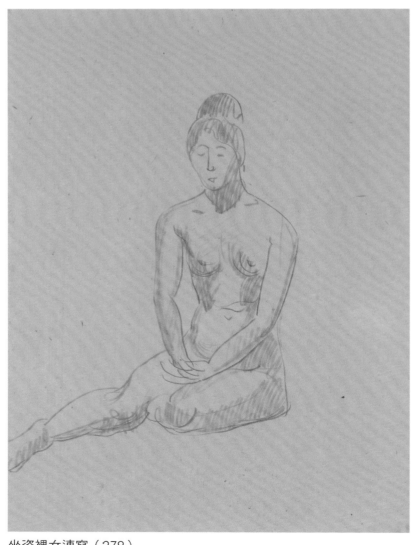

坐姿裸女速寫（279）
Seated Female Nude Sketch（279）

約1929　紙本鉛筆　33.2×24.7cm

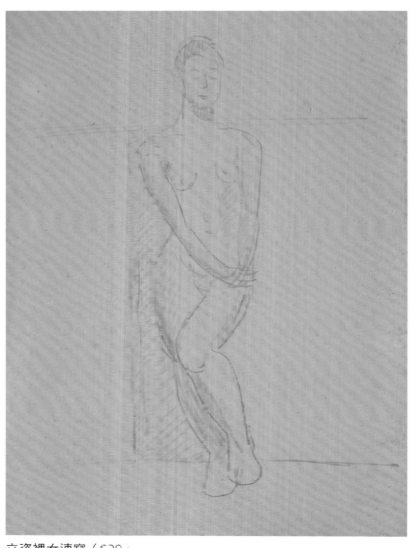

立姿裸女速寫（279）
Standing Female Nude Sketch（279）

約1929　紙本鉛筆　33.2×24.7cm

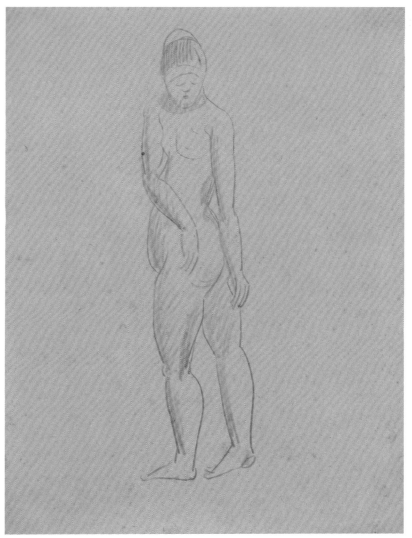

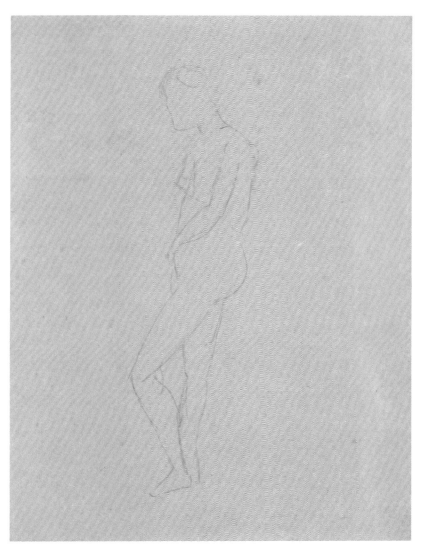

立姿裸女速寫（300）Standing Female Nude Sketch（300）

約1929　紙本鉛筆　33.3×24.7cm

立姿裸女速寫（301）Standing Female Nude Sketch（301）

約1929　紙本鉛筆　33.4×24.7cm
※為下一張之背面圖。

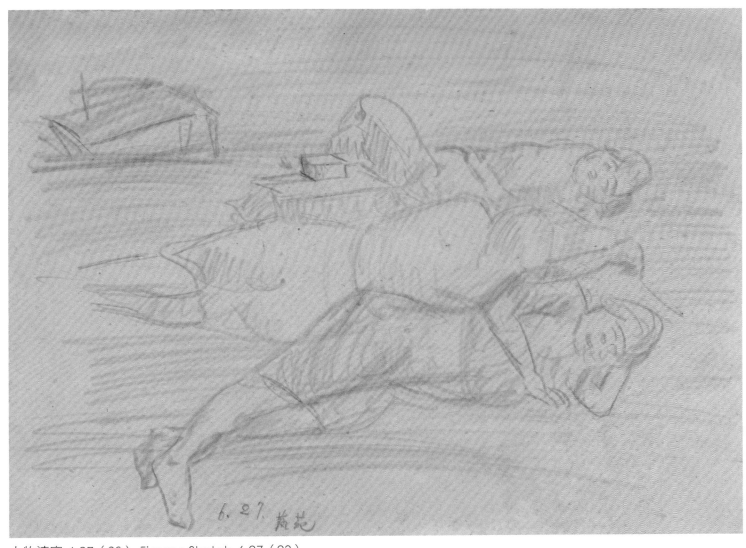

人物速寫-6.27（23）Figures Sketch-6.27（23）

約1929　紙本鉛筆　24.7×33.4cm

速寫
Sketch

1930-1945

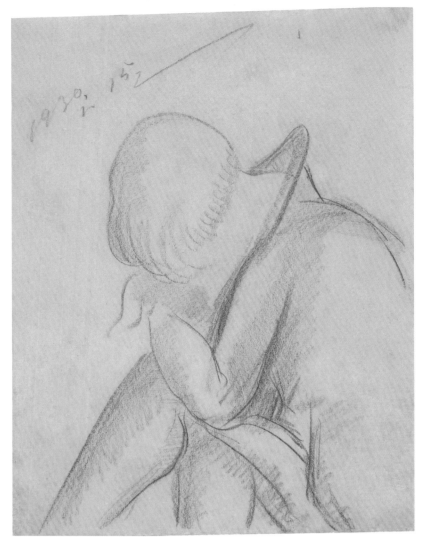

人物速寫-30.1.15（24）Figure Sketch-30.1.15（24）
1930　紙本色筆　25.5×18.8cm

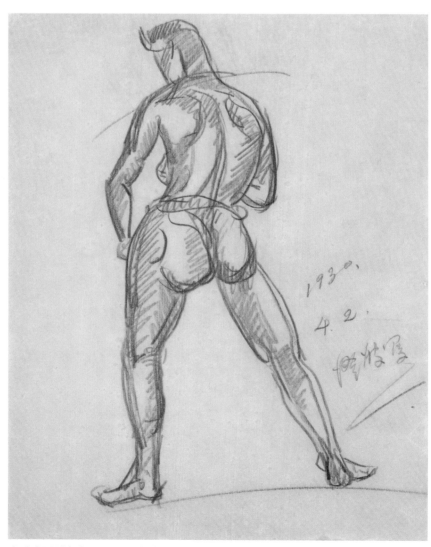

立姿裸男速寫-30.4.2（1）
Standing Male Nude Sketch-30.4.2（1）
1930　紙本鉛筆　31.9×23.9cm

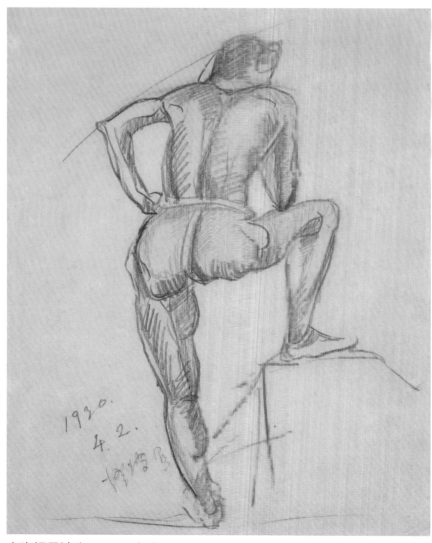

立姿裸男速寫-30.4.2（2）
Standing Male Nude Sketch-30.4.2（2）
1930　紙本鉛筆　31.2×24.4cm

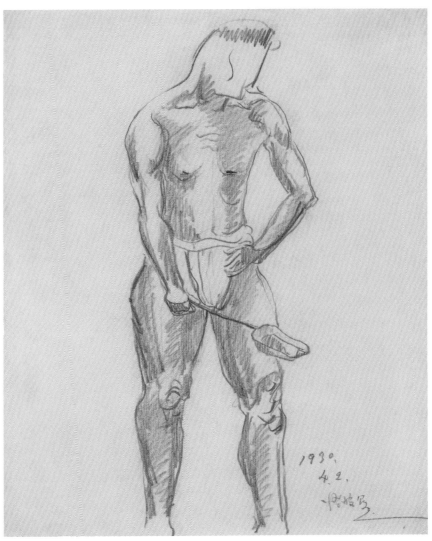

立姿裸男速寫-30.4.2（3）
Standing Male Nude Sketch-30.4.2（3）

1930　紙本鉛筆　31.3×24.8cm

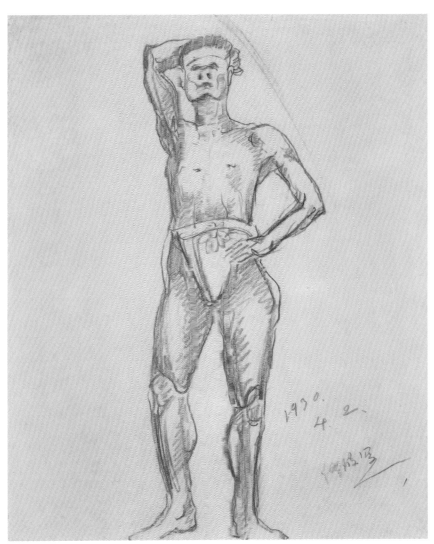

立姿裸男速寫-30.4.2（4）
Standing Male Nude Sketch-30.4.2（4）

1930　紙本鉛筆　31.9×23.9cm

在九段的舞廳-30.7 A Dance Hall in Kudan-30.7

1930　紙本鉛筆　22.7×17cm

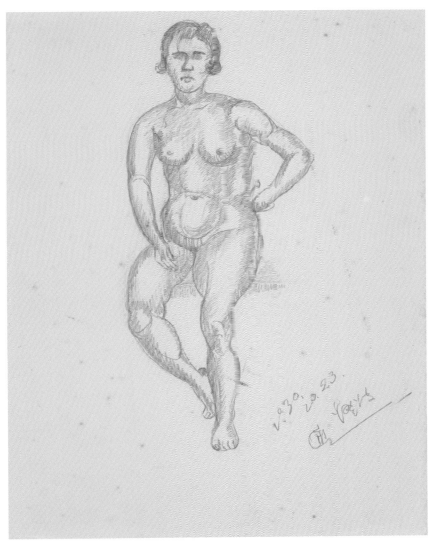

坐姿裸女速寫-30.10.23（280）
Seated Female Nude Sketch-30.10.23（280）

1930　紙本鉛筆　37.9×29.3cm

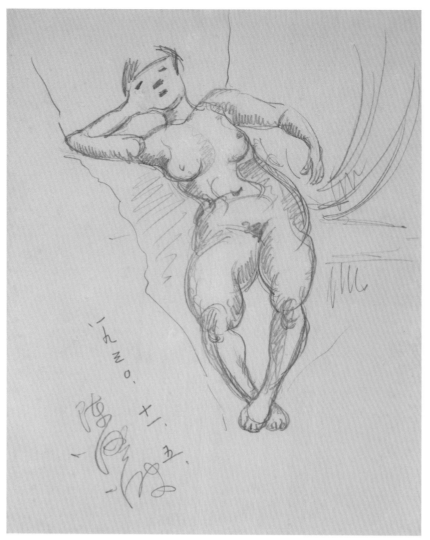

臥姿裸女速寫-30.11.5（41）
Reclining Female Nude Sketch-30.11.5（41）

1930　紙本鉛筆　38.2×29.3cm

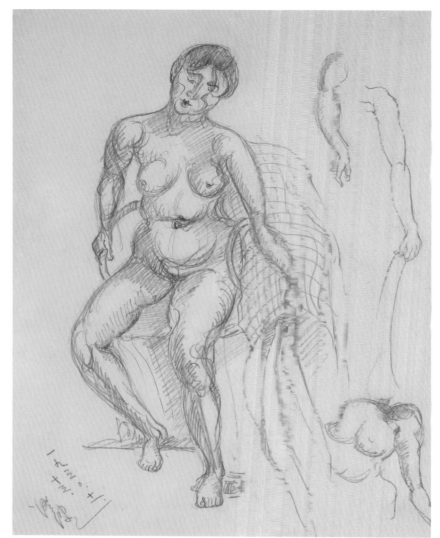

坐姿裸女速寫-30.11.13（281）
Seated Female Nude Sketch-30.11.13（281）

1930　紙本鉛筆　38.1×29.3cm

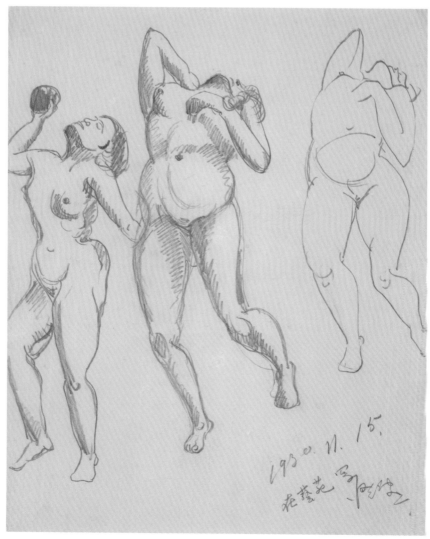

立姿裸女速寫-30.11.15（302）
Standing Female Nude Sketch-30.11.15（302）

1930　紙本鉛筆　38.1×29.5cm

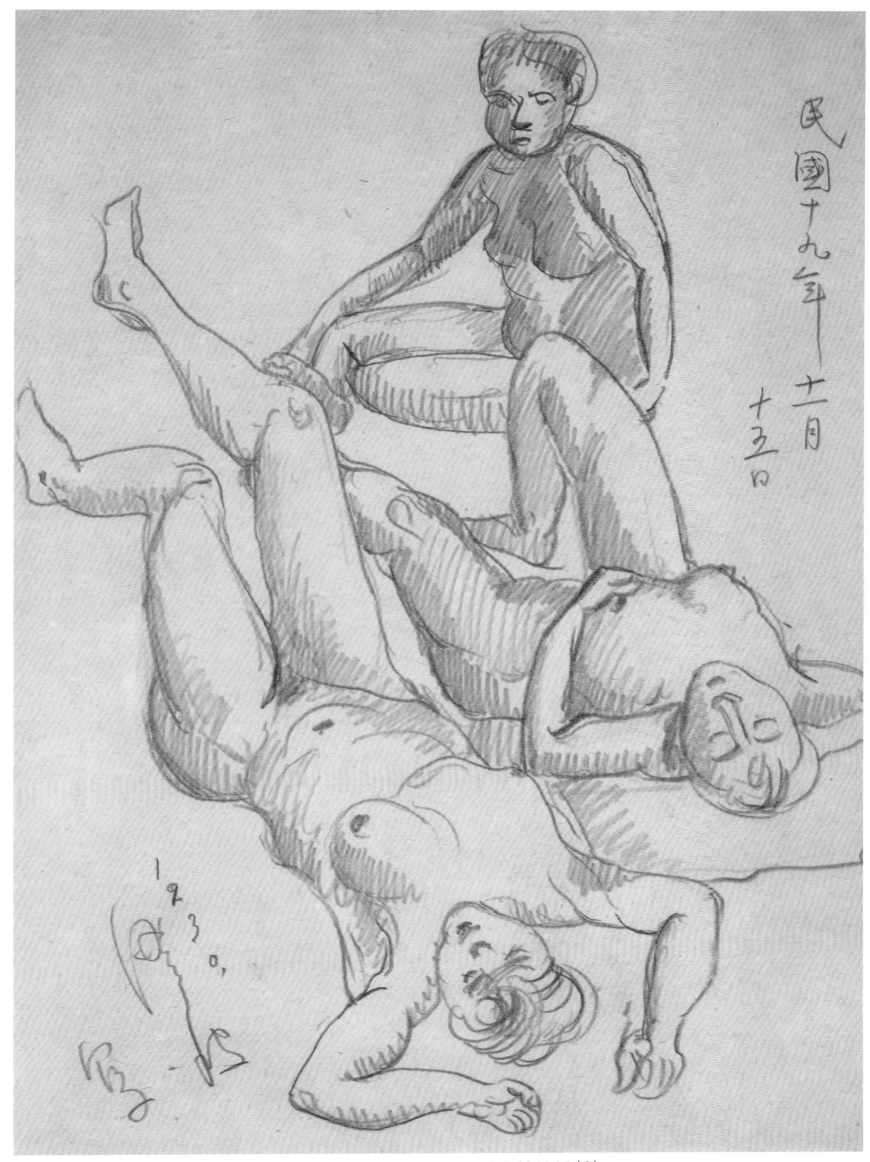

坐姿與臥姿裸女速寫-30.11.15（2） Seated and Reclining Female Nude Sketch-30.11.15（2）

1930　紙本鉛筆　33.4×24.1cm

法國公園一隅-30.11.21 A Corner in French Park-30.11.21

1930　紙本鉛筆　29.3×38.3cm

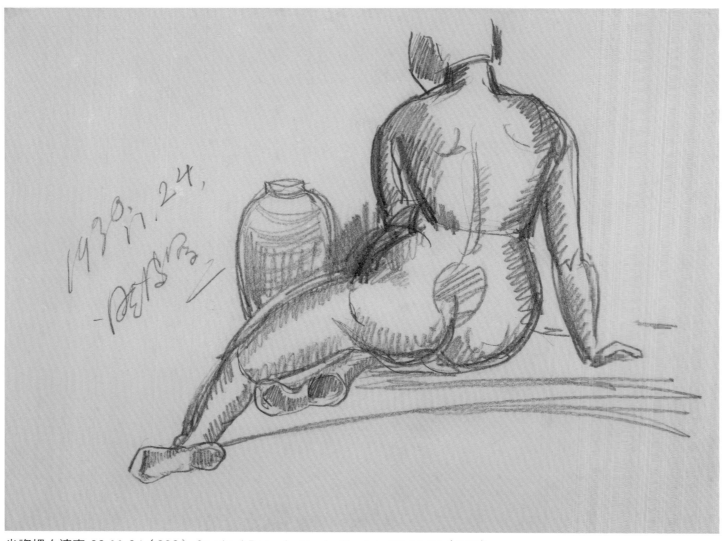

坐姿裸女速寫-30.11.24（282）Seated Female Nude Sketch-30.11.24（282）

1930　紙本鉛筆　29.2×38.4cm

重光-30.12.8 Tsung-kuang-30.12.8

1930　紙本鉛筆　38.3×29.4cm

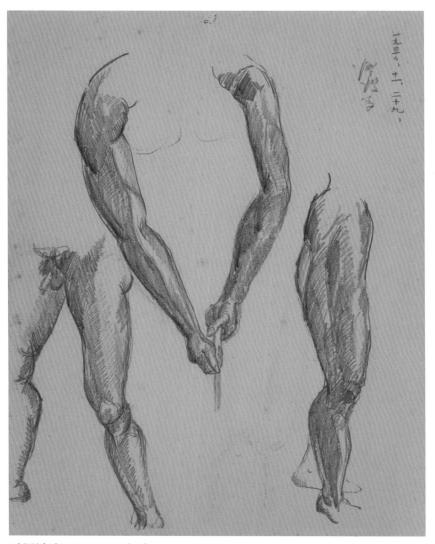

手腳速寫-30.11.29（1）
Hands and Feet Sketch-30.11.29（1）

1930　紙本鉛筆　38×29.3cm

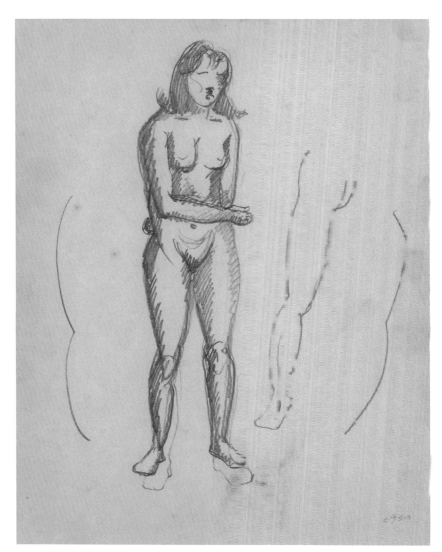

立姿裸女速寫-30（303）
Standing Female Nude Sketch-30（303）

1930　紙本鉛筆　38.3×29.2cm

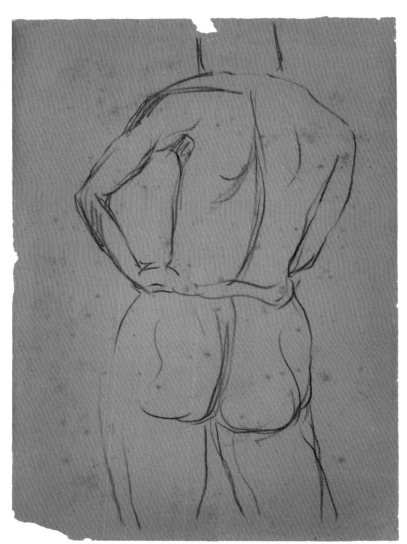

立姿裸男速寫（5）
Standing Male Nude Sketch（5）

約1930　紙本鉛筆　36.2×26cm

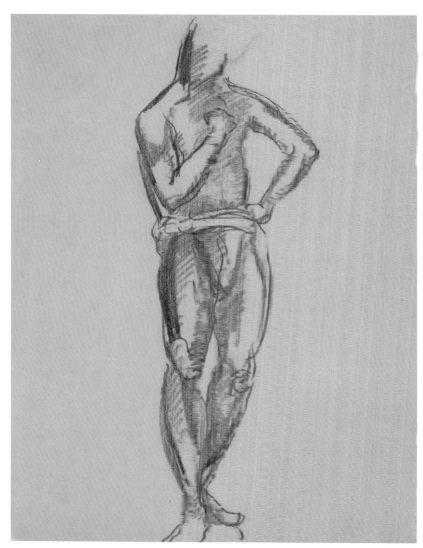

立姿裸男速寫（6）
Standing Male Nude Sketch（6）

約1930　紙本鉛筆　31.5×23.7cm

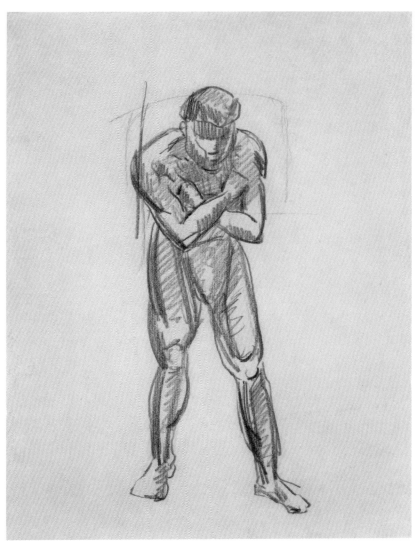

立姿裸男速寫（7）
Standing Male Nude Sketch（7）

約1930　紙本鉛筆　31.4×23.5cm

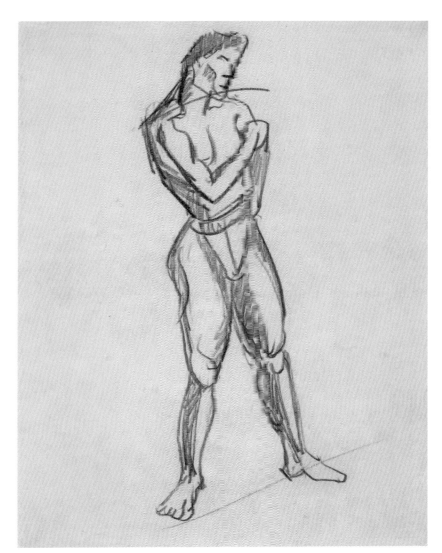

立姿裸男速寫（8）
Standing Male Nude Sketch（8）

約1930　紙本鉛筆　31.5×23.8cm

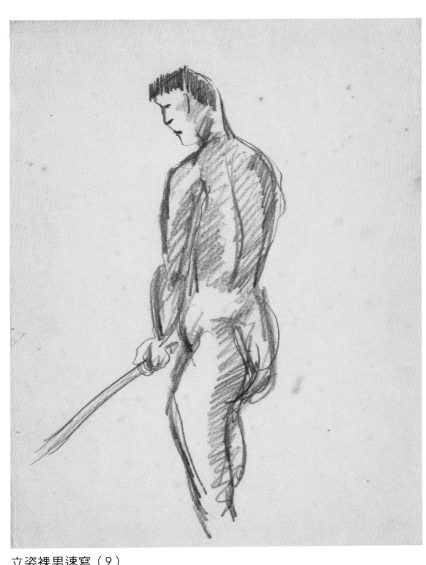

立姿裸男速寫（9）
Standing Male Nude Sketch（9）

約1930　紙本鉛筆　38.5×29.3cm

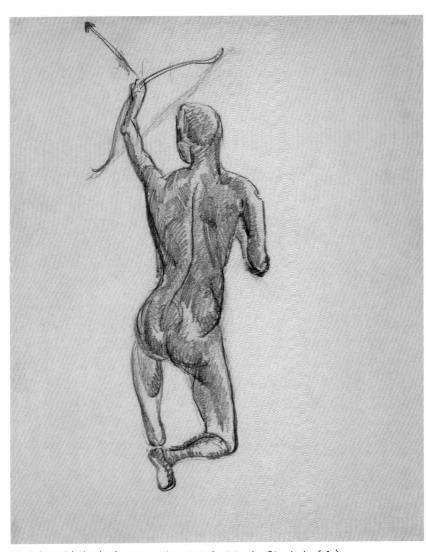

跪姿裸男速寫（1）　Kneeling Male Nude Sketch（1）

約1930　紙本鉛筆　38.2×29.2cm

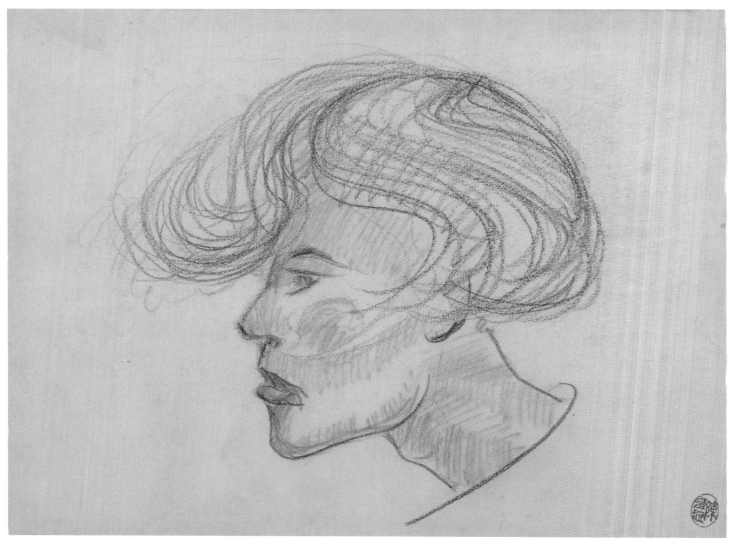

頭像速寫（23） Portrait Sketch（23）
約1930　紙本色筆　18.8×25.1cm

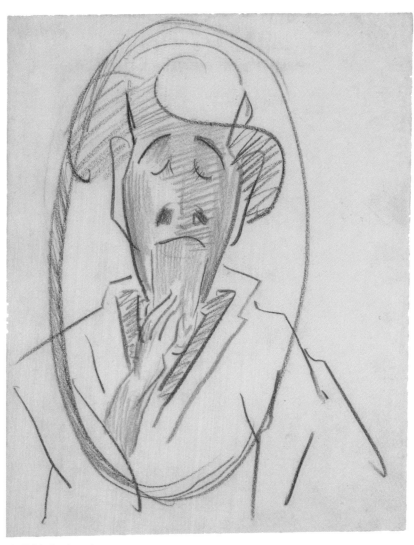

人物速寫（25） Figure Sketch（25）
約1930　紙本色筆　25.4×18.8cm

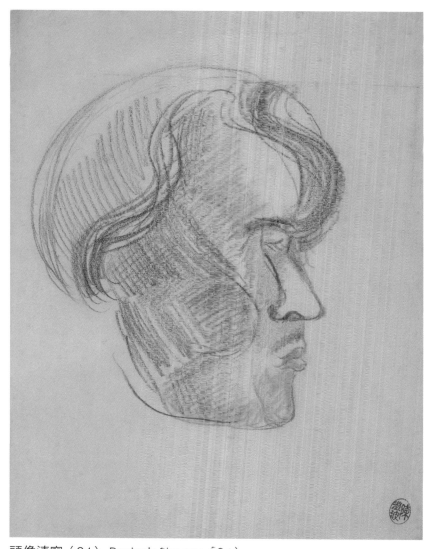

頭像速寫（24） Portrait Sketch（24）
約1930　紙本色筆　25.4×19.1cm

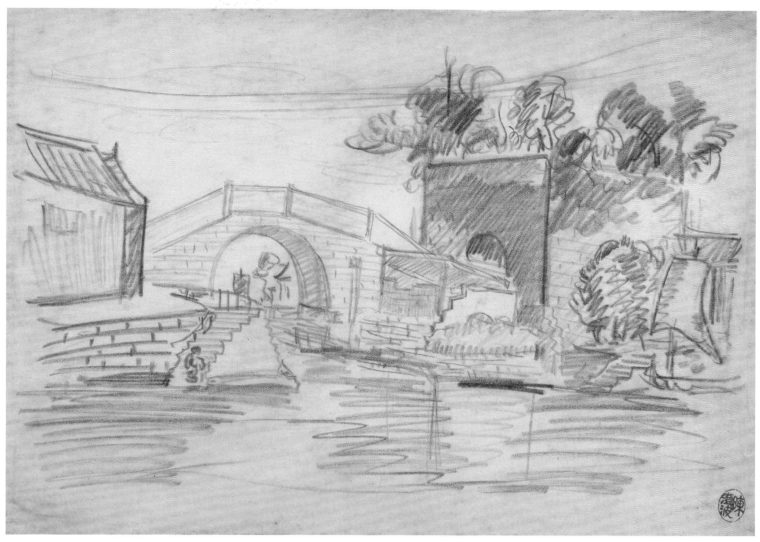

風景速寫（1） Landscape Sketch（1）

約1930　紙本色筆　19.3×26.6cm

・1931

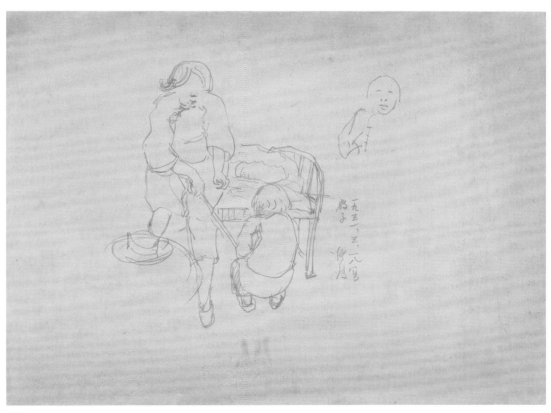

教子-31.3.18 Tutoring the Son-31.3-18

1931　紙本鉛筆　29.1×38.3cm

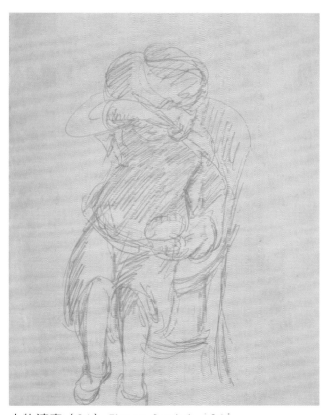

人物速寫（26） Figure Sketch（26）

約1931（疑1931.3.18）　紙本鉛筆　38.3×29.1cm
※為前一張之背面圖。

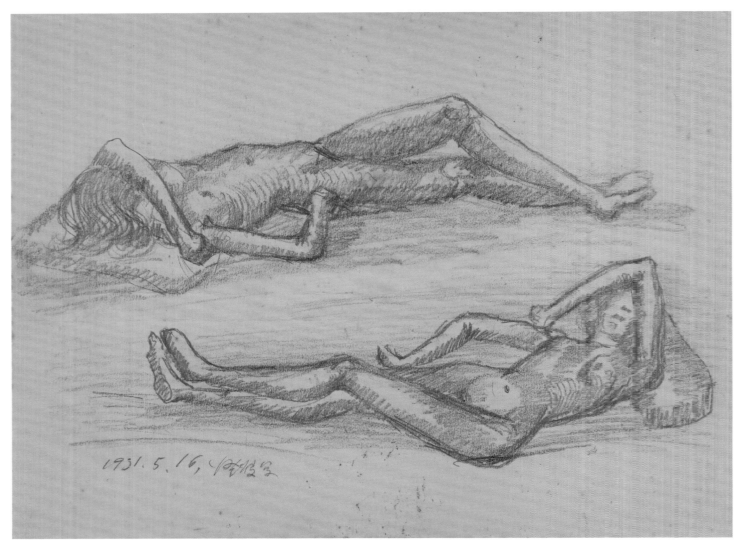

臥姿裸女速寫-31.5.16（42）Reclining Female Nude Sketch-31.5.16（42）

1931　紙本鉛筆　29.1×38.2cm

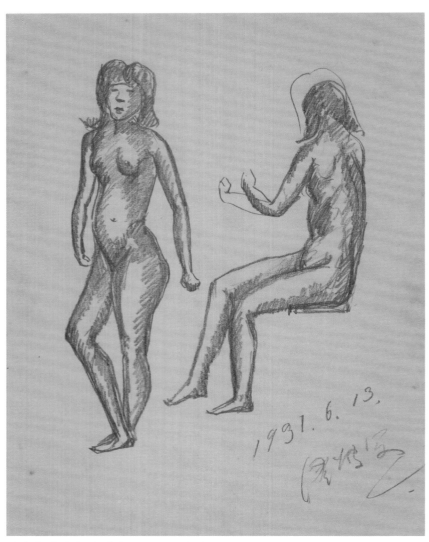

立姿與坐姿裸女速寫-31.6.13（1）
Standing and Seated Female Nude Sketch-31.6.13（1）

1931　紙本鉛筆　38.4×29.6cm

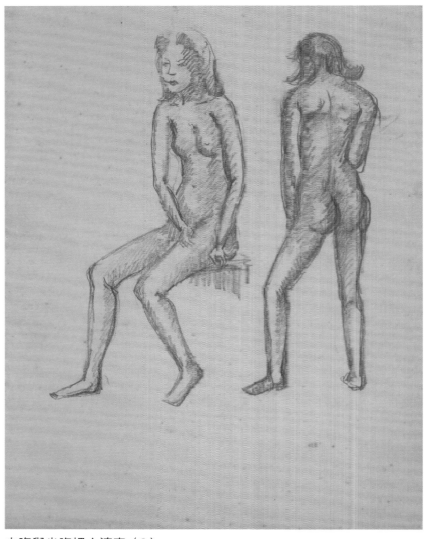

立姿與坐姿裸女速寫（2）
Standing and Seated Female Nude Sketch（2）

約1931（疑1931.6.13）　紙本鉛筆　38.2×29.4cm

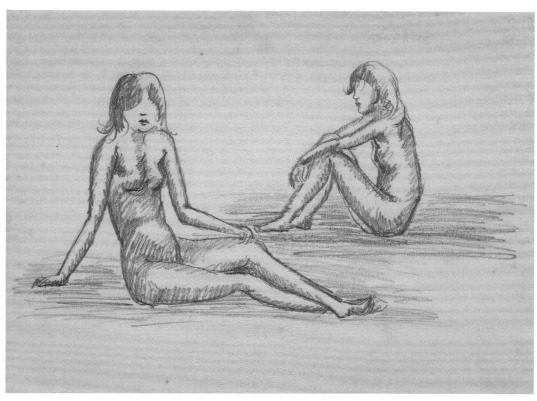

坐姿裸女速寫（283）
Seated Female Nude Sketch（283）

約1931（疑1931.6.13） 紙本鉛筆 29.3×33.5cm

人物速寫（27）
Figure Sketch（27）

約1931（疑1931.6.14） 紙本鉛筆 29.3×38.3cm

林蔭小學演劇-31.6.14
Drama Performance of Linyin Elementary School-31.6.14

1931 紙本鉛筆 29.5×38.3cm

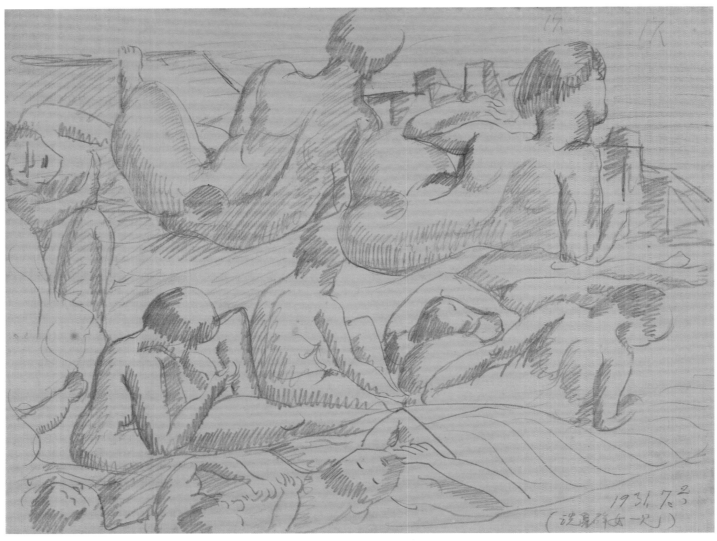

洗身群女一見-31.7.2 Bathing Girls-31.7.2
1931 紙本鉛筆 29.3×38.3cm

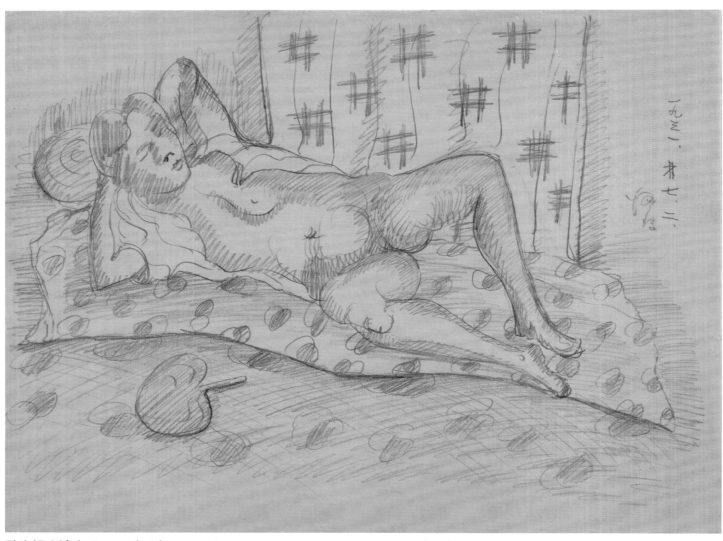

臥姿裸女速寫-31.7.2（43） Reclining Female Nude Sketch-31.7.2（43）
1931 紙本鉛筆 29.5×38.3cm

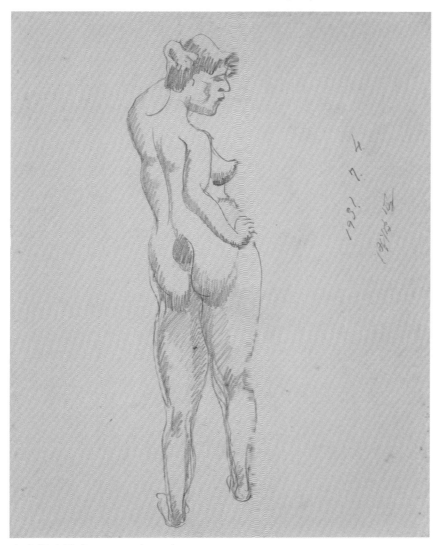

立姿裸女速寫-31.7.4（304）
Standing Female Nude Sketch-31.7.4（304）

1931　紙本鉛筆　37.9×29.3cm

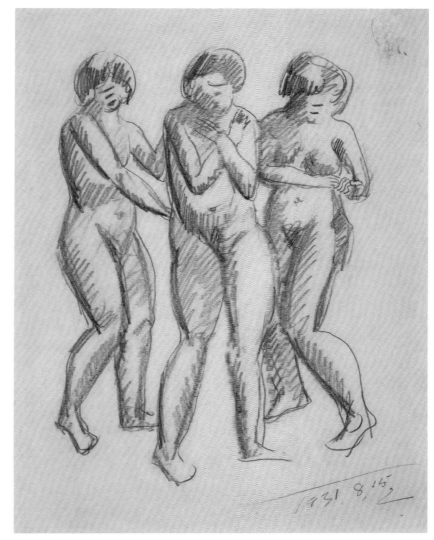

立姿裸女速寫-31.8.15（305）
Standing Female Nude Sketch-31.8.15（305）

1931　紙本鉛筆　38.4×29.4cm

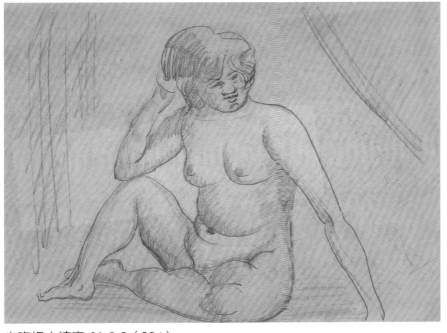

坐姿裸女速寫-31.9.2（284）
Seated Female Nude Sketch-31.9.2（284）

1931　紙本鉛筆　29.2×38.4cm

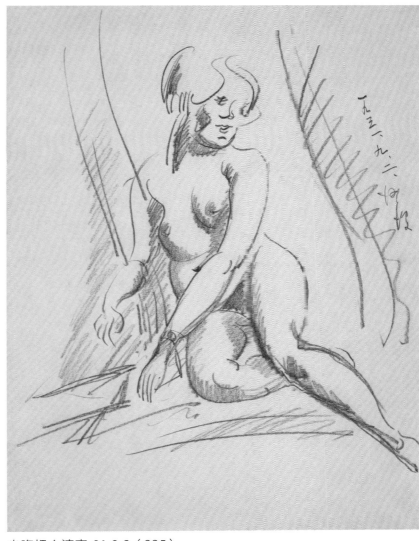

坐姿裸女速寫-31.9.2（285）
Seated Female Nude Sketch-31.9.2（285）

1931　紙本鉛筆　38.6×29.3cm

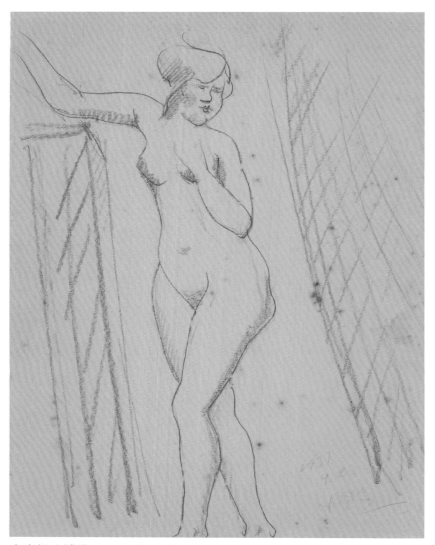

立姿裸女速寫-31.9.2（306）
Standing Female Nude Sketch-31.9.2（306）

1931　紙本鉛筆　38.3×29.3cm

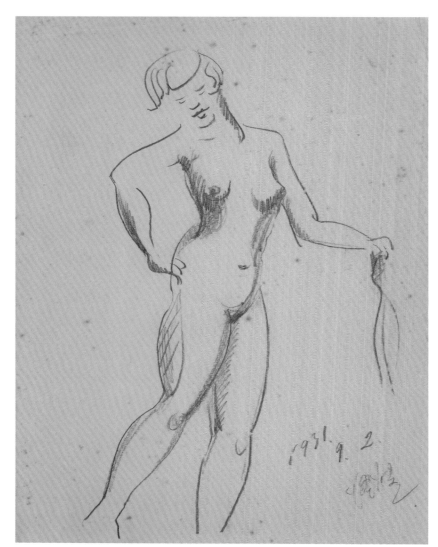

立姿裸女速寫-31.9.2（307）
Standing Female Nude Sketch-31.9.2（307）

1931　紙本鉛筆　38.3×29.1cm

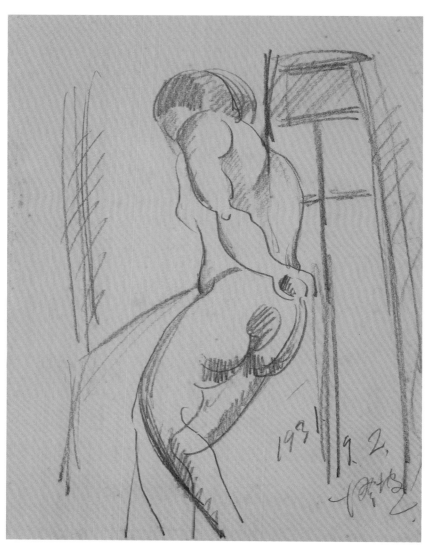

立姿裸女速寫-31.9.2（308）
Standing Female Nude Sketch-31.9.2（308）

1931　紙本鉛筆　38.3×29.3cm

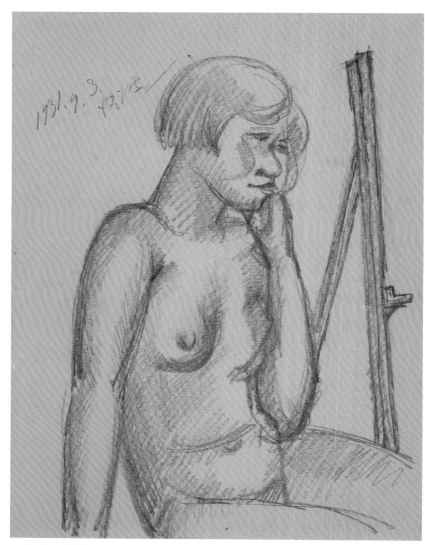

坐姿裸女速寫-31.9.3（286）
Seated Female Nude Sketch-31.9.3（286）

1931　紙本鉛筆　38.3×29.2cm

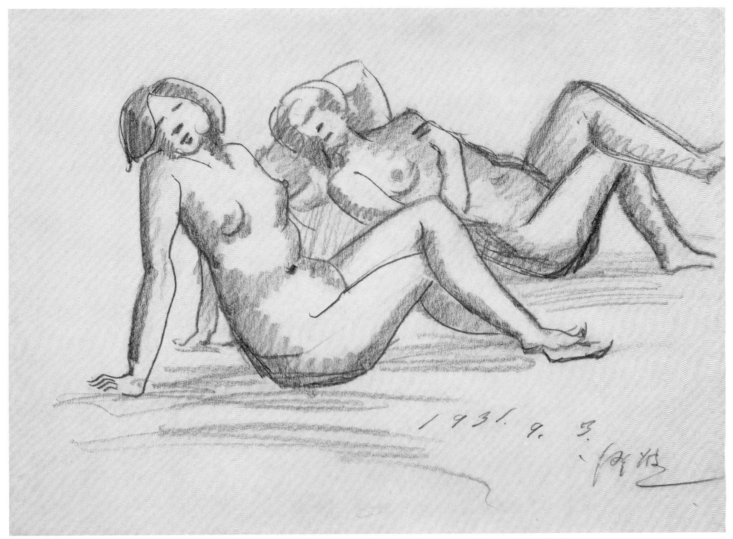

坐姿與臥姿裸女速寫-31.9.3（3） Seated and Reclining Female Nude Sketch-31.9.3（3）

1931　紙本鉛筆　19.4×38.3cm

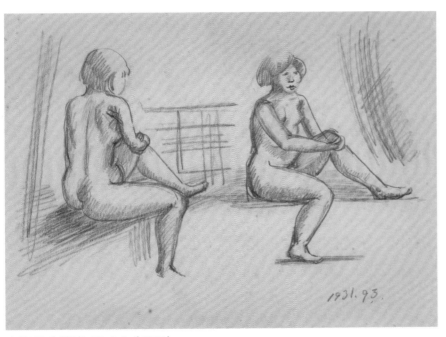

坐姿裸女速寫-31.9.3（287）
Seated Female Nude Sketch-31.9.3（287）

1931　紙本鉛筆　29.2×38.2cm

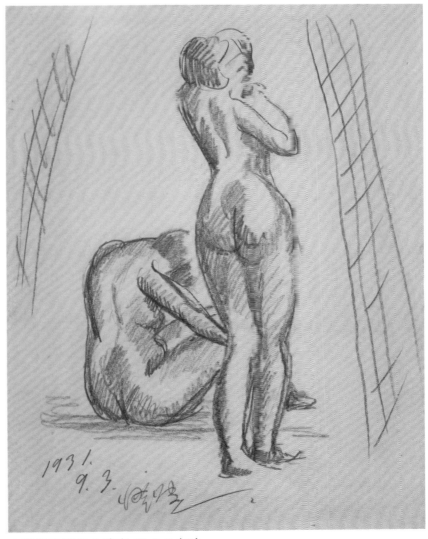

立姿與坐姿裸女速寫-31.9.3（3）
Standing and Seated Female Nude Sketch-31.9.3（3）

1931　紙本鉛筆　38.3×29.3cm

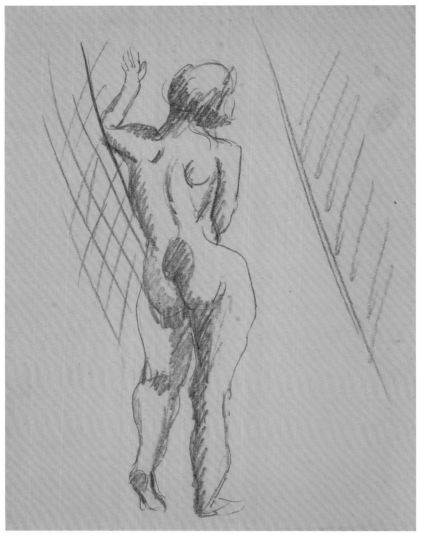

立姿裸女速寫（309）
Standing Female Nude Sketch（309）

約1931（疑1931.9.3）　紙本鉛筆　38.3×29.2cm

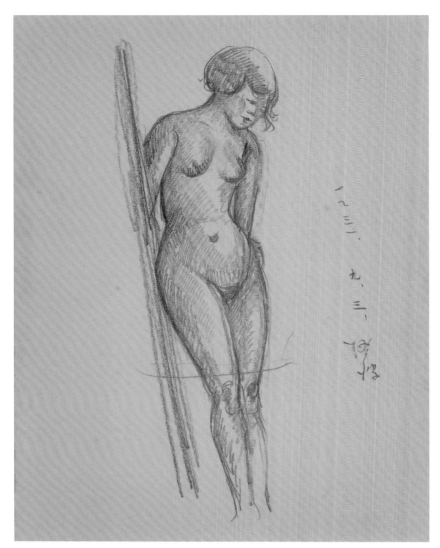

立姿裸女速寫-31.9.3（310）
Standing Female Nude Sketch-31.9.3（310）

1931　紙本鉛筆　38.3×29.2cm

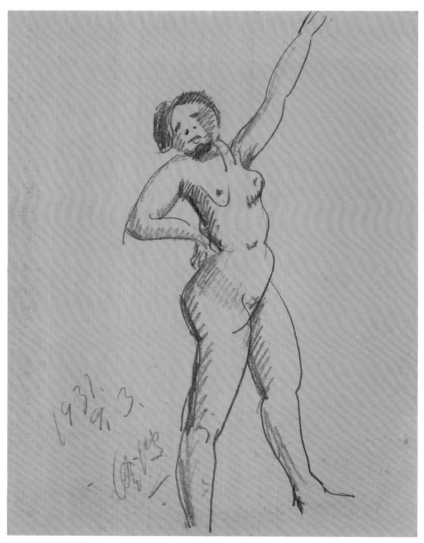

立姿裸女速寫-31.9.3（311）
Standing Female Nude Sketch-31.9.3（311）

1931　紙本鉛筆　38.2×29.2cm

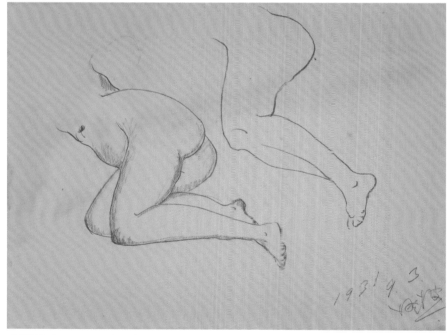

女體速寫-31.9.3（25）
Female Body Sketch-31.9.3（25）

1931　紙本鉛筆　29.4×38.2cm

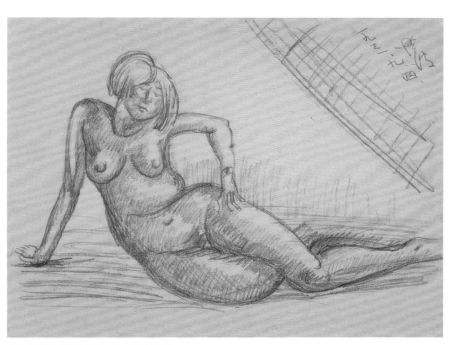

坐姿裸女速寫-31.9.4（288）
Seated Female Nude Sketch-31.9.3（288）

1931　紙本鉛筆　29.2×38.3cm

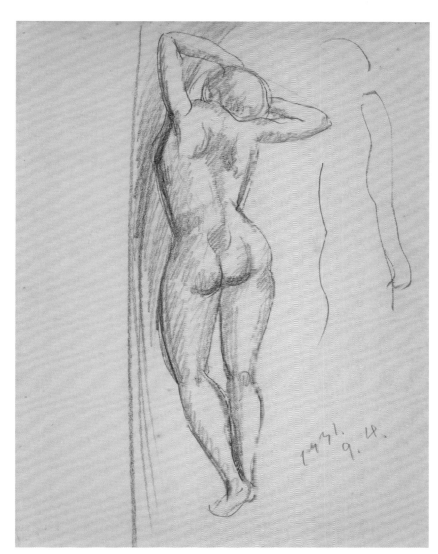

立姿裸女速寫-31.9.4（312）
Standing Female Nude Sketch-31.9.4（312）

1931　紙本鉛筆　38.4×29.1cm

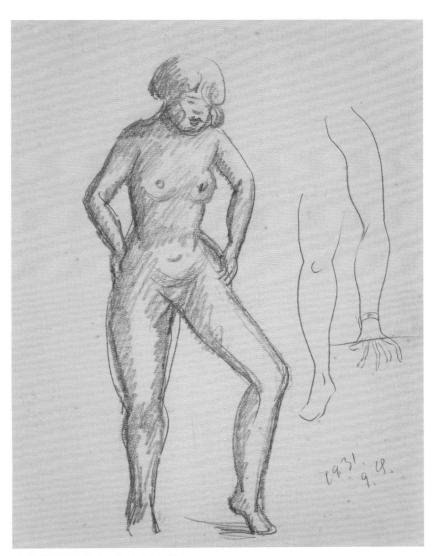

立姿裸女速寫-31.9.4（313）
Standing Female Nude Sketch-31.9.4（313）

1931　紙本鉛筆　38.3×29.1cm

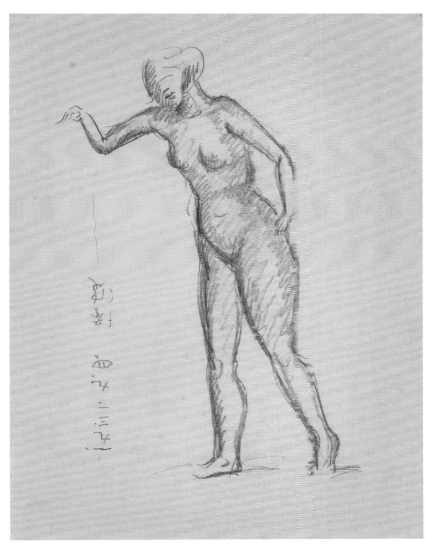

立姿裸女速寫-31.9.4（314）
Standing Female Nude Sketch-31.9.4（314）

1931　紙本鉛筆　38.4×29.3cm

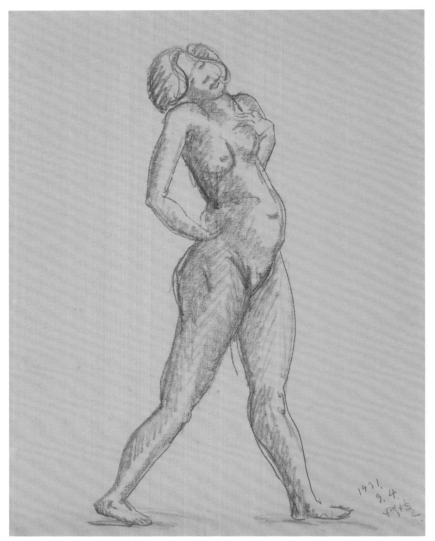

立姿裸女速寫-31.9.4（315）
Standing Female Nude Sketch-31.9.4（315）

1931　紙本鉛筆　38.4×29.3cm

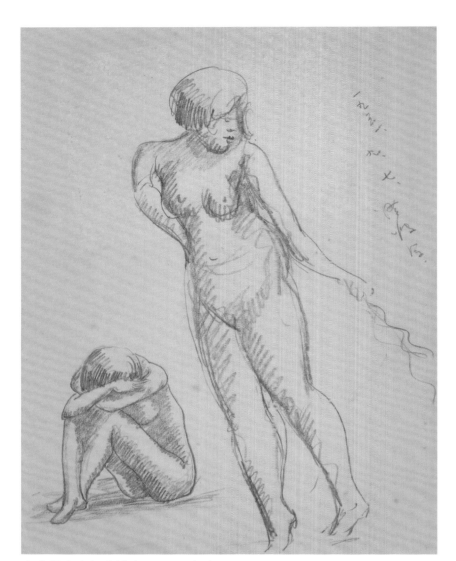

立姿與坐姿裸女速寫-31.9.7（4）
Standing and Seated Female Nude Sketch-31.9.7（4）

1931　紙本鉛筆　38.3×29.3cm

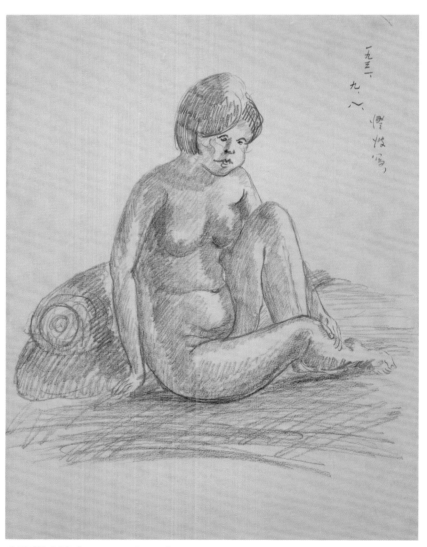

坐姿裸女速寫-31.9.8（289）
Seated Female Nude Sketch-31.9.8（289）

1931　紙本鉛筆　38.3×29.2cm

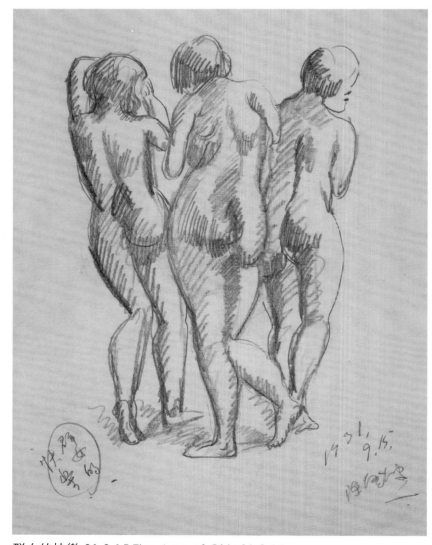

群女的快樂-31.9.15 The Joys of Girls-31.9.15

1931　紙本鉛筆　38.2×29.4cm

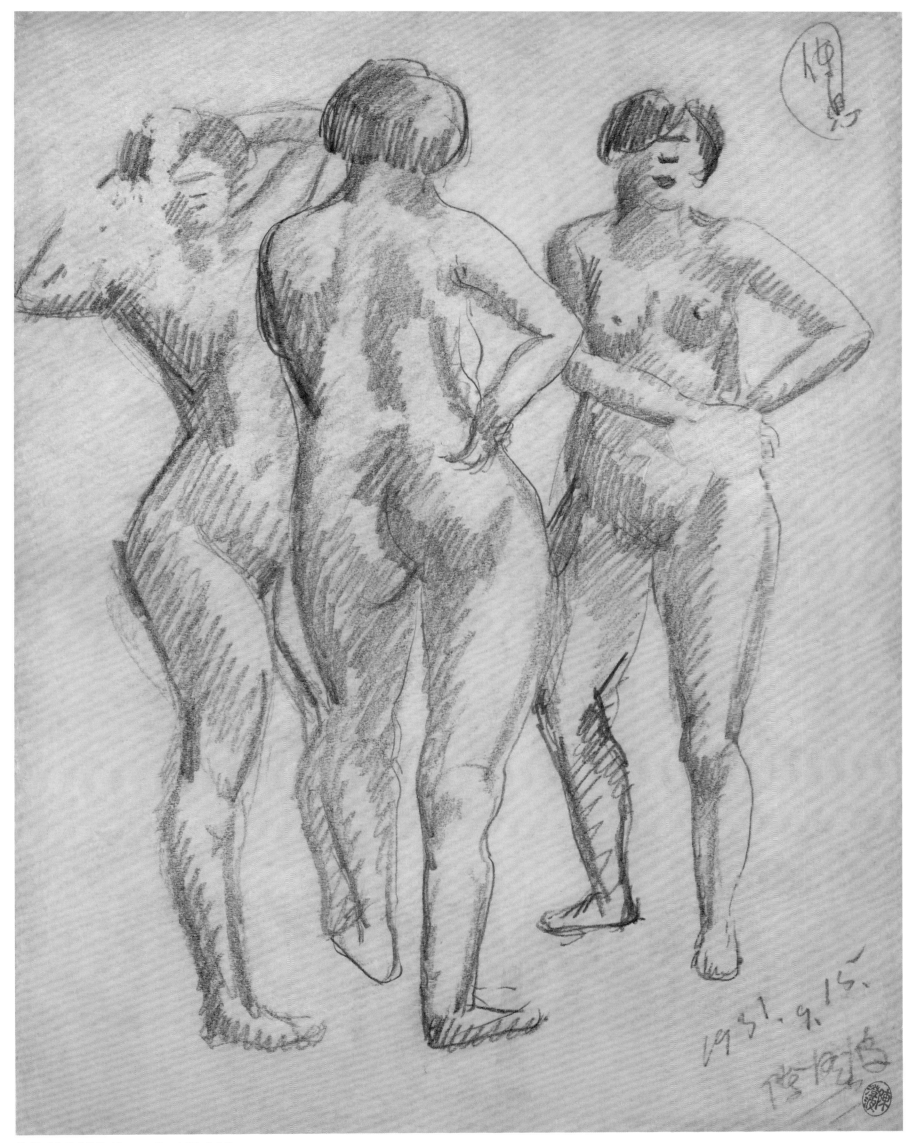

休息-31.9.15 Taking a Rest-31.9.15
1931　紙本鉛筆　38.2×29.2cm

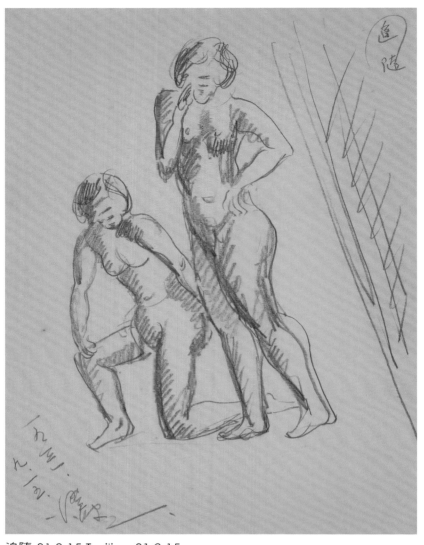

追隨-31.9.15 Trailing-31.9.15

1931　紙本鉛筆　38.2×29.2cm

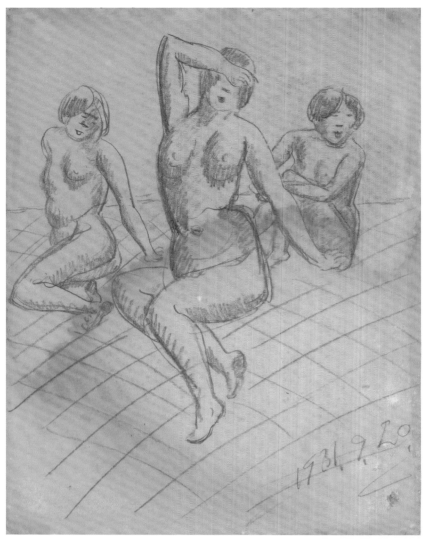

坐姿裸女速寫-31.9.20（290）
Seated Female Nude Sketch-31.9.20（290）

1931　紙本鉛筆　38×29cm

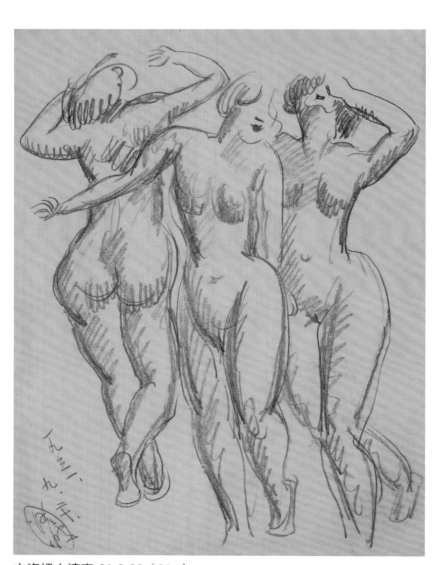

立姿裸女速寫-31.9.20（316）
Standing Female Nude Sketch-31.9.20（316）

1931　紙本鉛筆色筆　38.3×29.4cm

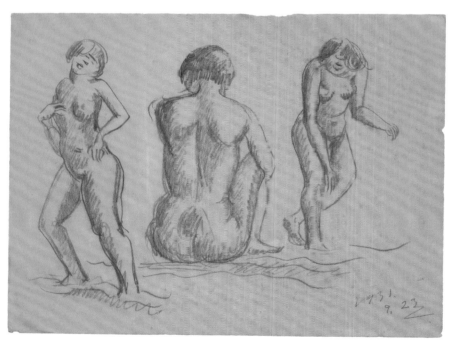

立姿與坐姿裸女速寫-31.9.23（5）
Standing and Seated Female Nude Sketch-31 9.23（5）

1931　紙本鉛筆　38.3×29.3cm

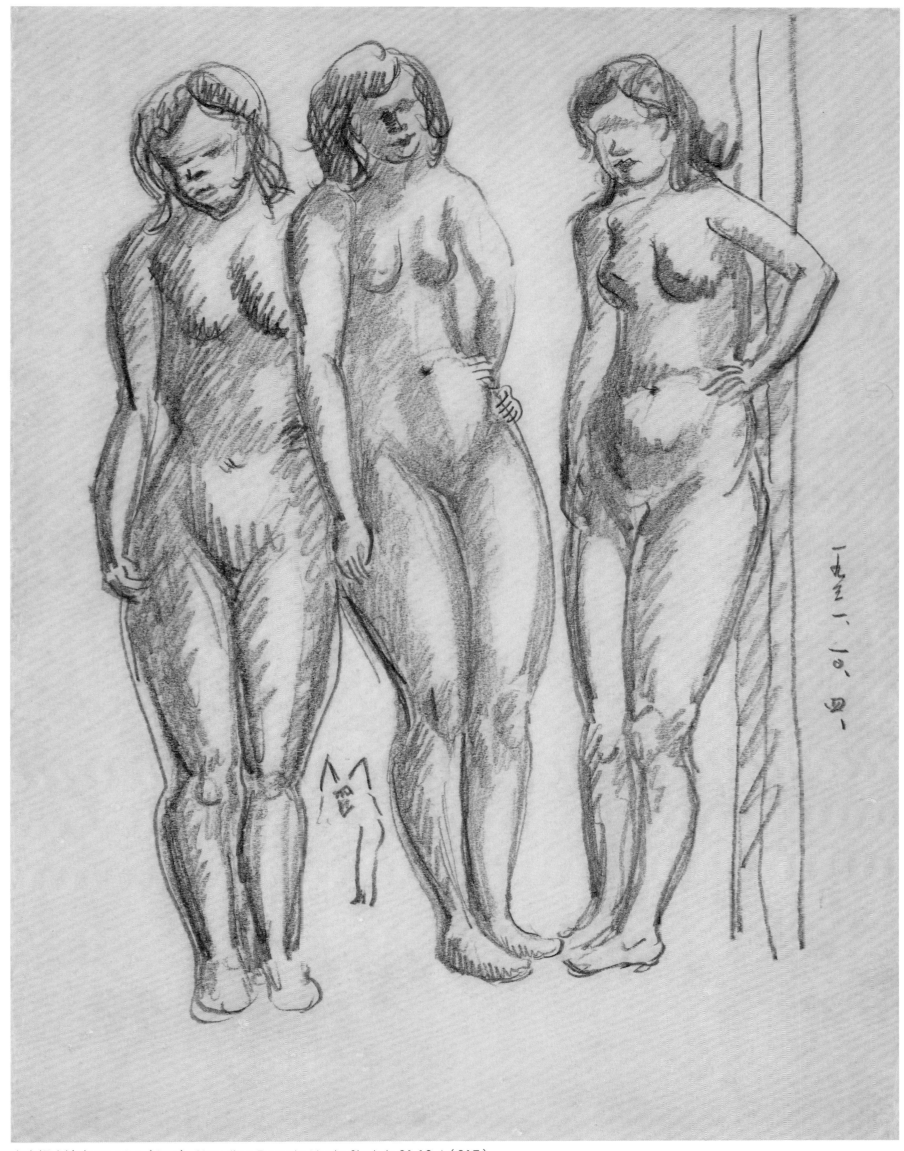

立姿裸女速寫-31.10.4（317） Standing Female Nude Sketch-31.10.4（317）

1931　紙本鉛筆　38.7×29.3cm

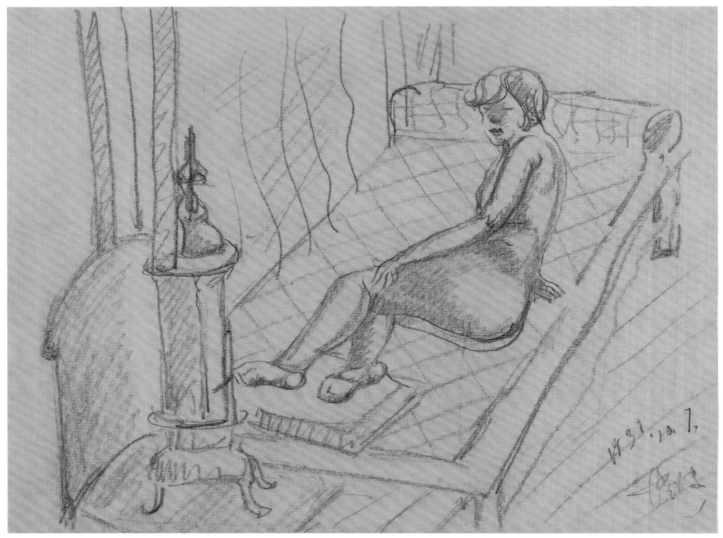

臥姿裸女速寫-31.10.7（44） Reclining Female Nude Sketch-31.10.7（44）

1931　紙本鉛筆　24.2×31.6cm

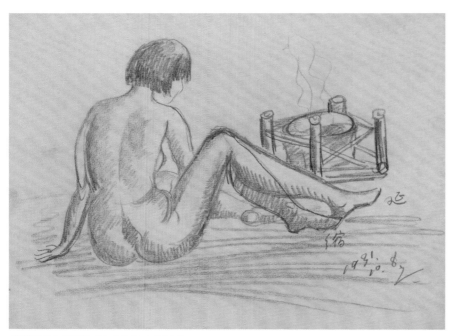

坐姿裸女速寫-31.10.8（291）
Seated Female Nude Sketch-31.10.8（291）

1931　紙本鉛筆　24.2×31.8cm

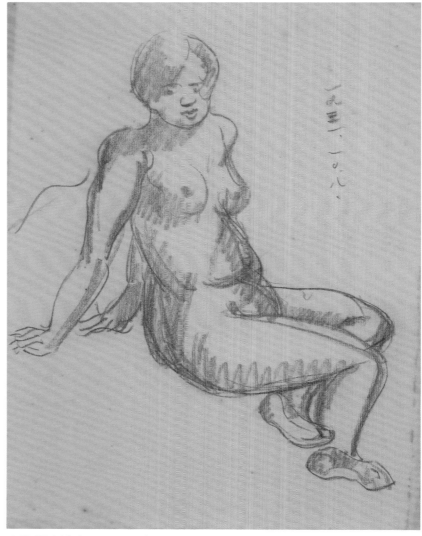

坐姿裸女速寫-31.10.8（292）
Seated Female Nude Sketch-31.10.8（292）

1931　紙本鉛筆　31.7×24.1cm

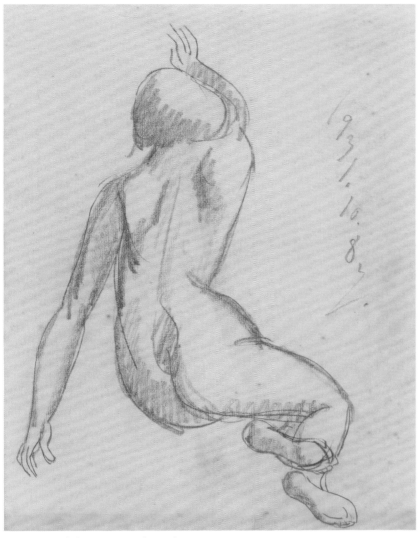

坐姿裸女速寫-31.10.8（293）
Seated Female Nude Sketch-31.10.8（293）

1931　紙本鉛筆　31.7×24.4cm

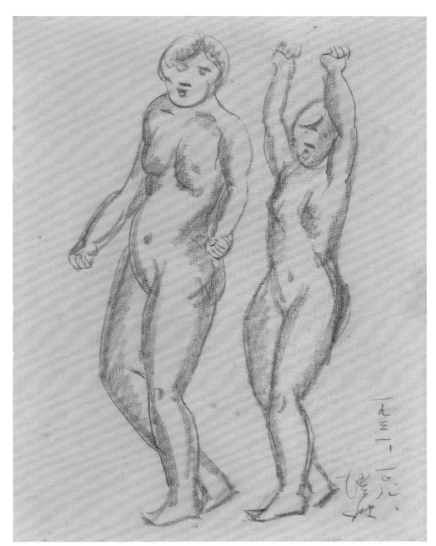

立姿裸女速寫-31.10.8（318）
Standing Female Nude Sketch-31.10.8（318）

1931　紙本鉛筆　31.7×24.1cm

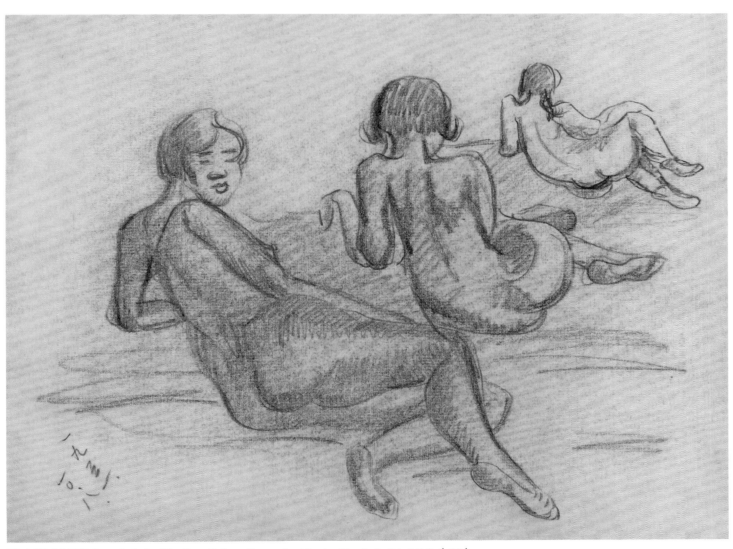

臥姿裸女速寫-31.10.8（45）　Reclining Female Nude Sketch-31.10.8（45）

1931　紙本鉛筆　24×31.8cm

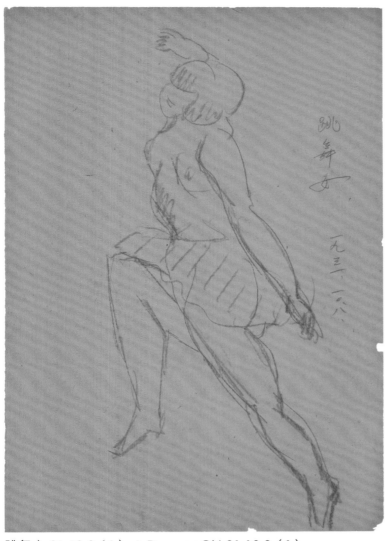

跳舞女-31.10.8（1） A Dancer Girl-31.10.8（1）

1931　紙本鉛筆　39.7×27.6cm

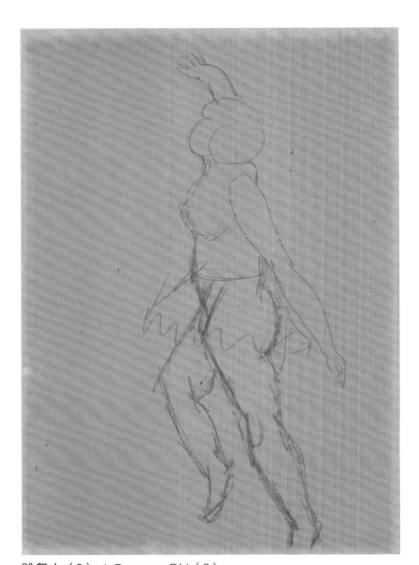

跳舞女（2） A Dancer Girl（2）

約1931（疑1931.10.8）　紙本鉛筆　39.7×27.6cm
※為前一張之背面圖。

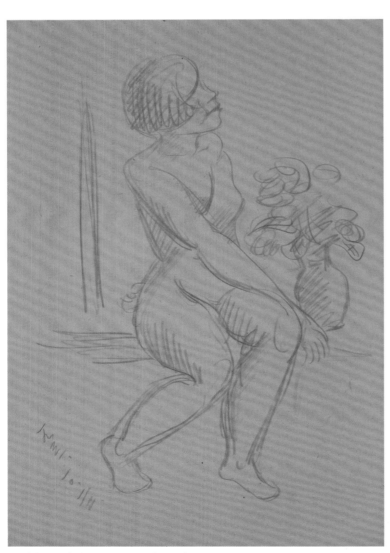

坐姿裸女速寫-31.10.22（294）
Seated Female Nude Sketch-31.10.22（294）

1931　紙本鉛筆　39.1×27.1cm

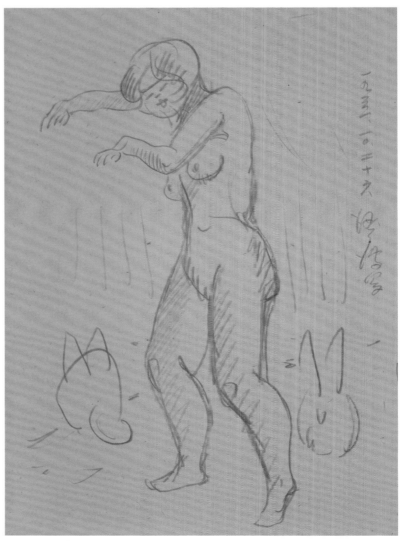

立姿裸女速寫-31.10.26（319）
Standing Female Nude Sketch-31.10.26（319）

1931　紙本鉛筆　36.3×26.3cm

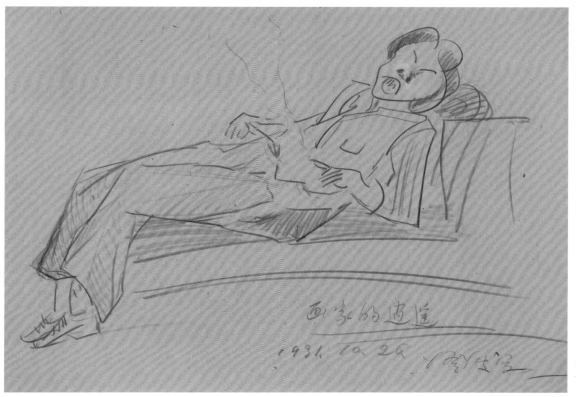

畫家的逍遙-31.10.26 A Carefree Artist-31.10.26

1931　紙本鉛筆　26.2×36.3cm

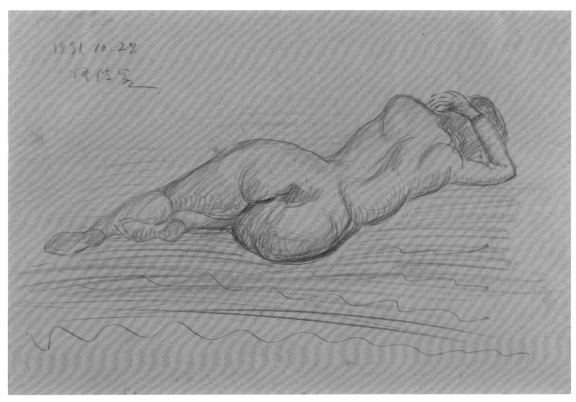

臥姿裸女速寫-31.10.27（46）
Reclining Female Nude Sketch-31.10.27（46）

1931　紙本鉛筆　23.5×35cm

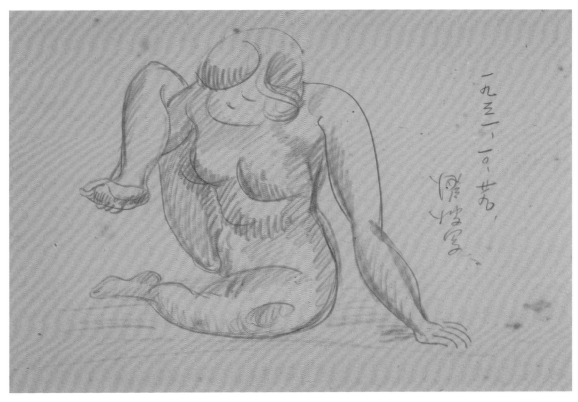

坐姿裸女速寫-31.10.29（295）
Seated Female Nude Sketch-31.10.29（295）

1931　紙本鉛筆　22.2×31.7cm

立姿裸女速寫-31.10.29（320）
Standing Female Nude Sketch-31.10.29（320）

1931　紙本鉛筆　31.6×22.5cm

立姿裸女速寫-31.10.29（321）
Standing Female Nude Sketch-31.10.29（321）

1931　紙本鉛筆　31.7×22.5cm

臥姿裸女速寫-31.10.29（47）
Reclining Female Nude Sketch-31.10.29（47）

1931　紙本鉛筆　22.2×31.7cm

坐姿裸女速寫-31（296）
Seated Female Nude Sketch-31（296）

1931　紙本鉛筆　36.3×26.2cm

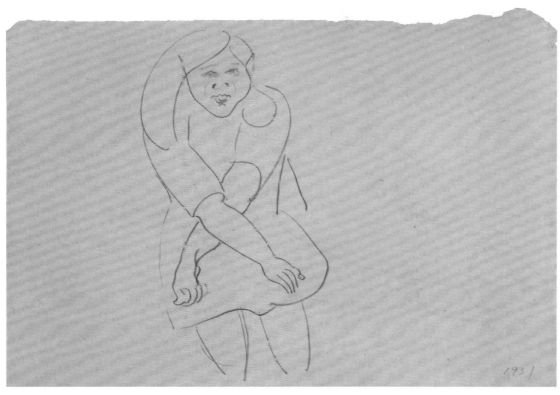

人物速寫-31（28）
Figure Sketch-31（28）
1931　紙本鉛筆　27.8×39.5cm

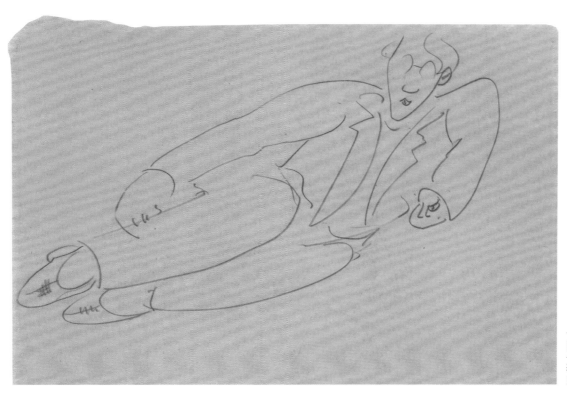

人物速寫（29）
Figure Sketch（29）
約1931　紙本鉛筆　27.8×39.5cm
※為前一張之背面圖。

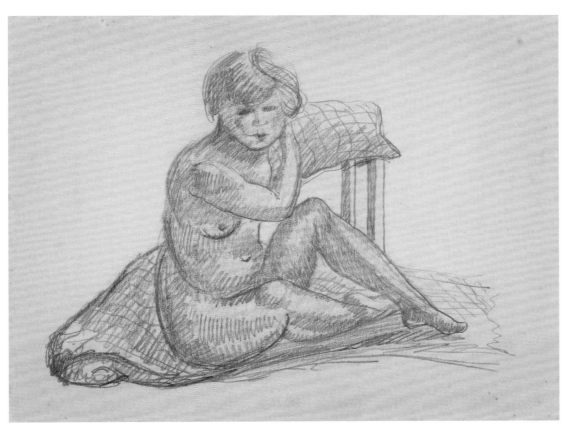

坐姿裸女速寫（297）
Seated Female Nude Sketch（297）
約1931　紙本鉛筆色筆　29.4×38.4cm

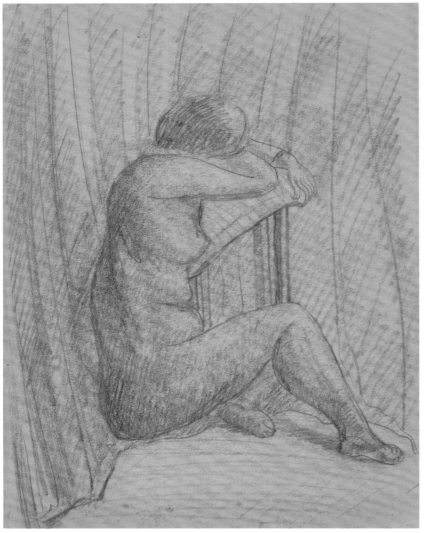

坐姿裸女速寫（298）
Seated Female Nude Sketch（298）

約1931　紙本鉛筆色筆　38.2×29.2cm

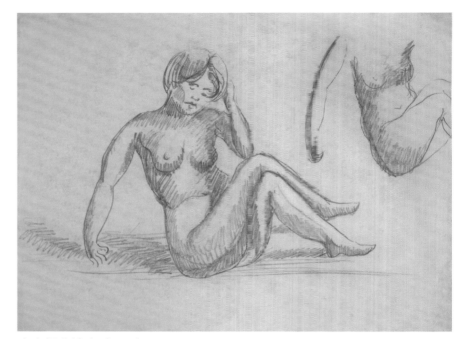

坐姿裸女速寫（299）
Seated Female Nude Sketch（299）

約1931　紙本鉛筆　29.2×38.2cm

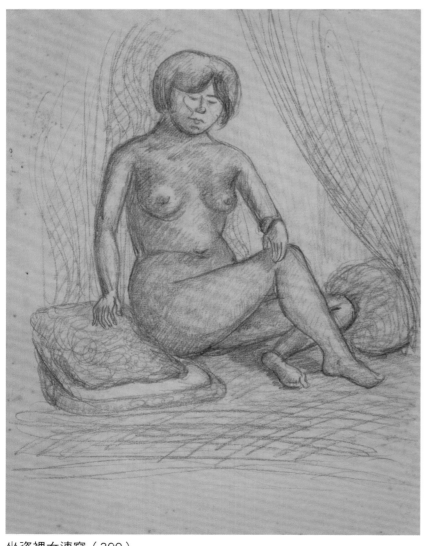

坐姿裸女速寫（300）
Seated Female Nude Sketch（300）

約1931　紙本鉛筆　38.2×29.3cm

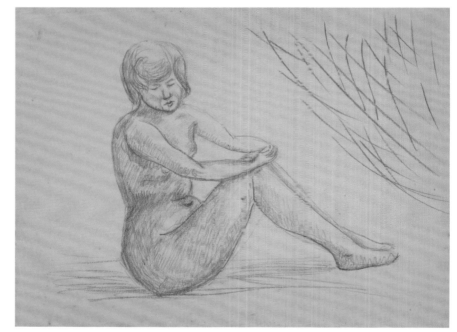

坐姿裸女速寫（301）
Seated Female Nude Sketch（301）

約1931　紙本鉛筆　29.2×38.2cm

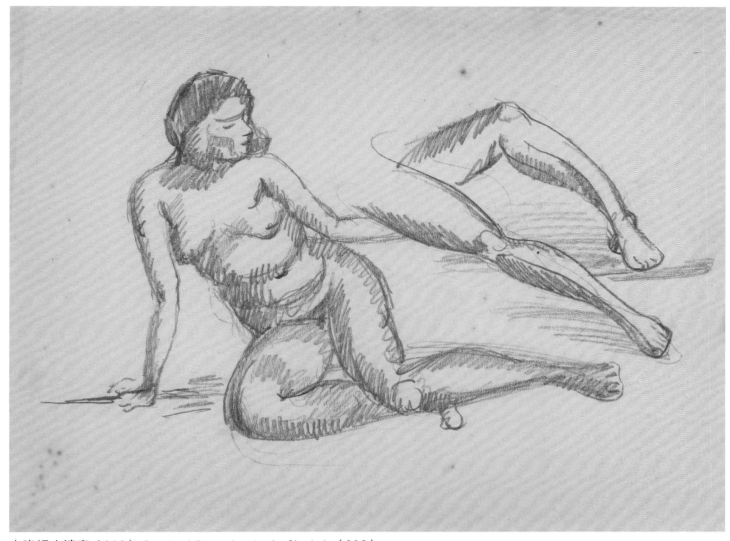

坐姿裸女速寫（302） Seated Female Nude Sketch（302）

約1931　紙本鉛筆　29.3×38.5cm

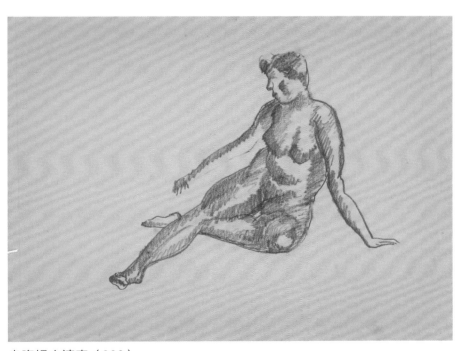

坐姿裸女速寫（303）
Seated Female Nude Sketch（303）

約1931　紙本鉛筆　29×38.2cm

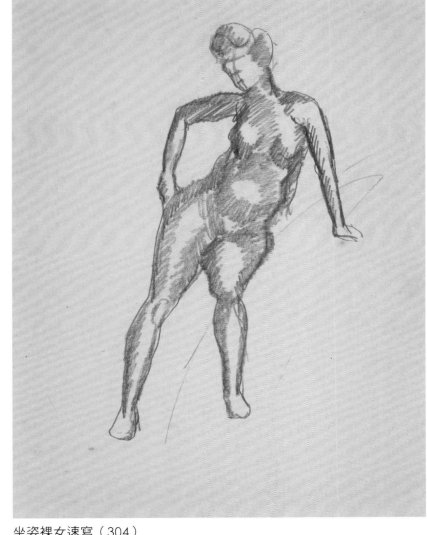

坐姿裸女速寫（304）
Seated Female Nude Sketch（304）

約1931　紙本鉛筆　38.2×29cm

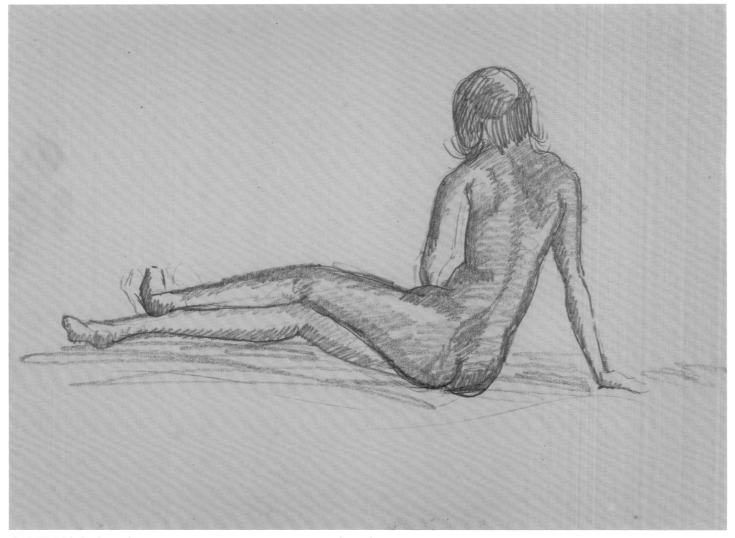

坐姿裸女速寫（305） Seated Female Nude Sketch（305）

約1931　紙本鉛筆　29.2×38.3cm

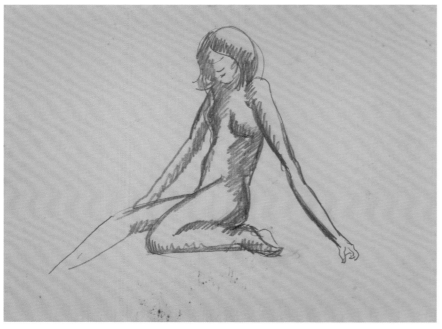

坐姿裸女速寫（306）
Seated Female Nude Sketch（306）

約1931　紙本鉛筆　29.3×38.3cm

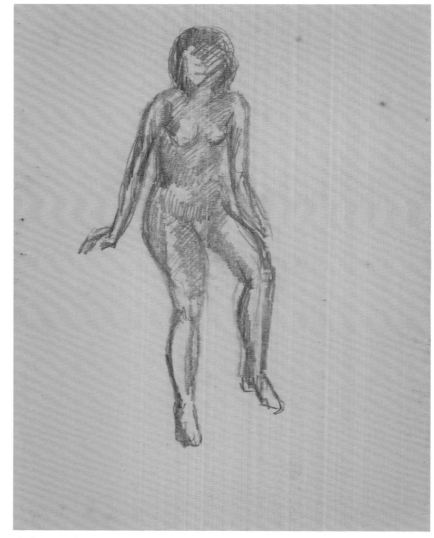

坐姿裸女速寫（307）
Seated Female Nude Sketch（307）

約1931　紙本鉛筆　38.3×29.4cm

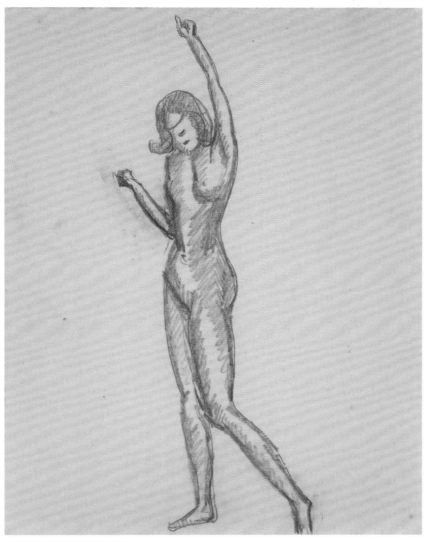

立姿裸女速寫（322）
Standing Female Nude Sketch（322）

約1931　紙本鉛筆　38.3×29.3cm

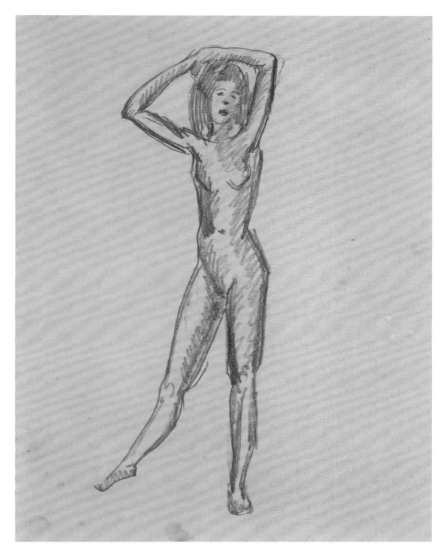

立姿裸女速寫（323）
Standing Female Nude Sketch（323）

約1931　紙本鉛筆　38.4×29.2cm

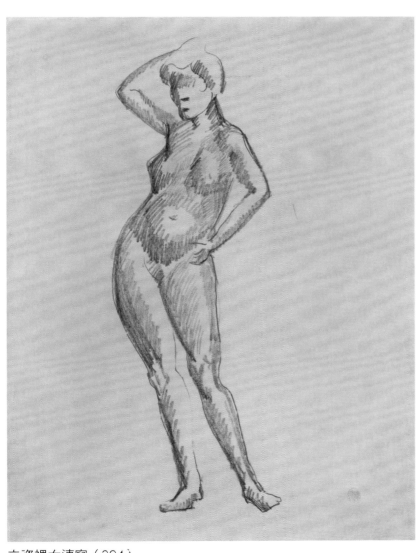

立姿裸女速寫（324）
Standing Female Nude Sketch（324）

約1931　紙本鉛筆　38.5×29.5cm

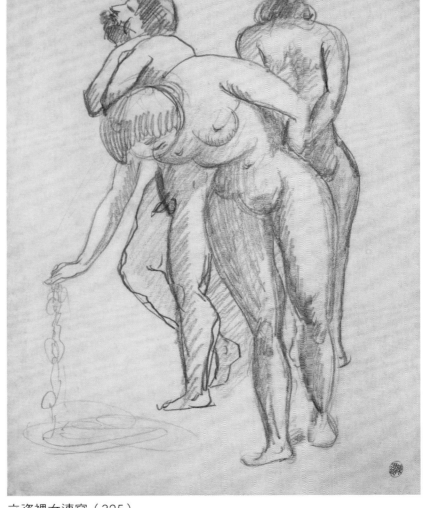

立姿裸女速寫（325）
Standing Female Nude Sketch（325）

約1931　紙本鉛筆　38×28.9cm

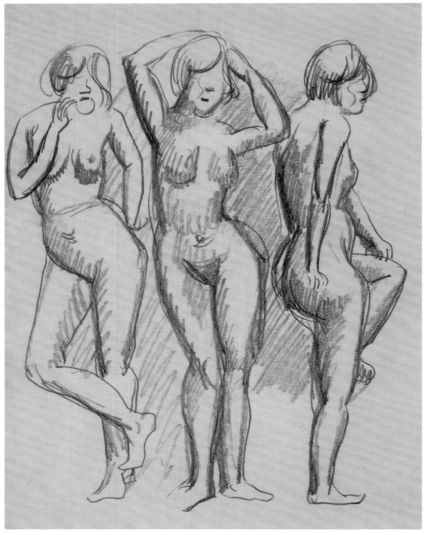

立姿裸女速寫（326）
Standing Female Nude Sketch（326）

約1931　紙本鉛筆　38.2×29.2cm

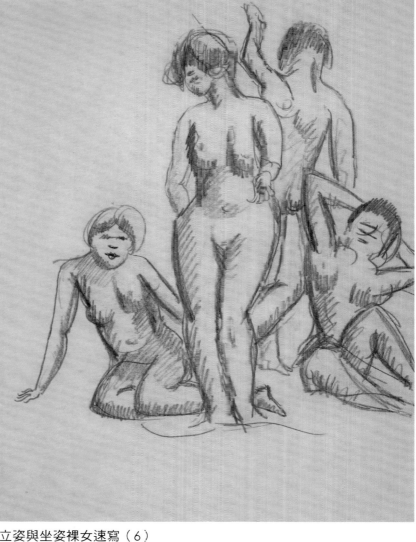

立姿與坐姿裸女速寫（6）
Standing and Seated Female Nude Sketch（6）

約1931　紙本鉛筆　38.2×29.3cm

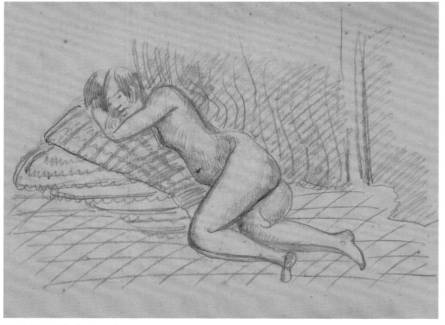

臥姿裸女速寫（48）
Reclining Female Nude Sketch（48）

約1931　紙本鉛筆　29.2×38.4cm

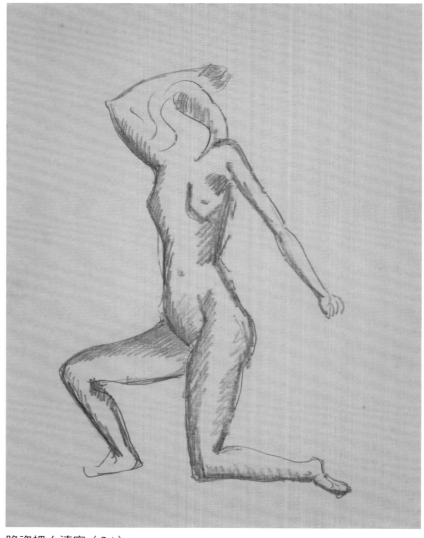

跪姿裸女速寫（24）
Kneeling Female Nude Sketch（24）

約1931　紙本鉛筆　38.1×29.3cm

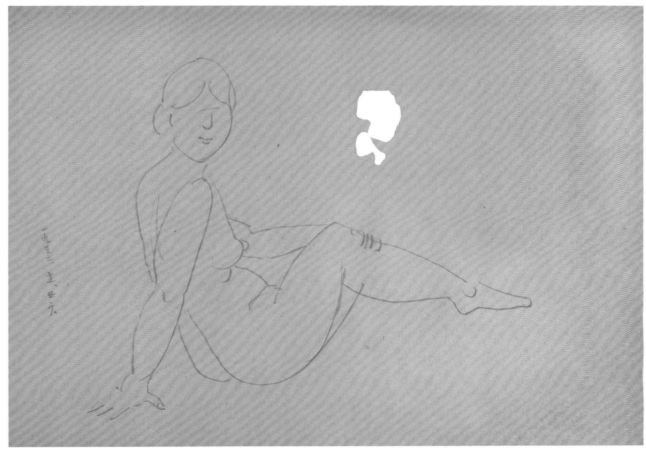

坐姿裸女速寫-32.11.26（308） Seated Female Nude Sketch-32.11.26（308）

1932　紙本鉛筆　27.2×37.4cm

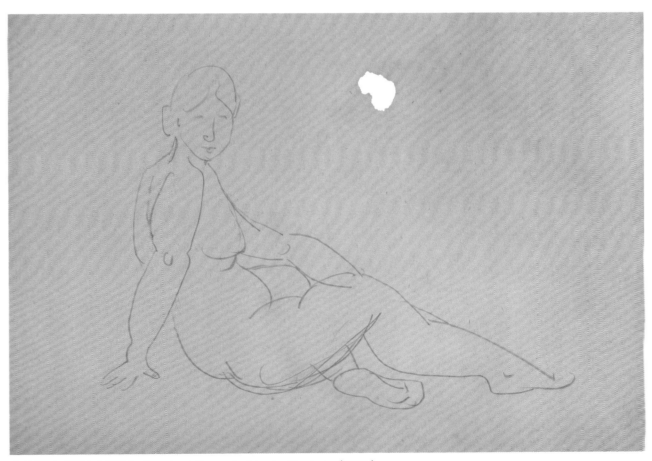

坐姿裸女速寫（309） Seated Female Nude Sketch（309）

約1932（疑1932.1.26）　紙本鉛筆　27.2×37.4cm

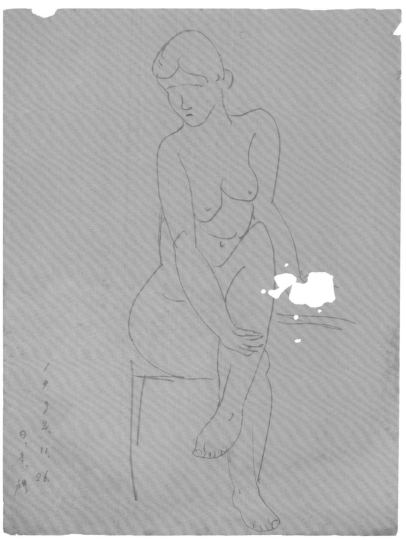

坐姿裸女速寫-32.11.26（310）
Seated Female Nude Sketch-32.11.26（310）

1932　紙本鉛筆　37.2×27.4cm

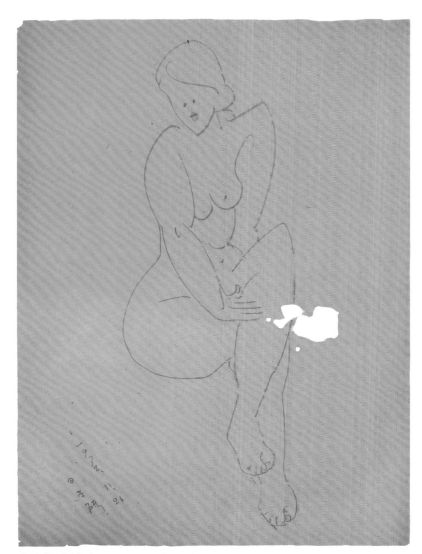

坐姿裸女速寫-32.11.26（311）
Seated Female Nude Sketch-32.11.26（311）

1932　紙本鉛筆　37.4×27.2cm

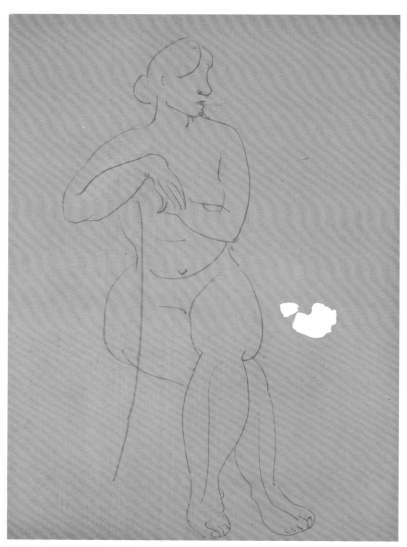

坐姿裸女速寫（312）
Seated Female Nude Sketch（312）

約1932　紙本鉛筆　37.5×27.3cm

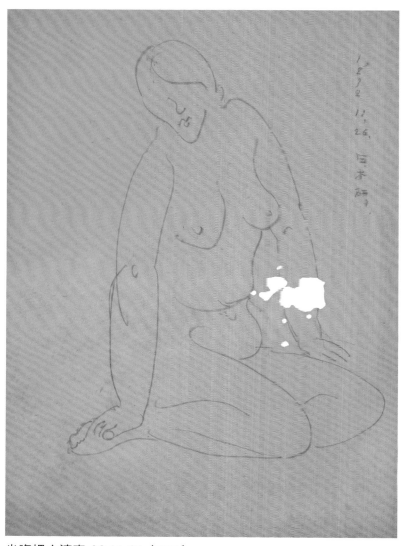

坐姿裸女速寫-32.11.26（313）
Seated Female Nude Sketch-32.11.26（313）

1932　紙本鉛筆　37.5×27.4cm

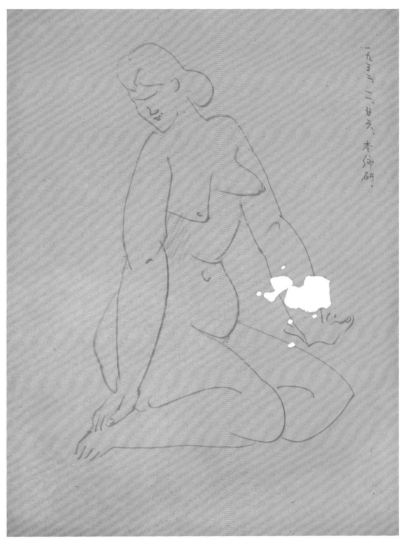

坐姿裸女速寫-32.11.26（314）
Seated Female Nude Sketch-32.11.26（314）

1932　紙本鉛筆　37.3×27.3cm

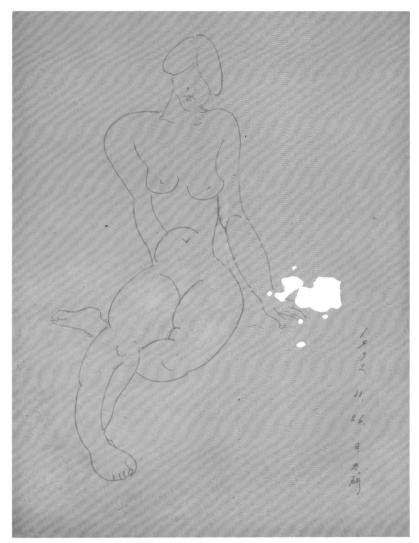

坐姿裸女速寫-32.11.26（315）
Seated Female Nude Sketch-32.11.26（315）

1932　紙本鉛筆　37.2×27.4cm

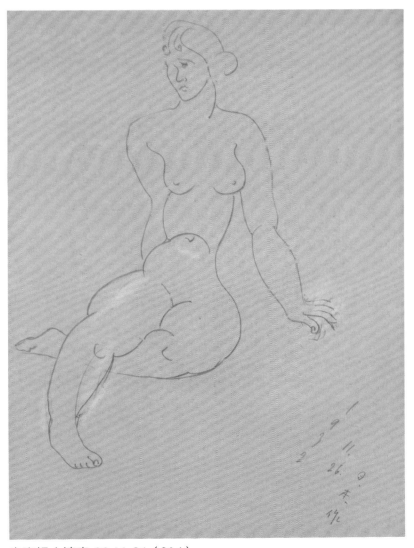

坐姿裸女速寫-32.11.26（316）
Seated Female Nude Sketch-32.11.26（316）

1932　紙本鉛筆　37.2×27.4cm

頭像速寫（25）Portrait Sketch（25）

約1932（疑1932.11.26）　紙本鉛筆　37.2×27.4cm
※為前一張之背面圖。

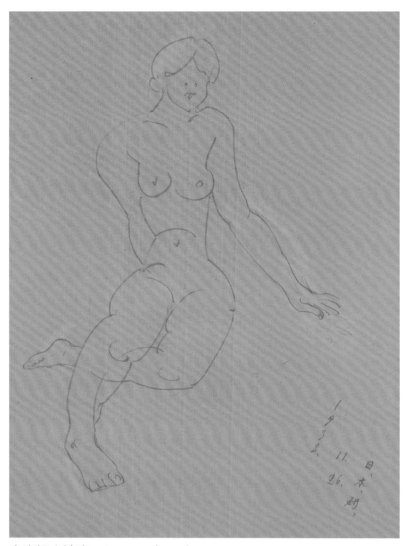

坐姿裸女速寫-32.11.26（317）
Seated Female Nude Sketch-32.11.26（317）

1932　紙本鉛筆　37.3×27.2cm

坐姿裸女速寫（318）
Seated Female Nude Sketch（318）

約1932（疑1932.11.26）　紙本鉛筆　37.3×27.3cm

坐姿裸女速寫（319）
Seated Femcle Nude Sketch（319）

約1932（疑1932.11.26）　紙本鉛筆　37.3×27.2cm

頭像速寫（26）Portrait Sketch（26）

約1932（疑1932.11.26）　紙本鉛筆　37.3×27.2cm
※為前一張之背面圖。

立姿裸女速寫-32.11.26（327）
Standing Female Nude Sketch-32.11.26（327）

1932　紙本鉛筆　37.5×27.1cm

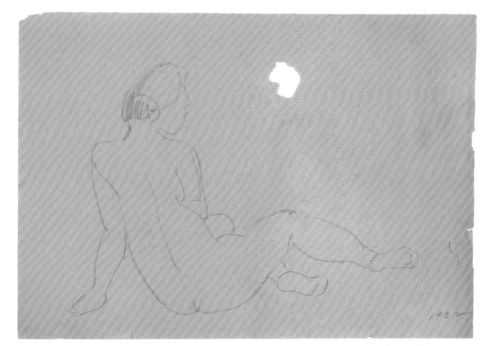

坐姿裸女速寫-32（320）　Seated Female Nude Sketch-32（320）

1932　紙本鉛筆　27.3×37.2cm

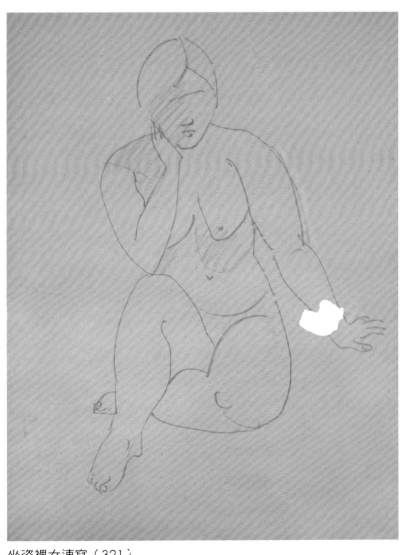

坐姿裸女速寫（321）
Seated Female Nude Sketch（321）

約1932　紙本鉛筆　37.3×27.3cm

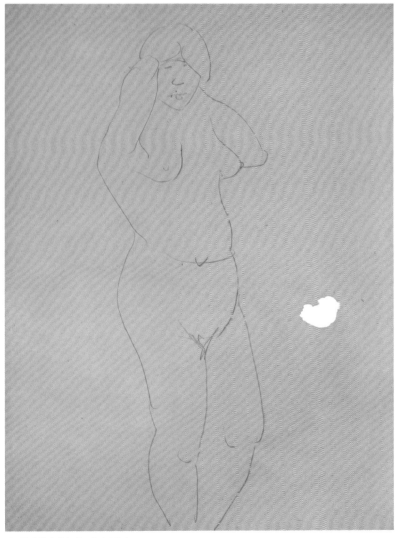

立姿裸女速寫（328）
Standing Female Nude Sketch（328）

約1932　紙本鉛筆　37.3×27cm

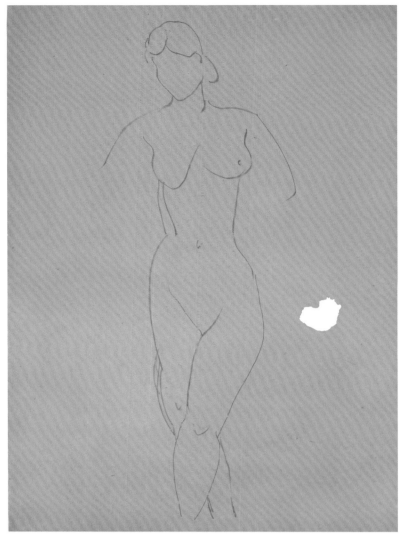

立姿裸女速寫（329）
Standing Female Nude Sketch（329）

約1932　紙本鉛筆　37.5×27.1cm

臥姿裸女速寫（49）
Reclining Female Nude Sketch（49）

約1932　紙本鉛筆　27.3×37.3cm

坐姿裸女速寫（323）
Seated Female Nude Sketch（323）

約1932　紙本鉛筆　27.5×37.2cm

坐姿裸女速寫（322）
Seated Female Nude Sketch（322）

約1932　紙本鉛筆　37.2×27.5cm

坐姿裸女速寫（324）
Seated Female Nude Sketch（324）

約1932　紙本鉛筆　37.4×27.4cm

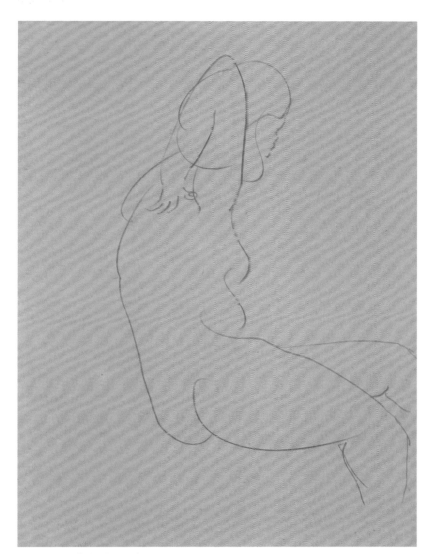

坐姿裸女速寫（325）
Seated Female Nude Sketch（325）

約1932　紙本鉛筆　37.1×27.3cm

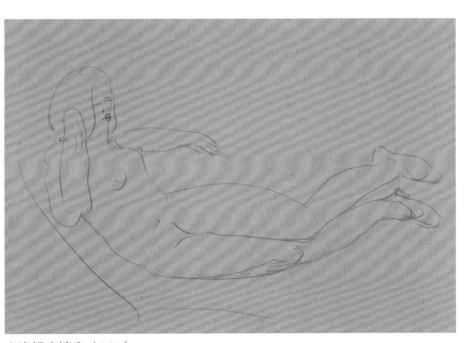

坐姿裸女速寫（326）
Seated Female Nude Sketch（326）

約1932　紙本鉛筆　37.1×27.3cm

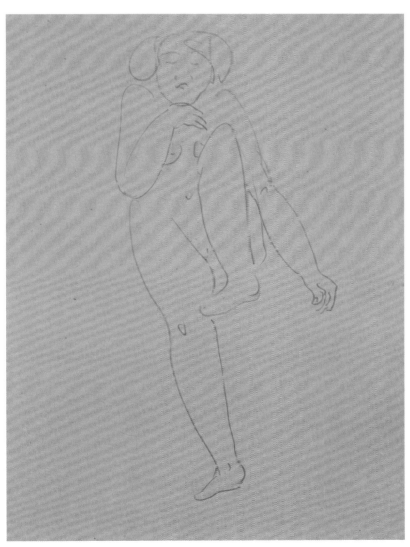

坐姿裸女速寫（327）
Seated Female Nude Sketch（327）

約1932　紙本鉛筆　37.1×27.3cm

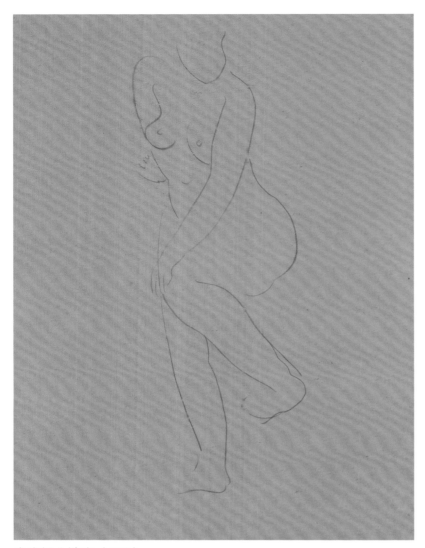

坐姿裸女速寫（328）
Seated Female Nude Sketch（328）

約1932　紙本鉛筆　37.1×27.5cm

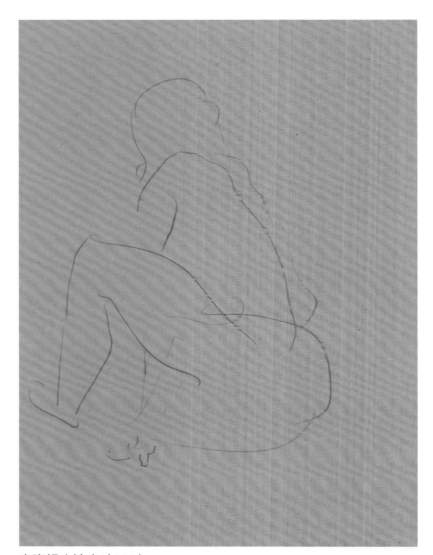

坐姿裸女速寫（329）
Seated Female Nude Sketch（329）

約1932　紙本鉛筆　37.4×27.5cm

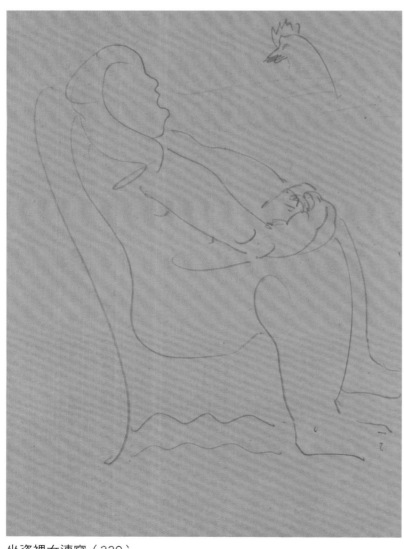

坐姿裸女速寫（330）
Seated Female Nude Sketch（330）

約1932　紙本鉛筆　37.4×27.2cm

頭像速寫（27）
Portrait Sketch（27）

約1932　紙本鉛筆　37.4×27.2cm
※為前一張之背面圖。

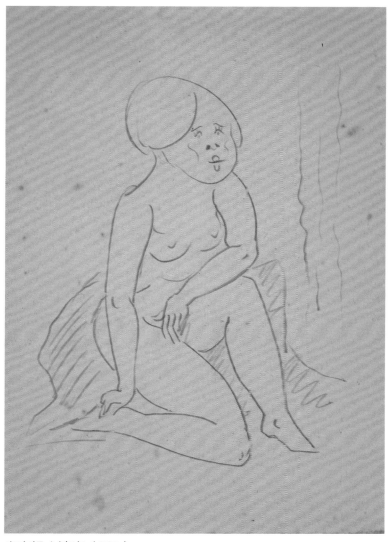

坐姿裸女速寫（331）
Seated Female Nude Sketch（331）

約1932　紙本鉛筆　31.7×22.4cm

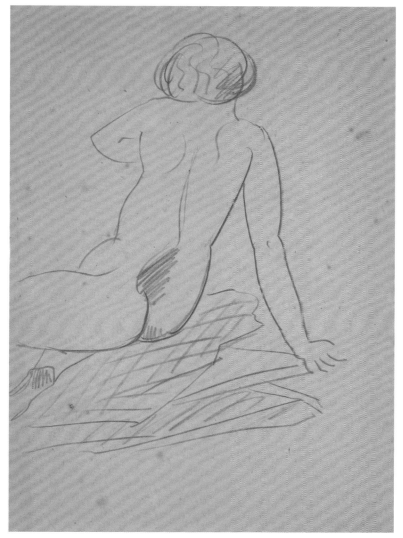

坐姿裸女速寫（332）
Seated Female Nude Sketch（332）

約1932　紙本鉛筆　31.6×22.5cm

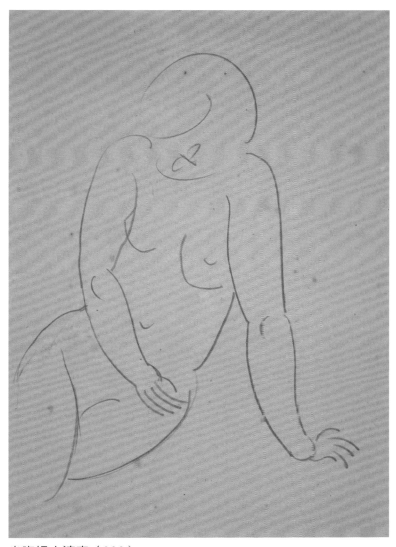

坐姿裸女速寫（333）
Seated Female Nude Sketch（333）

約1932　紙本鉛筆　31.7×22.5cm

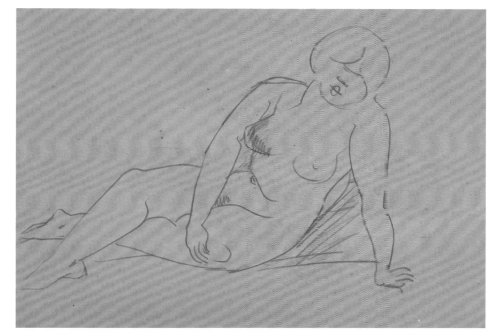

坐姿裸女速寫（334）
Seated Female Nude Sketch（334）

約1932　紙本鉛筆　22.5×31.6cm

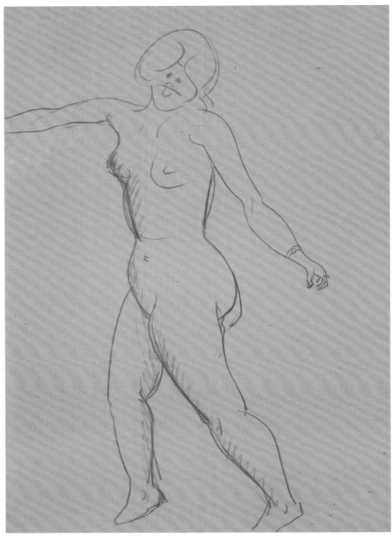

立姿裸女速寫（330）
Standing Female Nude Sketch（330）

約1932　紙本鉛筆　36.6×26.1cm

立姿裸女速寫（331）
Standing Female Nude Sketch（331）

約1932　紙本鉛筆　37.2×27.5cm

立姿裸女速寫（332）
Standing Female Nude Sketch（332）

約1932　紙本鉛筆　37.2×27.5cm

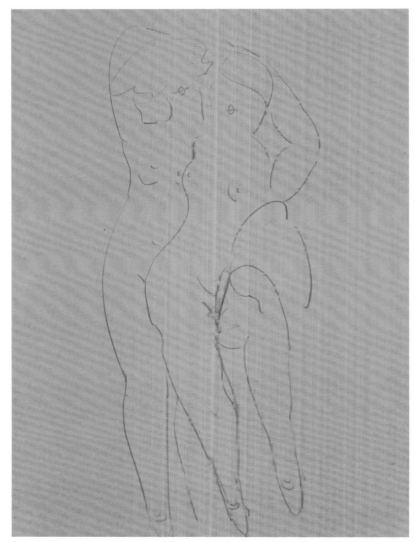

立姿裸女速寫（333）
Standing Female Nude Sketch（333）

約1932　紙本鉛筆　37.1×27.3cm

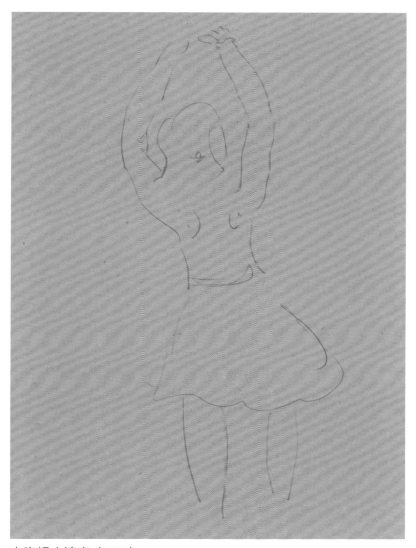

立姿裸女速寫（334）
Standing Female Nude Sketch（334）

約1932　紙本鉛筆　37.2×27.5cm

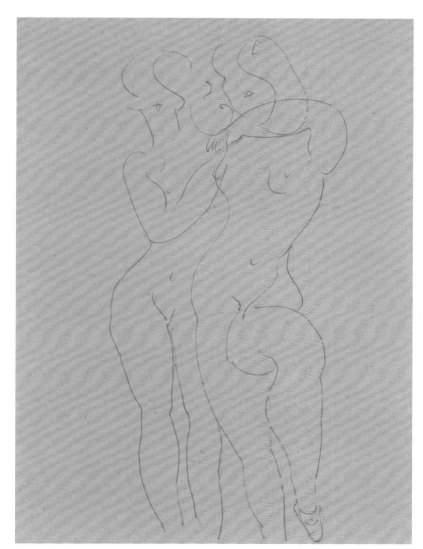

立姿裸女速寫（335）
Standing Female Nude Sketch（335）

約1932　紙本鉛筆　37.3×27.2cm

立姿裸女速寫（336）
Standing Female Nude Sketch（336）

約1932　紙本鉛筆　37.4×27.5cm

頭像速寫（28）　Portrait Sketch（28）

約1932　紙本鉛筆　37.4×27.5cm
※為前一張之背面圖。

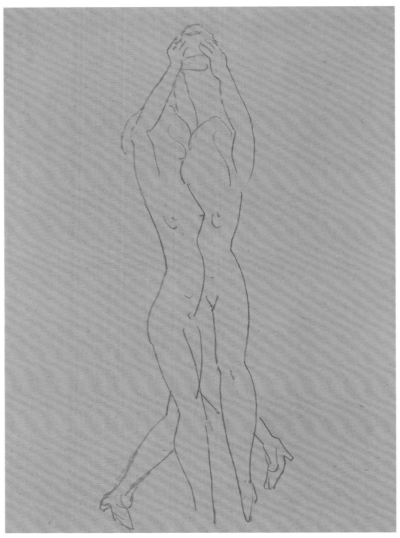

立姿裸女速寫（337）
Standing Female Nude Sketch（337）

約1932　紙本鉛筆　37.3×27.5cm

立姿裸女速寫（338）
Standing Female Nude Sketch（338）

約1932　紙本鉛筆　37.5×27.5cm

臥姿裸女速寫（50）
Reclining Female Nude Sketch（50）

約1932　紙本鉛筆　27.3×37cm

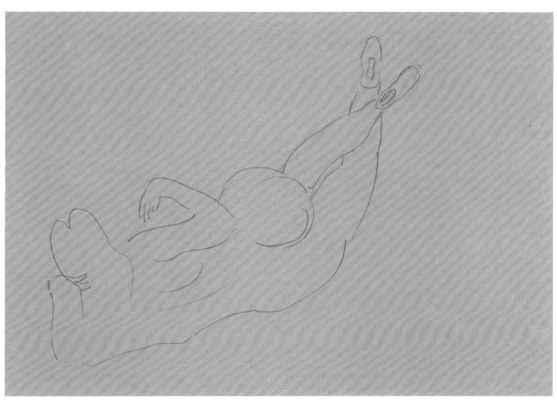

臥姿裸女速寫（51）
Reclining Female Nude Sketch（51）
約1932　紙本鉛筆　27.2×37.4cm

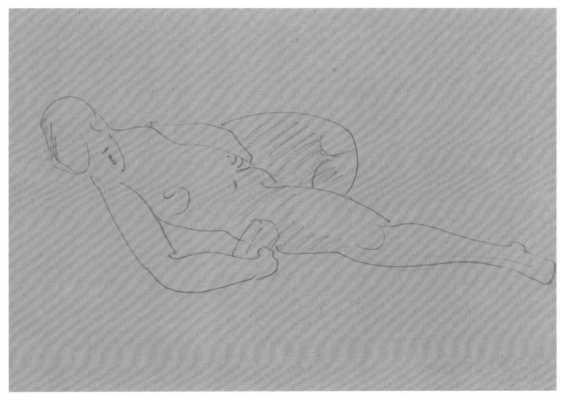

臥姿裸女速寫（52）
Reclining Female Nude Sketch（52）
約1932　紙本鉛筆　27.3×37.3cm

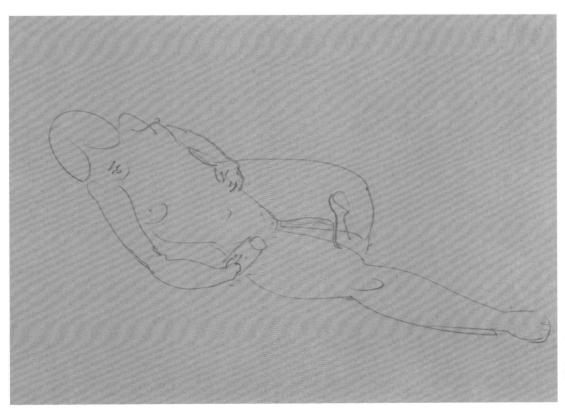

臥姿裸女速寫（53）
Reclining Female Nude Sketch（53）
約1932　紙本鉛筆　37.2×27.3cm

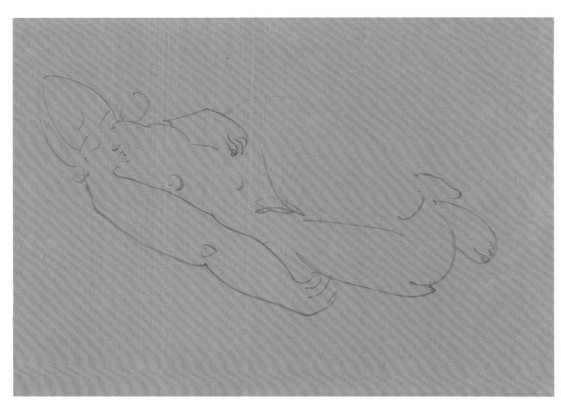

臥姿裸女速寫（54）
Reclining Female Nude Sketch（54）

約1932　紙本鉛筆　27.3×37.3cm

臥姿裸女速寫（55）
Reclining Female Nude Sketch（55）

約1932　紙本鉛筆　27.4×37.3cm

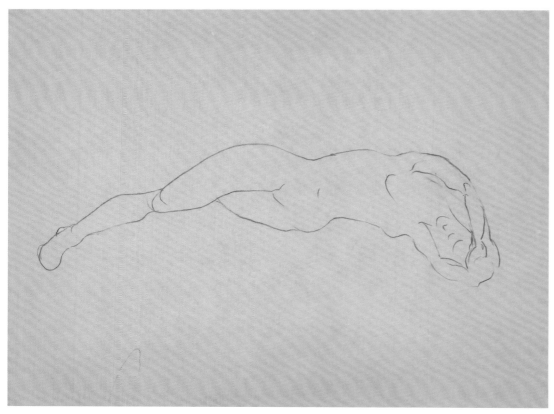

臥姿裸女速寫（56）
Reclining Female Nude Sketch（56）

約1932　紙本鉛筆　27.3×38.2cm

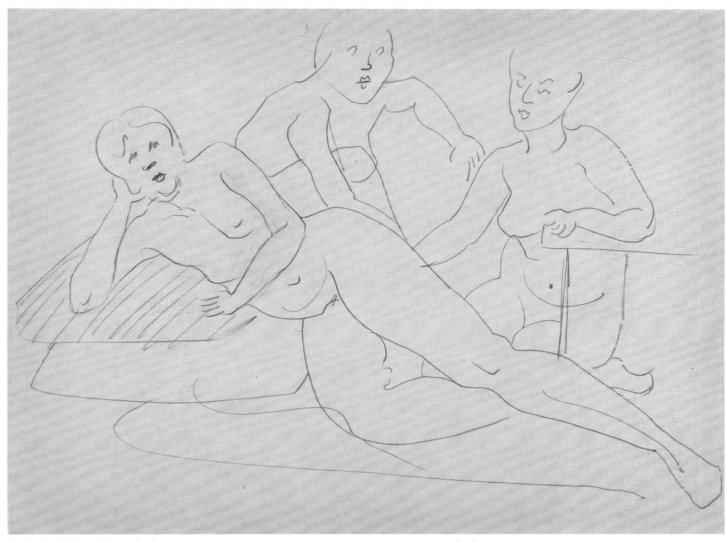

坐姿與臥姿裸女速寫（4）Seated and Reclining Female Nude Sketch（4）
約1932　紙本鉛筆　29.4×38.2cm

人物速寫（30）Figure Sketch（30）
約1932　紙本鉛筆　27.4×37.4cm

風景速寫-34.8.3（2）Landscape Sketch-34.8.3（2）

1934　紙本鉛筆　19.1×25.5cm

二萬平-35.3.27 Erwanping-35.3.27

1935　紙本鉛筆　25×28.4cm

人物速寫-35.4.7（31） Figure Sketch-35.4.7（31）
1935　紙本鋼筆　23.9×31.5cm

從對高岳展望開農台-35.4.7
Looking from Dueigaoyue to Kainongtai-35.4.7
1935　紙本鋼筆　24.4×32.9cm

阿里山鐵軌-35.4.8 Alishan Railroad-35.4.8
1935　紙本鋼筆　24.4×32.9cm

風景速寫-35.4（3） Landscape Sketch-35.4（3）
1935　紙本鋼筆　24.3×32.7cm

阿里山小學校-35.4 Alishan Primary School-35.4
1935　紙本鋼筆　24.5×32.9cm

阿里山區風景速寫-35.4.9（1） Alishan Landscape Sketch-35.4.9（1）

1935　紙本鉛筆　24.7×28.5cm

阿里山區風景速寫-35.4.9（2） Alishan Landscape Sketch-35.4.9（2）

1935　紙本鉛筆　24.9×27.6cm

阿里山區風景速寫（3） Alishan Landscape Sketch（3）
約1935　紙本鉛筆　24.7×28.8cm

獅子頭山 Shizaitou Mountain
約1935　紙本鉛筆　24.9×28.6cm

塔山 Tashan
約1935　紙本鋼筆　24.4×32.8cm

從祝山眺望松山-35.4.13
Looking from Chushan to Songshan-
35.4.13
1935　紙本鋼筆　32.9×24.5cm

淡江夕暮-35.9 Sunset in Tamsui-35.9
1935　紙本水墨　24×33cm

在霧峯-36 Wufeng-36
1936　紙本鉛筆　23.9×32.5cm

旗山街-37.8.23 Cishar Street-37.8.23

1937　紙本鋼筆　24.1×28.1cm

從幼葉林眺望交力坪-38.1.6 Looking from Youyelin to Jiaoliping-38.1.6

1938　紙本鉛筆　24.4×27.7cm

太平山-38.1.6 Taiping Mountain-38.1.6
1938　紙本鉛筆　23×27.7cm

霧峯-38.2 Wufeng-38.2
1938　紙本鉛筆　尺寸不詳

風景速寫-45.12.6（4） Landscape Sketch-45.12.6（4）

1945　紙本鉛筆　25.3×36.2cm

速寫
Sketch

年代不詳 Date Unknown

▪ 坐姿裸女 Seated Female Nude

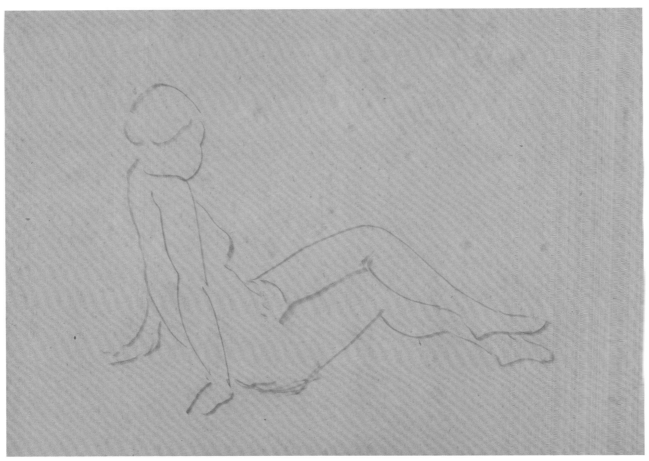

坐姿裸女速寫（335）Seated Female Nude Sketch（335）
年代不詳　紙本鉛筆　24.2×33.2cm

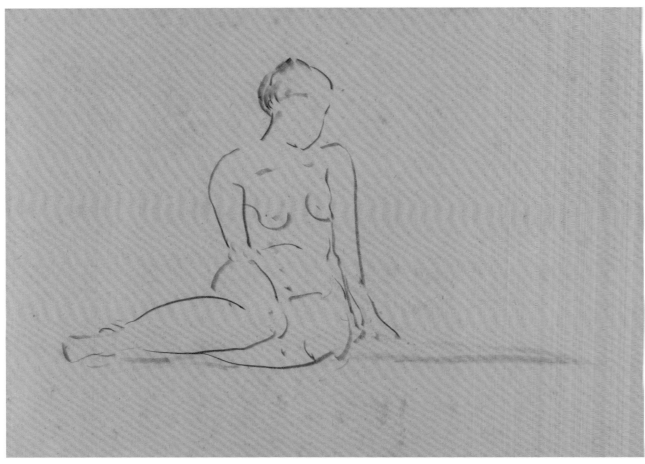

坐姿裸女速寫（336）Seated Female Nude Sketch（336）
年代不詳　紙本鉛筆　24.1×33.2cm

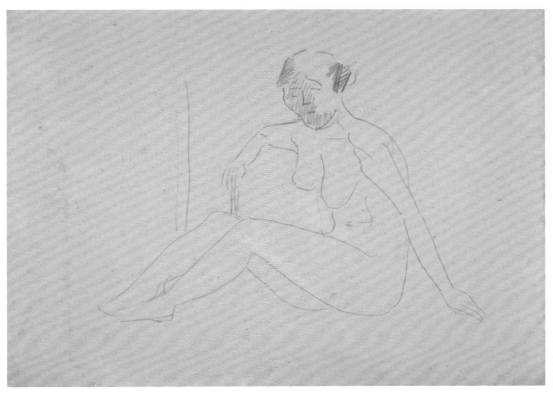

坐姿裸女速寫（337）
Seated Female Nude Sketch（337）

年代不詳　紙本鉛筆　24.3×33.3cm

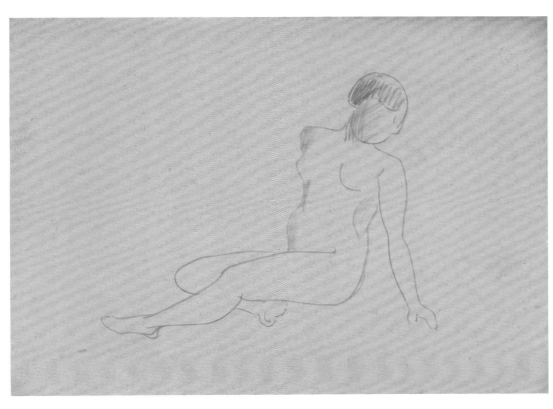

坐姿裸女速寫（338）
Seated Female Nude Sketch（338）

年代不詳　紙本鉛筆　24.3×33.1cm

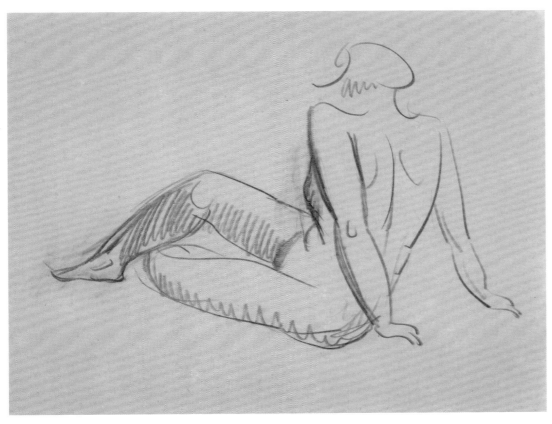

坐姿裸女速寫（339）
Seated Female Nude Sketch（339）

年代不詳　紙本鉛筆　24.5×31.4cm

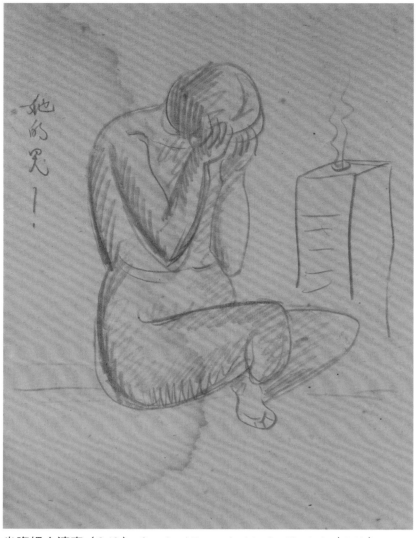

坐姿裸女速寫（340）　Seated Female Nude Sketch（340）
年代不詳　紙本鉛筆　28.3×21.3cm

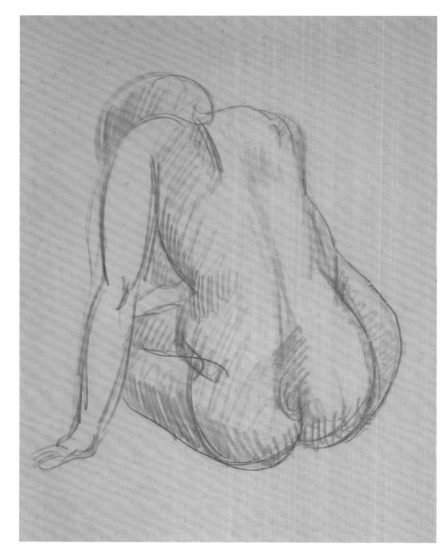

坐姿裸女速寫（341）　Seated Female Nude Sketch（341）
年代不詳　紙本鉛筆　31.3×24cm

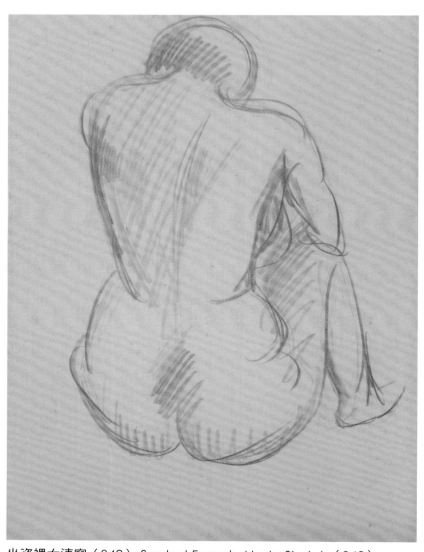

坐姿裸女速寫（342）　Seated Female Nude Sketch（342）
年代不詳　紙本鉛筆　32×24.1cm

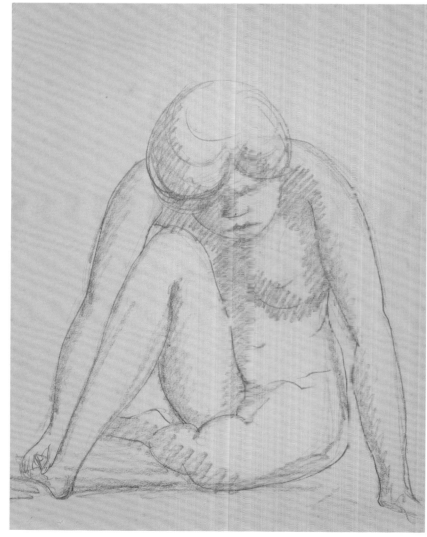

坐姿裸女速寫（343）　Seated Female Nude Sketch（343）
年代不詳　紙本鉛筆　38.3×29.3cm

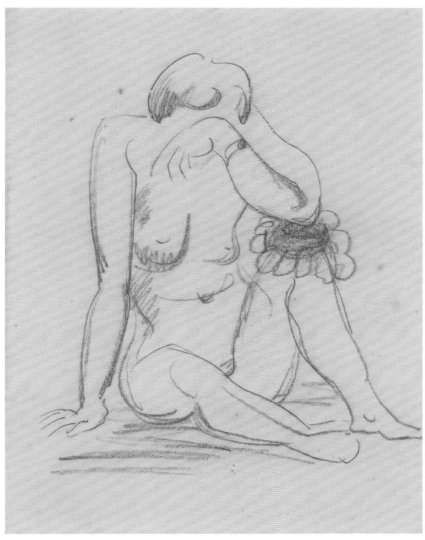

坐姿裸女速寫（344）Seated Female Nude Sketch（344）
年代不詳　紙本鉛筆　32×24.3cm

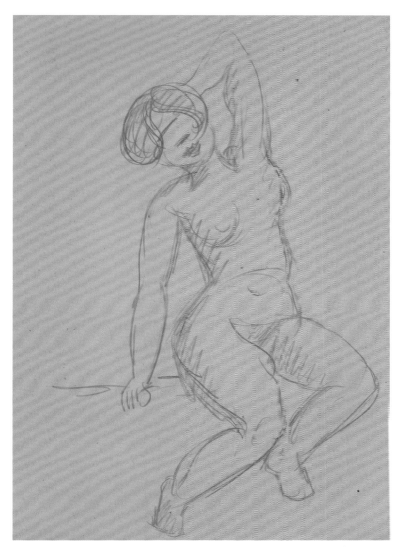

坐姿裸女速寫（345）Seated Female Nude Sketch（345）
年代不詳　紙本鉛筆　39.1×27.2cm

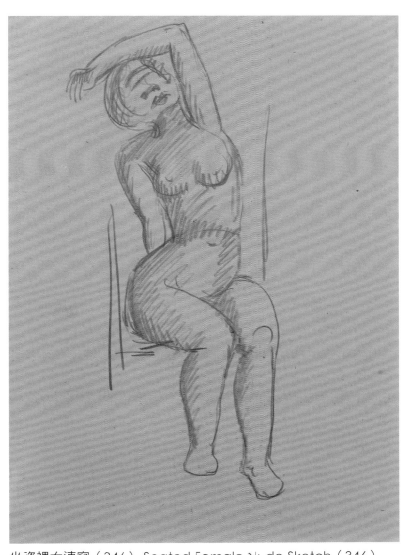

坐姿裸女速寫（346）Seated Female Nude Sketch（346）
年代不詳　紙本鉛筆　23.5×35cm

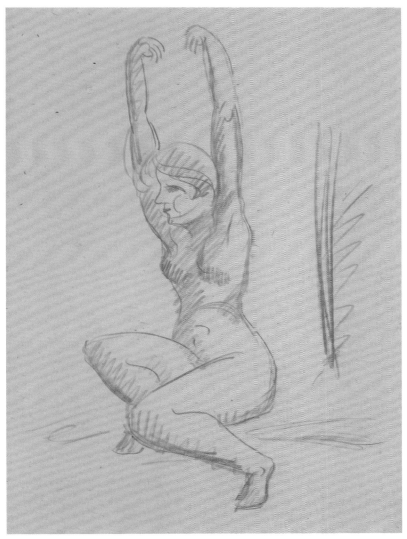

坐姿裸女速寫（347）Seated Female Nude Sketch（347）
年代不詳　紙本鉛筆　36.3×26.5cm

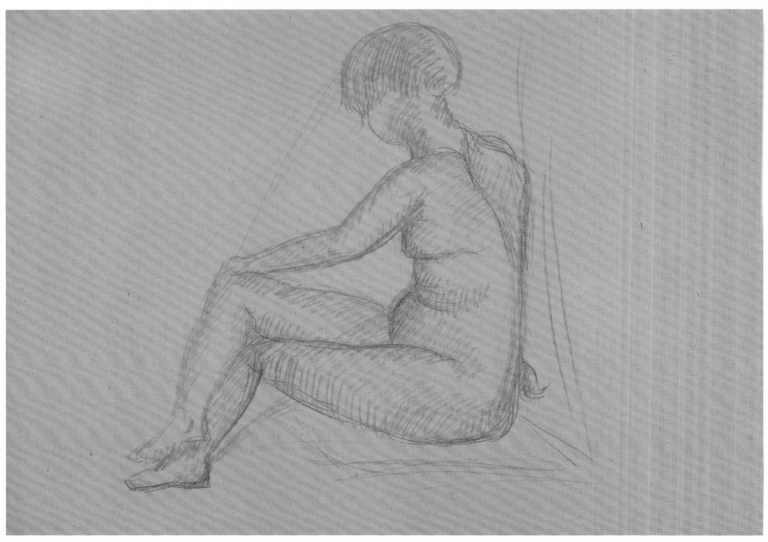

坐姿裸女速寫（348） Seated Female Nude Sketch（348）
年代不詳　紙本鉛筆　26.3×36.5cm

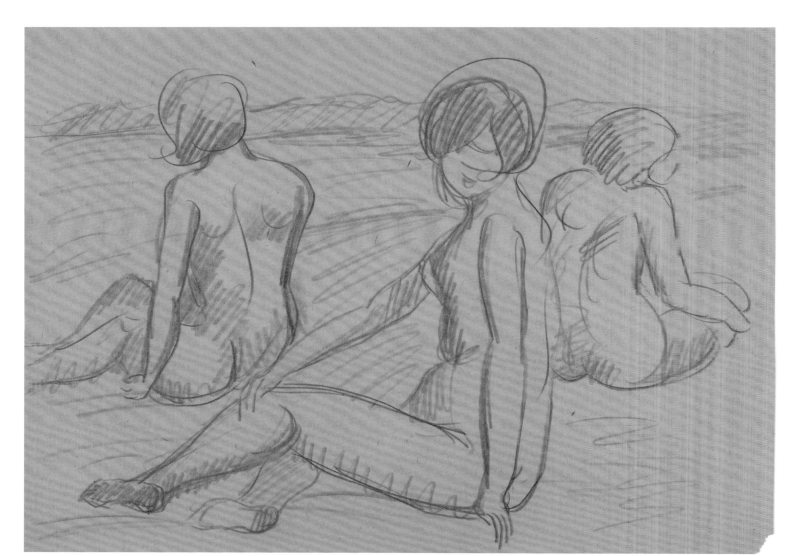

坐姿裸女速寫（349） Seated Female Nude Sketch（349）
年代不詳　紙本鉛筆　26.2×36.1cm

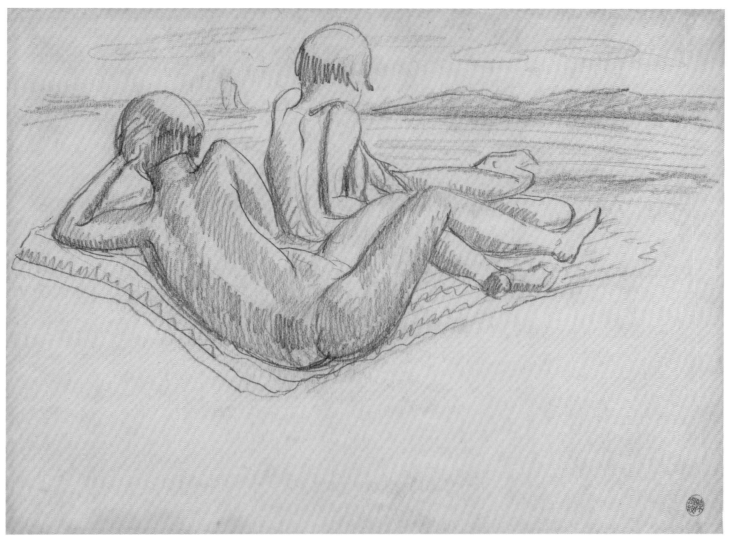

坐姿與臥姿裸女速寫（5） Seated and Reclining Female Nude Sketch（5）

年代不詳　紙本鉛筆　29.3×38.4cm

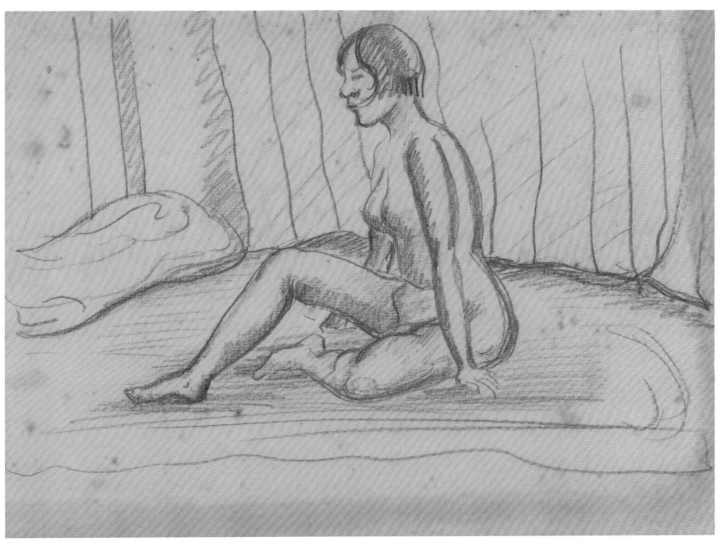

坐姿裸女速寫（350） Seated Female Nude Sketch（350）

年代不詳　紙本鉛筆　24.9×31.7cm

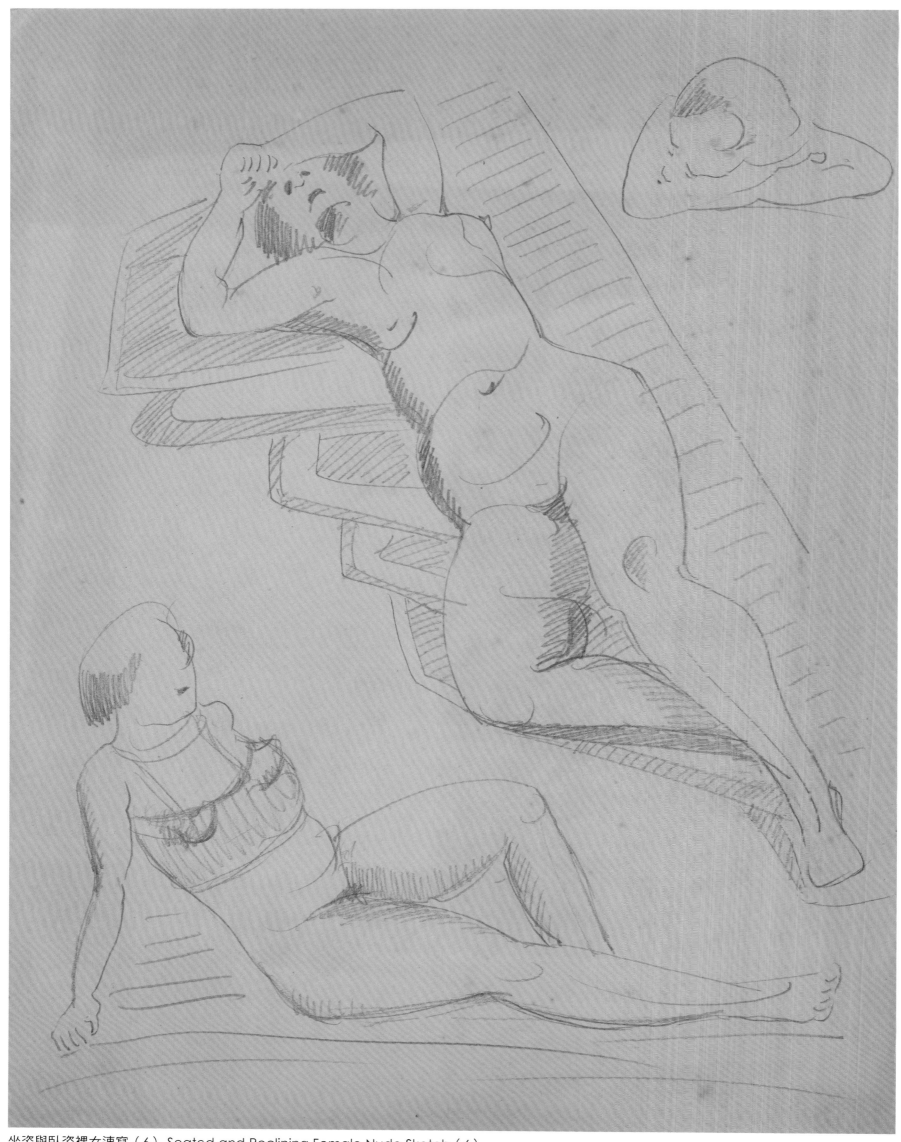

坐姿與臥姿裸女速寫（6） Seated and Reclining Female Nude Sketch（6）

年代不詳　紙本鉛筆　38.3×29.1cm

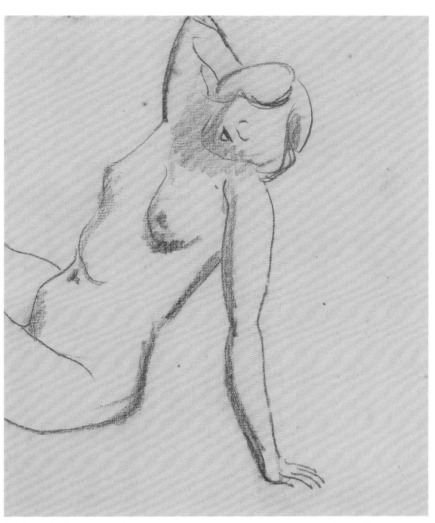

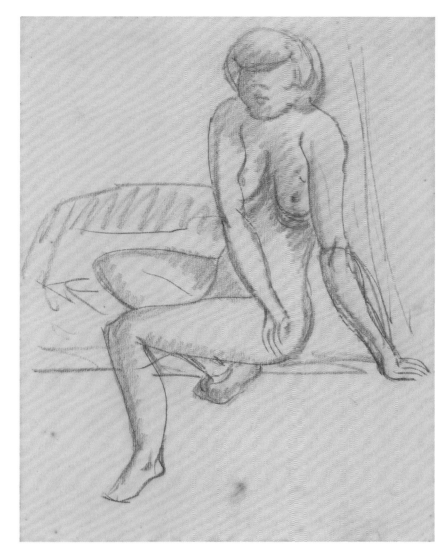

坐姿裸女速寫（351）Sectec Female Nude Sketch（351）

年代不詳　紙本鉛筆　24.1×20.1cm

坐姿裸女速寫（352）Seated Female Nude Sketch（352）

年代不詳　紙本鉛筆　31.6×24.4cm

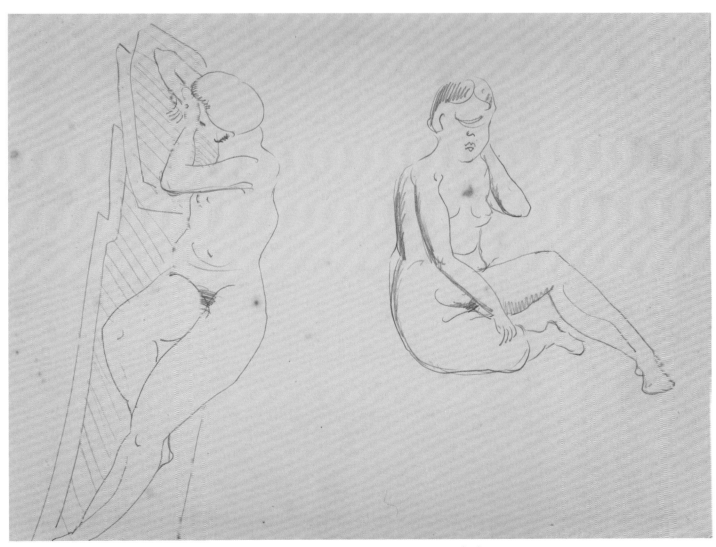

坐姿與臥姿裸女速寫（7）　Seated and Reclining Female Nude Sketch（7）

年代不詳　紙本鉛筆　29.3×38cm

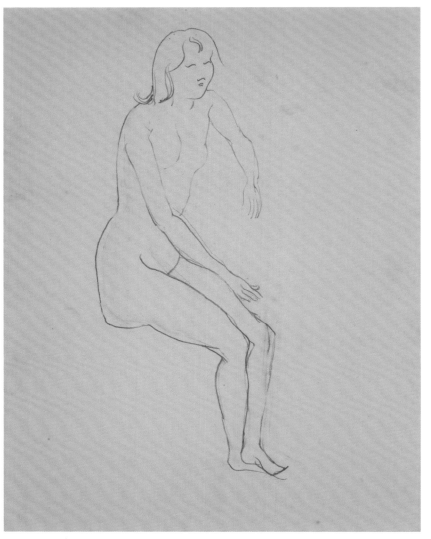

坐姿裸女速寫（353）Seated Female Nude Sketch（353）

年代不詳　紙本鉛筆　38.1×29.3cm

坐姿裸女速寫（354）Seated Female Nude Sketch（354）

年代不詳　紙本鉛筆　29.2×38cm

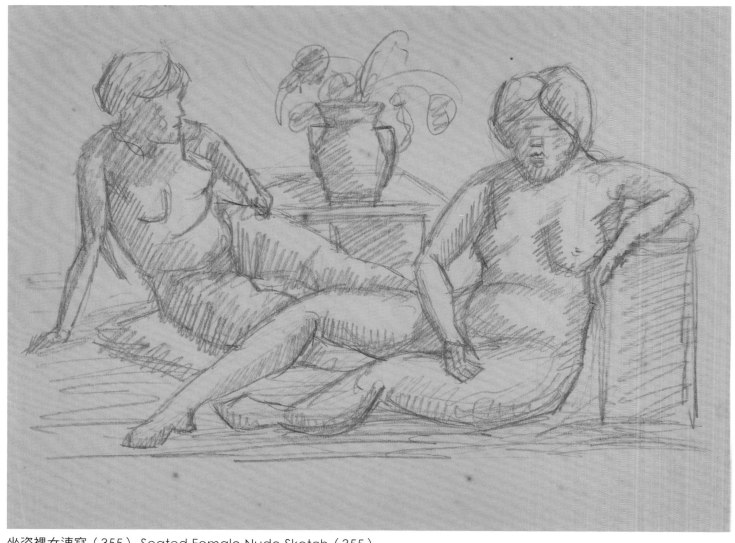

坐姿裸女速寫（355）Seated Female Nude Sketch（355）

年代不詳　紙本鉛筆　29.2×38.8cm

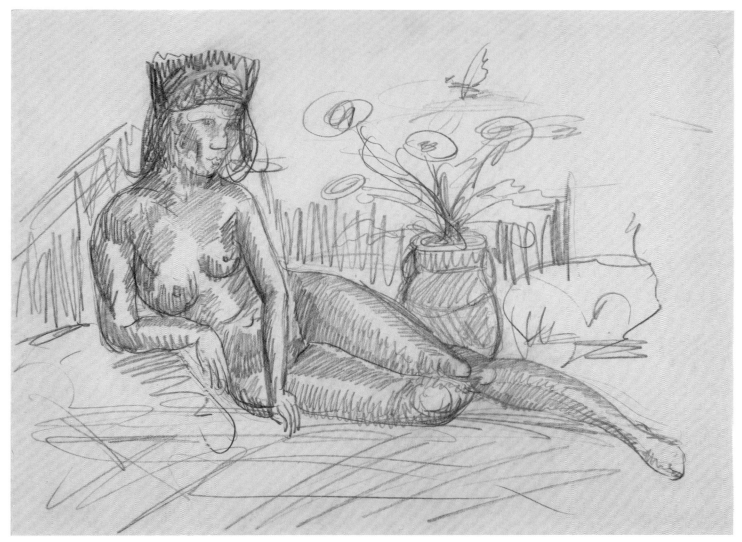

坐姿裸女速寫（356） Seated Female Nude Sketch（356）
年代不詳　紙本鉛筆　29.1×38.4cm

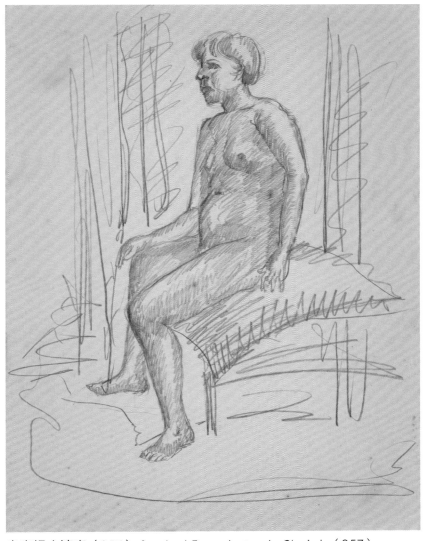

坐姿裸女速寫（357） Seated Female Nude Sketch（357）
年代不詳　紙本鉛筆　38.2×29cm

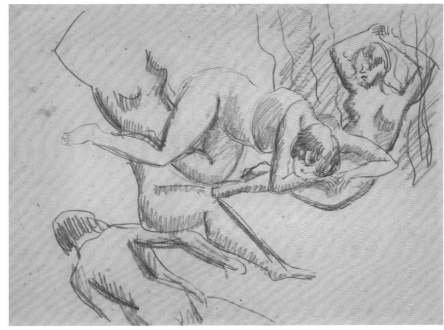

坐姿與臥姿裸女速寫（8）
Seated and Reclining Female Nude Sketch（8）
年代不詳　紙本鉛筆　29.2×38.2cm

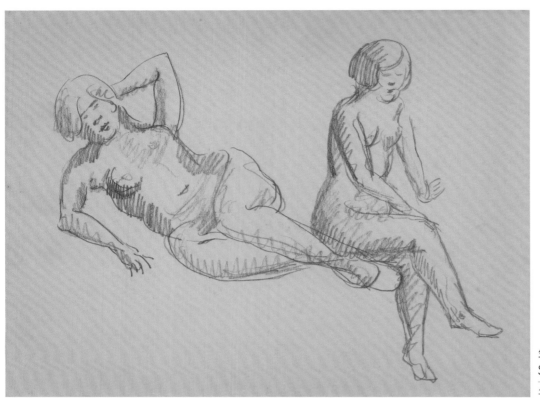

坐姿與臥姿裸女速寫（9）
Seated and Reclining Female Nude Sketch（9）
年代不詳　紙本鉛筆　29.2×33.2cm

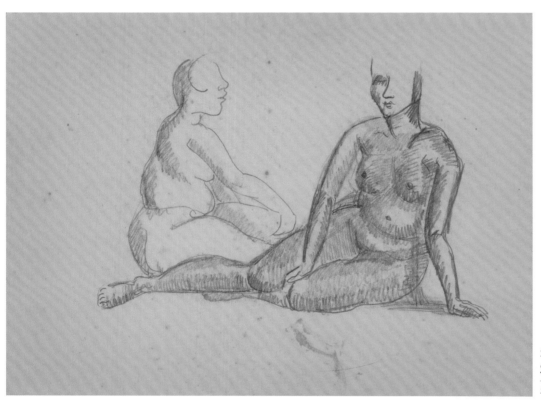

坐姿裸女速寫（358）
Seated Female Nude Sketch（358）
年代不詳　紙本鉛筆　29.4×38.4cm

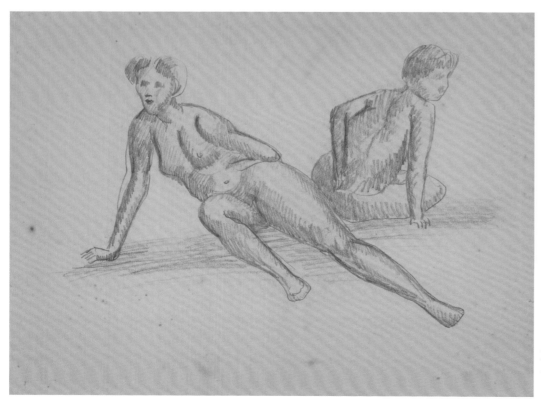

坐姿裸女速寫（359）
Seated Female Nude Sketch（359）
年代不詳　紙本鉛筆　29.7×38.2cm

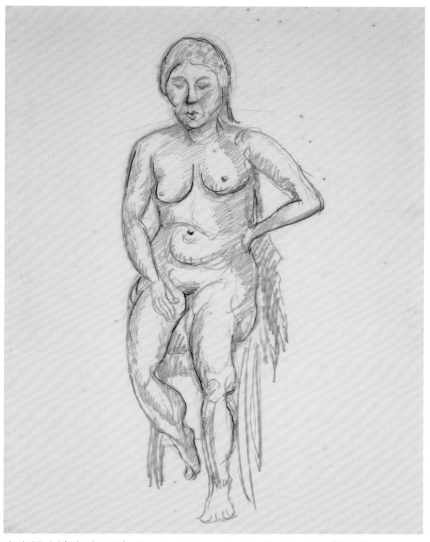

坐姿裸女速寫（360） Seated Female Nude Sketch（360）
年代不詳　紙本鉛筆　38×29.3cm

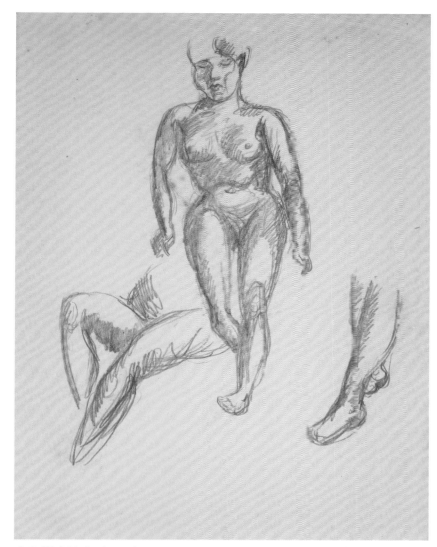

坐姿裸女速寫（361） Seated Female Nude Sketch（361）
年代不詳　紙本鉛筆　38.2×29.1cm

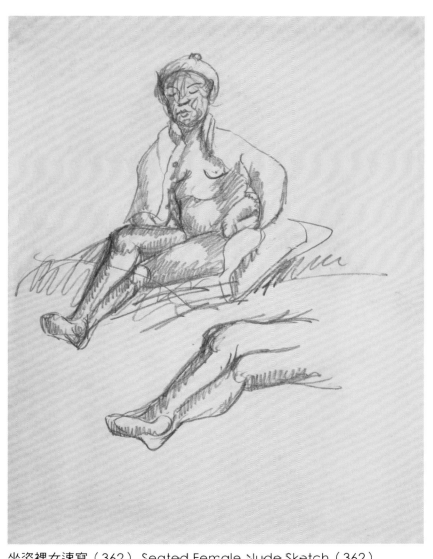

坐姿裸女速寫（362） Seated Female Nude Sketch（362）
年代不詳　紙本鉛筆　38.3×29.2cm

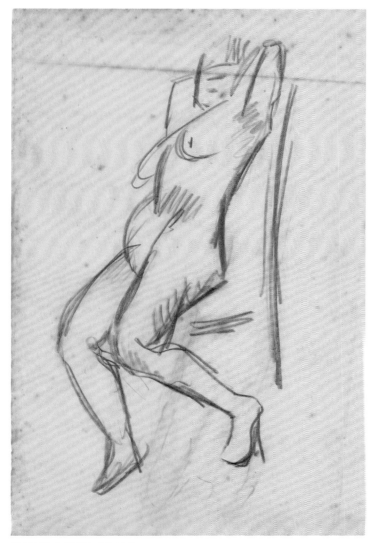

坐姿裸女速寫（363）
Seated Female Nude Sketch（363）
年代不詳　紙本鉛筆　26.6×17.8cm

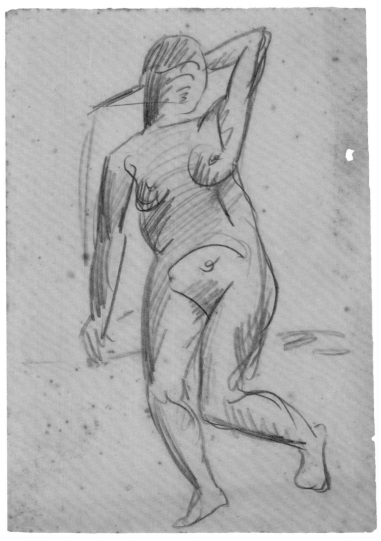

坐姿裸女速寫（364） Seated Female Nude Sketch（364）

年代不詳　紙本鉛筆　26.4×18.5cm

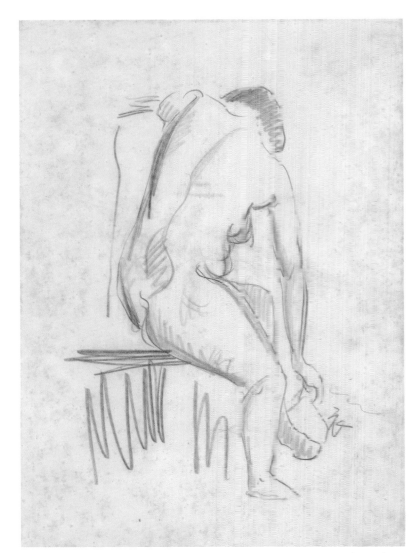

坐姿裸女速寫（365） Seated Female Nude Sketch（365）

年代不詳　紙本鉛筆　26.1×18.5cm

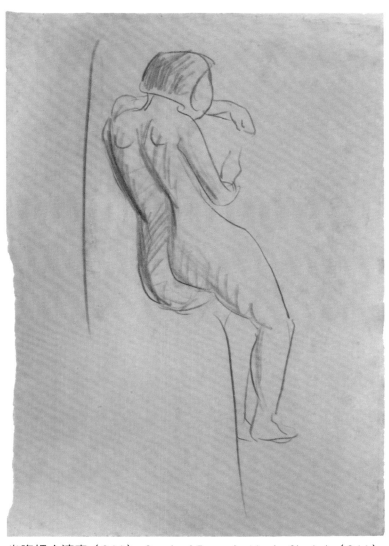

坐姿裸女速寫（366） Seated Female Nude Sketch（366）

年代不詳　紙本鉛筆　26.6×18.5cm

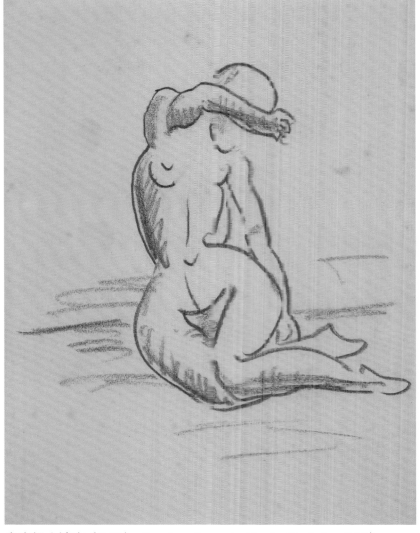

坐姿裸女速寫（367） Seated Female Nude Sketch（367）

年代不詳　紙本鉛筆　25.5×19cm

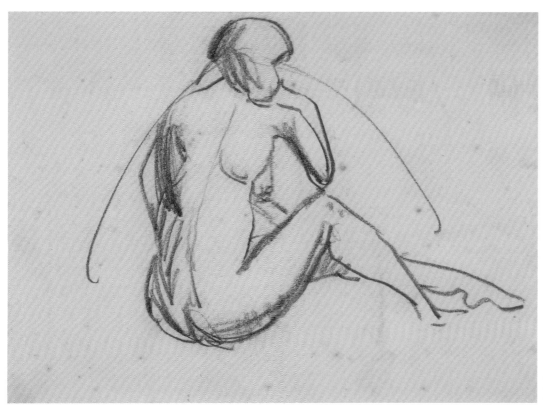

坐姿裸女速寫（368）
Seated Female Nude Sketch（368）

年代不詳　紙本鉛筆　19×25.5cm

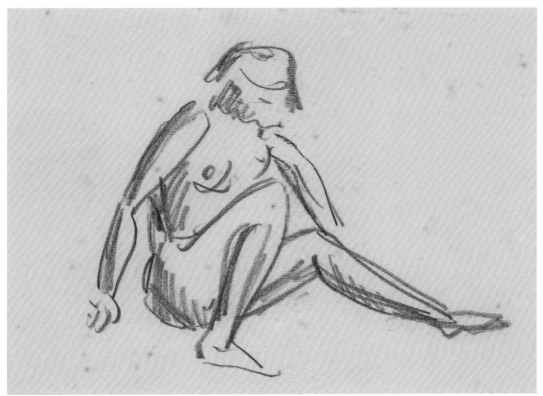

坐姿裸女速寫（369）
Seated Female Nude Sketch（369）

年代不詳　紙本鉛筆　19×25.5cm

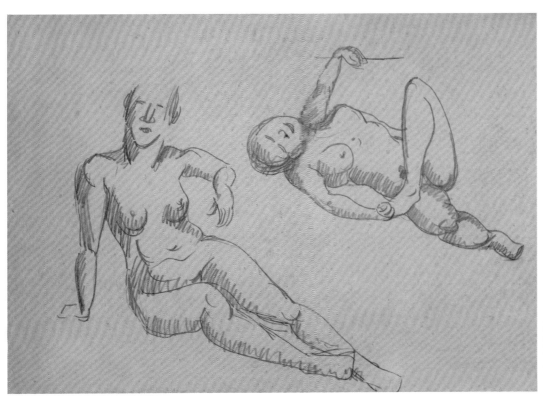

坐姿與臥姿裸女速寫（10）
Seated and Reclining Female Nude Sketch（10）

年代不詳　紙本鉛筆　24.2×33.1cm

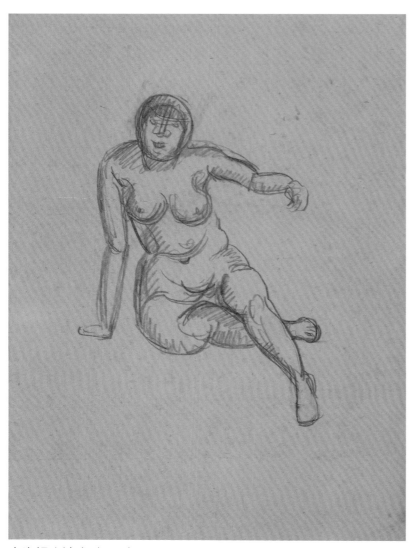

坐姿裸女速寫（370）Seated Female Nude Sketch（370）
年代不詳　紙本鉛筆　33.1×24.2cm

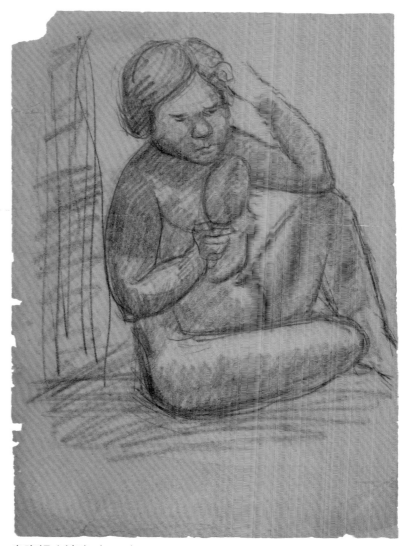

坐姿裸女速寫（371）Seated Female Nude Sketch（371）
年代不詳　紙本鉛筆　36.5×25.9cm

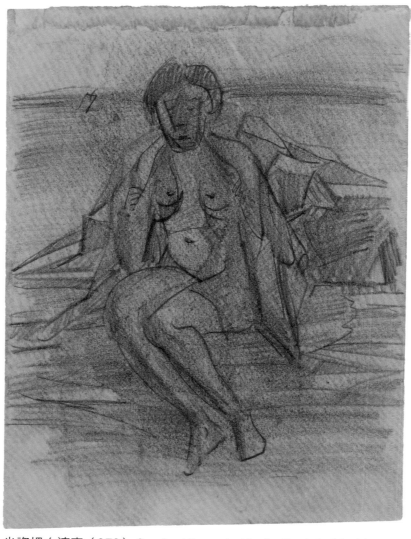

坐姿裸女速寫（372）Seated Female Nude Sketch（372）
年代不詳　紙本鉛筆　25×18.8cm

・立姿裸女 Standing Female Nude

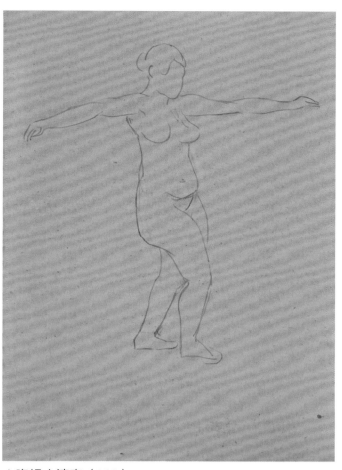

立姿裸女速寫（339）
Standing Female Nude Sketch（339）

年代不詳　紙本鉛筆　33.2×23.7cm

・立姿裸女 Standing Female Nude

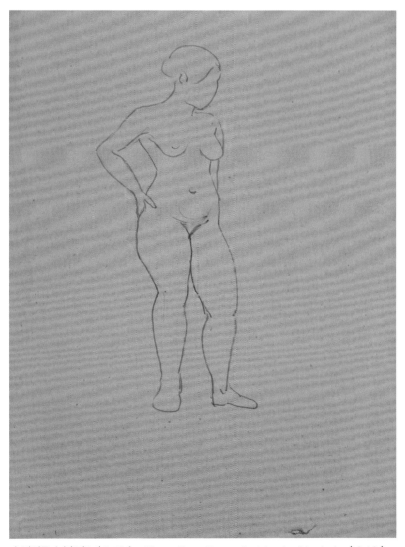

立姿裸女速寫（340）Standing Female Nude Sketch（340）

年代不詳　紙本鉛筆　33.2×23.7cm

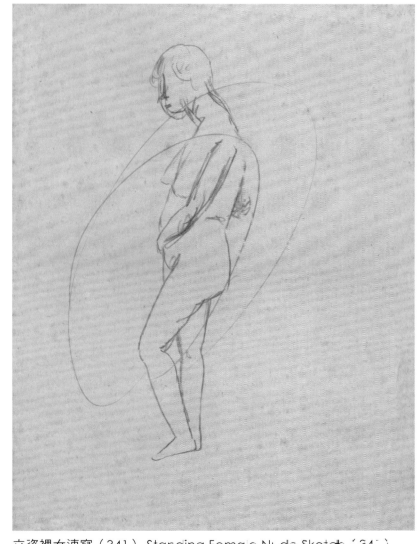

立姿裸女速寫（341）Standing Female Nude Sketch（341）

年代不詳　紙本鉛筆　33.2×24.7cm

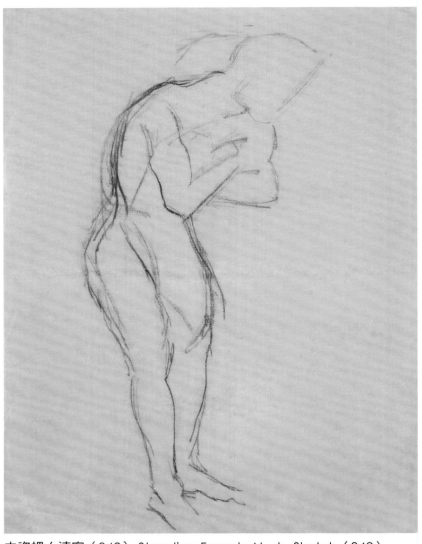

立姿裸女速寫（342）Standing Female Nude Sketch（342）

年代不詳　紙本鉛筆　31.3×23.7cm

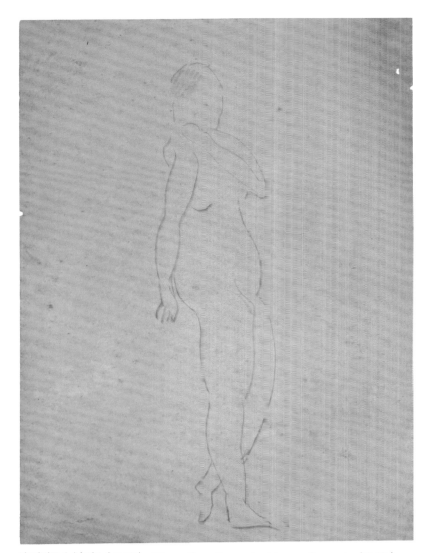

立姿裸女速寫（343）Standing Female Nude Sketch（343）

年代不詳　紙本鉛筆　33.2×24.2cm

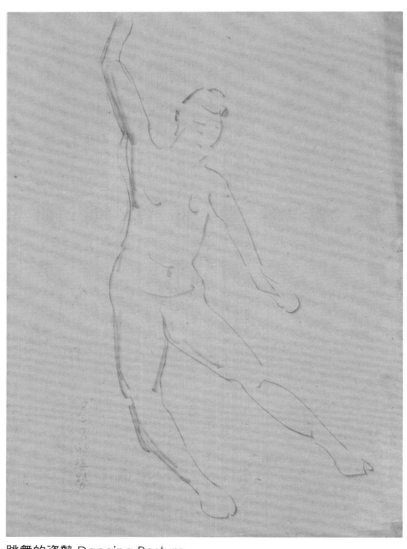

跳舞的姿勢 Dancing Posture

年代不詳　紙本鉛筆　33.3×24.2cm

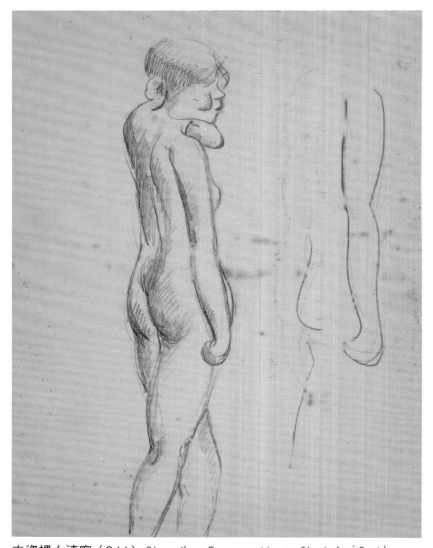

立姿裸女速寫（344）Standing Female Nude Sketch（344）

年代不詳　紙本鉛筆　38.3×28.9cm

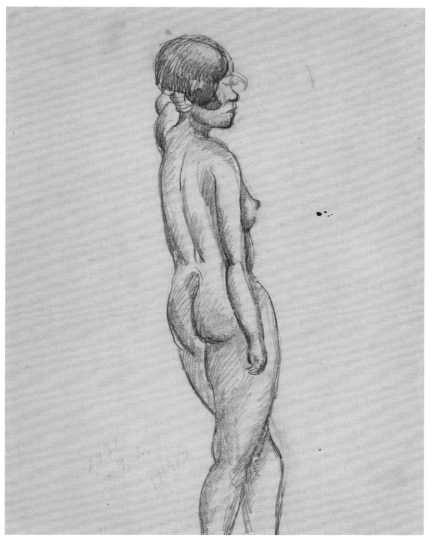

立姿裸女速寫（345）Standing Female Nude Sketch（345）
年代不詳　紙本鉛筆　38.1×29.4cm

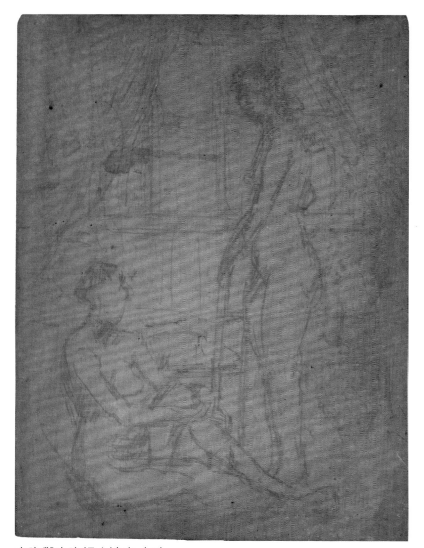

立姿與坐姿裸女速寫（7）
Standing and Seated Female Nude Sketch（7）
年代不詳　木板鉛筆　33×24.5cm

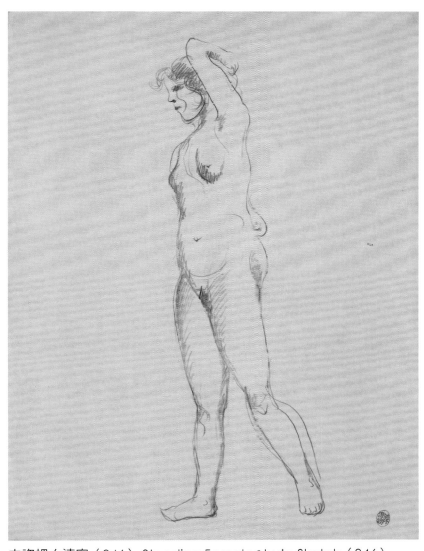

立姿裸女速寫（346）Standing Female Nude Sketch（346）
年代不詳　紙本鉛筆　38.6×29.4cm

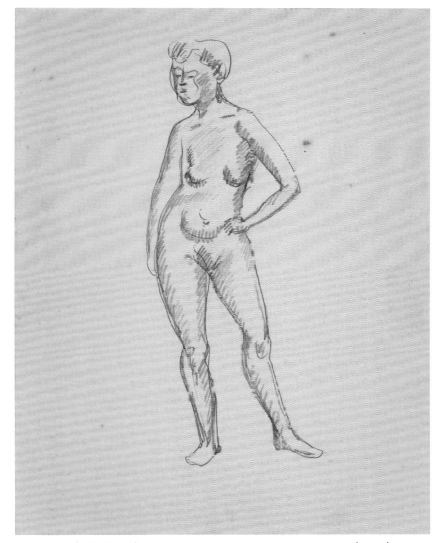

立姿裸女速寫（347）Standing Female Nude Sketch（347）
年代不詳　紙本鉛筆　38.3×29.1cm

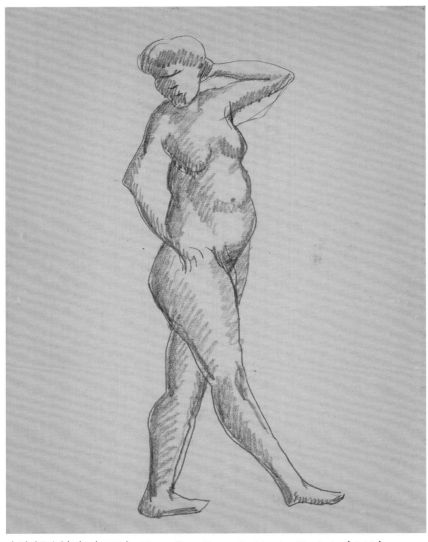

立姿裸女速寫（348）Standing Female Nude Sketch（348）

年代不詳　紙本鉛筆　38.2×29.5cm

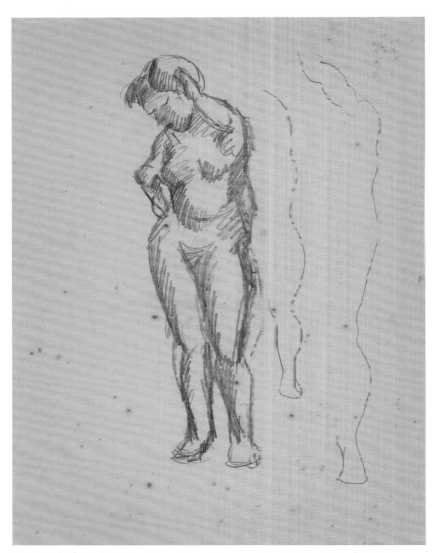

立姿裸女速寫（349）Standing Female Nude Sketch（349）

年代不詳　紙本鉛筆　38.3×29.4cm

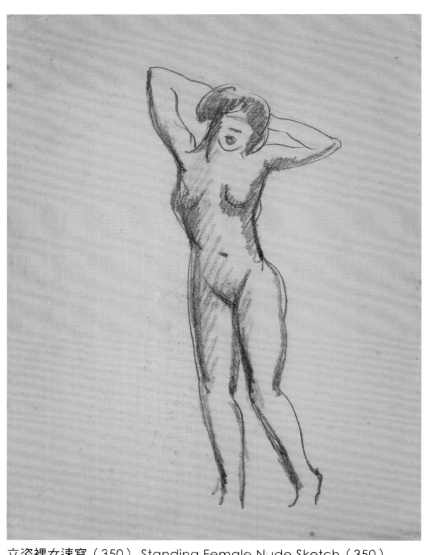

立姿裸女速寫（350）Standing Female Nude Sketch（350）

年代不詳　紙本鉛筆　38.2×29.3cm

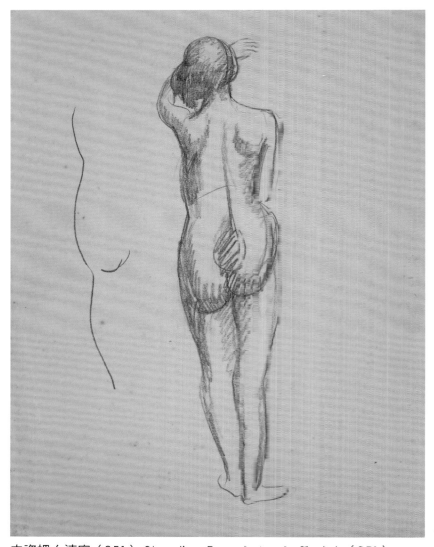

立姿裸女速寫（351）Standing Female Nude Sketch（351）

年代不詳　紙本鉛筆　38.3×29.1cm

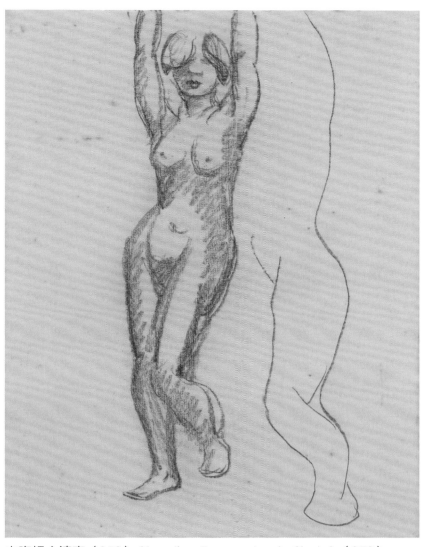

立姿裸女速寫（352） Standing Female Nude Sketch（352）
年代不詳　紙本鉛筆　31.8×24.4cm

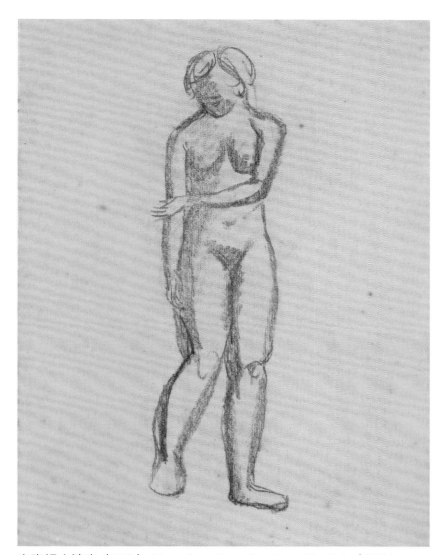

立姿裸女速寫（353） Standing Female Nude Sketch（353）
年代不詳　紙本鉛筆　31.6×24.2cm

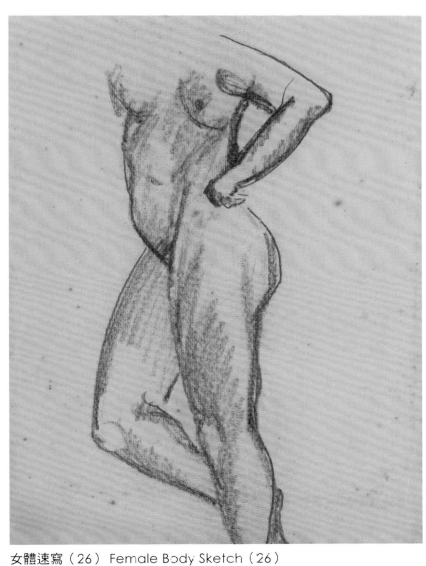

女體速寫（26） Female Body Sketch（26）
年代不詳　紙本鉛筆　31.6×24.2cm
※為前一張之背面圖。

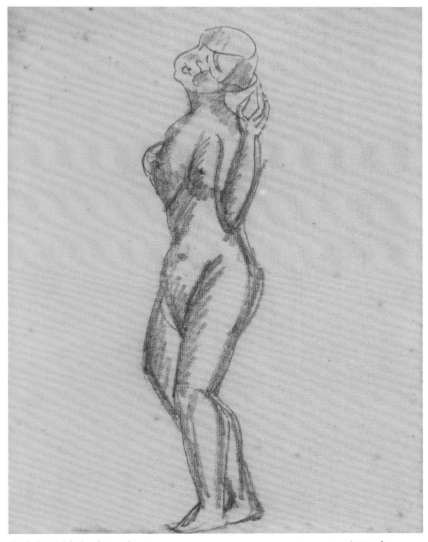

立姿裸女速寫（354） Standing Female Nude Sketch（354）
年代不詳　紙本鉛筆　31.5×24.3cm

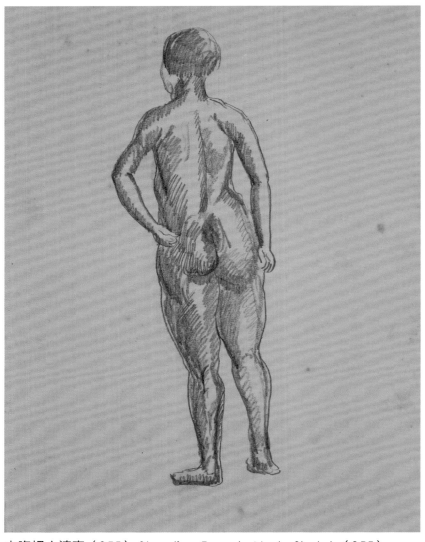

立姿裸女速寫（355） Standing Female Nude Sketch（355）
年代不詳　紙本鉛筆　38.2×29.3cm

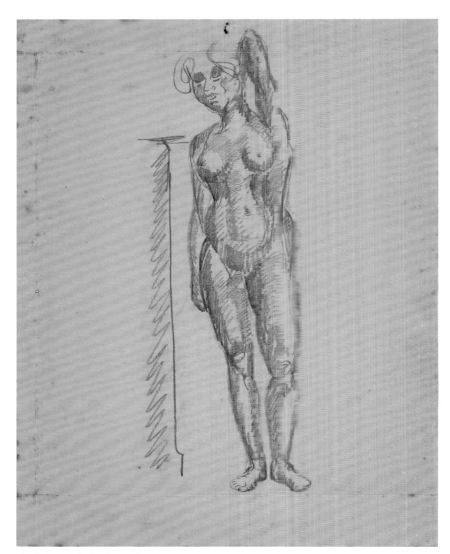

立姿裸女速寫（356） Standing Female Nude Sketch（356）
年代不詳　紙本鉛筆　38.1×29.4cm

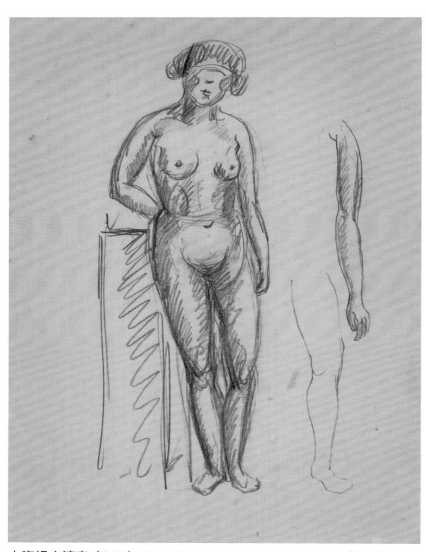

立姿裸女速寫（357） Standing Female Nude Sketch（357）
年代不詳　紙本鉛筆　38.2×29cm

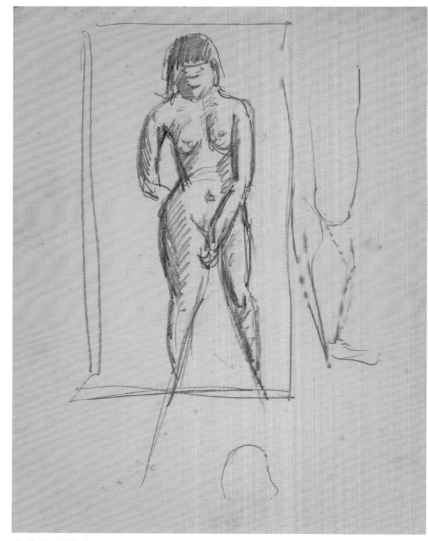

立姿裸女速寫（358） Standing Female Nude Sketch（358）
年代不詳　紙本鉛筆　38.2×29.3cm

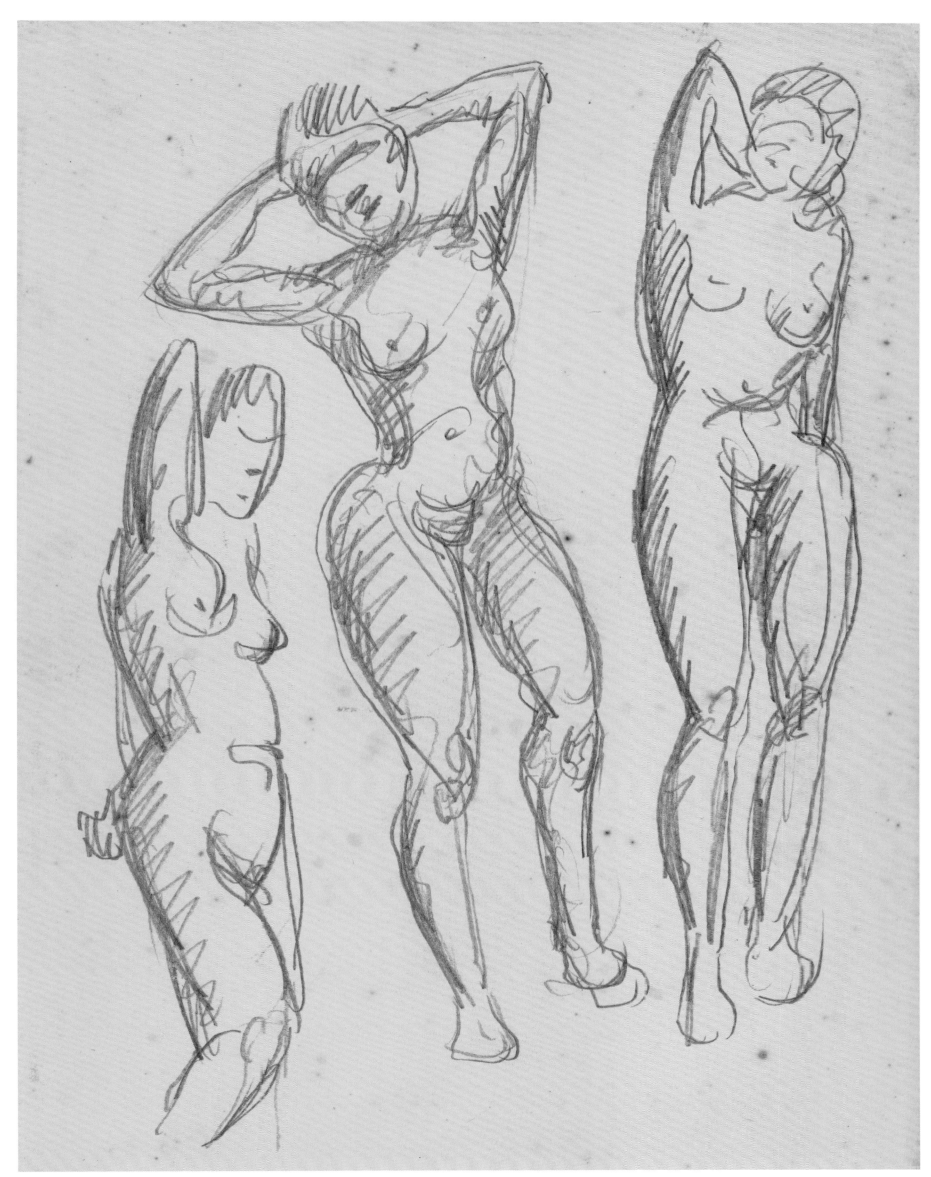

立姿裸女速寫（359）Standing Female Nude Sketch（359）

年代不詳　紙本鉛筆　38.2×29.2cm

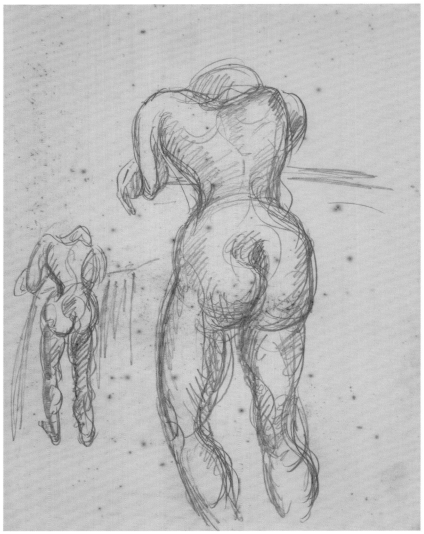

立姿裸女速寫（360）Standing Female Nude Sketch（360）
年代不詳　紙本鉛筆　38.2×29.2cm

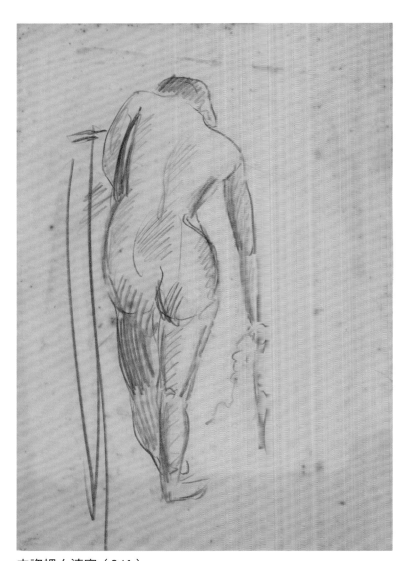

立姿裸女速寫（361）
Standing Female Nude Sketch（361）
年代不詳　紙本鉛筆　26.6×18.5cm

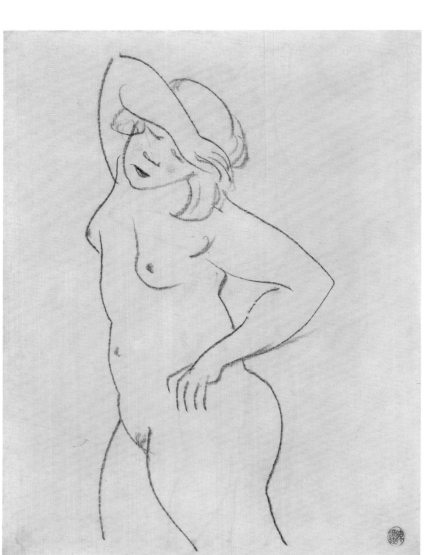

立姿裸女速寫（362）Standing Female Nude Sketch（362）
年代不詳　紙本鉛筆色筆　31.8×24.5cm

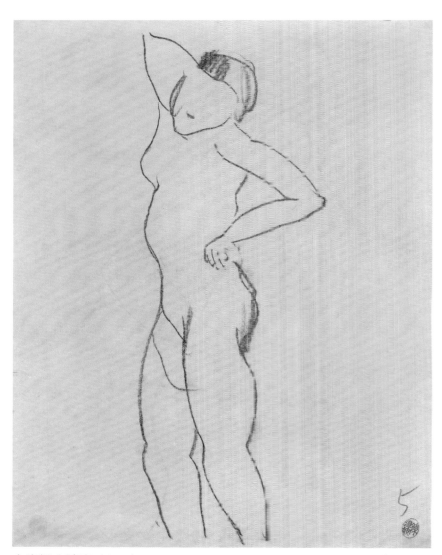

立姿裸女速寫（363）Standing Female Nude Sketch（363）
年代不詳　紙本鉛筆　31.8×24.5cm
※為前一張之背面圖。

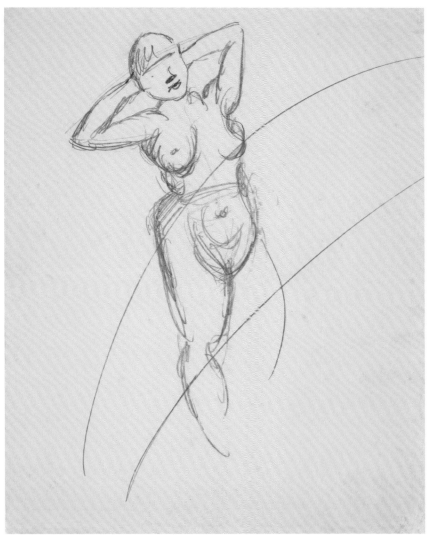

立姿裸女速寫（364）Standing Female Nude Sketch（364）
年代不詳　紙本鉛筆　38.2×29.4cm

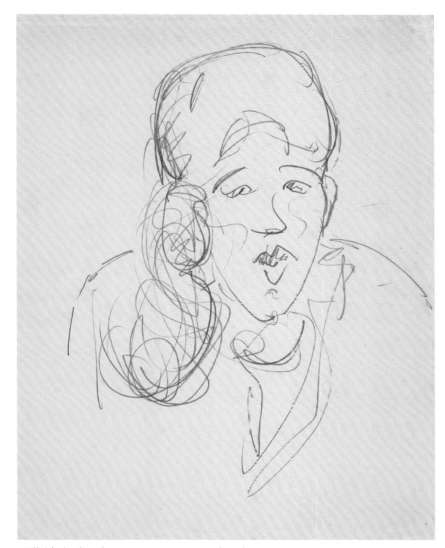

頭像速寫（29）Portrait Sketch（29）
年代不詳　紙本鉛筆　38.2×29.4cm
※為前一張之背面圖。

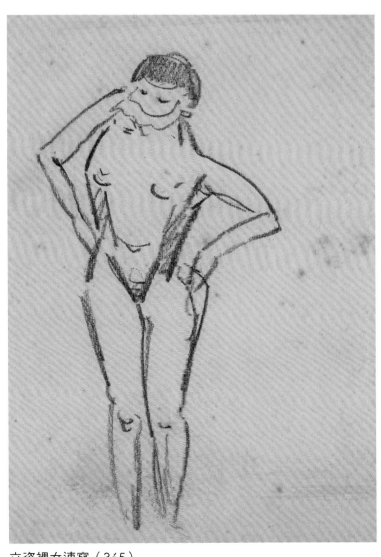

立姿裸女速寫（365）
Standing Female Nude Sketch（365）
年代不詳　紙本鉛筆　25.5×17.3cm

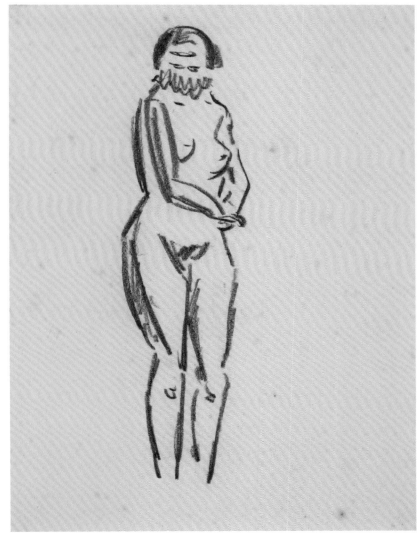

立姿裸女速寫（366）Standing Female Nude Sketch（366）
年代不詳　紙本鉛筆　25.5×19cm

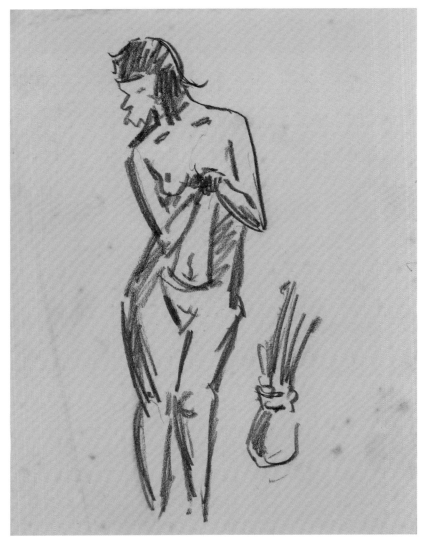

立姿裸女速寫（367） Standing Female Nude Sketch（367）

年代不詳　紙本鉛筆　25.5×19cm

·臥姿裸女 Reclining Female Nude

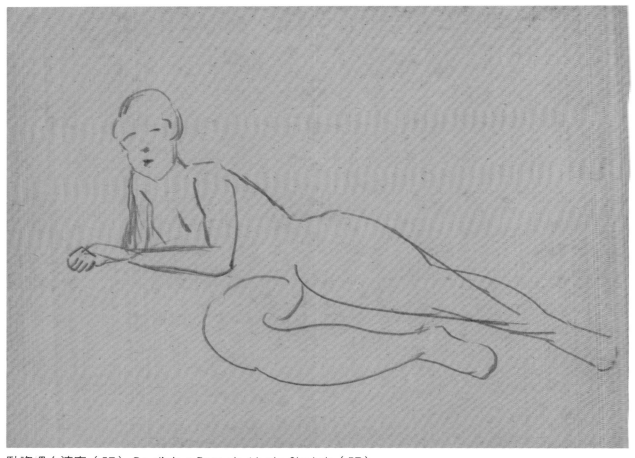

臥姿裸女速寫（57） Reclining Female Nude Sketch（57）

年代不詳　紙本鉛筆　24.5×33.2cm

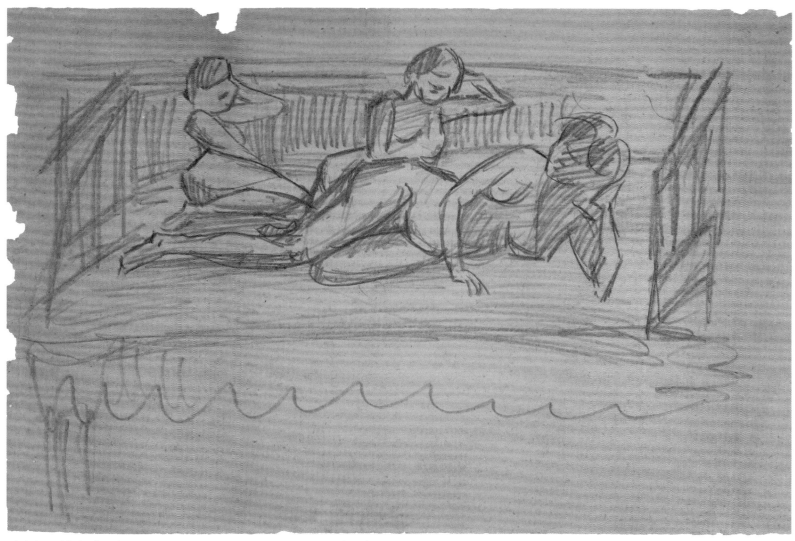

臥姿裸女速寫（58）Reclining Female Nude Sketch（58）

年代不詳　紙本鉛筆　27×39cm

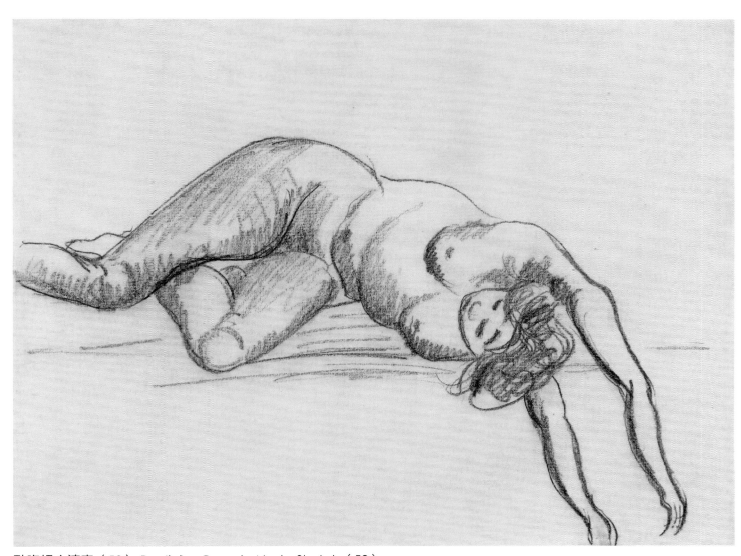

臥姿裸女速寫（59）Reclining Female Nude Sketch（59）

年代不詳　紙本鉛筆　24.3×31.8cm

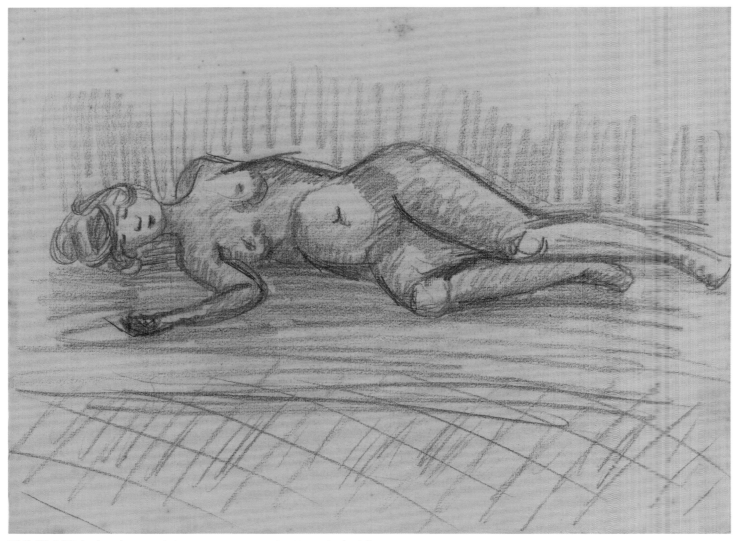

臥姿裸女速寫（60） Reclining Female Nude Sketch（60）
年代不詳　紙本鉛筆色筆　24.1×32cm

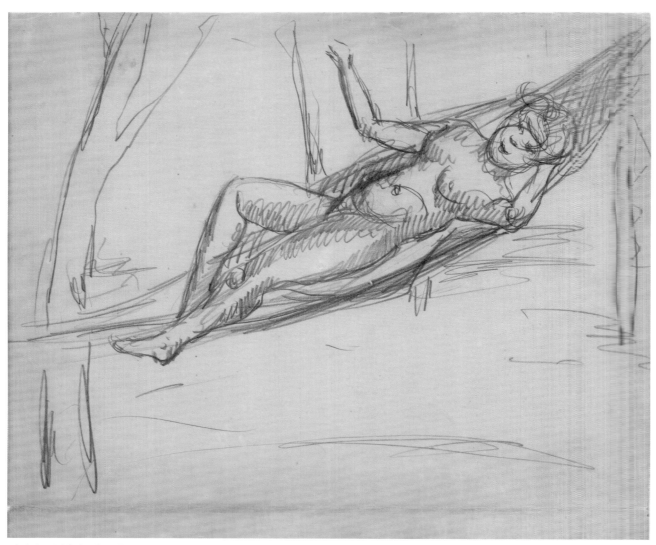

臥姿裸女速寫（61） Reclining Female Nude Sketch（61）
年代不詳　紙本鉛筆　32.1×38.4cm

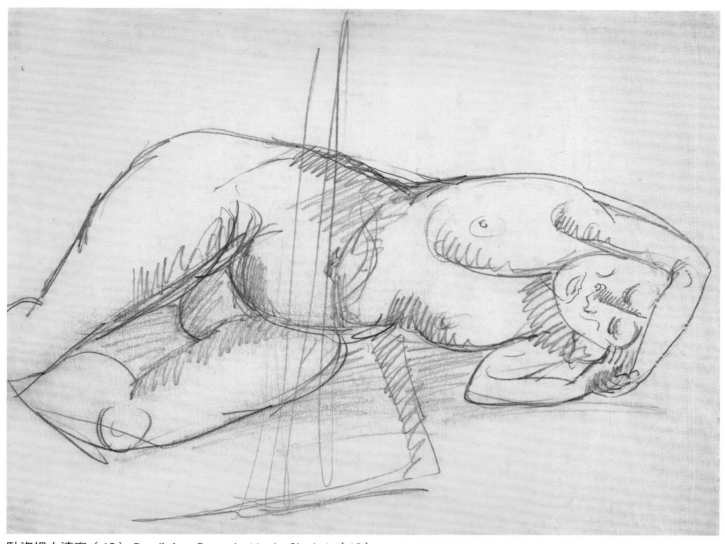

臥姿裸女速寫（62） Reclining Female Nude Sketch（62）
年代不詳　紙本鉛筆　29.3×3⒌3cm

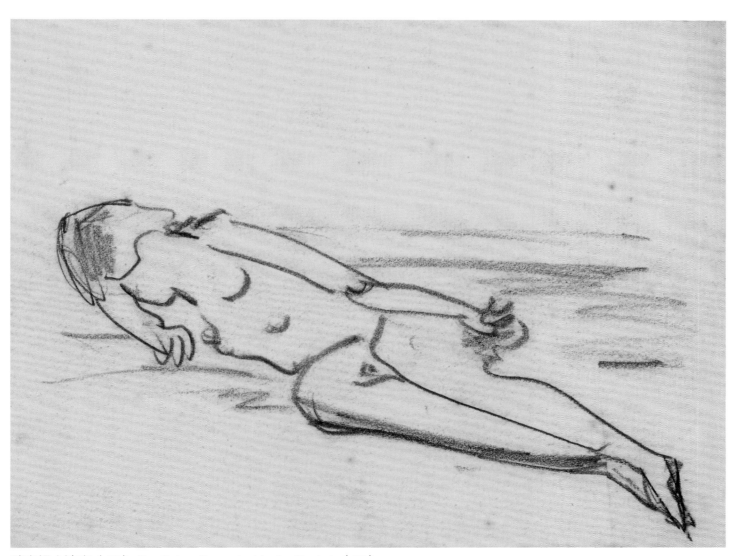

臥姿裸女速寫（63） Reclining Female Nude Sketch（63）
年代不詳　紙本鉛筆　19×25.5c⌐

· 女體 Female Body

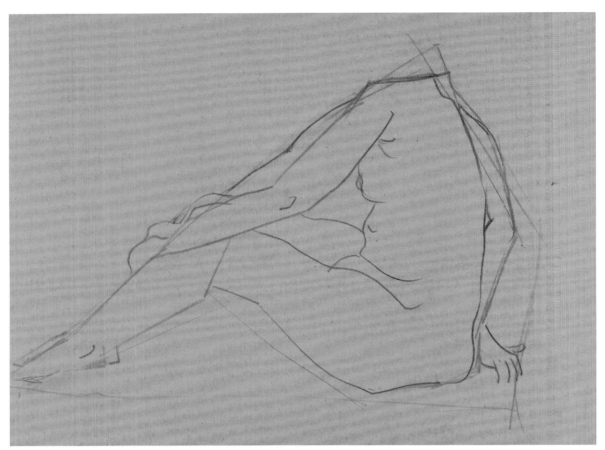

女體速寫（27）Female Body Sketch（27）
年代不詳　紙本鉛筆　20.9×27.4cm

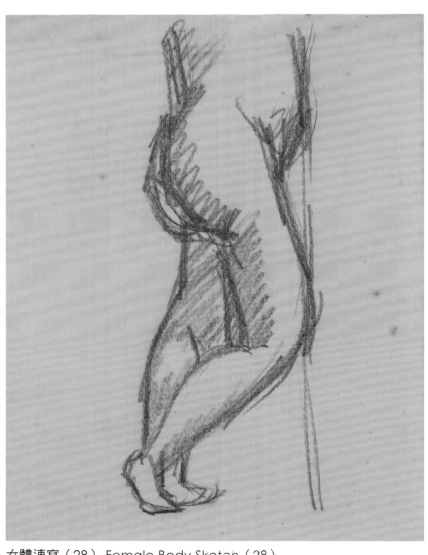

女體速寫（28）Female Body Sketch（28）
年代不詳　紙本鉛筆　32×24.5cm

頭像速寫（30）Portrait Sketch（30）
年代不詳　紙本鉛筆　32×24.5cm
※為前一張之背面圖。

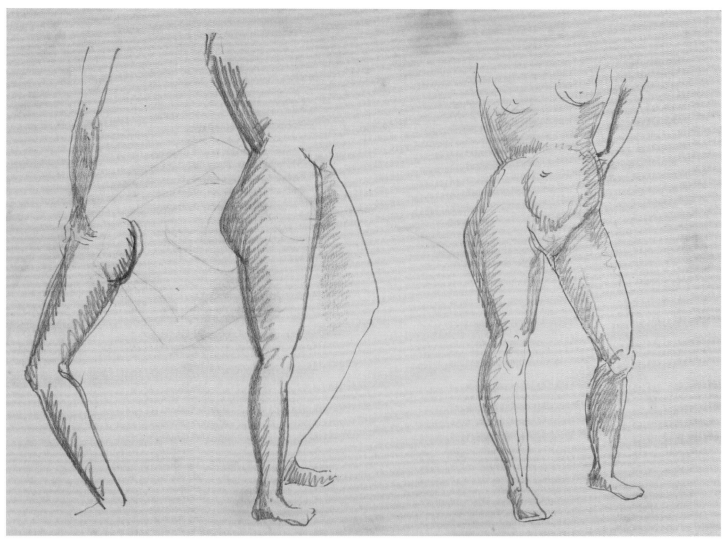

女體速寫（29）Female Body Sketch（29）

年代不詳　紙本鉛筆　29.2×38.3cm

・裸男
Male Nude

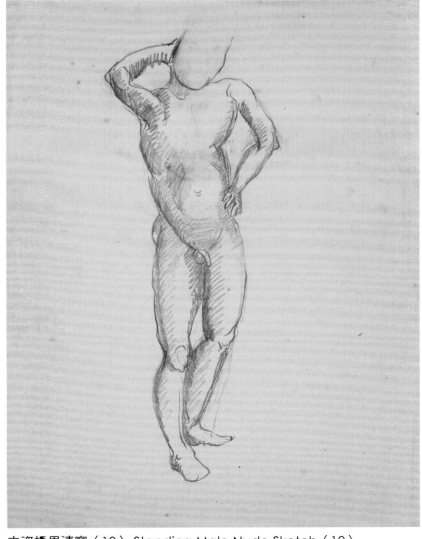

立姿裸男速寫（10）Standing Male Nude Sketch（10）

年代不詳　紙本鉛筆　38.3×29.2cm

・人物 Figure

人物速寫（32）Figure Sketch（32）
年代不詳　紙本鉛筆　38.2×29.5cm

人物速寫（33）Figure Sketch（33）
年代不詳　紙本鉛筆　24.4×33.1cm

文字與線條 Words and Lines
年代不詳　紙本鉛筆　33.1×24.4cm
※為前一張之背面圖。

336

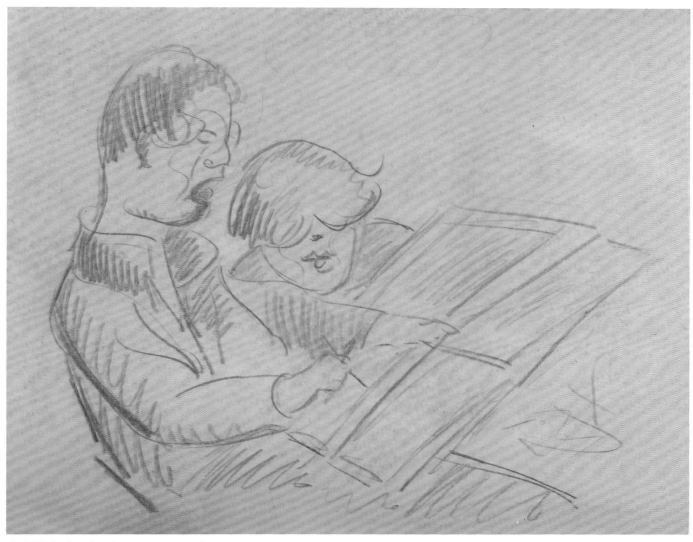

人物速寫（34）Figure Sketch（34）
年代不詳　紙本鉛筆　25×31.5cm

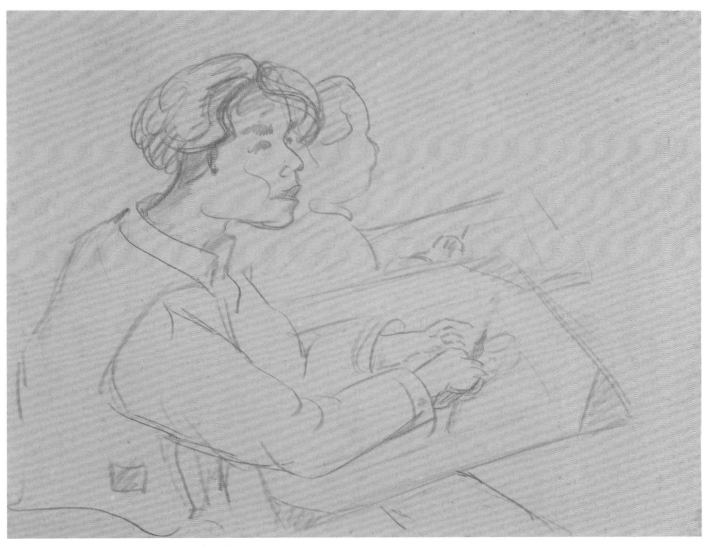

人物速寫（35）Figure Sketch（35）
年代不詳　紙本鉛筆　24.8×31.7cm

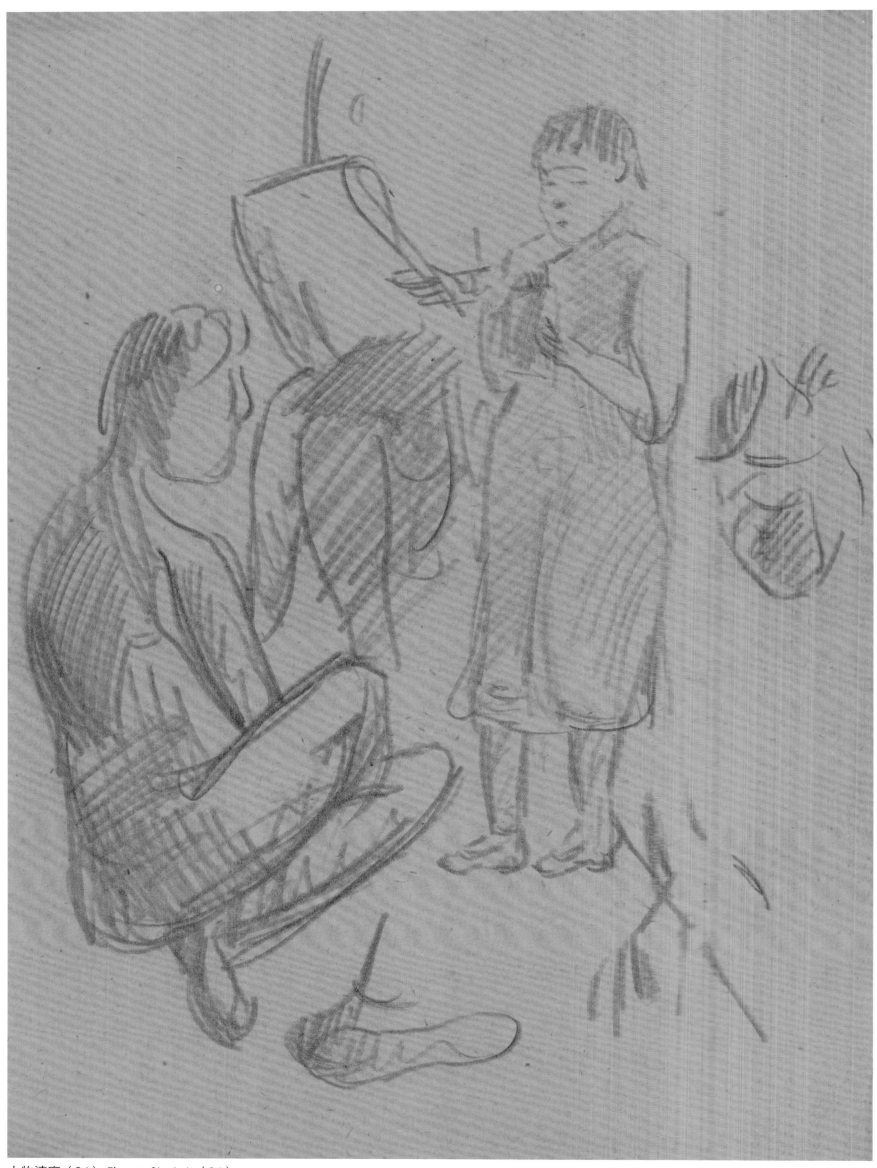

人物速寫（36）Figure Sketch（36）

年代不詳　紙本鉛筆　33×24.2cm

人物速寫（37）Figure Sketch（37）

年代不詳　紙本鉛筆　21.7×13.8cm

人物速寫（38）Figure Sketch（38）

年代不詳　紙本鉛筆　21.1×27.8cm

人物速寫（39）Figure Sketch（39）

年代不詳　紙本鉛筆　33.3×24.5cm

人物速寫（40）Figure Sketch（40）

年代不詳　紙本鉛筆　24.7×33.4cm

坐姿裸女與人物速寫（3）Seated Female Nude and Figure Sketch（3）
年代不詳　紙本鉛筆　24.1×33.3cm

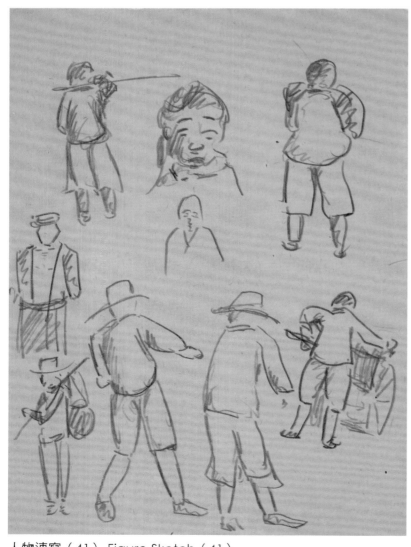

人物速寫（41）Figure Sketch（41）
年代不詳　紙本鉛筆　33.3×24.5cm

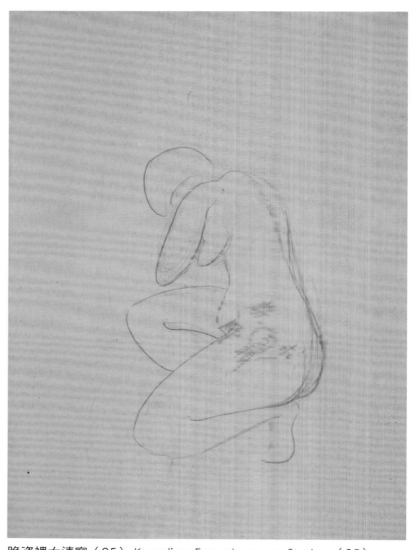

跪姿裸女速寫（25）Kneeling Female Nude Sketch（25）
年代不詳　紙本鉛筆　33.3×24.5cm
※為前一張之背面圖。

人物速寫（42）Figure Sketch（42）

年代不詳　紙本鉛筆　33.3×24.5cm

人物速寫（43）Figure Sketch（43）

年代不詳　紙本鉛筆　33.4×24.2cm

人物速寫（44）Figure Sketch（44）

年代不詳　紙本鉛筆　33×23.8cm

人物速寫（45）Figure Sketch（45）

年代不詳　紙本鉛筆　33.6×24.3cm

人物速寫（46）Figure Sketch（46）
年代不詳　紙本鉛筆　29.5×36.3cm

人物速寫（47）Figure Sketch（47）
年代不詳　紙本鋼筆　16.5×26.7cm

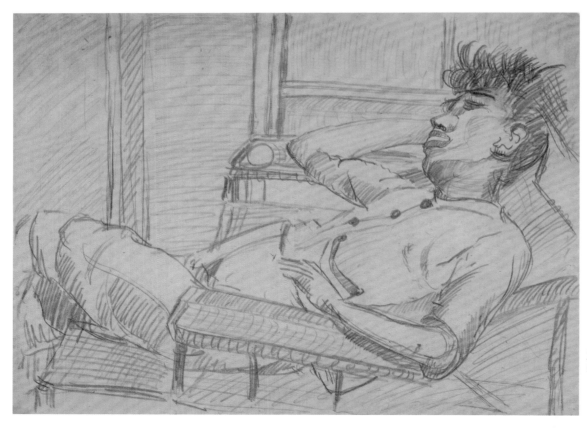

人物速寫（48）Figure Sketch（48）
年代不詳　紙本鉛筆　24.5×33.3cm

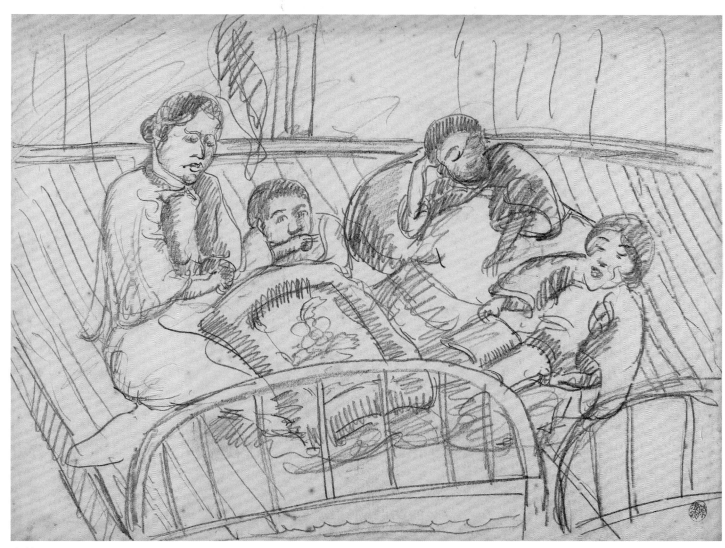

家族 Family
年代不詳　紙本鉛筆　29×38cm

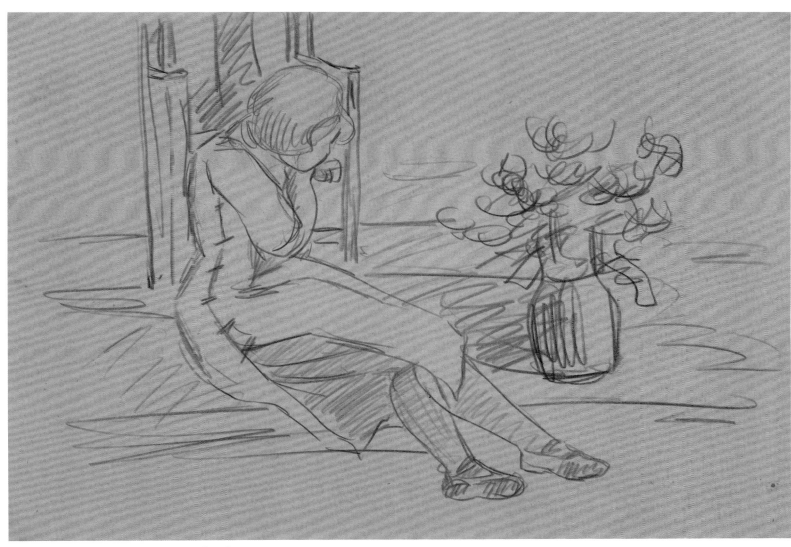

人物速寫（49）Figure Sketch（49）
年代不詳　紙本鉛筆　27.1×39.1cm

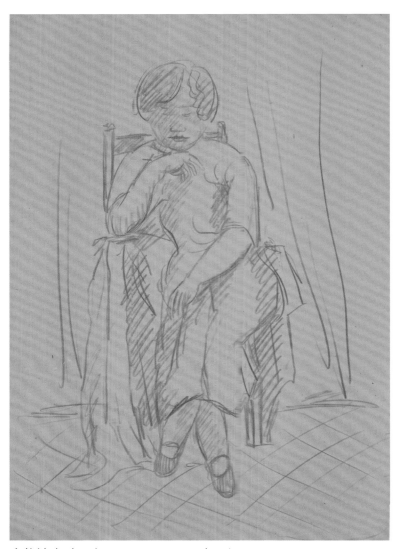

人物速寫（50）Figure Sketch（50）

年代不詳　紙本鉛筆　39×27cm

人物速寫（51）Figure Sketch（51）

年代不詳　紙本鉛筆　39×27.1cm

人物速寫（52）Figure Sketch（52）

年代不詳　紙本鉛筆　39×26.9cm

人物速寫（53）Figure Sketch（53）

年代不詳　紙本鉛筆　39×27.2cm

人物速寫（54）Figure Sketch（54）
年代不詳　紙本鉛筆　39×27cm

人物速寫（55）Figure Sketch（55）
年代不詳　紙本鉛筆　39×27.1cm

人物速寫（56）Figure Sketch（56）
年代不詳　紙本鉛筆　39.1×27.2cm

人物速寫（57）Figure Sketch（57）
年代不詳　紙本鉛筆　39×26.9cm

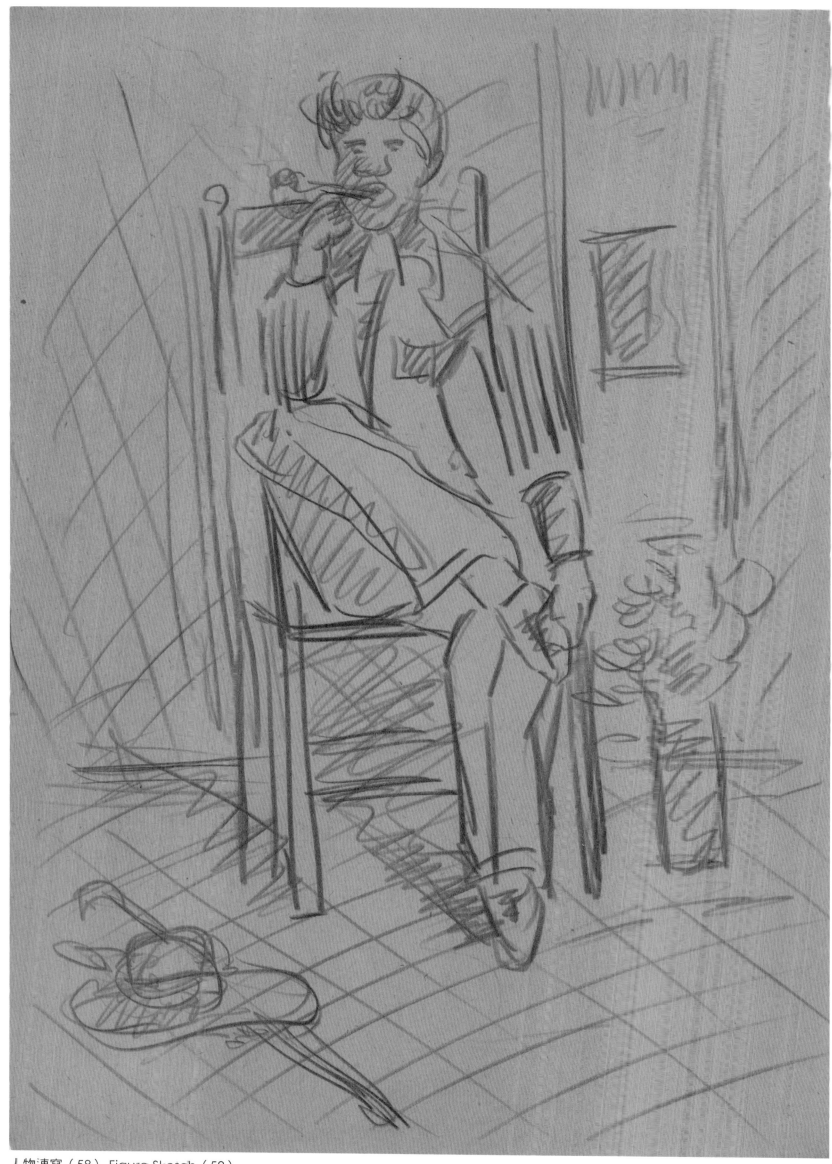

人物速寫（58）Figure Sketch（58）

年代不詳　紙本鉛筆　39.2×27cm

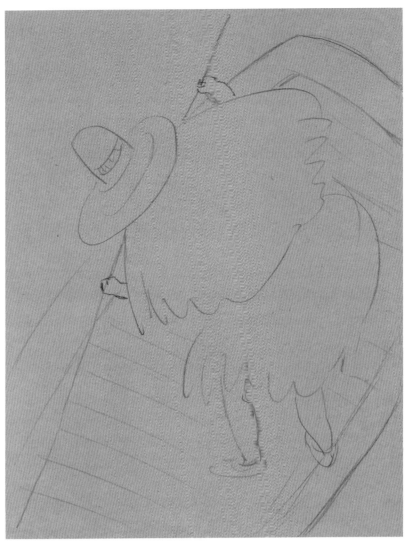

人物速寫（59）Figure Sketch（59）
年代不詳　紙本鉛筆　37.2×27.4cm

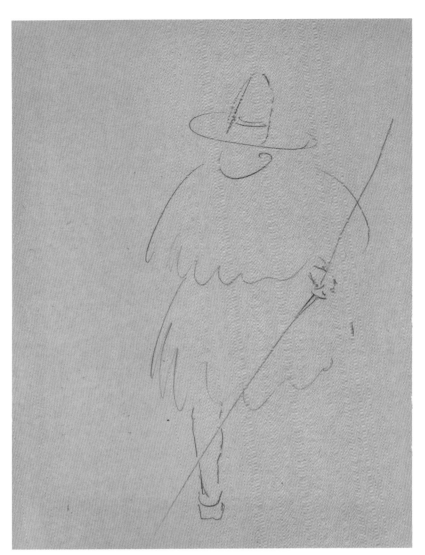

人物速寫（60）Figure Sketch（60）
年代不詳　紙本鉛筆　37.1×27.4cm

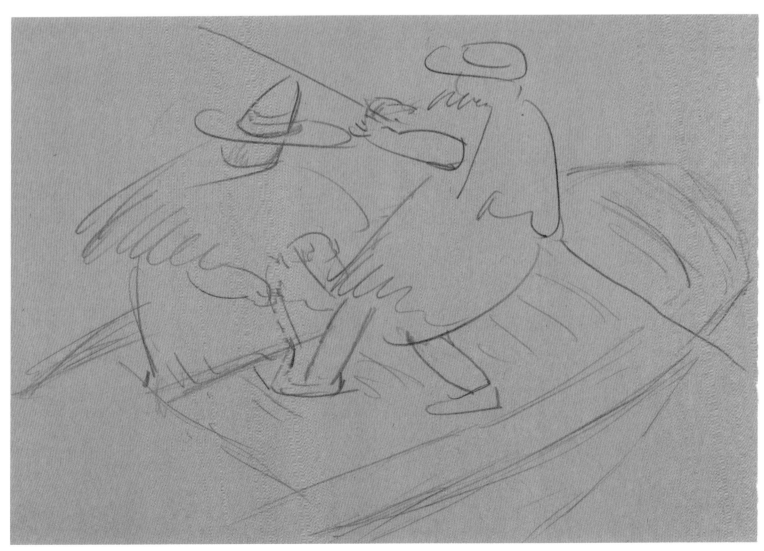

人物速寫（61）Figure Sketch（61）
年代不詳　紙本鉛筆　27.5×37.4cm

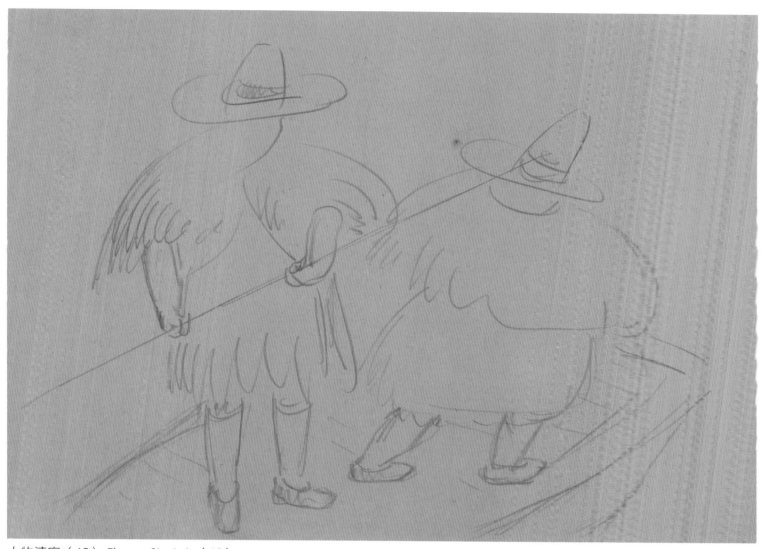

人物速寫（62）Figure Sketch（62）
年代不詳　紙本鉛筆　27.5×37.4cm

人物速寫（63）Figure Sketch（63）
年代不詳　紙本鉛筆　27.4×37.1cm

人物速寫（64）Figure Sketch（64）
年代不詳　紙本鉛筆　29.2×38　cm

人物速寫（65）Figure Sketch（65）
年代不詳　紙本鉛筆　38.5×29.2cm

頭像速寫（31）Portrait Sketch（31）
年代不詳　紙本鉛筆　29.2×38.5cm
※為前一張之背面圖。

人物速寫（66）Figure Sketch（66）

年代不詳　紙本鉛筆　27.4×37.3cm

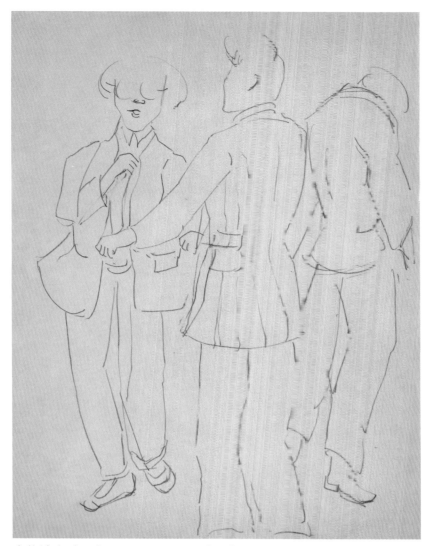

人物速寫（67）Figure Sketch（67）

年代不詳　紙本鉛筆　38.2×29.2cm

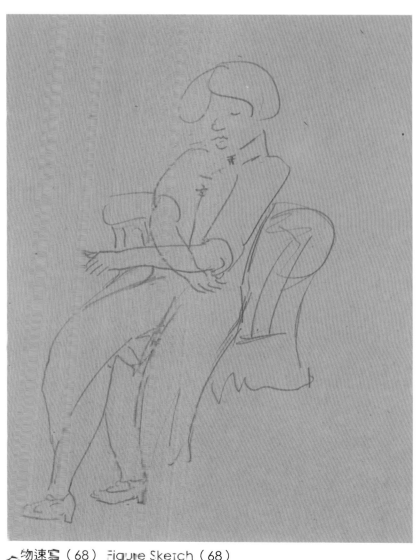

人物速寫（68）Figure Sketch（68）

年代不詳　紙本鉛筆　36.5×27.6cm

人物速寫（69）Figure Sketch（69）

年代不詳　紙本鉛筆　36.6×27.5cm
※為前一張之背面圖。

人物速寫（70）Figure Sketch（70）
年代不詳　紙本鉛筆　37.2×27.2cm

人物速寫（71）Figure Sketch（71）
年代不詳　紙本鉛筆　37.2×27.2cm
※為前一張之背面圖。

人物速寫（72）Figure Sketch（72）
年代不詳　紙本鉛筆　37.2×27.4cm

人物速寫（73）Figure Sketch（73）
年代不詳　紙本鉛筆　37.4×27.5cm

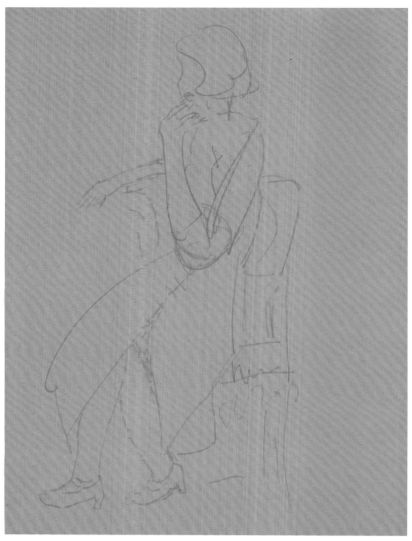

人物速寫（74）Figure Sketch（74）
年代不詳　紙本鉛筆　36.9×27.3cm

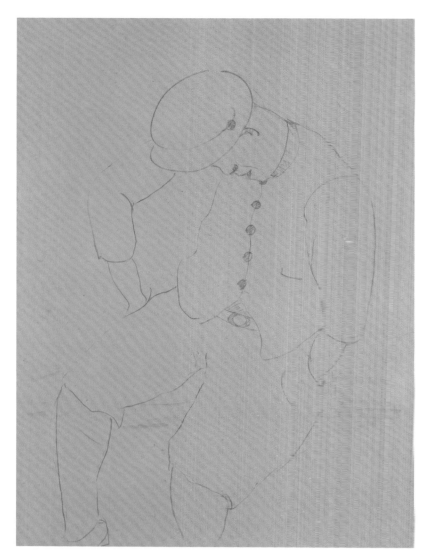

人物速寫（75）Figure Sketch（75）
年代不詳　紙本鉛筆　37.2×27.3cm

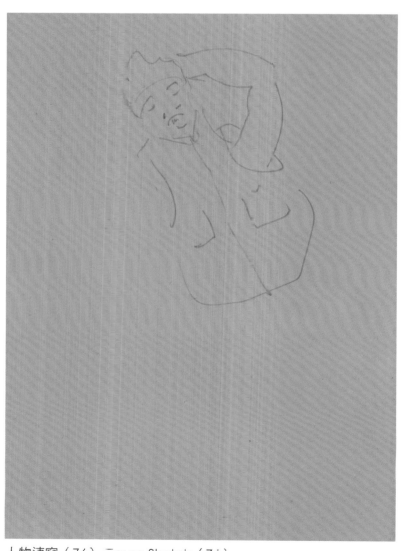

人物速寫（76）Figure Sketch（76）
年代不詳　紙本鉛筆　37.4×27.1cm

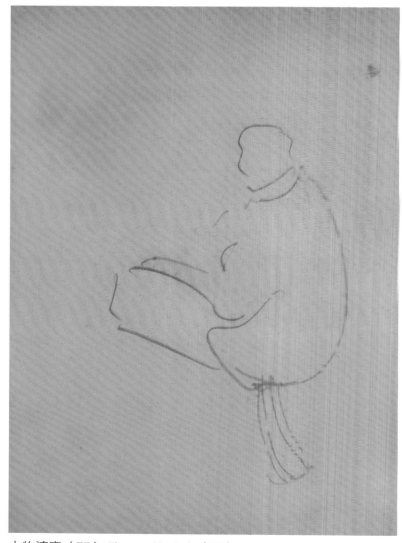

人物速寫（77）Figure Sketch（77）
年代不詳　紙本鉛筆　37.3×27.2cm

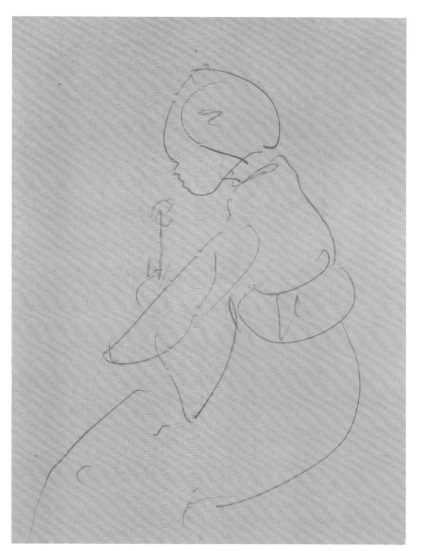

人物速寫（78） Figure Sketch（78）
年代不詳　紙本鉛筆　37.4×27.1cm

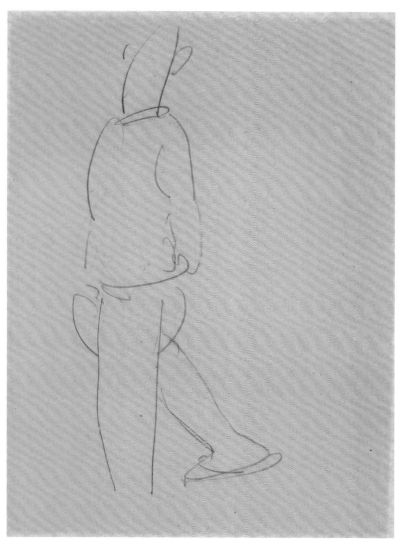

人物速寫（79） Figure Sketch（79）
年代不詳　紙本鉛筆　37.4×27.1cm
※為前一張之背面圖。

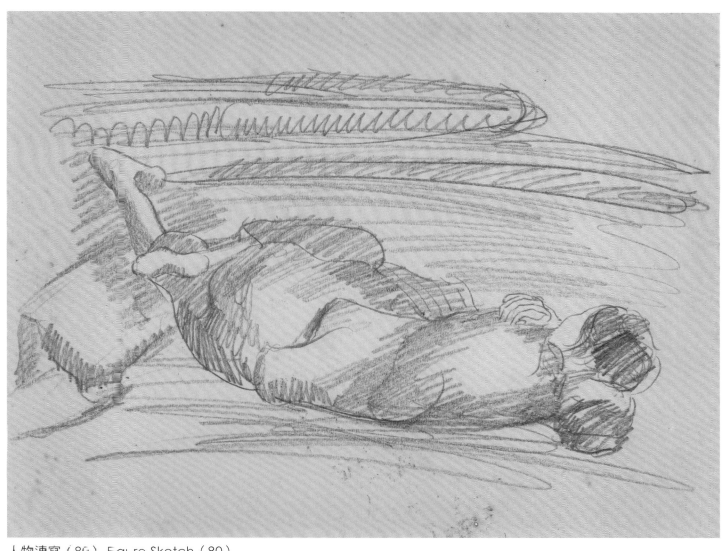

人物速寫（80） Figure Sketch（80）
年代不詳　紙本鉛筆　29.1×38.3cm

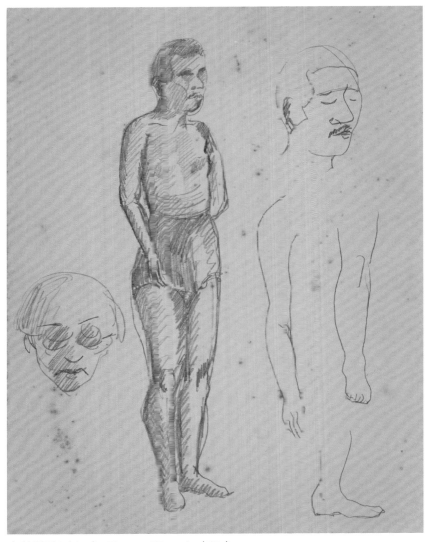

人物速寫（81）Figure Sketch（81）

年代不詳　紙本鉛筆　38.3×27.5cm

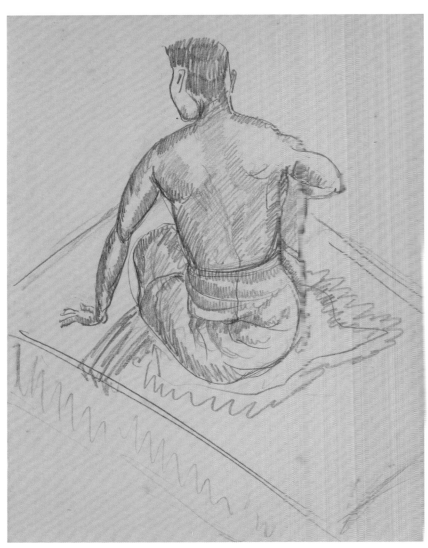

人物速寫（82）Figure Sketch（82）

年代不詳　紙本鉛筆　38.3×29.3cm

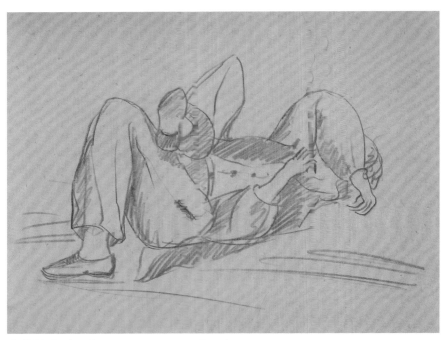

人物速寫（83）Figure Sketch（83）

年代不詳　紙本鉛筆　21.5×28cm

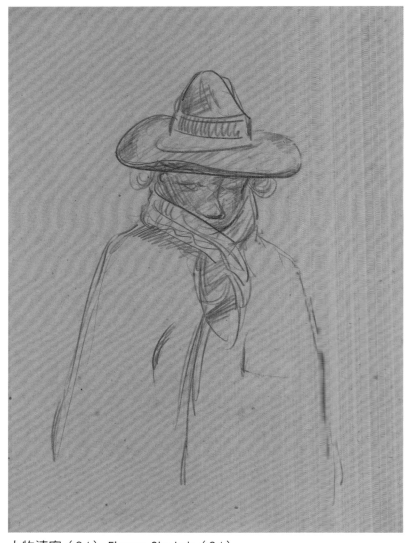

人物速寫（84）Figure Sketch（84）

年代不詳　紙本鉛筆　32.7×24cm

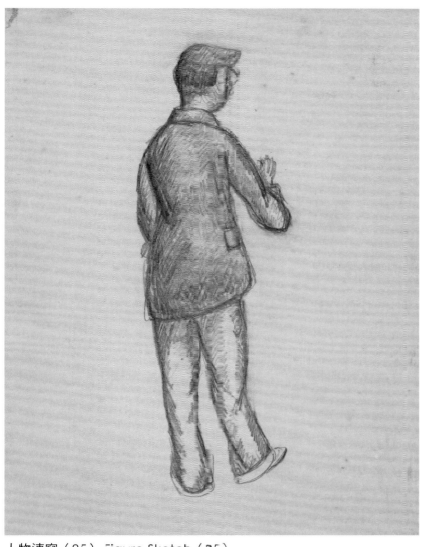

人物速寫（85）Figure Sketch（85）

年代不詳　紙本鉛筆　38.2×29.5cm

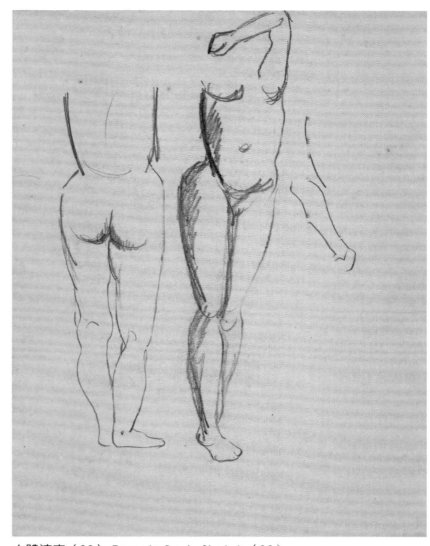

女體速寫（30）Female Body Sketch（30）

年代不詳　紙本鉛筆　38.2×29.5cm
※為前一張之背面圖。

人物速寫（86）Figure Sketch（86）

年代不詳　紙本鉛筆　31.7×24.5cm

人物速寫（87）Figure Sketch（87）

年代不詳　紙本鉛筆　38.6×29.4cm

人物速寫（88） Figure Sketch（88）
年代不詳　紙本鉛筆　31.5×24.2cm

・頭像 Portrait

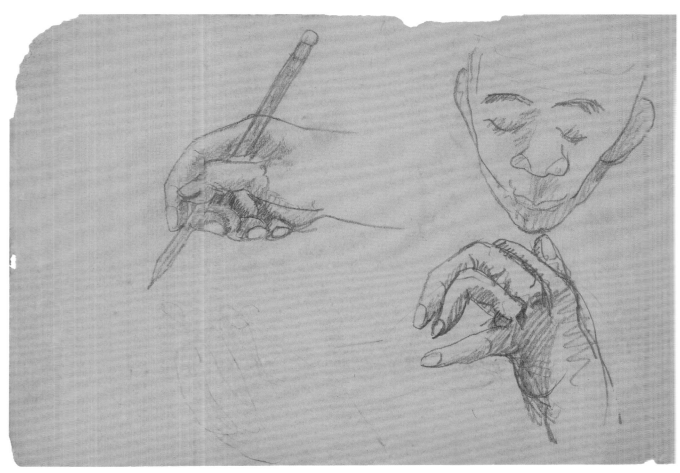

頭像與手部速寫（1） Portrait and Hands Sketch（1）
年代不詳　紙本鉛筆　18.7×26.6cm

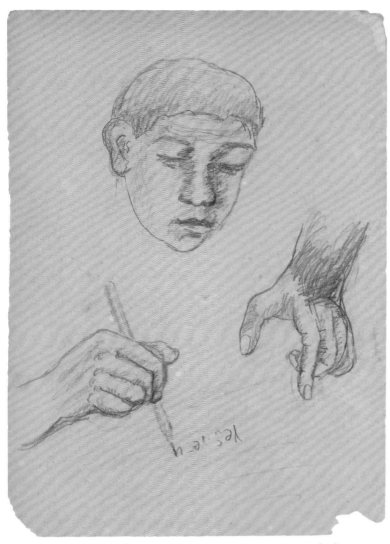

頭像與手部速寫（2）Portrait and Hands Sketch（2）
年代不詳　紙本鉛筆　26.6×13.7cm

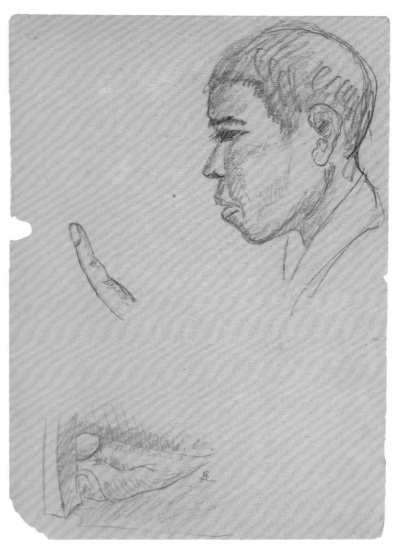

頭像與手部速寫（3）Portrait and Hands Sketch（3）
年代不詳　紙本鉛筆　26.6×13.7cm

頭像速寫（32）Portrait Sketch（32）
年代不詳　紙本鉛筆　24.9×18.8cm

頭像速寫（33）Portrait Sketch（33）
年代不詳　紙本鉛筆　24.9×18.8cm
※為前一張之背面圖。

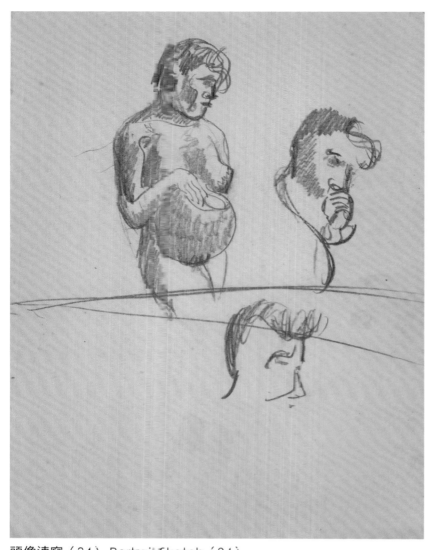

頭像速寫（34） Portrait Sketch（34）
年代不詳　紙本鉛筆　38.4×2□.2cm

頭像速寫（35） Portrait Sketch（35）
年代不詳　木板鉛筆　22.7×15.6cm

· 動物 Animal

狗 Dog
年代不詳　紙本鋼筆　24.5×32.8cm

雞 Chicken
年代不詳　紙本鋼筆　32.8×24.5cm
※為前一張之背面圖。

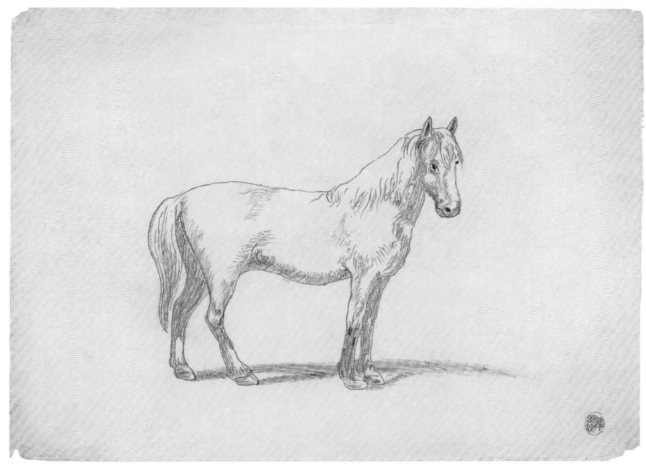

馬 Horse
年代不詳　紙本鉛筆　23.3×31.2cm

・靜物 Still Life

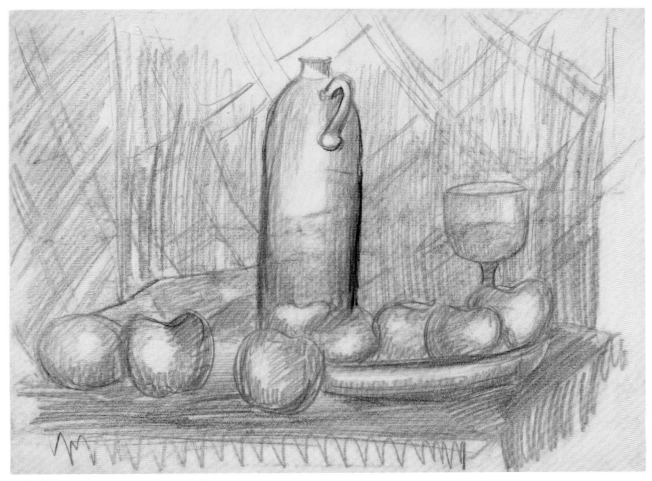

靜物速寫（1）Still Life Sketch（1）
年代不詳　紙本鉛筆　23.8×31.2cm

靜物速寫（2）Still Life Sketch（2）
年代不詳　紙本鉛筆　31.8×24.1cm

靜物速寫（3）Still Life Sketch（3）
年代不詳　紙本鉛筆　33.1×24.3cm

靜物速寫（4）Still Life Sketch（4）
年代不詳　紙本鉛筆　23.4×31.2cm

靜物速寫（5）Still Life Sketch（5）
年代不詳　紙本鉛筆　31.2×24.3cm
※為前一張之背面圖。

・風景 Landscape

風景速寫（5） Landscape Sketch（5）
年代不詳　紙本鉛筆　23.8×27.9cm

風景速寫（6） Landscape Sketch（6）
年代不詳　紙本鋼筆　24.3×28.9cm

風景速寫（7） Landscape Sketch（7）
年代不詳　紙本鋼筆　24.1×27.9cm

山岳標高圖（1） Elevation Profile of Mountains（1）
年代不詳　紙本鉛筆　24.4×32.9cm

山岳標高圖（2） Elevation Profile of Mountains（2）
年代不詳　紙本鉛筆　24.4×32.9cm

風景速寫（8） Landscape Sketch（8）
年代不詳　紙本鉛筆　21×29.5㎝

風景速寫（9） Landscape Sketch（9）
年代不詳　紙本鉛筆　21×29.5㎝

風景速寫（10）Landscape Sketch（10）

年代不詳　紙本鉛筆　30.2×21.5cm

合歡山 Hehuan Mountain
年代不詳　紙本鉛筆　23×29.2㎝

風景速寫（11）Landscape Sketch（11）
年代不詳　紙本鉛筆　24×32.5cm

風景速寫（12） Landscape Sketch（12）
年代不詳　紙本鉛筆　19×26.7cm

風景速寫（13） Landscape Sketch（13）
年代不詳　紙本鉛筆　19×26.7cm

風景速寫（14） Landscape Sketch（14）
年代不詳　紙本鉛筆　19×24cm

風景速寫（15） Landscape Sketch（15）
年代不詳　紙本鉛筆　23.6×32cm

風景速寫（16）Landscape Sketch（16）
年代不詳　紙本鉛筆　21×29.5cm

風景速寫（17）Landscape Sketch（17）
年代不詳　紙本鉛筆　24.4×27.7cm

風景速寫（18）Landscape Sketch（18）
年代不詳　紙本鉛筆　22.9×28.3cm

風景速寫（19） Landscape Sketch（19）

年代不詳　紙本鉛筆　28.4×22.8cm

風景速寫（20） Landscape Sketch（20）

年代不詳　紙本鉛筆　28.2×24.8cm

風景速寫（21） Landscape Sketch（21）
年代不詳　紙本水墨　24.1×27.7cm

風景速寫（22 Landscape Sketch（22）
年代不詳　紙本水墨　22.3×26.5cm

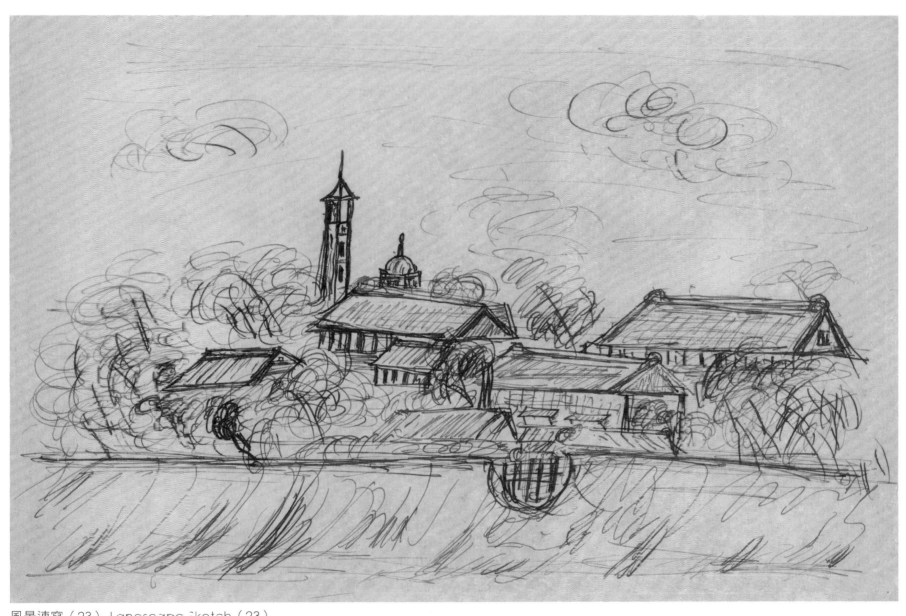

風景速寫（23）Landscape Sketch（23）

年代不詳　紙本鉛筆　15.9×28.9cm

參考圖版

Reference Plates

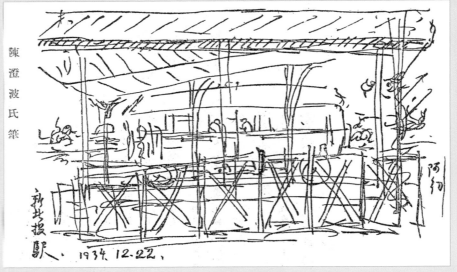

新北投車站-34.12.22 Xinbeitou Station-34.12.22

1934　材質不詳　尺寸不詳

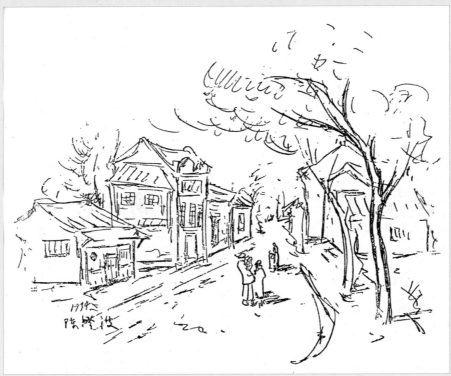

街景速寫-34 Street Scene-34

1934　材質不詳　尺寸不詳

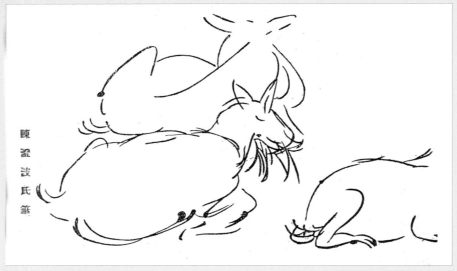

羊群 Goats

約1934-1935　材質不詳　尺寸不詳

圖版目錄
Catalogue

1920-1925

SK0001　40
手部速寫（一）
Hand Sketch 1

水上公
陳澄波

1925.10.5
研1
SK0002　40
立姿裸女速寫-25.10.5（1）
Standing Female Nude Sketch-25.10.5 (1)

1925.10.5
研2
SK0003　40
立姿裸女速寫-25.10.5（2）
Standing Female Nude Sketch-25.10.5 (2)

1925.10.5
研3
SK0004　40
立姿裸女速寫-25.10.5（3）
Standing Female Nude Sketch-25.10.5 (3)

1925.10.10
研1
SK0005　41
立姿裸女速寫-25.10.10（4）
Standing Female Nude Sketch-25.10.10 (4)

1925.10.10
研三
SK0006　41
頭像與人體速寫-25.10.10（1）
Portrait and Body Sketch-25.10.10 (1)

1925.10.16
研5
友人
SK0007　41
人物速寫-25.10.16（1）
Figure Sketch-25.10.16 (1)

1925.10.16
研7
友人
SK0008　41
頭像速寫-25.10.16（1）
Portrait Sketch-25.10.16 (1)

1925.10.16
研8
友人
SK0009　42
頭像速寫-25.10.16（2）
Portrait Sketch-25.10.16 (2)

1925.10.17
研外
SK0010　42
人物速寫-25.10.17（2）
Figure Sketch-25.10.17 (2)

1925.10.17
研1
SK0011　42
立姿裸女速寫-25.10.17（5）
Standing Female Nude Sketch-25.10.17 5)

1925.10.17
研2
SK0012　42
立姿裸女速寫-25.10.17（6）
Standing Female Nude Sketch-25.10.17 (6)

SK0013　43
坐姿裸女速寫-25.10.17（1）
Seated Female Nude Sketch-25.10.17 (1)
1925.10.17
研3

SK0014　43
坐姿裸女速寫-25.10.17（2）
Seated Female Nude Sketch-25.10.17 (2)
1925.10.17
研4

1925.10.17
研5
SK0015　43
立姿裸女速寫-25.10.17（7）
Standing Female Nude Sketch-25.10.17 (7)

SK0016　4
臥姿裸女速寫-25.10.17（1）
Reclining Female Nude Sketch-25.10.17 (1)
1925.10.17
研6

1925.10.17
研8
SK0017　44
立姿裸女速寫-25.10.17（8）
Standing Female Nude Sketch-25.10.17 (8)

1925.10.17
研10
SK0018　44
跪姿裸女速寫-25.10.17（1）
Kneeling Female Nude Sketch-25.10.17 (1)

1925.10.17
研11
SK0019　44
坐姿裸女速寫-25.10.17（3）
Seated Female Nude Sketch-25.10.17 (3)

SK0020　45
臥姿裸女速寫-25.10.17（2）
Reclining Female Nude Sketch-25.10.17 (2)
1925.10.17
研12

1925.10.24
研1
SK0021　45
立姿裸女速寫-25.10.24（9）
Standing Female Nude Sketch-25.10.24 (9)

1925.10.24
研2
SK0022　45
立姿裸女速寫-25.10.24（10）
Standing Female Nude Sketch-25.10.24 (10)

1925.10.24
研3
SK0023　45
立姿裸女速寫-25.10.24（11）
Standing Female Nude Sketch-25.10.24 (11)

1925.10.24
研4
SK0024　46
立姿裸女速寫-25.10.24（12）
Standing Female Nude Sketch-25.10.24 (12)

1925.10.24
研5
SK0025　46
立姿裸女速寫-25.10.24（13）
Standing Female Nude Sketch-25.10.24 (13)

1925.10.24
研6
SK0026　46
立姿裸女速寫-25.10.24（14）
Standing Female Nude Sketch-25.10.24 (14)

1925.10.24
研7
SK0027　46
坐姿裸女速寫-25.10.24（4）
Seated Female Nude Sketch-25.10.24 (4)

1925.10.24
研7
SK0028　47
立姿裸女速寫-25.10.24（15）
Standing Female Nude Sketch-25.10.24 (15)

1925.10.24
研8
SK0029　47
立姿裸女速寫-25.10.24（16）
Standing Female Nude Sketch-25.10.24 (16)

1925.10.24
研9
SK0030　47
坐姿裸女速寫-25.10.24（5）
Seated Female Nude Sketch-25.10.24 (5)

1925.10.24
研外1
SK0031　47
立姿裸女速寫-25.10.24（17）
Standing Female Nude Sketch-25.10.24 (17)

1925.10.24
研外2
SK0032　48
人物速寫-25.10.24（3）
Figure Sketch-25.10.24 (3)

研4
SK0033　48
坐姿裸女速寫（6）
Seated Female Nude Sketch (6)

研5
SK0034　48
坐姿裸女速寫（7）
Seated Female Nude Sketch (7)

研6

SK0035　48
立姿裸女速寫（18）
Standing Female Nude Sketch (18)

研7

SK0036　49
立姿裸女速寫（19）
Standing Female Nude Sketch (19)

研二

SK0037　49
立姿裸女速寫（20）
Standing Female Nude Sketch (20)

SK0038　49
立姿裸女速寫（21）
Standing Female Nude Sketch (21)

研12
研13

1926

SK0039　50
坐姿裸女速寫-26.1.16（8）
Seated Female Nude Sketch-26.1.16 (8)

1926.1.16
研11

SK0040　50
坐姿裸女速寫-26.1.16（9）
Seated Female Nude Sketch-26.1.16 (9)

1926.1.16
研15

1926.1.30
研1

SK0041　50
坐姿裸女速寫-26.1.30（10）
Seated Female Nude Sketch-26.1.30 (10)

1926.1.30
研2

SK0042　51
立姿裸女速寫-26.1.30（22）
Standing Female Nude Sketch-26.1.30 (22)

1926.1
美2

SK0043　51
立姿裸女速寫-26.1（23）
Standing Female Nude Sketch-26.1 (23)

1926.1
美3

SK0044　51
立姿裸女速寫-26.1（24）
Standing Female Nude Sketch-26.1 (24)

1926.1
美4

SK0045　51
立姿裸女速寫-26.1（25）
Standing Female Nude Sketch-26.1 (25)

1926.1
美5

SK0046　52
蹲姿裸女速寫-26.1（1）
Squatting Female Nude Sketch-26.1 (1)

1926.1
美6

SK0047　52
蹲姿裸女速寫-26.1（2）
Squatting Female Nude Sketch-26.1 (2)

1926.2.1
美1

SK0048　52
立姿裸女速寫-26.2.1（26）
Standing Female Nude Sketch-26.2.1 (26)

1926.2.1
美2

SK0049　52
立姿裸女速寫-26.2.1（27）
Standing Female Nude Sketch-26.2.1 (27)

1926.2.1
美3

SK0050　53
立姿裸女速寫-26.2.1（28）
Standing Female Nude Sketch-26.2.1 (28)

1926.2.1
美4

SK0051　53
立姿裸女速寫-26.2.1（29）
Standing Female Nude Sketch-26.2.1 (29)

1926.2.
美5

SK0052　53
跪姿裸女速寫-26.2.1（2）
Kneeling Female Nude Sketch-26.2.1 (2)

1926.2.1
美6

SK0053　53
坐姿裸女速寫-26.2.1（11）
Seated Female Nude Sketch-26.2.1 (11)

1926.2.1
美7

SK0054　54
立姿裸女速寫-26.2.1（30）
Standing Female Nude Sketch-26.2.1 (30)

1926.2.1
美8

SK0055　54
立姿裸女速寫-26.2.1（31）
Standing Female Nude Sketch-26.2.1 (31)

SK0056　54
坐姿裸女速寫（12）
Seated Female Nude Sketch (12)

SK0057　54
坐姿裸女速寫（13）
Seated Female Nude Sketch (13)

SK0058　55
立姿裸女速寫（32）
Standing Female Nude Sketch (32)

SK0059　55
立姿裸女速寫（33）
Standing Female Nude Sketch (33)

SK0060　55
立姿裸女速寫（34）
Standing Female Nude Sketch (34)

SK0061　55
立姿裸女速寫（35）
Standing Female Nude Sketch (35)

SK0062　56
立姿裸女速寫（36）
Standing Female Nude Sketch (36)

SK0063　56
立姿裸女速寫（37）
Standing Female Nude Sketch (37)

SK0064　56
立姿裸女速寫（38）
Standing Female Nude Sketch (38)

SK0065　56
立姿裸女速寫（39）
Standing Female Nude Sketch (39)

SK0066　57
立姿裸女速寫（40）
Standing Female Nude Sketch (40)

SK0067　57
立姿裸女速寫（41）
Standing Female Nude Sketch (41)

SK0068　57
臥姿裸女速寫（3）
Reclining Female Nude Sketch (3)

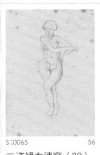
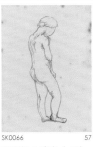
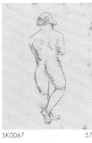
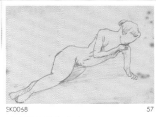

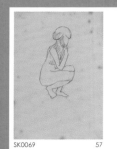
SK0069　57
蹲姿裸女速寫（3）
Squatting Female Nude Sketch (3)

SK0070　58
女體速寫（1）
Female Body Sketch (1)

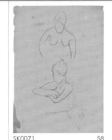
SK0071　58
頭像速寫（3）
Portrait Sketch (3)

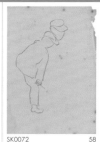
SK0072　58
人物速寫（4）
Figure Sketch (4)

SK0073　53
人物速寫（5）
Figure Sketch (5)

1927

1927.2.5 研1
SK0074　59
立姿裸女速寫-27.2.5（42）
Standing Female Nude Sketch-27.2.5 (42)

1927.2.5 研2
SK0075　59
立姿裸女速寫-27.2.5（43）
Standing Female Nude Sketch-27.2.5 (43)

1927.2.5 研3
SK0076　59
坐姿裸女速寫-27.2.5（14）
Seated Female Nude Sketch-27.2.5 (14)

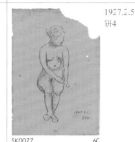
1927.2.5 研4
SK0077　60
坐姿裸女速寫-27.2.5（15）
Seated Female Nude Sketch-27.2.5 (15)

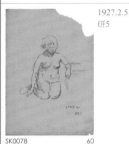
1927.2.5 研5
SK0078　60
坐姿裸女速寫-27.2.5（16）
Seated Female Nude Sketch-27.2.5 (16)

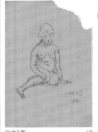
1927.2.5 研6
SK0079　60
坐姿裸女速寫-27.2.5（17）
Seated Female Nude Sketch-27.2.5 (17)

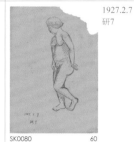
1927.2.7 研7
SK0080　60
立姿裸女速寫-27.2.5（44）
Standing Female Nude Sketch-27.2.5 (44)

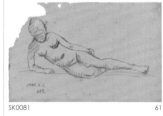
SK0081　61
臥姿裸女速寫-27.2.5（4）
Reclining Female Nude Sketch-27.2.5 (4)
1927.2.5 研8

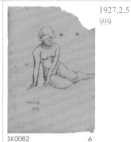
1927.2.5 研9
SK0082
坐姿裸女速寫-27.2.5（18）
Seated Female Nude Sketch-27.2.5 (18)

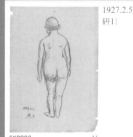
1927.2.5 研11
SK0083　61
立姿裸女速寫-27.2.5（45）
Standing Female Nude Sketch-27.2.5 (45)

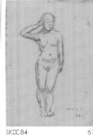
1927.2.5 研12
SK0084　61
立姿裸女速寫-27.2.5（46）
Standing Female Nude Sketch-27.2.5 (46)

1927.2.5 研13
SK0085　62
立姿裸女速寫-27.2.5（47）
Standing Female Nude Sketch-27.2.5 (47)

SK0086　62
坐姿裸女速寫-27.2.5（19）
Seated Female Nude Sketch-27.2.5 (19)
1927.2.5 研14

1927.2.5 研15
SK0087　62
坐姿裸女速寫-27.2.5（20）
Seated Female Nude Sketch-27.2.5 (20)

1927.2.5 研16
SK0088　62
坐姿裸女速寫-27.2.5（21）
Seated Female Nude Sketch-27.2.5 (21)

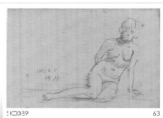
SK0089　63
坐姿裸女速寫-27.2.5（22）
Seated Female Nude Sketch-27.2.5 (22)
1927.2.5 研17

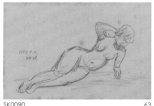
SK0090　63
臥姿裸女速寫-27.2.5（5）
Reclining Female Nude Sketch-27.2.5 (5)
1927.2.5 研18

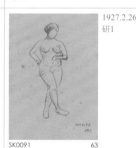
1927.2.26 研1
SK0091　63
立姿裸女速寫-27.2.26（48）
Standing Female Nude Sketch-27.2.26 (48)

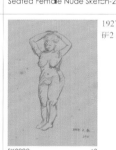
1927.2.26 研2
SK0092　63
立姿裸女速寫-27.2.26（49）
Standing Female Nude Sketch-27.2.26 (49)

1927.2.26 研3
SK0093　64
立姿裸女速寫-27.2.26（50）
Standing Female Nude Sketch-27.2.26 (50)

1927.2.26 研4
SK0094　64
坐姿裸女速寫-27.2.26（23）
Seated Female Nude Sketch-27.2.26 (23)

SK0095　64
坐姿裸女速寫-27.2.26（24）
Seated Female Nude Sketch-27.2.26 (24)
1927.2.26 研5

1927.2.26 研6
SK0096　64
坐姿裸女速寫-27.2.26（25）
Seated Female Nude Sketch-27.2.26 (25)

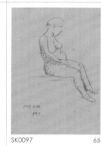
1927.2.26 研7
SK0097　65
坐姿裸女速寫-27.2.26（26）
Seated Female Nude Sketch-27.2.26 (26)

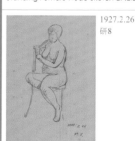
1927.2.26 研8
SK0098　65
坐姿裸女速寫-27.2.26（27）
Seated Female Nude Sketch-27.2.26 (27)

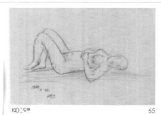
SK0099　55
臥姿裸女速寫-27.2.26（6）
Reclining Female Nude Sketch-27.2.26 (6)
1927.2.26 研9

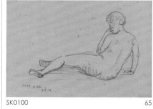
SK0100　65
坐姿裸女速寫-27.2.26（28）
Seated Female Nude Sketch-27.2.26 (28)
1927.2.26 研10

1927.2.26 研11
SK0101　66
立姿裸女速寫-27.2.26（51）
Standing Female Nude Sketch-27.2.26 (51)

1927.2.26 研12
SK0102　66
立姿裸女速寫-27.2.26（52）
Standing Female Nude Sketch-27.2.26 (52)

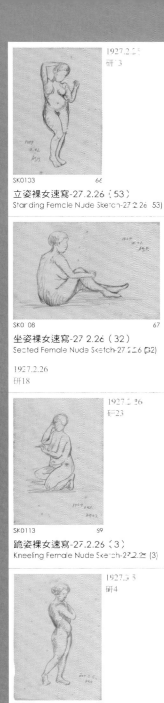

1927.2.26 研13
SK0103　66
立姿裸女速寫-27.2.26（53）
Standing Female Nude Sketch-27.2.26 (53)

1927.2.26 研14
SK0104　66
坐姿裸女速寫-27.2.26（29）
Seated Female Nude Sketch-27.2.26 (29)

1927.2.26 研15
SK0105　67
坐姿裸女速寫-27.2.26（30）
Seated Female Nude Sketch-27.2.26 (30)

SK0106　67
坐姿裸女速寫-27.2.26（31）
Seated Female Nude Sketch-27.2.26 (31)
1927.2.26 研16

1927.2.26 研17
SK0107　67
蹲姿裸女速寫-27.2.26（4）
Squatting Female Nude Sketch-27.2.26 (4)

SK0108　67
坐姿裸女速寫-27.2.26（32）
Seated Female Nude Sketch-27.2.26 (32)
1927.2.26 研18

SK0109　68
坐姿裸女速寫-27.2.26（33）
Seated Female Nude Sketch-27.2.26 (33)
1927.2.26 研19

1927.2.26 研20 參考圖
SK0110　68
坐姿裸女速寫-27.2.26（34）
Seated Female Nude Sketch-27.2.26 (34)

1927.2.26 研21
SK0111　68
立姿裸女速寫-27.2.26（54）
Standing Female Nude Sketch-27.2.26 (54)

1927.2.26 研22
SK0112　68
立姿裸女速寫-27.2.26（55）
Standing Female Nude Sketch-27.2.26 (55)

1927.2.26 研23
SK0113　69
跪姿裸女速寫-27.2.26（3）
Kneeling Female Nude Sketch-27.2.26 (3)

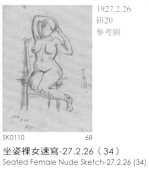
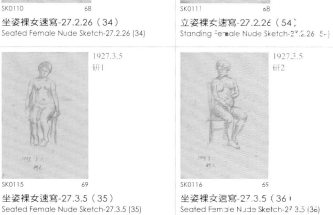
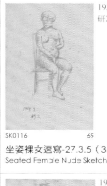
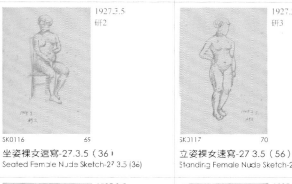

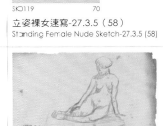
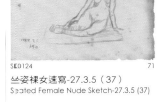

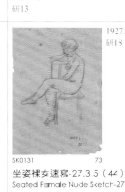
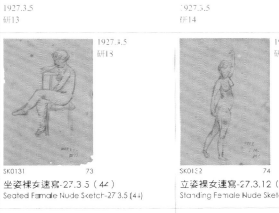
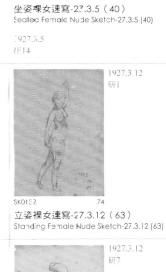
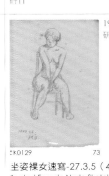

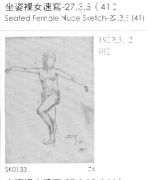

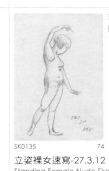
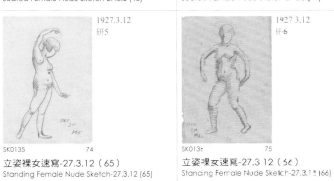
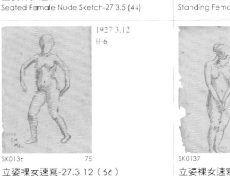

SK0114　69
頭像速寫-27.2.26（4）
Portrait Sketch-27.2.26 (4)
1927.2.26 研外一
スケチノ人々（大家的素描）

1927.3.5 研1
SK0115　69
坐姿裸女速寫-27.3.5（35）
Seated Female Nude Sketch-27.3.5 (35)

1927.3.5 研2
SK0116　69
坐姿裸女速寫-27.3.5（36）
Seated Female Nude Sketch-27.3.5 (36)

1927.3.5 研3
SK0117　70
立姿裸女速寫-27.3.5（56）
Standing Female Nude Sketch-27.3.5 (56)

1927.3.5 研4
SK0118　70
立姿裸女速寫-27.3.5（57）
Standing Female Nude Sketch-27.3.5 (57)

1927.3.5 研5
SK0119　70
立姿裸女速寫-27.3.5（58）
Standing Female Nude Sketch-27.3.5 (58)

一九二七・三・五 研六
SK0120　70
立姿裸女速寫-27.3.5（59）
Standing Female Nude Sketch-27.3.5 (59)

1927.3.5 研7
SK0121　71
立姿裸女速寫-27.3.5（60）
Standing Female Nude Sketch-27.3.5 (60)

1927.3.5 研8
SK0122　71
立姿裸女速寫-27.3.5（61）
Standing Female Nude Sketch-27.3.5 (61)

1927.3.5 研9
SK0123　71
立姿裸女速寫-27.3.5（62）
Standing Female Nude Sketch-27.3.5 (62)

SK0124　71
坐姿裸女速寫-27.3.5（37）
Seated Female Nude Sketch-27.3.5 (37)
1927.3.5 研11

SK0125　72
坐姿裸女速寫-27.3.5（38）
Seated Female Nude Sketch-27.3.5 (38)
1927.3.5 研12

SK0126　72
坐姿裸女速寫-27.3.5（39）
Seated Female Nude Sketch-27.3.5 (39)
1927.3.5 研13

SK0127　72
坐姿裸女速寫-27.3.5（40）
Seated Female Nude Sketch-27.3.5 (40)
1927.3.5 研14

1927.3.5 研15
SK0128　73
坐姿裸女速寫-27.3.5（41）
Seated Female Nude Sketch-27.3.5 (41)

1927.3.5 研16
SK0129　73
坐姿裸女速寫-27.3.5（42）
Seated Female Nude Sketch-27.3.5 (42)

1927.3.5 研17
SK0130　73
坐姿裸女速寫-27.3.5（43）
Seated Female Nude Sketch-27.3.5 (43)

1927.3.5 研18
SK0131　73
坐姿裸女速寫-27.3.5（44）
Seated Female Nude Sketch-27.3.5 (44)

1927.3.12 研1
SK0132　74
立姿裸女速寫-27.3.12（63）
Standing Female Nude Sketch-27.3.12 (63)

1927.3.12 研2
SK0133　74
立姿裸女速寫-27.3.12（64）
Standing Female Nude Sketch-27.3.12 (64)

1927.3.12 研3
SK0134　74
跪姿裸女速寫-27.3.12（4）
Kneeling Female Nude Sketch-27.3.12 (4)

1927.3.12 研5
SK0135　74
立姿裸女速寫-27.3.12（65）
Standing Female Nude Sketch-27.3.12 (65)

1927.3.12 研6
SK0136　75
立姿裸女速寫-27.3.12（66）
Standing Female Nude Sketch-27.3.12 (66)

1927.3.12 研7
SK0137　75
立姿裸女速寫-27.3.12（67）
Standing Female Nude Sketch-27.3.12 (67)

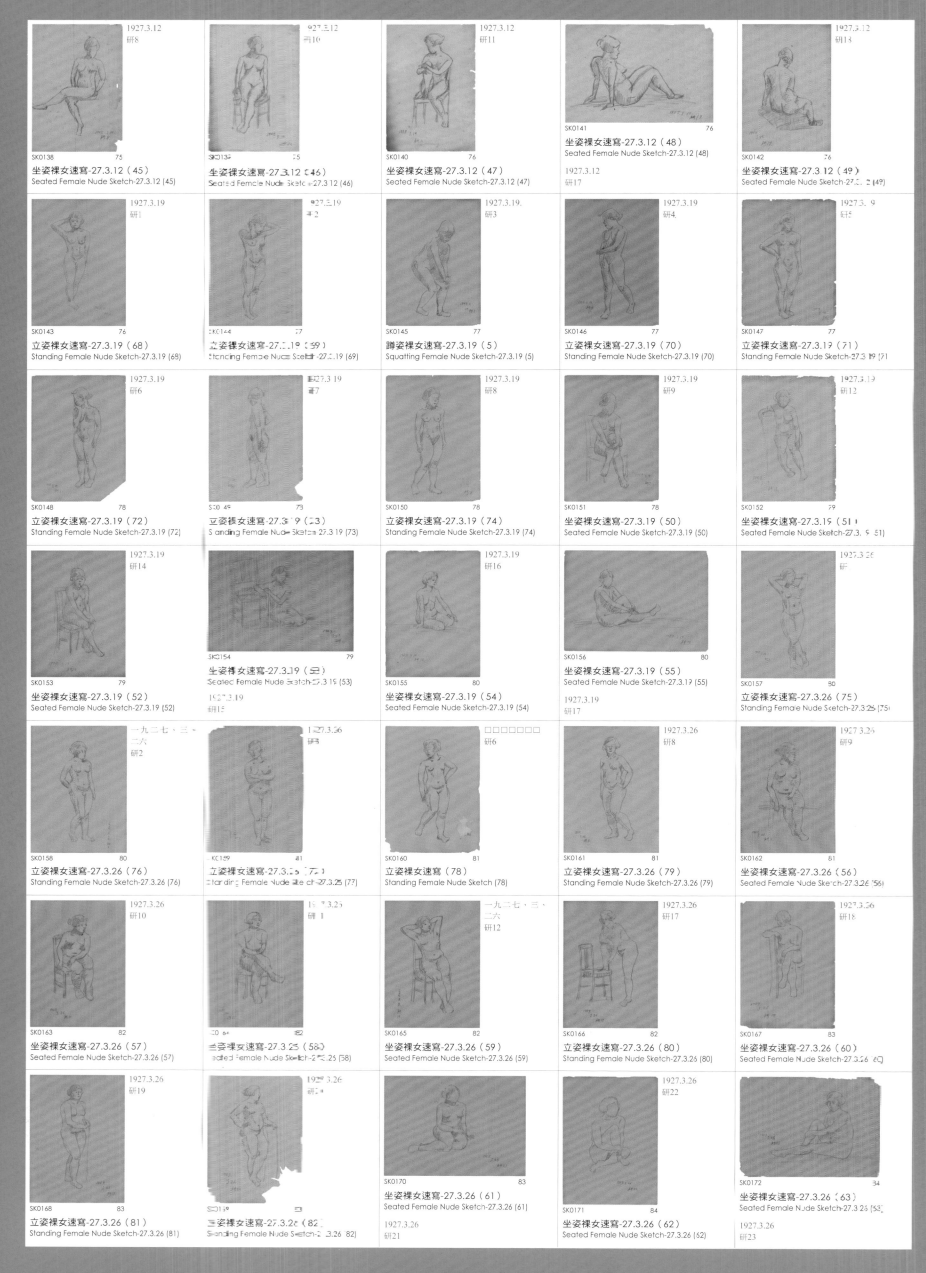

1927.3.12
研8
SK0138　　75
坐姿裸女速寫-27.3.12（45）
Seated Female Nude Sketch-27.3.12 (45)

1927.3.12
研10
SK0139　　75
坐姿裸女速寫-27.3.12（46）
Seated Female Nude Sketch-27.3.12 (46)

1927.3.12
研11
SK0140　　76
坐姿裸女速寫-27.3.12（47）
Seated Female Nude Sketch-27.3.12 (47)

SK0141　　76
坐姿裸女速寫-27.3.12（48）
Seated Female Nude Sketch-27.3.12 (48)
1927.3.12
研17

1927.3.12
研13
SK0142　　76
坐姿裸女速寫-27.3.12（49）
Seated Female Nude Sketch-27.3.12 (49)

1927.3.19
研1
SK0143　　76
立姿裸女速寫-27.3.19（68）
Standing Female Nude Sketch-27.3.19 (68)

1927.3.19
研2
SK0144　　77
立姿裸女速寫-27.3.19（69）
Standing Female Nude Sketch-27.3.19 (69)

1927.3.19.
研3
SK0145　　77
蹲姿裸女速寫-27.3.19（5）
Squatting Female Nude Sketch-27.3.19 (5)

1927.3.19
研4
SK0146　　77
立姿裸女速寫-27.3.19（70）
Standing Female Nude Sketch-27.3.19 (70)

1927.3.19
研5
SK0147　　77
立姿裸女速寫-27.3.19（71）
Standing Female Nude Sketch-27.3.19 (71)

1927.3.19
研6
SK0148　　78
立姿裸女速寫-27.3.19（72）
Standing Female Nude Sketch-27.3.19 (72)

1927.3.19
研7
SK0149　　78
立姿裸女速寫-27.3.19（73）
Standing Female Nude Sketch-27.3.19 (73)

1927.3.19
研8
SK0150　　78
立姿裸女速寫-27.3.19（74）
Standing Female Nude Sketch-27.3.19 (74)

1927.3.19
研9
SK0151　　78
坐姿裸女速寫-27.3.19（50）
Seated Female Nude Sketch-27.3.19 (50)

1927.3.19
研12
SK0152　　79
坐姿裸女速寫-27.3.19（51）
Seated Female Nude Sketch-27.3.19 (51)

1927.3.19
研14
SK0153　　79
坐姿裸女速寫-27.3.19（52）
Seated Female Nude Sketch-27.3.19 (52)

SK0154　　79
坐姿裸女速寫-27.3.19（53）
Seated Female Nude Sketch-27.3.19 (53)
1927.3.19
研15

1927.3.19
研16
SK0155　　80
坐姿裸女速寫-27.3.19（54）
Seated Female Nude Sketch-27.3.19 (54)

SK0156　　80
坐姿裸女速寫-27.3.19（55）
Seated Female Nude Sketch-27.3.19 (55)
1927.3.19
研17

1927.3.26
研
SK0157　　80
立姿裸女速寫-27.3.26（75）
Standing Female Nude Sketch-27.3.26 (75)

一九二七・三・
二六
研2
SK0158　　80
立姿裸女速寫-27.3.26（76）
Standing Female Nude Sketch-27.3.26 (76)

1927.3.26
研3
SK0159　　81
立姿裸女速寫-27.3.26（77）
Standing Female Nude Sketch-27.3.26 (77)

研6
SK0160　　81
立姿裸女速寫（78）
Standing Female Nude Sketch (78)

1927.3.26
研8
SK0161　　81
立姿裸女速寫-27.3.26（79）
Standing Female Nude Sketch-27.3.26 (79)

1927.3.26
研9
SK0162　　81
坐姿裸女速寫-27.3.26（56）
Seated Female Nude Sketch-27.3.26 (56)

1927.3.26
研10
SK0163　　82
坐姿裸女速寫-27.3.26（57）
Seated Female Nude Sketch-27.3.26 (57)

1927.3.26
研11
SK0164　　82
坐姿裸女速寫-27.3.26（58）
Seated Female Nude Sketch-27.3.26 (58)

一九二七・三・
二六
研12
SK0165　　82
坐姿裸女速寫-27.3.26（59）
Seated Female Nude Sketch-27.3.26 (59)

1927.3.26
研17
SK0166　　82
立姿裸女速寫-27.3.26（80）
Standing Female Nude Sketch-27.3.26 (80)

1927.3.26
研18
SK0167　　83
坐姿裸女速寫-27.3.26（60）
Seated Female Nude Sketch-27.3.26 (60)

1927.3.26
研19
SK0168　　83
立姿裸女速寫-27.3.26（81）
Standing Female Nude Sketch-27.3.26 (81)

1927.3.26
研20
SK0169　　83
立姿裸女速寫-27.3.26（82）
Standing Female Nude Sketch-27.3.26 (82)

SK0170　　83
坐姿裸女速寫-27.3.26（61）
Seated Female Nude Sketch-27.3.26 (61)
1927.3.26
研21

1927.3.26
研22
SK0171　　84
坐姿裸女速寫-27.3.26（62）
Seated Female Nude Sketch-27.3.26 (62)

SK0172　　84
坐姿裸女速寫-27.3.26（63）
Seated Female Nude Sketch-27.3.26 (63)
1927.3.26
研23

SK0173　8+
坐姿裸女速寫-27.3.26（64）
Seated Female Nude Sketch-27.3.26 (64)
1927.3.26 研24

192□□□□ 研2
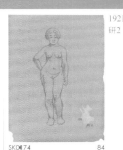
SK0174　84
立姿裸女速寫（83）
Standing Female Nude Sketch (83)

1927.4.2 研3
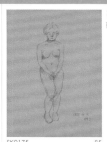
SK0175　85
立姿裸女速寫-27.4.2（84）
Standing Female Nude Sketch-27.4.2 (84)

1927.4.2 研6
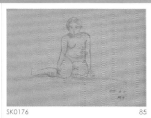
SK0176　85
坐姿裸女速寫-27.4.2（55）
Seated Female Nude Sketch-27.4.2 (55)
1927.4.2 研4

1927.4.2 研6
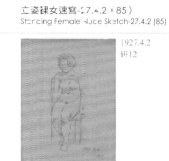
SK0177　85
立姿裸女速寫-27.4.2（85）
Standing Female Nude Sketch-27.4.2 (85)

SK0178
臥姿裸女速寫-27.4.2（7）
Reclining Female Nude Sketch-27.4.2 (7)
1927.4.2 研7

ミジカシ（短）
1927.4.2 研8
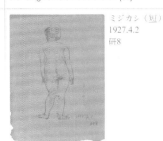
SK0179　86
立姿裸女速寫-27.4.2（86）
Standing Female Nude Sketch-27.4.2 (86)

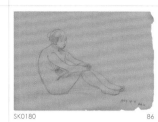
SK0180　86
坐姿裸女速寫-27.4.2（66）
Seated Female Nude Sketch-27.4.2 (66)
1927.4.2 研10

SK0181　86
坐姿裸女速寫-27.4.2（67）
Seated Female Nude Sketch-27.4.2 (67)
1927.4.2 研11

1927.4.2 研12
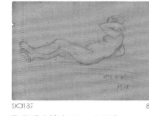
SK0182　85
坐姿裸女速寫-27.4.2（68）
Seated Female Nude Sketch-27.4.2 (68)

1927.4.2 研13
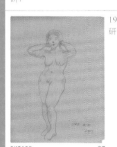
SK0183　87
立姿裸女速寫-27.4.2（87）
Standing Female Nude Sketch-27.4.2 (87)

1927.4.2 研14
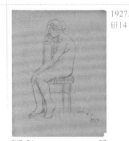
SK0184　87
坐姿裸女速寫-27.4.2（69）
Seated Female Nude Sketch-27.4.2 (69)

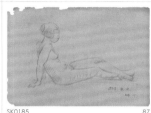
SK0185　87
坐姿裸女速寫-27.4.2（70）
Seated Female Nude Sketch-27.4.2 (70)
1927.4.2 研15

SK0186　88
坐姿裸女速寫-27.4.2（71）
Seated Female Nude Sketch-27.4.2 (71)
1927.4.2 研17

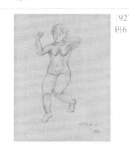
SK0187　88
臥姿裸女速寫-27.4.2（8）
Reclining Female Nude Sketch-27.4.2 (8)
1927.4.2 研18

1927.4.9 研1
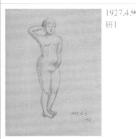
SK0188　86
立姿裸女速寫-27.4.9（88）
Standing Female Nude Sketch-27.4.9 (88)

1927.4.9 研2
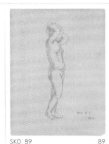
SK0189　89
立姿裸女速寫-27.4.9（89）
Standing Female Nude Sketch-27.4.9 (89)

1927.4.9 研3
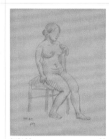
SK0190　89
坐姿裸女速寫-27.4.9（72）
Seated Female Nude Sketch-27.4.9 (72)

1927.4.9 研5

SK0191　89
坐姿裸女速寫-27.4.9（73）
Seated Female Nude Sketch-27.4.9 (73)

1927.4.9 研6
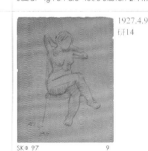
SK0192　89
蹲姿裸女速寫-27.4.9（6）
Squatting Female Nude Sketch-27.4.9 (6)

1927.4.9 研7
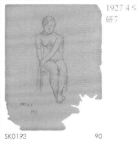
SK0193　90
坐姿裸女速寫-27.4.9（74）
Seated Female Nude Sketch-27.4.9 (74)

1927.4.9 研8
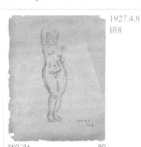
SK0194　90
立姿裸女速寫-27.4.9（90）
Standing Female Nude Sketch-27.4.9 (90)

1927.4.9 研10
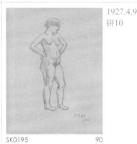
SK0195　90
立姿裸女速寫-27.4.9（91）
Standing Female Nude Sketch-27.4.9 (91)

1927.4.9 研12
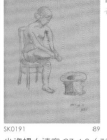
SK0196　90
坐姿裸女速寫-27.4.9（75）
Seated Female Nude Sketch-27.4.9 (75)

1927.4.9 研14
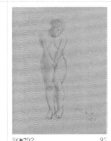
SK0197　9
坐姿裸女速寫-27.4.9（76）
Seated Female Nude Sketch-27.4.9 (76)

有美過大之詣（豎）
1927.4.9 研16
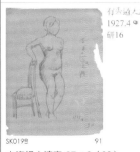
SK0198　91
立姿裸女速寫-27.4.9（92）
Standing Female Nude Sketch-27.4.9 (92)

1927.4.9 研17
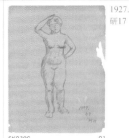
SK0199　91
立姿裸女速寫-27.4.9（93）
Standing Female Nude Sketch-27.4.9 (93)

1927.4.9 研18
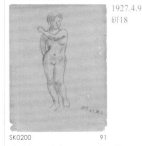
SK0200　91
立姿裸女速寫-27.4.9（94）
Standing Female Nude Sketch-27.4.9 (94)

1927.4.16 研1
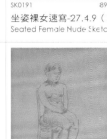
SK0201　92
立姿裸女速寫-27.4.16（95）
Standing Female Nude Sketch-27.4.16 (95)

1927.4.16 研2
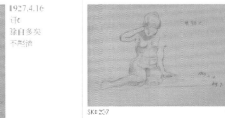
SK0202　92
立姿裸女速寫-27.4.16（96）
Standing Female Nude Sketch-27.4.16 (96)

寫不來了
1927.4.16 研3
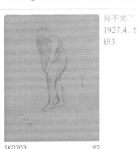
SK0203　92
立姿裸女速寫-27.4.16（97）
Standing Female Nude Sketch-27.4.16 (97)

頭大 胴小
1927.4.16 研4

SK0204　92
立姿裸女速寫-27.4.16（98）
Standing Female Nude Sketch-27.4.16 (98)

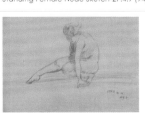
SK0205　93
蹲姿裸女速寫-27.4.16（7）
Squatting Female Nude Sketch-27.4.16 (7)
1927.4.16 研5

1927.4.16 研
除自多突
不易練
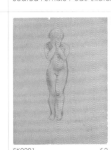
SK0206　93
坐姿裸女速寫-27.4.16（77）
Seated Female Nude Sketch-27.4.16 (77)

1927.4.16
SK0207　93
坐姿裸女速寫-27.4.16（78）
Seated Female Nude Sketch-27.4.16 (78)
頭最大
1927.4.16 研7

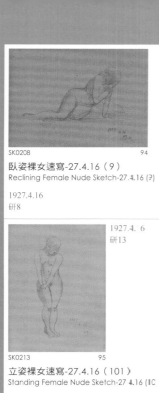
SK0208　94
臥姿裸女速寫-27.4.16（9）
Reclining Female Nude Sketch-27.4.16 (?)

1927.4.16
研8

1927.4.16
研9
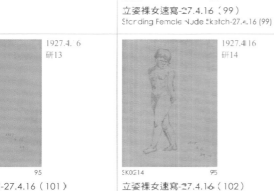
SK0209　94
立姿裸女速寫-27.4.16（99）
Standing Female Nude Sketch-27.4.16 (99)

1927.4.16
研10
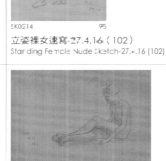
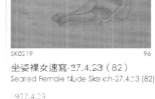
SK0210　94
立姿裸女速寫-27.4.16（100）
Standing Female Nude Sketch-27.4.16 (100)

SK0211　94
坐姿裸女速寫-27.4.16（79）
Seated Female Nude Sketch-27.4.16 (79)

1927.4.16
研11

SK0212　95
坐姿裸女速寫-27.4.16（80）
Seated Female Nude Sketch-27.4.16 (80)

1927.4.16
研12

1927.4.16
研13
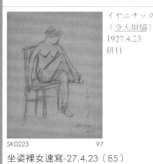
SK0213　95
立姿裸女速寫-27.4.16（101）
Standing Female Nude Sketch-27.4.16 (101)

1927.4.16
研14
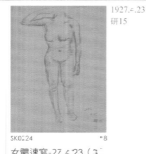
SK0214　95
立姿裸女速寫-27.4.16（102）
Standing Female Nude Sketch-27.4.16 (102)

1927.4.16
研15
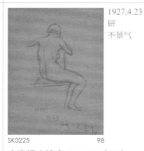
SK0215　95
立姿裸女速寫-27.4.16（103）
Standing Female Nude Sketch-27.4.16 (103)

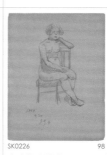
SK0216　96
坐姿裸女速寫-27.4.16（81）
Seated Female Nude Sketch-27.4.16 (81)

1927.4.16
研16

1927.4.16
研17
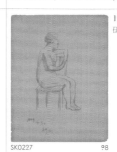
SK0217　96
跪姿裸女速寫-27.4.16（5）
Kneeling Female Nude Sketch-27.4.16 (5)

1927.4.23
研1
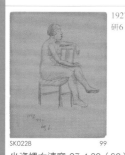
SK0218　96
立姿裸女速寫-27.4.23（104）
Standing Female Nude Sketch-27.4.23 (104)

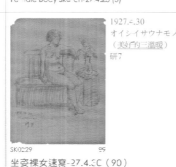
SK0219　96
坐姿裸女速寫-27.4.23（82）
Seated Female Nude Sketch-27.4.23 (82)

1927.4.23
研5

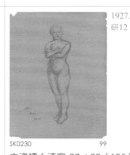
SK0220　97
坐姿裸女速寫-27.4.23（83）
Seated Female Nude Sketch-27.4.23 (83)

1927.4.23
研7

1927.4.23
研9

SK0221　97
坐姿裸女速寫-27.4.23（84）
Seated Female Nude Sketch-27.4.23 (84)

1927.4.23
研10

SK0222　97
女體速寫-27.4.23（2）
Female Body Sketch-27.4.23 (2)

イヤニナッタ
（令人煩惱）
1927.4.23
研11

SK0223　97
坐姿裸女速寫-27.4.23（85）
Seated Female Nude Sketch-27.4.23 (85)

1927.4.23
研15

SK0224　98
女體速寫-27.4.23（3）
Female Body Sketch-27.4.23 (3)

1927.4.23
研
不景気

SK0225　98
坐姿裸女速寫-27.4.23（86）
Seated Female Nude Sketch-27.4.23 (86)

1927.4.30
研4

SK0226　98
坐姿裸女速寫-27.4.30（87）
Seated Female Nude Sketch-27.4.30 (87)

1927.4.30
研5

SK0227　98
坐姿裸女速寫-27.4.30（88）
Seated Female Nude Sketch-27.4.30 (88)

1927.4.30
研6

SK0228　99
坐姿裸女速寫-27.4.30（89）
Seated Female Nude Sketch-27.4.30 (89)

1927.4.30
オイシイサウナモノ
（美的的三溫暖）
研7
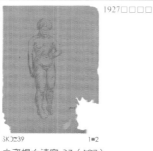
SK0229　99
坐姿裸女速寫-27.4.30（90）
Seated Female Nude Sketch-27.4.30 (90)

1927.4.30
研12
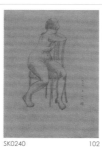
SK0230　99
立姿裸女速寫-27.4.30（105）
Standing Female Nude Sketch-27.4.30 (105)

1927.4.30
研13
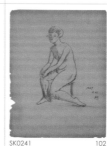
SK0231　99
立姿裸女速寫-27.4.30（106）
Standing Female Nude Sketch-27.4.30 (106)

1927.4.30
研□
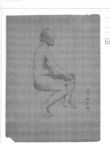
SK0232　100
坐姿裸女速寫-27.4.30（91）
Seated Female Nude Sketch-27.4.30 (91)

1927.5.14
研6
SK0233　100
坐姿裸女速寫-27.5.14（92）
Seated Female Nude Sketch-27.5.14 (92)

1927.5.14
研12
SK0234　100
坐姿裸女速寫-27.5.14（93）
Seated Female Nude Sketch-27.5.14 (93)

SK0235　100
坐姿裸女速寫-27.5.14（94）
Seated Female Nude Sketch-27.5.14 (94)

1927.5.14
研14

SK0236　101
坐姿裸女速寫-27.5.14（95）
Seated Female Nude Sketch-27.5.14 (95)

1927.5.14
研15

SK0237　10
跪姿裸女速寫-27.5.14（6）
Kneeling Female Nude Sketch-27.5.14 (6)

1927.5.14
研16

SK0238　10
坐姿裸女速寫-27.5.14（96）
Seated Female Nude Sketch-27.5.14 (96)

1927.5.14
波

1927□□□
SK0239　1□2
立姿裸女速寫-27（107）
Standing Female Nude Sketch-27 (107)

一九二七・五・
二一
波
SK0240　102
坐姿裸女速寫-27.5.21（97）
Seated Female Nude Sketch-27.5.21 (97)

1927.5.21
研
SK0241　102
坐姿裸女速寫-27.5.21（98）
Seated Female Nude Sketch-27.5.21 (98)

一九二七・五・
二一
研
SK0242　1C2
坐姿裸女速寫-27.5.21（99）
Seated Female Nude Sketch-27.5.21 (99)

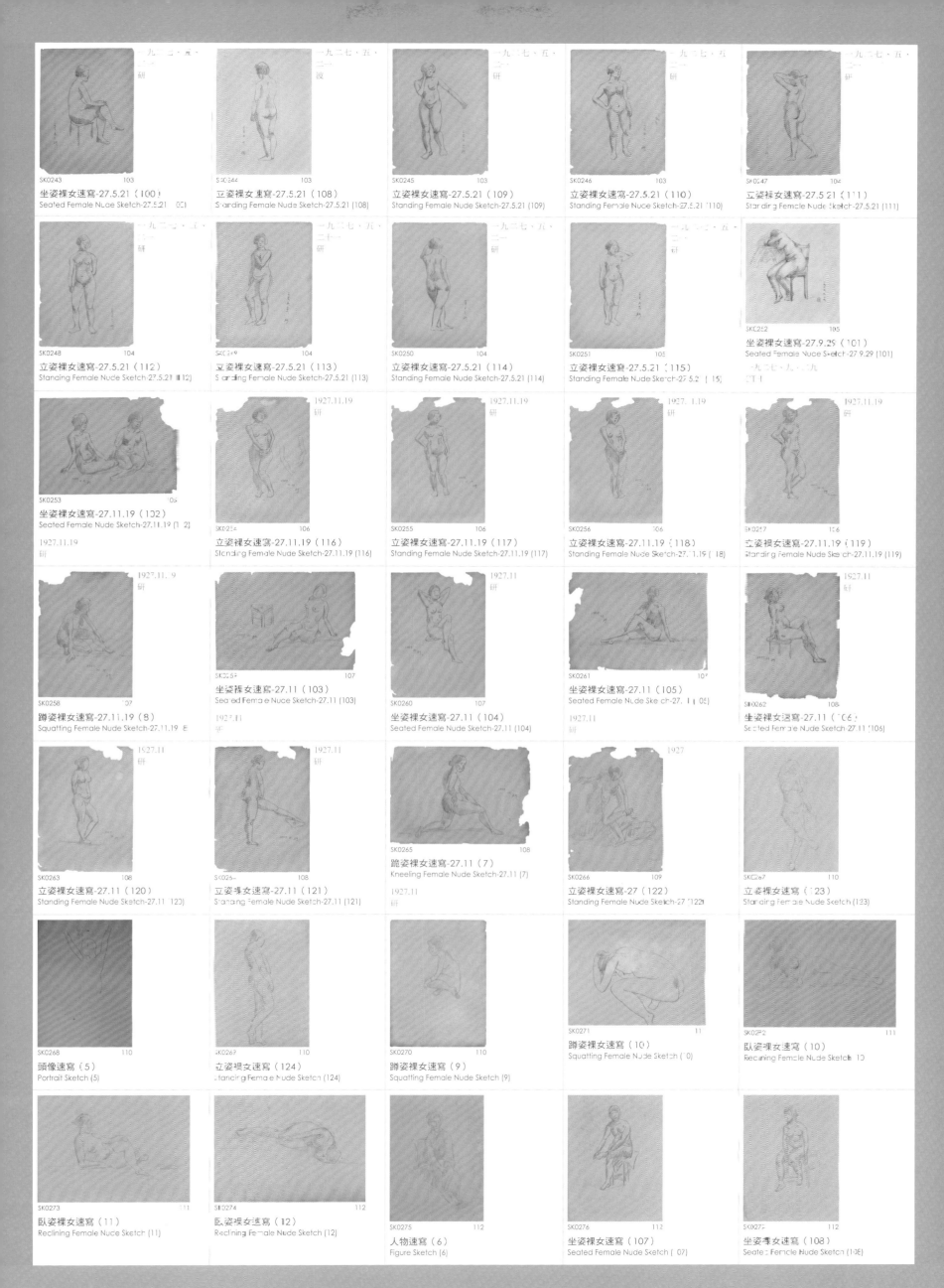

坐姿裸女速寫-27.5.21（100）
Seated Female Nude Sketch-27.5.21 (100)

立姿裸女速寫-27.5.21（108）
Standing Female Nude Sketch-27.5.21 (108)

立姿裸女速寫-27.5.21（109）
Standing Female Nude Sketch-27.5.21 (109)

立姿裸女速寫-27.5.21（110）
Standing Female Nude Sketch-27.5.21 (110)

立姿裸女速寫-27.5.21（111）
Standing Female Nude Sketch-27.5.21 (111)

立姿裸女速寫-27.5.21（112）
Standing Female Nude Sketch-27.5.21 (112)

立姿裸女速寫-27.5.21（113）
Standing Female Nude Sketch-27.5.21 (113)

立姿裸女速寫-27.5.21（114）
Standing Female Nude Sketch-27.5.21 (114)

立姿裸女速寫-27.5.21（115）
Standing Female Nude Sketch-27.5.21 (115)

坐姿裸女速寫-27.9.29（101）
Seated Female Nude Sketch-27.9.29 (101)

坐姿裸女速寫-27.11.19（102）
Seated Female Nude Sketch-27.11.19 (102)

立姿裸女速寫-27.11.19（116）
Standing Female Nude Sketch-27.11.19 (116)

立姿裸女速寫-27.11.19（117）
Standing Female Nude Sketch-27.11.19 (117)

立姿裸女速寫-27.11.19（118）
Standing Female Nude Sketch-27.11.19 (118)

立姿裸女速寫-27.11.19（119）
Standing Female Nude Sketch-27.11.19 (119)

蹲姿裸女速寫-27.11.19（8）
Squatting Female Nude Sketch-27.11.19 (8)

坐姿裸女速寫-27.11（103）
Seated Female Nude Sketch-27.11 (103)

坐姿裸女速寫-27.11（104）
Seated Female Nude Sketch-27.11 (104)

坐姿裸女速寫-27.11（105）
Seated Female Nude Sketch-27.11 (105)

坐姿裸女速寫-27.11（106）
Seated Female Nude Sketch-27.11 (106)

立姿裸女速寫-27.11（120）
Standing Female Nude Sketch-27.11 (120)

立姿裸女速寫-27.11（121）
Standing Female Nude Sketch-27.11 (121)

跪姿裸女速寫-27.11（7）
Kneeling Female Nude Sketch-27.11 (7)

立姿裸女速寫-27（122）
Standing Female Nude Sketch-27 (122)

立姿裸女速寫（123）
Standing Female Nude Sketch (123)

頭像速寫（5）
Portrait Sketch (5)

立姿裸女速寫（124）
Standing Female Nude Sketch (124)

蹲姿裸女速寫（9）
Squatting Female Nude Sketch (9)

蹲姿裸女速寫（10）
Squatting Female Nude Sketch (10)

臥姿裸女速寫（10）
Reclining Female Nude Sketch (10)

臥姿裸女速寫（11）
Reclining Female Nude Sketch (11)

臥姿裸女速寫（12）
Reclining Female Nude Sketch (12)

人物速寫（6）
Figure Sketch (6)

坐姿裸女速寫（107）
Seated Female Nude Sketch (107)

坐姿裸女速寫（108）
Seated Female Nude Sketch (108)

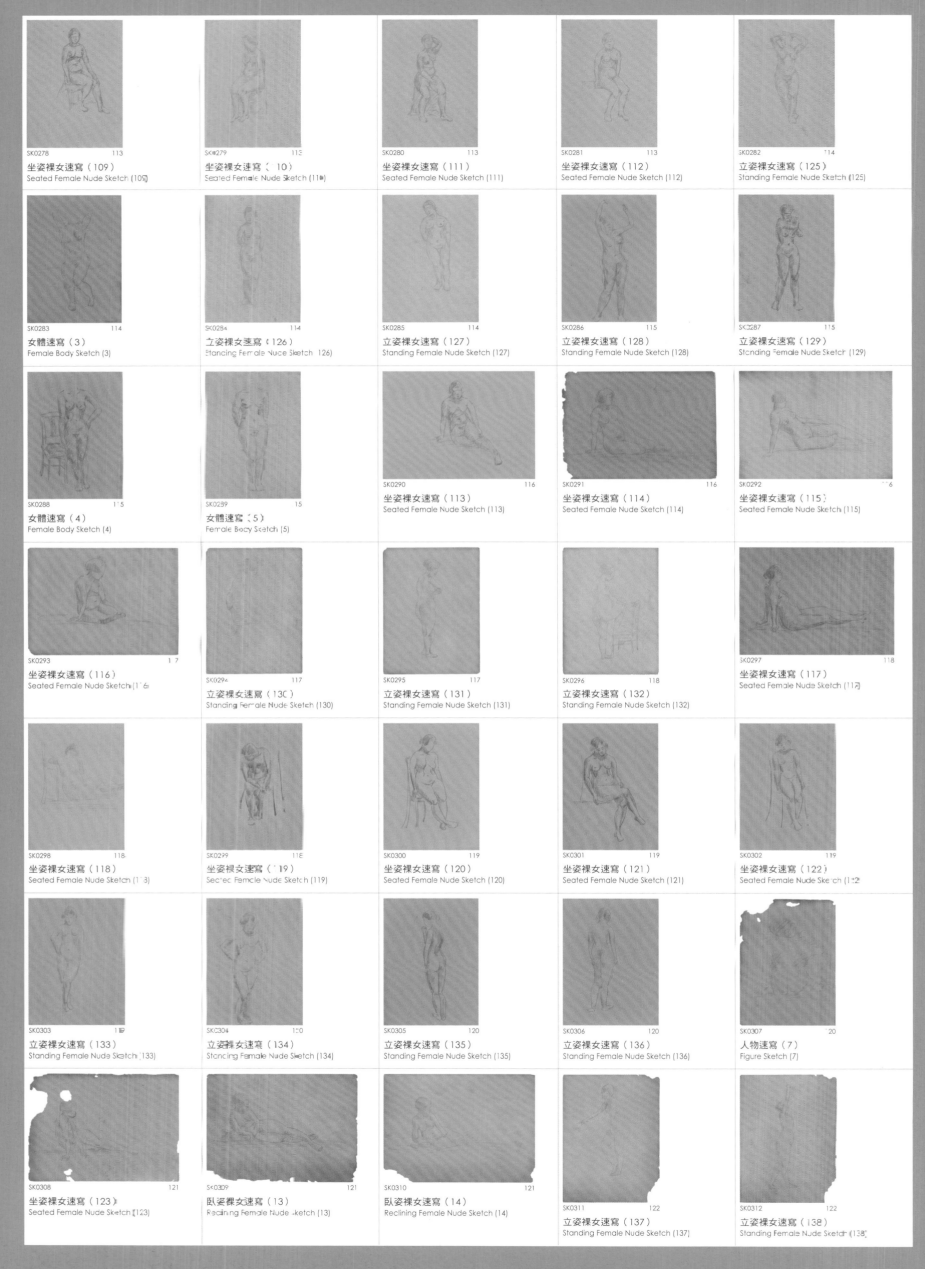

SK0278 113
坐姿裸女速寫（109）
Seated Female Nude Sketch (109)

SK0279 113
坐姿裸女速寫（110）
Seated Female Nude Sketch (110)

SK0280 113
坐姿裸女速寫（111）
Seated Female Nude Sketch (111)

SK0281 113
坐姿裸女速寫（112）
Seated Female Nude Sketch (112)

SK0282 114
立姿裸女速寫（125）
Standing Female Nude Sketch (125)

SK0283 114
女體速寫（3）
Female Body Sketch (3)

SK0284 114
立姿裸女速寫（126）
Standing Female Nude Sketch (126)

SK0285 114
立姿裸女速寫（127）
Standing Female Nude Sketch (127)

SK0286 115
立姿裸女速寫（128）
Standing Female Nude Sketch (128)

SK0287 115
立姿裸女速寫（129）
Standing Female Nude Sketch (129)

SK0288 115
女體速寫（4）
Female Body Sketch (4)

SK0289 115
女體速寫（5）
Female Body Sketch (5)

SK0290 116
坐姿裸女速寫（113）
Seated Female Nude Sketch (113)

SK0291 116
坐姿裸女速寫（114）
Seated Female Nude Sketch (114)

SK0292 116
坐姿裸女速寫（115）
Seated Female Nude Sketch (115)

SK0293 117
坐姿裸女速寫（116）
Seated Female Nude Sketch (116)

SK0294 117
立姿裸女速寫（130）
Standing Female Nude Sketch (130)

SK0295 117
立姿裸女速寫（131）
Standing Female Nude Sketch (131)

SK0296 118
立姿裸女速寫（132）
Standing Female Nude Sketch (132)

SK0297 118
坐姿裸女速寫（117）
Seated Female Nude Sketch (117)

SK0298 118
坐姿裸女速寫（118）
Seated Female Nude Sketch (118)

SK0299 118
坐姿裸女速寫（119）
Seated Female Nude Sketch (119)

SK0300 119
坐姿裸女速寫（120）
Seated Female Nude Sketch (120)

SK0301 119
坐姿裸女速寫（121）
Seated Female Nude Sketch (121)

SK0302 119
坐姿裸女速寫（122）
Seated Female Nude Sketch (122)

SK0303 119
立姿裸女速寫（133）
Standing Female Nude Sketch (133)

SK0304 120
立姿裸女速寫（134）
Standing Female Nude Sketch (134)

SK0305 120
立姿裸女速寫（135）
Standing Female Nude Sketch (135)

SK0306 120
立姿裸女速寫（136）
Standing Female Nude Sketch (136)

SK0307 120
人物速寫（7）
Figure Sketch (7)

SK0308 121
坐姿裸女速寫（123）
Seated Female Nude Sketch (123)

SK0309 121
臥姿裸女速寫（13）
Reclining Female Nude Sketch (13)

SK0310 121
臥姿裸女速寫（14）
Reclining Female Nude Sketch (14)

SK0311 122
立姿裸女速寫（137）
Standing Female Nude Sketch (137)

SK0312 122
立姿裸女速寫（138）
Standing Female Nude Sketch (138)

SK0313　　　122
蹲姿裸女速寫（11）
Squatting Female Nude Sketch (11)

SK0314　　　122
跪姿裸女速寫（8）
Kneeling Female Nude Sketch (8)

SK0315　　　123
跪姿裸女速寫（9）
Kneeling Female Nude Sketch (9)

SK0316　　　123
坐姿裸女速寫（124）
Seated Female Nude Sketch (124)

SK0317　　　123
坐姿裸女速寫（125）
Seated Female Nude Sketch (125)

SK0318　　　123
坐姿裸女速寫（126）
Seated Female Nude Sketch (126)

SK0319　　　124
坐姿裸女速寫（127）
Seated Female Nude Sketch (127)

SK0320　　　124
立姿裸女速寫（139）
Standing Female Nude Sketch (139)

SK0321　　　124
立姿裸女速寫（140）
Standing Female Nude Sketch (140)

SK0322　　　124
坐姿裸女速寫（128）
Seated Female Nude Sketch (128)

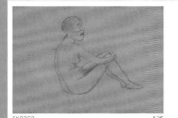

SK0323　　　125
坐姿裸女速寫（129）
Seated Female Nude Sketch (129)

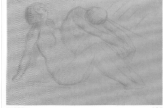

SK0324　　　125
坐姿裸女速寫（130）
Seated Female Nude Sketch (130)

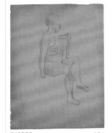

SK0325　　　126
坐姿裸女速寫（131）
Seated Female Nude Sketch (131)

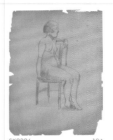

SK0326　　　126
坐姿裸女速寫（132）
Seated Female Nude Sketch (132)

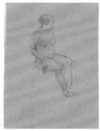

SK0327　　　126
坐姿裸女速寫（133）
Seated Female Nude Sketch (133)

SK0328　　　126
坐姿裸女速寫（134）
Seated Female Nude Sketch (134)

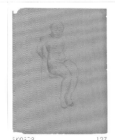

SK0329　　　127
坐姿裸女速寫（135）
Seated Female Nude Sketch (135)

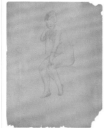

SK0330　　　127
坐姿裸女速寫（136）
Seated Female Nude Sketch (136)

SK0331　　　127
跪姿裸女速寫（10）
Kneeling Female Nude Sketch (10)

SK0332　　　127
立姿裸女速寫（141）
Standing Female Nude Sketch (141)

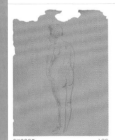

SK0333　　　128
立姿裸女速寫（142）
Standing Female Nude Sketch (142)

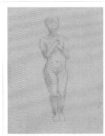

SK0334　　　128
立姿裸女速寫（143）
Standing Female Nude Sketch (143)

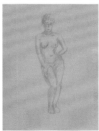

SK0335　　　128
立姿裸女速寫（144）
Standing Female Nude Sketch (144)

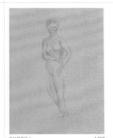

SK0336　　　128
立姿裸女速寫（145）
Standing Female Nude Sketch (145)

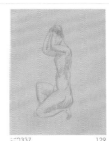

SK0337　　　129
跪姿裸女速寫（11）
Kneeling Female Nude Sketch (11)

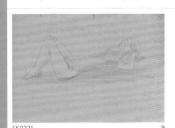

SK0338
臥姿裸女速寫（15）
Reclining Female Nude Sketch (15)

SK0339　　　129
立姿裸女速寫（146）
Standing Female Nude Sketch (146)

SK0340　　　129
立姿裸女速寫（147）
Standing Female Nude Sketch (147)

SK0341　　　130
立姿裸女速寫（148）
Standing Female Nude Sketch (148)

SK0342　　　130
立姿裸女速寫（149）
Standing Female Nude Sketch (149)

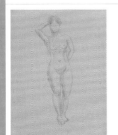

SK0343　　　130
立姿裸女速寫（150）
Standing Female Nude Sketch (150)

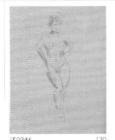

SK0344　　　130
立姿裸女速寫（151）
Standing Female Nude Sketch (151)

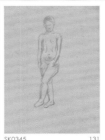

SK0345　　　131
立姿裸女速寫（152）
Standing Female Nude Sketch (152)

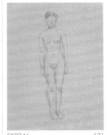

SK0346　　　131
立姿裸女速寫（153）
Standing Female Nude Sketch (153)

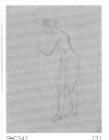

SK0347　　　131
立姿裸女速寫（154）
Standing Female Nude Sketch (154)

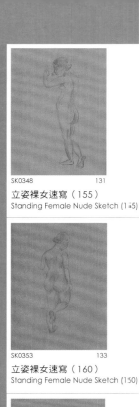

SK0348　　　131
立姿裸女速寫（155）
Standing Female Nude Sketch (145)

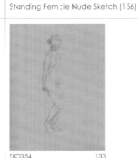

SK0349　　　132
立姿裸女速寫（156）
Standing Female Nude Sketch (156)

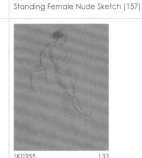

SK0350　　　132
立姿裸女速寫（157）
Standing Female Nude Sketch (157)

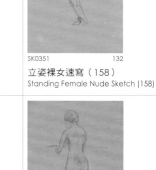

SK0351　　　132
立姿裸女速寫（158）
Standing Female Nude Sketch (158)

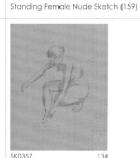

SK0352　　　132
立姿裸女速寫（159）
Standing Female Nude Sketch (159)

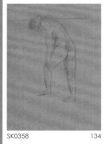

SK0353　　　133
立姿裸女速寫（160）
Standing Female Nude Sketch (150)

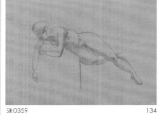

SK0354　　　133
立姿裸女速寫（161）
Standing Female Nude Sketch (161)

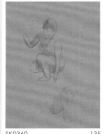

SK0355　　　133
立姿裸女速寫（162）
Standing Female Nude Sketch (162)

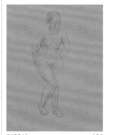

SK0356　　　133
立姿裸女速寫（163）
Standing Female Nude Sketch (163)

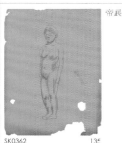

SK0357　　　134
蹲姿裸女速寫（12）
Squatting Female Nude Sketch (12)

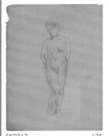

SK0358　　　134
立姿裸女速寫（164）
Standing Female Nude Sketch (164)

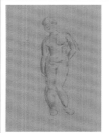

SK0359　　　134
臥姿裸女速寫（16）
Reclining Female Nude Sketch (6)

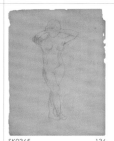

SK0360　　　135
蹲姿裸女速寫（13）
Squatting Female Nude Sketch (13)

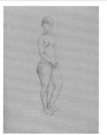

SK0361　　　135
立姿裸女速寫（165）
Standing Female Nude Sketch (165)

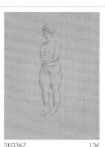

帝展
SK0362　　　135
立姿裸女速寫（166）
Standing Female Nude Sketch (166)

SK0363　　　135
立姿裸女速寫（167）
Standing Female Nude Sketch (167)

SK0364　　　136
立姿裸女速寫（168）
Standing Female Nude Sketch (68)

SK0365　　　136
立姿裸女速寫（169）
Standing Female Nude Sketch (169)

SK0366　　　136
立姿裸女速寫（170）
Standing Female Nude Sketch (170)

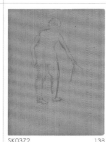

SK0367　　　136
立姿裸女速寫（171）
Standing Female Nude Sketch (171)

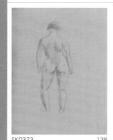

SK0368　　　137
跪姿裸女速寫（12）
Kneeling Female Nude Sketch (2)

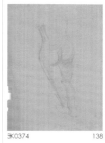

SK0369　　　137
立姿裸女速寫（172）
Standing Female Nude Sketch (172)

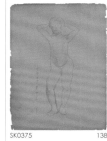

SK0370　　　137
立姿裸女速寫（173）
Standing Female Nude Sketch (173)

SK0371　　　137
立姿裸女速寫（174）
Standing Female Nude Sketch (174)

SK0372　　　138
立姿裸女速寫（175）
Standing Female Nude Sketch (175)

SK0373　　　138
立姿裸女速寫（176）
Standing Female Nude Sketch (176)

SK0374　　　138
女體速寫（6）
Female Body Sketch (6)

イヤニナッタナ
アー（真令人煩
惱）
SK0375　　　138
立姿裸女速寫（177）
Standing Female Nude Sketch (177)

SK0376　　　139
立姿裸女速寫（178）
Standing Female Nude Sketch (178)

SK0377　　　139
立姿裸女速寫（179）
Standing Female Nude Sketch (179)

SK0378　　　139
立姿裸女速寫（180）
Standing Female Nude Sketch (180)

SK0379　　　139
立姿裸女速寫（181）
Standing Female Nude Sketch (181)

SK0380　　　140
立姿裸女速寫（182）
Standing Female Nude Sketch (182)

SK0381　　　140
立姿裸女速寫（183）
Standing Female Nude Sketch (183)

SK0382　　　140
立姿裸女速寫（184）
Standing Female Nude Sketch (184)

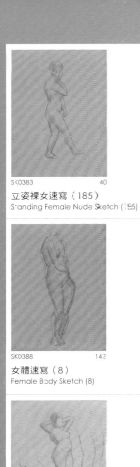

SK0383 40
立姿裸女速寫（185）
Standing Female Nude Sketch (185)

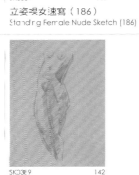

SK0384 141
立姿裸女速寫（186）
Standing Female Nude Sketch (186)

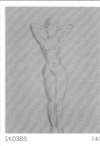

SK0385 141
立姿裸女速寫（187）
Standing Female Nude Sketch (187)

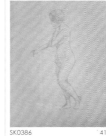

SK0386 141
立姿裸女速寫（188）
Standing Female Nude Sketch (188)

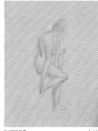

SK0387 141
立姿裸女速寫（189）
Standing Female Nude Sketch (189)

SK0388 142
女體速寫（8）
Female Body Sketch (8)

SK0389 142
女體速寫（9）
Female Body Sketch (9)

SK0390 142
立姿裸女速寫（190）
Standing Female Nude Sketch (190)

SK0391 142
女體速寫（10）
Female Body Sketch (10)

SK0392 143
立姿裸女速寫（191）
Standing Female Nude Sketch (191)

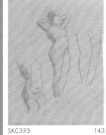

SKC393 143
立姿裸女速寫（192）
Standing Female Nude Sketch (192)

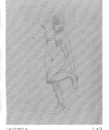

SK0394 143
立姿裸女速寫（193）
Standing Female Nude Sketch (193)

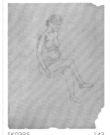

SK0395 143
坐姿裸女速寫（137）
Seated Female Nude Sketch (137)

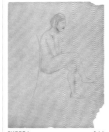

SK0396 144
坐姿裸女速寫（138）
Seated Female Nude Sketch (138)

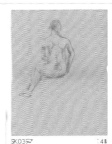

SK0397 144
坐姿裸女速寫（139）
Seated Female Nude Sketch (139)

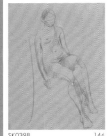

SK0398 144
坐姿裸女速寫（140）
Seated Female Nude Sketch (140)

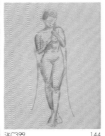

SKC399 144
立姿裸女速寫（194）
Standing Female Nude Sketch (194)

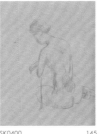

SK0400 145
坐姿裸女速寫（141）
Seated Female Nude Sketch (141)

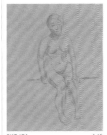

SK0401 145
坐姿裸女速寫（142）
Seated Female Nude Sketch (142)

SK0402 145
女體速寫（11）
Female Body Sketch (11)

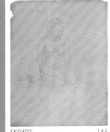

SK0403 145
坐姿裸女速寫（143）
Seated Female Nude Sketch (143)

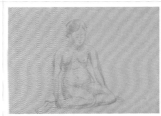

SK0404 146
坐姿裸女速寫（144）
Seated Female Nude Sketch (144)

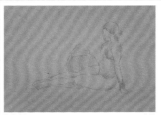

SK0405 146
坐姿裸女速寫（145）
Seated Female Nude Sketch (145)

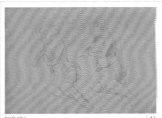

SK0406 146
坐姿裸女速寫（146）
Seated Female Nude Sketch (146)

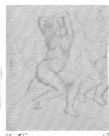

SK0407 147
坐姿裸女速寫（147）
Seated Female Nude Sketch (147)

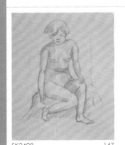

SK0408 147
坐姿裸女速寫（148）
Seated Female Nude Sketch (148)

SK0409 147
坐姿裸女速寫（149）
Seated Female Nude Sketch (149)

SK0410 147
坐姿裸女速寫（150）
Seated Female Nude Sketch (150)

SK0411 148
坐姿裸女速寫（151）
Seated Female Nude Sketch (151)

SK0412 148
坐姿裸女速寫（152）
Seated Female Nude Sketch (152)

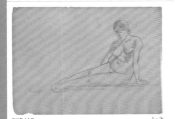

SK0413 148
坐姿裸女速寫（153）
Seated Female Nude Sketch (153)

SK0414 149
女體速寫（12）
Female Body Sketch (12)

SK0415 149
坐姿裸女速寫（154）
Seated Female Nude Sketch (154)

SK0416 149
女體速寫（13）
Female Body Sketch (13)

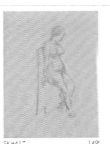

SK0417 149
坐姿裸女速寫（155）
Seated Female Nude Sketch (155)

SK0418 150
坐姿裸女速寫（156）
Seated Female Nude Sketch (156)

SK0419 150
女體速寫（1-）
Female Body Sketch (14)

SK0420 150
坐姿裸女速寫（157）
Seated Female Nude Sketch (157)

SK0421 150
坐姿裸女速寫（158）
Seated Female Nude Sketch (158)

SK0422 151
坐姿裸女速寫（159）
Seated Female Nude Sketch (159)

SK0423 151
坐姿裸女速寫（160）
Seated Female Nude Sketch (160)

SK0424 151
坐姿裸女速寫（161）
Seated Female Nude Sketch (161)

SK0425 151
坐姿裸女速寫（162）
Seated Female Nude Sketch (162)

SK0426 152
坐姿裸女速寫（163）
Seated Female Nude Sketch (163)

SK0427 152
坐姿裸女速寫（164）
Seated Female Nude Sketch (164)

SK0428 152
坐姿裸女速寫（165）
Seated Female Nude Sketch (165)

SK0429 152
坐姿裸女速寫（166）
Seated Female Nude Sketch (166)

SK0430 153
跪姿裸女速寫（13）
Kneeling Female Nude Sketch (13)

SK0431 153
臥姿裸女速寫（17）
Reclining Female Nude Sketch (17)

SK0432 53
坐姿裸女速寫（167）
Seated Female Nude Sketch (167)

SK0433 54
坐姿裸女速寫（168）
Seated Female Nude Sketch (168)

SK0434 154
坐姿裸女速寫（169）
Seated Female Nude Sketch (169)

SK0435 154
坐姿裸女速寫（170）
Seated Female Nude Sketch (170)

SK0436 155
坐姿裸女速寫（171）
Seated Female Nude Sketch (171)

SK0437 155
坐姿裸女速寫（172）
Seated Female Nude Sketch (172)

SK0438 55
坐姿裸女速寫（173）
Seated Female Nude Sketch (173)

SK0439 156
坐姿裸女速寫（174）
Seated Female Nude Sketch (174)

SK0440 156
坐姿裸女速寫（175）
Seated Female Nude Sketch (175)

SK0441 156
坐姿裸女速寫（176）
Seated Female Nude Sketch (176)

SK0442 157
坐姿裸女速寫（177）
Seated Female Nude Sketch (177)

SK0443 157
坐姿裸女速寫（178）
Seated Female Nude Sketch (178)

SK0444 57
坐姿裸女速寫（179）
Seated Female Nude Sketch (179)

SK0445 157
坐姿裸女速寫（180）
Seated Female Nude Sketch (180)

SK0446 158
坐姿裸女速寫（181）
Seated Female Nude Sketch (181)

SK0447 158
坐姿裸女速寫（182）
Seated Female Nude Sketch (182)

SK0448 158
坐姿裸女速寫（183）
Seated Female Nude Sketch (183)

SK0449 158
坐姿裸女速寫（184）
Seated Female Nude Sketch (184)

SK0450 159
跪姿裸女速寫（14）
Kneeling Female Nude Sketch (14)

SK0451 159
跪姿裸女速寫（15）
Kneeling Female Nude Sketch (15)

SK0452 159
坐姿裸女速寫（185）
Seated Female Nude Sketch (185)

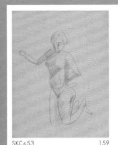

SKC453 159
跪姿裸女速寫（16）
Kneeling Female Nude Sketch (16)

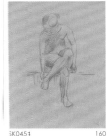

SK0454 160
坐姿裸女速寫（186）
Seated Female Nude Sketch (186)

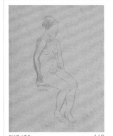

SK0455 160
坐姿裸女速寫（187）
Seated Female Nude Sketch (187)

SK0456 160
坐姿裸女速寫（188）
Seated Female Nude Sketch (188)

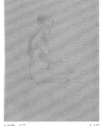

SK0457 160
坐姿裸女速寫（189）
Seated Female Nude Sketch (189)

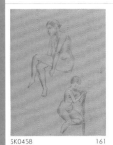

SK0458 161
坐姿裸女速寫（190）
Seated Female Nude Sketch (190)

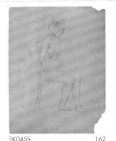

SK0459 162
坐姿裸女速寫（191）
Seated Female Nude Sketch (191)

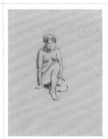

SK0460 162
坐姿裸女速寫（192）
Seated Female Nude Sketch (192)

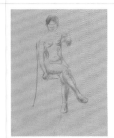

SK0461 162
坐姿裸女速寫（193）
Seated Female Nude Sketch (193)

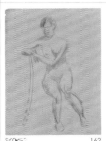

SK0462 162
坐姿裸女速寫（194）
Seated Female Nude Sketch (194)

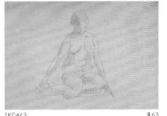

SK0463 163
坐姿裸女速寫（195）
Seated Female Nude Sketch (195)

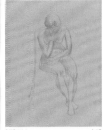

SK0464 163
坐姿裸女速寫（196）
Seated Female Nude Sketch (196)

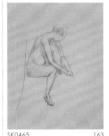

SK0465 163
坐姿裸女速寫（197）
Seated Female Nude Sketch (197)

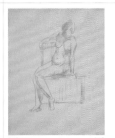

SK0466 163
坐姿裸女速寫（198）
Seated Female Nude Sketch (198)

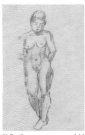

SK0467 164
立姿裸女速寫（195）
Standing Female Nude Sketch (195)

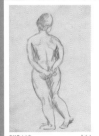

SK0468 164
立姿裸女速寫（196）
Standing Female Nude Sketch (196)

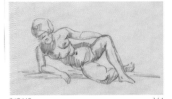

SK0469 164
臥姿裸女速寫（18）
Reclining Female Nude Sketch (18)

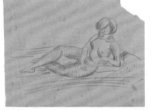

SK0470 165
臥姿裸女速寫（19）
Reclining Female Nude Sketch (19)

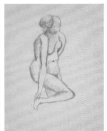

SK0471 165
立姿裸女速寫（197）
Standing Female Nude Sketch (197)

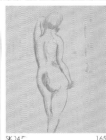

SK0472 165
立姿裸女速寫（198）
Standing Female Nude Sketch (198)

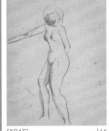

SK0473 166
立姿裸女速寫（199）
Standing Female Nude Sketch (199)

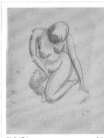

SK0474 166
跪姿裸女速寫（17）
Kneeling Female Nude Sketch (17)

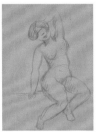

SK0475 166
坐姿裸女速寫（199）
Seated Female Nude Sketch (199)

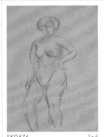

SK0476 166
立姿裸女速寫（200）
Standing Female Nude Sketch (200)

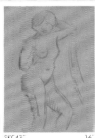

SK0477 166
立姿裸女速寫（201）
Standing Female Nude Sketch (201)

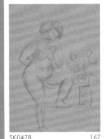

SK0478 167
立姿裸女速寫（202）
Standing Female Nude Sketch (202)

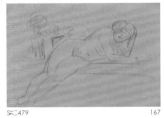

SK0479 167
臥姿裸女速寫（20）
Reclining Female Nude Sketch (20)

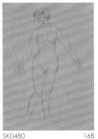

SK0480 168
立姿裸女速寫（203）
Standing Female Nude Sketch (203)

SK0481 168
立姿裸女速寫（204）
Standing Female Nude Sketch (204)

SK0482 168
立姿裸女速寫（205）
Standing Female Nude Sketch (205)

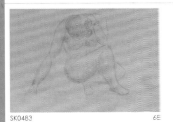

SK0483 168
蹲姿裸女速寫（14）
Squatting Female Nude Sketch (14)

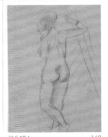

SK0484 169
立姿裸女速寫（206）
Standing Female Nude Sketch (206)

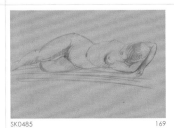

SK0485 169
臥姿裸女速寫（21）
Reclining Female Nude Sketch (21)

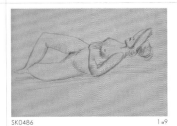

SK0486 169
臥姿裸女速寫（22）
Reclining Female Nude Sketch (22)

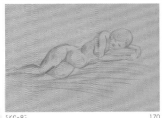

SK0487 170
臥姿裸女速寫（23）
Reclining Female Nude Sketch (23)

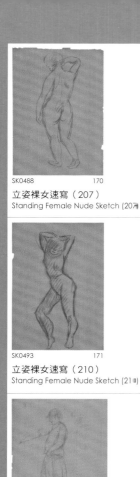

SK0488　　　170
立姿裸女速寫（207）
Standing Female Nude Sketch (207)

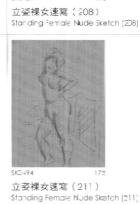

SK0489　　　170
立姿裸女速寫（208）
Standing Female Nude Sketch (208)

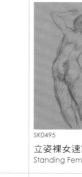

SK0490　　　171
女體速寫（15）
Female Body Sketch (15)

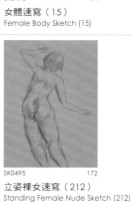

SK0491　　　171
立姿裸女速寫（209）
Standing Female Nude Sketch (209)

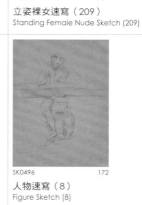

SK0492　　　171
女體速寫（16）
Female Body Sketch (16)

SK0493　　　171
立姿裸女速寫（210）
Standing Female Nude Sketch (210)

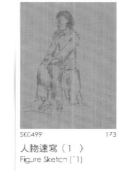

SK0494　　　172
立姿裸女速寫（211）
Standing Female Nude Sketch (211)

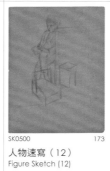

SK0495　　　172
立姿裸女速寫（212）
Standing Female Nude Sketch (212)

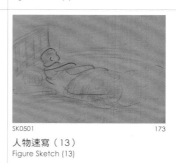

SK0496　　　172
人物速寫（8）
Figure Sketch (8)

SK0497　　　172
人物速寫（9）
Figure Sketch (9)

SK0498　　　173
人物速寫（10）
Figure Sketch (10)

SK0499　　　173
人物速寫（11）
Figure Sketch (11)

SK0500　　　173
人物速寫（12）
Figure Sketch (12)

SK0501　　　173
人物速寫（13）
Figure Sketch (13)

SK0502　　　174
人物速寫（14）
Figure Sketch (14)

SK0503　　　174
坐姿裸女與人物速寫（1）
Seated Female Nude and Figure Sketch (1)

SK0504　　　174
人物速寫（15）
Figure Sketch (15)

SK0505　　　174
人物速寫（16）
Figure Sketch (16)

SK0506　　　175
人物速寫（17）
Figure Sketch (17)

SK0507　　　176
頭像速寫（6）
Portrait Sketch (6)

SK0508　　　176
頭像速寫（7）
Portrait Sketch (7)

SK0509　　　176
頭像速寫（8）
Portrait Sketch (8)

SK0510　　　176
頭像速寫（9）
Portrait Sketch (9)

SK0511　　　177
頭像速寫（10）
Portrait Sketch (10)

SK0512　　　178
頭像速寫（11）
Portrait Sketch (11)

SK0513　　　178
頭像速寫（12）
Portrait Sketch (12)

SK0514　　　178
頭像速寫（13）
Portrait Sketch (13)

SK0515　　　178
頭像速寫（14）
Portrait Sketch (14)

SK0516　　　179
頭像速寫（15）
Portrait Sketch (15)

SK0517　　　179
頭像速寫（16）
Portrait Sketch (16)

SK0518　　　180
頭像速寫（17）
Portrait Sketch (17)

1928

1928.2.10
研一
SK0519　　　182
立姿裸女速寫-28.2.10（213）
Standing Female Nude Sketch-28.2.10 (213)

1928.2.10
研2
SK0520　　　182
坐姿裸女速寫-28.2.10（200）
Seated Female Nude Sketch-28.2.10 (200)

一九二八・二・十
研三
SK0521　　　182
立姿裸女速寫-28.2.10（214）
Standing Female Nude Sketch-28.2.10 (214)

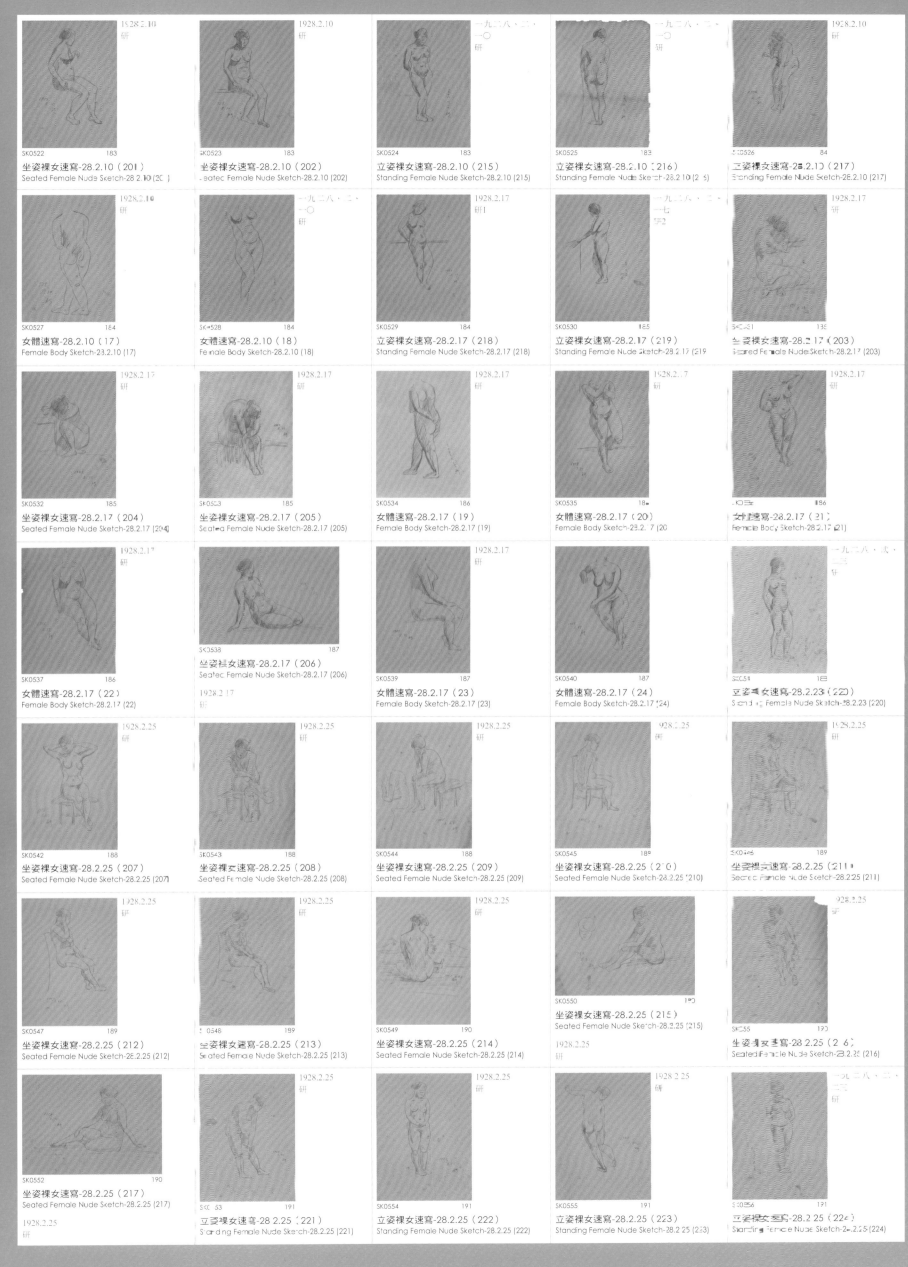

坐姿裸女速寫-28.2.10（201）
Seated Female Nude Sketch-28.2.10 (201)

坐姿裸女速寫-28.2.10（202）
Seated Female Nude Sketch-28.2.10 (202)

立姿裸女速寫-28.2.10（215）
Standing Female Nude Sketch-28.2.10 (215)

立姿裸女速寫-28.2.10（216）
Standing Female Nude Sketch-28.2.10 (216)

立姿裸女速寫-28.2.10（217）
Standing Female Nude Sketch-28.2.10 (217)

女體速寫-28.2.10（17）
Female Body Sketch-28.2.10 (17)

女體速寫-28.2.10（18）
Female Body Sketch-28.2.10 (18)

立姿裸女速寫-28.2.17（218）
Standing Female Nude Sketch-28.2.17 (218)

立姿裸女速寫-28.2.17（219）
Standing Female Nude Sketch-28.2.17 (219)

坐姿裸女速寫-28.2.17（203）
Seated Female Nude Sketch-28.2.17 (203)

坐姿裸女速寫-28.2.17（204）
Seated Female Nude Sketch-28.2.17 (204)

坐姿裸女速寫-28.2.17（205）
Seated Female Nude Sketch-28.2.17 (205)

女體速寫-28.2.17（19）
Female Body Sketch-28.2.17 (19)

女體速寫-28.2.17（20）
Female Body Sketch-28.2.17 (20)

女體速寫-28.2.17（21）
Female Body Sketch-28.2.17 (21)

女體速寫-28.2.17（22）
Female Body Sketch-28.2.17 (22)

坐姿裸女速寫-28.2.17（206）
Seated Female Nude Sketch-28.2.17 (206)

女體速寫-28.2.17（23）
Female Body Sketch-28.2.17 (23)

女體速寫-28.2.17（24）
Female Body Sketch-28.2.17 (24)

立姿裸女速寫-28.2.23（220）
Standing Female Nude Sketch-28.2.23 (220)

坐姿裸女速寫-28.2.25（207）
Seated Female Nude Sketch-28.2.25 (207)

坐姿裸女速寫-28.2.25（208）
Seated Female Nude Sketch-28.2.25 (208)

坐姿裸女速寫-28.2.25（209）
Seated Female Nude Sketch-28.2.25 (209)

坐姿裸女速寫-28.2.25（210）
Seated Female Nude Sketch-28.2.25 (210)

坐姿裸女速寫-28.2.25（211）
Seated Female Nude Sketch-28.2.25 (211)

坐姿裸女速寫-28.2.25（212）
Seated Female Nude Sketch-28.2.25 (212)

坐姿裸女速寫-28.2.25（213）
Seated Female Nude Sketch-28.2.25 (213)

坐姿裸女速寫-28.2.25（214）
Seated Female Nude Sketch-28.2.25 (214)

坐姿裸女速寫-28.2.25（215）
Seated Female Nude Sketch-28.2.25 (215)

坐姿裸女速寫-28.2.25（216）
Seated Female Nude Sketch-28.2.25 (216)

坐姿裸女速寫-28.2.25（217）
Seated Female Nude Sketch-28.2.25 (217)

立姿裸女速寫-28.2.25（221）
Standing Female Nude Sketch-28.2.25 (221)

立姿裸女速寫-28.2.25（222）
Standing Female Nude Sketch-28.2.25 (222)

立姿裸女速寫-28.2.25（223）
Standing Female Nude Sketch-28.2.25 (223)

立姿裸女速寫-28.2.25（224）
Standing Female Nude Sketch-28.2.25 (224)

1928.2.25
研
SK0557　192
立姿裸女速寫-28.2.25（225）
Standing Female Nude Sketch-28.2.25 (225)

1928.2.25
研
SK0558　192
立姿裸女速寫-28.2.25（226）
Standing Female Nude Sketch-28.2.25 (226)

1928.2.25
研
SK0559　192
立姿裸女速寫-28.2.25（227）
Standing Female Nude Sketch-28.2.25 (227)

1928.2.25
研
SK0560　192
立姿裸女速寫-28.2.25（228）
Standing Female Nude Sketch-28.2.25 (228)

SK0561　193
臥姿裸女速寫-28.2.25（24）
Reclining Female Nude Sketch-28.2.25 (24)
1928.2.25
研

SK0562　193
臥姿裸女速寫-28.2.25（25）
Reclining Female Nude Sketch-28.2.25 (25)
1928.2.25
研

SK0563　193
臥姿裸女速寫-28.2.25（26）
Reclining Female Nude Sketch-28.2.25 (26)
1928.2.25
研

SK0564　194
臥姿裸女速寫-28.2.25（27）
Reclining Female Nude Sketch-28.2.25 (27)
1928.2.25
研

1928.2
研1
SK0565　194
立姿裸女速寫-28.2（229）
Standing Female Nude Sketch-28.2 (229)

1928.2
研2
SK0566　194
立姿裸女速寫-28.2（230）
Standing Female Nude Sketch-28.2 (230)

1928.2
研3
SK0567　194
立姿裸女速寫-28.2（231）
Standing Female Nude Sketch-28.2 (231)

SK0568　195
坐姿裸女速寫-28.2（218）
Seated Female Nude Sketch-28.2 (218)
1928.2
研4

1928.2
研5
SK0569　195
跪姿裸女速寫-28.2（18）
Kneeling Female Nude Sketch-28.2 (18)

SK0570　195
坐姿裸女速寫-28.2（219）
Seated Female Nude Sketch-28.2 (219)
1928.2
研6

1928.2
研7
SK0571　195
坐姿裸女速寫-28.2（220）
Seated Female Nude Sketch-28.2 (220)

1928.2
研8
SK0572　196
坐姿裸女速寫-28.2（221）
Seated Female Nude Sketch-28.2 (221)

1928.2
研9
SK0573　196
坐姿裸女速寫-28.2（222）
Seated Female Nude Sketch-28.2 (222)

SK0574　196
坐姿和臥姿裸女速寫-28.2（1）
Seated and Reclining Female Nude Sketch-28.2 (1)
1928.2
研10

SK0575　197
坐姿裸女速寫-28.2（223）
Seated Female Nude Sketch-28.2 (223)
1928.2
研11

1928.3.3
研
SK0576　197
立姿裸女速寫-28.3.3（232）
Standing Female Nude Sketch-28.3.3 (232)

1928.3.3
研
SK0577　197
立姿裸女速寫-28.3.3（233）
Standing Female Nude Sketch-28.3.3 (233)

1928.3.3
研
SK0578　197
立姿裸女速寫-28.3.3（234）
Standing Female Nude Sketch-28.3.3 (234)

1928.3.3
研
SK0579　198
立姿裸女速寫-28.3.3（235）
Standing Female Nude Sketch-28.3.3 (235)

1928.3.3
研
SK0580　198
立姿裸女速寫-28.3.3（236）
Standing Female Nude Sketch-28.3.3 (236)

1928.3.3
研
SK0581　198
立姿裸女速寫-28.3.3（237）
Standing Female Nude Sketch-28.3.3 (237)

1928.3.3
研
SK0582　198
立姿裸女速寫-28.3.3（238）
Standing Female Nude Sketch-28.3.3 (238)

1928.3.3
研
SK0583　199
立姿裸女速寫-28.3.3（239）
Standing Female Nude Sketch-28.3.3 (239)

1928.3.3
研
SK0584　199
立姿裸女速寫-28.3.3（240）
Standing Female Nude Sketch-28.3.3 (240)

1928.3.3
研
SK0585　199
立姿裸女速寫-28.3.3（241）
Standing Female Nude Sketch-28.3.3 (241)

1928.3.3
研
SK0586　199
立姿裸女速寫-28.3.3（242）
Standing Female Nude Sketch-28.3.3 (242)

1928.3.3
研
SK0587　200
坐姿裸女速寫-28.3.3（224）
Seated Female Nude Sketch-28.3.3 (224)

1928.3.3
研
SK0588　200
坐姿裸女速寫-28.3.3（225）
Seated Female Nude Sketch-28.3.3 (225)

1928.3.3
研
SK0589　200
坐姿裸女速寫-28.3.3（226）
Seated Female Nude Sketch-28.3.3 (226)

SK0590　200
坐姿裸女速寫-28.3.3（227）
Seated Female Nude Sketch-28.3.3 (227)
1928.3.3
研

SK0591　201
坐姿裸女速寫-28.3.3（228）
Seated Female Nude Sketch-28.3.3 (228)
1928.3.3
研

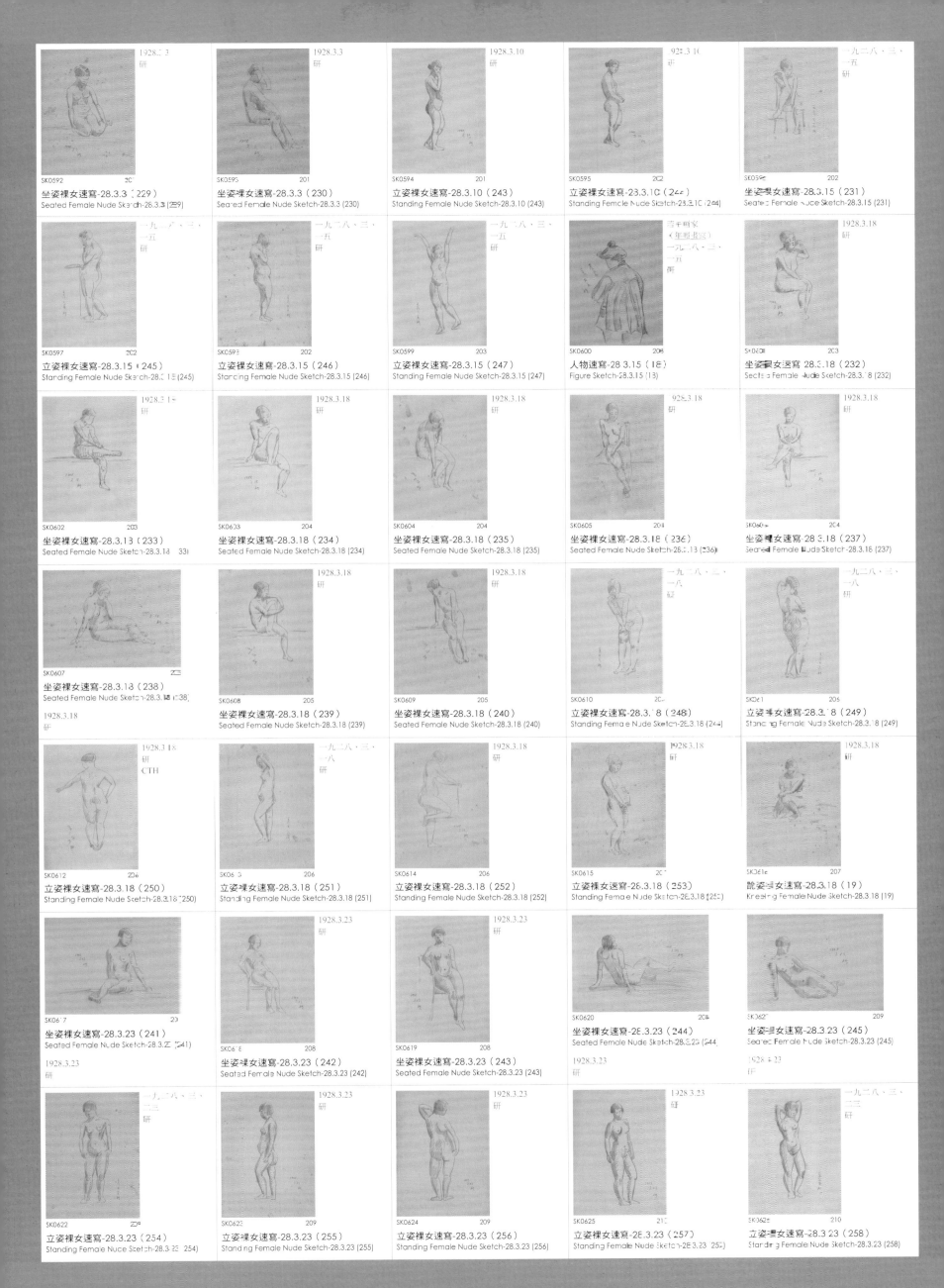

SK0592 　　　 20□
坐姿裸女速寫-28.3.3（229）
Seated Female Nude Sketch-28.3.3 (229)

SK0593 　　　 201
坐姿裸女速寫-28.3.3（230）
Seated Female Nude Sketch-28.3.3 (230)

SK0594 　　　 201
立姿裸女速寫-28.3.10（243）
Standing Female Nude Sketch-28.3.10 (243)

SK0595 　　　 2□2
立姿裸女速寫-23.3.10（244）
Standing Female Nude Sketch-23.3.10 (244)

SK059□ 　　　 202
坐姿裸女速寫-28.3.15（231）
Seated Female Nude Sketch-28.3.15 (231)

SK0597 　　　 2□2
立姿裸女速寫-28.3.15（245）
Standing Female Nude Sketch-28.3.15 (245)

SK059□ 　　　 202
立姿裸女速寫-28.3.15（246）
Standing Female Nude Sketch-28.3.15 (246)

SK0599 　　　 203
立姿裸女速寫-28.3.15（247）
Standing Female Nude Sketch-28.3.15 (247)

SK0600 　　　 208
人物速寫-28.3.15（13）
Figure Sketch-28.3.15 (13)

SK0□01 　　　 203
坐姿裸女速寫-28.3.18（232）
Seated Female Nude Sketch-28.3.18 (232)

SK0602 　　　 203
坐姿裸女速寫-28.3.13（233）
Seated Female Nude Sketch-28.3.18 33l

SK0603 　　　 204
坐姿裸女速寫-28.3.18（234）
Seated Female Nude Sketch-28.3.18 (234)

SK0604 　　　 204
坐姿裸女速寫-28.3.18（235）
Seated Female Nude Sketch-28.3.18 (235)

SK0605 　　　 204
坐姿裸女速寫-28.3.18（236）
Seated Female Nude Sketch-28.3.13 (236)

SK0□0□ 　　　 2C4
坐姿裸女速寫-28.3.18（237）
Seated Female Nude Sketch-28.3.18 (237)

SK0607 　　　 2C3
坐姿裸女速寫-28.3.18（238）
Seated Female Nude Sketch-28.3.18 (38)

SK0608 　　　 205
坐姿裸女速寫-28.3.18（239）
Seated Female Nude Sketch-28.3.18 (239)

SK0609 　　　 205
坐姿裸女速寫-28.3.18（240）
Seated Female Nude Sketch-28.3.18 (240)

SK0610 　　　 2C□
立姿裸女速寫-28.3.18（248）
Standing Female Nude Sketch-28.3.18 (248)

SK0□11 　　　 205
立姿裸女速寫-28.3.18（249）
Standing Female Nude Sketch-28.3.18 (249)

SK0612 　　　 2□6
立姿裸女速寫-28.3.18（250）
Standing Female Nude Sketch-28.3.18 (250)

SK06□3 　　　 206
立姿裸女速寫-28.3.18（251）
Standing Female Nude Sketch-28.3.18 (251)

SK0614 　　　 206
立姿裸女速寫-28.3.18（252）
Standing Female Nude Sketch-28.3.18 (252)

SK0615 　　　 2C□
立姿裸女速寫-28.3.18（253）
Standing Female Nude Sketch-28.3.18 (253)

SK0□1□ 　　　 207
跪姿裸女速寫-28.3.18（19）
Kneeling Female Nude Sketch-28.3.18 (19)

SK06□7 　　　 23
坐姿裸女速寫-28.3.23（241）
Seated Female Nude Sketch-28.3.23 (241)

SK06□8 　　　 208
坐姿裸女速寫-28.3.23（242）
Seated Female Nude Sketch-28.3.23 (242)

SK0619 　　　 208
坐姿裸女速寫-28.3.23（243）
Seated Female Nude Sketch-28.3.23 (243)

SK0620 　　　 20□
坐姿裸女速寫-28.3.23（244）
Seated Female Nude Sketch-28.3.23 (244)

SK062□ 　　　 209
坐姿裸女速寫-28.3.23（245）
Seated Female Nude Sketch-28.3.23 (245)

SK0622 　　　 2□□
立姿裸女速寫-28.3.23（254）
Standing Female Nude Sketch-28.3.23 (254)

SK0623 　　　 209
立姿裸女速寫-28.3.23（255）
Standing Female Nude Sketch-28.3.23 (255)

SK0624 　　　 209
立姿裸女速寫-28.3.23（256）
Standing Female Nude Sketch-28.3.23 (256)

SK0625 　　　 210
立姿裸女速寫-28.3.23（257）
Standing Female Nude Sketch-28.3.23 (257)

SK062□ 　　　 210
立姿裸女速寫-28.3.23（258）
Standing Female Nude Sketch-28.3.23 (258)

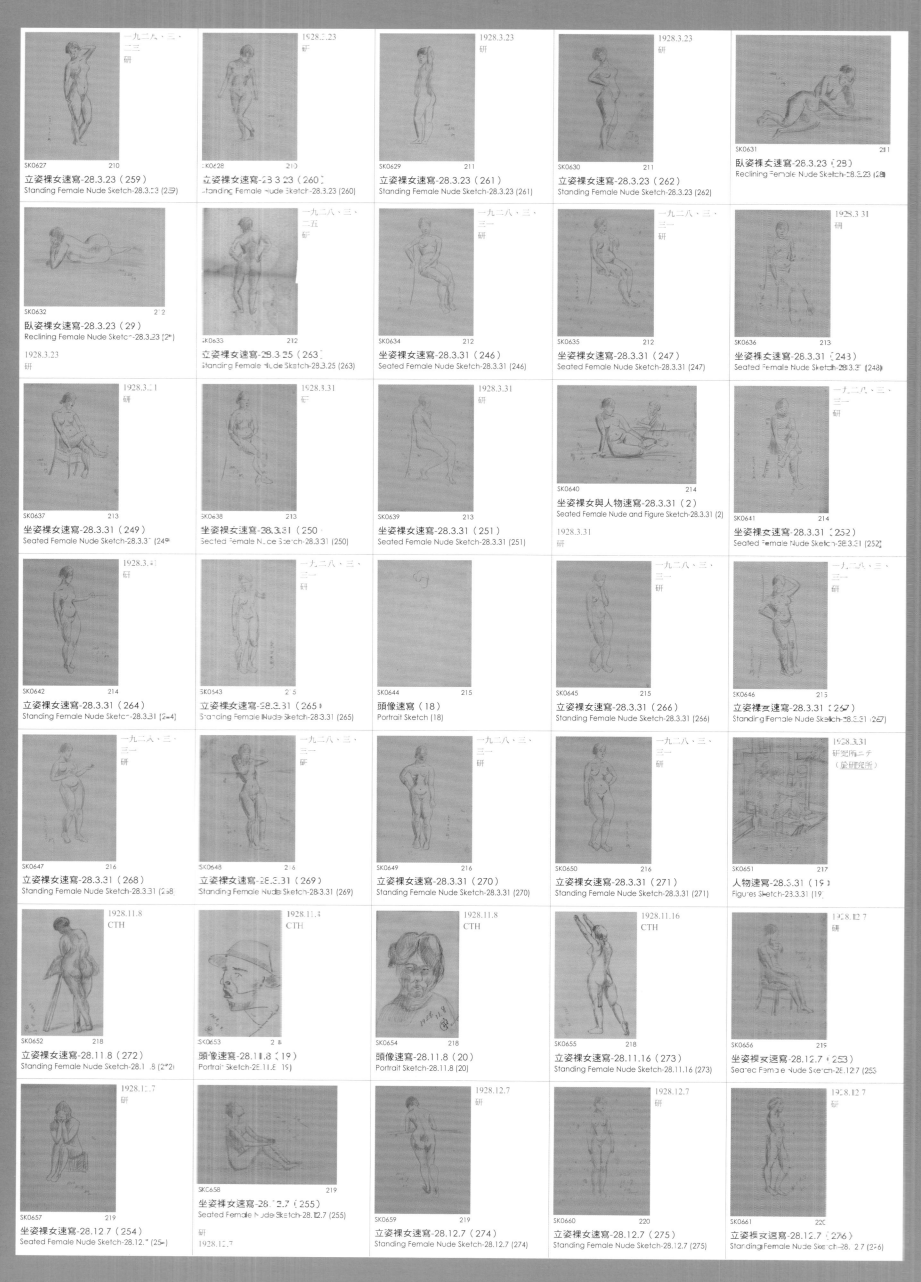

SK0627　210
立姿裸女速寫-28.3.23（259）
Standing Female Nude Sketch-28.3.23 (259)

SK0628　210
立姿裸女速寫-28.3.23（260）
Standing Female Nude Sketch-28.3.23 (260)

SK0629　211
立姿裸女速寫-28.3.23（261）
Standing Female Nude Sketch-28.3.23 (261)

SK0630　211
立姿裸女速寫-28.3.23（262）
Standing Female Nude Sketch-28.3.23 (262)

SK0631　211
臥姿裸女速寫-28.3.23（28）
Reclining Female Nude Sketch-28.3.23 (28)

SK0632　212
臥姿裸女速寫-28.3.23（29）
Reclining Female Nude Sketch-28.3.23 (29)

SK0633　212
立姿裸女速寫-28.3.25（263）
Standing Female Nude Sketch-28.3.25 (263)

SK0634　212
坐姿裸女速寫-28.3.31（246）
Seated Female Nude Sketch-28.3.31 (246)

SK0635　212
坐姿裸女速寫-28.3.31（247）
Seated Female Nude Sketch-28.3.31 (247)

SK0636　213
坐姿裸女速寫-28.3.31（248）
Seated Female Nude Sketch-28.3.31 (248)

SK0637　213
坐姿裸女速寫-28.3.31（249）
Seated Female Nude Sketch-28.3.31 (249)

SK0638　213
坐姿裸女速寫-28.3.31（250）
Seated Female Nude Sketch-28.3.31 (250)

SK0639　213
坐姿裸女速寫-28.3.31（251）
Seated Female Nude Sketch-28.3.31 (251)

SK0640　214
坐姿裸女與人物速寫-28.3.31（2）
Seated Female Nude and Figure Sketch-28.3.31 (2)

SK0641　214
坐姿裸女速寫-28.3.31（252）
Seated Female Nude Sketch-28.3.31 (252)

SK0642　214
立姿裸女速寫-28.3.31（264）
Standing Female Nude Sketch-28.3.31 (264)

SK0643　215
立姿裸女速寫-28.3.31（265）
Standing Female Nude Sketch-28.3.31 (265)

SK0644　215
頭像速寫（18）
Portrait Sketch (18)

SK0645　215
立姿裸女速寫-28.3.31（266）
Standing Female Nude Sketch-28.3.31 (266)

SK0646　215
立姿裸女速寫-28.3.31（267）
Standing Female Nude Sketch-28.3.31 (267)

SK0647　216
立姿裸女速寫-28.3.31（268）
Standing Female Nude Sketch-28.3.31 (268)

SK0648　216
立姿裸女速寫-28.3.31（269）
Standing Female Nude Sketch-28.3.31 (269)

SK0649　216
立姿裸女速寫-28.3.31（270）
Standing Female Nude Sketch-28.3.31 (270)

SK0650　216
立姿裸女速寫-28.3.31（271）
Standing Female Nude Sketch-28.3.31 (271)

SK0651　217
人物速寫-28.3.31（19）
Figures Sketch-28.3.31 (19)

SK0652　218
立姿裸女速寫-28.11.8（272）
Standing Female Nude Sketch-28.11.8 (272)

SK0653　218
頭像速寫-28.11.8（19）
Portrait Sketch-28.11.8 (19)

SK0654　218
頭像速寫-28.11.8（20）
Portrait Sketch-28.11.8 (20)

SK0655　218
立姿裸女速寫-28.11.16（273）
Standing Female Nude Sketch-28.11.16 (273)

SK0656　219
坐姿裸女速寫-28.12.7（253）
Seated Female Nude Sketch-28.12.7 (253)

SK0657　219
坐姿裸女速寫-28.12.7（254）
Seated Female Nude Sketch-28.12.7 (254)

SK0658　219
坐姿裸女速寫-28.12.7（255）
Seated Female Nude Sketch-28.12.7 (255)

SK0659　219
立姿裸女速寫-28.12.7（274）
Standing Female Nude Sketch-28.12.7 (274)

SK0660　220
立姿裸女速寫-28.12.7（275）
Standing Female Nude Sketch-28.12.7 (275)

SK0661　220
立姿裸女速寫-28.12.7（276）
Standing Female Nude Sketch-28.12.7 (276)

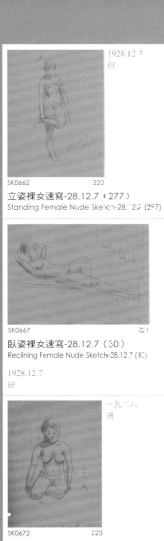
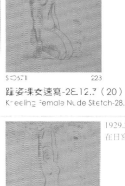
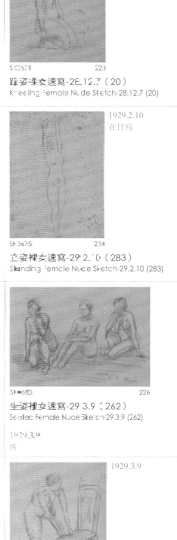

1928.12.7 研
SK0662　220
立姿裸女速寫-28.12.7（277）
Standing Female Nude Sketch-28.12.7 (277)

1928.12.7 研
SK0663　220
立姿裸女速寫-28.12.7（278）
Standing Female Nude Sketch-28.12.7 (278)

1928.12.7 研
SK0664　221
立姿裸女速寫-28.12.7（279）
Standing Female Nude Sketch-28.12.7 (279)

1928.12.7 研
SK0665　22
立姿裸女速寫-28.12.7（280）
Standing Female Nude Sketch-28.12.7 (280)

1928.12.7 研
SK0666　221
立姿裸女速寫-28.12.7（281）
Standing Female Nude Sketch-28.12.7 (281)

SK0667　221
臥姿裸女速寫-28.12.7（30）
Reclining Female Nude Sketch-28.12.7 (30)

SK0668　222
臥姿裸女速寫-28.12.7（31）
Reclining Female Nude Sketch-28.12.7 (31)

1928.12.7 研
SK0669　222
蹲姿裸女速寫-28.12.7（15）
Squatting Female Nude Sketch-28.12.7 (15)

1928.12.7
SK0670　223
蹲姿裸女速寫-28.12.7（16）
Squatting Female Nude Sketch-28.12.7 (16)

1928.12.7 研
SK0671　223
跪姿裸女速寫-28.12.7（20）
Kneeling Female Nude Sketch-28.12.7 (20)

1928.12.7 研
SK0672　223
坐姿裸女速寫-28（256）
Seated Female Nude Sketch (256)

1928.12.7 研
SK0673　223
坐姿裸女速寫（257）
Seated Female Nude Sketch (257)

1929

1929.2.10 在日寫
SK0674　224
立姿裸女速寫-29.2.10（282）
Standing Female Nude Sketch-29.2.10 (282)

1929.2.10 在日寫
SK0675　234
立姿裸女速寫-29.2.10（283）
Standing Female Nude Sketch-29.2.10 (283)

1929.3.9
SK0676　224
坐姿裸女速寫-29.3.9（258）
Seated Female Nude Sketch-29.3.9 (258)

1929.3.9 在日
SK0677　225
坐姿裸女速寫-29.3.9（259）
Seated Female Nude Sketch-29.3.9 (259)

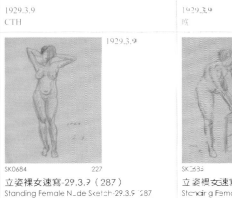
SK0678　225
坐姿裸女速寫-29.3.9（260）
Seated Female Nude Sketch-29.3.9 (260)
1929.3.9

SK0679　225
坐姿裸女速寫-29.3.9（261）
Seated Female Nude Sketch-29.3.9 (261)
1929.3.9 CTH

SK0680　226
坐姿裸女速寫-29.3.9（262）
Seated Female Nude Sketch-29.3.9 (262)
1929.3.9 研

1927.3.9 CTH
SK0681　226
立姿裸女速寫-29.3.9（284）
Standing Female Nude Sketch-29.3.9 (284)

1929.3.9
SK0682　226
立姿裸女速寫-29.3.9（285）
Standing Female Nude Sketch-29.3.9 (285)

1929.3.9
SK0683　227
立姿裸女速寫-29.3.9（286）
Standing Female Nude Sketch-29.3.9 (286)

1929.3.9
SK0684　227
立姿裸女速寫-29.3.9（287）
Standing Female Nude Sketch-29.3.9 (287)

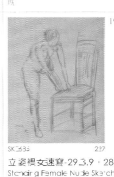
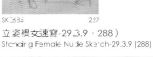
1929.3.9
SK0685　237
立姿裸女速寫-29.3.9（288）
Standing Female Nude Sketch-29.3.9 (288)

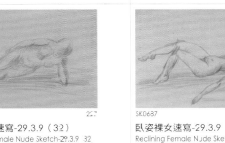
SK0686　227
臥姿裸女速寫-29.3.9（32）
Reclining Female Nude Sketch-29.3.9 32
1929.3.9

SK0687　228
臥姿裸女速寫-29.3.9（33）
Reclining Female Nude Sketch-29.3.9 (33)
1929.3.9 研

SK0688　228
臥姿裸女速寫-29.3.9（34）
Reclining Female Nude Sketch-29.3.9 (34)
1929.3.9 CTH

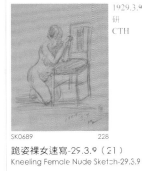
1929.3.9 研 CTH
SK0689　228
跪姿裸女速寫-29.3.9（21）
Kneeling Female Nude Sketch-29.3.9 (21)

SK0690　229
跪姿裸女速寫-29.3.9（22）
Kneeling Female Nude Sketch-29.3.9 (22)
1929.3.9

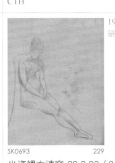
1929.3.9 CTH
SK0691　229
跪姿裸女速寫-29.3.9（23）
Kneeling Female Nude Sketch-29.3.9 (23)

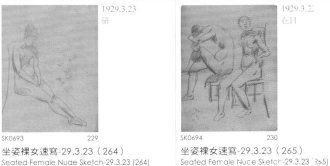

1929.3.23 研
SK0692　229
坐姿裸女速寫-29.3.23（263）
Seated Female Nude Sketch-29.3.23 (263)

1929.3.23 研
SK0693　229
坐姿裸女速寫-29.3.23（264）
Seated Female Nude Sketch-29.3.23 (264)

1929.3.23 在日
SK0694　230
坐姿裸女速寫-29.3.23（265）
Seated Female Nude Sketch-29.3.23 (265)

1929.3.23 研
※年代疑為筆誤，應為1929.3.23所畫。
SK0695　231
坐姿裸女速寫-29.3.23（266）
Seated Female Nude Sketch-29.3.23 (266)

1929.3.23 研	在日 1929.3.23 研	在日 1929.3.23 研 CTH	1929.3.23 研	1929 3.23 研
SK0696　231 立姿裸女速寫-29.3.23（289） Standing Female Nude Sketch-29.3.23 (289)	SK0697　231 立姿裸女速寫-29.3.23（290） Standing Female Nude Sketch-29.3.23 (290)	SK0698　231 立姿裸女速寫-29.3.23（291） Standing Female Nude Sketch-29.3.23 (291)	SK0699　232 立姿裸女速寫-29.3.23（292） Standing Female Nude Sketch-29.3.23 (292)	SK0700　232 立姿裸女速寫-29.3.23（293） Standing Female Nude Sketch-29.3.23 (293)
1929.3.23 研			1929.4.17 午后畫	
SK0701　232 立姿裸女速寫-29.3.23（294） Standing Female Nude Sketch-29.3.23 (294)	SK0702　232 人物速寫-29.3.23（20） Figure Sketch-29.3.23 (20)	SK0703　233 臥姿裸女速寫-29.3.29（35） Reclining Female Nude Sketch-29.3.29 (35)	SK0704　233 頭像速寫-29.4.17（21） Portrait Sketch-29.4.17 (21)	SK0705　234 坐姿裸女速寫-29.5.13（267） Seated Female Nude Sketch-29.5.13 (267)
1929.3.23 研	1929.3.23 研	1929.3.29 研	1929.5.13 在藝苑	
1929.5.13 在藝苑		1929.6.12		
SK0706　234 坐姿裸女速寫-29.5.13（268） Seated Female Nude Sketch-29.5.13 (268)	SK0707　234 臥姿裸女速寫-29.6.12（36） Reclining Female Nude Sketch-29.6.12 (36)	SK0708　234 臥姿裸女速寫-29.6.12（37） Reclining Female Nude Sketch-29.6.12 (37)	SK0709　235 臥姿裸女速寫-29.6.22（38） Reclining Female Nude Sketch-29.6.22 (38)	SK0710　235 人物速寫-29.6.23（21） Figure Sketch-29.6.23 (21)
	1929.6.12 病殘館（上海）	1929.6.12	1929.6.22 上海藝苑	1929.6.23 在藝苑
		1929.7.13 藝苑2	1929.7.13 3	
SK0711　233 坐姿裸女速寫-29.6.27（269） Seated Female Nude Sketch-29.6.27 (269)	SK0712　236 頭像速寫（22） Portrait Sketch (22)	SK0713　236 立姿裸女速寫-29.7.13（295） Standing Female Nude Sketch-29.7.13 (295)	SK0714　236 立姿裸女速寫-29.7.13（296） Standing Female Nude Sketch-29.7.13 (296)	SK0715　237 坐姿裸女速寫-29.7.13（270） Seated Female Nude Sketch-29.7.13 (270)
一九二九・六・廿七 在藝苑				1929.7.13 4
	1929.7.13 6	1929.7.13 7		1929.7.13 9
SK0716　237 坐姿裸女速寫-29.7.13（271） Seated Female Nude Sketch-29.7.13 (271)	SK0717　238 坐姿裸女速寫-29.7.13（272） Seated Female Nude Sketch-29.7.13 (272)	SK0718　238 立姿裸女速寫-29.7.13（297） Standing Female Nude Sketch-29.7.13 (297)	SK0719　238 臥姿裸女速寫-29.7.13（39） Reclining Female Nude Sketch-29.7.13 (39)	SK0720　239 坐姿裸女速寫-29.7.13（273） Seated Female Nude Sketch-29.7.13 (273)
1929.7.13 5			1929.7.13 7	
1929.7.13 10	1929.7.13 11	1929.7.13 12		1929.7.13 9
SK0721　239 坐姿裸女速寫-29.7.13（274） Seated Female Nude Sketch-29.7.13 (274)	SK0722　239 坐姿裸女速寫-29.7.13（275） Seated Female Nude Sketch-29.7.13 (275)	SK0723　239 坐姿裸女速寫-29.7.13（276） Seated Female Nude Sketch-29.7.13 (276)	SK0724　240 臥姿裸女速寫-29.7.13（40） Reclining Female Nude Sketch-29.7.13 (40)	SK0725　240 睡於墙下-29.7.13 Sleeping Against a Wall-29.7.13
			1929.7.13. （1）	1929.7.13 睡於墙下
1929.12.17 在新華藝大	1929.12.27 在 蜜司邱	1929.12.27		
SK0726　241 立姿裸女速寫-29.12.17（298） Standing Female Nude Sketch-29.12.17 (298)	SK0727　241 人物速寫-29.12.27（22） Figure Sketch-29.12.27 (22)	SK0728　241 坐姿裸女速寫（277） Seated Female Nude Sketch (277)	SK0729　241 坐姿裸女速寫（278） Seated Female Nude Sketch (278)	SK0730　242 畫室速寫（1） Studio Sketch (1)

SK0731　242
坐姿裸女速寫（279）
Seated Female Nude Sketch (279)

SK0732　242
立姿裸女速寫（299）
Standing Female Nude Sketch (299)

SK0733　243
立姿裸女速寫（300）
Standing Female Nude Sketch (300)

SK0734　2-3
立姿裸女速寫（301）
Standing Female Nude Sketch (301)

SK0735　243
人物速寫-6.27（23）
Figure Sketch-6.27 (23)
6.27

1930

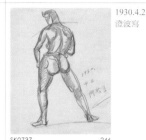

1930.1.15
SK0736　246
人物速寫-30.1.15（24）
Figure Sketch-30.1.15 (24)

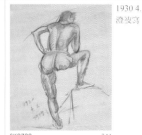

1930.4.2
澄波寫
SK0737　246
立姿裸男速寫-30.4.2（1）
Standing Male Nude Sketch-30.4.2 (1)

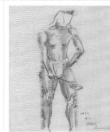

1930.4.2
澄波寫
SK0738　246
立姿裸男速寫-30.4.2（2）
Standing Male Nude Sketch-30.4.2 (2)

1930.4.2
澄波寫
SK0739　247
立姿裸男速寫-30.4.2（3）
Standing Male Nude Sketch-30.4.2 (3)

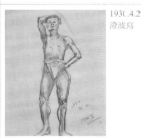

1930.4.2
澄波寫
SK0740　247
立姿裸男速寫-30.4.2（4）
Standing Male Nude Sketch-30.4.2 (4)

九段のダンスホールニテ（在九段的舞廳）
1930.7
CTH
SK0741　247
在九段的舞廳-30.7
A Dance Hall in Kudan-30.7

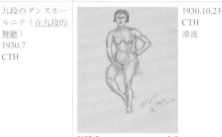

1930.10.23
CTH
澄波
SK0742　247
坐姿裸女速寫-30.10.23（280）
Seated Female Nude Sketch-30.10.23 (280)

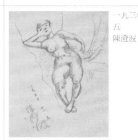

一九三〇・一一・五　陳澄波
SK0743　248
臥姿裸女速寫-30.11.5（41）
Reclining Female Nude Sketch-30.11.5 (41)

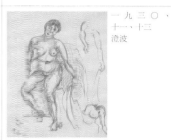

一九三〇・十一・十三　澄波
SK0744　248
坐姿裸女速寫-30.11.13（281）
Seated Female Nude Sketch-30.11.13 (281)

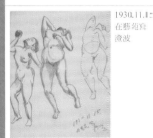

1930.11.15
在藝苑寫
澄波
SK0745　248
立姿裸女速寫-30.11.15（302）
Standing Female Nude Sketch-30.11.15 (302)

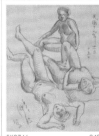

民國十九年十一月十五日
1930.
澄波寫
SK0746　249
坐姿與臥姿裸女速寫-30.11.15（2）
Seated and Reclining Female Nude Sketch-30.11.15 (2)

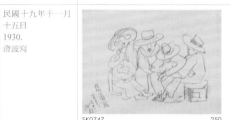

SK0747　250
法國公園一隅-30.11.21
A Corner in French Park-30.11.21
法國公園一隅
一九三〇・十一・廿一　澄波

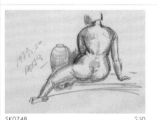

SK0748　250
坐姿裸女速寫-30.11.24（282）
Seated Female Nude Sketch-30.11.24 (282)
1930.11.24
澄波寫

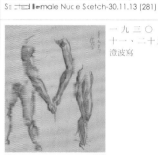

一九三〇・十一・二十九　澄波寫
SK0749　252
手部速寫-30.11.29（1）
Hand and Feet Sketch-30.11.29 (1)

一九三〇・十二・八晨　在廳　寫于重光　澄波
SK0750　251
重光-30.12.8
Tsung-kuang-30.12.8

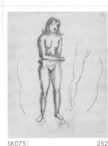

1930
SK0751　252
立姿裸女速寫-30（303）
Standing Female Nude Sketch-30 (303)

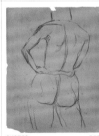

SK0752　252
立姿裸男速寫（5）
Standing Male Nude Sketch (5)

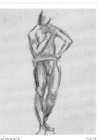

SK0753　252
立姿裸男速寫（6）
Standing Male Nude Sketch (6)

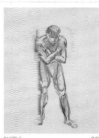

SK0754　253
立姿裸男速寫（7）
Standing Male Nude Sketch (7)

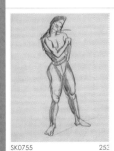

SK0755　253
立姿裸男速寫（8）
Standing Male Nude Sketch (8)

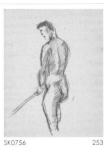

SK0756　253
立姿裸男速寫（9）
Standing Male Nude Sketch (9)

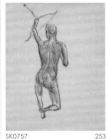

SK0757　253
跪姿裸男速寫（1）
Kneeling Male Nude Sketch (1)

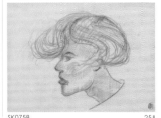

SK0758　254
頭像速寫（23）
Portrait Sketch (23)

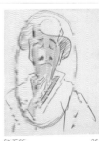

SK0759　254
人物速寫（25）
Figure Sketch (25)

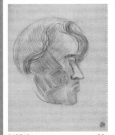

SK0760　254
頭像速寫（24）
Portrait Sketch (24)

SK0761　255
風景速寫（1）
Landscape Sketch (1)

1931

SK0762　255
教子-31.3.18
Tutoring the Son-31.3.18
一九三一・三・十八
教子
澄波

SK0763　255
人物速寫（26）
Figure Sketch (26)

397

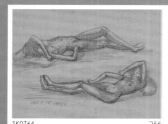

SK0764　256
臥姿裸女速寫-31.5.16（42）
Reclining Female Nude Sketch-31.5.16（42）

1931.5.16 澄波寫

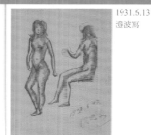

1931.6.13
澄波寫

SK0765　256
立姿與坐姿裸女速寫-31.6.13（1）
Standing and Seated Female Nude Sketch-31.6.13 (1)

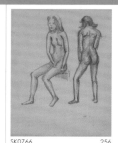

SK0766　256
立姿與坐姿裸女速寫（2）
Standing and Seated Female Nude Sketch (2)

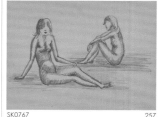

SK0767　257
坐姿裸女速寫（283）
Seated Female Nude Sketch (283)

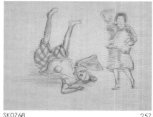

SK0768　257
人物速寫（27）
Figure Sketch (27)

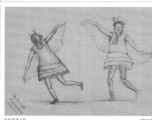

春風之舞
林隆季學頃劇
一九三一、六、一四

SK0769　257
林蔭小學演劇-31.6.14
Drama Performance of Linyin Elementary School-31.6.14

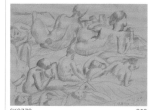

SK0770　258
洗身群女一見-31.7.2
Bathing Girls-31.7.2

1931.7.2
（洗身群女一見）

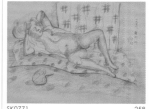

SK0771　258
臥姿裸女速寫-31.7.2（43）
Reclining Female Nude Sketch-31.7.2 (43)

一九三一、七、二
澄波

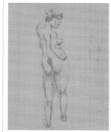

93.7.4
澄波寫

SK0772　259
立姿裸女速寫-31.7.4（304）
Standing Female Nude Sketch-31.7.4 (304)

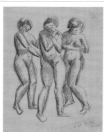

1931.8.1

SK0773　259
立姿裸女速寫-31.8.15（305）
Standing Female Nude Sketch-31.8.15（305）

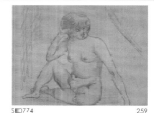

SK0774　259
坐姿裸女速寫-31.9.2（303）
Seated Female Nude Sketch-31.9.2 (303)

一九三一、九、二
澄波

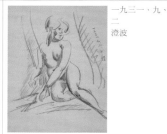

一九三一、九、
二
澄波

SK0775　259
坐姿裸女速寫-31.9.2（304）
Seated Female Nude Sketch-31.9.2 (304)

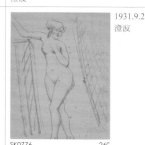

1931.9.2
澄波

SK0776　260
立姿裸女速寫-31.9.2（306）
Standing Female Nude Sketch-31.9.2 (306)

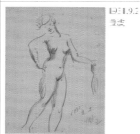

1931.9.2
澄波

SK0777　260
立姿裸女速寫-31.9.2（307）
Standing Female Nude Sketch-31.9.2 (307)

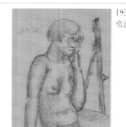

1931.9.2
澄波

SK0778　260
立姿裸女速寫-31.9.2（308）
Standing Female Nude Sketch-31.9.2 308）

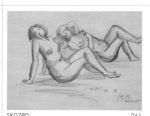

1931.9.3
澄波

SK0779　260
坐姿裸女速寫-31.9.3（286）
Seated Female Nude Sketch-31.9.3 (286)

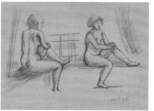

SK0780　261
坐姿與臥姿裸女速寫-31.9.3（3）
Seated and Reclining Female Nude Sketch-31.9.3 (3)

1931.9.3
澄波

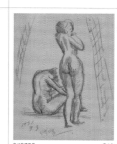

SK0781　261
坐姿裸女速寫-31.9.3（287）
Seated Female Nude Sketch-31.9.3 (287)

1931.9.3

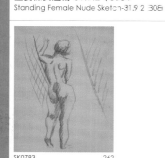

1931.9.3
澄波

SK0782　261
立姿與坐姿裸女速寫-31.9.3（3）
Standing and Seated Female Nude Sketch-31.9.3 (3

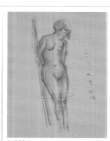

SK0783　262
立姿裸女速寫（309）
Standing Female Nude Sketch（309）

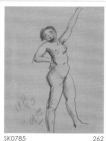

一九三一、九、
三
澄波

SK0784　262
立姿裸女速寫-31.9.3（310）
Standing Female Nude Sketch-31.9.3 (310)

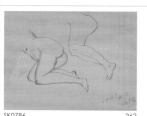

1931.9.3
澄波

SK0785　262
立姿裸女速寫-31.9.3（311）
Standing Female Nude Sketch-31.9.3 (311)

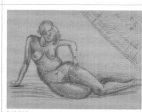

SK0786　262
女體速寫-31.9.3（25）
Female Body Sketch-31.9.3 (25)

1931.9.3
澄波

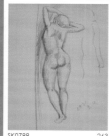

1931.9.4

SK0788　263
立姿裸女速寫-31.9.4（312）
Standing Female Nude Sketch-31.9.4 312）

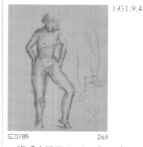

1931.9.4

SK0789　263
立姿裸女速寫-31.9.4（313）
Standing Female Nude Sketch-31.9.4 (313)

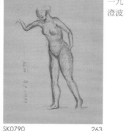

一九三一、九、四
澄波

SK0790　263
立姿裸女速寫-31.9.4（314）
Standing Female Nude Sketch-31.9.4 (314)

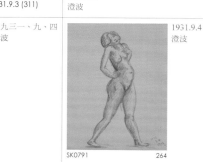

SK0787　263
坐姿裸女速寫-31.9.4（288）
Seated Female Nude Sketch-31.9.4 (288)

一九三一、九、四
澄波

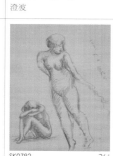

1931.9.4
澄波

SK0791　264
立姿裸女速寫-31.9.4（315）
Standing Female Nude Sketch-31.9.4 (315)

一九三一、九、七
澄波寫

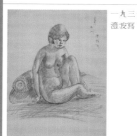

一九三一、九、八
澄波寫

SK0793　264
坐姿裸女速寫-31.9.8（289）
Seated Female Nude Sketch-31.9.8（289）

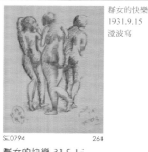

群女的快樂
1931.9.15
澄波寫

SK0794　264
春女的快樂-31.9.15
The Joys of Girls-31.9.15

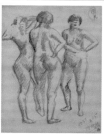

休息
1931.9.15
陳澄波

SK0795　265
休息-31.9.15
Taking a Rest-31.9.15

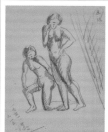

追隨
一九三一、九、
一五
澄波

SK0796　266
追隨-31.9.15
Trailing-31.9.15

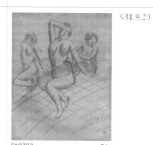

931.9.20

SK0797　266
坐姿裸女速寫-31.9.20（290）
Seated Female Nude Sketch-31.9.20 (290)

SK0792　264
立姿與坐姿裸女速寫-31.9.7（4）
Standing and Seated Female Nude Sketch-31.9.7 (4

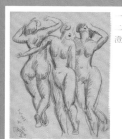

立姿裸女速寫-31.9.20（316）
Standing Female Nude Sketch-31.9.20（316）
SK0798　　26o
一九三一・九・二十　澄波

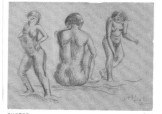

SK0799　　266
立姿裸女與坐姿裸女速寫-31.9.23（5）
Standing and Seated Female Nude Sketch-31.9.23 (5)
193 .9.23

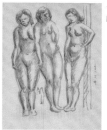

SK0800　　267
立姿裸女速寫-31.10.4（317）
Standing Female Nude Sketch-31.10.4（317）
一九三一・一〇・四

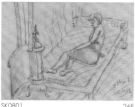

SK0801　　268
臥姿裸女速寫-31.10.7（44）
Reclining Female Nude Sketch-31.10.7 (44)
1931.10.7
澄波

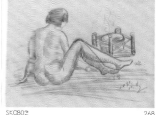

SK0802　　268
坐姿裸女速寫-31.10.8（291）
Seated Female Nude Sketch-31.10.8 (291)
1931.10.8

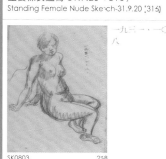

SK0803　　258
坐姿裸女速寫-31.10.8（292）
Seated Female Nude Sketch-31.10.8 (292)
一九三一・一〇・八

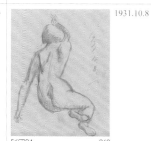

SK0804　　269
坐姿裸女速寫-31.10.8（293）
Seated Female Nude Sketch-31.10.8 (293)
1931.10.8

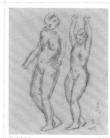

SK0805　　269
立姿裸女速寫-31.10.8（318）
Standing Female Nude Sketch-31.10.8（318）
一九三一・一〇・八　澄波

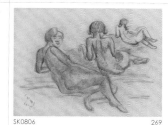

SK0806　　269
臥姿裸女速寫-31.10.8（45）
Reclining Female Nude Sketch-31.10.8 (45)
一九三一・一〇・八

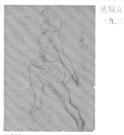

SK0807　　270
跳舞女-31.10.8（1）
A Dancer Girl-31.10.8 (1)
一九三一・一〇・八

SK0808　　270
跳舞女（2）
A Dancer Girl (2)

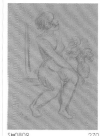

SK0809　　270
坐姿裸女速寫-31.10.22（294）
Seated Female Nude Sketch-31.10.22 (294)
一九三一・一〇・二二

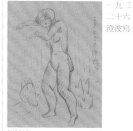

SK0810　　270
立姿裸女速寫-31.10.26（319）
Standing Female Nude Sketch-31.10.26（319）
一九三一・一〇・二十六　澄波寫

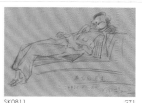

SK0811　　271
畫家的逍遙-31.10.26
A Carefree Artist-31.10.26
画家的逍遥
1931.10.26
澄波寫

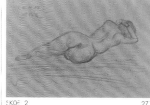

SK0812　　271
臥姿裸女速寫-31.10.27（46）
Reclining Female Nude Sketch-31.10.27 (46)
193 .10.27
澄波寫

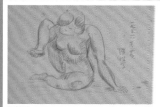

SK0813　　27
坐姿裸女速寫-31.10 29（295）
Seated Female Nude Sketch-31.10.29 (295)
一九三一・一〇・二九
澄波寫

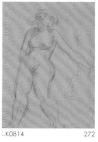

SK0814　　272
立姿裸女速寫-31.10.29（320）
Standing Female Nude Sketch-31.10.29 (320)
一九三一・一〇・二九　澄波寫

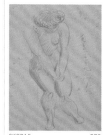

SK0815　　272
立姿裸女速寫-31.10.29（321）
Standing Female Nude Sketch-31.10.29 (321)
一九三一・一〇・二九　澄波寫

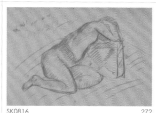

SK0816　　272
臥姿裸女速寫-31.10.29（47）
Reclining Female Nude Sketch-31.10.29 (47)
一九三一・一〇・二九
澄波寫

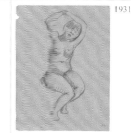

SK0817　　272
坐姿裸女速寫-31（296）
Seated Female Nude Sketch-31 (296)
1931

SK0818　　273
人物速寫-31（28）
Figure Sketch-31 (28)
1931

SK0819　　273
人物速寫（29）
Figure Sketch (29)

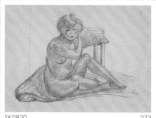

SK0820　　273
坐姿裸女速寫（297）
Seated Female Nude Sketch (297)

SK0821　　274
坐姿裸女速寫（298）
Seated Female Nude Sketch (298)

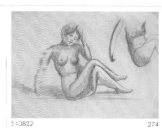

SK0822　　274
坐姿裸女速寫（299）
Seated Female Nude Sketch (299)

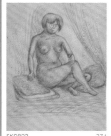

SK0823　　274
坐姿裸女速寫（300）
Seated Female Nude Sketch (300)

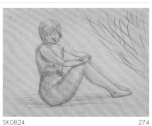

SK0824　　274
坐姿裸女速寫（301）
Seated Female Nude Sketch (301)

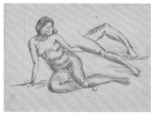

SK0825　　275
坐姿裸女速寫（302）
Seated Female Nude Sketch (302)

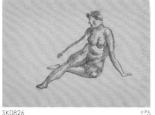

SK0826　　275
坐姿裸女速寫（303）
Seated Female Nude Sketch (303)

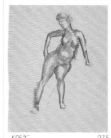

SK0827　　275
坐姿裸女速寫（304）
Seated Female Nude Sketch (304)

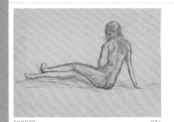

SK0828　　275
坐姿裸女速寫（305）
Seated Female Nude Sketch (305)

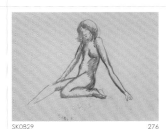

SK0829　　276
坐姿裸女速寫（306）
Seated Female Nude Sketch (306)

SK0830　　276
坐姿裸女速寫（307）
Seated Female Nude Sketch (307)

SK0831　　277
立姿裸女速寫（322）
Standing Female Nude Sketch (322)

SK0832　　277
立姿裸女速寫（323）
Standing Female Nude Sketch (323)

SK0833　277
立姿裸女速寫（324）
Standing Female Nude Sketch (324)

SK0834　277
立姿裸女速寫（325）
Standing Female Nude Sketch (325)

SK0835　278
立姿裸女速寫（326）
Standing Female Nude Sketch (326)

SK0836　278
立姿與坐姿裸女速寫（6）
Standing and Seated Female Nude Sketch (6)

SK0637　278
臥姿裸女速寫（48）
Reclining Female Nude Sketch (48)

SK0838　278
跪姿裸女速寫（24）
Kneeling Female Nude Sketch (24)

1932
一九三二・十一・廿六

SK0839　279
坐姿裸女速寫-32.11.26（308）
Seated Female Nude Sketch-32.11.26 (308)

SK0840　279
坐姿裸女速寫（309）
Seated Female Nude Sketch (309)

1932.11.26
日・本・研
SK0841　280
坐姿裸女速寫-32.11.26（310）
Seated Female Nude Sketch-32.11.26 (310)

1932.11.26
日本研
SK0842　280
坐姿裸女速寫-32.11.26（311）
Seated Female Nude Sketch-32.11.26 (311)

SK0843　280
坐姿裸女速寫（312）
Seated Female Nude Sketch (312)

1932.11.26
日本研
SK0844　280
坐姿裸女速寫-32.11.26（313）
Seated Female Nude Sketch-32.11.26 (313)

一九三二・一一・
廿六・
本鄉研
SK0845　281
坐姿裸女速寫-32.11.26（314）
Seated Female Nude Sketch-32.11.26 (314)

1932.11.26
日本研
SK0846　281
坐姿裸女速寫-32.11.26（315）
Seated Female Nude Sketch-32.11.26 (315)

1932.11.26
日本研
SK0847　281
坐姿裸女速寫-32.11.26（316）
Seated Female Nude Sketch-32.11.26 (316)

SK0848　281
頭像速寫（25）
Portrait Sketch (25)

1932.11.26
日本研
SK0849　282
坐姿裸女速寫-32.11.26（317）
Seated Female Nude Sketch-32.11.26 (317)

SK0850　282
坐姿裸女速寫（318）
Seated Female Nude Sketch (318)

SK0851　282
坐姿裸女速寫（319）
Seated Female Nude Sketch (319)

SK0852　282
頭像速寫（26）
Portrait Sketch (26)

1932.11.26
日本研
SK0853　283
立姿裸女速寫-32.11.26（327）
Standing Female Nude Sketch-32.11.26 (327)
1932

SK0854　283
坐姿裸女速寫-32（320）
Seated Female Nude Sketch-32 (320)

SK0855　283
坐姿裸女速寫（321）
Seated Female Nude Sketch (321)

SK0856　283
立姿裸女速寫（328）
Standing Female Nude Sketch (328)

SK0857　284
立姿裸女速寫（329）
Standing Female Nude Sketch (329)

SK0858　284
臥姿裸女速寫（49）
Reclining Female Nude Sketch (49)

SK0859　284
坐姿裸女速寫（322）
Seated Female Nude Sketch (322)

SK0860　284
坐姿裸女速寫（323）
Seated Female Nude Sketch (323)

SK0861　285
坐姿裸女速寫（324）
Seated Female Nude Sketch (324)

SK0862　285
坐姿裸女速寫（325）
Seated Female Nude Sketch (325)

SK0863　285
坐姿裸女速寫（326）
Seated Female Nude Sketch (326)

SK0864　285
坐姿裸女速寫（327）
Seated Female Nude Sketch (327)

SK0865　286
坐姿裸女速寫（328）
Seated Female Nude Sketch (328)

SK0866　286
坐姿裸女速寫（329）
Seated Female Nude Sketch (329)

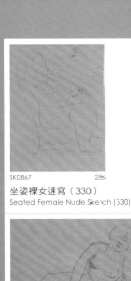

SK0867　285
坐姿裸女速寫（330）
Seated Female Nude Sketch (330)

SK0868　286
頭像速寫（27）
Portrait Sketch (27)

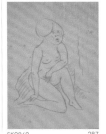

SK0869　287
坐姿裸女速寫（331）
Seated Female Nude Sketch (331)

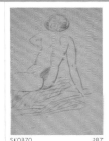

SK0870　287
坐姿裸女速寫（332）
Seated Female Nude Sketch (332)

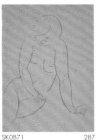

SK0871　287
坐姿裸女速寫（333）
Seated Female Nude Sketch (333)

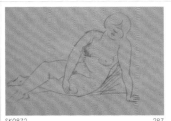

SK0872　287
坐姿裸女速寫（334）
Seated Female Nude Sketch (334)

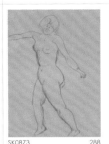

SK0873　288
立姿裸女速寫（330）
Standing Female Nude Sketch (330)

SK0874　288
立姿裸女速寫（331）
Standing Female Nude Sketch (331)

SK0875　288
立姿裸女速寫（332）
Standing Female Nude Sketch (332)

SK0876　288
立姿裸女速寫（333）
Standing Female Nude Sketch (333)

SK0877　289
立姿裸女速寫（334）
Standing Female Nude Sketch (334)

SK0878　289
立姿裸女速寫（335）
Standing Female Nude Sketch (335)

SK0879　289
立姿裸女速寫（336）
Standing Female Nude Sketch (336)

SK0880　289
頭像速寫（28）
Portrait Sketch (28)

SK0881　290
立姿裸女速寫（337）
Standing Female Nude Sketch (337)

SK0882　290
立姿裸女速寫（338）
Standing Female Nude Sketch (338)

SK0883　290
臥姿裸女速寫（50）
Reclining Female Nude Sketch (50)

SK0884　291
臥姿裸女速寫（51）
Reclining Female Nude Sketch (51)

SK0885　291
臥姿裸女速寫（52）
Reclining Female Nude Sketch (52)

SK0886　291
臥姿裸女速寫（53）
Reclining Female Nude Sketch (53)

SK0887　292
臥姿裸女速寫（54）
Reclining Female Nude Sketch (54)

SK0888　292
臥姿裸女速寫（55）
Reclining Female Nude Sketch (55)

SK0889　292
臥姿裸女速寫（56）
Reclining Female Nude Sketch (56)

SK0890　293
坐姿與臥姿裸女速寫（4）
Seated and Reclining Female Nude Sketch (4)

SK0891　293
人物速寫（30）
Figure Sketch (30)

1934-1945

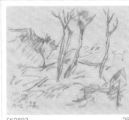

SK0892　294
風景速寫-34.8.3（2）
Landscape Sketch-34.8.3 (2)

1934.8.3
澄波寫

SK0893　294
二萬平-35.3.27
Erwanping-34.3.27

1935.3.27 二万平
澄波（阿里山）
岩

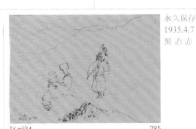

SK0894　295
人物速寫-35.4.7（31）
Figure Sketch-35.4.7 (31)

永久保存
1935.4.7
黑 赤 赤

SK0895　295
從對高岳展望開農台-35.4.7
Looking from Dueigaoyue to Kaiongtai-35.4.7

1935.4.7
対高岳ヨリ（笠）
開農台展望

SK0896　295
阿里山鐵軌-35.4.8
Alishan Railroad-35.4.8

阿里山
1935.4.8
レール（鐵軌）

SK0897　296
風景速寫-35.4（3）
Landscape Sketch-35.4 (3)

1935.4

阿里山ノ學校
1935.4
陳澄波

SK0898　296
阿里山小學校-35.4
Alishan Primary School-35.4

1935.4.9
2346海拔 シャクナゲ（石楠花）黃石石
獅子頭山黑綠 白黃 綠 黃土
塔山
祝山

SK0899　297
阿里山區風景速寫-35.4.9（1）
Alishan Landscape Sketch-35.4.9 (1)

一九号隧道 より（從）展望 新高主山
1935.4.9 獅子頭山 青樹 黃 黃原
1935.4.9 眠月より（從）達磨岩 赤 紅 灰 灰白

坐姿裸女速寫

SK0900　297
阿里山區風景速寫-35.4.9（2）
Alishan Landscape Sketch-35.4.9(2)

一三六〇米・石山 雪碧湖 青綠
海拔二〇〇〇米二二六米 青藍 青綠
棕胸寮留散（登）腳五三六夕
交力坪 より 云 生毛哥爭（於）烟
藍青赤

SK0901　298
阿里山區風景速寫（3）
Alishan Landscape Sketch (3)

青黑綠 黃 赤 白綠

SK0902　298
獅子頭山
Shizaitou Mountain

SK0903　299
塔山
Tashan

海拔二五〇四米 八二六二尺
一九三五・四・十三
祝山より松山を望む（從祝山眺望松山）
枯木 松 松柏 シャクナゲ（石楠花）

SK0904　299
從祝山眺望松山-35.4.13
Looking from Chushan to Songshan-35.4.13

SK0905　300
淡江夕暮-35.9
Sunset in Tamsui-35.9

淡江夕暮
1935.9 陳澄波

SK0906　300
在霧峯-36
Wufeng-36

1936
霧峯ニ於テ（在霧峯）

SK0907　301
旗山街-37.8.23
Cishan Street-37.8.23

1937.8.23
旗山街

一九三八・一・六
幼葉林ヨリ交力坪ヲ望ム（從幼葉林眺望交力坪）

SK0908　301
從幼葉林眺望交力坪-38.1.6
Looking from Youyelin to Jiaoliping-38.1.6

1938.1.6
太平山

SK0909　302
太平山-38.1.6
Taiping Mountain-38.1.6

SK0910　302
霧峯-38.2
Wufeng-38.2

一九三八・二 霧峯

SK0911　303
風景速寫-45.12.6（4）
Landscape Sketch-45.12.6 (4)

民國34・12・6

年代不詳

SK0912　306
坐姿裸女速寫（335）
Seated Female Nude Sketch (335)

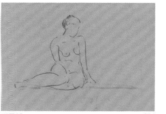

SK0913　306
坐姿裸女速寫（336）
Seated Female Nude Sketch (336)

SK0914　307
坐姿裸女速寫（337）
Seated Female Nude Sketch (337)

SK0915　307
坐姿裸女速寫（338）
Seated Female Nude Sketch (338)

SK0916　307
坐姿裸女速寫（339）
Seated Female Nude Sketch (339)

延窗突！

SK0917　308
坐姿裸女速寫（340）
Seated Female Nude Sketch (340)

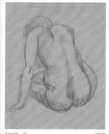

SK0918　308
坐姿裸女速寫（341）
Seated Female Nude Sketch (341)

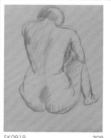

SK0919　308
坐姿裸女速寫（342）
Seated Female Nude Sketch (342)

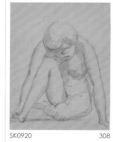

SK0920　308
坐姿裸女速寫（343）
Seated Female Nude Sketch (343)

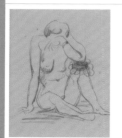

SK0921　309
坐姿裸女速寫（344）
Seated Female Nude Sketch (344)

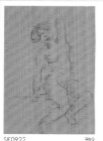

SK0922　309
坐姿裸女速寫（345）
Seated Female Nude Sketch (345)

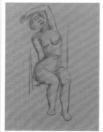

SK0923　309
坐姿裸女速寫（346）
Seated Female Nude Sketch (346)

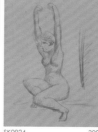

SK0924　309
坐姿裸女速寫（347）
Seated Female Nude Sketch (347)

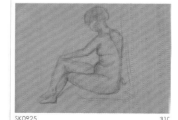

SK0925　310
坐姿裸女速寫（348）
Seated Female Nude Sketch (348)

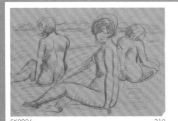

SK0926 310
坐姿裸女速寫（349）
Seated Female Nude Sketch (349)

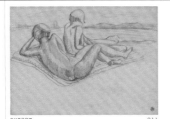

SK0927 311
坐姿與臥姿裸女速寫（5）
Seated and Reclining Female Nude Sketch (5)

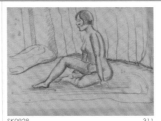

SK0928 311
坐姿裸女速寫（350）
Seated Female Nude Sketch (350)

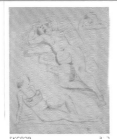

SK0929 312
坐姿與臥姿裸女速寫（6）
Seated and Reclining Female Nude Sketch (6)

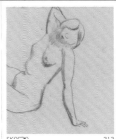

SK0930 313
坐姿裸女速寫（351）
Seated Female Nude Sketch (351)

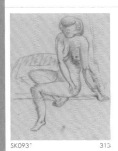

SK0931 313
坐姿裸女速寫（352）
Seated Female Nude Sketch (352)

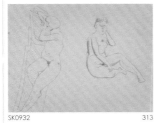

SK0932 313
坐姿與臥姿裸女速寫（7）
Seated and Reclining Female Nude Sketch (7)

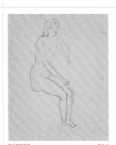

SK0933 314
坐姿裸女速寫（353）
Seated Female Nude Sketch (353)

SK0934 314
坐姿裸女速寫（354）
Seated Female Nude Sketch (354)

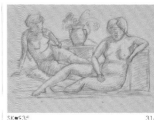

SK0935 314
坐姿裸女速寫（355）
Seated Female Nude Sketch (355)

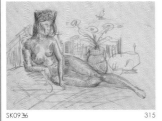

SK0936 315
坐姿裸女速寫（356）
Seated Female Nude Sketch (356)

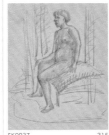

SK0937 315
坐姿裸女速寫（357）
Seated Female Nude Sketch (357)

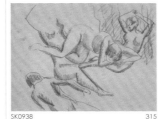

SK0938 315
坐姿與臥姿裸女速寫（8）
Seated and Reclining Female Nude Sketch (8)

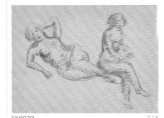

SK0939 316
坐姿與臥姿裸女速寫（9）
Seated and Reclining Female Nude Sketch (9)

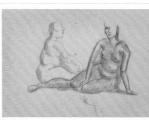

SK0940 316
坐姿裸女速寫（358）
Seated Female Nude Sketch (358)

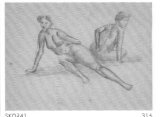

SK0941 316
坐姿裸女速寫（359）
Seated Female Nude Sketch (359)

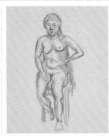

SK0942 317
坐姿裸女速寫（360）
Seated Female Nude Sketch (360)

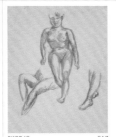

SK0943 317
坐姿裸女速寫（361）
Seated Female Nude Sketch (361)

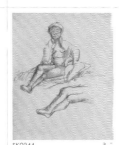

SK0944 317
坐姿裸女速寫（362）
Seated Female Nude Sketch (362)

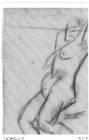

SK0945 317
坐姿裸女速寫（363）
Seated Female Nude Sketch (363)

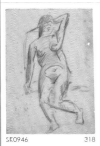

SK0946 318
坐姿裸女速寫（364）
Seated Female Nude Sketch (364)

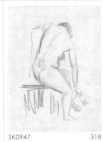

SK0947 318
坐姿裸女速寫（365）
Seated Female Nude Sketch (365)

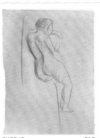

SK0948 318
坐姿裸女速寫（366）
Seated Female Nude Sketch (366)

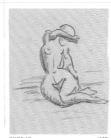

SK0949 318
坐姿裸女速寫（367）
Seated Female Nude Sketch (367)

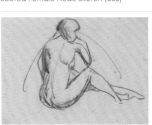

SK0950 319
坐姿裸女速寫（368）
Seated Female Nude Sketch (368)

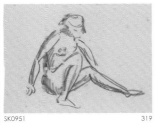

SK0951 319
坐姿裸女速寫（369）
Seated Female Nude Sketch (369)

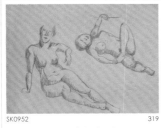

SK0952 319
坐姿與臥姿裸女速寫（10）
Seated and Reclining Female Nude Sketch (10)

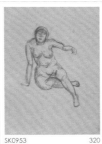

SK0953 320
坐姿裸女速寫（370）
Seated Female Nude Sketch (370)

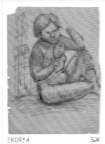

SK0954 320
坐姿裸女速寫（371）
Seated Female Nude Sketch (371)

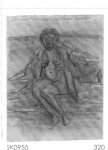

SK0955 320
坐姿裸女速寫（372）
Seated Female Nude Sketch (372)

SK0956 321
立姿裸女速寫（339）
Standing Female Nude Sketch (339)

SK0957 321
立姿裸女速寫（340）
Standing Female Nude Sketch (340)

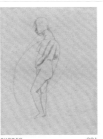

SK0958 321
立姿裸女速寫（341）
Standing Female Nude Sketch (341)

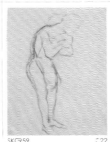

SK0959 322
立姿裸女速寫（342）
Standing Female Nude Sketch (342)

SK0960 322
立姿裸女速寫（343）
Standing Female Nude Sketch (343)

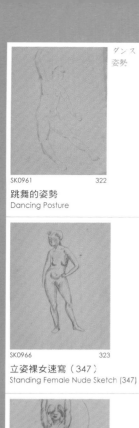

ダンス（跳舞）的
姿勢

SK0961 322

跳舞的姿勢
Dancing Posture

SK0962 322

立姿裸女速寫（344）
Standing Female Nude Sketch (344)

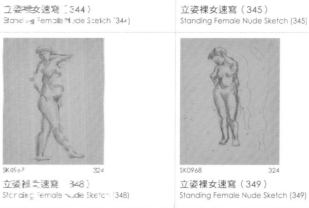

SK0963 323

立姿裸女速寫（345）
Standing Female Nude Sketch (345)

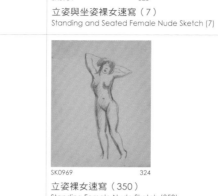

SK0964 323

立姿與坐姿裸女速寫（7）
Standing and Seated Female Nude Sketch (7)

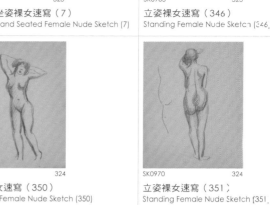

SK0965 323

立姿裸女速寫（346）
Standing Female Nude Sketch (346)

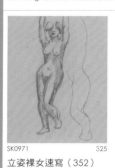

SK0966 323

立姿裸女速寫（347）
Standing Female Nude Sketch (347)

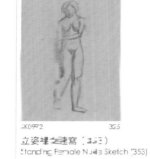

SK0967 324

立姿裸女速寫（348）
Standing Female Nude Sketch (348)

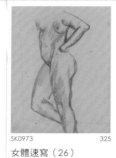

SK0968 324

立姿裸女速寫（349）
Standing Female Nude Sketch (349)

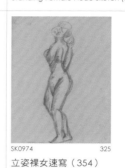

SK0969 324

立姿裸女速寫（350）
Standing Female Nude Sketch (350)

SK0970 324

立姿裸女速寫（351）
Standing Female Nude Sketch (351)

SK0971 325

立姿裸女速寫（352）
Standing Female Nude Sketch (352)

SK0972 325

立姿裸女速寫（353）
Standing Female Nude Sketch (353)

SK0973 325

女體速寫（26）
Female Body Sketch (26)

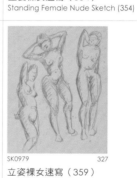

SK0974 325

立姿裸女速寫（354）
Standing Female Nude Sketch (354)

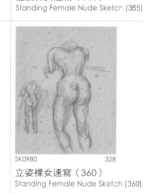

SK0975 326

立姿裸女速寫（355）
Standing Female Nude Sketch (355)

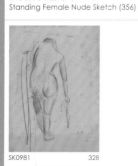

SK0976 326

立姿裸女速寫（356）
Standing Female Nude Sketch (356)

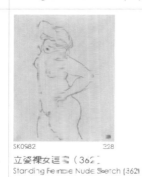

SK0977 326

立姿裸女速寫（357）
Standing Female Nude Sketch (357)

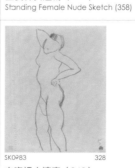

SK0978 326

立姿裸女速寫（358）
Standing Female Nude Sketch (358)

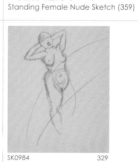

SK0979 327

立姿裸女速寫（359）
Standing Female Nude Sketch (359)

SK0980 328

立姿裸女速寫（360）
Standing Female Nude Sketch (360)

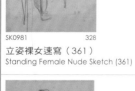
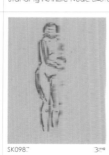

SK0981 328

立姿裸女速寫（361）
Standing Female Nude Sketch (361)

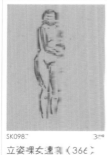

SK0982 328

立姿裸女速寫（362）
Standing Female Nude Sketch (362)

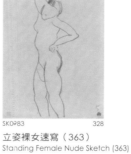
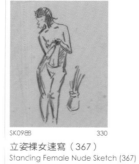

SK0983 328

立姿裸女速寫（363）
Standing Female Nude Sketch (363)

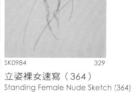
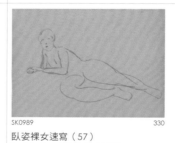

SK0984 329

立姿裸女速寫（364）
Standing Female Nude Sketch (364)

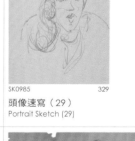
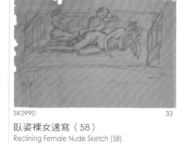

SK0985 329

頭像速寫（29）
Portrait Sketch (29)

SK0986 329

立姿裸女速寫（365）
Standing Female Nude Sketch (365)

SK0987 329

立姿裸女速寫（366）
Standing Female Nude Sketch (366)

SK0988 330

立姿裸女速寫（367）
Standing Female Nude Sketch (367)

SK0989 330

臥姿裸女速寫（57）
Reclining Female Nude Sketch (57)

SK0990 33

臥姿裸女速寫（58）
Reclining Female Nude Sketch (58)

SK0991 331

臥姿裸女速寫（59）
Reclining Female Nude Sketch (59)

SK0992 332

臥姿裸女速寫（60）
Reclining Female Nude Sketch (60)

SK0993 332

臥姿裸女速寫（61）
Reclining Female Nude Sketch (61)

SK0994 333

臥姿裸女速寫（62）
Reclining Female Nude Sketch (62)

SK0995 333

臥姿裸女速寫（63）
Reclining Female Nude Sketch (63)

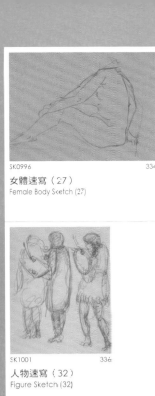

SK0996　　　334
女體速寫（27）
Female Body Sketch (27)

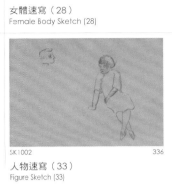

SK0997　　　334
女體速寫（28）
Female Body Sketch (28)

SK0998　　　334
頭像速寫（30）
Portrait Sketch (30)

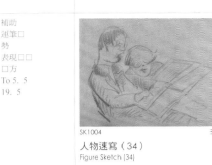

SK0999
女體速寫（29）
Female Body Sketch (29)

SK1000　　　335
立姿裸男速寫（10）
Standing Male Nude Sketch (10)

SK1001　　　336
人物速寫（32）
Figure Sketch (32)

SK1002　　　336
人物速寫（33）
Figure Sketch (33)

補助
運筆口
勢
表現口口
口方
To 5, 5
19, 5

SK1003　　　336
文字與線條
Words and Lines

SK1004　　　337
人物速寫（34）
Figure Sketch (34)

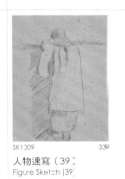

SK1005　　　337
人物速寫（35）
Figure Sketch (35)

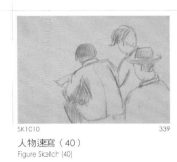

SK1006　　　338
人物速寫（36）
Figure Sketch (36)

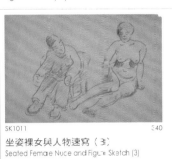

SK1007　　　339
人物速寫（37）
Figure Sketch (37)

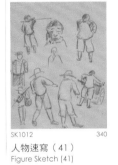

SK1008　　　339
人物速寫（38）
Figure Sketch (38)

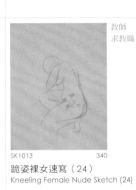

SK1009　　　339
人物速寫（39）
Figure Sketch (39)

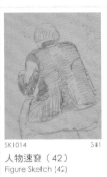

SK1010　　　339
人物速寫（40）
Figure Sketch (40)

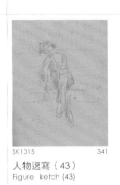

SK1011　　　340
坐姿裸女與人物速寫（3）
Seated Female Nude and Figure Sketch (3)

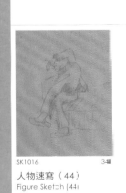

SK1012　　　340
人物速寫（41）
Figure Sketch (41)

教師
求教職

SK1013　　　340
跪姿裸女速寫（24）
Kneeling Female Nude Sketch (24)

SK1014　　　341
人物速寫（42）
Figure Sketch (42)

SK1015　　　341
人物速寫（43）
Figure Sketch (43)

SK1016　　　341
人物速寫（44）
Figure Sketch (44)

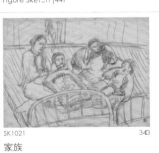

SK1017　　　341
人物速寫（45）
Figure Sketch (45)

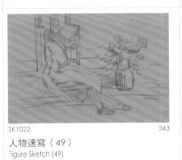

SK1018　　　342
人物速寫（46）
Figure Sketch (46)

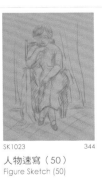

SK1019　　　342
人物速寫（47）
Figure Sketch (47)
下部

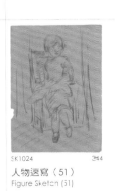

SK1020　　　342
人物速寫（48）
Figure Sketch (48)

SK1021　　　343
家族
Family

SK1022　　　343
人物速寫（49）
Figure Sketch (49)

SK1023　　　344
人物速寫（50）
Figure Sketch (50)

SK1024　　　344
人物速寫（51）
Figure Sketch (51)

SK1025　　　344
人物速寫（52）
Figure Sketch (52)

SK1026　　　344
人物速寫（53）
Figure Sketch (53)

SK1027　　　345
人物速寫（54）
Figure Sketch (54)

SK1028　　　345
人物速寫（55）
Figure Sketch (55)

SK1029　　　345
人物速寫（56）
Figure Sketch (56)

SK1030　　　345
人物速寫（57）
Figure Sketch (57)

SK1031　346
人物速寫（58）
Figure Sketch (58)

SK1032　347
人物速寫（59）
Figure Sketch (59)

SK1033　347
人物速寫（60）
Figure Sketch (60)

SK1034　347
人物速寫（61）
Figure Sketch (61)

SK1035　348
人物速寫（62）
Figure Sketch (62)

SK1036　348
人物速寫（63）
Figure Sketch (63)

SK1037　349
人物速寫（64）
Figure Sketch (64)

SK1038　349
人物速寫（65）
Figure Sketch (65)

SK1039　349
頭像速寫（31）
Portrait Sketch (31)

SK1040　350
人物速寫（66）
Figure Sketch (66)

SK1041　350
人物速寫（67）
Figure Sketch (67)

SK1042　350
人物速寫（68）
Figure Sketch (68)

SK1043　350
人物速寫（69）
Figure Sketch (69)

SK1044　351
人物速寫（70）
Figure Sketch (70)

SK1045　351
人物速寫（71）
Figure Sketch (71)

SK1046　351
人物速寫（72）
Figure Sketch (72)

SK1047　351
人物速寫（73）
Figure Sketch (73)

SK1048　352
人物速寫（74）
Figure Sketch (74)

SK1049　352
人物速寫（75）
Figure Sketch (75)

SK1050　352
人物速寫（76）
Figure Sketch (76)

SK1051　352
人物速寫（77）
Figure Sketch (77)

SK1052　353
人物速寫（78）
Figure Sketch (78)

SK1053　353
人物速寫（79）
Figure Sketch (79)

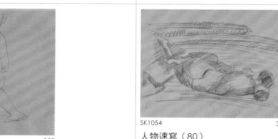
SK1054　353
人物速寫（80）
Figure Sketch (80)

SK1055　354
人物速寫（81）
Figure Sketch (81)

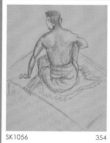
SK1056　354
人物速寫（82）
Figure Sketch (82)

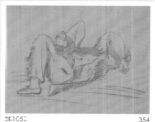
SK1057　354
人物速寫（83）
Figure Sketch (83)

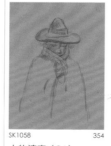
SK1058　354
人物速寫（84）
Figure Sketch (84)

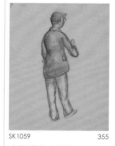
SK1059　355
人物速寫（85）
Figure Sketch (85)

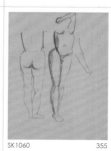
SK1060　355
女體速寫（29）
Female Body Sketch (29)

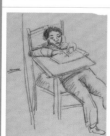
SK1061　355
人物速寫（86）
Figure Sketch (86)

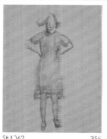
SK1062　355
人物速寫（87）
Figure Sketch (87)

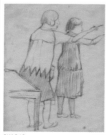
SK1063　356
人物速寫（88）
Figure Sketch (88)

SK1064　356
頭像與手部速寫（1）
Portrait and Hand Sketch (1)

SK1065　357
頭像與手部速寫（2）
Portrait and Hand Sketch (2)

SK1066　　　357
頭像與手部速寫（3）
Portrait and Hand Sketch (3)

SK1067　　　357
頭像速寫（32）
Portrait Sketch (32)

SK1068　　　357
頭像速寫（33）
Portrait Sketch (33)

SK1069　　　353
頭像速寫（34）
Portrait Sketch (34)

SK1070　　　358
頭像速寫（35）
Portrait Sketch (35)

SK1071　　　358
狗
Dog

SK1072　　　358
雞
Chicken

SK1073　　　359
馬
Horse

SK1074　　　359
靜物速寫（1）
Still Life Sketch (1)

SK1075　　　360
靜物速寫（2）
Still Life Sketch (2)

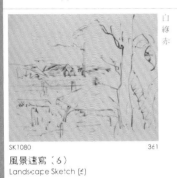

SK1076　　　360
靜物速寫（3）
Still Life Sketch (3)

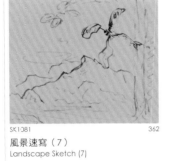

SK1077　　　360
靜物速寫（4）
Still Life Sketch (4)

SK1078　　　360
靜物速寫（5）
Still Life Sketch (5)

SK1079　　　361
風景速寫（5）
Landscape Sketch (5)

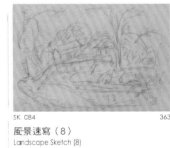

SK1080　　　361
風景速寫（6）
Landscape Sketch (6)

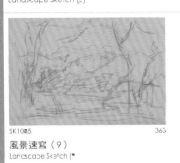

SK1081　　　362
風景速寫（7）
Landscape Sketch (7)

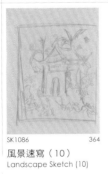

SK1082　　　362
山岳標高圖（1）
Elevation Profile of Mountains (1)

SK1083　　　362
山岳標高圖（2）
Elevation Profile of Mountains (2)

SK1084　　　363
風景速寫（8）
Landscape Sketch (8)

SK1085　　　363
風景速寫（9）
Landscape Sketch (9)

SK1086　　　364
風景速寫（10）
Landscape Sketch (10)

SK1087　　　365
合歡山
Hehuan Mountain

SK1088　　　365
風景速寫（11）
Landscape Sketch (11)

SK1089　　　366
風景速寫（12）
Landscape Sketch (12)

SK1090　　　366
風景速寫（13）
Landscape Sketch (13)

SK1091　　　367
風景速寫（14）
Landscape Sketch (14)

SK1092　　　367
風景速寫（15）
Landscape Sketch (15)

SK1093　　　368
風景速寫（16）
Landscape Sketch (16)

SK1094　　　368
風景速寫（17）
Landscape Sketch (17)

SK1095　　　368
風景速寫（18）
Landscape Sketch (18)

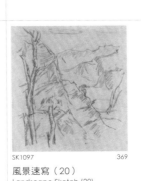

SK1096　　　369
風景速寫（19）
Landscape Sketch (19)

SK1097　　　369
風景速寫（20）
Landscape Sketch (20)

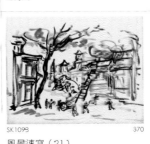

SK1098　　　370
風景速寫（21）
Landscape Sketch (21)

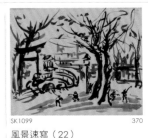

SK1099　　　370
風景速寫（22）
Landscape Sketch (22)

SK1100　37
風景速寫（23）
Landscape Sketch (23)

參考圖版

SK1101　374
新北投車站-34.12.22
Xinbeitou Station-34.12.22
新北投駅
1934.12.22

SK1102　374
街景速寫-34
Street Scene-34
1934 陳澄波

SK1103　374
羊群
Goats

SK1100　37
風景速寫（23）
Landscape Sketch (23)

SK1101　374
新北投車站-34.12.22
新北投駅

SK1102　374
街景速寫-34
Street Scene-34

SK1103　374
羊群

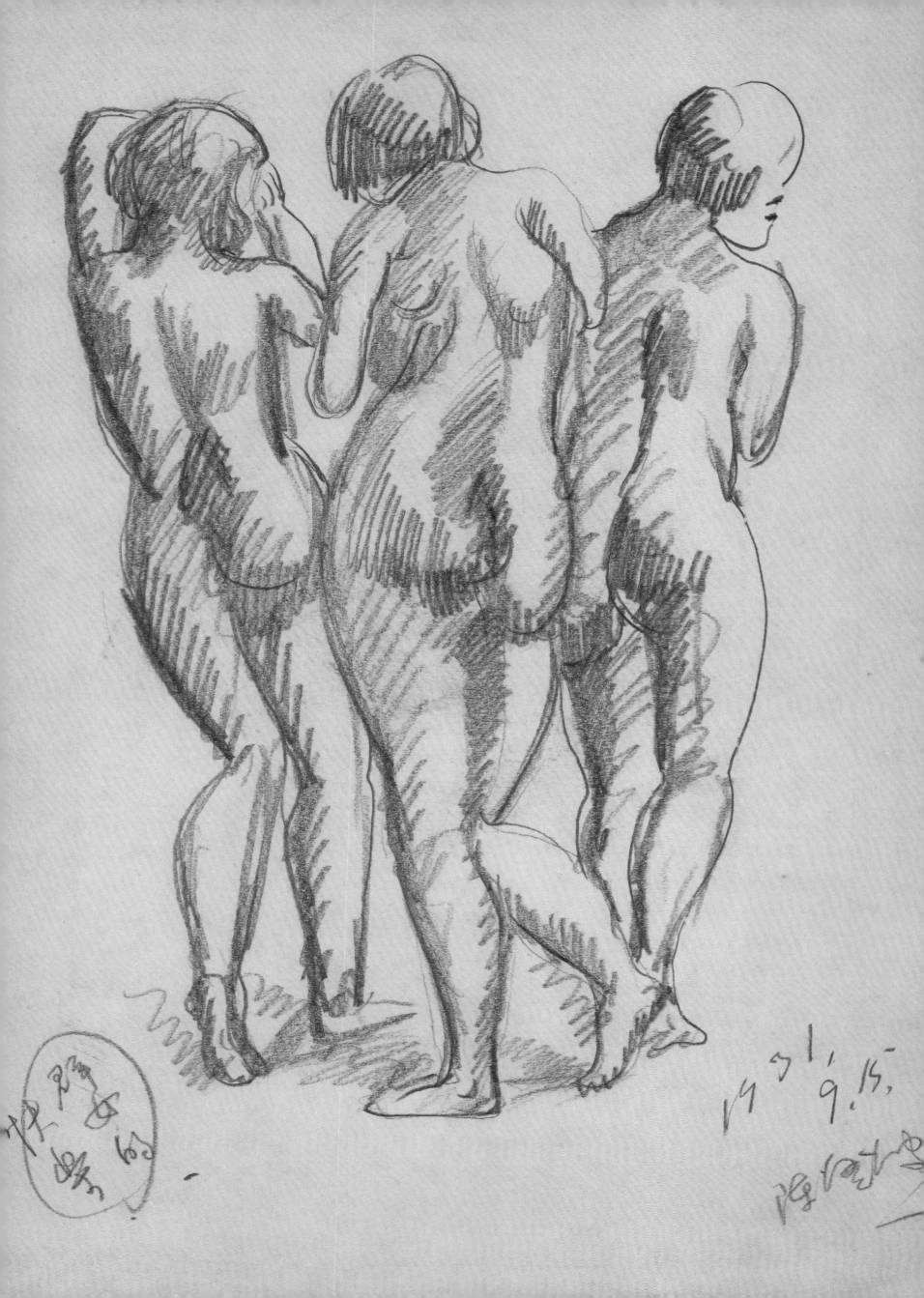

編後語

　　本卷收錄陳澄波約二10餘年的速寫作品，內容以裸女居多。有別於第五卷是畫在素描簿裡，本卷的作品均是畫在單頁紙上，有的甚至正反面都畫。這批速寫作品得以面世，最要感謝的是陳澄波妻子張捷女士；陳澄波過世後，這批速寫作品與其他畫作、文物，均被存放在嘉義蘭井街故居二樓，然而由於當時保存的環境並不理想，因此許多作品都留有蛀蟲啃食後的破洞。家屬曾戲言：這些速寫作品是被蟲吃剩下的！儘管如此，在當時艱困的環境下，能夠保留住千餘件速寫作品而沒有丟棄，亦是件不容易的事；因為比起油畫，速寫的重要性相對容易被忽略，卻由於張捷及家屬的費心保存，近年來又不計成本地一一修復，才能有今日為數可觀的速寫作品呈現在世人面前。

　　這批速寫作品約有一半沒有標註年代；編輯時，有年代的畫作按年代順序排列，年代不詳的，若可以大約判斷的，則插入那個年代之後，其餘則依類別置於最後。而年代不詳卻正反面都有畫作的，儘管屬於不同類別，編輯時為避免畫作分開，仍會將其排列在一起，並在反面畫作的圖說下方加註。

　　在畫名方面，由於這批速寫作品之前並無正式的作品名稱，為方便日後查尋，有書寫地點或落款者，以此為命名；無書寫任何名稱者，則依內容類型命名。此外，有年代日期的畫作，於名稱之後會再加入年代日期（但西元年的前兩個數字「19」省略），沒有的則不加；同一類型的作品依年代順序於名稱後再加入編號，如：1925年10月5日創作的第一件立姿裸女速寫，即命名為〔立姿裸女速寫-25.10.5（1）〕。至於同一天可能多達十幾件的畫作，有的陳澄波自己會編號，例如：1925年10月24日計有九張速寫，陳澄波就在落款時標註「1925.10.24 研1～研9」，編輯時就依陳澄波的編號排序。

　　要將上千件作品依序排列、分類、命名，是一件鉅大的工程，除了要檢視每張畫的落款並仔細記錄外，由於類別眾多，名稱編號一不小心可能錯編，就要重新順號；再加上計有高達500多張年代不詳的作品，其分類及排序更是耗費不少功夫，凡此都在考驗編者的耐心。然而看到原本雜亂無章的作品，開始有條不紊地呈現出來，心中的感動也是無以形容的。

　　《陳澄波全集》第四、五卷，總計收錄的速寫作品近2300餘件，從標記年代最早的一張水上公學校時期的手部速寫（頁40）到最後一張1945年12月3日的風景速寫（頁303）看來，陳澄波顯然從未間斷速寫的練習，可見其對速寫的重視。相信速寫不僅僅是在畫室中的練習之作，在那個相機尚不普及的年代，用畫筆隨手畫下的速寫，更是有著與相機相同的功能，是呈現畫家所見所聞和所到之處的風土民情的最真實紀錄；而有標記日期及地點的畫作，更可窺見陳澄波細緻的行蹤，對於陳澄波生命史的重建，具有不可取代的價值。

財團法人陳澄波文化基金會
研究專員　　賴鈴如

Editor's Afterword

In this volume are collected some 1,110 pieces of Chen Cheng-po's sketches, the majority of which are of nude females. Whereas the sketches in Volume 5 were drawn in sketchbooks, those in this volume were all drawn on single sheets and, in some cases, on both sides of a sheet. That these sketches can see daylight again owes much to Zhang Jie, Chen Cheng-po's wife. Upon the artist's demise, these sketches along with his other artworks and personal effects were all put away on the second floor of their Lanjing Street home in Chiayi. Unfortunately, the conditions of preservation in those days were far from desirable and holes left by bookworms were evident, so much so that one of Chen Cheng-po's descendants had once joked that these sketches were the leftovers of worms. Nevertheless, under the difficult situations of those days, it was not at all easy to keep more than a thousand sketches without throwing them away because, compared to oils, the importance of sketches could easily be overlooked. It is only with the wholehearted preservation by Madame Zhang and the descendants as well as the restoration efforts at all costs in recent years that such an appreciable number of sketches can be presented to the public today.

About half of these sketches are not dated. In compiling this volume, those dated are arranged chronologically. For the rest, if a date can be more or less determined, the sketch concerned will be inserted after the sketches of that year; or else they are placed at the end of different categories. Where there are sketches on both sides of a single sheet with an undetermined date, though the two sketches may be classified under different categories, they are placed together during editing and an explanatory note will be added below the caption of the sketch on the back.

As far as titles are concerned, since no formal title has ever been given to any of these sketches, for easy reference or search in future, if a location name or signature note is given, the sketch will be so titled. If there is no name of any sort, a sketch will be titled according to its category. Also, if a piece of work is dated, the date will be given after the title (but the first two digits of the year "19" will be omitted); if there is no date, nothing will be added. Works of the same category will be compiled chronologically and a serial number will be added after the category name. For example, the first standing nude female sketch drawn on October 5, 2015 will be titled *Standing Female Nude Sketch-25.10.5 (1)*. Sometimes when Chen Cheng-po made a dozen or so sketches on the same day, he would give his own serial numbers. For example, for the nine sketches he made on October 24, 1925, he put signature notes in the form of "1925.10.24 研 1~研 9". So in editing, these serial numbers are retained.

It is a considerable task to arrange more than a thousand artworks in order and to categorize and name them. Not only is it necessary to examine the signature note of each piece of work and record them carefully, it is also imperative that arrangements have to be error-free in spite of the large number of categories because one single error would require the re-assigning of serial numbers all over. Adding the fact that there are more than 500 undated works, the classification and arrangement are extremely time-consuming and contribute to trying the patience of the editor. Yet the reward is also beyond words when one sees the originally haphazard heap of artworks is being arranged in an orderly manner.

Roughly 2,300 sketches have been collected in the fourth and fifth volumes of *Chen Cheng-po Corpus*. Judging from the earliest dated sketch of a hand drawn during his Shuishang Public School period (p.40) to the scenery sketch dated December 6, 1945 (p.303), it is evident that Chen Cheng-po had never stopped practicing sketching, which is an indication of the high priority he gave to sketching. This was so not only because sketches were practices he carried out in his studio; in those days when cameras were not so common, sketching made quickly with drawing pens served the same function as cameras and were the truest records of local conditions and customs as seen through the artist's eyes. What is more, those artworks labelled with dates and locations allow a detail understanding of Chen Cheng-po's whereabouts and have therefore irreplaceable value in the reconstruction of his life history.

Researcher,
Judicial Person Chen Cheng-Po Cultural Foundation
Lai Ling-ju

Ling-ju Lai

國家圖書館出版品預行編目（CIP）資料

陳澄波全集. 第四卷. 速寫.1 / 蕭瓊瑞總主編.
-- 初版. -- 臺北市：藝術家出版；嘉義市：陳澄波文化基金
會；〔臺北市〕：中研院臺史所發行, 2016.02
　　面；37×26公分. -- (陳澄波全集；4)
　ISBN 978-986-282-178-7（精裝）

　1.素描 2.畫冊

947.16　　　　　　　　　105002856

陳澄波全集
CHEN CHENG-PO CORPUS
第四卷·速寫（I）
Volume 4 · Sketch（I）

發　　　行：財團法人陳澄波文化基金會
　　　　　　中央研究院臺灣史研究所
出　　　版：藝術家出版社
發 行 人：陳重光、翁啟惠、何政廣
策　　　劃：財團法人陳澄波文化基金會
總 策 劃：陳立栢
總 主 編：蕭瓊瑞
編輯顧問：王秀雄、吉田千鶴子、李淬鋒、李賢文、林柏亭、林保堯、林釗、張義雄
　　　　　張炎憲、陳重光、黃才郎、黃光男、潘元石、謝里法、謝國興、顏娟英
編輯委員：文貞姬、白適銘、林育淳、邱函妮、許雪姬、陳麗涓、陳水財、張元鳳
　　　　　張炎憲、黃冬富、廖瑾瑗、蔡獻友、蔣伯欣、黃姍姍、謝慧玲、蕭瓊瑞
執行編輯：賴鈴如、何冠儀
色彩管理：曾世豪
美術編輯：柯美麗
翻　　　譯：日文／潘襎（序文）、李淑珠　顧盼（圖版目錄）·英文／陳彥名（序文）、盧藹芹

出 版 者：藝術家出版社
　　　　　台北市重慶南路一段147號6樓
　　　　　TEL：（02）2371-9592～3
　　　　　FAX：（02）2331-7096
　　　　　郵政劃撥：01044793 藝術家雜誌社帳戶

總 經 銷：時報文化出版企業股份有限公司
　　　　　桃園市龜山區萬壽路二段351號
　　　　　TEL：（02）2306-6842
南區代理：台南市西門路一段223巷10弄26號
　　　　　TEL：（06）261-7268
　　　　　FAX：（06）263-7698

製版印刷：欣佑彩色製版印刷股份有限公司
初　　　版：2016年4月
定　　　價：新臺幣2600元

ISBN　978-986-282-178-7（精裝）

法律顧問　蕭雄淋
版權所有 · 不准翻印
行政院新聞局出版事業登記證局版台業字第1749號